THE KABBALISTIC TREE

DIMYONOT דמיונות
Jews and the Cultural Imagination

Samantha Baskind, General Editor

EDITORIAL BOARD
Judith Baskin, University of Oregon
David Biale, University of California, Davis
Katrin Kogman-Appel, University of Münster
Kathryn Hellerstein, University of Pennsylvania
Laura Levitt, Temple University
Ilan Stavans, Amherst College
David Stern, Harvard University

Volumes in the Dimyonot series explore the intersections, and interstices, of Jewish experience and culture. These projects emerge from many disciplines—including art, history, language, literature, music, religion, philosophy, and cultural studies—and diverse chronological and geographical locations. Each volume, however, interrogates the multiple and evolving representations of Judaism and Jewishness, by both Jews and non-Jews, over time and place.

OTHER TITLES IN THE SERIES:

David Stern, Christoph Markschies, and Sarit Shalev-Eyni, eds., *The Monk's Haggadah: A Fifteenth-Century Illuminated Codex from the Monastery of Tegernsee, with a prologue by Friar Erhard von Pappenheim*

Ranen Omer-Sherman, *Imagining the Kibbutz: Visions of Utopia in Literature and Film*

Jordan D. Finkin, *An Inch or Two of Time: Time and Space in Jewish Modernisms*

Ilan Stavans and Marcelo Brodsky, *Once@9:53am: Terror in Buenos Aires*

Ben Schachter, *Image, Action, and Idea in Contemporary Jewish Art*

Heinrich Heine, *Hebrew Melodies*, trans. Stephen Mitchell and Jack Prelutsky, illus. Mark Podwal

Irene Eber, *Jews in China: Cultural Conversations, Changing Perspectives*

Jonathan K. Crane, ed., *Judaism, Race, and Ethics: Conversations and Questions*

Yael Halevi-Wise, *The Multilayered Imagination of A. B. Yehoshua*

David S. Herrstrom and Andrew D. Scrimgeour, *The Prophetic Quest: The Windows of Jacob Landau, Reform Congregation Keneseth Israel, Elkins Park, Pennsylvania*

Laura Levitt, *The Afterlives of Objects: Holocaust Evidence and Criminal Archives*

Lawrence Fine, ed., *Friendship in Jewish History, Religion, and Culture*

Hassan Sarbakhshian, Lior B. Sternfeld, and Parvaneh Vahidmanesh, *Jews of Iran: A Photographic Chronicle*

The Kabbalistic Tree

האילן הקבלי

J. H. CHAJES

The Pennsylvania State University Press
University Park, Pennsylvania

This book was published with the support of the Israel Science Foundation.

Library of Congress Cataloging-in-Publication Data

Names: Chajes, J. H. (Jeffrey Howard), author.
Title: The Kabbalistic tree / J. H. Chajes.
Description: University Park, Pennsylvania : The Pennsylvania State University Press, [2022] | Series: Dimyonot : Jews and the cultural imagination | Includes bibliographical references and index.
Summary: "Explores the history and meanings of ilanot, diagrammatic representations of the Divine as a Porphyrian tree in Jewish mysticism and Kabbalistic manuscripts"—Provided by publisher.
Identifiers: LCCN 2022008561 | ISBN 9780271093451 (cloth)
Subjects: LCSH: Cabala—History. | Ilanot
Classification: LCC BM526 .C46 2022 | DDC 296.1/6—dc23/eng/20220526
LC record available at https://lccn.loc.gov/2022008561

Copyright © 2022 J. H. Chajes
All rights reserved
Printed in China
Book design & typesetting by Garet Markvoort, zijn digital
Published by The Pennsylvania State University Press,
University Park, PA 16802–1003

Second printing, 2023

The Pennsylvania State University Press is a member of the Association of University Presses.

It is the policy of The Pennsylvania State University Press to use acid-free paper. Publications on uncoated stock satisfy the minimum requirements of American National Standard for Information Sciences—Permanence of Paper for Printed Library Material, ANSI Z39.48–1992.

For William Gross, forester and friend

ועתה אשוב באר לך ענין האילן הידוע (נ״א הירִיעה המצוייה) אצלנו
Now I shall return to explain to you the matter of the tree, which is well known among us [other manuscripts: the parchment, which is (commonly) found among us].

Nunc vero declarandum est misterium arboris noti apud nos et in cuius scientia licet loqui.
Now we must elucidate the mystery of the tree, which is well known among us and about whose knowledge it is permitted to speak.

<div style="text-align: right;">

—R. Reuben Ṣarfati (fourteenth century),
Sha'ar ha-shamayim (Gate of heaven)

</div>

CONTENTS

Acknowledgments | ix
Abbreviations and Notes to the Reader | xiii

Introduction: A First History of a Forgotten Genre | 1

1 The Emergence of the Kabbalistic Tree | 9

2 Classical Ilanot | 37

3 Visualizing Lurianic Kabbalah 89

4 Ilanot 2.0: The Emergence of the Lurianic Ilan | 127

5 Luria Compounded | 201

6 Ilan Amulets | 291

7 The Printed Ilan | 307

Conclusion | 333

Appendix: Catalogue of the Gross Family Ilanot Collection | 347

Collector's Afterword, by William Gross | 363

Notes | 367
Bibliography | 405
Index | 425

ACKNOWLEDGMENTS

I am grateful to the many institutions and individuals who contributed to the research and writing of *The Kabbalistic Tree*. The Israel Science Foundation (ISF) has supported my ilanot-related research since 2008 (individual research grants 500–8; 85–11; 1259–14; 1568–18); funded two related advanced interdisciplinary workshops that I organized, "Text & Image in Religious Cosmography: Reading *Ilanot* and Parallel Artifacts" (July 2011, grant 1738/11) and "The Visualization of Knowledge in the Medieval and Early Modern Periods" (July 2016, grant 2147/15); and awarded this book a generous subvention award in 2020 (grant 79/21).

Basic research in an uncharted field is not a job for one scholar, and I thank the dedicated and erudite ISF-funded postdocs with whom I have worked over the years: Dr. Menachem Kallus (2008–15), Dr. Eliezer Baumgarten (2011–present), Dr. Uri Safrai (2019–present), and Dr. Hanna Gentili (2020–present). To Menachem I owe an extra measure of gratitude for having brought ilanot to my attention as he was writing the first descriptions of William Gross's collection. The project has benefited immensely from his profound knowledge of Kabbalah. Eliezer has worked intensively with me on this material for a decade. We have discovered it together and each of us on his own, in his own way. Eliezer's combination of knowledge, technical expertise, hard work, and humility make him the ideal collaborator. I thank him for generously allowing me to write this book on my own despite the fact that "under the hood" it was a joint effort. Eliezer and I welcomed Uri and Hanna to the Ilanot Project relatively recently; they brought new strengths and perspectives to the team. Uri's feedback on early drafts preempted errors and even provided inspiration. Hanna brought the Warburg—where she recently completed her PhD—to us: Latinity, philosophy, iconology, and even a bit of astrology.

This book has benefited from the digital humanities (DH) initiative of the Ilanot Project, "Maps of God," a Volkswagen Foundation–funded collaboration between our team and the DH lab at the University of Göttingen. The great classical ilanot have been marked up, transcribed, translated, sourced, and analyzed, and all the resultant metadata have been linked to high-definition images. This work has advanced research and deepened my knowledge of the genre in ways that directly affected the book. I encourage readers to explore the ever-growing library of ilanot appearing in digital scientific editions on www.ilanot.org. I also thank the members of the Göttingen team charged with building this unprecedented platform, directed by Dr. Jan Brase: Johannes Biermann, Alexander Jahnke, Christoph Kudella, and Uwe Sikora. Special thanks to Johannes for his invaluable assistance with a number of images that appear in this book.

My research benefited immensely from periods spent at the Herbert D. Katz Center for Advanced Judaic Studies at the University of Pennsylvania (2014, 2017), at the Israel Institute for Advanced Studies in Jerusalem (2014–15), and at the Forschungskolleg Humanwissenschaften at Goethe-Universität in Frankfurt (2016). My fellowships at the Katz Center bookend the period of research that culminated in *The Kabbalistic Tree*. The first took place during Prof. David B. Ruderman's last year as its visionary director. I thank David, my *doktorvater*, for over three decades of steadfast support. For the joys of my more recent tenure at the Katz Center, I thank its current director, Prof. Steve Weitzman, and associate director Dr. Natalie Dohrmann. The year spent in Jerusalem as part of the research group focusing on the visualization of knowledge in the Middle Ages and the early modern period was instrumental in expanding the horizons of my research. I thank Prof. Katrin Kogman-Appel for extending the invitation and its (then) director Prof. Michal Linial. Every page of this book testifies to the importance of the members of that group: Prof. Mary Carruthers, Prof. Adam Cohen, Prof. Yuval Harari, Prof. Katrin Kogman-Appel, Dr. Marcia Kupfer, Prof. Bianca Kühnel, Dr. Linda Safran, and Prof. Andrea Worm. Andrea and Adam also did me the extraordinary favor of reading the final draft of this book in its entirety and with great care. Linda did me the incredible kindness of taking on the job of editing it professionally. Last but not least, the summer spent in Frankfurt was particularly productive, and I thank Prof. Christian Wiese for having invited Dr. Julie Chajes and me to be fellows.

I also thank Prof. Sylvie-Anne Goldberg for her invitation to serve as visiting professor at the École des hautes études en sciences sociales (EHESS) in Paris (2018), during which I delivered a series of lectures on ilanot-related topics. Thanks to Prof. Miri Rubin for hosting my Erasmus+ visiting professorship at Queen Mary University of London in 2019, where I gave several public lectures as well. Prof. Pavel Sládek was kind enough to invite me to lecture on the ilanot at Charles University in Prague in 2015 and 2018. Finally, the 2019 Lehmann Memorial Master Workshop in the History of the Hebrew Book at the University of Pennsylvania was an important milestone, as it forced me to distill a decade of research into a twelve-hour panoramic master class. My thanks to Prof. Talya Fishman and Dr. Arthur Kiron for honoring me—and the topic—with the invitation.

Arthur, curator of Judaica Collections at Penn, also deserves gratitude for the assistance he has offered in that capacity. Arthur is one of many curators and librarians who have helped me repeatedly and graciously over the years. Others include Sophie Schrader at the Bayerische Staatsbibliothek; Dr. Cis van Heertum at the Bibliotheca Philosophica Hermetica; Heide Warncke at Bibliotheek Ets

Haim; Dr. César Merchán-Hamann and Dr. Rahel Fronda at the Bodleian; Dr. Ilana Tahan at the British Library; Michelle Chesner at Columbia University; Dr. Sven Limbeck of the Herzog August Bibliothek; Lenka Uličná and Eduard Feuereis at the Jewish Museum in Prague; Sharon Liberman Mintz at the Jewish Theological Seminary; Laurel Wolfson and Avigaille Bacon at the Klau Library of Hebrew Union College; Francesco Spagnolo at the Magnes Collection of Jewish Art and Life; Keren Barner and Naomi Greidinger at the University of Haifa; Dr. Yoel Finkelman, Yitzchack Gila, and Yael Okun at the National Library of Israel; Petra Figeac at the Staatsbibliothek Berlin; and Dr. Delio Proverbio at the Vatican. Rabbi Moshe Hillel and Hanan Benayahu also offered me unlimited access to the wonderful libraries of kabbalistic manuscripts that are entrusted to their stewardship.

I am indebted to those friends and colleagues who read drafts of this book and made valuable comments and corrections: Dr. Emma Abate, Dr. Julie Chajes, Peter Cole, Prof. Richard Cohen, Prof. Marc Michael Epstein, Dr. Symon Foren, Prof. Boaz Huss, Dr. Elly Moseson, Prof. Dov Stuczynski, and Prof. Joanna Weinberg. In addition to those mentioned above, friends and colleagues in the academic community who have graciously offered their assistance include Prof. Daniel Abrams, Prof. Avriel Bar-Levav, Dr. Naʿama Ben-Shachar, Prof. Gideon Bohak, Prof. Dagmar Börner-Klein, Prof. Jean-Pierre Brach, Prof. Giulio Busi, Menachem Butler, Prof. Javier Castaño, Dr. Evelien Chayes, Prof. Raz Chen-Morris, Prof. Lawrence Fine, Rabbi Elli Fischer, Dr. Peter Forshaw, Prof. Zeev Greis, Prof. Moshe Idel, Prof. Oded Israeli, Prof. Andreas Kilcher, Dr. Patrick Koch, Prof. Shaul Magid, Prof. Jonatan Meir, Prof. Ronit Meroz, Dr. Elke Morlok, Prof. Gerold Necker, Prof. Barbara Obrist, Prof. Judith Olszowy-Schlanger, Dr. Agata Paluch, Prof. Ada Rapoport-Albert, Prof. Elchanan Reiner, Dr. Zur Shalev, Prof. Jonathan Schorsch, Prof. Emile Schrijver, Prof. Yossef Schwartz, Prof. Moshe Sluhovsky, Prof. David Stern, Dr. Judith Weiss, Prof. Tzahi Weiss, Prof. Elliot R. Wolfson, Prof. Giuseppe Veltri, Dr. José Carlos Vieira, Prof. Rebekka Voß, and Prof. Martin Zwick. I also thank my students, Rabbi Asaf Fromer and Dr. Maximilian de Molière.

Grants provided by the Humanities Faculty and the Research Authority of the University of Haifa defrayed the costs of publishing the present work. I also thank Rabbi Scott N. Bolton of Congregation Or Zarua in Manhattan for making a generous earmarked contribution to Penn State University Press after his participation in the Lehmann Workshop.

The director of PSUP, Patrick Alexander, took immediate and enthusiastic interest in this book and has stewarded it through production with consummate professionalism. I am thrilled to have published with Penn State and to have benefited from its outstanding production team.

To my brothers, Richard and David Loring, love and gratitude for nearly six decades of having my back. To my children: Every one of you is a profound human being and a mensch. What a blessing to have five stellar kids, *tfu tfu tfu*. Ktoret Shalva, my beloved firstborn—your depth of feeling and integrity may at times make it hard for you to be in this world, but they also make me (among so many others) glad to be in this world with you. Levana Meira, how amazing you are as a talmidat ḥakhamim, an academic, a baker, a fiddler, a mother, and, last but not least, a phoenix. Keep up the good work! (But no need to practice resurrection again before 120.) Yoel Shlomo, Julius Jr., you are a star, and your light shines ever stronger. I so respect who you are "in all your 248 limbs and 365 sinews" and what you have accomplished already as an artist and a mensch. Nehora Sherei Leah, my baby girl—you are awesome; you [are my] rock.

Strong, emotionally intelligent, hard-working, musical, humble . . . what a package! My favorite thing will always be to [try to] spoil you. Yishai Zvi, you are sensitive, thoughtful, and brimming with good-heartedness. You rekindled the family fire with your shining soul. And you sing a mean *Anim zmirot*! I love each of you so much. And to Julie: you turned my world on with your smile . . . and it was all worthwhile. For all that has changed, I am grateful to have walked life's path with you.

Sefer yezirah §6 says of the sefirot, "their end is fixed in their beginning." Applying this notion to the ilanot brings me to the final acknowledgment. The curiosity of William Gross laid the foundation for this book, and his generosity has remained steadfast throughout its writing and publication. To William, visionary collector and good friend, my boundless gratitude and blessings for many years of good health and happiness with Lisa, your children, and grandchildren. To William, I lovingly dedicate *The Kabbalistic Tree*.

ABBREVIATIONS AND NOTES TO THE READER

Libraries and Private Collections

Cincinnati, HUC	Hebrew Union College—Jewish Institute of Religion, Klau Library
Jerusalem, IM	The Israel Museum
Jerusalem, NLI	National Library of Israel
London, BL	British Library
Moscow, RSL	Russian State Library
Munich, BSB	Bayerische Staatsbibliothek
New York, COL	Columbia University, Rare Book & Manuscript Library
New York, JTS	Jewish Theological Seminary
Oxford, BL	Bodleian Library
Parma, BP	Biblioteca Palatina
Paris, BnF	Bibliothèque nationale de France
Tel Aviv, GFC(T)	Gross Family Collection (Trust)
Vatican City, BAV	Biblioteca Apostolica Vaticana

Transliteration

I have followed the general transliteration rules found in the *Encyclopaedia Judaica*, 2nd ed. (Detroit: Macmillan Reference, 2007), 1:197. In the transliteration of Hebrew-titled works, only the first word and any proper nouns in the title are capitalized.

Translations

Biblical citations follow the New International Version (NIV) unless their plain sense was inappropriate in a particular instance. In such

cases, I have modified the translation accordingly. I have retranslated passages cited from the Hayman critical edition of *Sefer yezirah* as well as from other existing translations of primary sources. All translations of manuscripts are my own.

Lurianic "Great Tree" Type Abbreviations

Beginning in chapter 5, I make extensive use of abbreviations for the components of what I call "Great Trees," meaning rotuli composed of more than one originally independent Lurianic ilan. When the latter, which are introduced in chapter 4, are used in Great Trees, I refer to them as "modules"; I refer to other kabbalistic diagrams frequently used in Great Trees as "elements." For additional clarifications and a comprehensive key, see the "Great Tree Components Key" on p. 208.

A Note to Those Looking for More or *Less Than This Book Offers*

Were this a book about Euclidean diagrams, few readers without a background in geometry would expect to get much out of it. I nevertheless presume that many of my readers will hope—or even expect—this book to provide the background required to appreciate ilanot. Although I have written primarily for other scholars, I have not forgotten that many reading these lines are more interested in than educated in the subject. I have therefore made every effort to define terms when they first appear, to provide brief introductions to basic concepts, and to highlight fascinating points here and there with "Special Focus" sections. Those seeking deep dives into the ilanot that I introduce and analyze in the present book are encouraged to explore the interactive critical editions that my Ilanot Project digital humanities team, led by Dr. Eliezer Baumgarten, is publishing online incrementally at www.ilanot.org. These editions allow users to explore transcriptions, translations, and commentaries linked to high-resolution images of ilanot. Finally, speaking of images of ilanot: when an ilan has been presented in this book in segments, it is to be read from right to left. The top of any ilan pictured will be on the right.

Introduction

A FIRST HISTORY OF A FORGOTTEN GENRE

In the mid-sixteenth century, Guillaume Postel (1510–1581), Christian Hebraist and devoted student of Kabbalah, shared a list of "the secret accounts of sacred Hebraic writing" (secreti commentarii della scrittura sacra Hebraica) with his readers. Eight corpora made the list: the expected Zohar and *Bahir*, commentaries on the ten sefirot, and "*Raboth, Midras, Ialcuth, Tanchama,* [and] *Ilanoth*."[1] The learned Postel naturally included the central works of rabbinic *aggadah* alongside kabbalistic classics, given the widespread perception of the former as fundamentally esoteric. Commentaries on the sefirot, the divine categories or attributes at the heart of kabbalistic theosophical speculation, were also among the most ubiquitous works of the Kabbalah in its first centuries and thus a natural choice as well.[2] Only one term on Postel's list—*Ilanoth*—cannot be elucidated simply by consulting the *Encyclopaedia Judaica* in any of its editions, from which it is entirely absent.[3] There is nothing in the magisterial surveys of Jewish mysticism, either: Gershom Scholem's *Major Trends in Jewish Mysticism*, Moshe Idel's *Kabbalah: New Perspectives*, and Elliot R. Wolfson's *Through a Speculum That Shines: Vision and Imagination in Medieval Jewish Mysticism*, to name three of the most lauded and comprehensive works, make no mention of ilanot[h].[4]

This is the first book to be devoted to *ilanot*, a Hebrew word meaning "trees." An *ilan* is a cosmological iconotext inscribed on parchment. The term *ilan* (singular) refers both to the arboreal schema favored by kabbalists to represent the ten sefirot and, as a synecdoche, to the parchment upon which such an image is inscribed. Since the fourteenth-century kabbalists produced them, ilanot have never attracted the attention of modern scholars of Kabbalah. Even today, the genre remains an esoteric one.

How were ilanot, which rubbed shoulders with the Zohar and the *Bahir* in Postel's inventory of "the secret accounts of sacred Hebraic writing," entirely overlooked in modern research? As graphical visualizations of the Divine produced by Jews, they have at times been kept at some distance from the public eye. Their esoteric status in the Jewish community was not, however, what inhibited scholars from exploring them. The invisibility of ilanot in modern research is primarily the result of a deep-rooted bias against visual forms of knowledge. This bias blinded scholars of all disciplines well into the 1980s.[5] As a result, intellectual historians and historians of science ignored "epistemic images" throughout most of the twentieth century. Art historians also showed little interest in images—like diagrams—that were not art.[6] In Kabbalah research, this long era of neglect came to an end with the 2005 publication of *Qabbalah visiva*, in which Giulio Busi offered a pioneering survey of "visual Kabbalah."[7] The present book, distilled from a decade of study focused specifically on ilanot, tells the story of these artifacts for the first time.

An ilan is not a "tree of life"; nor is it a mythological motif or perennial symbol. It belongs to a genre whose name was borrowed from the arboreal schema signifying the Divine at its heart. The God being diagrammed is imagined at a considerable remove from the biblical God of Israel, creator of the universe, supreme and reigning above the innumerable ranks of divine beings. The Greco-Arabic conquest of Jewish thought in the Middle Ages brought with it theologies along a Platonic-Aristotelian spectrum, none of which accepted the God of scripture in the plain sense or the even more colorful deity conjured up in so many ancient rabbinic sources. God as Prime Mover or First Cause is utterly beyond cognition and description, but actions and attributes are God's interface with creation, and as such they can be known. These actions and attributes are systematized and susceptible to visualization, whether in the mind's eye or graphically inscribed.

Kabbalah, which emerged over the course of the twelfth and thirteenth centuries, embraced this philosophically informed theology. God, say the kabbalists, has two aspects: the utterly ineffable *Ein Sof* (lit., No End or Infinite) and the ten hypostatic sefirot, from *Keter* (Crown) to *Malkhut* (Kingdom). An ilan may show *Ein Sof* by the inscription of those very words, occasionally circled, on the blank parchment "beyond" the arboreal representation of the sefirot. I illustrate this with a ca. 1800 copy of a classical parchment (fig. 1). *Ein Sof* is in a half-blackened medallion, which I read as a symbolic signifier—it is not meant to resemble *Ein Sof* but, rather, to symbolize its impenetrability to human thought.[8] In the tree of ten sefirot, the name of each sefirah (singular) is written in bold script inside each of the circles, where it is followed by additional associated appellations. The channels that "network" the array are also captioned to indicate their directional flow and function. Lengthier pertinent texts are copied in the interstitial spaces closest to the diagrammatic representation of their subject matter.

Why image the Divine with an arboreal figure? First, the tree was a versatile diagrammatic device with widespread—albeit specialized—applications. It was an information graphic, akin to today's Venn diagram, ideally suited for mapping abstract relations of all kinds, including the family tree. The arboreal schema achieved preeminent status in the scientific treatises of the Middle Ages, particularly in works of natural philosophy in which it was deployed in Porphyry's commentary on Aristotle's *Categories* to visualize the scale of being (fig. 2).

Figure 1 | Classical ilan, Italy, seventeenth century. Ink on paper, 57.8 × 43 cm. Tel Aviv, GFCT, MS 083.011.002. Photo: Ardon Bar-Hama.

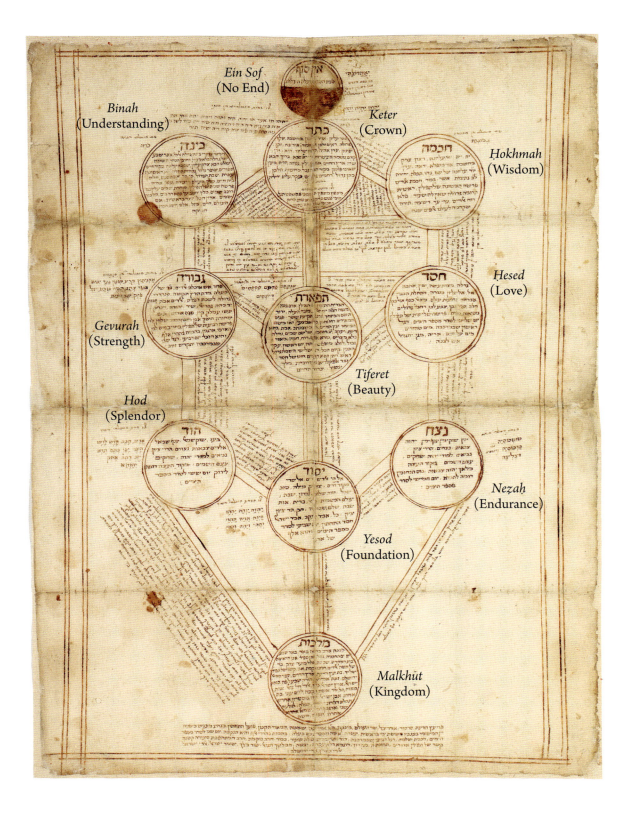

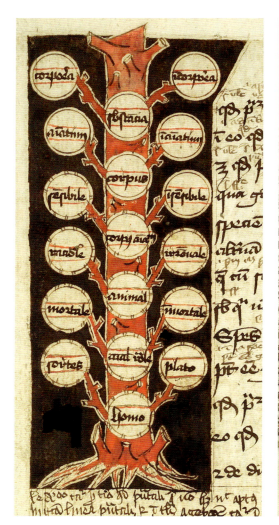 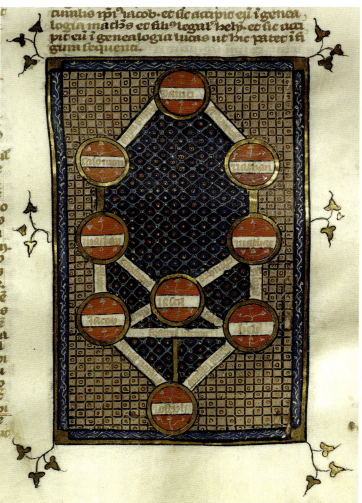

Figure 2 | Tree of Porphyry, fol. 116v, Peter of Spain, *Tractatus*, fifteenth century. Wolfenbüttel, Herzog August Bibliothek, Cod. Guelf. 800 Helmst.

Figure 3 | Tree of Jesse, fol. 122r, Nicolaus de Lyra, *Postilla on the Pentateuch and Gospels*, French, mid-fourteenth century. Princeton University Art Museum, MS Y1937-266.

The so-called Tree of Porphyry does so as a series of dichotomies that branch off of a central column with perfect symmetry.[9] The most abstract and general concept, Substance, is at the top, or crown, of the tree; then follow Body, Animate Body, Animal, and Man. The very same device conveniently mapped lineages as well (fig. 3). What might seem at first glance to be a kabbalistic tree of sefirot is actually a Tree of Jesse in a mid-fourteenth-century French manuscript. Representing the ancestry

of Jesus, it also provides a salutary warning that diagrams must not be interpreted on the basis of morphology alone.[10]

Why did the schema prove so congenial to the medieval kabbalists who appropriated it to visualize (mentally and graphically) the sefirotic expression of God? First, because the appropriation was consistent with the self-perception of kabbalists, who understood themselves as men of science, engaged in the pursuit of ḥokhmat ha-nistar, the occult science.[11] This perception was long validated by Europe's leading scientists, as the sustained attention of European savants from Marsilio Ficino to Isaac Newton to this "divine science" amply demonstrates.[12] It was thus no accident that, as they diagrammed the sefirotic divine structure, kabbalists availed themselves of trees and circles. These schemata were associated with natural philosophy and astronomy, the most prestigious scientific fields of the Middle Ages. Like astronomers, they treated—and attempted to visualize—the invisible.[13]

Trees, however, had an undeniable advantage over circles when it came to representing the Divine, and this is the second reason I believe the schema was ultimately embraced so extensively by kabbalists. Unlike the circles that signified the crystalline orbs they resembled (albeit in two dimensions), the arboreal schema was not an iconic signifier. When used to visualize concepts, from the scale of being to Virtues and Vices, the schema could easily contrast central and peripheral, primary and derivative, representing relations without actually resembling them. This ability to visualize without the assertion of morphological resemblance was an undeniably advantageous characteristic in a cultural setting that frowned on the iconic representation of the Divine. Relative *place* in a system could be shown without any implication of *space*. The kabbalistic tree could be, and was, plausibly defended as showing causal rather

than spatial relations.[14] The sefirotic Godhead was imaged using a schema with a prestigious scientific pedigree that bore no corporeal baggage.

It is telling that even after the near-canonical conflation of sefirotic structure with the arboreal schema, the latter were drawn with scientific austerity and not a trace of decorative phytomorphic embellishment. This stands in stark contrast to arboreal diagrams in the medieval and early modern Christian visual tradition from at least the

Figure 4 | Phytomorphic sefirotic tree, fol. 13a, *Booklet of Kabbalistic Forms*, Italy, 1578. Jerusalem, NLI, MS Heb. 8°2964. Photo courtesy of The National Library of Israel.

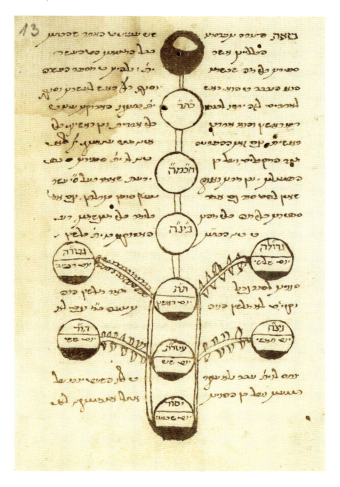

tenth century onward.[15] There are rare exceptions in kabbalistic manuscripts, but even in these, the representational embellishments are exceedingly subtle, as we may observe in a leafy sefirotic tree in an Italian manuscript dated 1578 (fig. 4).[16] One might argue that it is the phytomorphic enhancement of the diagrams that requires explanation rather than the reverse, given the disconnect between metaphor and schema. There is undeniable dissonance between the ascending roots-to-branches trajectory of the tree as a metaphor and the descending orientation found in most applications of the schema, whether used to show the chain of relations from ancestors to descendants or from *Keter* to *Malkhut*.[17]

Ilanot, then, picture the Divine as a tree of sefirot. A bit of background on the latter term is in order. The term *sefirot* did not originally refer to the ten constitutive hypostases of kabbalistic esotericism. The neologism appeared for the first time in the late antique cosmological work *Sefer yezirah* (Book of creation), where its primary signification was "things subject to counting."[18] The ten sefirot, i.e., things counted by *Sefer yezirah*, are far removed from theosophical Kabbalah, with which they can be reconciled only with stubborn determination. According to one passage (*mishnah*) in *Sefer yezirah*, the ten sefirot are the two vectors of time, which it calls "depth of beginning and depth of end"; the two vectors of value, "depth of good and depth of bad"; and the six directions of three-dimensional space, "depth of above and depth of below, depth of east and depth of west, depth of north and depth of south." According to another, the first four are the Spirit of the Living God, air from Spirit, water from air, and fire from water.[19] Its quasi-biblical status in the Kabbalah notwithstanding, *Sefer yezirah* must not be mistaken for a kabbalistic book.

Thanks to its multivocal Hebrew root *s-p-r* (ספר), the term *sefirah* carries a broad range of connotations and associations, from "story" and "thing written" to "sapphire." It also resonates with "sphere," even if not derived etymologically from the Greek *sphaira*.[20] In the hypostatic sense characteristic of sefirot's medieval transvaluation, some kabbalists understood them to be part and parcel of the divine essence (*'azmut*) and others as instruments of divine action (*kelim*). The latter was more theologically and philosophically defensible but was, over the *longue durée* of kabbalistic speculation, the less popular opinion. One thing, however, was a matter of universal consensus: thanks to the apodictic pronouncement of *Sefer yezirah*, "ten and not nine, ten and not eleven," it was axiomatic that there were ten sefirot and that the knowledge of their characteristics and pathways was the key to unlock the most profound secrets of nature and scripture.[21]

If the Porphyrian tree visualizes the incremental drilling down of ontological categories from the general to the specific, and the Tree of Jesse (or any genealogical tree) shows how an ancestral root could come to bear fruit, the sefirotic tree is the double helix of Kabbalah, underlying and generating the full panoply of reality. Not satisfied with a meager chain of being along Porphyrian lines, the kabbalists infused the tree with unprecedented implications of fractal fecundity, as we shall soon see. If its graphical image remained faithful to its natural philosophical origins, its mental image was more rhizomatic than arboreal. In performative contemplation, the kabbalist imbued it with aspects after and within aspects: it was endlessness encoded.[22] Such performance, anchored in the material image, was enacted in "the intermediary plane positioned between the spiritual and the corporeal."[23]

Kabbalah has many secrets but little mystery. For this reason more than any other, most

kabbalists would have recoiled at the thought of being considered mystics.[24] They often conceived of the sefirotic tree mechanistically, in technical terms we typically associate with the hard sciences: a kind of hydraulic system of networked hubs, each dominated by one essential quality but containing all ten. The ten sefirot are interconnected by *ẓinorot* (channels) through which *shefa*, divine abundance, flows. Any aspect of reality can be read as the expression of a unique recombination of a *shefa* trajectory within the tree. No less important is the presumption that the tree is the dynamically responsive substratum of reality. This is the meaning of theurgy in the kabbalistic context: the belief that human action—including thought—affects the operation of this underlying structure. *Tikkun*, the rectification or enhancement that is the ultimate goal of human activity informed by kabbalistic ideals, is fundamentally the intentional contribution to the restoration of the integrity of the sefirotic tree. Rather than relate to *tikkun* in the general terms we commonly encounter today—think positively and the universe will respond in kind—kabbalists demanded of themselves to live in accordance with a rigorous regimen attentive to every act and its intended consequence. Jewish life in all its detail was a laboratory. Scientists who work in laboratories are charged with carrying out their work with precision; the subjective experience of the technician is rarely salient to lab work, the processes and results of which are objective. Kabbalistic discourse is characterized, with few exceptions, by just such an approach to the Divine and its *tikkun*. The structure of the Divine—a turn of phrase that tellingly titles the earliest systematic kabbalistic treatise, *Ma'arekhet ha-elohut*—is known, as is the work that needs to be done for its maintenance, repair, and enhancement. To scroll through an ilan inscribed on a parchment roll is mimetic: it is to enact the intradivine emanation in its ideal state. The mimesis that adheres to the specific material text of the ilan only amplifies Wolfson's assertion that "a key to the dynamics of the kabbalistic aesthetic is that the one who imaginatively contemplates the sefirotic emanations emulates the divine process of autogenesis."[25]

An ilan may map the actual relational or ontological structure of the Godhead and be a tool deployed to effect its *tikkun*. As it does so, it leverages the diagrammatic potential of its schemata to facilitate the organization, representation, and production of knowledge. Its nonlinear texts are read vis-à-vis these schemata.[26] Unlike a conventional treatise, the ideational content of an ilan is represented spatially in a manner that reveals complex but ordered fields of meaning. The spatial presentation is key to its mnemonic and pedagogic utility, encouraging, as it does, the absorption of content inscribed *in loco*. This process should not be mistaken for one prioritizing passive memorization. From execution to enactment, the kabbalistic tree does not merely display information but produces the knowledge it draws.[27]

We are not talking merely about an alternative vehicle for the transmission and generation of knowledge, however, for the ilan is, perhaps more than anything, a devotional instrument. Kabbalists, like all traditional Jews, pray three times a day. Rather than change the liturgy, kabbalists augment it with *kavanot* (intentions), which in this context means mapping its elements to the sefirotic tree. For the words of prayer to do their work, they must be intended with the appropriate sefirah in mind. R. [Rabbi] Moses Cordovero (1522–1570), the greatest kabbalist of sixteenth-century Safed until his death (and arguably beyond it), validates the ilan as the form of the sefirot to be visualized in the act of prayer. "The kabbalists," he writes, "have drawn ilanot and engraved them as forms. These forms have been established in the hearts

of beginners so that when they intend any of the intentions of prayer . . . they inevitably intend [and picture] the sefirot one above the other and one beside another."[28] Cordovero expresses some misgivings about this seeming corporealizing of the Divine before offering the reassurance that the ilan, like so many other accoutrements of Jewish ritual, is "a body to clothe spiritual reality."

The ilan thus serves devotional ends: an image presumed to make its referent immanent and to invite the contemplative on a journey of imaginal pilgrimage. As we will see, in the medieval kabbalistic imagination the ilan was nothing less than the esoteric image of the Tabernacle, a structure designed to facilitate divine presence.

I have thus far painted the ilan in broad brushstrokes befitting a variety of kabbalistic opinions and schools of thought. Increasing the order of magnification by a step, let us now divide ilanot into two inclusive categories: those visualizing the cosmology of the classical Kabbalah and those visualizing that of Lurianic Kabbalah, referring to the bodies of knowledge associated with R. Isaac Luria (1534–1572). A "classical ilan" images—and thereby makes present—the Divine by mapping it with an arboreal schema. A Lurianic ilan, tasked with visualizing the dynamic emanatory emergence of an exponentially more complex Divinity, retains the tree as a fundamental structure, but rather than map the topography it signifies, the Lurianic ilan presents it as a process in motion. The fundamental difference between classical and Lurianic ilanot may thus be characterized as akin to that between a synchronic map and a diachronic timeline.[29]

Although ilanot may be likened to maps or timelines, they are laden with substantially more text than we associate with either. Texts are inscribed in the sefirotic medallions and the channels that run between them, in the areas carved out within the arboreal figure, and in the remaining marginal space. No less important is the nature of the relationship between the image and text of an ilan: the two are mutually interdependent. Together, and *only* together, they establish the meaning of an ilan. In this sense ilanot are quintessential "iconotexts," a term referring to a work in which image and text form an inseparable totality.[30]

Finally, rather than presenting idealized abstractions of timeless perfection, ilanot present us with expressions—often cluttered and messy—of over half a millennium of cosmological visualization. This visualization and drawing took place in cultural contexts as varied as Italy, Spain, and the Byzantine Empire; western, central, and eastern Europe; Morocco, Tunisia, and Yemen; Iraq and Kurdistan. The particular cultures of these diverse locales lent distinctive color to the ilanot that their kabbalists produced. Kabbalists were also part of a diasporic network that brought them into contact with teachers, texts, and traditions from elsewhere. The negotiation among local esoteric traditions, aesthetics, conventions of representation, and the knowledge introduced by a never-ending flow of newly arrived wandering Jews, many bearing manuscripts and printed books, is often recognizable in the eclectic diversity and organization of materials in a given ilan.

Chapter 1

The Emergence of the Kabbalistic Tree

Metaphor, Schema, Genre

In the beginning—and ever since—kabbalists drew diagrams. Most were epistemic images intended to clarify the texts beside which they appeared.[1] For all the importance of the medium in the constitution of the ilanot genre, this genre would not exist were it not for the older, ongoing tradition of visual thinking and diagrammatic drawing among kabbalists. The images drawn by kabbalists to visualize their lore were in the repertoire of those who made ilanot. The arboreal schema may gradually have assumed pride of place, but concentric circles, tables, and a broad range of schemata were called upon.[2] An examination of early kabbalistic diagrams does more than introduce us to the iconographic repertoire of the kabbalists, however; it affords an opportunity to appreciate the significance of metaphor and medium in the constitution of the genre.

Even if appropriated from medieval science, the arboreal device was—and is—a tree, and the question of its possible relation to the trees of folklore, mythology, and religion must at least be raised. Early kabbalists retained the ancient biblical and rabbinic presumption that it was the human form that principally expressed the likeness of God.[3] The two options were, of course, compatible. "How do we know that a person is called a tree," asks R. Yehudah in the Zohar (III:24a)? The answer is derived from Deuteronomy 20:19: "for a person is a tree of the field."[4] The interchangeability of human and tree in the rabbinic imagination facilitated their implied conflation in the kabbalistic tree, in which we often see body parts labeled alongside sefirotic names or the tree as a whole "sitting" upon a representation of the Throne of Glory.[5] Divine-human-tree is, then, an isomorphic triangle in Jewish tradition. In the first centuries of kabbalistic creativity, the tree was nevertheless only one metaphor among many used to imagine

the Godhead. When invoked, the emphasis was squarely on fruitfulness rather than structure.

Jews were certainly intimately familiar with legends of the trees (or, according to some rabbis, the single tree) of the Garden of Eden. As the Genesis story has teased its readers for millennia, to eat from the tree of life is to become like God. Jews were undoubtedly fascinated by this foundational account, not least by the questions it raised about human potential. I would nevertheless submit that the Jewish exegetical tradition was more interested in the moral questions raised by the story than by any particular obsession with the tree(s) as such. When the rabbis of the Talmud argue over the variety of tree from which Adam and Eve had eaten, their three answers—grape, fig, and wheat [sic]— are no more than springboards for homiletic statements.[6] The tree of life looms more prominently in Christian than in Jewish religious imagination; according to the well-known legend, the wood of the Cross was fashioned from its lumber.[7] This association may have contributed to the undeniable and disproportionate attention to the kabbalistic tree among those Christians who took an interest in Kabbalah over the centuries.[8] As I will now show, the kabbalists used arboreal metaphors without conflating them with the arboreal schema, even when metaphor and diagram appear side by side. If there was a Jewish tradition of the tree of life that ultimately emerged as the kabbalistic tree, they knew nothing of it.[9]

Ilanot deploy the visual language and diagrammatic repertoire of the kabbalistic milieu in which the genre emerged. It is telling that the two oldest kabbalistic manuscripts that survive, copied in 1284 and 1286 from Spanish manuscripts that had reached Italy not long before, preserve a number of diagrams, and freestanding ones at that.[10] The notion that an inscribed diagrammatic image could constitute an independent work in its own right thus goes back to the beginning. Even though these miscellanies present an eclectic selection of esoteric works, rather than clarifying passages in the treatises, the diagrams have been copied in the spaces between them.

A diverse range of schemata is on display in these manuscripts. In the 1284 codex, we find the ten sefirot configured as a wagon wheel (fig. 5). Very nearly in the locations we later come to expect them, this visualization of the network places eight sefirot on the outer rim, symmetrically arrayed, with the remaining two in the center and on the vertical spoke below it. The sefirah of *Tiferet* (Beauty) is at the axis point, signaling its special status in the theosophical doctrine of the kabbalist who fashioned it. *Malkhut*, the lowest sefirah, seems intentionally bottom-weighted at six o'clock; it too was fundamentally different from the others. All the medallions are inscribed with the common theosophical names of the sefirot, to which the names of their respective associated biblical patriarchs have been added. The circular morphology of the schema was likely meant to evoke an axiomatic phrase of *Sefer yeẓirah* (§6), "their end is fixed in their beginning."

The 1286 codex, for its part, features two rotae, or circle diagrams, of the sefirot. These two diagrams became widely known due to their inclusion in the foundational treatise *Meirat 'einayim* (Enlightening of the eyes), composed by the renowned kabbalistic R. Isaac of Acre (late thirteenth to mid-fourteenth century). The first is designed to expose the correspondences among the sefirot, the Ten Commandments, the planetary spheres, the human body, and the ten "utterances of Creation" (fig. 6).[11] These correspondences could have been made plain by a simple table. The diagram *is* a table, but it

Figure 5 | Sefirotic wheel, fol. 35a, kabbalistic miscellany, copied in Italy, 1284. Paris, BnF, MS hébr. 763.

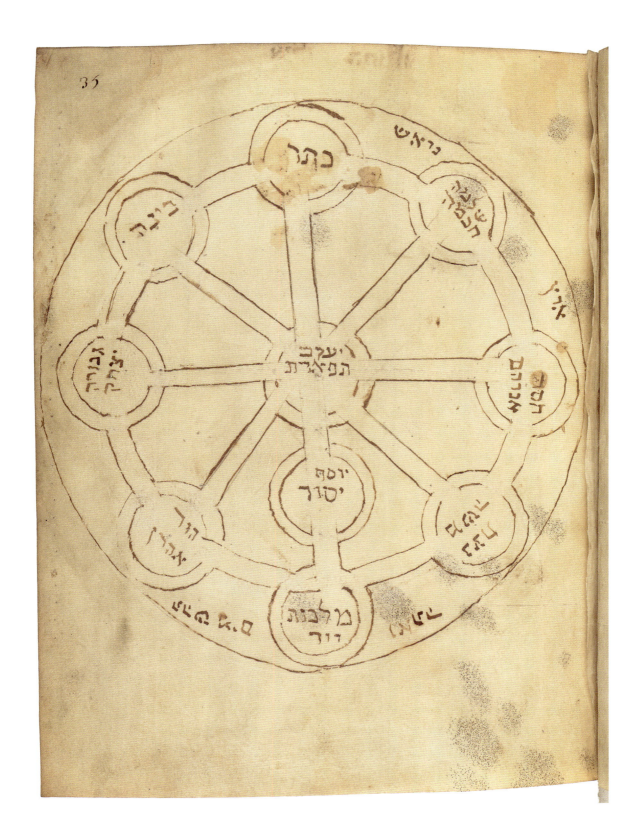

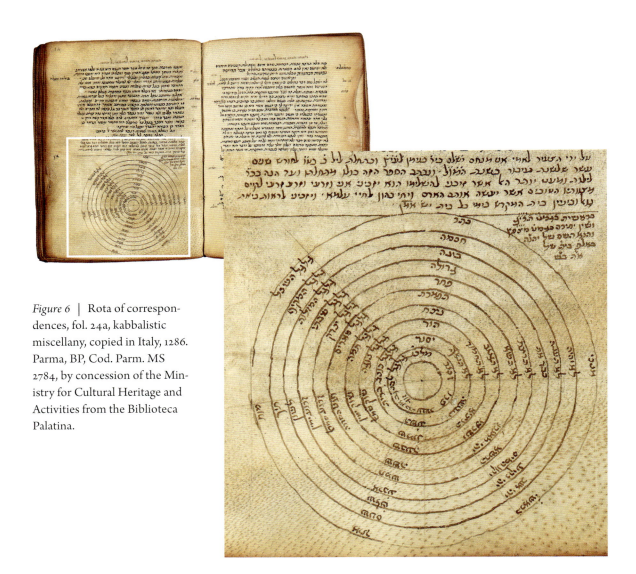

Figure 6 | Rota of correspondences, fol. 24a, kabbalistic miscellany, copied in Italy, 1286. Parma, BP, Cod. Parm. MS 2784, by concession of the Ministry for Cultural Heritage and Activities from the Biblioteca Palatina.

has been reformatted as a rota calculated to conjure up the image of the celestial spheres. This connotation reveals the implication of the sefirot in the very structure of the cosmos alongside the other "tens" that govern reality. Although a rectangular table would have been easier to study, the message conveyed by the schema was of no less significance than the data it organized.[12]

The second diagram takes a more iconic approach to representing the sefirot as the cosmic spheres (fig. 7). At first glance, the reader may wonder what on earth I mean. A closer look will reveal that each of the nested shapes is a Hebrew letter, the initials of each of the ten sefirot. The outermost is the *kaf* of *Keter*, the innermost the *mem* of *Malkhut*. The placement of the letters as well as

many of their shapes is meant to suggest circularity, or even sphericity.[13] The kabbalists were fond of a metaphor they picked up from astronomers that likened the structure of the cosmos to the skins of an onion. This is the oldest graphical visualization of that kabbalistic appropriation, and it went on to become one of the most widely reproduced in the history of Kabbalah.[14] We will see it in Lurianic ilanot discussed below.

The two miscellanies share one diagram in common, captioned "Ilan ha-ḥokhmah" (Tree of wisdom/science) (fig. 8). When I first saw it, it reminded me of Darwin's tree of evolution rather than of a variation on—or precursor of—the sefirotic tree. Indeed, it is not a sefirotic tree, at least not in the kabbalistic sense of sefirot. This "Ilan ha-ḥokhmah" is, rather, a visualization of the cosmological core of *Sefer yezirah*.[15] Two passages in *Sefer yezirah* account for most of its details:

Figure 7 | Concentric sefirotic acrostics, fol. 43b, kabbalistic miscellany, copied in Italy, 1286. Parma, BP, Cod. Parm. MS 2784, by concession of the Ministry for Cultural Heritage and Activities from the Biblioteca Palatina.

§16 These are the ten sefirot of *belimah*:[16] *one*, the Spirit of the Living God; *two*, air from Spirit; *three*, water from air; *four*, fire from water; and [five through ten,] the height above and below, east and west, north and south. . . . §47 Twelve diagonal lines, radiating out to the six faces (of a cube), separating in each direction:—the south-eastern line, the upper eastern line, the lower eastern line, the lower northern line, the north-western line, the upper northern line, the lower western line, the upper western line, the lower western line, the lower southern line, the upper southern line. And they expand continually for ever and ever and *they are the arms of the universe* (cf. Deut. 33:27).[17]

The diagram, meant to be read from the bottom up, begins with a circle/sphere divided into ten and labeled "it is one." As the inscription just above it confirms, this is the one of "one, the Spirit of the Living God." As the fount of all, the ten sefirot exist in potentiality within this sphere; thus its internal division. The node just above it on the central axis is labeled "air from Spirit." The other elements and their derivations, "water from air" and "fire from water," are inscribed below the lower and upper horizontal lines of the central figure. These are the first four "counted things," or sefirot, as the term is used in *Sefer yezirah* §16. The other six sefirot are the six facets of cubic space: "the height above and below, east and west, north and south." These infinitely extending vectors are also inscribed under the heading "the six ends." The sefirot of "Ilan ha-ḥokhmah" thus have nothing to do with sefirot in the kabbalistic sense of the term. Not surprisingly, "Ilan ha-ḥokhmah" never entered the diagrammatic repertoire of later kabbalists.

Though it bears no evident trace of kabbalistic theosophy, "Ilan ha-ḥokhmah" is the earliest extant visualization of an esoteric tree in Jewish sources.

תלונת [אסירה]

הנני דמע לחבוש לעשיה מן הכבוד
זהו הרב מן העו׳ ונבנו על הדברים
התחתונים שהם תכמה וכונה וכונה זה
מתעלה לעעלה מן הרב והע׳
וענין בהן גדול ומעם
מיימינו וראש כי דאיב משמאלו
דמע לרוגעה שלמעלה והמן
וכל אב דמע לחב׳ נמ׳
שכן נאל משה ממעלה אל
ה׳ ברד רתמי הרב מרדכיון
אמ לעעלה עלה לג שנקרא מ׳
מרד לילה והוא המלאך השר
עליו ט שמי כקדרני׳ נך הש׳
העעה וידאו את אלהי ישר דמע
לנו נחר שתחתיו כמעל ועמ׳
ושלהב מלאך איה השרך לעעלה
על נן ממא אין פתר הלבוש
אל השליח ממה׳ כן הם פום של
עשה לבלות העויבים והוא הרב
נאחר כן שעה פני ילבן והשתן
לן כלעומ׳ אבל העויבים אתריב
להט התרב המהפכתיב בב זה
יצר הרע שמונע כל השומע
אלו מלאכות לבוא בדרך עץ
התייתי׳ זהו הרב וזהו צבור המיים
וזהו השמור דרך עץ התיים
למעל והרב יפרש לגיהנ׳ לנפש
משוינות ברורה בצרור התיים
שהיא מפתקליהא המאירה
אמן סלה

Understanding its visual language thus remains well within the mandate of the present chapter and promises to sensitize us to the possible ways in which such figures do their work. A few bullet points suffice to demonstrate that a close reading of the tree is rewarded by insights with surprisingly broad implications.

- The oddly shaped central figure is a cuboid (a cubic shape with edges of unequal lengths) *in plano*, i.e., as it appears when flattened out into a single surface. Its twelve straight lines are its edges. The eight lines that radiate from its central node establish its eight vertices. These lines from center to corners are not the static objects of modern geometry. They are, rather, the tracings of movements in time, in keeping with premodern Neoplatonist geometries that defined lines as unfolding from a single point.[18]
- Although the central figure has the vertices and edges of a cuboid, it has only five faces. This it shares with other medieval planar representations of cubic figures, as exemplified in the beautiful "Heavenly City" images associated with Beatus manuscripts of medieval Spanish provenance, which typically leave the sixth face open. This open sixth face is our vantage point from above.[19] It should also be noted that "east" has been assigned to the top of the planar image. This mapping of *Sefer yeẓirah* thus shares the orientation of the *mappae mundi* of its period, including the Hereford Map made around 1300.[20] The centering of Jerusalem on such *mappae mundi* may also have its parallel here in the central node that establishes the "Z" axis of above and below.
- For all its resemblance to a flattened takeout container, the central figure does not fold into a cube with equal edge lengths, either as a mental exercise or when printed on paper and physically manipulated. If its vertices and edges were intended to suggest cubicity, its shape seems to be a representational allusion to the divine throne. The image may thus have been inspired by *Sefer yeẓirah* (§4), "set up the thing on its proper place and return the Creator [yoẓer] to his throne [mekhono]."
- *Sefer yeẓirah* divides the Hebrew alphabet into three groups: three "mother" letters, seven "doubled" letters, and twelve "simple" letters. Each finds indexical expression in the diagram. The group of three corresponds to the three labeled elements of air, water, and fire.[21] The seven "doubles" seem to be the primary referent of the seven-branched tree with its doubled nodes.[22] The twelve "simples" correspond to the edges of the cube.
- The seven-branched tree growing out of the cube displays precisely sixty-eight nodes.[23] The importance of this detail was clear to the copyists, who reproduced it with uncanny accuracy. Furthermore, five nodes play no role in the establishment of the cube: two have been added beside those at the ends of the lower horizontal line, a third at its center, a fourth on the "air from spirit" line, and the fifth at the center of the lower sphere. The sum of sixty-eight plus five is thus encoded in "Ilan ha-ḥokhmah." The gematria (numerical value) of ḥokhmah is, in turn, seventy-three. The correspondence between this indexical feature of the diagram and the gematria of ḥokhmah is signaled by the hash marks added

Figure 8 | *Ilan ha-ḥokhmah* (Tree of wisdom/science), fol. 94a, kabbalistic miscellany, copied in Italy, 1286. Parma, BP, Cod. Parm. MS 2784, by concession of the Ministry for Cultural Heritage and Activities from the Biblioteca Palatina.

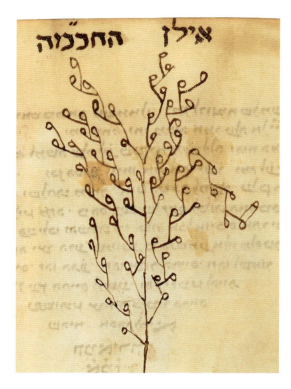

Figure 9 | *Ilan ha-ḥokhmah* (Tree of wisdom/science), fol. 34b, kabbalistic miscellany, copied in Italy, 1284. Paris, BnF, MS hébr. 763.

above the word as it titles the Paris diagram (fig. 9).²⁴

Bringing these disparate insights together reveals the "Ilan ha-ḥokhmah" to be a sophisticated visualization of the core cosmology of *Sefer yeẓirah*. Neoplatonist geometries are cleverly combined with iconic and indexical signifiers to form a single integrated image. The ambition of "Ilan ha-ḥokhmah" brings Ramon Llull's 1295 work of the same name, *Arbor scientiae*, to mind.²⁵ Llull's well-known treatise relies on diagrammatic illustrations.²⁶ Gerhart Ladner's characterization of Llull's trees might describe "Ilan ha-ḥokhmah" as well: "not merely logical schemata . . . [they were] also and above all ontological representations: they symbolize the grades of being."²⁷ The similarity may bespeak familiarity or, at the very least, betray the workings of kindred Spanish spirits.²⁸ Although it is not a kabbalistic tree, an understanding of "Ilan ha-ḥokhmah" sheds light on the ways that esoteric cosmology was graphically encoded in the milieu within which the hypostatic theosophical sefirotic system was then consolidating.

The earliest kabbalistic tree—albeit imagined rather than drawn—is the demiurgic All-Tree of the *Bahir*, a twelfth-century Provençal text that predates fully articulated sefirotic theosophy. In the *Bahir*, God (!) describes the tree he has planted: "It is I who have planted this tree [ilan] that the whole world may delight in it. With it, I have spanned the All, [and] called it '*Kol*' (All), for on it depends the All and from it emanates the All. All things need it and look upon it and yearn for it, and it is from it that all souls fly forth. I was alone when I made it, and no angel can raise himself above it. . . . Who was there with me to whom I would have confided this secret?"²⁹ This astonishing text in no way alludes to the sefirot. Another *Bahir* passage, however, appears to understand the All-Tree in terms suggestive of a sefirotic array: "'What is this tree [ilan] of which you speak?' He responded, 'All of the powers of the Blessed Holy One are one atop another and they resemble a tree.'"³⁰ This second (possibly later) passage may signal the emergence of the novel sefirotic cosmology—making it an intrabahiric kabbalistic commentary. The All-Tree is described in terms demiurgic and literal; in the commentary, though, the tree has become a metaphor well suited to describe the structure of the arrayed powers. Might the author of this passage already have had a kabbalistic tree in mind? With divine "powers" visualized as a treelike hierarchy, the passage certainly marks a significant and influential milestone. R. Moses de Leon (ca. 1240–1305), for example, invokes the

All-Tree repeatedly, referring to it as "the tree from which all souls fly forth" and "the tree delimited by the twelve diagonals."[31] Although it is tempting to see in this conflation an allusion to the arboreal schema seen in fig. 122 below, in these passages the diagonals more likely refer to the cosmogonic expanse visualized in "Ilan ha-ḥokhmah" (fig. 8). Still, for kabbalists of this era, *ilan* was a term that could be used to refer to the full array of ten sefirot, a usage indeed found in zoharic literature.[32]

By 1300 kabbalists had made considerable efforts to work out the ideas that had been gestating over the previous century or so and to systematize them with unprecedented coherence. The treatises of this era often make this process transparent, perhaps no more vividly than when they take up the question of how the sefirotic array ought to be visualized. As they grapple with that question, epistemic images are used to clarify the options under consideration. The contenders are placed side by side, the competing arrays established by words alone. Names of the sefirot are arranged hierarchically from top to bottom, divided into left, right, and center (fig. 10).[33] As is the case with Porphyrian trees in Christian manuscripts from the same period, there are no medallions, but lines are used in some witnesses to connect the words.

Isaac of Acre's *Meirat 'einayim* is not a systematic introduction to the Kabbalah.[34] It takes the form, rather, of a "supercommentary" devoted primarily to unpacking the kabbalistic hints scattered throughout the Torah commentary of R. Moses ben Naḥman (known as Nachmanides, 1194–1270).[35] Nachmanides, who may reasonably be described as the leading rabbi of his day, chose what Daniel Abrams calls a "two-fold strategy of elevating the status of his own Kabbalah and

Figure 10 | Comparative sefirotic arrays, fol. 40b. Shem Tov ibn Shem Tov, commentary on the sefirot, Sephardi script, sixteenth century. Jerusalem, NLI, MS Heb. 8°404. Photo courtesy of The National Library of Israel.

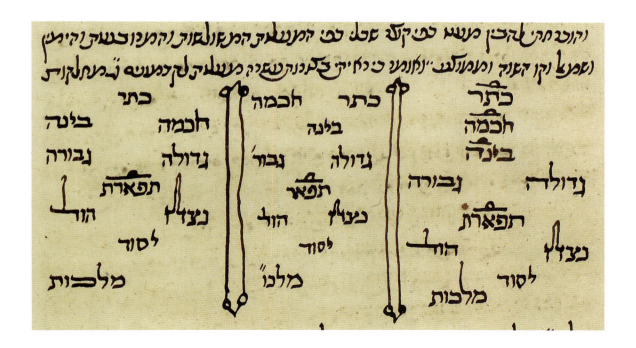

THE EMERGENCE OF THE KABBALISTIC TREE | 17

curtailing speculation about it" in his *Commentary on the Pentateuch*.[36] This entailed alerting students to passages with secret kabbalistic meaning without committing such secrets to writing. His approach simultaneously contributed to the ascending stature of Kabbalah as a body of knowledge in the Jewish world and to a cottage industry of speculation with regard to the content of those concealed traditions, i.e., the supercommentaries. The secrets "revealed" in such supercommentaries, needless to say, often tell us more about the opinions of the revealer than of Nachmanides.[37] In the case of Isaac of Acre, the supercommentary offered a congenial structure for the organization of kabbalistic secrets. These he assiduously gathered and collated following his arrival in Spain around 1305, including those preserved by students of Nachmanides who had themselves written supercommentaries devoted to revealing, even if only speculatively, a bit more than their master had been comfortable sharing in written form.[38] Like other supercommentators, Isaac treated sefirotic structure in pericope *Terumah* (Exod. 25:1–27:19).[39] This portion of the Torah has but one subject: the Tabernacle. Why there, of all places, do we find comprehensive discussions of the sefirotic structure? It might be argued that the plain sense of the biblical text is already suggestive; in it, God offers Moses visual rather than verbal instruction: "Make this tabernacle and all its furnishings exactly like the pattern [tavnit] I will show you" (Exod. 25:9).[40] This was the complex in which, only one verse before, God had promised to dwell among the Israelites. Opening his treatment of this pericope, Nachmanides asserts the fundamental parity of Sinai and the Tabernacle as revelatory portals. What is particularly emphasized is the divine presence that they both facilitate. Nachmanides's explanation in his first comment on the pericope identifies the many constitutive elements that Sinai and the Tabernacle share in common. The latter replicates and miniaturizes the former, albeit with one key difference. Unlike the exoteric revelation of the Divine at Sinai, God's presence in the Tabernacle was esoteric: "The secret of the Tabernacle is that the Glory [kavod] that dwelled [shakhan] on Mount Sinai dwells upon it esoterically [ba-nistar]."[41] It is interesting to note that, as opposed to most of the comments by Nachmanides that were explicated and supplemented by his supercommentators, in which the master had stated explicitly that there was a kabbalistic secret to the matter under discussion, this opening comment is presented by Nachmanides as *peshat*: the plain, contextual reading of the biblical text.

R. Joshua ibn Shuaib (ca. 1280–ca. 1340), a student of Nachmanides's foremost disciple, R. Shlomo ibn Aderet (1235–1310), offered the following generalization of the master's position: "The intention of the Torah with regard to the Tabernacle and the Temple is [to offer] a hint [remez] with regard to supernal matters. . . . And all the drawings [ẓiyyurei] of the Tabernacle and the Temple are drawings of spiritual matters" (fig. 11).[42] This characterization is indeed confirmed by Nachmanides's own slightly more revealing statements outside the framework of the biblical commentary, as in his *Torat ha-adam* (The human doctrine), where he writes that "the Tabernacle . . . and the array of everything in it, and the drawings of the cherubs: all are to understand secrets of the workings of the supernal [sefirotic], medial [celestial], and lower [sublunar] world. Allusions to the entire Chariot are there."[43] This constellation of kabbalists thus justifiably gave particular attention to the cherubs of the Ark, fashioned of hammered gold, and to the showbread (lit., face bread, *leḥem ha-panim*) table and the menorah, the great candelabrum. These last were positioned north and south, opposite

Figure 11 | Menorah flanked by sefirotic trees, front matter, Joseph Gikatilla, *Sha'arei orah*, Sephardi script, fifteenth century. Paris, BnF, MS hébr. 819.

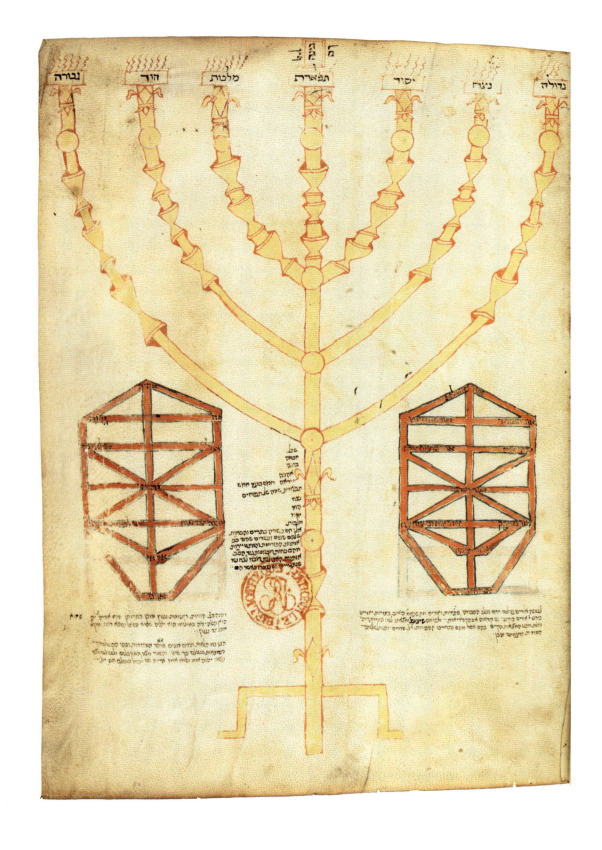

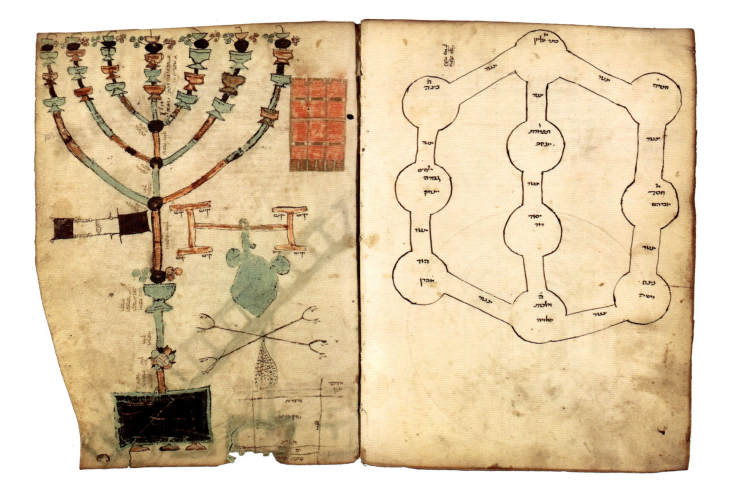

Figure 12 | Temple implements and sefirotic tree, fols. 100b–101a, Ashkenazi fourteenth-century miscellany. Moscow, RSL, MS Guenzburg 82.

each other. Their esoteric valence was so charged that even writers of supercommentaries, the mandate of which was to expose what Nachmanides had preferred to conceal, were circumspect about sharing too much.[44] Still, on the basis of what these writers do reveal, the role they understood these implements to play in the channeling of divine effulgence and in making the Divine present, "face to face," is clear.[45] These valences, as well as the juxtaposition with the verse that launched the deep dive into sefirotic structure, surely inspired the near-universal incorporation of images of the table and the menorah in classical ilanot, as we will see in the next chapter (fig. 12).[46]

The passage that provided a springboard for the treatment of sefirotic structure in supercommentaries on Nachmanides—*Meirat 'einayim* foremost among them—is hardly an obvious choice. In describing the Tabernacle courtyard, the Hebrew words for the cardinal directions east, west, north,

and south appear alongside the term *yam* (sea) and *kedmah* (forward) (Exod. 27:11, 13). It is at this point that Nachmanides offers an utterly unassuming primer on the difference between names (*shemot*) and appellations (*kinuim*). His explanation is lucid and in keeping with the plain sense of the text; few would contest that in the Land of Israel people use the appellation "sea" to refer to the west. But there is more going on here. It is, after all, the Tabernacle that is being surveyed in these verses, and its named coordinates encode the supernal structure. Nachmanides makes do with little more than a wink: "and the secret of these names is known from the 'Work of the Supernal Chariot' [mi-ma'aseh ha-merkavah ha-'elyonah]."[47]

Nachmanides's wink was all the supercommentators needed to get them going. R. Shem Tov ibn Gaon's gloss on "known from the 'Work of the Supernal Chariot'" thus reads, "Know that east is Abraham, west is Isaac, south is Jacob, north is David . . . and of the Chariot [the Sages] said Michael to his right, Gabriel to his left. . . . For in Ezekiel's Chariot they are listed according to their descending progression [hishtalshelutam]: south is also called right and north left. Therefore I will allude their form to you [ermoz lekha ẓuratan]."[48] Ibn Gaon (ca. 1270–ca. 1330) then provides a diagram that closely resembles the far-left option in fig. 10. Isaac of Acre validates his own wide-ranging excursus on the sefirotic array by invoking this precedent: "Having seen that this sage [ibn Gaon] wrote in his book *Keter shem tov* (Crown of a good name) the form of the standing of the sefirot [ẓurat ha'amadat ha-sefirot] in Kabbalah, I saw fit to speak of this matter: to compose words and to draw forms [leẓayyer ẓurot] that illuminate the eyes of the intellect."[49]

In the course of his treatment of "the form of the standing of the sefirot," Isaac presents four sefirotic diagrams; each, he believes, has something to teach.[50] The first appears in his incorporation of ibn Gaon's gloss as the prologue to his own more extensive treatment. In Isaac's version, the diagram accords with the rightmost rather than the leftmost option of the lineup seen in fig. 10. Rather than present the top three sefirot in triangulation, Isaac has aligned them on the central axis. This emendation was in keeping with a position associated with *Ma'arekhet ha-elohut* (The structure of the Divine), composed ca. 1300 by an anonymous kabbalist belonging to the Girona school, according to which "the sublime grade of the three and their hiddenness places them beyond the powers of human cognition . . . and placements of right or left. It is, rather, appropriate to unify them in one unification, perfect, balanced, and simple . . . to allude to their unity" (fig. 13).[51] Note that this passage relates to the placement of sefirot in specific locations or arrays as symbolic rather than iconic. In other words, the claim is that the drawing of the constellation of the sefirot—or at the very least its highest dimension—is not determined by the presumptive locations of the sefirot but, rather, by the idea symbolized by a given configuration. Triangulation is taken to imply differentiation susceptible to human perception in the upper stratum of Divinity; an aligned vertical tower suggests the opposite.

This pushback against the implicit assertion of the ontological reality of the sefirot and the iconic resemblance of the kabbalistic tree to that which it signifies evinces an awareness of the issue more than a principled and consistently implemented position. One might argue that by confining the debate to the upper three sefirot, even those who favored the aligned vertical tower left open the possibility that the lower seven were indeed susceptible to human apprehension and to representation by means of iconic signifiers.

Isaac's second and third diagrams are adduced as part of his treatment of the related issues of sefirotic differentiation and networking. Were the ten sefirot each unique essential qualities, it would be

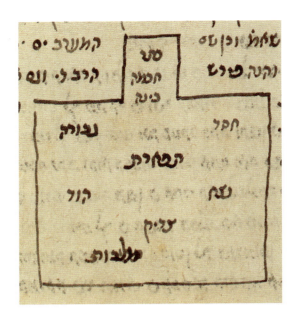

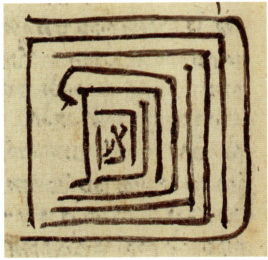

Figure 13 | Sefirotic array 1, fol. 38b, Isaac of Acre, *Meirat 'einayim*, Sephardi script, fourteenth–fifteenth century. London, BL, MS Or. 12260. © The British Library Board.

Figure 14 | Sefirotic array 2, fol. 39a, Isaac of Acre, *Meirat 'einayim*, Sephardi script, fourteenth–fifteenth century. London, BL, MS Or. 12260. © The British Library Board.

all but impossible to explain their emanatory unfolding, subsequent channels of interconnection, and limitless fecundity. Isaac leverages the nested sefirotic acrostics we saw in fig. 7 as a visualization of the fundamental principle according to which each sefirah contains all of them (fig. 14). The image shows all ten as if they were one all-inclusive sefirah. Here too, signs of internal conceptual conflict find expression in Isaac's presentation: the image is of the sefirot "without existence" (*bli mahut*) yet "in the form of their standing/constellation" (*zurat ha'amadatan*). He likens the image to the celestial "onion skins" centered around the earth to another metaphor that, in its original setting in the *Bahir*, compared the material world at the center of the ten spheres to "a mustard seed in a ring."[52] The seed, in this case, is the lowest of the ten sefirot. In the passage surrounding the image, Isaac urges his readers repeatedly to observe it carefully and contemplatively in order to internalize these fundamental properties of the sefirot.

Isaac then tackles the vexing question of sefirotic differentiation. Occult pathways are forged by resemblance, making it difficult to understand how sefirot of opposing qualities could be networked.[53] The "all-inclusive" nature of each sefirah shown, in Isaac's reading, by the second diagram means that their differentiation was more a matter of emphasis than of exclusion. He complements this perspective with an explanation of their emanation in which each sefirah, except *Keter*, is an admixture of "right" and "left." To show this, he pulls down the innermost "seed" of the nested acrostics—*Malkhut* (here called *'Atarah*, diadem)—as if opening a collapsed spiral paper lantern. Fully extended, the sefirot in this third diagram are now hierarchically organized from top to bottom (fig. 15). The placement of each letter under the *kaf* of *Keter* is shifted slightly to the right or left of the central line to suggest subtle leanings amid overall unity. This image is also touted as rewarding

contemplation: "Before you is the form of the ten sefirot in the manner we have said. If you gaze upon the form of their standing, truly wonderous secrets will be revealed to you, if you have received [im kibbalta]. Verily, the eyes of your flesh and eyes of your intellect see that each of the ten sefirot comprises judgment and mercy."[54]

Isaac's fourth and final diagram is a mirrored version of the first. The tower remains as it was, but the right-left triangulations below it have been reversed: *Paḥad* (Fear), like *Din* (Judgment, an alternative name for the sefirah more commonly referred to as *Gevurah*, Strength) and *Hod* (Majesty) are on the right, and *Gedulah* (Greatness, an alternative name for *Ḥesed*, Benevolence) and *Neẓaḥ* (Endurance) are on the left (fig. 16). It was axiomatic that the right was the side of love, the left of its "sinister" opposite. Rather than dismiss the odd inversion of this schema, however, Isaac forcefully asserts its legitimacy. He does so with witty wordplay: "Anyone who says that this structure [tavnit] is reversed [mehupekhet] belongs to the 'perverse generation' [dor tahapukhot, from whom God will hide his face according to Deut. 32:20]."[55] Isaac champions this particular visualization of the kabbalistic tree because, unlike the others, it captures the Divine from the Divine's perspective. The standard ilan, showing *Ḥesed* on the *viewer's* right and *Gevurah* on the *viewer's* left, presents God from behind, as it were. Isaac preferred a "heraldic" view of the sefirotic array. What seemed an image that got it all backward was, when

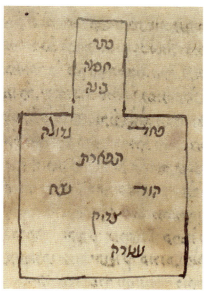

Figure 15 | Sefirotic array 3, fol. 40a, Isaac of Acre, *Meirat 'einayim*, Sephardi script, fourteenth–fifteenth century. London, BL, MS Or. 12260. © The British Library Board.

Figure 16 | Sefirotic array 4, fol. 40b, Isaac of Acre, *Meirat 'einayim*, Sephardi script, fourteenth–fifteenth century. London, BL, MS Or. 12260. © The British Library Board.

properly understood, the image appropriate to a true encounter. From Isaac's perspective, given the profound implication of sefirotic visualization in the act of prayer, this was a critical point. Kabbalistic prayer did not address God in the plain sense of the liturgical texts. Prayer was intentionally "aimed" at particular sefirot and designed to advance the cause of cosmic amelioration though intradivine interventions. For all the spiritual materialism that such an understanding might suggest, kabbalistic prayer remained, for Isaac, a standing before God. He thus concludes his excursus with an invocation of the final moments of the central section of the daily liturgy, the so-called eighteen benedictions or 'Amidah (standing) prayer. The customary practice is to take three steps forward at the beginning of this recitation and three steps back upon its conclusion, followed by bows left and right. For all his philosophical, anti-anthropomorphic sensibilities, Maimonides (1138–1204) had explained these bows in the following way: "Why does the worshiper first bow toward the left? Because his left corresponds to the right of the person whom he faces. And just as one who stands before a king bows to the king's right and then to the king's left, so the sages ordained that at the conclusion of the 'Amidah, the same etiquette should be observed as in taking leave of the royal presence."[56] Isaac's God, now imagined in sefirotic terms, retains a fundamental fidelity to this ethos: "The enlightened, who receive the face of the *Shekhinah*, say 'shalom' [peace] and bow to their left—to the right of the *Shekhinah*—and then again say 'shalom' and bow to their right—to the left of the *Shekhinah*. One who has received the way of truth, in saying 'shalom' directs his attention [mekhaven] to the Supernal so as to draw down the blessing and peace from the first cause to the last cause. The ten sefirot must always be opposite his eyes, united in the true unity in the manner that I have drawn in this structure [tavnit] that I have received."[57]

Note that nowhere in this long discussion of sefirotic schemata does Isaac use the language of "tree" to refer to the diagrams. They are *zurot* (forms), a term with Platonic associations, that the kabbalist is to draw (*lezayyer*)—this versatile verb here serving primarily in the mental-contemplative rather than graphical-diagrammatic sense. Isaac also makes frequent use of the term *tavnit*. A verbal noun of *livnot* (to build) resonant with connotations of form and structure, Maimonides had pointedly warned in the *Guide of the Perplexed* (1.3) that the term should *not* be applied to God, "since it implies the physicality of the object in question (e.g., its being a square, circle, etc.)."[58] Isaac's usage was grounded in Nachmanides's having adduced "the plan for the Chariot" [tavnit ha-merkavah, 1 Chron. 28:18] in his first comment on the pericope.[59] We recall that the entire excursus took flight from Nachmanides's "wink" to the effect that the secret of the Tabernacle texts was "known from the work of the Supernal Chariot."

Isaac was not averse to imagining the sefirot as a tree. On the contrary: throughout *Meirat 'einayim*, he reveled in using a diverse range of metaphors to bring readers closer to an appreciation of their nature. He happily analogized them to chains (of being) and springs (of water), to gemstones, flaming coals, and a cluster of grapes. Most of all, though, they were like a tree. Isaac tells us that his kabbalistic teachers have taught:[60] "the allegory [mashal] of the tree [ilan], allegorizing them [the sefirot] to a tree whose roots are singularly in the earth, thus alluding to the ten sefirot that are singularly in the Infinite [Ein Sof]. [The tree] has sprigs and twigs, branches, boughs and offshoots, some fruit and some peels, leaves and seeds. They all draw one from another, this one from that one. And they all draw from the central line [kav ha-emẓa'i] that is within. All is from the root and all singular in one unity without any division forever. For all is one tree; they suckle from one source."[61]

Isaac conjures an image of a sefirotic tree that is lushly botanical, but it has nothing to do with the diagrams in *Meirat 'einayim*.

Meirat 'einayim was written in the period that saw the composition of the first wave of systematic kabbalistic literature. Among the most seminal were *Sha'arei orah* (Gates of light), by the Castilian R. Joseph Gikatilla (1248–1305), and *Ma'arekhet ha-elohut*. They too evince a special affinity for the tree metaphor but never use the term *ilan* to refer to their sefirotic diagrams, which, like Isaac, they refer to as *zurot* (forms) and *ziyyurim* (drawings). As popular foundational introductions to Kabbalah, *Sha'arei orah* and *Ma'arekhet ha-elohut* were among the first works of Kabbalah to be printed and were treated to important commentaries over the generations. These commentaries allow us to see how the words and images of the primary texts were understood a century or two after they were written.

Gikatilla wrote *Sha'arei orah* as an introduction to the Kabbalah—meaning, in this case, the sefirot.[62] A perennial favorite, it represents the apex of the "Commentaries on the Sefirot" genre. Its clear and engaging style endeared it to readers from the beginning, Christians among them. In 1516 Paulus Riccius (1480–1541), a German-Jewish convert to Christianity, published a paraphrastic translation, *Portae Lucis*, making it the first work of Kabbalah ever printed. Its often reproduced frontispiece, crafted by Leonhard Beck, shows an elderly man, perhaps Paulus Riccius, holding a sefirotic tree by the channel that connects *Yesod* to *Malkhut* (fig. 17).[63] Yet the tree pictured in this iconic image was inspired neither by Gikatilla's text nor by the most significant diagram of the original Hebrew work. If anything, it seems an inverted homage to a twelfth-century image of Lady Dialectic (*dialectica domina*) presenting the Tree of Porphyry or its like (fig. 18).[64] The image may be understood as a visual argument for the Kabbalah as a kind of *philosophia perennis*, linking as it does the old philosopher and the Porphyrian/kabbalistic tree.

Riccius's *Portae Lucis* did not include a reproduction of Gikatilla's own sefirotic diagram. The latter micrographically formed figure was nevertheless copied with remarkable consistency in Hebrew manuscripts and printed editions over the centuries (fig. 19). From a representational standpoint, Gikatilla's diagram is ambiguous. With its balanced symmetry, one might think it a candelabrum or a scale, a stick-figure human or a tree. Gikatilla designed the diagram as an epistemic image intended to clarify his discussion of *Tiferet*, which he, like Isaac, referred to as "the central line" (*ha-kav ha-emza'i*) of the sefirotic array. *Tiferet* was literally central to Gikatilla's understanding of Kabbalah. As he wrote in his introduction, *Tiferet* is the Tetragrammaton—the true name of God—and all other biblical divine names, which he equated with the sefirot, are in its orbit. Conceptually, the idea brings the spoked-wheel diagram of the 1284 Paris miscellany to mind (fig. 5). Gikatilla has more to say, however: the *entire* sefirotic array may be represented as the Tetragrammaton, YHVH. *Keter* is the "thorn" of the *yud* (i.e., its calligraphic crown); *Ḥokhmah* is the letter *yud*; *Binah*, the first *heh*; the six sefirot, from *Ḥesed* to *Yesod*, are the *vav*; and *Malkhut* is the final *heh*. In this framework, as the heart of the central complex of six sefirot, *Tiferet* becomes its metonym and thus uniquely associated with the *vav*. The morphology of the letter *vav* (ו)—a straight line—is apt for the sefirah that encapsulates the central line of the structure. It is in this context that the tree makes an appearance, but only as a passing metaphor; the central line is "like the trunk of the tree" (*ke-guf ha-ilan*).[65] Mostly, though, Gikatilla emphasizes geometric ideals of balance and proportionality. Thus even the letter *vav* in its "expanded" form, spelled out

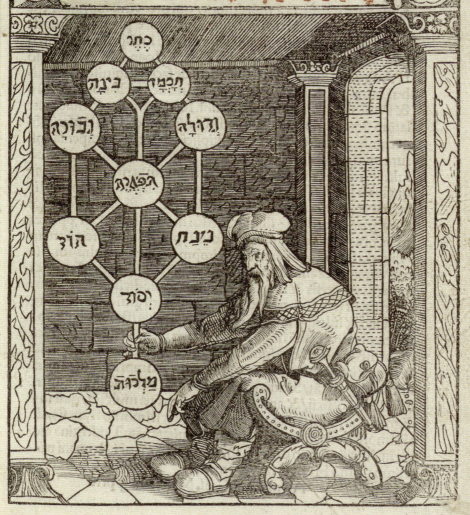

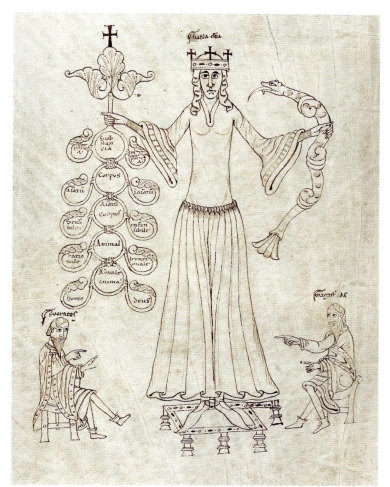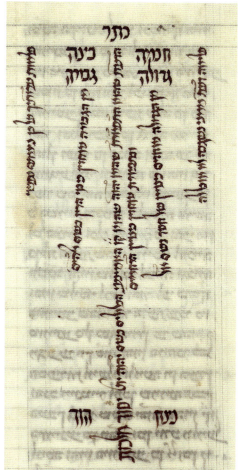

fully as *vav-yud-vav* (ויו) as if it were a word in itself, resembles two arms evenly flanking a torso. With this sort of visualized symmetry in mind, Gikatilla concludes his discussion with an image designed to make these properties vividly clear: "I draw [meẓayyer] before you a figure [ẓurah, also used to translate the term *form*], from which you will understand the matter . . . and this is the figure."[66]

And now to the commentary "time machine." A glance at the gloss on this passage by a University of Bologna–educated sixteenth-century rabbi fast-forwards us roughly to Riccius's era.[67]

Figure 17 (*opposite*) | Frontispiece, "Portae Lucis," woodcut by Leonhard Beck, in Paulus Riccius, *Portae Lucis*, Augsburg, 1516. Courtesy of the Embassy of the Free Mind, Bibliotheca Philosophica Hermetica Collection.

Figure 18 | Lady Dialectic, fol. 1v, Boethius, *Isagoge*, Paris, ca. 1140. Universitäts- und Landesbibliothek Darmstadt, MS 2282.

Figure 19 | Sha'arei orah diagram, fol. 87b (column 341), Joseph Gikatilla, *Sha'arei orah*, Ashkenazi hand, 1367. Jerusalem, NLI, MS Heb. 38°6330. Photo courtesy of The National Library of Israel.

THE EMERGENCE OF THE KABBALISTIC TREE | 27

R. Matathias Delacrut, whose commentary on *Sha'arei orah* was one of the first works of Polish Kabbalah to be published, takes up an issue related to *Tiferet* that remained unresolved in Gikatilla's text: the precise location of its higher analogue, the quasi-sefirah of *Da'at* (Knowledge).[68] The question did not vex Gikatilla, but for Delacrut, structural questions could not be ignored entirely even in a book for beginners.[69] According to Delacrut, such quandaries could be resolved by consulting "the drawings of ilanot drawn by masters of the Kabbalah" [be-ẓiyyurei ha-ilanot she-ẓiyyaru ba'alei ha-kabbalah].[70] To this comment Delacrut added a modest tree diagram of his own. In so doing, he was reinforcing a passage from his general introduction in which he presented the reader with a drawing of the sefirot for their reference: "Here you have their drawing [ẓiyyuran] in the order of their progression [hishtalshelutam] and branching out [hista'afutam] in the likeness of a tree [ke-dimyon ha-ilan] in its branches and divisions. And this is what they call an 'ilan of Kabbalah' [ilan ha-kabbalah]."[71] Delacrut's employment of the term *ilan/ot* and his reference to "what they call an 'ilan'" make clear that by his time the usage was well established.

In this same introduction, Delacrut recommends that students study *Ma'arekhet ha-elohut* after completing *Sha'arei orah*. The *Ma'arekhet*, as is it often called, was the first systematic presentation of a mature, integrated kabbalistic system.[72] Looking back over the literary remains of kabbalistic—and "protokabbalistic"—speculation of the preceding period, one finds a plethora of approaches. Inchoate notions of the sefirot abound; a fully consolidated theosophy is not in place. The *Ma'arekhet* represents a bold shift in the history of kabbalistic discourse: an intentionally anonymous and synthetic (in the integrative sense) voice that mutes the particular voices of the historical kabbalists of the previous centuries and even, possibly, the zoharic literature. Kabbalah has been systematized, its theosophy presented with unprecedented methodical range and rigor.

Entire chapters of the *Ma'arekhet* are devoted to discussions of the graphical array of the sefirot. The treatment of their structure and its visualization begins in chapter 7, entitled "Ma'arekhet ha-seder" (The structure of the order [of the sefirot]).[73] The *Ma'arekhet* is utterly unambiguous about the objective of these discussions: to establish the correct image of the sefirotic constellation.[74] The image is not accidental but essential to the matter at hand. The importance of its graphical realization—the *ẓiyyur* (drawing)—is stressed in repeated calls for the reader to contemplate the image drawn on the page. Concluding a detailed discussion, the author declares that the structure resembles "this form" (*zot ha-ẓurah*). The diagram that follows again resembles the right-hand option seen in fig. 10, with the three highest sefirot vertically aligned.[75]

Once the constellation has been established, the eighth chapter of the *Ma'arekhet* turns to its interpretation. The metaphors of the text are predominantly anthropomorphic: the sefirotic array is in accord with "the human edifice" (*binyan adam*). In a rhetorical gesture that may suggest an awareness of a schematic affinity to the family tree, we are also told that the upper sefirot are the "cosmic fathers" (*avot 'olam*) and those beneath them "are called 'sons of the fathers.'"[76] Soon, though, human and arboreal metaphors mix: "The fathers are like the roots of the tree [ke-shorshei ha-ilan], the principal part of the edifice ['ikar ha-binyan], and the sons are like the branches. Yet only the branches produce fruit, meaning that only the sons—and not the fathers—are worthy of maintaining the world. There is, however, no existence for the branch without its root."[77] Having invested in this powerful metaphor, the *Ma'arekhet* seamlessly continues by recalling the cosmic All-Tree of the *Bahir*, but, on the whole, anthropomorphic discourse

dominates. Taken together, the sefirot constitute the "supernal image" (*dmut 'elyon*), the image of God in which humans were created.

Here again, a leap from text (ca. 1300) to commentary (ca. 1500) lets us see a consolidation of the arboreal perception of the sefirotic array. Since its first printings both in Mantua and Ferrara in 1558, the *Ma'arekhet* has been inseparable from R. Judah Ḥayyat's commentary *Minḥat Yehudah* (Offering of Judah), which appeared alongside it in these and all subsequent editions. A Spanish kabbalist exiled in 1492, Ḥayyat (ca. 1450–ca. 1510) found refuge in northern Italy after enduring terrible tribulations.[78] In that safe haven, he found himself thrust into a position of authority: he was Spanish Kabbalah personified. The *Ma'arekhet* was popular among Italian Jews, who, given their propensity for autodidacticism and philosophical sophistication, found the work appealing. As such, it was the ideal platform upon which to assert the primacy of Spanish traditions—the Zohar foremost among them—at this historical juncture. Like the Zohar and Ḥayyat, the *Ma'arekhet* was Spanish, but it had charted its own course. If its anonymous author was familiar with zoharic literature, which in so many ways represented a Kabbalah antithetical to his own, his work effectively suppressed any mention of it. Italian Jews knew little Zohar at the cusp of the sixteenth century apart from passages quoted by R. Menaḥem Recanati (1250–1310) in his Torah commentary.[79] Ḥayyat thus gave the *Ma'arekhet* "the Zohar treatment."

When the *Ma'arekhet* contradicted the Zohar, Ḥayyat took pains to establish the authority of the latter in the eyes of his readers. In this spirit, regarding the structure of the sefirotic array, Ḥayyat rejected the tower-topped configuration seen in figs. 10 and 13 in favor of a pyramidal triangulation that mirrored (or inverted) the lower triads.[80] The latter, Ḥayyat argued, was implicit in the half-dozen lengthy zoharic passages adduced in steady succession in his commentary on chapter 7. After expressing his fervent disagreement, the quotations begin: "See too what is in the book Zohar: 'Thus we have learned: From the aspect of Father is suspended supernal *Ḥesed*. From the aspect of Mother is suspended *Gevurah*. In this manner, all are joined to one another' [Zohar III:118b]. This establishes that *Ḥokhmah*, the supernal Father, is on the right side and that *Binah* is on the left side."[81] *Ḥesed* is below *Ḥokhmah* and *Gevurah* below *Binah*; the authority of the Zohar left no room for doubt. What is particularly striking in the present context is Ḥayyat's language. In the interim between the *Ma'arekhet* and the *Minḥat Yehudah* commentary, the lexicon has changed. The configuration of the sefirot is no longer referred to as a "figure" or "form" but consistently as "ilan."

Ḥayyat uses this nomenclature *en passant* as he reviews the zoharic passages that contravene the structure advocated by the author of the *Ma'arekhet*. In his engagement with one such passage (Zohar I:21b), we see this novel usage going hand in hand with a heightened ontologization of the schema. As we saw with Isaac of Acre, a consideration of the image of the sefirot forced Ḥayyat to confront the question of perspective. Are the right and left sides of the sefirotic tree our own or God's?[82] Ḥayyat's grappling with the issue was catalyzed not by an odd ilan, however, but by an odd zoharic text. In the text, *Nezaḥ*—the sefirah just below *Ḥesed* on the right of the tree—is called "the *left* thigh of Jacob," and Ḥayyat was forced to account for this odd assertion on the part of the authoritative work.[83] Confoundingly, the same passage counted *Nezaḥ* and *Hod* as the fourth and fifth of the lower powers, respectively, as if their positions had remained unchanged (right axiomatically preceding left). To express this latter implication, Ḥayyat writes, "in saying that *Nezaḥ* is the fourth rung and *Hod* the fifth, we may see that they figure *as they are now drawn* in the ilan [*ba-ilan*], and not

reversed [emphasis added]." This unselfconscious usage of the term *ilan* shows that, at least two generations before Delacrut, it was well established.

If the tree represented the sefirot in the proper sequence, how could it be harmonized with a zoharic text that called for the positions of *Neẓaḥ* and *Hod* to be inverted? Here again, the consideration of perspective was put into play: "I found no solution for this other than to say that one who approaches his fellow finds his right opposite his [fellow's] left, and his left opposite his [fellow's] right. If so, *Neẓaḥ*, as it is drawn on the ilan, is on our right, which is the Holy Blessed One's left; *Hod* is the Holy Blessed One's right and our left."[84] Needless to say, the garden-variety ilan repeatedly invoked by Ḥayyat did not represent such a perspective; its right side was incontestably God's own. And if *Neẓaḥ* and *Hod* were relatively indeterminate sefirot and therefore amenable to inversion, those above them, *Ḥesed* and *Din*, Benevolence and Judgment, had to be associated with right and left, respectively. The entire ilan would have to be spun 180 degrees on its vertical axis to express the divine perspective: right and left as dexter and sinister. But had such an exceptional ilan ever existed?

Ḥayyat's answer to this unexpected question takes us beyond schema, to genre: "And I bear witness that in an Italian city called Reggio, I saw an ilan in the possession of a man of understanding that was drawn in this [reversed] manner. And they told me that a great man had made it."[85] Ḥayyat was unlikely to have been referring to a diagram on a codex page—as could be found in manuscripts of *Meirat 'einayim*, as we have seen—but to a parchment ilan, an exemplar of the genre. The pedigree of this ilan, attributed, as it was, to a "great man," meant that its mirror image of the prevailing kabbalistic tree could not simply be dismissed as the error of an ignoramus. More important for Ḥayyat, it enabled him to affirm that even when it contradicted itself, the Zohar was never wrong if properly understood.

Ilanot became the common name for the genre over the course of the fifteenth century, gradually replacing *yeri'ot* (lit., sheets). This last synecdoche was anchored in the materiality of the artifacts but also bore heavenly associations, recalling Psalm 104:2, the Lord who "stretches out the heavens like a tent" or a curtain [yeri'ah], a verse ubiquitous in kabbalistic sources. It also recalled the famous dictum of R. Yoḥanan ben Zakkai (first century CE) adduced in the talmudic tractate devoted to scribal arts, *Masekhet sofrim* (16:8), "If all the heavens were parchment [yeri'ah], and all the trees [ilanot] pens, and all the seas ink, it would be insufficient to write the wisdom I learned from my teachers." Cordovero elaborated on the symbolic significance of the term *yeri'ah* in his magnum opus, the mid-sixteenth-century *Pardes rimonim* (Orchard of pomegranates), explaining that "the matter of the *yeri'ah* is the secret of the expansion of [the central sefirah of] *Tiferet*"—a statement that is to be understood in light of Psalm 104:2. Here again we see a *Tiferet*-centric conception of the sefirotic tree that had real graphical consequences. Such associations enabled Cordovero to declare that in fact each sefirah could be called a *yeri'ah*. The fact that the preparation of parchment membranes for writing required a period of stretching the skins certainly abetted the expansive association. The identification of the arboreal schema with the parchment sheet was so complete that it was possible to refer to such a tree diagram on a codex page by the term *yeri'ah* as well. Thus in *Iggeret ḥamudot* (The precious letter), a work by the Italian kabbalist R. Elijah Ḥayyim ben Benjamin of Genazzano (ca. 1440–ca. 1510), the author's own diagram of the sefirotic tree is introduced this way: "And here for you is the drawing [ẓiyyur] of the *yeri'ah*, in

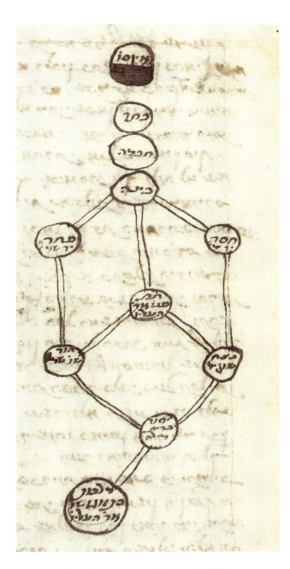

Figure 20 | "The drawing of the *yeri'ah*," fol. 9a, in Elijah Ḥayyim Genazzano, *Iggeret ḥamudot*, copied in Viterbo, Italy, 1527. Paris, BnF, MS hébr. 857.

accordance with the aforesaid intention" (fig. 20).[86] Elijah Ḥayyim may have meant that he reproduced in miniature the image he associated with a parchment ilan.

A *terminus ad quem* for the emergence of the genre may be established by the dated works composed with ilanot specifically in mind in the circle of the fourteenth-century Italian kabbalist R. Reuben Ṣarfati (or Ẓarfati), himself an early commentator on the *Ma'arekhet*.[87] Two of his compositions are revealingly titled *Perush ha-yeri'ah ha-gedolah* (Commentary on the *Great Parchment*) and *Perush ha-yeri'ah ha-ketanah* (Commentary on the *Small Parchment*).[88] Textual variants among the copies of Ṣarfati's commentaries confirm the interchangeability of the terms *yeri'ah* and *ilan* by the mid-fifteenth century.[89] Around 1550, a Venetian scribe who copied Ṣarfati's *Perush ha-yeri'ah ha-gedolah* from a parchment to a codex miscellany explained to his reader, "this is [from] a parchment sheet [*yeri'ah*] called 'ilan.' And I copied the story [*sippur*] written in each sefirah. . . . And I copied it without a drawing [*ẓiyyur*], though I found it drawn like a tree [*kemo ilan*]."[90]

Cordovero defined the genre in *Pardes rimonim*, the kabbalistic *summa* in which he systematically reviewed all aspects of classical kabbalistic thought. As he did so, Cordovero offered reasoned judgments on fundamental and often contested questions; not surprisingly, he treated the question of the true structure of the sefirotic array. Cordovero opened the sixth chapter, titled "The Order of their Array," by noting that although kabbalists often disagreed about the precise arrangement of the sefirot, they "drew forms [*ẓurot*] for themselves on parchment sheets [*yeri'ot*] and called them '*ilan*.'"[91] Cordovero's devoted younger Italian contemporary, R. Menaḥem Azariah da Fano (1548–1620), quickly composed an interpretive précis of the *Pardes* entitled *Pelaḥ ha-rimon* (The pomegranate slice).[92] In his version, Menaḥem Azariah pointedly renamed the chapter "Drawing the ilan" (*ẓiyyur ha-ilan*), calling the first chapter *Elonei moreh*, a clever play on Deuteronomy 11:30 that conveyed their pedagogical and even revelatory potential. The word *elonei* means "[oak] trees" and

THE EMERGENCE OF THE KABBALISTIC TREE | 31

moreh means "teaches" or "shows." The kabbalists of sixteenth- and seventeenth-century Italy were indeed the foremost producers of impressively large and lavish ilan parchments, a fact that colors Menaḥem Azariah's adaptation of Cordovero's opening statement. Menaḥem Azariah writes: "The custom of the fathers is the law of the children [evoking an early modern Jewish proverb, "the acts of the fathers are a sign for the children"]: they have placed signs [ẓiyyunim] for the names of the sefirot and their appellations on large parchments and called them '*ilanot*.'"[93] This description captures a fundamental characteristic of the classical ilan: the aggregation of sefirotic terms and associations within medallions.

The definitive configuration of the sefirotic tree now established, Cordovero treats the networking of the sefirotic hubs in the seventh "gate" (*sha'ar*, a term frequently used in traditional texts for broad chapters consisting of multiple units [*prakim*, pl.], usually translated as "chapters"). As we have already seen problematized in *Meirat 'einayim*, a fundamental question facing theosophical kabbalists was how to account for intrasefirotic communication given the presumption of their distinct essential qualities. Furthermore, how could such a simple mechanism—the "tree of the sefirot"—generate the diversity of creation? Communication was effected by means of the *ẓinorot* (channels) that connect them to one another. The tree is an occult structure, unseen by the eye, so these channels are established by resemblance or "sympathies." Because each sefirah comprises all ten, resemblances between them exist. Ḥesed and Gevurah may be opposites on the face of it, but the *Gevurah* within *Ḥesed* and the *Ḥesed* within *Gevurah* are alike, and therefore they establish a link. Just as Ramon Llull had used rotating wheels in his 1275 *Ars generalis ultima* to list divine attributes and the possible connections among them, Cordovero fashioned a knowledge-generating diagram to advance his own similar argument. In a now iconic image of the sefirotic tree, Cordovero showed the twenty-two channels that network the sefirotic hubs. These are augmented in early manuscripts by ten revolving disks pierced at their center by small knotted strings and sewn in place: volvelles, from the Latin *volvere* (to turn). These combinatoric spinning wheels, inscribed with spokelike sefirotic names, model and provide experiential confirmation of the infinite potential of the structure (fig. 21).[94]

Not all kabbalists availed themselves of such mechanical calculators to do this work. Cordovero refers to a *Sefer ha-ẓinorot* (The book of channels), in which no fewer than 600,000 channels coursing within the sefirotic tree were detailed. The work, he writes, was known to the kabbalists of Fez but sadly not to him.[95] The aside spurred Menaḥem Azariah da Fano to remark that he was actually familiar with it firsthand, and that it was not a book but "an ilan of 600,000 channels" crafted by a master to the very highest standards and specifications.[96] "Upon it," he writes, were "numerous instructions" (*halakhot merubot*) for its execution. These he then proceeds to paraphrase over five of the nine chapters of his version of *Sha'ar ha-ẓinorot* (Gate of the channels).

The complete instructions are extant in a number of manuscripts. One sixteenth-century Italian manuscript presents the manual after fifteen introductory kabbalistic teachings.[97] The first of these is the requirement to believe in "the First Cause and the ten sefirot" and the last that "one who begins the study of this science must first learn all the drawings [ẓiyyurim] and how all the Worlds concatenate one after another. And these must be drawn [meẓuyarin] before him so that he comprehends and understands"(106a). The full four-thousand-word instruction manual then follows, deploying a distinctive and highly technical vocabulary to guide the draftsman. The scribe is

to secure a blank parchment on which he will draft medallions of precise circumferences and lines angled to specific degrees. "First one must obtain a large scroll [megillah gedolah]—at the very least 60 gudlim by 162 in length—and score it vertically from top to bottom, excepting the top 12 gudlim. The top six of these will remain blank and the bottom will be used to draw a circle to allude to *Ein Sof*" (106a). A *gudel* is a measure of length based on the width of the thumb at its center. If we take it to be roughly 2 centimeters, the ilan would measure at a minimum 320 by 120 centimeters. To one familiar with the hyperbolic ramification of elements demanded by this manual, such measurements are hardly surprising. Menaḥem Azariah's lavish praise of the ilan's craftsman-kabbalist would have been

Figure 21 | Volvelle sefirot, before fol. 33a, in Samuel Gallico, *Asis rimmonim*, Italy, 1579. MS X893 C81, Rare Book & Manuscript Library, Columbia University in the City of New York. Photo: author.

fairly earned. An ilan built to these specifications would have been about fifty percent larger than the *Magnificent Parchment* scrolls that we will explore in the next chapter.

No ilan has reached us that corresponds to the diagram that would be produced by following these directions, although I have long nursed the fantasy of producing one. Cordovero's seventh gate and Menaḥem Azariah's response teach us that the nature of the sefirotic tree could be communicated by means of two alternative media that transcended

THE EMERGENCE OF THE KABBALISTIC TREE | 33

the inherent limitations of the bound book and the parchment sheet. The codex page could be made into a dynamic object by fastening volvelles to the hubs of the arboreal diagram, or many sheets of parchment could be joined to create a scroll of epic proportions. On such a scroll, a scribe might draw a sprawling diagram displaying dizzying arrays of channels, branches branching out of branches almost endlessly. Unsurprisingly, the medium favored to convey this message remained the volvelle.

The intricately networked ilan, whether drawn with 600,000 lines or spun with ten volvelles raised to the tenth power, was imagined to be the endlessly prolific generator of reality itself. Seen in this light, the kabbalistic tree was presumed to do far more than produce, let alone simply represent, knowledge. It is the image of the All-Tree. The 600,000 "lines of flight," to borrow a phrase from Gilles Deleuze and Félix Guattari, effectively constitute the ilan as a "rhizomatic tree," thus overcoming the binary opposition established by Deleuze and Guattari themselves.[98]

The Medium and the Message

Once the primary signification of the term *ilan* became the maplike genre associated with the arboreal schema of the same name, its medium became an inseparable part of its message. How the ilan was drawn and what it was drawn on were questions that intersected. We have already seen signs of this: enormous parchments to be procured, volvelles to be cut out and sewn. To a considerable extent, this materiality effected the meanings of ilanot, by which I mean the many things they were meant to do.[99]

Classical, pre-Lurianic Kabbalah made do with ten sefirot, visualized in a variety of ways. The versatile arboreal schema gradually proved most popular for representing the sefirot as a branched array of labeled medallions. As we have already seen, a parchment sheet was not strictly necessary to draw such a figure. It did, however, enable kabbalists to enlarge the image, allowing for the drafting of spacious circles connected by broad channels. The geometry of the schema ensured that considerable blank space would remain in and around it. This too could be put to good use. Every student of the Kabbalah had to study the sefirot; they were the keys to the kingdom. In practice this meant being conversant with their primary names, secondary appellations, and tertiary associations, as well as the qualities of each of the pathways that connected them all. One could read a treatise like Gikatilla's *Sha'arei orah* to learn about each sefirah, its divine name, corresponding limb, day of the week, patriarch, color, and so on, but one could also explore a maplike parchment sheet that featured the same information inscribed right where it belonged. To explore *Ḥesed*, for example, one would read the inscriptions in and around its medallion. Unlike Gikatilla's linear presentation in *Sha'arei orah*, the ilan offered a memory palace–like matrix of layered, patterned information.[100] By communicating kabbalistic knowledge in this manner, ilanot abetted its retention and stimulated its creative recombination.[101]

With the emergence of Lurianic Kabbalah in the late sixteenth century, the theosophical blueprint became staggeringly intricate. As R. Ḥayyim Vital (1543–1620), the most prominent and prolific writer among Luria's disciples, wrote, it had once been possible to master the theosophical mechanics of the classical sefirotic Godhead in just a few days of study, but Luria's teaching was of an altogether different order of complexity.[102] He wasn't kidding. The new system added unprecedented structural details as well as a new emphasis on the dynamic emanatory process within the Godhead. The specifics need not concern us just

yet; for now, it is enough simply to mention the considerable demands the new Kabbalah made on the diagrammatic imagination, and consequently, on the physical media used to learn, teach, and practice it. Beyond the inscription of texts *in loco*, the Lurianic ilan had to present a diachronic image of the topography of the Godhead. If the classical ilan was a map, then the Lurianic ilan was a map on a timeline.

Although the demands of Lurianism made multiple stitched-membrane rolls the rule rather than the exception, the generic constitution of the ilan as a parchment (sc)roll meant that they were not simply read but *unrolled*. Even if stored folded, once it was opened the parchment would naturally be scrolled as it was explored. This movement, intrinsic to reading a scroll, is captured by the Latin *volumen*, which one unrolls (*voluere*). This simple fact reveals a great deal about the genre. As Peter Stallybrass put it, "The scroll as a technology depends upon a literal unwinding, in which the physical proximity of one moment in the narrative to another is both materially and symbolically significant. One cannot move easily back and forth between distant points on a scroll. But it is precisely such movement back and forth that the book permits."[103] Stallybrass's reflection needs only minor adjustments to fit the ilan: narrative may be extended to include the "story" encoded in the diagrammatic presentation of the structures and processes of emanation, from the Infinite to the elements of the sublunar world. If anything, the significance of physical proximity is even greater in ilanot than in typical textual scrolls because the diagrammatic elements are interlocking, sequential, and continuous, their proximity no less meaningful than the placement of adjacent stops on subway maps.

The unique valence of the scroll in Jewish culture is of paramount importance. Much has been written on the transition from scroll to codex; by all accounts Jews adopted the latter sometime around the ninth century.[104] Of the hundreds of rotuli that have been discovered in the Cairo Genizah, roughly half are liturgical and designed for "personal devotion."[105] They are predominantly of eleventh-century Egyptian provenance and were often produced by their users from cheap, recycled materials for convenience and portability. Many were written on the blank side of rotuli originally written in Arabic. Although it is tempting to draw a parallel with the liturgical application of these rotuli for personal devotion, I think it unlikely that these inexpensive paper rotuli had anything to do with parchment becoming the constitutive ilan medium in pre-expulsion Spain, Byzantium, or Italy. Kabbalistic ilanot can be said to have served for personal devotion, but they were no less dedicated to mapping cosmological topography and, especially in the case of Lurianic artifacts, to tracing a cosmogonic timeline. Another potential source of inspiration did exist, however: rotuli presenting the genealogies of kings and the chronicles of history were widely disseminated, and hundreds of copies exist all over Europe.[106] When the need arose, a (sc)rolling timeline might have presented itself as a natural choice.

Scholars of Hebrew codicology have never noted the kabbalistic readoption of the rotulus. To appreciate the implication of this late development, it must be stressed that by the late Middle Ages, scrolls had no mundane applications in Jewish life. Books were studied; parchments were performed. Although I often refer to ilanot as "rotuli"—the preferred technical term for parchments that are rolled vertically rather than horizontally, the latter often called "scrolls"—Hebrew nomenclature makes no such distinction.[107] Jews used parchment rolls, referred to by terms that include *sefer* (book) and *megillah* (scroll), exclusively in ritual contexts: the Sefer Torah and Scroll of Esther, the phylacteries, and the mezuzah. In addition to these scrolls

required by tradition, Jews might use amulets that, like phylacteries and the mezuzah, did their work rolled up and encased. By virtue of its materiality, the ilan was thus ipso facto a ritual object in the Jewish context. The ritual called for a combination of textual study, visualization, and mental manipulation, this last referring to the work to be done in the mind's eye that begins with the graphical cues of the diagrammatic image.

The image, to put it very bluntly, was of God. Its ritual enactment is best analogized to the use of maps—not to the practical navigational aids so common today but, rather, to the core "virtual reality" function of premodern maps. Just as a Holy Land map invited imaginary pilgrimage, a sefirotic map offered its user an encounter with the Divine.[108] The lines that network the arboreal figures on ilanot preserved traces of emanatory pathways and invited dynamic contemplation. Even left uncontemplated, such images were possessions of inestimable value. Ilanot were magical "not by virtue of some special designs and symbols, but because their representational content connected them causally with the relationally constituted cosmos."[109] Simply by signifying what they did, ilanot were talismanic, presumed capable of capturing and making present that which they imaged.[110] To scroll contemplatively through a map of God was to practice Kabbalah.[111]

Chapter 2

Classical Ilanot

Commentaries on Parchment

Ilanot are not simply Jewish mandalas. As treatises integrated within diagrammatic matrices, ilanot made rigorous reading demands on their users. The experience is very different from that of typical linear text study; to read an ilan is to engage in a dynamic process in which one's attention shifts repeatedly from details to the whole in a reciprocal process of perception.

One sign of the prominence—perhaps even primacy—of the text in these iconotexts is evident from the fact that the ilanot that established the genre have in common only a small number of dedicated treatises. Their visual as well as textual content was fluid, but each foundational ilan presents a version of these texts integrated with an appropriate schema. For example, if the text conflates *Ein Sof* with *Keter*, the former will not be represented on the parchment, as we will soon see in the oldest *yeri'ot* to have reached us. Text and schema are correlated with particular stability in the channels that network the sefirotic hubs. These inscriptions typically relate to the specific trajectory and function of a channel and were less prone to accretions than the medallions, interstitial spaces, and margins of an ilan, making them relatively stable markers of manuscript families. There was no particular reason *not* to take an additive approach to these templates. Kabbalists were keen to supplement a sparsely inscribed ilan with material discovered elsewhere, including on other ilanot.[1]

The emergence of the genre in this form is intimately linked to the systematization of kabbalistic lore associated with the now familiar *Ma'arekhet ha-elohut*. Its discussion of the structure of the sefirotic array was less salient to this development than its treatment of sefirotic names and appellations in the fourth chapter, devoted to the "names of the qualities" (*shemot ha-middot*).[2] The *Ma'arekhet* took a minimalist,

listlike approach to the topic, moving from sefirah to sefirah. As the anonymous author explained, some of these terms had been deduced by kabbalists and others—presumably the less intuitive associations—received as part of the secret tradition. And even though it was possible to read the entire Torah as a sequence of divine names, each subject to classification under the rubric of one or more sefirot, those mentioned in the chapter are, he claims, exemplary.[3] Once they are understood, one can extrapolate the rest.

To take one sefirah as an example, Ḥesed is treated as follows: "The fourth: Ḥesed. Love [Ahava]. The quality of Abraham. Greatness. Priest. Right. Great Compassion. Milk and anything white allude to it. East. Supernal Waters. Silver. One of the legs of the Chariot, being the face of the lion on the right. The third day, according to the order of the number of days. The 'Hear, O Israel' scroll inside the phylactery upon which 'and you shall love' is written, alluding to it."[4] Such a list, when inscribed in the medallions of an arboreal schema on a parchment sheet, is a classical ilan reduced to its essentials. The real estate of the medium, however, accommodated significantly more: the channels that linked the medallions bear inscriptions of their own. The brief texts of the medallions and channels were treated to expansive explication and elaboration in the lengthier passages that filled the large proximate spaces carved out by the schema, within and without. These were commentaries, quite literally *on* the ilan. Here the ilan converges with its popular text-only sister genre, "Commentaries on the Ten Sefirot," the treatises of which are also devoted to explaining sefirotic nomenclature.

This convergence may be seen clearly in *Perush zulati* (Commentary by another), the early commentary on the *Maʿarekhet* by R. Reuben Ṣarfati.[5] Read on its own, Ṣarfati's commentary on the fourth chapter of the *Maʿarekhet* is in fact

Figure 22 | *Keter* of deconstructed classical ilan, fol. 53b, Italy, seventeenth century. Paris, BnF, MS hébr. 876.

indistinguishable from such a work. Every term in the *Maʿarekhet* chapter associated with the sefirot is glossed, its derivation and meanings explained. *Ahava* (Love), to give a brief example, is explained by Ṣarfati as the impetus that underlies all acts of *Ḥesed* (Benevolence); its numerical value (13) also alludes to the "thirteen attributes of mercy" (Exod. 34:6–7). Ṣarfati's commentary on this chapter of

the *Ma'arekhet* is also remarkably similar to his "Commentary on the *Small Parchment*," to which it makes frequent reference.[6] The classical ilan that features the latter composition is preserved in a bewilderingly diverse body of witnesses, from a page at the end of a fourteenth-century parchment codex to single sheet copies executed three or four centuries later.[7] The text was also copied into codices, usually together with vestigial diagrammatic elements.[8] In what follows, I refer to such a reformatted artifact as a "deconstructed ilan." Although considerable research remains to be done on these early materials, it is clear that Ṣarfati was a pioneer of the ilan genre and among the first to realize its potential.

The fact that ilanot were, in their way, ritual objects—used regularly and thus subject to the kind of wear and tear we associate with prayer books—has undoubtedly skewed our picture of their first centuries. Not surprisingly, luxury parchments were most likely to benefit from infrequent handling and careful preservation. Modest parchments of quotidian kabbalistic practice from these first centuries are, by contrast, rare finds.[9] The earliest ilanot are therefore known to us primarily in reformatted expressions, having been modified

Figure 23 | *Ḥokhmah* of deconstructed classical ilan, fols. 3b–4a, Italy, sixteenth century. London, BL, MS Or. 9045. © The British Library Board.

for inclusion in codices by being "deconstructed" or miniaturized to fit a page (or two). In the case of deconstructed classical ilanot, emphasis is placed on the preservation of the text, organized around the visual elements that suggest the tree from which it has been extracted. The ilan is implied by densely inscribed sefirotic circles and, occasionally, an intimation of the channels that implicate them in a network (fig. 22). The scribe of one particularly elegant deconstructed ilan used red ink for the medallion and its names and appellations; in the texts that followed, written in black ink, he helpfully used red for each term explicated in the "commentary" (fig. 23).[10]

Sparse classical ilanot—with little more than inscribed medallions and channels—could fit manageably onto a codex page (fig. 24). These need not have originated on a large parchment. Denser expressions almost certainly did, though, and these constituted a scribal challenge. With the codex rotated to vertical orientation and a couple of pages to work with, a copyist might just manage. This is precisely what we find in the back binding of a miscellany now in Munich: a miniaturized ilan drafted in semicursive script by a fifteenth-century Italian scribe (fig. 25).[11] The classical parchment behind it is easily discerned. A sefirotic tree dominates the double page, flanked by the menorah and table, which are never found in the simple epistemic images of the tree that merely remind the reader of its basic structure. Their evocative presence communicates the capacity of the ilan to summon and hold divine immanence. Another indication of the ambitious program of the Munich codex ilan is to be found in its representation of the realm beneath the sefirotic tree. The lowest sefirah of *Malkhut* appears as if docking atop the celestial spheres, which are represented in accord with astronomical convention as concentric circles.[12] In this seemingly ad hoc sketch—an impression confirmed by the scribe's attestations to elements

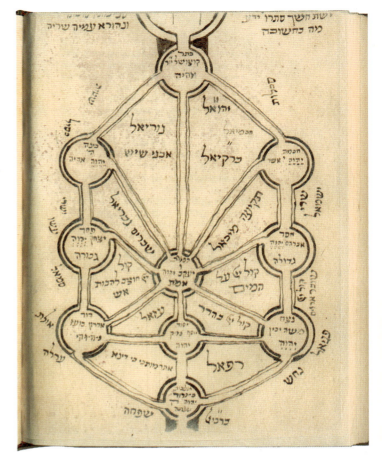

Figure 24 | Classical ilan with Psalm 29 and shofar additions, fol. 122b, Sephardi script, 1554. Jerusalem, NLI, MS Heb. 28°613. Photo courtesy of The National Library of Israel.

Figure 25 (opposite) | Classical ilan in codex reduction, fols. 24a–25b (each page 27.2 × 20.8 cm), Italy, fifteenth century. Munich, BSB, Cod.hebr. 119.

in need of revision—we find texts written at every conceivable angle in and around the diagram. The visual confusion also reflects the fact that the scribe has taken an additive approach to his work. Having compressed one ilan parchment to fit these facing pages, he then supplemented it with material he found on others, to which he refers when noting their divergences from his base model. "I saw in

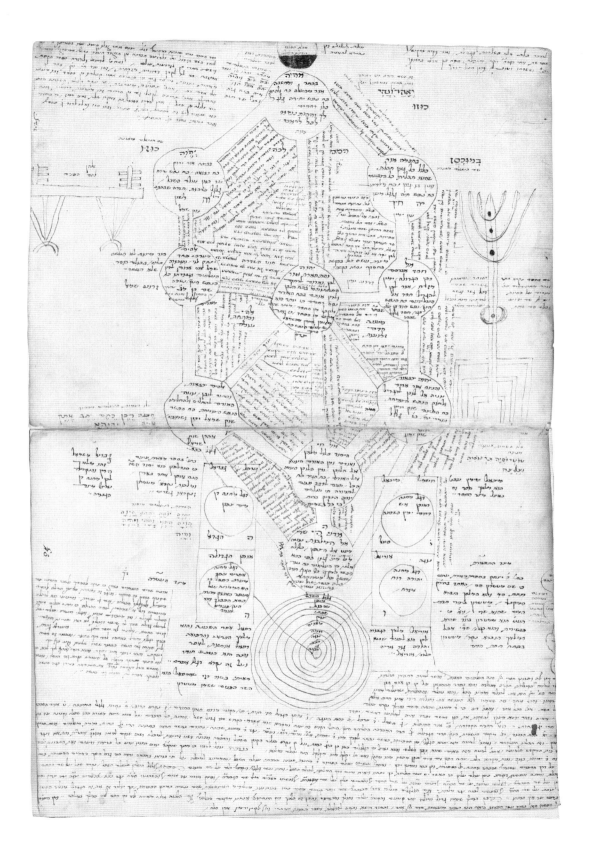

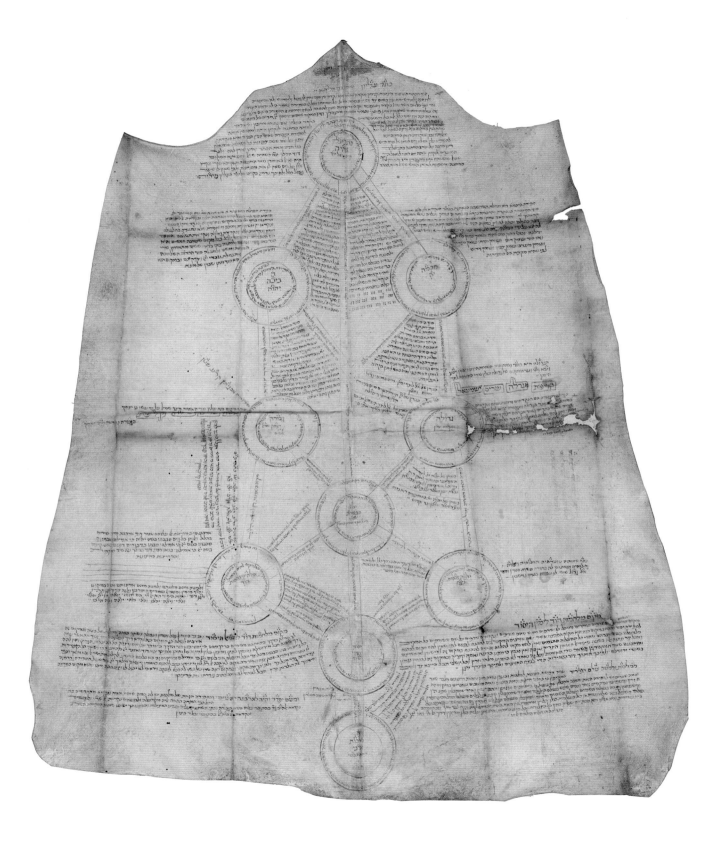

another *yeri'ah*" is a recurring inscription on these cramped pages. The scribe has supplemented texts from *Meirat 'einayim* and Recanati as well, perhaps culled from another ilan. The jumble is a snapshot of the fifteenth-century Italian kabbalistic bookshelf or, at the very least, of its representation in the ilanot at this scribe's disposal.

The Elders

The two oldest ilan parchments to have reached us are truly austere. The striking ilan preserved in the Vatican library exhibits a top edge cut in a manner that retains the natural contours of the animal skin while suggesting something like a peaked roof (fig. 26). According to the colophon on its verso, this intriguing artifact was drafted in Crete in the year 1451. Its text, in a Byzantine script, is an anonymous commentary on the sefirot likely authored by Joseph Gikatilla or one of his disciples.[13] Sefirotic names, appellations, and associations are featured in its medallions, with more extensive discussions inscribed in the nearest available spaces. In these spaces, each sefirah is described in a few hundred words that address the reader in the second person, sharing the secret of each: its essential characteristics, its role in the overall system, the "unerasable" divine name and biblical figure to which it corresponds, elements from *Sefer yezirah*, and more.[14] Matters of sefirotic positioning and spatial relationships are also emphasized throughout the short treatise. Thus not only are the qualities of each sefirah attended to but also their networking; an accounting of the channels that connect them to one another is integral to the presentation.

Codices that preserve this text betray its ilan-parchment origins. This is clearly implied in two Vatican manuscripts, where roughly a third of the space on each page is allocated to medallions that maintain the content and styling of their source:

Figure 26 (opposite) | Classical ilan, parchment, ca. 70 × 60 cm, copied by Solomon Astruc b. Elijah for Jeremiah b. Moses Nomico, Candia, Crete, 1451. Vatican City, BAV, MS Vat.ebr. 530 III © 2022 Biblioteca Apostolica Vaticana, with all rights reserved.

Figure 27 | *Binah, Gedulah, Gevurah* of deconstructed classical ilan, fol. 16v, Sephardi script, copied in Ankara, 1556. Vatican City, BAV, MS Vat.ebr. 456 © 2022 Biblioteca Apostolica Vaticana, with all rights reserved.

key terms are in large, bold script, secondary associations in a diminutive semicursive, and longer inscriptions follow the circle of the circumference (fig. 27). The parchment could not be miniaturized to fit the codex, but it could be deconstructed. This

Figure 28 | Comparison of *Binah* and *Gevurah*, details from figs. 26 and 27 © 2022 Biblioteca Apostolica Vaticana, with all rights reserved.

Figure 29 (opposite) | Classical ilan, parchment, 76 × 56 cm, Sephardi script, late fourteenth century. Brescia, Biblioteca Queriniana, MS L FI 11.

dissection and reformatting is the work of a kabbalist accustomed to copying short treatises into his notebook as he came across them. Carrying out a full reproduction of the parchment would have been costly and impractical, making his approach a compelling option.

In this detail (fig. 28) we see the medallions of three sefirot, *Binah*, *Gedulah*, and *Gevurah*; the texts inside them are found in their counterparts on the ilan. *Gedulah*, for example, appears in square script with Abraham–Right–*EL* in semicursive just below. The text abutting the circumference of the circle warns of the demonic forces attracted to this quality. Four expressions of these parasitic forces are shown leeching onto its perimeter: *klippot* (shells), *'orlah* (foreskin), *sarim* (ministers), and *Ishmael* (from Gen. 16:3), which requires no translation. Additional lore surrounds each circle, maintaining the proximity of text and picture. What is lost in the codex is the immediacy and presence of the structure as a whole, as well as its indeterminacy: one begins with *Keter* and concludes with *Malkhut*. By contrast, the ilan is not governed by the linearity dictated by the ordered codex pages: one begins and ends anywhere one desires. This intrinsic indeterminacy opens up the

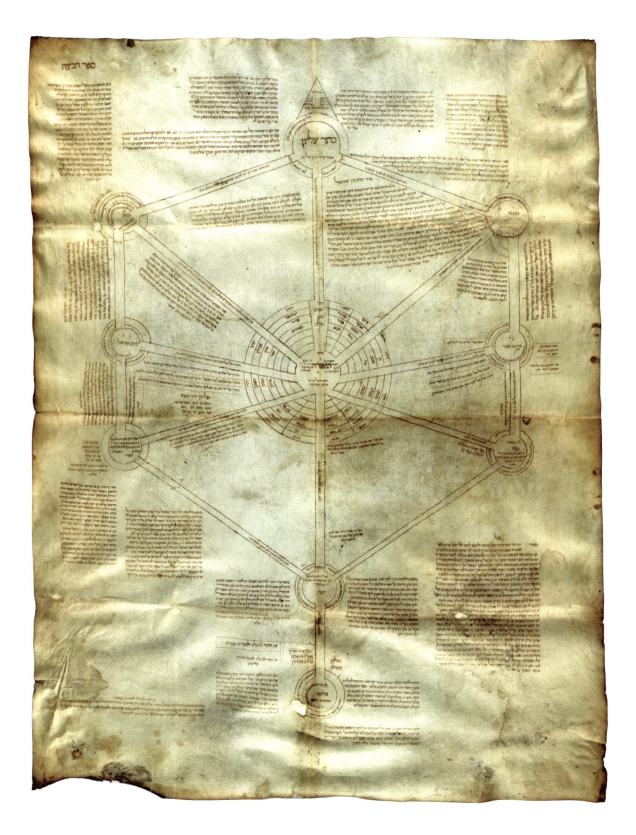

full creative and generative potential of the ilan as a tool of devotion, contemplation, and speculation. The codex made for an easier and more economical copying job, but the convenience came at a cost.[15]

The second early ilan was discovered not long ago in the Biblioteca Queriniana in Brescia (fig. 29).[16] It was likely written by a Spanish scribe in the late fourteenth century, making it even older than the Vatican parchment, which has a version of the same text. This common text lets us see with particular clarity the significance of the schemata in iconotextual artifacts. The Vatican and Brescia parchments both have arboreal diagrams, but the trees are of different species, as it were.

The topmost schematic element in the Brescia ilan is the triangle atop *Keter*. In its upward-pointing peak is the highest inscription on the parchment, the interwoven eight-letter integration of the Tetragrammaton and *ADNY* (Lord): יאהדונהי. This is the fundamental *yiḥud* or "unification" at the heart of kabbalistic performance. It so happens that its numerical value (91) is shared with the word *ilan*. This seems to be a knowing wink that simultaneously titles the parchment and communicates a conceptual evaluation of the genre it exemplifies. The lower section of the triangle is inscribed, "Know that this is the tradition, received by one from the mouth of another." The tradition visualized in this ilan also explains why this *yiḥud* atop *Keter* is the highest inscription on the parchment, rather than *Ein Sof*. As the text within the circle of *Keter* explains, *Ein Sof* is, in fact, one of its names: they are one.[17]

The distinctive rota-augmented arboreal schema of the Brescia ilan stands out as its most distinguishing feature. Its message is clear: *Tiferet*, the hub of the entire sefirotic tree, is emblazoned just above the compass-point perforation mark at the center of the concentric circles. As in the Vatican ilan, the Tetragrammaton is atop the innermost circle in its "normal" letter order, along with inscriptions that stress the central position of Jacob. Yet the rotae ringing *Tiferet* have no parallel in the other parchment. Recalling the logic of fig. 6, these circles comprise a table devoted to the layering and patterning of key categories, in this case, "twelves": the signs of the zodiac, Hebrew months, tribes of Israel, and the possible sequences of the four letters of the Tetragrammaton. The cosmological valence is clear: *Ein Sof* may be the fount of all, but *Tiferet* is the cosmic center. The caption inside the medallion, taken from *Sefer yeẓirah* §38, is consistent with this perception: "the Holy Temple set at the center" (heikhal ha-kodesh mekhuvan ba-'emẓa). Although the inscriptions in the channels that connect *Tiferet* to the sefirot that surround it betray theosophical content, e.g., "the pathways of *Ḥokhmah* coming to *Tiferet*," the layout of these channels is unusual.[18] Despite the impetus to represent the theosophical transvaluation of the ten sefirot and twenty-two letters of *Sefer yeẓirah* as an arboreal diagram with ten circles connected by twenty-two channels—an aspiration achieved when prioritized, as we will see below—most classical trees display fewer interconnections. The Brescia ilan has half the number of channels of its peers, and all eight radiate exclusively from *Tiferet*. Recalling the "Ilan ha-ḥokhmah" (figs. 8 and 9)—now in a theosophical key—the designer of this variation on the arboreal schema thought of *Tiferet* as the center not only of the divine sefirotic constellation but ultimately of three-dimensional space itself. The eight spokes of *Tiferet* reach eight implied vertices of the tree, imbuing it with connotations of cubic structure.[19]

Even though the basic elements of classical ilanot remained stable, particular kabbalistic opinions gave rise to graphical variation, as in the *Tiferet*-centered network of the Brescia parchment. Unlike the Brescia and Vatican ilanot, the sketch at the back of the Munich codex features *Ein Sof* above the tree (fig. 25). When included in classical ilanot,

Ein Sof was often given a medallion of its own, suspended above *Keter* or engaging it by means of a funnel-shaped channel.[20] The medallion of *Ein Sof* was usually split horizontally into two semicircles, the lower filled with black ink. Each graphical choice expressed a distinct theosophical and/or epistemological position. What is the relationship between the Infinite and the sefirot? What is the last frontier of human knowledge? The black semicircle within the medallion of *Ein Sof* suggests that the mind has reached its limit and can know no more, a meaning made explicit in adjacent texts. So too in the layout of the top three sefirot. The kabbalistic tree most commonly seen today, with its triangular top, represents the triumph of Judah Ḥayyat and the Spanish school in the sixteenth century.

Renaissance Ilanot

The Vatican and Brescia ilanot preserve examples of the genre in its infancy. Neither was executed by an Italian scribe, but their preservation in Italy and Ṣarfati's fourteenth-century ilan commentaries point to the centrality of Italy in the classical period of the genre. The great ilanot of the sixteenth century only reinforce that impression. Building on the skeletal frames of their austere precursors, these parchments have been treated to enhancements of every kind, and all reflect the milieu in which they were reimagined.

The image of the Renaissance has changed remarkably over the past few generations. Historians in the late nineteenth and early twentieth centuries cast it as the precocious precursor of the rational, disenchanted outlook that they associated with modernity. Starting in the mid-twentieth century, historians increasingly turned their attention to the kabbalistic and magical pursuits of its leading exponents and architects. These pursuits were just as dear to those Renaissance men as their commitments to the advancement of humanism, and they were often profoundly intertwined. Thus, for example, Giovanni Pico della Mirandola's 1486 *De hominis dignitate* (On the dignity of man), sometimes called the "manifesto of the Renaissance," is suffused with Kabbalah.[21] Pico della Mirandola (1463–1494) was one of the Christian intellectuals of the era who took great interest in the subject, studying it privately with rabbis and engaging the services of Jewish converts to Christianity to gather, translate, and teach kabbalistic sources. Many Italian rabbis of the era were enthusiastic participants in this activity.[22] Historians of Renaissance Jewish culture first focused on secular expressions of this sensibility before embracing a more complex picture in which rationalism and Kabbalah were no longer cast as oppositional but, rather, as concurrent and even complementary.[23]

If the historical picture of the "Hebrew-speaking Renaissance" is now richly drawn, the great ilanot of the era have only recently been given their first round of scholarly attention.[24] Renaissance ilanot capture the essence of their provenance. They are the products of Jews (and Christians) who shared a common conviction that the Kabbalah was the most ancient and sublime expression of philosophical and magical esotericism. As we would expect, their visualizations of kabbalistic cosmology use the distinctive representational language of their time and place.

An Ancient Parchment Renewed

I begin with a liminal artifact: a copy of an early Italian ilan (fig. 30). A strong case could be made for presenting it alongside the parchments in Brescia and the Vatican, but its visual language forced my hand. Although crafted decades later than the other ilanot in this section, in deference to its strong underlying affinities with earlier artifacts

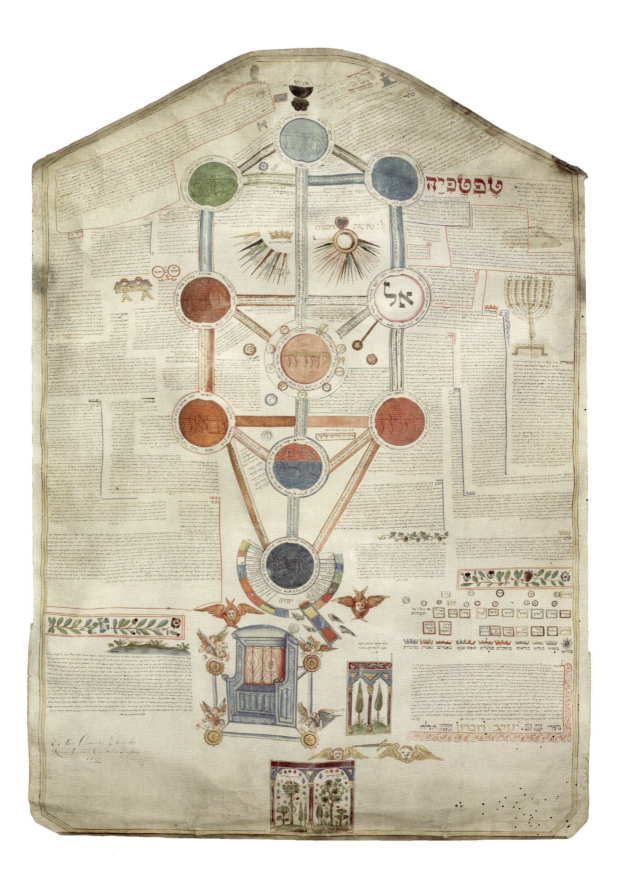

I treat it, figuratively speaking, as the first Renaissance ilan. And now to the story.

Once upon a time—early in the sixteenth century, to be more exact—an old Italian ilan was acquired by the Italian humanist and philosopher Cardinal Egidio da Viterbo (1472–1532).[25] The text it bore was the idiosyncratic introduction to the sefirot, *Iggeret sippurim* (Letter of stories), and Ṣarfati's commentary on it, the "Commentary on the *Great Parchment*"—making it, therefore, "the" *Great Parchment*.[26] The ilan subsequently found its way to the library of Catherine de' Medici (1519–1589), the Italian noblewoman who became queen of France. Manuscripts from Catherine's collection arrived at the royal library of Paris in 1599. It was there that the great scholar Isaac Casaubon (1559–1614) discovered the ilan. The old parchment, which by then may have celebrated its bicentennial, was in such poor condition and so difficult to read that Casaubon found it impossible to decipher. He therefore commissioned the Scottish Hebraist James Hepburn (1573–1620) to undertake its reproduction in 1606 or early 1607.[27] Hepburn was a fine artist and a learned Hebraist with a penchant for Christianity-validating syncretistic *prisca theologia* (ancient theology).[28] These skills and sensibilities are sumptuously shown in a large engraving entitled *Virga Aurea* (Golden rod), an iconotextual feast that praises the Virgin in a kabbalistic whirlwind of seventy-two different alphabets. Hepburn prepared it with the engraver Philippe Thomassin (1562–1622) and printed it in Rome in 1616, while serving as curator of Oriental manuscripts in the Vatican (fig. 31).[29] In the print's Hebrew dedication, Hepburn refers to himself as "the younger brother Jacob Ḥebroni, the Scot."

Figure 30 | The *Great Parchment*, parchment, 108 × 75 cm, copied in Paris in 1606 or 1607 by James Hepburn. Oxford, BL, MS Hunt. Add. E. Courtesy of The Bodleian Libraries, University of Oxford, CC-BY-NC 4.0.

In 1678 this Hebrew *nom de plume* was added to Hepburn's copy of the old ilan, today in the Bodleian Library.[30] In addition to Ṣarfati's text, the *Great Parchment* displays the elements found in the Ṣarfati template: the half-blackened circle of *Ein Sof* hovering above a tree of sefirot with large inscribed medallions and channels. Note that the typical theosophical names of the sefirot, from *Keter* to *Malkhut*, appear among the lists of appellations inscribed around the perimeters of each medallion. The large, hollow-lettered captions centered in each one reveal its related "unerasable" divine name, from *EHYH* (from Exod. 3:14) to *Adonai*. And even though many classical ilanot include the names of colors alongside biblical figures, body parts, and other associations, the Hepburn copy is unique in its use of actual color to dye each medallion a distinctive hue. The more conventional menorah and table are to the right and left of the tree, in accordance with their placement on the southern and northern sides of the Temple and their historic symbolic and contemplative connotations. Hepburn has arrayed novel, colorful images beneath the tree: the Chariot, with four four-headed cherubs (Heb. *kruvim*) supporting the Throne of Glory, and two views of the Garden of Eden with its cherub-guarded gates.[31]

Without a fourteenth-century *Great Parchment* for comparison, it is hard to know just how much liberty Hepburn took when undertaking his restoration. My impression is that his source resembled the Vatican and Brescia parchments more than it did his "restoration." Hepburn almost certainly beautified the *Great Parchment*, aestheticizing it in a manner befitting his artistic prowess and the conventions of representation with which he was familiar. If they were even in his source, the Chariot and cherubs would have been rendered with schematic austerity, as we typically find them in kabbalistic manuscripts. Hepburn brought them into his own world, so instead of geometric abstractions they were winged chubby children (putti).[32] There

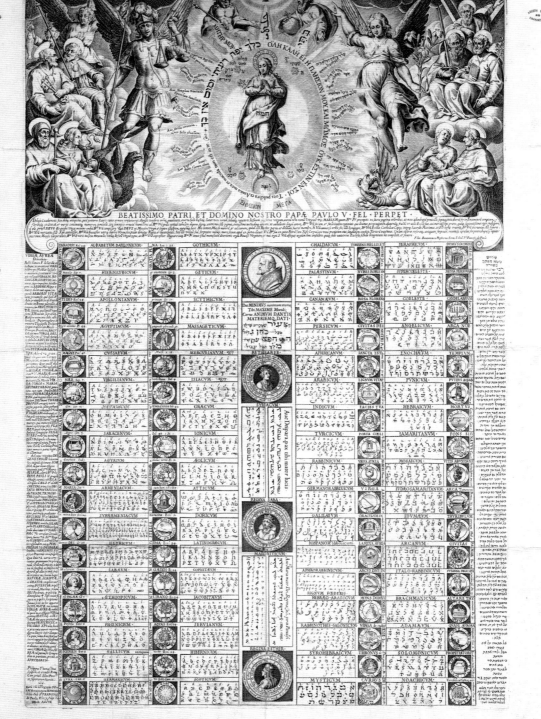

nevertheless remains a certain dissonance between their baby faces and the threatening sword that hangs between them at the gates of Eden, let alone their four-headedness when powering the Chariot. And what of the technicolor representation of the ladder descending from the lowest sefirah? Was it based on an element in the original *Great Parchment*? Or the two-tone (beating?) heart icon tied by a golden string to the medallion of Ḥokhmah (here captioned *EL*) and suspended amid the bold inscription "*Lamed-bet* [i.e., 32] Paths of Wisdom?" (The Hebrew numerals for thirty-two also spell the word for heart, *lev*.[33]) Or the black "cloud of unknowing" floating between *Keter* (here captioned *EHYH*) and *Ein Sof*? To all of these rhetorical questions—and more could easily be added—the answer is the same: I think not. Still, Hepburn should not be accused of introducing crassly Christological interpolations into his makeover of the *Great Parchment*; the Tetragrammaton has not become a "Pentagrammaton."[34] These embellishments are, rather, the gifts of a scholar-artist entrusted with the task of providing Casaubon with a *Great Parchment* he could read. Hepburn carried out that mission with supreme skill.

Hepburn did not limit himself to deciphering the intimidatingly difficult script on the worn parchment: he gave it the royal treatment. Rich dyes—including sefirotic medallions colored to match their symbolic associations—as well as genteel decorative motifs and putti were all part of the new picture. The Throne of Glory was drawn as a cabinet-style throne chair akin to those found in the homes of Florentine nobility.[35] Unlike the rest of the figures on the ilan, the table and throne were even rendered in perspective, albeit amateurish by the standards of the time. The firmament upon which the throne rests was also drawn as a cube, with diagonals converging underneath it from each of its four corners—a technique used in medieval treatises on geometry to convey three-dimensionality.[36] Given the representational sophistication on display in his *Virga Aurea*, Hepburn seems to have deliberately used an archaic visual language as a gesture of fidelity to his source.

The *Grand Venetian Parchment* of R. Elijah Menaḥem Ḥalfan and R. Abraham Ṣarfati

In 1533, R. Elijah Menaḥem Ḥalfan (active first part of sixteenth century) extended his gracious hospitality to an older kabbalist by the name of R. Abraham Ṣarfati (active late fifteenth–first part of sixteenth century). Ḥalfan's comfortable home in Venice provided Ṣarfati with a place to recover following the tragic execution of his revered master, the former converso and messianic activist Shlomo Molcho (ca. 1500–1532).[37] Four years earlier, Ṣarfati had abandoned his home and family to follow Molcho. Ṣarfati was grateful for the succor offered by Ḥalfan, an affluent physician, rabbinic scholar, and kabbalist. Deep in conversation, the two hit upon a wonderful idea: they would collaborate in the making of an ilan. I will return to this backstory shortly and allow them to share it in their own words.

The ilan created by Ḥalfan and Ṣarfati has reached us largely intact (fig. 32). The imposing, squarish ilan was constructed of six oddly shaped parchment sheets sewn together like a patchwork quilt. The ilan seems never to have been copied. Ḥalfan and Ṣarfati used the genre and its established conventions with clever creativity to produce an ilan that testifies to their cultural world.

Figure 31 | *Virga Aurea—Schema Alphabeti 54 Diversarum Lingarum*, paper engraving, 76 × 50 cm, by James Hepburn, Rome, 1616. Simancas, Archivo General de Simancas, MPD, 26,041. España, Ministerio de Cultura y Deporte.

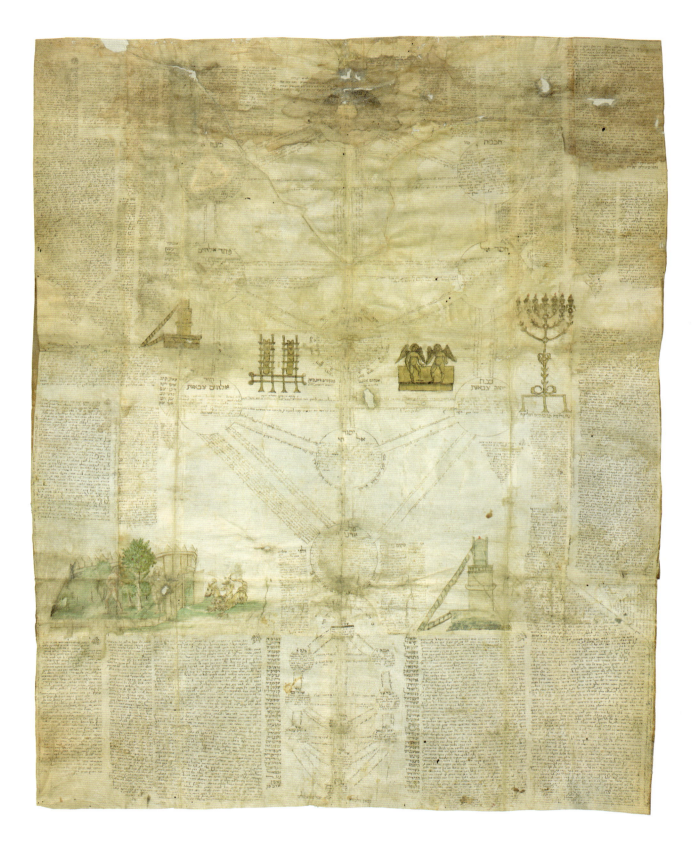

The two kabbalists began their collaboration in full cognizance of the foundational classical ilanot with which they were demonstrably familiar; these were their points of reference even as they pursued an innovative and ambitious approach to the genre. The conventions of the genre determined the basic character of their artifact, from the wedding of diagram and parchment to the inclusion of stock iconographic elements. The latter include the half-blackened circle of *Ein Sof*, the large arboreal diagram dominating the center, the menorah, and the table. Additional Temple vessels—the altar and the Ark of the Covenant—have also been added, the latter sporting two golden cherubs. As in Hepburn's *Great Parchment*, these are of the putti variety, though distinctly gendered as male and female—a representation consistent with ancient rabbinic tradition (e.g., b*Yoma* 74a).

Ḥalfan and Abraham Ṣarfati incorporated much of a *Small Parchment* ilan into their creation, with its text filling all but the bottom quarter of the recto of the new ilan.[38] To this core text Ḥalfan and Ṣarfati added selections from early kabbalistic works by Gikatilla and the so-called Circle of the Special Cherub.[39] These are found primarily in the bottom quarter of the recto and on the verso. The Gikatilla texts are closely related to those found on the Brescia and Vatican parchments, making it plausible that more than one ilan was at the disposal of these two men in Venice. The Special Cherub texts cast an angel, the Special Cherub, as the proxy of the transcendent God for the purposes of prayer, contemplation, and visionary ascent. The philosophical appeal of this esoteric tradition lies in its positing of a seen (manifestation of) God who is nevertheless at a remove from the (true) unseen God. The threat of corporealizing the Divine, whether in the mind's eye as one studied the *Shi'ur komah* (Measurement of the height [of the divine body]) or in the form of a map of God on parchment, was thus lessened.[40] That such a threat was real to Ḥalfan is apparent from the first gloss on the *Grand Venetian Parchment*, just beside the upper semicircle of *Ein Sof* inscribed "Ein Sof, 'ilat ha-'ilot, sibat ha-sibot" [Infinite, First Cause, Prime Mover]. The gloss, likely the words of Ḥalfan himself, reads like a disclaimer: "Anyone reading here (!) [kol ha-kore kan] is hereby cautioned lest, heaven forbid, it occurs to him to believe in the attributes [ba-tearim] or in corporeality [be-gashmut]. For one who believes in corporeality has effectively denied the fundamental [belief in God] [kofer be-'ikar]. Instead, [let it be understood that] all is pure, clear light. . . ."

Ḥalfan and Ṣarfati should therefore be regarded as the designers, editors, and anthologizers of the *Grand Venetian Parchment* rather than the authors of its kabbalistic texts. This understanding, as we will see shortly, is consistent with their own descriptions of their collaboration in the testimonies appended to the verso in their own names. This reassessment of their contribution to the ilan does not lessen the significance of their achievement and its degree of innovation. Without fundamentally changing the rules of the genre, the two kabbalistic craftsmen took the ilan to an unprecedented realization of its cartographic potential. Among classical ilanot, none exhibit a greater dedication to the meaningful placement of secondary, supporting text. Editorial glosses, including bold titles, relate to general areas using such phrases as, "from here and up," "from here down," and "from here outward." The warning just cited also began, "Anyone reading here." No less extraordinary is the unprecedented manner in which Ḥalfan and Ṣarfati conceptualized the parchment itself as a map feature.

Figure 32 | The *Grand Venetian Parchment*, parchment, 122 × 94 cm, Elijah Menaḥem Ḥalfan and Abraham Ṣarfati in Venice, 1533. Florence, Biblioteca Medicea Laurenziana, MS Plut.44.18, by permission of the MiC. Any further reproduction by any means is prohibited.

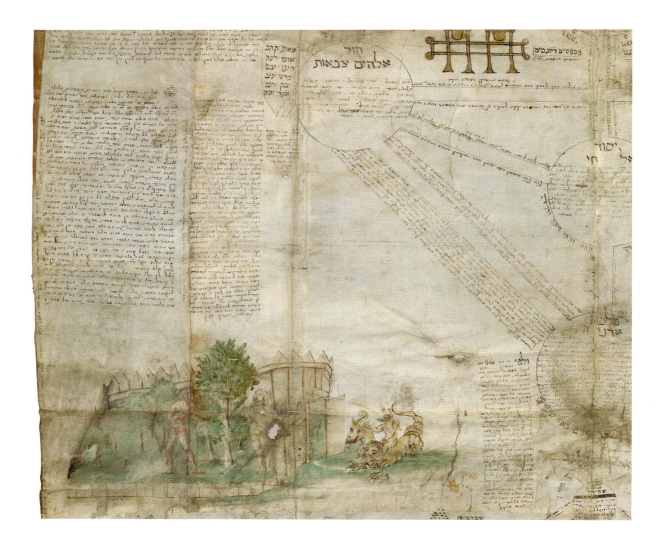

Figure 33 | The sin in the Garden, detail from the *Grand Venetian Parchment*, parchment, 122 × 94 cm, Elijah Menaḥem Ḥalfan and Abraham Ṣarfati in Venice, 1533. Florence, Biblioteca Medicea Laurenziana, MS Plut.44.18, by permission of the MiC. Any further reproduction by any means is prohibited.

Attention to precise placement of iconographic and textual elements on the parchment is evident throughout. Take, for example, the complex in the lower left section of the central tree (fig. 33). Three elements, all in close proximity to one another and to a specific location on the "map," are at play. First, on either side of the channel that connects the sefirah of *Hod* with that of *Malkhut*—the lowest channel on the left—we find a text that relates to it directly: "From this channel, the first Adam [Adam ha-rishon, more accurately, 'first person'] burst the fence [paraẓ ha-gader] and thereby allowed the serpent to cast his filth into Eve. For before the first Adam sinned, the serpent was outside of the orchard." The text goes on to discuss the connection

between Adam's sin of "drawing forward his foreskin" (b*Sanhedrin* 38b), the fruit of young trees (Lev. 19:23–25), and evil. Two blocks of text may be seen to the left of this lowest section of the tree; the narrower of the two, closest to the channel, begins, "This is the location of the breach ruptured by the first Adam from which the serpent came and cast his filth into *Malkhut*, for the serpent stood beyond the bounds of the inner Chariot." The serpent is cast as the perennial underminer of *Malkhut*, the "gliding serpent, Leviathan the coiling serpent" (Isa. 27:1), who will only be conquered at the end of days. A horizontal inscription to the left of this column reinforces its locative character. Even though much of the first of its two lines was cut in a sloppy restoration of the parchment at some point in the past, the gist is clear: "From here . . . the place of the serpent . . . to the bottom, beyond the bounds of *Malkhut*."

The third element hardly needs pointing out: a scene from the Garden of Eden.[41] Within a walled garden stands an attractive couple on either side of a tree. Set apart from the rest, its green-leaved branches are adorned with red fruit. The naked man and woman gaze in attraction not at each other but, rather, upon the low-hanging fruit between them. They smile in the thick of temptation, but their joy is to be short-lived. The garden has already been breached, and a dragon-driving demon is fast approaching from the right: Samael has "mounted the serpent, whose appearance was something like that of the camel."[42] Unaccustomed as we are to such illuminations in kabbalistic manuscripts, we would think the image out of place were it not a precise visualization of the adjacent texts. It was thus clearly executed in accordance with Ḥalfan and Ṣarfati's specifications.[43] Ḥalfan likely commissioned a local artisan to undertake the illumination, which in itself is noteworthy. Ilanot show the full range of craftsmanship, from the sketches of rank amateurs to the precision of dedicated draftsmen. In nearly every case, these iconotexts are the work of one hand—the scribe of the text is the draftsman of the diagrams—but the Ḥalfan-Ṣarfati ilan is an exception; it is an illuminated manuscript in the conventional sense.

The attention to placement evident throughout the *Grand Venetian Parchment* is given its most inventive expression in the lowest margin, which features a mini-tree of its own.[44] This diminutive tree represents the sefirot apprehensible by the human mind; they are separated from the larger tree above them by an arching biblical inscription, "no one may see me and live" (Exod. 33:20). Here again we see a graphical representation of an epistemic position: the picturing of the divine world allows one to see what can and cannot be known. The proximate texts this time are again found in Reuben Ṣarfati's *Perush zulati*, which here delves into the complexities of the Special Cherub, the apprehensible divinity. Nearly two thousand words are devoted to the kabbalistic meaning of Exodus 33:18–23: Moses's request that God show him his glory, God's response ("no one may see me and live"), and the consolation prize offered, "you will see my back." The ten sefirot are the *kavod 'elyon* (supernal Glory) and, as such, are not apprehensible even to the prophets. In this context, the smaller sefirotic tree represents the lower Chariot, the lower Glory or God's "back." The divine topography pictured on the map ends here. The lower edge of the parchment leaves us with the cosmological equivalent of a highway direction sign: "from here and below is the World of the Spheres [galgalim]."

The attention to careful maplike placement shown by Ḥalfan and Ṣarfati may be unmatched by other classical ilanot, but such considerations are constitutive of the genre and hardly unique. What sets the *Grand Venetian Parchment* apart from all others is its transformation of the medium itself into part of the picture. The ilan *qua* map locates

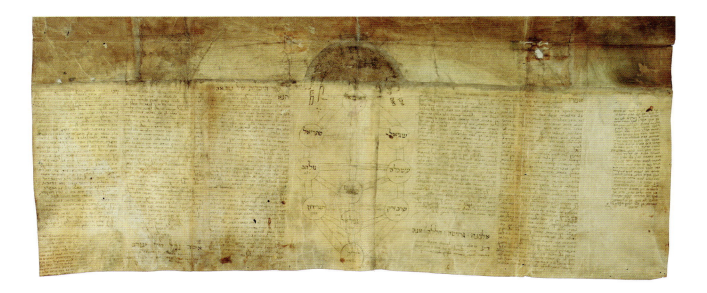

Figure 34 | The demonic tree, verso detail from the *Grand Venetian Parchment*, parchment, 122 × 94 cm, Elijah Menaḥem Ḥalfan and Abraham Ṣarfati in Venice, 1533. Florence, Biblioteca Medicea Laurenziana, MS Plut.44.18, by permission of the MiC. Any further reproduction by any means is prohibited.

its referents on X-Y coordinates; in their unprecedented deployment of the back of the parchment, Ḥalfan and Ṣarfati added a Z. Their ilan now had right and left, up and down, *and* front and back; it was in three dimensions. This they accomplished by inscribing an ilan on the verso, precisely sized and aligned with the diminutive tree on the recto (fig. 34). If the latter is "God's back," the former is the *other side* of God's back. In this way they created a literal *Sitra Aḥra*—the kabbalistic-Aramaic term for evil that translates to "the Other Side"—that is unique in the corpus. Its medallions are filled with the names of sinister spirits; it is the ilan of evil. Here again, the figure and its sparse inscriptions are elaborated upon in the nearly two thousand words on either side of the demonic tree. Whereas the central and bottom medallions of its holy twin are inscribed "Tiferet YHVH" and "Malkhut Adonai H" (the final letter of the Tetragrammaton), their counterparts on the verso read "Samael" and "Lilit." Opposing trees are occasionally found on the facing pages of kabbalistic codices, recalling the Virtues and Vices of medieval Christian manuscripts, but this front-and-back use of the parchment communicates the structural parallelism of good and evil with unmatched material tangibility.[45]

The verso of the *Grand Venetian Parchment* also provides a rare opportunity to learn about the production of an ilan. Much more than a colophon, we find testimonies written by Ḥalfan (far left) and Ṣarfati (far right) in columns flanking the texts devoted to the *Sitra Aḥra* (evil side).[46] Ṣarfati relates that from the moment he reached Venice, Ḥalfan proved a generous host: "I arrived here and found ready a bed and a table, a chair and a lamp." Moreover, his host was one of those rare men of whom he could say, "and to one as wise as he, it is befitting to reveal the secrets of Torah." How could Ṣarfati repay such a host for his hospitality? Quoting Ahasuerus in Esther 6:6, he asks rhetorically, "What

SPECIAL FOCUS | *Rolled or Folded? What's in a Name? Solving an Old Mystery*

When we think of ilanot, scrolling understandably comes immediately to mind. Yet early ilan parchments exhibit lines that clearly indicate their having been folded (rather than rolled) in the past. Imagining them folded is hardly a challenge; following the lines, these ilanot become their own envelopes. To use an ancient rabbinic metaphor beloved by the kabbalists, they were "like the locust whose garment is in and of itself" (Genesis Rabbah 21:5).

The orientations of the inscriptions on the verso of the Vatican parchment corroborate this impression; they would have been visible as its "address" on the exterior of the folded sheet (fig. 35). The considerably more elaborate *Grand Venetian Parchment* exhibits similar fold lines and, as we have seen, includes on the back statements written

Figure 35 | Dedication, verso of Vatican City, BAV, MS Vat.ebr. 530 III, classical ilan, parchment, ca. 70 × 60 cm, copied by Solomon Astruc b. Elijah for Jeremiah b. Moses Nomico, Candia Crete, 1451. © 2022 Biblioteca Apostolica Vaticana, with all rights reserved.

by the two men addressed to readers of the ilan. The verso inscriptions of these early ilanot are thus their *addresses*, in both senses of the term. Indeed, a medieval letter was nothing more than a sheet of parchment, folded and addressed.[49]

As material texts, the oldest ilanot were therefore letters of a sort. This realization illuminates the first words of the title found on some copies of the *Great Parchment* text: "Iggeret sippurim" (Letter of stories). The title was so incomprehensible to Gershom Scholem that this preeminent twentieth-century scholar recorded it as *Iggeret Purim* (Letter of Purim). This misreading is hardly more comprehensible or defensible, given the lack of any reference to Purim in the text. Thanks to Scholem's authority, this nonsensical title is still in use by the National Library of Israel.[50] But if the oldest ilanot were folded and "addressed" to their recipients— as are MS Vat.ebr.530 III and the *Grand Venetian Parchment*—then calling them "letters" becomes rather easier to understand.

What, though, were the "stories" referred to in the second word of the title? The term may refer to the quirky nature of this particular introduction to the sefirot: they are explained in storylike narratives rather than in the typical prosaic style based on the aggregation of appellations and associations. More likely, though, the reference is to the sefirot themselves. This interpretation derives from the beginning of *Sefer yezirah*, which declares that God created the cosmos with three things that share the spelling and Hebrew root s-p-r (ספר). Different vocalizations of these consonants (i.e., added vowels) made for a variety of potential readings. *Sippur* (story) was typically one of the three.[51] Reuben Ṣarfati, the pioneer of the genre whose commentary on the *Great Parchment* takes *Iggeret sippurim* as its base text, explicitly embraced this understanding in *Shaʿar ha-shamayim* (Gate of heaven), positing a cognitive distinction between *Ein Sof* and the sefirot.[52] The former was unknowable, and nothing could be said of it; the latter were knowable qualities, and much could be said of them. Ṣarfati wrote, "That which is apprehended by our intellect is called *sefirah*. And the term *sefirah* [ספירה] connotes story [סיפור], as it is permissible to tell [לספר] of them."[53] With these words, he introduced yet another commentary on a parchment ilan.[54]

The connection between story and sefirot was also buttressed by an intellectual tradition that was at once more foreign and more proximate to the Italian Jewish scholars who produced ilanot. I refer to the widely read Hebrew translations of Neoplatonic works that use the term *sippur* in a very relevant sense.[55] In Judah Romano's (ca. 1293–after 1330) Hebrew translation of Gerard of Cremona's (ca. 1114–1187) Latin translation of Pseudo-Aristotle's *Liber de causis*, the phrase "Causa prima superior est omni narratione" was rendered as "the First Cause [ha-sibbah ha-rishonah] is above the story [hiʿal ha-sippur]."[56] In its original context, of course, there are no sefirot, yet phrases from this very section of Romano's translation are inscribed surrounding the term *Ein Sof* atop the *Magnificent Parchment*. Just below *Ein Sof*, the kabbalistic moniker of the First Cause, is the sefirotic tree. The location of the passage amounts to a visual argument in which "the story" is conflated with the sefirotic tree. Such an understanding is in keeping with the most elemental of kabbalistic practices: reading the stories in the Torah as veiled accounts of intradivine life. To one who held the cipher, Isaac's blessing of Jacob revealed something of the flow between *Gevurah* and *Tiferet*, for example. The sefirot were stories—and the stuff of which stories were made.

should be done for the man the king delights to honor?" "We agreed," he answers, "to bestow a blessing upon his house, a fruit-bearing tree, an *ilana kadisha* [holy ilan/tree, in Aramaic rather than Hebrew], the feet of which are upon the earth and the head of which reaches the heavens." (Cf. Gen. 28:12) The blessing of this ilan was not merely talismanlike, however; it was also to be an object of learning and contemplation. "May the heavens grant him the merit to study it [lehagot bo], he and his children and his children's children, to the last of the generations. . . ."

Ḥalfan's dedication tells the story from the perspective of the host who is also the student of his older guest. He makes the idea of collaboration his own:

> It arose in my mind and I said to this venerable [sage], "let us make an ilan . . . with the names of divine angels, various and sundry vessels, a likeness [dugmat, a term used also for platonic archetypes] of *du parzufin* [two faces, here *Tiferet* and *Malkhut*], with 'behind and before' [Ps. 139:5] which were formed, and left and right as He created them, with its details and its commentaries—'revealing a hands-breadth and concealing two' [b*Nedarim* 20b]. It shall be kept for 'the elite though they are few' [b*Sukkah* 45b]. And he answered my voice and said, 'one who comes to purify is assisted'" [b*Yoma* 38b].[47]

With Ṣarfati as his advisor, Ḥalfan recounts his diligent quest "to assemble many books and treatises new and old." From them—and only from them, he insists—he populated the front and back of the ilan, creating the roughly fifteen-thousand-word anthology. He declares that none of the texts are their own compositions and that all have been arduously selected. Like Ṣarfati, Ḥalfan imagines that the ilan will be savored in its full iconotexual complexity. A tree (of the genre, featuring the schema) has angelic names, vessels (the Temple implements), and visualizations of the Godhead in its various dualities. It is an ilan in "its details and its commentaries."

Like Ṣarfati, we ought to thank Ḥalfan for his hospitality, without which one of the great ilanot of the Renaissance would never have been produced. Ṣarfati blessed his genial host with the hope that the ilan they crafted together would be studied "to the last of the generations." The blessing has proved to be remarkably potent. With the open-access online edition of the ilan, its texts transcribed, translated, and linked to high-resolution images, it can be studied as never before for years to come.[48]

The *Magnificent Parchment*

We have arrived at the crowning achievement of Italian ilan-making in the Renaissance: the *Magnificent Parchment* (fig. 36, gatefold following page 60).[57] Roughly a dozen copies have reached us, many of them complete.[58] The original was crafted around 1500 by an anonymous Italian kabbalist and scribal artist inspired to create an ilan of unprecedented scale and beauty.[59] Stylistically the parchment brings to mind the *Carta Marina*, a map created in Rome and published in Venice in 1539 (fig. 37), as well as the structural and decorative elements of Leon Battista Alberti's churches.[60] A broad, long parchment rotulus, densely inscribed with diagrammatic and figurative images as well as texts, the *Magnificent Parchment* is an undeniable masterpiece. Over multiple stitched membranes, it maps the heavens—and the Heaven of Heavens—stretched out not *like* parchment, as in Psalm 104:2, but *upon* it. Texts and images assembled from the entire kabbalistic library of its time and place are interwoven and arrayed as an unrivaled iconotextual *summa*. Mapping as it does the heavens—the

Figure 36 | *The Magnificent Parchment* (gatefold opposite)

Figure 37 | Olaus Magnus, *Carta Marina et Descriptio Septentrionalium Terrarum* (Venice, 1539). Minneapolis, James Ford Bell Library, University of Minnesota.

grand zodiac rota of its bottom third—and the divine world above them, its image of the cosmos is all-embracing.

The parchment is filled with hundreds of discrete visual elements, diagrammatic schemata, symbolic forms, and decorative embellishments, around and within which texts are inscribed. The texts alone constitute a formidable 33,000-word kabbalistic miscellany, described by Scholem as an "unbekannter Riesentext" (unknown gigantic text),[61] and myriad fascinating images abound. Atop the highest sefirah of *Keter*, the Infinite is figured as an open eye with "*Ein Sof*" inscribed at the center of the iris (fig. 38). There are dragons and snakes, bubbling wells and flowing rivers, and, most surprisingly, rabbis (fig. 39).[62] A small sefirotic tree with leafy branches will strike the careful reader as familiar; if not, look back at fig. 4 above (fig. 40). The sefirot are also depicted by means of other schemata, including a *ḥuppah* (wedding canopy) (fig. 41).[63] The walls and canopy roof are labeled with the names of the sefirot in this evocative kabbalistic *hieros gamos*, a sacred intradivine wedding. Another vignette represents them as a schematized Garden of Eden (fig. 42). The rotary array preserves a picture of the divine constellation that differs from the usual, with *Tiferet* and *'Atarah* sharing the central hub and *Yesod* and *Malkhut* the lowest medallion just below it. Where do these unusual elements come from, and what do they signify? All are to be found in the treatise I have dubbed the *Booklet of Kabbalistic Forms*.[64] The *Booklet* presents a series of kabbalistic images, each explicated by an accompanying text—a format that recalls that of the incipient genre of emblem books in its milieu. As with the *emblemata*, the reader is tasked with studying each image in light of an adjoining text that unpacked and elaborated upon its

60 | THE KABBALISTIC TREE

The *Magnificent Parchment* (*overleaf*)

Figure 36 | The *Magnificent Parchment*, parchment, 255 × 75 cm, Italy, ca. 1600. Oxford, BL, MS Hunt. Add. D. Courtesy of The Bodleian Libraries, University of Oxford, CC-BY-NC 4.0.

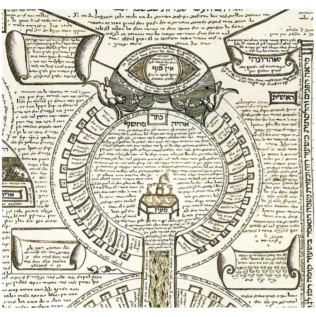

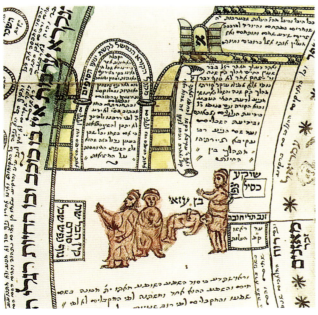

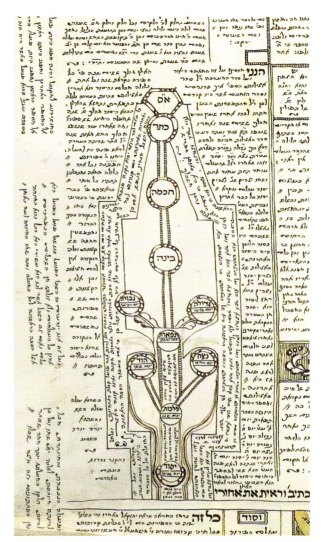

Figures 38 (left top), 39 (left bottom), and 40 (right) | *Ein Sof* and *Keter*, detail A; the four who entered Pardes, detail B; phytomorphic sefirotic tree, detail C, all from the *Magnificent Parchment*, parchment, 255 × 75 cm, Italy, ca. 1600. Oxford, BL, MS Hunt. Add. D. Courtesy of The Bodleian Libraries, University of Oxford, CC-BY-NC 4.0.

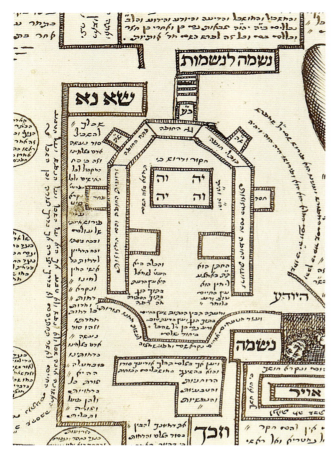

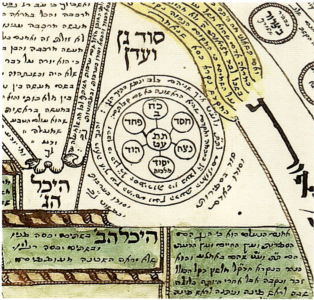

meaning. Yet we should not presume the influence of *emblemata* on the *Booklet*; rather, it would seem that both the genre and this Jewish parallel are expressions of a budding cultural trend. The texts of the *Booklet* exhibit a consistent style, especially in their opening words. These formulaic openings vary slightly in wording but share a common orientation, e.g., "In this form, two matters were made apparent," "This form comes to make apparent," "I have drawn this form in order to make apparent two matters. . . ."[65] Many of the secondary figures in the *Magnificent Parchment* were adapted from this fascinating work, along with paraphrastic abridgments of their accompanying texts.

Copying the intricate *Magnificent Parchment* was no trivial matter. A fragment in Leeds preserves one scribe's work in progress: the diagrammatic elements are in place and provide structure as the empty spaces begin to fill with texts in variously sized and stylized Italian scripts (fig. 43). When this fragment was abandoned, bold headers—the headlines of the ilan, so to speak—were in place, and the first word of the passage that was later to be inscribed in each text box had been written in its upper right. Only scribes with a mastery of their craft, including complex draftsmanship and decorative illustration, could take on such a commission. And only the wealthy could have afforded

Figures 41 (top) and *42 (bottom)* | Wedding-canopy sefirotic array, detail D; "The Secret of Garden and Eden," detail E, both from the *Magnificent Parchment*, parchment, 255 × 75 cm, Italy, ca. 1600. Oxford, BL, MS Hunt. Add. D. Courtesy of The Bodleian Libraries, University of Oxford, CC-BY-NC 4.0.

Figure 43 (opposite) | Unfinished fragment, the *Magnificent Parchment*, vellum, 82.2 × 48.7 cm, Italy, sixteenth century. Leeds University Library, MS Roth 418, reproduced with the permission of Special Collections.

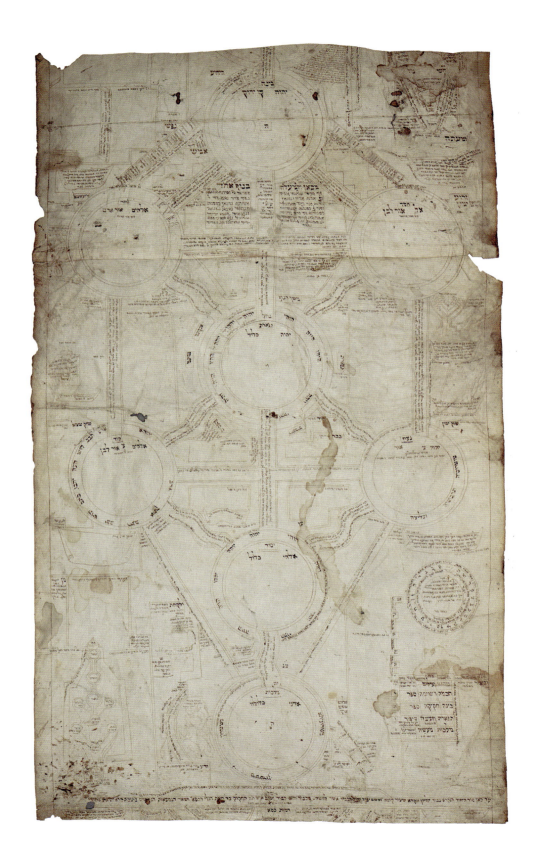

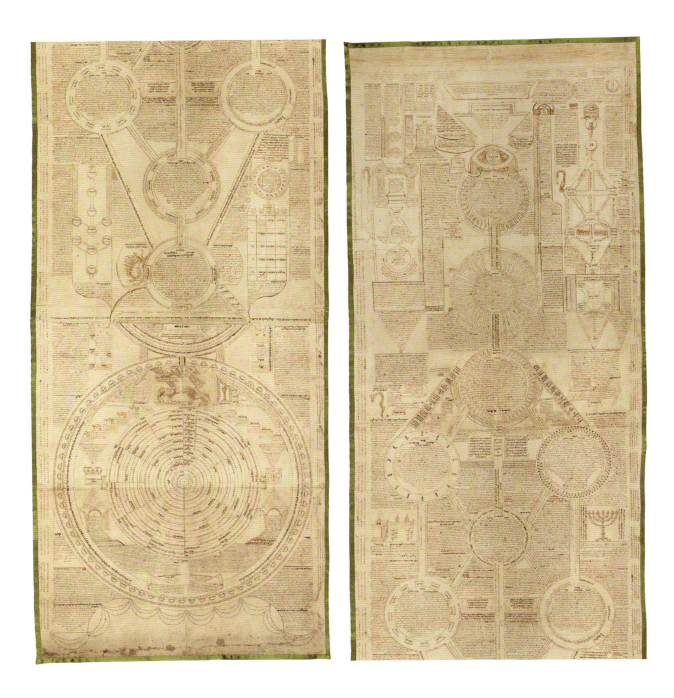

Figure 44 | The *Magnificent Parchment*, paper, 276 × 71 cm, Italy, sixteenth century. Private collection (Tel Aviv and London). Photo: Ardon Bar-Hama.

such a luxury manuscript akin to illuminated festival prayer books, Passover *haggadot*, marriage ketubot, and the like.[66] Given the interest in Kabbalah among non-Jewish elites in Renaissance Italy, the acquisition need not have been limited to wealthy Jews alone. In all likelihood, a *Magnificent Parchment* was the "Tree of Kabbalah" to which Benedetto Blanis, a Florentine Jew of the early seventeenth century, referred in a letter to his patron Don Giovanni de' Medici: "I am delighted to have so important a 'Tree of Kabbalah' here in Florence, brought from Lippiano at my request. I am having it copied on vellum with great diligence, so it will not be inferior to the original in any way but even better. I hope that this Tree will please Your Most Illustrious Excellency and that we will be able to enjoy it together."[67] Blanis understood the value of the *Magnificent Parchment* even to a Christian of Don Giovanni's stature. It was an all-encompassing picture of existence, drawn in an age that elided distinctions between the depiction and the depicted, the sign and its referent. This resemblance naturally made it attractive to its supernal analogues.[68]

The *Magnificent Parchment* was far more than a talismanic treasure coveted by the wealthy. Affluent kabbalists would have enjoyed exploring the ilan in its full glory. The less affluent might be content with a workmanlike copy that dispensed with color, gold leaf, and even parchment. A recently discovered witness provides a wonderful example of this option (fig. 44). The copyist was clearly a scholar who did not slavishly reproduce his source. As he copied, he took pains to optimize text placement and provide cues to the order of reading when a continuous passage had been divided into separate pieces. He also saw fit to censor elements he thought inappropriate, including the images of Rabbi Akiva (d. 135) and his colleagues (fig. 39). The quality of his craftsmanship has few peers, notwithstanding his choice—whether born of economic or ideological considerations—to use monochrome ink on paper. The Polish kabbalist David Darshan (ca. 1527–late sixteenth century) also drafted a simpler copy for himself while visiting Modena in 1556 (fig. 45).[69] Darshan was the perfect man for the job; an erudite rabbinic scholar, he was also an accomplished scribe who raised the funds to build his own impressive library by writing and selling hundreds of amulets.[70] Although austere by comparison to the colorful, gold-leaf-adorned copies of the *Magnificent Parchment* held by the Bodleian (fig. 36) and the Vatican (MS Vat.ebr. 598), Darshan's strengths are on display in his copy of the parchment: the texts have been copied with exceptional accuracy, as befits a scribe who understood them.

The creator of the *Magnificent Parchment* carefully selected, modified, and integrated a disparate but coherent range of kabbalistic, philosophical, and magical materials, both verbal and visual, to create his masterpiece. His literary sources and intellectual proclivities may be compared to those of Yoḥanan Alemanno (ca. 1435–ca. 1504), Abraham de Balmes (ca. 1440–1523), Elijah Ḥayyim Genazzano, and the banker-kabbalist Isaac da Pisa (second half of fifteenth century); the last would even have had the financial wherewithal to underwrite its commission.[71] The cursive inscription surrounding *Ein Sof* in the open eye atop the ilan exemplifies this milieu: "Languages fail to speak of it, as it transcends narration, and no utterance follows it, for it is the Cause of Causes." What is this text that glosses the marker of the apophatic kabbalistic divinity? None other than the passage noted above from Judah Romano's Hebrew translation of *Liber de causis*.[72] In the intellectual world of our creator, disparate kabbalistic, philosophical, and magical sources were relentlessly paraphrased and harmonized.[73]

Even as the *Magnificent Parchment* epitomizes the cultural world of Jewish scholars in Renaissance Italy, like the Ḥalfan-Ṣarfati ilan, it bears the

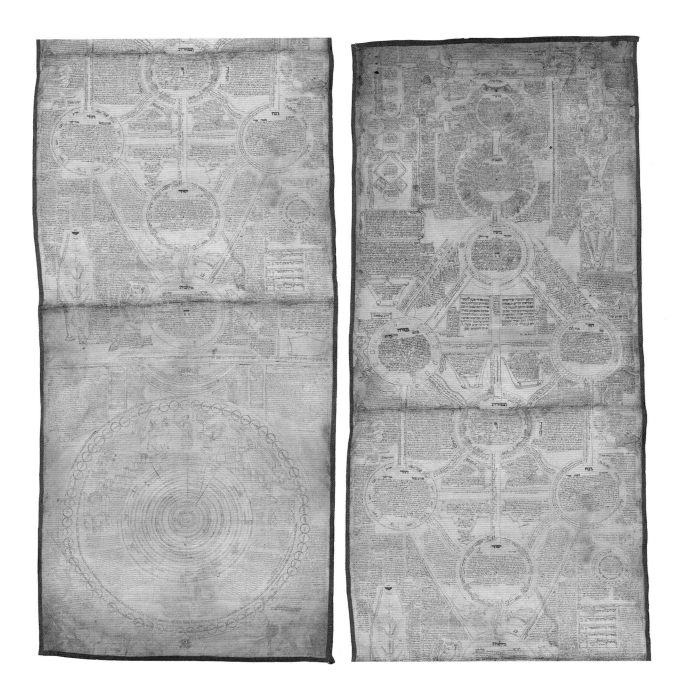

Figure 45 | The *Magnificent Parchment*, parchment, 200 × 57.2 cm, copied by David Darshan in Modena, 1556. London, BL, MS Or. 6465 Scroll. © The British Library Board.

DNA of its forebears: a parchment dominated by a central tree, flanked by the table and menorah. Its medallions are still devoted to the names and appellations of the sefirot. Divine names abound, as they do in its precursors: the perimeters of the sefirotic circles sport the *shemot ne'elamim* (hidden [divine] names), as in the seventy-two triads of the so-called *Shem 'ayin bet* (Name of seventy-two) inscribed in the arches surrounding Ḥesed.[74] Selections from kabbalistic works that circulated in fifteenth-century Italy—among them the *Ma'arekhet*, Recanati, and Joseph ben Shalom Ashkenazi (fourteenth century) on *Sefer yezirah*—are also found among the inscriptions. The voice of Abraham Abulafia (1240–ca. 1291) is particularly prominent. Abulafian Maimonideanism and his identification of the sefirot with the intellects are woven deeply into the warp and weft of the parchment.[75]

Figure 46 | Geomantic asterisms, detail from the *Magnificent Parchment*, parchment, 255 × 75 cm, Italy, ca. 1600. Oxford, BL, MS Hunt. Add. D. Courtesy of The Bodleian Libraries, University of Oxford, CC-BY-NC 4.0.

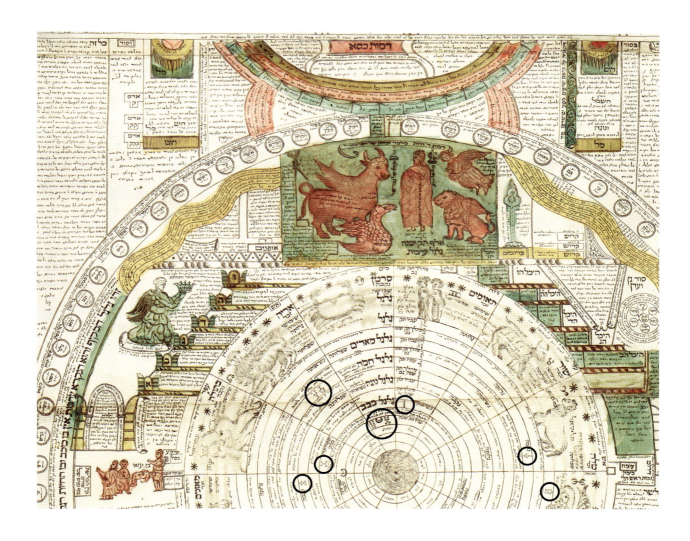

CLASSICAL ILANOT | 67

Just as the creator of the *Magnificent Parchment* assembled its texts from the corpus at hand, so too its images. Gazing from afar, two stand out: the tree that dominates the upper two-thirds of the parchment and the zodiac rota below it. For a kabbalist of this era, these were the two authoritative schemata for mapping the structure of the sefirot and the planetary spheres with their intellects, respectively. The tree features the pillar array of the three uppermost sefirot that appealed to philosophically minded Italian kabbalists. The rota, with its concentric circles divided into the twelve astrological signs, was in full accord with the science of its day.

A feature of the zodiac, common to all witnesses, is its inclusion of lunar mansions or asterisms that divide the path of the moon into twenty-eight stations (fig. 46).[76] Originally part of the Greek astronomical tradition, asterisms made their way to Europe via Arabic sources, one channel being the works of Abraham ibn Ezra (ca. 1093–1167).[77] The astronomical legacy of these asterisms was unlikely to have interested the creator of this parchment, however. Beginning in the twelfth century, the asterisms were appropriated in the Latin West as the figures of the divinatory "geomantic tableau" (fig. 47).[78] Not long after the *Magnificent Parchment* was produced, Heinrich Cornelius Agrippa (1486–1535) composed a treatise on geomancy of lasting influence. The system of correspondences between the sixteen figures and the zodiac that Agrippa synthesized from his sources largely overlaps with

Figure 47 | Geomantic asterisms, fols. 123b–124b, *Goralot* (divinatory techniques), Italy, fifteenth century. Amsterdam, Ets Haim Bibliotheek, Livraria Montezinos, MS D 47 20.

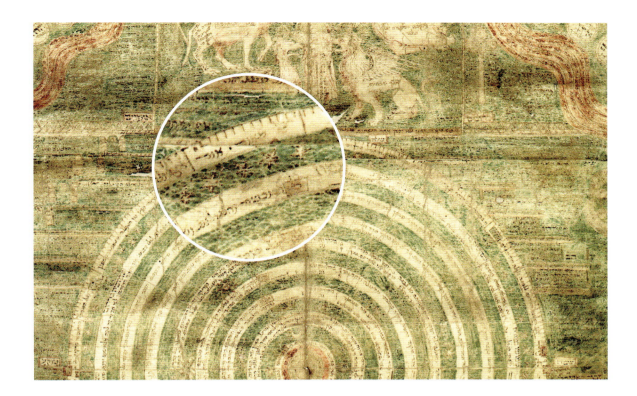

those on our parchment and suggests their common reliance on an earlier authority, perhaps the *Geomantiae astronomicae* of Gerard of Cremona.[79]

The geomantic asterisms are part of the astrological-divinatory material to which the bottom third of the *Magnificent Parchment* is dedicated. They appear in the rota next to inscriptions marking ascendants and descendants of the astrological signs. Along the inner edge of the outermost circle of the zodiac in the Cincinnati copy, which appears to be the oldest among those that have reached us, markings measure the thirty degrees allotted to each of the twelve signs (fig. 48). In an astrological natal chart, the precise degrees of the plotted signs determine whether they are in harmony, regardless of their general characteristics. Are we therefore looking at a tool designed to serve the needs of a working astrologer? I think not. Even

Figure 48 | Degree markings of the twelve signs, detail from the *Magnificent Parchment*, detail, parchment, 156 × 46 cm, Italy, ca. 1500. Cincinnati, HUC, Klau Scrolls 65.1.

though the markings convey this sense, they were unlikely to have been truly useful. Like the rest of the astrological content—and perhaps the texts of the *Magnificent Parchment* more generally—they seem primarily intended to represent the body of knowledge from which they have been extracted for inclusion within a comprehensive system.

The elementary astrological and divinatory texts that supplement the content of the zodiac never directly engage the question of how the *Magnificent Parchment* might be used. Thus, for example, in the lower right corner, a brief introduction to astrology lays out the basic characteristics of the twelve signs. In the lower left corner, directions

for making a horoscope make no mention of the rotae: "If you would like to know the horoscope of a person, calculate his name and his mother's name, and combine the values and divide by 12. If the remainder equals one, his sign is Aries, his planetary domicile is Mars, and his day is Tuesday. Sometimes he will be rich and sometimes poor. He will frequently be captured by other nations or arrested by the authorities. He will marry a woman and have children by her, whom he will bury. He will wander the earth. And he is handsome in appearance and lacking in nothing." This is very useful information indeed, but hardly a manual for deploying the zodiac alongside which it is inscribed. I should also emphasize that this lowest section weaves into its presentation rabbinic and kabbalistic texts and traditions that relate in some manner to the "lower" heavens. The overall result is a picture of the spheres *of the rabbis*. It includes, but is not limited to, the astrological content of the universally accepted worldview in which they operated even as they lifted their eyes heavenward.

Was the *Magnificent Parchment* intended to present the image of God? Clearly, the concentric circles of its zodiac were understood as representations of the very real spheres of the celestial heavens. Was the sefirotic tree hovering above them, beyond the heavens, to be understood as no less ontologically real? In the kabbalistic milieu within which this artifact was crafted, was the tree meant as an iconic signifier? Though this complex question might rightly be asked of any ilan, I pose this provocative question here because the *Magnificent Parchment* pushes the limits of the genre in both words and images, giving us that much more to work with as we grapple with the issue. As something of an extreme case, it is not meant to be representative of the perceptions of all kabbalists who crafted ilanot, but it is nevertheless broadly instructive.

The simple answer to this difficult question is no—the tree is not an iconic signifier of God in this ilan. In other words, God was not presumed to look like a tree, even though the tree is indeed parked in God's place on the throne just above the heavens. The tree is indexical insofar as it signifies the relations among the divine attributes. In this respect it had a certain primacy among signifiers but hardly a monopoly. The diversity of schemata used in the *Magnificent Parchment* to diagram the sefirot implies that such representations were not regarded as corresponding to any ontologically real "shape of the Godhead." Moreover, kabbalists had (and have) a long history of expressing anxiety regarding the potential corporeal misreading of their doctrines. The audacious mapping of the Godhead was likely enabled by the unequivocal nominalism of its creator, as expressed in so many of the texts that crowd the parchment. The texts of the *Magnificent Parchment* are inscribed in meaningful locations up and down, left and right, over the entire pictured great chain of being. Nevertheless, as though pushing back against the implicit realism of this maplike representation, these texts engage repeatedly, relentlessly, in systematic scientific allegorizing of their "locations," aligning them with the intellects and other elements of Neoplatonic cosmology. The tradition of the Special Cherub is also salient in this regard. Inscriptions repeatedly remind us that even the figure seen by Ezekiel on the Throne of Glory in his biblical vision was not God, who cannot be seen, but "merely" the Glory, a created entity rather than the Creator. The tree "sitting" on the parchment's throne is at best a signifier, whether iconic or indexical, of that Glory. To reiterate and sharpen an earlier point, I believe that it was precisely the aniconic character of the tree schema that paved the way for its reception as the preferred signifier of the God of the kabbalists. The Divine could be pictured without the implication

SPECIAL FOCUS | *"Be as Rabbi Akiva"*

The *Magnificent Parchment* features an abundance of extraordinary illustrations and illuminations, from the springs and serpents above to the angels and Chariot beasts below.[81] Among these images, one in particular stands out: the four sages who, according to the famous account in the Babylonian Talmud (b*Ḥagigah* 14b), entered the "orchard" (fig. 39).

> The Sages taught: Four entered the orchard [*pardes*], and they are as follows: Ben Azzai; and ben Zoma; *Aḥer* ["other," the derogatory nickname of the rabbi-heretic Elisha ben Abuya]; and Rabbi Akiva. Rabbi Akiva said to them, "When you reach pure marble stones, do not say: 'Water, water,' because it is stated: 'He who speaks falsehood shall not be established before My eyes'" [Ps. 101:7]. Ben Azzai glimpsed and died. And with regard to him the verse states: "Precious in the eyes of the Lord is the death of His pious ones" [Ps. 116:15]. Ben Zoma glimpsed and was harmed. And with regard to him the verse states: "Have you found honey? Eat as much as is sufficient for you, lest you become full from it and vomit it" [Prov. 25:16]. *Aḥer* chopped down the shoots. Rabbi Akiva came out safely.

Along the perimeter of the zodiac, the creator of the *Magnificent Parchment* inscribed a version of a short anonymous work known as *Roshei prakim mi-ma'aseh merkavah* (Chapter headings of the work of the Chariot).[82] The text, which treats the mistakes of three of the sages and the success of Rabbi Akiva, provides an interesting perspective from which to approach the ilan. It begins: "'Four entered the orchard' by their actions and the prayers that they prayed in purity. They used the Crown [Keter] and gazed and saw the manner of the angelic watches in their stations in the Palace. [And they saw] the manner in which Palace follows Palace. [And they saw] within the Palace. They are Ben Azzai and ben Zoma, *Aḥer* and Rabbi Akiva."

This passage summarizes the journey of the four sages pictured. Actions, prayers, and the secret name of God—the crown—facilitated their visionary ascent.[83] The visualization of this journey may be traced from the image of the four sages at 9 o'clock on the rota (fig. 49). The temporality of the visualization is somewhat ambiguous. In the first frame, the four are together. We might think them about to ascend were it not for the fact that Ben Azzai has already fallen. The figure on the far left may be *Aḥer*, his wayward glance gesturing heresy. On the far right, Akiva seems to be lecturing his fellow travelers, as the Mishnah reports he did before their ascent. Above the sages, the numbered gates of the six *heikhalot* (heavenly halls or palaces) beckon; the journey to gaze upon the enthroned deity, here pictured as the great sefirotic tree towering over the zodiac below, passes through them. The crown is being carried by the angel Sandalphon just to the left of the *heikhalot*.[84] Arriving at 12 o'clock, above the circles and beyond the *heikhalot* we see the *kruvim* (cherubim), the angelic beasts who powered the divine Chariot (Ezek. 1). The four winged creatures—bull, eagle, lion, and human (no putti here)—surround their new guest and honored interloper, R. Akiva. Now greatly enlarged, Akiva's body is inscribed from top to bottom with the words, "R. Akiva entered in peace and left in peace."[85]

Above R. Akiva is the veil partitioning the upper and lower Worlds. The caption on its gateway reads, "The heavens opened at the moment

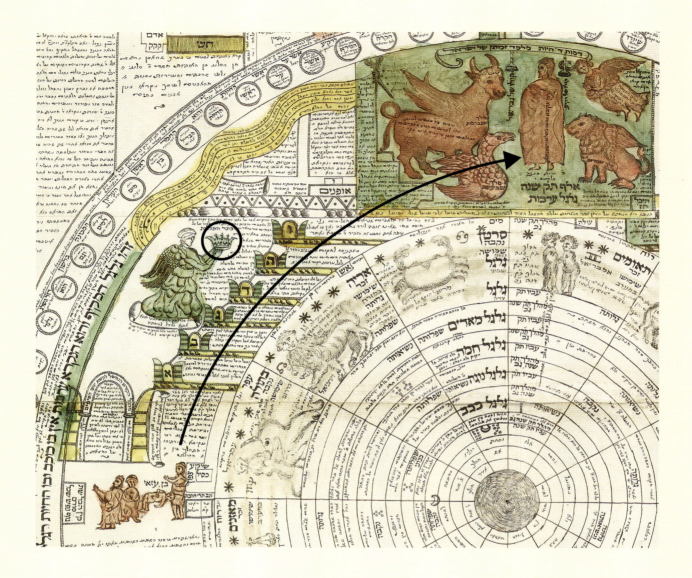

Figure 49 | Akiva's journey, detail from the *Magnificent Parchment*, parchment, 255 × 75 cm, Italy, ca. 1600. Oxford, BL, MS Hunt. Add. D. Courtesy of The Bodleian Libraries, University of Oxford, CC-BY-NC 4.0.

the prophet began to prophesize." This gateway provides passage for the divine abundance (*shefa*) flowing downward, pictured in the upper section of the ilan as flowing rivers. It is also the portal through which R. Akiva—and those who would emulate him—may gaze upon the Divine, the tree of the sefirot. "Be as R. Akiva, who entered in peace and departed in peace," says the text of the ilan, summoning the reader to set out on a journey that, for all its wonder, is not without its dangers.

of physical resemblance. The *Magnificent Parchment* thus uses the concentric circles of astronomy, iconic signifiers, to show the celestial heavens. It presents the sefirotic realm with the tree, an indexical signifier of the Glory by which the Divine is revealed, and it presents *Ein Sof*, the apophatic deity, using the symbolic signifier of an open eye.

The milieu in which the creator of the *Magnificent Parchment* worked is familiar to students of Renaissance Jewish cultural history. Its texts are coherent, detailed in their informational content, and occasionally prescriptive and performative. There is only one problem: they are nearly impossible to study as presented on the grand rotulus. Hung on a wall, the parchment is only legible one small section at a time. Unrolling it on a table, one might manage more easily—were it not for the fact that many of its continuous passages are presented as multiple noncontiguous fragments. Piecing them together is not an easy job. Among the copies that have reached us, we find occasional signs of compassion for the reader facing this arduous task. Some scribes consolidated fragmented passages into one text box, others used catchwords (the last word of one section repeated atop the next), manicules (small pointing hands), or Hebrew-letter numbering to convey the order of reading when passages were broken up. Were it not for such signs, I might have thought that the *Magnificent Parchment* was made with utter disregard for the plight of its potential reader. Indeed, if these gestures were the additions of compassionate copyists, it may well have been.

If the study of its textual miscellany was not a paramount concern of its designer, what was the intended function of such abundant verbiage? Why fill the parchment to capacity with lengthy excerpts adapted from the books on his shelf? Did he believe that the words themselves, even left unstudied, would attract and make present the divinity they described?[80] Were the texts so many "signatures" in its network of resemblances, placeholders for the full body of knowledge—the kabbalist's library—that they represented anthologically? I do not know. After careful study, the *Magnificent Parchment* remains an artifact of intimidating and enigmatic complexity. One thing is clear: this magnum opus of a genre witnessing its efflorescence invites us to expand the boundaries of our conceptions of text, image, media, and the communities that create and consume them.

GROSS COLLECTION | TEL AVIV, GFC, MS 083.012.001 | *MAGNIFICENT PARCHMENT* (FRAGMENT)

This fragment contains the majority of the bottom third of the *Magnificent Parchment*, including most of the zodiac (fig. 51). William Gross discovered its direct continuation while visiting the Jewish community archives in Rome (fig. 50).[86] The two pieces had been separated at the seam that once joined them together. Close examination reveals them to be the remains of what must have been a particularly beautiful copy, on par with that preserved in the Vatican Library (MS Vat.ebr. 598). The unusually colorful Vatican parchment features delicate, precise illustrations and gold-leaf adornments. These unmistakable signs of a luxury manuscript are also found in the fragmentary Tel Aviv and Roman parchments.

Figure 50 (overleaf top) | Upper zodiac and *Malkhut* fragment from the *Magnificent Parchment*, parchment, 51.4 × 72.5 cm, Italy, seventeenth century. Rome, Historical Archive of the Jewish Community of Rome "Giancarlo Spizzichino," MS ASCER—Aa 2.

Figure 51 (overleaf bottom) | Zodiac fragment from the *Magnificent Parchment*, parchment, 49 × 71.5 cm, seventeenth century, Italy. Tel Aviv, GFCT, MS 083.012.001. Photo: Ardon Bar-Hama.

Remote Forests: The Ilanot of Kurdistan and Yemen

Just as Newton's mathematics remained valid in the era of Einstein, so too medieval Kabbalah in the era of Lurianism. Classical ilanot continued to be produced and reproduced well into modernity, reflecting their enduring utility to students of Kabbalah. Despite the rise of Lurianic Kabbalah to hegemonic status in the seventeenth century, it neither reached that point overnight nor proved compelling to every kabbalist. We need only point to the famous seventeenth-century kabbalist Shabtai Zevi (1626–1676). Lurianism did not speak to Zevi, and, unfazed by its status, he actively chose to ignore it and keep studying the Zohar.[87] The classical ilanot that I discuss next would seem to stem first and foremost from another consideration, however: they are the products of kabbalists who had yet to encounter—or at the very least, to integrate—the new teachings because they lived far from the main centers of Jewish life. Despite being produced in the Lurianic era, the ilanot made by these kabbalists are classical, and I therefore treat them here.

Visual Kabbalah in Kurdistan

Until recently, little was known about rabbinic culture in seventeenth-century Kurdistan and even less about its kabbalistic traditions.[88] With the discovery in 2015 of a parchment ilan in the collection of the National Library of Israel (MS 1257), a new era of scholarship on the learned culture of this community began (fig. 52). The ilan was crafted by R. Joshua ben David, a kabbalist and communal rabbi in Maragheh (Iran) who was active in the first half of the seventeenth century. We know very little about him, but Joshua's kabbalistic erudition is evident from his correspondence with the greatest Kurdish sage of the era, his teacher R. Samuel Barzani (d. ca. 1643).[89] Barzani's letters to his student entreat him to share his kabbalistic manuscripts and commentaries, casting the student as the master in this domain. Barzani writes that he has heard of Joshua's parchment ilan and requests that his student make a paper copy to be included among other materials sent to him. In another letter, he refers to Joshua as his beloved pupil, not only wise and erudite but "a great scribe of tefillin, mezuzah [parchments], and Torah scrolls."[90] Barzani was right; Joshua's scribal prowess is very much on display in his ilan as well.

The ilan, roughly 4.5 meters long in its current condition, was damaged by fire and its upper section destroyed. Luckily, a codex miscellany prepared by Joshua's colleague (and fellow student of Barzani), R. Judah Sidkani (active first half of seventeenth century), preserves a deconstructed reduction of the ilan that includes the diagrammatic elements of the missing section of the rotulus (fig. 53).[91] The miscellany includes Lurianic material, but the ilan reflects exclusively classical kabbalistic sources. That said, the structure of the ilan, which presents visualizations of the Four Worlds over a long rotulus, is reminiscent of Lurianic ilanot, as we will see. Eliezer Baumgarten has shown, however, that each of the Four Worlds visualized in this ilan was inspired by a different medieval kabbalistic work. What these works have in common may come as a surprise: all were printed in sixteenth-century Italy and conveyed to Kurdistan by merchants traveling east.[92] The texts in the ilan are mostly paraphrases of passages in these books. Judah felt free to modify the texts to integrate them effectively with his diagrammatic presentation.

This unique Kurdish ilan upends the way we presume a rotulus is to be read. In general, we scroll an ilan from top to bottom, beginning with *Ein Sof*, which abuts the upper horizontal edge of the parchment. In this case, however, the texts—selections from R. Meir ibn Aldabi's fourteenth-century *Shevilei emunah* (Paths of belief) and a passage

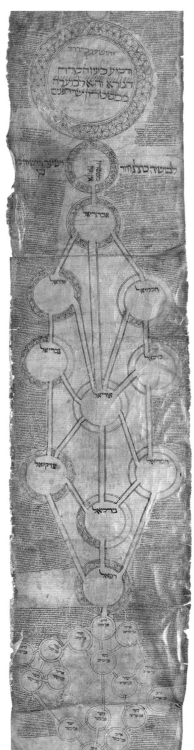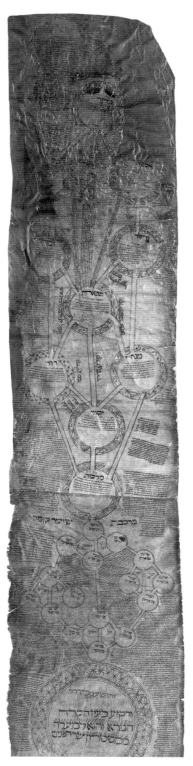

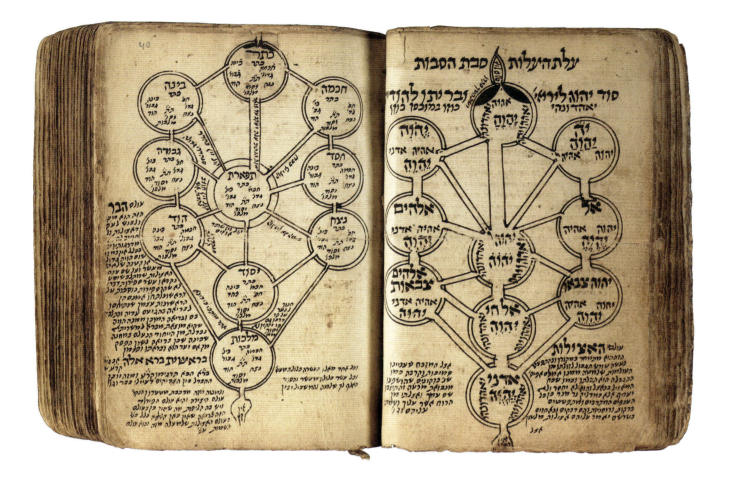

adapted from Gikatilla's commentary on Maimonides's *Guide of the Perplexed*—encourage one to begin from the bottom, the lowest World, and work one's way up.⁹³ Gikatilla's passage charges one aspiring to prophecy to begin with the four elements of the lower World and to ascend from there. This ilan is, then, a ladder of ascent.⁹⁴

The ilan is also of considerable visual interest. Its decorative elements recall those of Kurdish folk art. Geometric and floral patterns fill broad rings that surround the sefirotic medallions of the arboreal diagrams that represent each of the Worlds. Joshua's schematic representation of the Chariot stands out for its striking graphics and

Figure 52 (opposite) | Kurdish ilan, brown leather, 450 × 39 cm, Kurdistan, seventeenth century. Jerusalem, NLI, MS 1257. Photo courtesy of The National Library of Israel.

Figure 53 | Trees of *Azilut* and *Beriah* from deconstructed Kurdish ilan, fols. 39b–40a, Judah Sidkani, Kurdistan, 1613. Jerusalem, NLI, MS 28°6247. Photo courtesy of The National Library of Israel.

cosmological hermeneutic. Chariots indeed punctuate the ilan, appearing between each of the lower Worlds.⁹⁵ For Joshua, there is no ascent from one level to the next that does not involve a traversal of this Chariot-cherub complex. The idea seems to

אדם פני כל חיה ותוך מאחריהן מיוכן במולהכב אדכם יחזקאל וגד עולותנה פנה
פני אדם
שאחת וארבעה כנפים לאחת לכם והופתיהם פני אדם ופני להי אל הימין לארבעתם
ופני שור מהשמאל לארבעתן
ופני נשר לארבעתן

מענין כל פניהם של כל חיה שהם עשר פנים כמו שפרש ובהן שהפנה של עשר פנים לבד ועל
חדל מענין כל פנים של ארבעה חיות של פני. וכל ארבעתן ולהם לל ארבעה כנפים כמו שפרש
ונתן בתך ולארבעה פנים לכל חד וחד שארבעתם פנים לכל אחד ולכל ארבעה פנים לכל
חדל ונגון מענין פני נשר בלכתם בה מולא וחמצין פנה. ונעשה לארבעה כנפים לכל כנפה
ופנים באמצע. כאמר שור ונשר אם יעופף

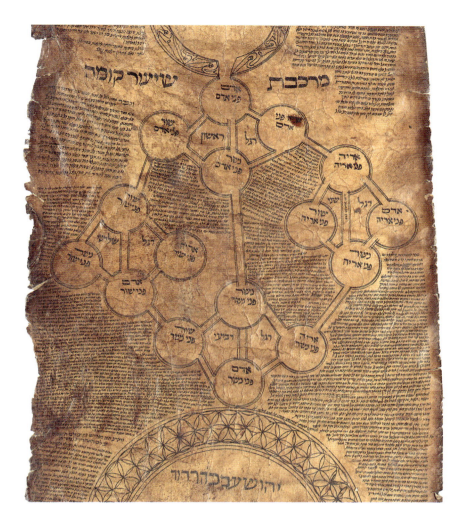

Figure 54 (opposite) | Expanding cherubs diagram, fol. 143b, Sephardi script, sixteenth century. Oxford, BL, MS Reggio 24. Courtesy of The Bodleian Libraries, University of Oxford, CC-BY-NC 4.0.

Figure 55 | Geometric cherubs diagram, detail from Kurdish ilan (fig. 52).

have been his own, an innovation he visualized and incorporated in his ladder-ilan.

Chariot speculation was the heart of ancient Jewish esotericism.[96] How did kabbalists, with their own theosophical conceptual structures and repertoire of diagrammatic schemata, visualize it? We have seen the representational approaches of Renaissance parchments, from the putti-flanked three-dimensional firmament and throne chair of Hepburn's ilan to the beasts surrounding Akiva beneath the Throne of the *Magnificent Parchment* (figs. 30 and 49). The geometric visualizations of the Chariot found in early kabbalistic codices are nevertheless more pertinent to Joshua's approach.

Placing Joshua's chariots alongside such earlier visualizations—represented here by a sixteenth-century Bodleian manuscript in Sephardi script—makes for an interesting comparison (fig. 54).[97] Although both present a kaleidoscopic schematic visualization of the four four-headed beasts, the diagram in the Bodleian manuscript is perhaps more complex. It shows, at its center, one creature—honoring the singular of Ezekiel 1:20–22—with four faces. Each of these four faces

then becomes one of the four faces of the four beasts that intersect with and surround the central circle. Both diagrams take a geometric approach to visualizing the Chariot beasts, but, to my mind, the Venn diagram–style suggestion of fractal multiplication lends the Bodleian image an air of the expansive movement of the Chariot reiterated in verses 9 and 12 of Ezekiel 1.

Joshua was, in any case, unlikely to have been inspired by such a diagram. His interlinked medallions merely modify the arboreal schema that he used throughout the rotulus (fig. 55).[98] In Joshua's chariots, a beehivelike array represents each of the cherubs in one of its interconnected four corners. Each corner, in turn, is composed of four linked circles. The inscriptions establish the intended meaning of the array: four connected four-faced creatures.[99] As we will see, this visualization soon made its way from Maragheh to Baghdad, where it became a staple of the extraordinary series of Lurianic ilanot created by the city's great kabbalist-artist, R. Sasson ben Mordekhai Shandukh (1747–1830).[100]

GROSS COLLECTION | TEL AVIV, GFCT, MS KU.011.009 | A MAGICAL PRAYER ILAN

The artifact to which I now turn was fashioned in Persian Kurdistan (fig. 56). It resembles a deconstructed ilan in which inscription-filled sefirotic medallions are followed by related texts. As we have seen, these present the sefirot one by one, over a series of pages, rather than as elements within a full schematic array on a single sheet.

The present artifact, however, has a form and function all its own. The manuscript is a tablet-style notebook, bound on the short edge. On its

Figure 56 | *Keter* and *Ḥokhmah* from magical prayer, deconstructed ilan, paper, 18 × 12 cm, Kurdistan, 1794, Tel Aviv, GFCT, MS KU.011.009. Photo: William Gross.

SPECIAL FOCUS | *"Give Me of Your Beauty"*

The central sefirah of *Tiferet* is represented by the large decorated circle atop the double page (fig. 57). "Minister Michael," the governing angel of the sefirah, has been inscribed above it. Variously vocalized versions of the Tetragrammaton (*YHVH*) are just outside the perimeter of the circle, and within its broad band are the names of the ten sefirot; collectively these signify the inclusive and comprehensive nature of this central sefirah. Although this constellation of names and associations was surely intended to intensify the potency of the image, its most prominent performative element is the petitionary formula inscribed in the circle:

> TIFERET—May it be your will, YHVH, my God and the God of my fathers, by the power of the name Michael the angel, by the power of "the Beauty of Israel" [Tiferet Yisrael], that you give me of your Beauty. Hear my prayer whenever I call out to you in prayer, in every time of sorrow and trouble, as you hear the prayer of every mouth. Blessed are you, who hears the prayers of every mouth. Blessed are you, who hears prayer. *Amen, nezaḥ, selah.*[102]

The line beneath the prayer adds that *Tiferet* is also called *Daʿat*. The association with clear-minded knowledge explains its use: *le-shigaʿon* (for madness). The lower two-thirds of the double page are devoted to the sefirotic associations that would typically be found in the center of each medallion. The complexity of this procedure from a theological point of view is worth noting: it is directed to God (rather than to the sefirah) and asks that God activate the qualities of the sefirah in every time of need.

Figure 57 | *Tiferet*, detail from magical prayer ilan (fig. 56).

long, narrow pages are a series of brief compositions that share a common practical orientation: divinatory, astrological, and, in a sense, liturgical. Following the simple divinatory and astrological tables of the opening pages, a large decoratively banded circle marks the beginning of the (deconstructed) ilan. In the subsequent pages are seven such circles; three smaller ones, in triangular array, mark the end of the ilan. These circles—at least through *Tiferet*—prominently feature the names of the sefirot, beginning with *Keter*, written in bold square script. Divine and angelic names are above each of the large circles, within them are prayers of a magical nature, and below are additional names and appellations of the sefirah.

The composition, dedicated to the uses (*shimushim*) of the sefirot, is intimately related to the classical ilan. The Kurdish scribe has shifted the content he found in its medallions to the space below and, in its place, inscribed each circle with a magical-liturgical text to be recited by one seeking to leverage the particular qualities of the sefirah. In this rare genre of Jewish magical literature, the performance was to be carried out with an ilan, whether on parchment or in the mind's eye.[101]

Visual Kabbalah in Yemen

R. Isaac ben Abraham Wanneh (ca. 1575–ca. 1670) was one of the most prominent kabbalists in seventeenth-century Yemen, when Kabbalah reached the southern end of the Arabian Peninsula. Wanneh's library included a number of kabbalistic works, all printed in sixteenth-century Italy. On his shelves were Gikatilla's *Sha'arei orah*, *Ma'arekhet ha-elohut*, *Arzei ha-Levanon* (Cedars of Lebanon), the two (!) first editions of the Zohar (published in Mantua and Cremona in 1558), Cordovero's *Or ne'erav* (Pleasant light), and R. Abraham Galante's *Kol bokhim* (Voice of the weeping). Wanneh drew freely from these classics in his own work.[103]

Wanneh lived in Mabar, a village south of Sana'a. His communal and scholarly activity was wide-ranging, and he was particularly known for his liturgical compositions. As part of his scholarly efforts focusing on the rites of prayer, Wanneh edited the *Tiklāl* (Golden bell), which was the first Yemenite liturgical work to include Spanish customs. In this capacity he played a central role in the absorption of the customs and rites of Sepharad, including those of the kabbalists, into the Yemenite service. In addition to the *Tiklāl*, we know about Wanneh's glosses on *Tola'at Ya'akov* (Worm of Jacob), a kabbalistic work by R. Meir ibn Gabbai (1480–ca. 1540), as well as a lost work by Wanneh titled *Sha'ar ha-shamayim* (Gate of heaven). Finally, there is his *Rekhev Elohim* (Vehicle [recalling *merkavah*, Chariot] of God), to which I attend here.

Rekhev Elohim is a work of visual Kabbalah. It is organized according to the four kabbalistic Worlds, in descending order: *Azilut* (Emanation), *Beriah* (Creation), *Yezirah* (Formation), and *'Assiah* (Action). Each section opens with a diagrammatic representation of the World to which it is devoted. As the diagrams are central to the composition, Wanneh begins by explaining their function to his readers:

> Because I yearned for this matter, I relied on the everlasting Rock and gathered a few gems, new and old, and made of them an exceedingly modest book. I gave it the name *Rekhev Elohim*. And I drew the palaces [*heikhalot*] and stations [*medorin*] down to the material World of *'Assiah*. Afterwards I transferred them to a large chart [*luaḥ*], since those Worlds are very large and are bound and connected to each other.
>
> It is my wish that all be revealed to a person as if [it were within his] four cubits, which he apprehends and comprehends. And he should visualize them [*yezuyar*

bahen] as if he is seeing a grand castle built before him, containing grand upper stories and grand halls, higher and higher. This is to be understood as the World of *Azilut* and the World of the Throne. Under them are grand palaces and inner chambers; this is to be understood as the World of *Yezirah*. And outside of them are verandas and courtyards all around, outer and inner; this is to be understood as the spiritual [dimension of the] World of *'Assiah*. Outside them are the homes of the servants of the king, his officials, and his ministers; this is to be understood as the physical [dimension of the] World of *'Assiah*, and in it are the lower crowns. Beneath them are the cattle and straw barns, and the woodsheds; these are external crowns.[104]

In this passage, Wanneh reveals the importance of visualization to his notion of Kabbalah. He describes his process step by step, beginning with the composition of the "exceedingly small book," *Rekhev Elohim*, which is all that remains today of his graphical efforts. Wanneh accurately describes it as a combination of "pearls" he has gleaned from sources new and old, to which he has added his own original drawings. Despite its diminutive size, the book surveyed the Worlds from the supernal heights of *Azilut* to the physical realm of *'Assiah*. To better achieve his goal, he transferred its content to an entirely different medium: a *luaḥ*, which may refer to a schema (a tabular chart) as well as to a medium (a large writing surface). The term was used in both senses to refer to ilanot as well as to maps.[105]

Wanneh's discussion makes it clear that he regarded ilanot as cartographic in form and function. First, the medium made all the difference; it was vital that the flow and interconnection of the Worlds be visually evident. This was impossible in codex form but enabled by the transfer to the large format. Second, when standing before this topographic representation of the Four Worlds, the kabbalist was literally to see the Godhead as a "great metropolis" containing everything from royal palaces to woodsheds. From his wording, the precise relationship between visualization in the mind's eye and actual gazing is not entirely clear, but it would seem that he intended the kabbalist to undertake a virtual journey through the pictured Worlds with the assistance of the ilan. The centrality of the performative aspect of this engagement with the ilan is striking, particularly in light of Wanneh's interest in liturgy.

Wanneh was not unaware of the possible objections to his mapping of the Godhead, and he anticipated potential critics by invoking precedents:

Had the author of *Sha'arei orah* not illustrated the likeness in this manner, it would not have been permissible for me to do so. Nevertheless I have done so only to make [the matter] more proximate to the mind, so that it would be engraved in the heart as if it were so, rather than [merely an abstract] form. We drew nothing but the appellations used by the sages. As you shall see, the form is engraved, out of love; but, in any case, *it* is not the form. And the same kabbalist [Gikatilla] drew a likeness of the *merkavah* [Chariot] in the ilan at the entrance of his house, as adduced by R. Judah Ḥayyat in his commentary on *Sefer ha-ma'arekhet [ha-elohut]*. So we have done for ourselves as well. And if a person is lacking fear and knowledge, he will not be able to enter. . . .[106]

Having organized these texts and matters pertaining to the order of *ABY'A* (*Azilut, Beriah, Yezirah, 'Assiah*) and their form according to [their] order, we must also draw all Four Worlds in the order of *ABY'A* upon a

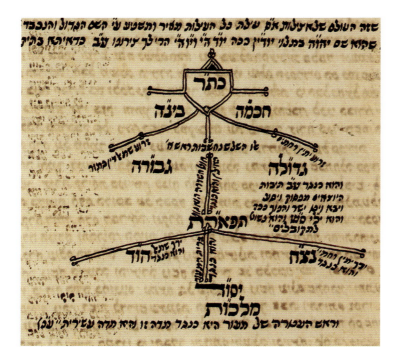

Figure 58 | *Shaʿarei orah* diagram (cf. fig. 19), paper, 21.4 × 15 cm, Isaac ben Abraham Wanneh, *Rekhev Elohim*, Yemen, nineteenth century. Tel Aviv, GFCT, MS YM.011.035. Photo: William Gross.

single sheet [be-luaḥ eḥad], so that the matter be accurately visualized [keday she-yuvan ha-davar ʿal ẓiyyuro ve-ʿal amitato] . . . and we shall draw everything together to show its progressive unfolding [derekh shilshul].[107]

To justify his graphical visualization of the divine realm, Wanneh relied on the authority and prestige of Gikatilla, a founding father of Spanish Kabbalah. As noted above, Gikatilla's sefirotic diagram was reproduced in manuscripts over the centuries and incorporated into print versions beginning with the first edition, produced in Riva, Italy in 1561.[108] Its influence on Wanneh is obvious, especially in the first diagram of *Rekhev Elohim* (fig. 58).

Wanneh described his diagrams as arrayed sefirotic appellations that imply the form of the Godhead without using representational imagery. This is the implication of his convoluted apologetic: "We drew nothing but the appellations used by the sages. As you shall see, the form is engraved, out of love; but in any case, *it* is not the form." If in his book he looked to Gikatilla for inspiration and authorization, what of his large, maplike *luaḥ*? Here too, Wanneh relied on Gikatilla, asserting that the latter had not only fashioned such a grand ilan but also displayed it at the entrance to his home. So, at least, Wanneh claimed to have read in Ḥayyat's commentary to the *Maʿarekhet*. I can only imagine that he had in mind the story, related above, of Ḥayyat having seen an ilan "made by a very important person" in Reggio. Wanneh either recalled this passage inaccurately or embellished it intentionally to create a new tradition that suited his needs. Wanneh concluded by sharing his plan to adapt his little book to a more appropriate format. His acknowledgment of the salience of the material text to his ambitions is worth emphasizing. The medium was inextricably bound up with the message, the form with the intended function.

84 | THE KABBALISTIC TREE

Wanneh's ilan is not extant, but his descriptions give us a good sense of it. Although we know of no direct ties between Wanneh and his Kurdish contemporaries, the former's lost ilan likely had more than a passing resemblance to the one fashioned by R. Joshua ben David. In the Kurdish ilan, the four kabbalistic Worlds are presented in succession, with "chariots" marking the liminal zones between them; beneath are the celestial orbs, the elements, and the earth. Wanneh used the term *Chariot* more expansively than did his Kurdish contemporary. For him, each of the Worlds in its entirety was a "Chariot" for the realm above it—*Azilut* for *Ein Sof*, *Beriah* for *Azilut*, and so on. This usage is not as far removed from the ancient biblical sense as one might imagine, because both presume the Divine to be a Chariot rider. The kabbalistic sense of this notion is, if anything, far less mythical than its biblical inspiration.[109]

Already in *Rekhev Elohim*, Wanneh included a short chapter titled "The Order of All that Exists" that succinctly diagrammed on a single page "the World of *Azilut*" atop "the World of the Throne" atop the ten sefirot (fig. 59). Below the sefirot we see "the World of the Palaces," meaning the world of the archangel Metatron. At the bottom is "the World of the Levels (*medorin*)." This presentation was the graphical preamble to "the Order of the Corporeal *'Assiah*," which follows immediately and features a rendering of the seven *reki'im* (firmaments) as nested arches (fig. 60).[110]

Wanneh emphasized that kabbalists must make ilanot for themselves: "Every kabbalist must draw for himself that which he has learned. He should take this [drawing] to heart and not avert his

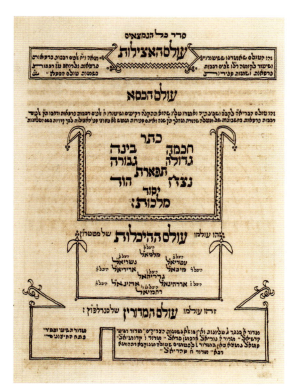

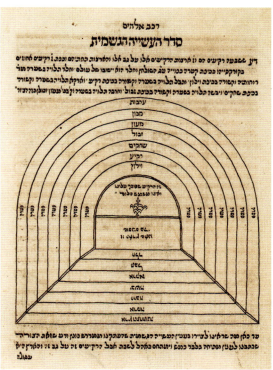

Figure 59 | The Order of All that Exists, from *Rekhev Elohim* (fig. 58).

Figure 60 | The Order of the Corporeal *'Assiah*, from *Rekhev Elohim* (fig. 58).

CLASSICAL ILANOT | 85

corporeal eyes from it, as his [David's] saying, 'I have set YHVH before me always; because He is at my right hand, I shall not be shaken'" (Ps. 16:8).¹¹¹ The conviction that drawing—and not merely mental visualization—is a critical component of the kabbalist's work was rarely articulated so vigorously.¹¹²

Wanneh's Chariots

The four primary diagrams of *Rekhev Elohim* correspond to the four kabbalistic Worlds.¹¹³ Wanneh refers to each of these Worlds as a Chariot, hence the name of the book. The first, corresponding to the highest World of *Azilut*, is inspired by Gikatilla's stick-figure sefirotic diagram. Wanneh details the complex network that connects this highest World with the divine "Emanator," who remains unpictured. The second Chariot, of *Beriah*, closely resembles the first and is described by Wanneh as "a Garment [malbush] worn by the Tree of *Azilut*." The stick figure has been decked out accordingly in ornamental Yemenite garments (fig. 61). With the third Chariot, of *Yezirah*, we reach the realm of the *heikhalot* (fig. 62). The corresponding diagram retains the same basic configuration as the previous two, but the stick figure is no longer discernible. Instead, the elements are drawn as an interconnected structure of three horizontal

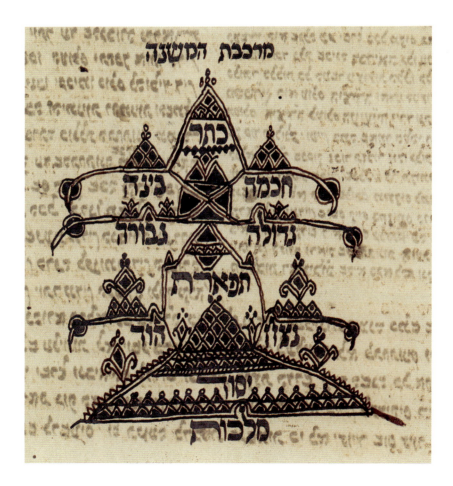

Figure 61 | Chariot of *Beriah*, from *Rekhev Elohim* (fig. 58).

86 | THE KABBALISTIC TREE

rectangles separated by symmetrically balanced squares. Each of these is inscribed with the name of the palace and its reigning angel, correlated to the sefirah. In this structure, the three highest sefirot are grouped together in the same "palace." This palace is unnamed, but names of the three angels that govern it are written in bold lettering: Malkiel, 'Atriel, and Nashriel. Wanneh's sources for these sections included the Zohar and the elaborations on its teachings in the commentary *Tola'at Ya'akov* by ibn Gabbai.

Wanneh divided *'Assiah*, the lowest of the Four Worlds, into several strata: the World of Spiritual (*ruḥani*) Action, the Chariot of the External Serpent (*ha-naḥash ha-ḥizoni*), and the World of Physical (*gashmi*) Action. The source of these stratifications was Cordovero's *Or ne'erav*.[114] The schemata chosen by Wanneh for these hierarchical levels reflect a sensibility according to which the spiritual realms are best captured using an array recalling the sefirotic tree and the celestial and material realms by cosmological diagrams with natural-philosophical and astronomical pedigrees. The first diagram in this section closely resembles the schema Wanneh used for the Palaces of *Yeẓirah*. Here, however, the rectangular elements are labeled as "levels" (*medorin*) and arranged somewhat differently from the array of the Palaces. In the uppermost level is inscribed, "The first level, corresponding to the third Palace of the third World; none govern it besides the souls of the righteous. . . ." The level just below corresponds to the "World of *Ḥesed*," and "in it are the four who are appointed over the four winds of the World, like the flagged [tribal encampments on their Sinai] journey." Beneath are two levels, that of *Gevurah* and *Tiferet*, arrayed symmetrically and in alignment with the two beneath them, the levels of *Neẓaḥ* and *Hod*. The lowest level, in a horizontal rectangle positioned like a fulcrum to the pairs above it, is shared by *Yesod* and *Malkhut*.[115]

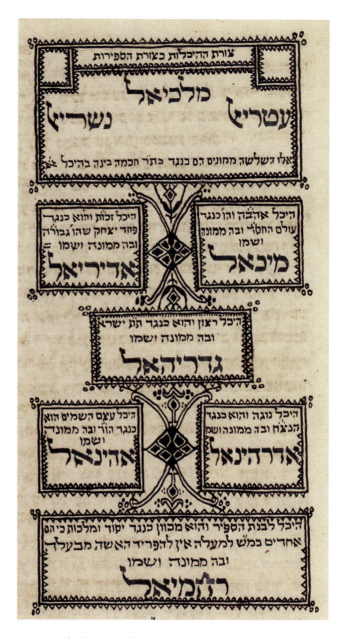

Figure 62 | Chariot of *Yeẓirah*, from *Rekhev Elohim* (fig. 58).

SPECIAL FOCUS | *Four Worlds from Two Perspectives*

Wanneh's sensitivity to the problematics of the graphical representation of his subject is made particularly explicit in his side-by-side diagrams of the interlocking Four Worlds (fig. 63). In this pair of diagrams, he sought to represent the structure of the Worlds in a manner that would reveal how, on the one hand, the higher Worlds encompass those beneath them, and, on the other, how the higher Worlds are contained—he uses the term *nivl'a*, literally "swallowed"—by those underneath them. The figure on the right, resembling tables stacked one upon the other, shows the former; that on the left, the latter. Wanneh thought that graphical representation of the divine World was central to kabbalistic understanding, but he was no less acutely aware of the limitations of such images. In sketching this pair, he attempted to overcome them by approaching his subject from different perspectives, quite literally, from above and from below. In the adjacent caption, Wanneh expresses his intention succinctly and in fascinating language: "Behold, I have fashioned these two forms [ẓurot] to render the spiritual [ruḥani] matter apprehensible to the intellect. For it is impossible to draw [leẓayyer] in writing the spiritual figure [ẓiyyur] as it really is."

Figure 63 | The Four Worlds, from *Rekhev Elohim* (fig. 58).

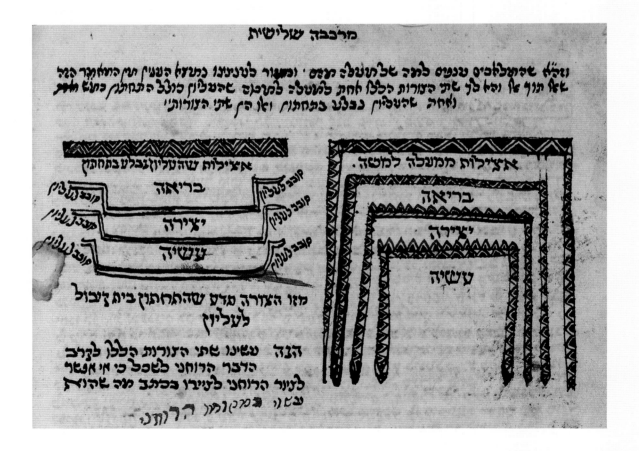

88 | THE KABBALISTIC TREE

Chapter 3

Visualizing Lurianic Kabbalah

In the early 1570s, for barely two years, the kabbalist R. Isaac Luria taught a handful of students in the small Galilean village of Safed before dying of the plague. Luria was born in Jerusalem but lived most of his life in Egypt before the attraction of Safed—which was home to R. Moses Cordovero and overlooked the tomb of R. Shimon bar Yoḥai (second century CE) on Mount Meron—proved irresistible.[1] Luria had devoted years of study and contemplation to the Zohar, delving deeply into its most arcane treatises, the *Idrot* (lit., threshing floors).[2] These texts probed the Divine in unusually graphic and highly anthropomorphic detail. Upon Luria's death, R. Ḥayyim Vital took primary responsibility for the preservation and elaboration of his master's teachings. Confident that he alone among Luria's students had truly understood the secrets revealed, and believing that Luria's death had been a divine punishment for having divulged to him, at his insistence, the most recondite among them, Vital became the architect of a new system founded on Luria's lessons. For decades he wrote and rewrote works based on what he had learned in barely two years of study. The systematic body of knowledge and practice today known as Lurianic Kabbalah is largely the product of those efforts.[3]

The Kabbalah taught by Luria was far more complex than any that had come before it. The structure and developmental dynamics of the Godhead are described with unprecedented precision.[4] Central to Luria's cosmogony is the figure of *Adam Kadmon*, literally "Primordial Anthopos" but denoting the first expression of positive creation (or emanation, to be precise) and differentiated from the philosophically simpler *Ein Sof* (Infinite). *Adam Kadmon*—also referred to by the acronym *AK*, both in the sources and, occasionally, in the rest of this book—is at once the first creation and its locus, depicted as a complex hierarchy of lights that generate and permeate lower levels of existence. Creative lights flow from the ears, nose, mouth, eyes, and forehead of

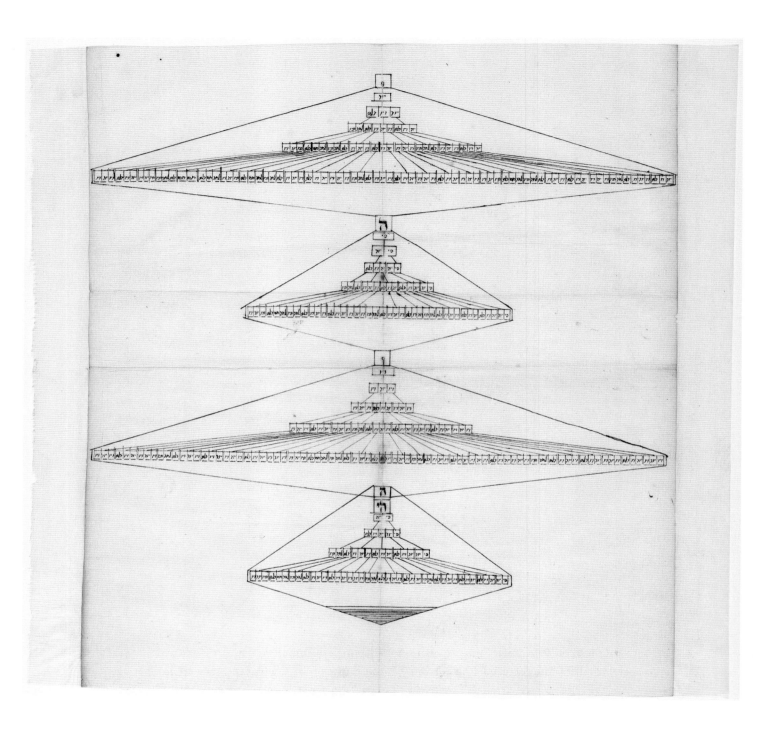

Figure 64 | Expansions of the Tetragrammaton, paper, 34.2 × 30.1 cm, Eastern Europe, ca. 1825. Tel Aviv, GFCT, MS 083.011.003. Photo: William Gross.

AK's face as well as from *AK*'s skin pores and navel. Each emits a distinct form of light denominated by a term drawn from a broad reservoir of sources, which has been transvalued and infused with novel signification. *'Akudim, nekudim, u'brudim* (bound, speckled, and spotted), for example, terms that describe the sheep in Jacob's dream (Gen. 31:12), refer to three distinct stages in the emergence of the primordial sefirot. More broadly, the divine realm is understood as a fractal, stratified hierarchy, a *divina quaternitas*.[5] As noted in chapter 2 in the discussion of Wanneh's ilan, there are Four Worlds: *Azilut* (Emanation), *Beriah* (Creation), *Yezirah* (Formation), and *'Assiah* (Action). There are four elements in the Hebrew biblical text: cantillation marks, vowel signs, crowns, and letters. There are four letters of the Tetragrammaton: YHVH. And there are four ways of "expanding" the Tetragrammaton by spelling out each of its letters in full. The first letter, *yud*, is a constant, but using the variable vowels *yud* (י), *alef* (א), and *heh* (ה)—spelling H as *Hi* (הי), *Ha* (הא), or *He* (הה), for example—produces the *miluim* (expansions) עב, סג, מה, בן, with numerical values of seventy-two, sixty-three, forty-five, and fifty-two, respectively (fig. 64).[6] There were quinternities as well and, of course, the denary default of the sefirotic system. Lurianic Kabbalah layers these symbolic systems, explicating their correspondences and instructing the adept in their theurgic operation.

The ten sefirot are prominent, if recontextualized, in Lurianic discourse. First of all, they are broken: *shevirat ha-kelim*, the breaking of the vessels, is said to have resulted from their initial emanation as an unstable pillar.[7] The balanced array we find in the classical sefirotic tree reflects, in Luria's teaching, their reconfiguration in the World of *Tikkun* (Rectification) in response to the shattering.[8] The stable flow of divine flux through the sefirot was not accomplished simply by re-emanation as tree rather than tower, however. With the zoharic *Idrot* as inspiration, the tree was refracted into multiple divine personae called the *parzufim* (lit., countenances).[9] *Keter* became *Arikh Anpin* (Long-Faced or Patient One), *Ḥokhmah* became *Abba* (Father), *Binah* became *Imma* (Mother), the six sefirot from *Ḥesed* to *Yesod* became *Ze'ir Anpin* (Short-Faced One or Impatient One), and *Malkhut* became *Nukba* [*de Ze'ir*] (Female [of Ze'ir]). These are the five principal *parzufim*. These personae and the roles they play in the unfolding of the cosmic drama—the unflappable equanimity of *Arikh*, the nurturing of *Abba* and *Imma*, the recovery, growth, and reconnection of *Ze'ir* and *Nukba*—aroused empathy in the practitioner called upon to assist this Godhead-in-process. The *parzufim* also effected the progressive diminution of the lights of *Adam Kadmon*. Not unlike the electrical voltage powering our homes, these great lights had to be stepped down incrementally to allow for the very existence of a reality differentiated from the Divine. Although the interlocking hierarchy of the *parzufim* mediates and attenuates the flux as it proceeds down the emanatory chain, the *parzufim* are not merely stable delivery conduits. The three highest are expressions of the sefirot that weathered the storm of the shattering, including the stable, fruitful coupling of *Abba* and *Imma*. *Ze'ir Anpin* and *Nukba*, however, are vulnerable personae born of the breaking; their nurturing and uplifting are the object of Lurianic *tikkun*.

The Lurianic notion of *tikkun* could allow a simple good deed to send a rectifying ripple up the great chain of being, but for real impact the act had to be accomplished by someone expert in the workings of this grand, ever-developing cosmos. Such expertise was born of prolonged, intensive study and practice. To acquire a knowledge of the dynamic structure and of how to operate in a manner optimized to affect it, visualization was indispensable. Much could be drawn in the mind's eye. Realistically, however, the demands made upon it

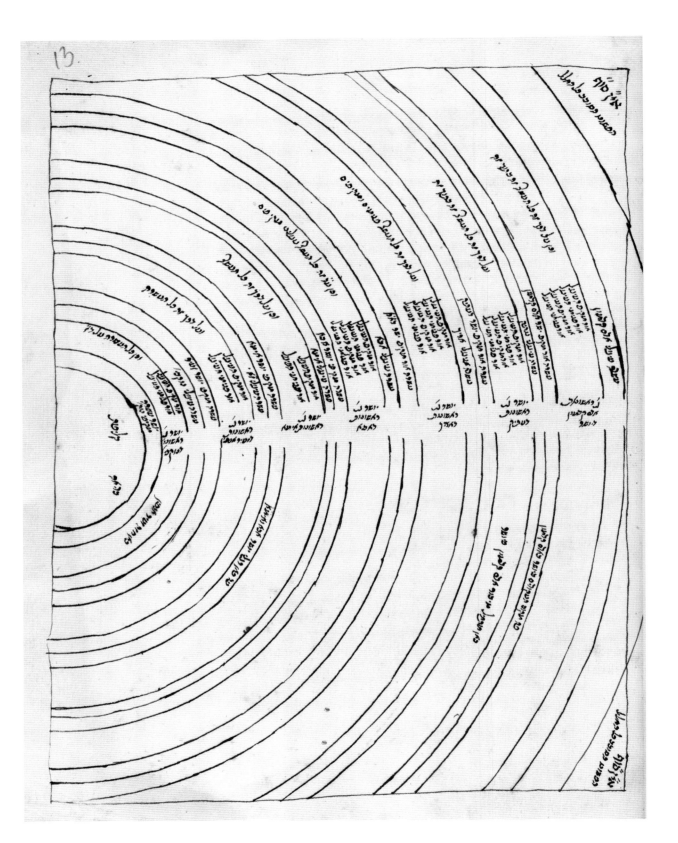

were enormous: a vast, moving topography of the Divine signposted with a dizzying array of technical terms and layered symbolic systems. Luria may not have needed diagrams as he developed or taught what were, by all accounts, teachings that had not been systematically formulated. Referring to the widespread use of sefirotic trees by contemporary teachers of Kabbalah, R. Shlomo Carlebach used to say, "maps are for tourists." Luria, in this sense, was a local—almost solipsistically so, given that so much of his world was born of his own imagining. Exponents of the systematic expressions of his teachings, however, regarded them as necessary pedagogical and performative tools.

Vital's autograph *'Ez Ḥayyim* (Tree of life) manuscript no longer includes the ambitious diagram with which he chose to open it.[10] The large foldout page was vividly remembered by R. Meir Poppers (ca. 1624–1662), who had studied it during the eight days he spent in Damascus in 1649 poring over Vital's *magnum opus* under the watchful eye of the latter's son, R. Samuel (1598–1677).[11] Judging from Poppers's description—and in light of the complex diagrams that Vital incorporated into other manuscripts, the copies of which have reached us—this grand opening diagram was likely a close cousin to those we find in his other works (fig. 65). Vital's precedent may have served as the inspiration for later kabbalists, who opened or closed their codices with foldout paper ilanot (fig. 66).

These detailed diagrams aspired to present synoptic pictures of the whole system and largely spoke for themselves. In many respects they were magnifications of the simple diagram that, with minor variations, was ubiquitous in the opening expositions of Lurianic cosmogonic treatises. This was a typical epistemic image designed to clarify an adjacent text, generally introduced by something to the effect of, "like this."[12] It was known by what it visualized with schematic austerity: *'iggulim ve-yosher* (circles and straight [line]).

Luria taught that the divine lights, the sefirot, are governed by an overarching dualism of distinctly geometric character: there are circular lights (*'iggulim*) and linear lights (*yosher*). The former took their shape by filling the sphere cleared by the *zimzum* (withdrawal), the auto-evacuation of *Ein Sof*.[13] The initial pulses of creation progressively nested spheres of primordial light within one another, circles within circles.[14] The outermost, proximate to *Ein Sof*, was the highest, and the innermost, at greatest remove, the lowest. The point at which the outer circle opened to *Ein Sof*, called the *ḥalon* (window), headed the straight channel through which coursed the light of *Ein Sof*. In this linear emanation, the innermost light, the one most deeply connected to its source, was the highest. It was also the *nefesh*—the lowest of the stratified soul-rungs—of *Adam Kadmon*, the primordial linear emanation personified.

Vital discusses these first positive cosmogonic stages in a manner reminiscent of Cordovero's survey of sefirotic structures in the sixth gate of *Pardes rimonim*.[15] Like Cordovero, Vital recognizes that the true structure of the Godhead was a matter of debate among kabbalists and asks rhetorically whether the ten sefirot were emanated as a pillar, one atop the other; as a triadic hierarchy with three lines of emanation (the tree); or as concentric circles. Cordovero had presented a critical inventory of the arrays before ultimately settling on the one he authorized as correct. Vital, however, leverages the "enormous disagreement that divided all the kabbalists" to draw a cosmogonic picture in which

Figure 65 | *Ein Sof* to *Klippot*, fol. 13r, Ḥayyim Vital, *Mevo she'arim*, Eastern script, eighteenth century. COL MS X 893 V 837, Rare Book & Manuscript Library, Columbia University in the City of New York. Photo: Ardon Bar-Hama.

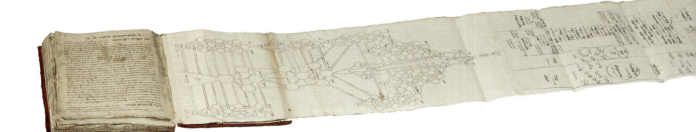

Figure 66 (*above*) | Great Tree, front-matter paper foldout preceding Ẓemaḥ's commentary on the *Idra rabba*, 256 × 32 cm, kabbalistic miscellany, Ashkenazi hand, mid-seventeenth century. Oxford, BL, MS Opp. 128.

Figure 67 (*below*) | *ʿIggulim ve-yosher*, fol. 1b, Ḥayyim Vital, *Sefer ha-drushim*, Eastern script, 1644–46. New York, JTS, MS 1985, courtesy of The Jewish Theological Seminary Library. Photo: author.

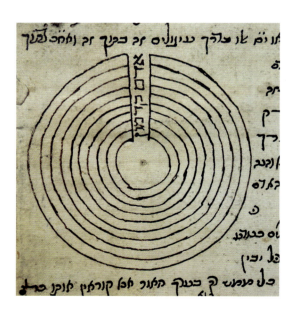

each array became one stage in a process. When properly understood, each was an expression of "the words of the living God" (quoting b*ʿEruvin* 13b). The ten primordial sefirot, known as *nekudim*, the "speckled" lights, were thus emanated as a pillar; their instability resulted in the "shattering," a subject to which Vital promises to return. As we will see, the schema used to represent the *nekudim* suggests an unstable tower. Damage to an upper sefirah will lead, domino-style, to the sequential collapse of those beneath it. The three-column arboreal schema suggests a scale-type equilibrium.

Did the subsequent emanation, then, take the form of a triadic hierarchy or of concentric circles? The answer, not surprisingly, is both; taken together, they form the complex known as *ʿiggulim ve-yosher*.[16] And here we arrive at Vital's modest epistemic image.[17] The integration of circles and the linear channel is easily illustrated by a few circles (there need not be ten) pierced from the top by a channel, "like this drawing" (*ka-ẓiyyur ha-zeh*), Vital adds, pointing to it. I draw attention to Vital's manner of introducing the diagram for what it reveals about the manner in which he understood its relation to the text. If these diagrams carry a caption, it is inscribed within the vertical

channel, as in this example: "*Adam Kadmon*" (fig. 67).

Even if the foldout with which Vital prefaced his magnum opus is no longer extant, conscientious copies of his ambitious synoptic images demonstrate his expansive approach to the visualization of Lurianic knowledge. Rather than clarifying texts, these large diagrams are their coequals, to be similarly studied and contemplated. Surrounding texts and captions ask the reader to think with these images (fig. 68).[18] When introducing the diagram seen here, which is more complex than the basic *'iggulim ve-yosher* but not nearly as intricate as one I examine below, Vital wrote, "I will now draw a circle"—his synecdoche for the diagram as a whole—"and from it, you will understand what you need to understand."[19] The reader is left to explore a diagram without labels or inscriptions. We see three outer concentric circles and three inner bottom-weighted ones, each ostensibly representing one of the *parzufim*. These are pierced by a channel—we are not far from *'iggulim ve-yosher* after all—within which floats a pillar of small circles. These are the *nekudim* just before their shattering. Going beyond these very general correlations is surprisingly difficult, however. Did Vital think the referents of each of the elements were so obvious that they required no labels? Or was he aspiring to give students an exercise in relatively open contemplation? A certain indeterminacy and its attendant speculation might have been the point.

I return to the basic elements of schemata and media. For all their complexity, Vital's diagrams remained . . . circles. The ubiquitous arboreal schema of classical Kabbalah finds no place in his images. The circles communicated cosmic continuity; as he put it, the sefirot were nested within one another "like the skins of onions, one within another, in the manner of the picture of the spheres [*temunat ha-galgalim*] of astronomical books [*be-sifrei tokhni'im*]."[20] Even so, Vital was the first to admit that Lurianic Kabbalah had little to say about the *'iggulim* and concerned itself chiefly with the *yosher* (i.e., *Adam Kadmon*) and the subsequent *parzufim*.[21] It was *yosher* that was associated with the triadic hierarchy of sefirot in Vital's harmonizing treatment of the different kabbalistic positions to which he appended the simple diagram. Rather than draw a little tree in the channel, he made do with the caption.[22] And if his most complex circle diagrams required an oversize page to give a

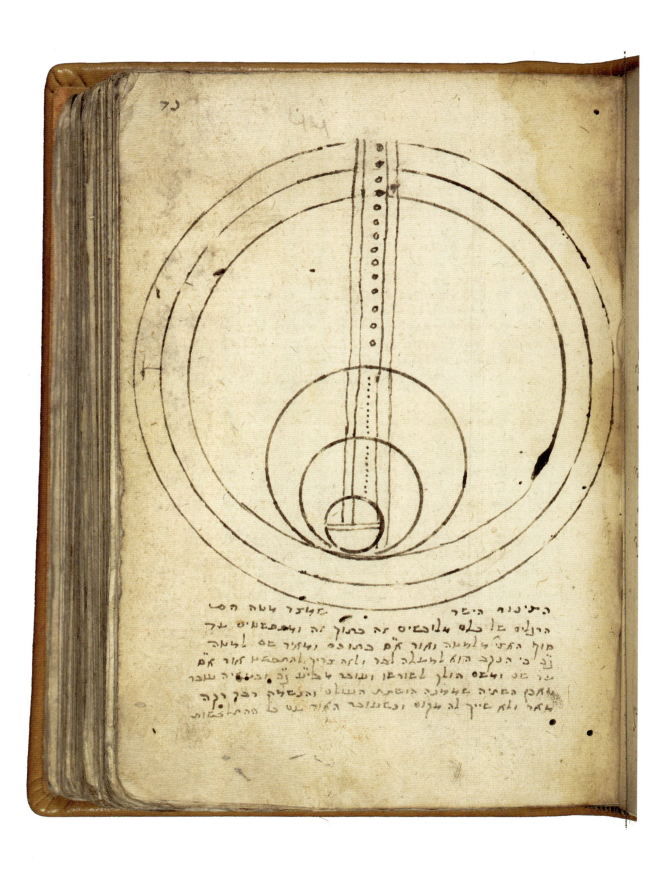

הצינור היישר בעבר עוה הסי
הרגלים של כלי הלוחטים זה בתוך זה ומפסמעים עד
תוך הכלי הלמנה ואמר אם בתוכם ועוד פה לעמד
עד כי הנקב הוא לעגלה אחר ואיזה צריך להמשאא אור אם
עד שו ועצם הולך לאורון ועובר עליו עד שמניעה עובר
עד תוך הצינור הפנימי הסתרת השטח והגיעה רבן ינה
לאור ולא שייך לה מעלה ובעבור האור שני כל התחלטות

detailed synoptic enlargement of *'iggulim ve-yosher*, there is no indication that he ever used the ilan rotulus format to represent the cosmogonic process to which he devoted so many volumes.

He may have drawn only circles, but Vital dreamed of trees. In a dream he recorded in the fascinating egodocument known as *Sefer ha-ḥezyonot* (Book of visions), we find a description that seems downright prescient.[23] In the dream, Vital finds himself enrobed in a Lurianic ilan—he doesn't use the term, but does analogize the garment to a *yeri'ah*—upon which the *parzufim* have been embroidered in the form of kabbalistic trees.

> 14 Adar I [5369 (=1609)]: I dreamed that I was wrapped in a *ẓiẓit katan* (lit., small fringe, the poncholike fringed garment worn on the male body rather than the larger shawl wrapped around it during prayer) upon which five lines had been drawn. On each of the lines were three circles, fashioned in the manner of a *segol*, as the latter-day kabbalists draw them in their books: the picture of the ten sefirot, three-three-three, one above the other.[24] And I was surprised, because the ten sefirot are three-three-three in three lines, and on my *ẓiẓit* they were five lines of three-three. I awoke only to fall back to sleep again and dream all of this four or five times. Now the *ẓiẓit* itself was of one cloth, like ours, but the ten sefirot pictured upon it—three of three-three—were pictured by the embroiderer's art, as were [the images on] the curtains [*yeri'ot*] of the Tabernacle.
>
> It seems to me that in the dream I was saying that the five lines corresponded to the five *parzufim* that exist in each of the [Four] Worlds of *ABY'A* and that each *parzuf* contained only three sefirot, corresponding to the lines that contain all nine sefirot of the *parzuf*. It also seems to me that the meaning of the dream is that I had completed the rectification of the garment of my lower soul of *'Assiah* that includes five *parzufim*.[25]

The parzufic trees of Vital's dream are not easy to picture on the basis of his description, but when read alongside one of the early Lurianic ilanot devoted to exposing the interfaces among the *parzufim*, the images in the dream snap into sharper focus.

Vital's dream ilan featured a complete array of the five primary *parzufim* that recur in each World. Vital managed to make it about him—it is an egodocument, after all—but I have to wonder about its connection to the ilanot it foreshadows. Might the dream have inspired the designer of the first Lurianic ilan? As it happens, that pioneer could very well have heard about this dream one late Friday night in Damascus, read aloud by R. Samuel Vital, keeper of his father's manuscripts.

R. Jacob Ẓemaḥ: Late Portuguese Humanism and the Revival of the Ilan

Among those who attended R. Samuel Vital's Shabbat readings in early 1630s Damascus was an erudite physician-kabbalist who had been raised among the conversos of Viana de Caminha (today Viana do Castelo), a town in northwest Portugal that had a Jewish quarter until 1496. R. Jacob Ẓemaḥ (ca. 1578–1667) fled Portugal in his mid-thirties to live openly as a Jew, arriving first in Salonica (Thessaloniki).[26] Ẓemaḥ was responsible for the

Figure 68 | Synoptic *parzufim* diagram, fol. 54a, Ḥayyim Vital, *Sefer ha-drushim*, copied by the scribe of Ephraim Penzieri, Damascus, ca. 1600. Jerusalem, Rabbi Yakov Moshe Hillel Library, MS 572.

renaissance of the ilan in its Lurianic form—making him a central figure in the present study—and, more broadly, for the consolidation of the Lurianic literary corpus in the middle third of the seventeenth century. Ẓemaḥ's revival of the ilan should be situated in the broader context of a scholarly *curriculum vitae* that began long before his flight from Portugal, if only because he embraced Jewish life as a fully formed humanist. His ilan is only one of many expressions of his deeply ingrained sensibilities and formal training. Coupled with his natural gifts, Ẓemaḥ's background served him remarkably well in his new life, catapulting him in a few short years from a neophyte donning tefillin for the first time in Salonica to a venerated rabbinic sage in Jerusalem.

Much of Ẓemaḥ's life remains shrouded in mystery; even his year of birth and "Christian" name are unknown.[27] The latter in particular makes it all but impossible to uncover details about his formative decades in Portugal. Ẓemaḥ's demonstrated mastery of rabbinics and Kabbalah within a few years of his departure prompted Isaia Sonne to presume that he had acquired his comprehensive Jewish literacy before leaving Portugal.[28] Sonne conjectured that Ẓemaḥ had been given training in Kabbalah in a covert Church-sponsored program to prepare him to missionize "Judaizers," i.e., backsliding conversos. This elaborate theory was rightly dismissed for lack of evidence.[29] All we know for certain is that Ẓemaḥ was a physician and "New Christian" from Viana de Caminha, but these facts allow for some informed speculation. Ẓemaḥ likely studied medicine at the University of Coimbra, although many New Christians from Portugal in this period pursued such study at the University of Salamanca.[30] At the turn of the seventeenth century, both institutions were rife with converso faculty and students, no few of them Judaizers. Dr. António Homem, the leading professor of canon law at Coimbra and a canon in the cathedral there, led the clandestine Jewish community of Coimbra—over sixty clerics, physicians, lawyers, students, merchants, and farmers—beginning in 1607. In 1619, the year Ẓemaḥ seems to have fled Portugal, Homem was arrested for his crime, making for a suggestive correlation at the very least.[31]

Ẓemaḥ would have received inspiration and support from the covert communities in Coimbra or Salamanca. Yet he could not have acquired his knowledge of rabbinics and Kabbalah under the tutelage of Homem or any other known figure because the leading Portuguese Jesuit humanists and university Hebraists had nowhere near Ẓemaḥ's command of Jewish languages and literature. Might Ẓemaḥ have discovered Jewish sources in a college or monastery library and been an autodidact? Nearly one hundred years earlier, Diogo Pires (ca. 1500–1532) had circumcised himself and escaped Portugal to become R. Shlomo Molcho. Molcho began writing kabbalistic treatises within a year or two, raising precisely the same questions that pertain to Ẓemaḥ.[32] But what a difference a century makes: Molcho's chances of finding books and teachers would have been incomparably greater than Ẓemaḥ's. Most Jewish books had been incinerated or sold abroad by enterprising merchants in the wake of the forced mass conversion of 1497. The possibility nevertheless remains that Ẓemaḥ discovered a trove of books that had been confiscated or hidden.[33] Another possibility is that Ẓemaḥ procured Hebrew books that had just arrived in Portugal. His hometown was a port city, and enough books arrived there to attract the attention of the Inquisition's censor, who sent representatives to clear the new arrivals before their distribution in Portugal. Hebrew books were likely to have been aboard some of these vessels, and New Christians would inevitably have been involved in the distribution process. A more remote possibility is that books reached Ẓemaḥ from Castile, just across Portugal's northeastern border;

it had been a kabbalistic center for centuries. Clandestine trafficking between these regions might have made it possible for Ẓemaḥ to study Zohar long before his flight from the peninsula.

As tantalizing as such speculations may be, they are highly unlikely; Ẓemaḥ offers no hint in his autobiographical asides about accessing any proscribed possessions while still in Portugal. Given what we know about his subsequent accomplishments, it seems more prudent to accept that Ẓemaḥ achieved his mastery of rabbinic and kabbalistic literature in an "impossibly" short period of time. His early studies may have given him a head start, but his rapid assimilation of the traditional Jewish corpus was primarily due to the indisputable genius, trained memory, and disciplined study habits of an indefatigable scholar.

Not only has the search for Ẓemaḥ's imaginary Jewish education in Portugal failed to produce real insight, but it has also taken us down the wrong road. The interesting question is not "how might he have learned Torah in Portugal" but "how did his Portuguese educational background affect his Jewish scholarship?"[34] The latter question also has the distinct advantage of being answerable: the imprint of Ẓemaḥ's humanist education is visible on nearly every page of his oeuvre. Ẓemaḥ's singular impact on the history of Kabbalah is, more than anything, the result of his scholarly habitus. The ethos he internalized from being educated in late Portuguese humanism guided his approach to the Lurianic corpus, as his remarkable textual restorations, reconstructions, and redactions all testify.[35] His own manuscripts and the copies made under his supervision reveal attention to the *mise-en-page* and invariably include tabled indices of subjects and sources.

Ẓemaḥ's editions of Vital's texts are, as a rule, diplomatic rather than eclectic.[36] These terms refer, respectively, to a critical edition of a manuscript family based on a single witness, with variants adduced from other manuscripts in the apparatus, and to an edition that creates a text based on what the editor believes to be the best of each. By referring to Ẓemaḥ's diplomatic approach, I highlight his commitment to maintaining the integrity of each work he tasked himself with restoring. The eclectic approach of other Lurianic editors led them to create new works that combined materials from all the manuscripts at their disposal. In his *'Edut be-Ya'akov* (Testimony in Jacob), for instance, Ẓemaḥ meticulously distinguished among the strata of Vital's writings. Vital's early *Oẓrot Ḥayyim* (Treasures of life or Treasures of Ḥayyim) provided the core text, surrounded, commentary-style, by his later works *Adam yashar* (Upright Adam [Kadmon]) and *Kehilat Ya'akov* (Community of Jacob). Finally, signaling both pride and precaution, lest errant copyists presume his annotation to be part of Vital's text, every comment is marked unequivocally by its first word: "Ẓemaḥ." Ẓemaḥ applied his humanist skills and sensibilities to the task of his lifetime: consolidating a Lurianic canon based on the critical redaction of Vital's writings.

Ẓemaḥ's Imaginal Kabbalah

In 1648, as a revered septuagenarian kabbalist in Jerusalem, Ẓemaḥ wrote a work in which he finally gave his authorial voice free reign. That book, *Tiferet Adam* (Beauty of an Adam [Kadmon], from Isa. 44:13), is Ẓemaḥ's synthetic review of Lurianic cosmology. The unique manuscript that has reached us is Ẓemaḥ's florilegium, an anthological mélange of selections drawn from different strata of Vital's writings—something Ẓemaḥ never allowed himself to do otherwise—with his own introduction and "connective tissue."[37] *Tiferet Adam* is also Ẓemaḥ's only work to mention gentile authors and works; even if his references are disparaging, they expose his shared background with such men as Abraham Herrera and Menasseh ben Israel.[38]

Unlike his peers, however, who were proud to flaunt their erudition in non-Jewish sources to buttress the faith of their fellow ex-conversos with external validation, Ẓemaḥ spoke as one whose familiarity with gentile corpora had bred ambivalence, if not contempt. The particular subject matter of *Tiferet Adam* meant that his foils were mostly thinkers associated today with the tradition of "Western esotericism."[39] But Ẓemaḥ did not simply invoke and compare; he responded and even reacted to this tradition. He used its great books to demonstrate that the origins of esoteric knowledge are prophetic and therefore known exclusively to the Jews. Whatever true secrets they hold are merely the vestigial remains of our own, he writes, invariably intermingled with spurious accretions.[40]

Ẓemaḥ thus begins *Tiferet Adam* by framing it in corrective terms:

> I saw numerous books treating the beginning of the creation of the Worlds and everything that is in them, and also the sefirot and their order. Their words are sealed and concealed due to their limited knowledge. There are books of the gentile astronomers and philosophers, ancient and modern, in the Latin language as well as in Spanish. In some of these are found a few words in the holy tongue within charts and in circles, names and drawings made and ordered in accordance with their will. Those of limited comprehension will be inclined to accept their opinions. See [below] chapter IV section 11 from the Zohar on books that are not from the side of the Torah that are forbidden to mention or to learn, especially with regard to the Torah.[41]

Rather than open by explaining that he has taken it upon himself to summarize Lurianic cosmogony, Ẓemaḥ begins *Tiferet Adam* by telling us what it *is not*. It is not a work of "gentile astronomers and philosophers." The invocation of the sefirot and the use of Hebrew, magical circles, and diagrams in such books is more invention than true tradition. Their truth is, in any event, beside the point; the secrets of creation are part of the Torah and must not be gleaned from external sources. Thanks to Ẓemaḥ's ubiquitous cross-referencing, it is not difficult to jump from this opening to his discussion of the warning found in the Zohar, to which he appends examples of books from which one should not learn. The zoharic passage (Zohar II:124) is adduced in *Tiferet Adam* IV:11 and, beside it, his comment, "Ẓemaḥ: It seems to me that the reason [one may not learn secrets from their books] is because they do not know or believe in the oneness of God. . . . For there is no book of science of the gentiles that is free from an admixture of the profane and impurity . . . leading ultimately to their error."[42]

Exhibit A is *Clavicula Salomonis*, the Key of Solomon. This famous Renaissance grimoire was attributed, as the title says, to the wisest of all kings. Fifteenth- and sixteenth-century manuscripts of *Clavicula Salomonis* survive in half a dozen languages (although not in Portuguese), as does a Latin edition printed ca. 1600.[43] Rather than deny the attribution, Ẓemaḥ dismisses the famous grimoire as the meager remains of material stolen in antiquity from King Solomon, who had received the authentic work as a gift from the demon Ashmedai.[44] Lest one infer from this genealogy of *Clavicula Salomonis* that demons were the source of Jewish secrets, Ẓemaḥ immediately follows his critique with the broad assertion that the rabbis of antiquity were prophets and the source of their knowledge divine. The teachings of classical rabbinic literature, "the words of our rabbis, may their memories be a blessing," were inspired by the Holy Spirit. Judaism in its entirety—meaning the "oral" (rabbinic) as well as the "written" (biblical) Torah—is the product of divine revelation. The

Zohar would naturally have been included under this rubric.

Rather than allow the assertion to stand alone, buttressed by zoharic proof texts, Ẓemaḥ quickly moves to establish it comparatively. His marginal annotation to this passage finds him adducing support from the work of "a certain gentile" according to whom Christianity is a man-made religion: "It is known that this mode of existence [meẓiut] is not to be found among the gentiles for their religion [datam] was made by flesh and blood, as is known. Therefore they have many sects, for one builds from one side until another clever one [pikeaḥ] destroys that side; every clever one makes a religion, as is known. Some of this is mentioned in a book made by a certain gentile that he called *Ropica Pneuma* in Greek, meaning *seḥorah ruḥanii* [spiritual merchandise]."[45] The work Ẓemaḥ thought apposite to his discussion was published in 1532 in Lisbon by the eminent Portuguese historian João de Barros. Ẓemaḥ's explanation of its enigmatic title—*Ropicapnefma* on the title page—was based on the one offered to the original dedicatee of the work by Barros himself: "mercadoria spiritual" (fig. 69).[46] *Ropicapnefma* was written as an allegorical dialogue at "the crest of the wave of the Portuguese Renaissance and Humanism."[47] I. S. Révah asserted that *Ropicapnefma* was written expressly to persuade Portuguese New Christians to abandon their crypto-Judaism and deistic beliefs.[48] Any such missionizing and polemical ambitions were compromised, however, by certain ambiguities due primarily to *Ropicapnefma* being "the completest and most explicit manifestation of Portuguese Erasmianism."[49] Explicitly invoking Erasmus's *Moriae Encomium* (In praise of folly), conversos might read past the claims for the truth of Christianity and the New Testament found in *Ropicapnefma* and savor instead its critique of "the established religion." Indeed, rather than being persuaded, Ẓemaḥ remembered *Ropicapnefma* as a work that gave

Figure 69 | Frontispiece, João de Barros, *Ropicapnefma*. Vienna, Österreichische Nationalbibliothek, *31.J.117 Titelblatt.

evidence for the human rather than divine origins of Christianity; studying it had bolstered, at least indirectly, his own ethnocentric fideism. Ẓemaḥ may not have been trained in a covert program to missionize other conversos, as Sonne speculated, but he was conversant with a work ostensibly composed to shore up the wavering Christian faith of conversos. Ẓemaḥ was content to eat its Erasmian fruit and cast away its peel.[50]

Although it would be a distortion to characterize *Tiferet Adam* as a polemical work, one gets the impression that Ẓemaḥ was incapable of raising the big questions—what is Kabbalah and what are

its secrets—in anything but comparative terms.[51] Even as an older man at the pinnacle of the rabbinic world, Ẓemaḥ retained a certain reactivity; his midlife flight from Portugal in pursuit of "authentic" Torah and Kabbalah must have been fueled, at least in part, by his rejection of this Other. His own feelings remained conflicted, knowing as he did that "the scholars of the nations"—humanists, antiquarians, Renaissance magicians and astrologers—were men of great learning, paragons of science to be reckoned with rather than dismissed. At least in this most personal and introductory work, Ẓemaḥ *had* become a missionary to his fellow conversos. His mission, however, was to lead them away from the literature that he and they knew well, and could not but admire, to the fuller truth of Torah. By highlighting the gentile appropriations of Jewish secrets, Ẓemaḥ simultaneously validated their kernel of truth and their dependence on the authentic, uncorrupted tradition of the Jews.

For Ẓemaḥ, as for kabbalists generally, the engine of kabbalistic hermeneutics—to be applied to all of creation, including sacred texts—is its approach to language and the techniques of divine-name generation.[52] These are the secret keys to the kingdom of the People of the Book. Yet Ẓemaḥ cannot share them without first setting them against the woefully inadequate kabbalistic understanding of the gentiles. This leads him to undertake his most extensive critique and gives us the clearest picture of his early encounters with esoteric texts in Western languages. The fact that these works contain abundant images is significant in the present context. Might their formative influence on Ẓemaḥ's general (visual) perception of Kabbalah have persisted long after he had rejected the particulars of their content?[53]

Ẓemaḥ opens the chapter in which he provides an exhaustive review of the "real" secrets of the Kabbalah by reminding his readers that the greatest minds among the gentiles haven't a clue.

Behold, the philosophers ancient and modern, as well as the astronomers, for all of their investigations—though they grasped a bit of the oneness of *Ein Sof*, which they call "First Cause"—remain ignorant of the principal matter, both in general terms as well as in its particulars.[54] They write [simply] that the First Cause is above the eleventh firmament.[55] What little they have managed to comprehend they stole from our ancestors. Although the plain sense of the Torah might be possible for one of their greatest scholars to interpret in some manner, among all the scholars of the nations there is not one who can [grasp] its depth and its secret in any way.[56] This is because no nation but Israel was given a prophet. The prophet would utter the prophecy on [Pentateuchal] verses; he also knew their secret, which he explained orally.

Ẓemaḥ proceeds to explain that the oral explanations of Moses, "the master of the prophets," were made with the same direct divine revelation that had produced the written Torah.[57] The rabbinic tradition—including, of course, its secret, kabbalistic stratum—was no less divine that the Bible, and only the Jews have access to it. This need not have implied metaphysical rather than historical Jewish privilege, but Ẓemaḥ certainly intended the former; the very next chapter of *Tiferet Adam* is devoted to the particular nature of the "soul of the proselyte."[58] The fact is, Ẓemaḥ writes, not every Jew merits the secrets of the Torah. Being a Jew is necessary but not sufficient; only the pious are granted true understanding. Even among Jews, the secrets must not be divulged to those who are unworthy. This almost unreachable standard of admission is not merely a function of the sensitivity of the subject matter, however, or some unutterable profundity; the Kabbalah is an advanced and

difficult science. His demonstration of kabbalistic sophistication and complexity is presented as if to counter the simplifications found in gentile scholarship.

The text that I am now discussing is written on a page of the *Tiferet Adam* manuscript that is particularly congested (40a). Ẓemaḥ's annotations and revisions crowd three of the four margins (fig. 70). Like a Beethoven autograph partita, the heavily scored page bespeaks its creator's struggle. Ẓemaḥ was opening a window into his former life and not having an easy time of it. The jumble of insertions and deletions resulted in a page that is difficult to parse, and the two printed editions—both based on this unique manuscript—present different readings, neither entirely coherent.[59] In fact, Ẓemaḥ's emendations damaged the intelligibility of a text that was lucid in its first draft.

Let us read the text as Ẓemaḥ first wrote it. As his deletions are marked by a simple strikethrough, the original text is not difficult to restore.

> From what they learned from our ancestors, they attained their modicum [of knowledge]. They called the book they wrote *De Umbris Idearum*, which means "image of the figures" [ẓelem de-diyukanim] or "soul image" [ẓelem nafshii].[60] So too a gentile inscribed the entire territory of the Land of Israel in captioned maps [luḥot] illustrating a printed book in the Latin language. After its conclusion, on page 201 א״ר, he wrote the great fourfold Name and said in the Latin language[61] saying "God is a refined and bright spirit" and so forth. Immediately thereafter, he begins to say things according to his meager knowledge and attainment, writing the creation of the world in his own words: "In the beginning, God created the eleventh firmament from chaos and in it innumerable spirits." Behold how immediately after the unique Name he has written the eleventh firmament!

A "modicum" of ancient Jewish secrets may indeed be found in gentile books. Ẓemaḥ's odd phrasing—"*they* called *the* book *they* wrote"—seems to be an infelicity of style that also expresses his conviction that *De Umbris Idearum* (On the shadows of ideas), Giordano Bruno's 1582 treatise on the memory arts, constituted the epitome of gentile esotericism.[62]

Bruno's early mnemonic treatise is not subjected to any critique here. Ẓemaḥ knew a thing or two about memory and presumably regarded the secrets of *De Umbris Idearum* as genuine. As we shall soon see, Ẓemaḥ's editions of Vital's works from the 1630s were based on his memory of the texts he had heard R. Samuel recite over the previous twenty-four hours. Such a feat seems more likely the result of natural gift than of artifice, but Bruno's treatise taught an esoteric science that worked, and Ẓemaḥ knew it. He had almost certainly been introduced to the memory arts at a tender age. As a young student in Portugal, he likely attended a Jesuit school where *De Arte Rhetorica* (1562) by the Castilian Jesuit humanist Cyprian Soarez (1524–1593) was part of the core curriculum. Soarez's work, which was printed more than two hundred times during its long use as the standard textbook for the study of "humanities," emphasized the importance of artificial memory and included lessons designed to develop it.[63] Ẓemaḥ would have also known that these arts were not to be found in Jewish sources, but if all real secrets are part of the Torah, the memory arts had to be there as well.

Figure 70 (overleaf) | Ẓemaḥ's autograph marginal emendations, fol. 40a, Jacob Ẓemaḥ, *Tiferet Adam*, copied by David Nachmias, Jerusalem, 1648. Jerusalem, Benayahu Collection, MS K 109, courtesy of the Library of the late Rabbi Professor Meir Benayahu.

Unable to provide reliable transcription of this handwritten Hebrew manuscript page.

שער ד׳ חלק י״ג

מרגלית טובה

בזוהר ותקונים נזכרו עשרה תשב׳ דפיקין. ופתוק קול דוה תרבד כענין זה כמו הד
פרסת פנחם דף רי״ע וכדי אמצא להעיר
כמתוק דינן אסתלק דפיקו. והעשון אלדך
שגדע פ חטאה הנקרא אבא הוא חיות
אל כל האצלות ותתפשט בתיכן כענין
באורך כדרושים כסוד כלא בחלכמתה
עשית והנה החכמה נקראת ק׳ כנודע

צמח
הנה נודע כי כל חולאים נתשוך יעשדה
הכלים ורפא׳ נעשה והנה רופא נאמ׳ דפא
עם הכולל. וזדך להתעשיך תעשב דילין
כענין אמ״ר שהוא הרופא ק״ל וגו׳.

ולכן הס עשרה תשב׳ דפיקו. והנה כתוא שאבא תתרפשע בכל אצלות לחיות הנה ג׳ לבנתשאל כאדם
יש פרניינס מלאבד׳טי רוחני לקיים והעטרה וחיו׳ בל הדפק תחביבת אבא הוא תמיר הוא
תוקנו ונעש בה ב׳ צמח׳ ופעם לזק שלהבתיה כ תמיר תופעננט
להתפשע בכל אותך הטוק החיות שכפנייהנו. והנה אבא הוא כתיבת ג׳ כנל׳. וכל הנלה דאבא הוא דהנלה
יודן ניש כמעלויו ד׳ אותיות ולכן הס ג׳ תשב׳ דפיקו. והנה אחותס העשר אותיענו דתעלו׳ דס כטנו דפק
נתחך העשר תוצרפשעאס באצלות כאחד כנ״ל ועס עשר אנפין הנקרא כאס אדם וכס הוא כתיבת
רוח וממענו נתעש לאאחר כזה העולה וזהו פיריש הפתוק קולדה דופק. קילדה בשעת אותו תוב עשך
תשב דפקיס שהם מתפשעאס בעולם קליה. הס כתי הליגוך. והנה דוגמתו זה נתעשך לבן כנ
ישראל וכשקארס תוכא תוכעלס החדשו דפיקו בלא׳ כתי תיגאו כתה שפעו. ואם כתיב טוקך עון
אכוכי על כעם כפוקך חסד ד׳. וסס אוכילות דתפך אחוה הואבא כנ״ל וזהו דפק אבא׳. על כעם
הס כני ישראל שענלו כהס חולי תניותס עליו דתשב׳ דפקי. והנה תו׳ ענן הנקרא אב׳ ואורדנו
ד׳ יקיה דופק וקולד״ה רחבא וכף כטוק וזהו טוק עון אבות על בנים :

סם עשון הנל תמה בתפוק י״ג יפתעדנו על ערב דוי שעורבכ בחולה והוא ם שלא זה כא הוא בכחינ׳ על יודי י׳
יודן ניש בו ד׳ אותיות כנל וסס עשר אותיות עלב׳. וסוא חיות התפשעה באצלות כנל׳ ולו סס פעד׳ל שטע
דפקין התפשעאס כנ״ל וסס ד׳ אותיות יו״ד ותפ׳ עלואטה לעשולך. גס הבריב׳ דל׳ רחוכ דו ני׳ שתב״ם
העט בפניעו וכאצלות וכלנל צמח

ורהנו לחו׳ ג׳ באתור ויחטאו דפתוק הנל שפאלו כדרך הילוך בכד
והוא הי׳ שנתשע׳ על ערב דוי והאלי קדושים בדרכך נוכ׳ קלעך. ם׳ המוך החולה נתשוך לו תוחבתה
אבוא כתיבא׳ וכתמא נאמר נפעל על ערב נתל וכל״ב זאת דוי תולעין יולך כנל׳. והחורתו נאמר בתשוכ
תאריס כו אותן עשר אותיאל על אבה ובנו י׳ יפעדו על ערב דוי. וכסוכו בתשוכב כנד כל תשבך נתכב
בחולה ם׳ הפך נתעשבב שהיה כעלס ועשה ם עשר והפך לו׳ ועשך יוד :

טמן

Figure 71 | Mnemonic wheel, page 44v, Giordano Bruno, *De Umbris Idearum*. Munich, BSB, Res/Paed.th. 670.

Ergo, he concluded they had been lost to the Jews and preserved by Bruno. Bruno's martyrdom in Rome in 1600, after he was sentenced to death by the Inquisition, may well have consolidated the conviction of the former converso that *De Umbris Idearum* was, at the very least, a shadow of the Torah.

De Umbris Idearum was full of Bruno's own carefully designed mnemonic woodcuts.[64] A number of them present wheels within wheels inscribed with letters, Hebrew among them.[65] They are alphanumeric code generators, mental volvelles that could also be fashioned of spinning paper disks (fig. 71). Bruno considered the images in his works to be so important that he "carved the figures with his own hand," in the words of his 1591 Frankfurt printer.[66] I am unaware of any attempt on Zemah's part to restore the secret arts of memory to the Jewish people with Bruno's inspiration, but the

centrality of what we might call performative images in *De Umbris Idearum* must have made an impression on his own notion of applied esotericism.

From Bruno's *Shadows* Ẓemaḥ pivots sharply to another work to demonstrate the *limits* of gentile cosmogonic understanding. The *Chronicon* is not typically associated with Western esotericism; it is a chronology appended to Christian van Adrichem's geographical treatise *Theatrum Terrae Sanctae et Biblicarum Historiarum* (Cologne, 1590).[67] Ẓemaḥ seems to have been impressed by the detailed maps of the Land of Israel in the treatise, but he takes the chronology to task for its inadequacies. The problems begin "on page 201," he tells us. The title of the book and its author—the latter referred to simply as "ha-goy," the

Figure 72 | Ẓemaḥ's "page 201," Christian van Adrichem, *Theatrum Terrae Sanctae et Biblicarum Historiarum* (Cologne, 1590). Munich, BSB, Hbks/F 118 za.

VISUALIZING LURIANIC KABBALAH | 107

gentile—are not named by Ẓemaḥ, but the *Chronicon* indeed begins on page 201; Ẓemaḥ substituted Hebrew letters for the Arabic numerals found in the best-selling work. "The great fourfold Name," vocalized and inscribed at the center of a solar icon, is indeed emblazoned atop the page (fig. 72). Adrichem's description of God beneath the Tetragrammaton, rendered by Ẓemaḥ in Hebrew as "Elohim hu ruaḥ zakh u-bahir ve-gomer" (God is a refined and bright spirit and so forth), reads "Deus est spiritus lucidissimus, aeternus, & ubique praesens" (God is the most luminous, eternal, and everywhere present spirit). Although the passage goes on to assert that God is one in essence and three in persons, Trinitarianism—not stolen from the Jews—is not what demonstrates the author's "meager knowledge and attainment." Instead, Ẓemaḥ ridicules Adrichem's account of creation. A look at page 201 shows that the first paragraph after the Tetragrammaton is devoted to "Mundi creatio" (creation of the world) and begins, "In principio creauit Deus ex nihilo caelum empyreum, & in ipso innumerabiles spiritus Angelicos" (In the beginning, God created the empyrean heaven from nothing, and within it innumerable angelic spirits). Ẓemaḥ had rendered the passage in Hebrew as "In the beginning God created the eleventh firmament from chaos, and within it innumerable spirits," and he chided the author for his jump from *YHVH* to the eleventh firmament as evidence of his impoverished cosmogonic knowledge. Adrichem, we see, had referred in the original to the empyrean heaven, "the abode of God and the elect" surrounding the spheres. Rather than attempt a translation of the Latin *empyreus*, Ẓemaḥ converts it to its numerical equivalent: the eleventh firmament of medieval astronomy and natural philosophy.[68] From there he merely suggests that the reader compare this cosmogony, in which God abuts the eleventh firmament, to the one presented in the early chapters of *Tiferet Adam*, which detail the "endless Worlds from the First Cause to the World of *Aẓilut*, and from there to this World, which is the end of *ʿAssiah*." The eleventh firmament (which, Ẓemaḥ fastidiously reminds us, he treated in II:6–8 of the book) is located well down the great chain of being, at the beginning of the lowest World of *ʿAssiah*. Adrichem knew of *YHVH*, the radiant sun-bounded Hebrew name of God bespeaking his indebtedness to Jewish revelation, but he was otherwise ignorant of the innumerable Worlds known only to the Jews.

Ẓemaḥ faithfully translated passages from Adrichem, referenced the relative position of Adrichem's discussion in the Latin treatise, and cited the exact page number. Does this mean that Ẓemaḥ had a copy of this grand folio volume of some three hundred pages in his Jerusalem library?[69] I think not—and not simply because the thought of him transporting it from Portugal to Salonica, Safed, and Damascus is laughable. The prodigious feats of memory accomplished by Ẓemaḥ on a weekly basis in the 1630s make his recollection of passages and page number nothing more than incidental testimony to a mind capable of recording everything it saw and heard. Note, too, that the precise page reference immediately follows the invocation of Bruno's mnemonic treatise. Ẓemaḥ was not simply gifted with an astounding memory but also a trained practitioner of the memory arts.

For Ẓemaḥ, the clearest and most important example of the inadequacy of Christian Kabbalah was to be found in the work of Heinrich Cornelius Agrippa, to which he turns next in his discussion.[70] Unlike Bruno or Adrichem, Agrippa is referred to by name.

> There is also the gentile who wrote a book of occult philosophy [*philosophia ha-neʿelemet*, referring to *De Occulta Philosophia*] by the name of Heinrich Cornelius Agrippa. In it, he wrote a bit of every science, but failed to

present even one in its perfection. For he mixed [these sciences] with the profane and the impure "that shall not be admitted into the community of the Lord" [Deut. 23:4]. Although [Agrippa] found a few circles and charts and names and drawings of Kabbalah, he did not know that God did not grant him the apprehension of the truth—but only His people.

The passage clearly parallels the opening statement of *Tiferet Adam*, but here Ẓemaḥ explicitly names the Christian kabbalist he chiefly had in mind.[71] As Ẓemaḥ tells the story, Agrippa realized the folly of his endeavors after concluding his kabbalistic work. He then wrote a follow-up book in which he expressed his newfound skepticism: *De Incertitudine et Vanitate Scientiarum* [The uncertainty and vanity of the sciences].[72] Agrippa now knew one thing: he would never know the truth. The story suits Ẓemaḥ's agenda, but it does involve a bit of (unintentional?) historical sleight of hand. Agrippa published his Erasmian *De Incertitudine* in 1526 and the three books of *De Occulta Philosophia* between 1531 and 1533; the latter work is thought to have been Agrippa's attempt to overcome the skepticism of the former. For Ẓemaḥ, however, Agrippa's resignation to ignorance was the end of his wisdom rather than beginning. The sciences of chiromancy and geomancy, Ẓemaḥ parenthetically adds, "were also stolen from our ancestors by a few gentiles, who wrote books bearing their names."[73] He names four authors of classic works treating these divination techniques but does not elaborate further, having discussed kabbalistic sources on physiognomy, chiromancy, and geomancy earlier in *Tiferet Adam*.[74]

It is against this background of the demonstrated inadequacies of Christian Kabbalah—indeed, on the very next line of the manuscript—that Ẓemaḥ asks what, then, *is* Kabbalah? Even here, he begins his answer by characterizing the view of the *ḥakhmei ha-goyim*, "the sages of the gentiles." In their view, he says, "Kabbalah is the general term [*shem ha-kolel*] for the science explicated from certain points, calculations, and diagrams."[75] They are not wrong per se, but they have no inkling of the sophistication of the real thing. Ẓemaḥ then proceeds to provide a dizzying litany of sophisticated kabbalistic textual manipulations to demonstrate that Jewish Kabbalah is in a league of its own.

This review of Ẓemaḥ's engagement with books and authors from his previous life as a converso helps contextualize his place in the history of visual Kabbalah and especially in the Lurianic revival of the ilanot genre. The takeaway is as simple as it is striking: Ẓemaḥ relates to his Latin library as a repository of truth, albeit stolen and limited. Every work he mentions is replete with images, many of them diagrams. Even the abstract definition of Kabbalah proffered by the gentile sages, with its "points, calculations, and diagrams," expresses a highly visual perception of the lore.[76] This is the Kabbalah that Ẓemaḥ knew as a converso and that he absorbed well into his thirties. His study of a wide range of scientific works (in the sense of *science* current ca. 1600) had a formative impact on his development, whetting his appetite for what he evidently came to believe was the font of the wisdom that these books preserved and presented. Ẓemaḥ aspired to more and better gnosis than they could provide, but he did not fundamentally stray from their humanistic model of scholarship or from their imaginal approach to Kabbalah.

Every source recalled by Ẓemaḥ in 1648 would have been fresher in his mind when he made the ascent to Safed in 1619, determined to study the new Kabbalah of R. Isaac Luria. He brought with him the financial resources to establish himself in his new life and the scholarly habitus that made him the man he was. Although Ẓemaḥ was just getting

started, he was hardly at the beginning; his humanistic training, systematic editorial practices, and imaginal perception of Kabbalah were well established and primed for the challenge ahead.

At the time of Ẓemaḥ's arrival, it was still easier to acquire Lurianic treatises in Safed than anywhere else. R. Ḥayyim Vital had resettled in Damascus in 1594, ʿEz Ḥayyim in tow, but many of his other works had been leaked before his departure. As the story goes, while Vital was briefly incapacitated by illness, a number of his early writings—*not* including ʿEz Ḥayyim—were "borrowed" and copied over three days by one hundred scribes.[77] The resulting bootleg treatises were precious contraband; Ẓemaḥ spent the last of his savings acquiring these books in Safed. "I sold all the silver and gold that I had and bought books," he recalled, "and [especially] books of the Rav [Luria], may his memory be a blessing in the World to Come."[78] The investment helped him establish a modest business model that allowed him to continue his important work. Ẓemaḥ received donations from those whom he permitted to copy his manuscripts. He would then proofread, correct, and annotate the copies.[79] His master copies were standardized and indexed for page-specific cross-referencing. Such assiduous editorial practices were a hallmark of Ẓemaḥ's scholarly work throughout his life.

After roughly a dozen years in Safed, Ẓemaḥ went to Damascus to study with R. Samuel Vital, a great kabbalist in his own right and keeper of his late father's ʿEz Ḥayyim. Why Ẓemaḥ waited so many years to pursue study with Samuel is unknown; perhaps he did not want to present himself to Vital's heir before he felt worthy and ready. Although Samuel would eventually allow eminent visitors to inspect the manuscript, during Ẓemaḥ's years in Damascus (ca. 1632–1640) the only way to study ʿEz Ḥayyim was to listen to Samuel read it aloud. This he did every Friday night and again from midday to nightfall on Saturday. The listeners could not take notes on the Sabbath. The plan had a flaw, however; Ẓemaḥ remembered what he had heard and reproduced it in writing after the Sabbath ended each week. His library of Lurianic works therefore expanded to include a series of books based on these Saturday-night transcriptions, prefaced by apologies for possible errors resulting from lapses of memory. These works, too, he indexed meticulously.

Ẓemaḥ resettled in Jerusalem around 1640, the change of place once again effecting a change in his Lurianic library. After nearly two decades of struggling to cobble together a collection of Vital's writing by hook or by crook—from the contraband treatises in Safed to the books based on Samuel's recitations in Damascus—Ẓemaḥ finally hit the proverbial jackpot in Jerusalem. Soon after his arrival, he obtained a significant cache of Vital's original autograph manuscripts. There was a catch, though: they had been underground for decades. In a fit of neurotic fury, Vital had decided to destroy them before leaving for Damascus, burying them in the genizah of Safed.[80] The manuscripts reached Ẓemaḥ in various states of decay. One treatise survived miraculously intact, still bound and missing only its title page and some of the letters bordering its damaged margins; Ẓemaḥ gave it the name *Oẓrot Ḥayyim*. It was an orderly extended exposition of the grand emanatory scheme that Vital distilled after completing his first phase of writing in the years after Luria's death. The decomposing and disordered pages of Vital's other books were painstakingly reconstructed and copied by Ẓemaḥ, who endeavored to reassemble each one in its original form. Ẓemaḥ ran his own bet midrash in Jerusalem as a restoration and reproduction lab, with as many as nine scribes working under his supervision.[81] No fewer than five "new" Vital works resulted from their efforts.

Ẓemaḥ's dedication to restoring each of Vital's texts—an expression of his antiquarian scholarly

sensibilities—was unique. R. Samuel Vital, in his *Eight Gates*, preferred thematic redaction, as did Ẓemaḥ's student R. Meir Poppers. To put this another way, in editing Vital's texts Ẓemaḥ strove to recover what had been written, Poppers to create what should have been written. Ẓemaḥ's Jerusalem series thus rendered his Safed and Damascus corpora effectively obsolete. But the Jerusalem restorations would soon fall victim to their own success.[82] Not long after Vital's treatises had been salvaged from oblivion by Ẓemaḥ and meticulously re-created, they became obsolete thanks to their cannibalization in the eclectic Poppers edition, which quickly became the canonical expression of Lurianic Kabbalah.

These redaction details are relevant to the history of ilanot because Ẓemaḥ made his pioneering ilan in Damascus. As he described it, the diagrammatic presentation of the ilan was fully annotated and framed by texts and commentaries that included the page numbers of their sources in the master copies of his Damascus library. With the eclipse of that library—first by the new Jerusalem editions and shortly thereafter by the new Poppers edition of *'Ez Ḥayyim*—the value of Ẓemaḥ's fully annotated ilan plummeted rapidly.[83]

Thinking with Diagrams

Before turning to Ẓemaḥ's account of the ilan he made in Damascus, which has not reached us in its original form, it is worth asking what we can learn about Ẓemaḥ and visual Kabbalah from his diagrams that have survived. He carefully copied the original diagrams in Vital's autograph works when he restored them in Jerusalem in the 1640s, treating them as authentic expressions of Lurianic thought that deserved the same respect as the texts. The restored volumes painstakingly preserve and present them, and his annotations include diagrams of his own making. These original drawings show Ẓemaḥ, the visual commentator, thinking with diagrams.

A modest marginal note in Ẓemaḥ's own hand provides a fascinating example. The note appears in the oldest known copy of Ẓemaḥ's restoration of a buried Vital treatise to which he gave the name *Toldot Adam* (Generations/History of *Adam* [*Kadmon*]); it had lost its title page in the moldy genizah. Vital's original was composed in the early 1590s as a summary of the emanatory mechanics of Luria's system, and it came to be known as *Mevo she'arim* (Entrance to the gates). The mid-1640s manuscript, produced in Ẓemaḥ's bet midrash atelier, features marginalia and an index in Ẓemaḥ's own hand.[84] Near the beginning of the cosmogonic exposition, in which Vital explains the emanation of the Worlds one within another, Ẓemaḥ poses a question in the margin: Might the Worlds have emanated one *after* another, each as its own circle? To make his meaning clear, he refers the reader to a diagram he has devised himself, "as in this drawing" (fig. 73). The drawing, a circle in which three smaller circles are aligned vertically, does more than illustrate his question, however: it provides him with the answer. Considering it, Ẓemaḥ writes, one can immediately see the problems. If each of the internal circles—of which, he points out, he has only bothered to draw three—were independent, their connection to *Ein Sof* would be identical. There would thus be no difference among them.[85] Furthermore, were they arrayed in such a manner, the vacated space (*ḥallal*) within *Ein Sof* would be in a state of disequilibrium: the top and bottom circle-worlds would be closer to the all-encompassing circle than the middle one. This diagram neither visualizes nor clarifies a text for the reader; it is, to borrow Nelson Goodman's term, a "counterfactual conditional" diagram visualizing a false "if clause."[86] Ẓemaḥ's diagram presents a false visualization of Vital's cosmogonic teaching, and by examining it—that is, thinking with it—one can

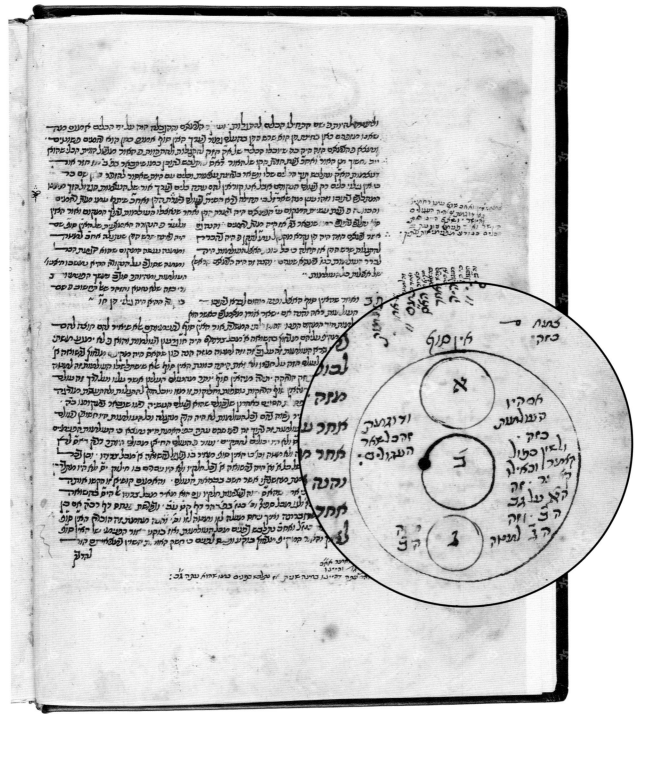

understand why the interpretation it represents is incorrect. This modest figure shows us Ẓemaḥ's visual kabbalistic thinking in action and suggests just how deeply implicated diagrams might be in kabbalistic epistemology. Its reception history is also revealing. As a rule, Ẓemaḥ's autograph marginalia were integrated by the copyists working under his supervision into the more sophisticated *mise-en-page* of second-generation manuscripts. In this case, not only was the diagram preserved in such early copies but it was also enlarged, the clearest possible indication of its importance (fig. 74).

Although that earliest copy of *Toldot Adam* shows us Ẓemaḥ's original counterfactual-conditional diagram, it no longer includes large-format foldout diagram pages. We can be certain that these oversize pages were torn out and lost given their preservation in copies in which they have been downsized to fit on a standard page. A fine example can be found in a copy executed by R. Samuel Laniado of Aleppo (d. 1750). Laniado copied *Toldot Adam* roughly a century after its restoration by Ẓemaḥ, rendering its large diagrams on octavo-size pages.[87] These allow us to see other facets of Ẓemaḥ's relationship to images. As in

Figure 73 (opposite) | Ẓemaḥ's autograph counterfactual diagram, fol. 1b, Ḥayyim Vital, *Mevo she'arim*, mid-seventeenth-century Eastern script. Ramat Gan, Bar-Ilan University Library, Rare Books Collection, Moussaieff MS 1095.

Figure 74 | Ẓemaḥ's counterfactual diagram, fol. 16a, Ḥayyim Vital, *Mevo she'arim*, eighteenth-century Eastern script. COL MS X 893 V 837, Rare Book & Manuscript Library, Columbia University in the City of New York. Photo: Ardon Bar-Hama.

Figure 75 (overleaf) | Synoptic circles of Ẓemaḥ and Vital, fols. 49b–50a, 21.2 × 16 cm, Ḥayyim Vital, *Mevo she'arim*, copied by Samuel Laniado in Aleppo, early eighteenth century. Jerusalem, NLI, MS Heb. 28°8815. Photo courtesy of The National Library of Israel.

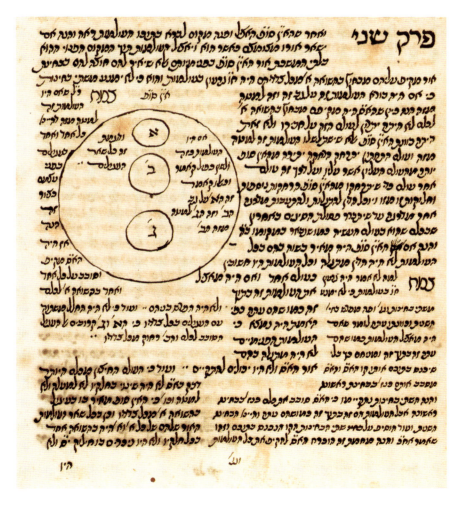

VISUALIZING LURIANIC KABBALAH | 113

בתחי' ציור זה כך היה תאריו וכתוב תחת הצ' זל- - - - "רה

בתוך דור זה בייתן כמו זהר הד הדר זלה"ה כדף שעבה כתו שינש //

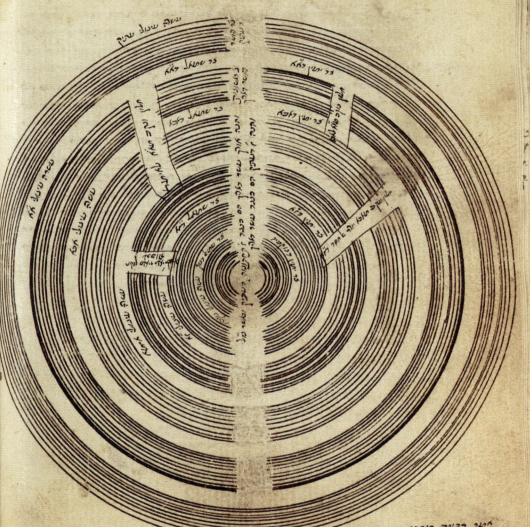

חותך הכותב מספר שהתעתק ההעתק הזה/
והנער שהעתיק ומעיען לפי שהיה זה הציור בעגולה ונתעלם ממקום לא היה מהם כלל ושני
תמונה תשולם בעדור המצוות להכין דברים שאינם לגמרי לגמרי...

the last example, they show Ẓemaḥ reading Vital visually but also demonstrate his conviction that Vital's images are no less "*torah*" than his texts. As such, they deserved meticulous preservation even when Ẓemaḥ had his own, somewhat different visualization of the same material. Ẓemaḥ took Vital's diagrammatic expositions seriously, and this fundamental appreciation of the communicative, ideational power of images, coupled with Ẓemaḥ's principled antiquarianism, ensured their preservation.

Laniado's copy, which we have every reason to believe was faithful to its source, presents the reader with two facing pages, each of which is dedicated in its entirety to an intricate diagram (fig. 75).[88] They visualize the same ideational content, so their juxtaposition, rather than conflation, reflects their significance in Ẓemaḥ's eyes. Laniado's marginal notes and his care in producing these finely executed copies show that he took them no less seriously. Ẓemaḥ captions each with his typical transparency. The first (fol. 49b, reading from right to left) reads, "Ẓemaḥ: This drawing [*ziyyur*] I have drawn on the basis of the Rav [Vital] of blessed memory's words on the preceding page, as you will see." The second reads, "Ẓemaḥ: This drawing is as it was drawn and written by the hand of the Rav of blessed memory." Vital's diagram was a visualization of the ideas expressed in the text immediately preceding it. Ẓemaḥ, reading the same text and having carefully scrutinized Vital's diagram, thought it would be useful for his readers to study his own visualizations as well.

The two diagrams, not surprisingly, have much in common. Ẓemaḥ offered a more thorough graphic elucidation than did Vital by adding details and leaving a bit less to the imagination. Comparing the two, the following differences stand out:

- Ẓemaḥ replaced Vital's semicircles with full circles.
- Where Vital wrote "the ten circles of," Ẓemaḥ replaced the inscription with ten circles.
- Ẓemaḥ's reorientation of the diagram enabled him to distinguish between the right and left of the major *parzufim*. To the central shaft he also added various "windows" (*ḥalonot*), cosmic "Chutes and Ladders" connecting higher (outer) and lower (inner) elements.
- Concentric-circle diagrams need to be labeled only on one side—or, as Vital had opted, show a semicircle—because the referent of each band remains constant. The full circles of Ẓemaḥ's version nevertheless permitted him to show something that could not be pictured in Vital's diagram: the linear channel traversing the circles from the top almost to the bottom. The cosmogonic text had explained that the channel had to stop before piercing the bottom. Were it to extend through that bottom, the light of *Ein Sof* within the channel would reconnect to *Ein Sof* surrounding the circles, short-circuiting creation and restoring the pre-*zimzum* primordial simplicity. Ẓemaḥ's image brings home this point tangibly.

Ẓemaḥ did not deem it necessary to replicate every last detail of Vital's diagram in his own, including the inscription of *Ein Sof* in the outermost ring, the recurring inscriptions of "light surrounding circle/light within circle," and the innermost circle bearing the label "*Beriah klippot*" ([World of] Creation—[evil] shells)." After all, his own diagram was not meant to replace Vital's.

The Making of a Lurianic Ilan

It should hardly come as a surprise to find Ẓemaḥ reminiscing in the 1640s about the visually oriented projects that he had undertaken while still in Damascus.[89] Marrying his organizational and

pedagogical orientation to his profound appreciation for the power of images, he had created a series of charts. The large format enabled him to present structured presentations of material not easily accommodated on the pages of a book. One, he tells us, was devoted to the grades of prophecy according to Vital's *Sha'ar ruaḥ ha-kodesh* (Gate of the holy spirit); we can only presume that it integrated considerable textual material in the framework of a boldly lettered outline. Two others provided kavanot (the intentions that are to accompany the performance of the commandments) for short but significant liturgical performances: the *Shma* ("Hear, O Israel," Deut. 6:4) and the *Kaddish* (sanctification). These kavanot attended to the secrets encoded in every word and the vocalized divine names associated with them; gazing upon these names was essential to the performance of the technique. By transferring them from the crowded pages of handwritten codices to large sheets of paper, Ẓemaḥ must have hoped to facilitate the successful implementation of these demanding practices. He was ahead of his time and perhaps ours as well; a look at any Lurianic *siddur* (prayer book) shows just how many pages must be turned to get through these prayers. If he were alive today, Ẓemaḥ might have suggested praying with a teleprompter app or even designed one himself.

The large-format project to which he devoted his richest account, however, was "an ilan of the *parzufim*." The passage in Ẓemaḥ's introduction to his commentary on the *Idra rabba*, titled *Kol be-Ramah* (A voice is heard in Ramah, from Jer. 31:15), in which he describes his ilan project, could hardly be more consequential to the history of the genre. The two earliest manuscripts that include the introduction, one in the British Library and the other in the Jewish Theological Seminary, date to the seventeenth century. They present us with slightly different versions, perhaps reflecting updates made by Ẓemaḥ over the years to different master copies.[90] Given its significance, I translate the passage as it appears in both versions:

LONDON, BL ADD. MS 26997, 1B–2A (AVIVI §836)
Afterward, on one large sheet of paper, I wrote an ilan of the *parzufim* ordered in drawings (*mesudarim be-ziyyurim*) as mentioned in the books. The *parzufim* and their subsections are sectioned as they enrobe (*mitlabshim*) one another. A full explication surrounds, with a reference to the page of the work from which I have copied [each element].[91]
NEW YORK, JTS MS 1996, 1B (AVIVI §834)
Afterward, on one large sheet of paper, I wrote an ilan of the *parzufim*, according to the order written in the books. I clarified each and every element (*davar*). The five *parzufim* I drew in sectioned units (*be-frakim ha-neḥelakim*) [connected] from one to another and from *parzuf* to *parzuf* and from sefirah to sefirah. The explication of every element is written surrounding it, each with a reference to the place from which I took it.[92]

The two versions have much in common. On the basis of content I would be hard-pressed to decide which might have been the first draft and which the second, if indeed the differences reflect Ẓemaḥ's own revision. The ostensibly later copy does not necessarily reflect a later version of the text. They are, in any case, in complete agreement on the fundamentals. Ẓemaḥ drew an ilan of the *parzufim* on a large sheet of paper; he ordered them in accordance with the teachings in the works of Vital at his disposal; and he framed the diagrams with elucidating texts. Ẓemaḥ's use of the term *ilan* must have been a conscious invocation of the long-established genre.[93] He describes his *biur* (explication)

surrounding the diagrams as anthological and based on primary sources. Zemaḥ provided each with a full reference—using a frequently recurring term in his vocabulary, *moreh makom* (lit., showing the place)—noting the name of the book from which he had adduced it as well as the precise page number. The assembled sources would have provided basic characterizations of each of the *parzufim* and detailed the interfaces between them. In fashioning his innovatory ilan in this manner, Zemaḥ was effectively updating the established convention of ilanot. The embedding of texts that taught the fundamentals of kabbalistic cosmogony in and around a large diagrammatic representation of the divine structure was, after all, the essence of the classical ilan. The earliest ilanot arrayed a single introduction to (or "commentary on") the sefirot on the parchment but, as we have seen, sixteenth-century ilanot could also be ambitiously anthological. Zemaḥ's juxtaposition of elucidating primary sources and their diagrammatic representations was therefore traditional.

Teasing out the significance of the differences between the versions, we note that the British Library witness is more concise, thanks to its reliance on kabbalistic shorthand. In it, Zemaḥ describes having divided up the *parzufim* to show their sections "enrobing one another" (ha-mitlabshim mi-zeh la-zeh). Using the technical language of *hitlabshut* (enrobing or "engarmentation") permitted greater brevity of exposition. The longer version, in the New York, JTS witness, does not use that term but opts instead for a richer description of the diagrammatic visualization. In it Zemaḥ has "clarified every single thing" (birarti kol davar ve-davar); drawn precisely five *parzufim*; and pictured them in a manner that reveals their relative positions and precise sefirotic interfaces. He seems pleased by the granularity of his visual exposé, having found a way to show the process of *hitlabshut* down to "sefirah-to-sefirah" resolution.

This, then, is the verbal description of the first Lurianic ilan. Does it correspond to anything we see among the earliest Lurianic ilanot? I answer with an image (fig. 76). A close reading of this ilan opens my survey of Lurianic ilanot, below. For now, however, it is sufficient to observe the manner in which the arboreal figures of its bottom half—each representing a *parzuf*—are interlinked. This array of small trees exposes the minutiae of these enrobings, "sefirah to sefirah." There is nothing quite like it in the diagrammatic repertoire of the Lurianic kabbalists. Its early incorporation and endurance as a constitutive element of early Lurianic ilanot (e.g., figs. 66 and 130) strengthens the case for attribution to an authoritative creator. In light of its congruence with Zemaḥ's description of the diagrammatic heart of his ilan, we can presume that this version preserves his innovative visualization, albeit shorn of the original framing commentary.

Zemaḥ's ilan made its European debut in the diagrammatic appendices to early copies of Vital's *Ozrot Ḥayyim*. Vital's lucid, concise, and mechanistic presentation of Lurianic cosmology was particularly well suited to graphical visualization.[94] Even after it was "swallowed up" in Poppers's *'Ez Ḥayyim*, it remained a favorite of some kabbalists, first and foremost R. Moses Zacuto (1625–1697). Zemaḥ recovered and restored *Ozrot Ḥayyim* in 1643; by 1649, Zacuto had obtained and annotated a copy.[95] The 1649 witness includes a fascinating note by Zacuto in which he asserts that among the schemata rejected by Cordovero were, unbeknown to him, representations of particular *parzufim*.[96] Thus, Zacuto claimed, the rightmost array in Shem Tov ibn Shem Tov's lineup (fig. 10), rejected by Cordovero in *Pardes rimonim* (6:2:2), in fact represents *Arikh Anpin*. Zacuto then refers his readers to a diagram of *Arikh Anpin* based on that configuration, which he himself has drawn and inscribed on the following page (fig. 77). Although it is not

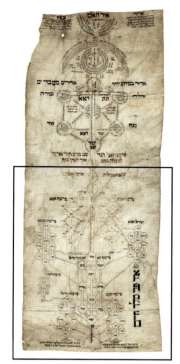
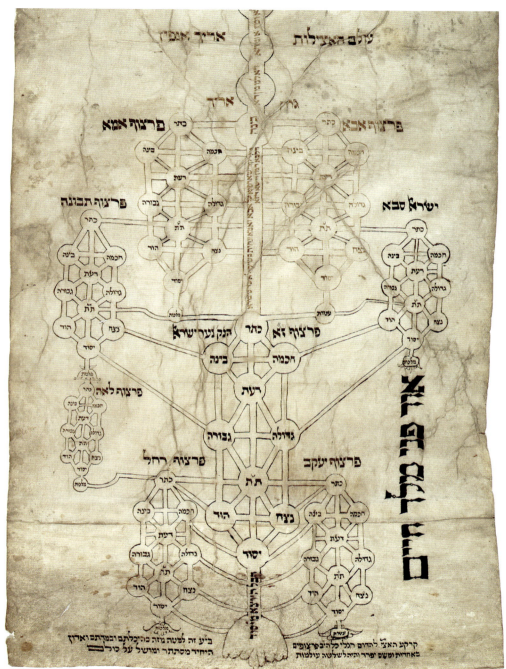

Figure 76 | Zacuto-Ẓemaḥ *Arikh and the Enrobings* ilan, parchment, 70 × 32 cm, seventeenth-century Ashkenazi hand. Jerusalem, Benayahu Collection, courtesy of the Library of the late Rabbi Professor Meir Benayahu.

found in the 1649 manuscript, subsequent copies of *Oẓrot Ḥayyim* made under Zacuto's direction and based on the 1649 master copy often present the "Ẓemaḥ ilan" (hereafter without quotation marks), showing the sefirah-to-sefirah networked array of arboreal *parẓufim*, adjacent to the *Arikh* diagram (fig. 78).[97] Their juxtaposition in these codices undoubtedly inspired their coupling soon thereafter on dedicated parchment rotuli.

The heuristic value of the sefirah-to-sefirah parẓufic ilan, which probably reached Zacuto in the late 1640s along with other Ẓemaḥ materials, would have encouraged him to preserve it. Zacuto saw to its inclusion in the copies of *Oẓrot Ḥayyim* that he worked diligently to distribute far and wide. Zacuto's transvalued classical ilan had an important contribution to make, but its *raison d'être* was certainly not to reveal the manner in which the lower

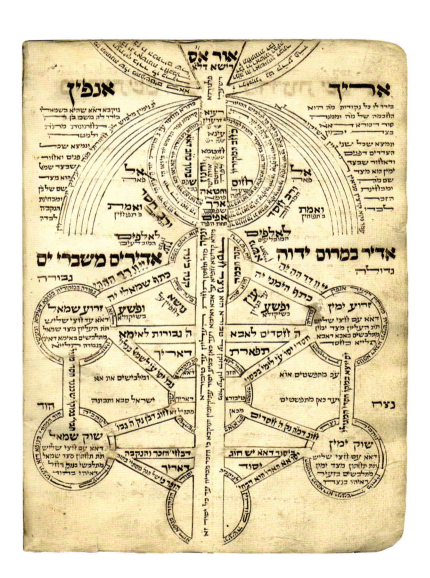

Figure 77 | Ilan of *Arikh Anpin*, by Moses Zacuto, back matter following Ḥayyim Vital, *Oẓrot Ḥayyim*, master copy by Raphael Moreno with Zacuto's autograph marginalia, 1649. Private collection (Tel Aviv).

Figure 78 (opposite) | *Ilan of the Enrobings*, fol. 204b, Jacob Ẓemaḥ, in Ḥayyim Vital, *Oẓrot Ḥayyim*, seventeenth-century Italian script. Moscow, RSL, MS Guenzburg 53, manuscript belongs to the Russian State Library.

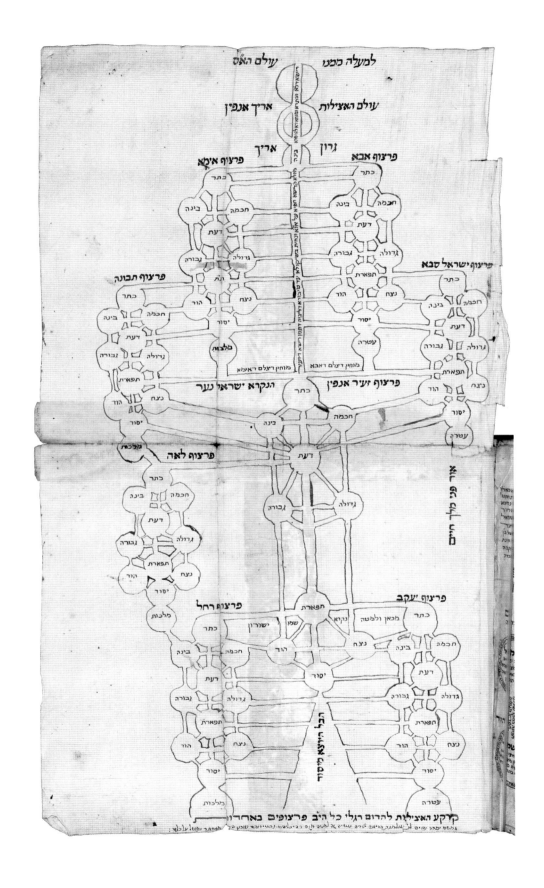

elements of higher *parzufim* were "enrobed" by the higher elements of lower *parzufim*, something that Ẓemaḥ's ilan accomplished with unrivaled clarity. As these *hitlabshuyot* (enrobings, plural) were at the core of Lurianic theory and practice, the question of how best to visualize them graphically was of no small importance. Vital's synoptic circles showed the entire structure at a glance without, however, exposing intraparẓufic interfaces. Ẓemaḥ seems to have been the first to come up with a workable approach to doing so. Just as Zacuto restored a "rejected" classical ilan to become the image of *Arikh*, Ẓemaḥ, in his own kabbalistic return of the repressed, revived both the iconic classical schema and the ilanot genre to accomplish his goal.

As Vital saw them in his dream, the *parzufim* were "the picture of the ten sefirot, three-three-three, one above the other." Although Ẓemaḥ's description of his ilan does not state explicitly that he represented each *parzuf* as a sefirotic tree, the *parzufim* are routinely described as configurations of the ten sefirot; the arboreal schema would be presumed. The tree could also represent the specific "docking" of a higher into a lower *parzuf*, its *hitlabshut*, such as the *Neẓaḥ-Hod-Yesod* of one enrobing in the *Ḥesed-Gevurah-Tiferet* of another. Even without the inspiration of Vital's dream, Ẓemaḥ would have asked himself how best to visualize this process and, more likely than not, arrived at this solution.

"All the details possible for me to draw"

Ẓemaḥ's work—as a redactor of Ḥayyim Vital's texts and as a designer of ilanot—was soon eclipsed by that of his student, Meir Poppers. Poppers was not merely another redactor in the chain reaching back to Vital; he was also the kabbalist responsible for editing Vital's materials into their canonical expression, the work known ever since as *'Eẓ Ḥayyim*.[98] By 1651 Poppers had completed his reediting of the entire corpus of Vital's writings—into which all the Ẓemaḥ editions were subsumed—under the topical rubrics *Derekh* (the path of), *Peri* (the fruit of), and *Nof* (the bough/crown of) *'Eẓ Ḥayyim* (tree of life/Ḥayyim). The second and third sections collected the teachings pertaining to the intentional performance of the commandments, various commentaries of canonical literature, and teachings on reincarnation. The first, dedicated to the orderly presentation of the grand Lurianic emanation narrative, quickly became the standard work known simply as *'Eẓ Ḥayyim*.

Poppers, like Ẓemaḥ, took images seriously. He was well aware of Vital's graphical visualizations and considered them to be of the highest epistemic and hermeneutic value.[99] In one of Vital's more ambitious efforts, called by Poppers "the drawn page" (*daf ha-ẓiyyur*), Poppers believed he had found the key to settling a fraught question of Lurianic exegesis. It was a question that texts alone could not resolve: Where was the precise location on *Adam Kadmon* from which the *nekudim* lights emerged? The text was clear; they emerged from the *tabur*. The problem was whether that term referred to the solar plexus or to the navel. Poppers argued that Vital's "drawn page" diagram left no room for doubt; it meant the former.[100] The marshaling of a diagram to settle a contested hermeneutical question attests to the authority of Vital's image in Poppers's estimation and, more broadly, to the fact that some teachings were more amenable to pictorial than to textual presentation.

Inspired by the precedent set by his illustrious teacher, Poppers also invested his energies in fashioning an ilan. Like Ẓemaḥ, who thought it appropriate to offer his own more intricate version of a diagram by Vital, Poppers charged himself with pushing the ilanot genre to its very limits.

Thanks to a passing remark in his commentary on *'Ez Ḥayyim*, we are privy to the context in which Poppers did so, as well as to his ambitions and aspirations. Poppers's comment underscores a major point that he feared might get lost as a student struggled with the minutiae of the system. The plethora of detail communicated in Vital's exposition of the *parzufim*, he insisted, should not obscure the fact that they all served to enrobe *Adam Kadmon*. Continuing this very sentence, Poppers writes, "and in the ilan that I fashioned for my colleagues abroad"—the students who studied with him in Cracow around 1650—"I represented all the details possible for me to draw; below we shall write the order of its enrobing."[101] As we shall soon see, the Poppers ilan expanded Ẓemaḥ's in two respects: it included *Adam Kadmon*, and it diagrammed the enrobings of the *parzufim* in unprecedented detail. Moreover, as much as *Adam Kadmon* and the *parzufim* personae seem, *prima facie*, to demand anthropomorphic representation, it was Poppers—rather than the ex-converso Ẓemaḥ, perhaps overcompensating for his Christian past—who was the first to (have the audacity to) use it.

Only one Lurianic ilan that was in circulation in Europe just after the middle of the seventeenth century is a perfect match. This ilan, discussed below, begins with *Adam Kadmon* and then continues with a richly detailed graphical accounting of the enrobing process. Its attribution to Poppers may be further strengthened on a philological basis. The captions labeling the four *moḥin* (modes of consciousness; lit., brains) of *AK*, which may be seen in the dome atop the "forehead" of the first figure of the ilan, use Poppers's distinctive terminology: *maḥshava* (thought), *ziyyur* (drawing), *zikaron* (memory), and *'iyun* (concentration) (see below, fig. 83).[102] These terms are fascinating for their straightforward identification—or at least correlation—of theosophical categories with distinct modes of consciousness. When these terms are found just after mid-century, we may presume Poppers's authorship.

Finally, a word about an ilan that Poppers did not make. In a gloss on *'Ez Ḥayyim*, Poppers expressed a desire to create a single, comprehensive ilan that would include and integrate the teachings of Cordovero and Luria. The task, however, was too daunting even for the master. "It is quite nearly a new science [kim'at mi-ḥokhmah ḥadasha] to compare the science of the ancients [i.e., classical Kabbalah] in one ilan with the homilies on the *parzufim*. . . . It would be very useful to know the unity of the sefirot in one ilan and one existence [meẓiut]. Even now, I have no ability to know this secret. May the Lord be gracious unto us and illuminate our intellects, for such is my desire: to reconcile the words of R. Moses Cordovero with those of R. Isaac Luria."[103]

The Pedagogical Imperative

Ilanot provided the clarity that kabbalists in the seventeenth century increasingly demanded. Luria had been more prophet than pedagogue. The teachings that inspired the systematic renderings of "Lurianic Kabbalah" had been delivered spontaneously rather than systematically and for barely two years before his untimely death.[104] Vital's writings and rewritings, followed by the subsequent editorial efforts of his son Samuel, Samuel's student Ẓemaḥ, and Ẓemaḥ's student Poppers, were all carried out—so they report in their introductions—in order to make it possible for a student to learn the system. As the elder Vital had already noted, the classical Kabbalah could be mastered in days, but Luria's had no beginning and no end . . . and no way in. These remarks highlight the pedagogical imperative in much of the Lurianic redactional enterprise. The key point is this: the architects of the ilanot were not only kabbalists but also teachers. Ẓemaḥ's ilan was one of a series of educational-

SPECIAL FOCUS | *Lurianic Cosmogony: What You Need to Know*

A basic familiarity with Lurianic Kabbalah is required in order to grasp what is pictured on a Lurianic ilan. With few exceptions, scholarly works devoted to Lurianic Kabbalah have been content to paint it with the kind of broad mythopoetic-historiosophic brushstrokes pioneered in the twentieth century by Gershom Scholem. Scholem memorably characterized it as expressing the exilic condition of the Jewish people post-1492 in cosmic terms; Lurianic cosmogony, he asserted, resonated with a difficult but hopeful history.[107] Alas, this Lurianism—which itself is a reification rather than a single, stable historical subject—is hard to find among the thousands of pages that prosaically present the various versions of its calculus of creation. The situation recalls the scene in the Coen brothers' film *A Serious Man* (2009) in which, having followed the story of Schrödinger's cat, a student claims to have understood physics. His professor can only reply that physics isn't about the story but about the math.

The remainder of this book is devoted to Lurianic ilanot, their history, and their stories. At times it may seem otherwise, but be assured that I go easy on the math. Even so, I cannot do justice to this genre without asking the reader for two favors: to attempt to learn just a bit of the math and to accept the inevitable discomforts of reading a technical language. The latter is simplified throughout, but it retains a measure of daunting alterity.

To help with the rudimentary math acquisition, I have prepared the following outline of the core cosmogonic sequence visualized by Zemah and Poppers. Their ilanot have a surfeit of detail to which I cannot attend, but having a sense of the primary structures and movements will serve the reader well. Rather than create a new introduction *ex nihilo*, I base my outline on a short work by Vital named *Seder ha-azilut be-kizur muflag* (Order of emanation in exaggerated brevity). In 1585 this treatise reached Italy, where it was greatly appreciated by the local kabbalists, Menahem Azariah da Fano foremost among them. Zemah thought it worthy of inclusion in *Adam yashar*, whence Poppers subsequently adopted it. It was published in 1631 by R. Joseph Solomon Delmedigo (ha-YaShaR, Yosef Shlomo *Rofeh* [doctor]; 1591–1655), making it the first exposition of Lurianic cosmogony to appear in print.[108]

After translating the short treatise literally, I paraphrased it for the sake of clarity. The result remained more likely to confuse than to clarify. In the final redaction below, I have put intelligibility first and emphasized essential technical vocabulary. The end product is a sequential lexicon of the cosmogony visualized in Lurianic ilanot.

- *Ein Sof* (No End; the Infinite) surrounds all Worlds. *Ein Sof* also permeates all Worlds, thanks to the process of *hitlabshut* (enrobing) in which the lower sections of higher elements in the Godhead become concealed or "dressed" in the higher sections of lower elements. In this way *Ein Sof* is present at the bottom of the World of *Azilut*, though hidden under many "robes."
- The *zimzum* (auto-evacuation) of *Ein Sof* clears a sphere for subsequent emanation.
- *'Iggulim* (sefirotic spheres) followed by a linear sefirotic structure, *yosher*—*Adam Kadmon* or *AK* (Primordial [hu]man)—are emanated into the *halal ha-panui* (vacant sphere, also known as the *Tehiru*) within *Ein Sof*. *Adam Kadmon* has a structure akin to that of the sefirotic tree.
- *Malkhut* of the sefirotic tree that constitutes *Adam Kadmon* is home to *Azilut*, the highest of the Four Worlds and the World to which

most Lurianic ilanot are devoted. *Malkhut* of *Adam Kadmon* also bears the structure of a full sefirotic tree.

- The top three of the sefirot within *Malkhut* of *Adam Kadmon* are referred to as *'Atik* (Ancient One) and "head."
- The lower seven sefirot within *Malkhut* of *Adam Kadmon* are referred to as *'Atik Yomin* (Ancient of Days) and "body."
- *Reisha de-lo ityada* (the head that is not known) is the name given to the inner dimension of this body.[109]
- The highest *parzuf* (divine persona) is called *Arikh Anpin* (Long-Faced or Patient One). *Arikh Anpin* "enrobes" *'Atik Yomin*, its *neshama* (soul). Of the ten sefirot of *Azilut*, *Arikh Anpin* corresponds to *Keter*. This expression of the Divine is beyond the grasp of the demonic and immune to the impact of human sin.
- *Abba* and *Imma* are the next *parzufim*, corresponding to *Ḥokhmah* and *Binah* of *Azilut*. They also correspond to *'Atika Kadisha*, the seven lower sefirot of *Arikh*. Their productive coupling is constant. Like *Arikh*, they are situated beyond demonic influence, but given their role in the nurturing of their "offspring," they lack *Arikh*'s immunity. Their enrobing in *Ze'ir* is critical to the latter's growth and post-shattering restoration.
- *Ze'ir Anpin* (Short-Faced or Impatient One), the next *parzuf*, corresponds to the six sefirot of *Azilut* that follow *Ḥokhmah* and *Binah*. The lower seven sefirot of *Abba* and *Imma* are enrobed in *Ze'ir Anpin*. Human sin severs its connection to its female counterpart. The amelioration of the state of this divine persona through the restoration of this connection is central to Lurianic practice.
- *Nukba de-Ze'ir* (Female of *Ze'ir*) is *Malkhut* of *Azilut* and enrobes the seven lower sefirot of *Ze'ir*.

The ten sefirot of *Azilut* thus divide into five primary *parzufim*—*Arikh*, *Abba*, *Imma*, *Ze'ir*, *Nukba*—which in turn correspond to the Tetragrammaton (four letters plus the thorn of the *yud*). The five primary *parzufim* split into the sub-*parzufim* represented in Lurianic ilanot. These include *Israel Saba* and *Tevunah* (from *Abba* and *Imma*), *Israel* and *Leah* (from *Ze'ir Anpin*), and *Jacob* and *Rachel* (from *Nukba*). Although the *parzufim* begin at lesser or greater remove from *Ein Sof*, they all culminate together—the feet of *'Atik* as well as feet of *Nukba*—at the base of the World of *Azilut*.

Beneath the heads of the *parzufim*, their bodies enrobe one another. Even though only heads are "visible," all five *parzufim* have complete bodies of 248 limbs and 365 sinews. As Vital puts it, "It is the task of the reader [ha-me'ayen] to examine and to analyze the limbs of each and how they meet the limbs of the *parzuf* in which they are enrobed."[110] This is the key to understanding the emphasis on the enrobing process in Lurianic ilanot.

Having filled *Azilut*, the light of *Ein Sof* "thickened" somewhat to form a veil (*masakh*). The seven lower sefirot of *Malkhut* of *Azilut* traverse this threshold to become the ten sefirot of the World of *Beriah*. The enrobings of the *parzufim* of *Beriah* then ensue according to the pattern described above, as it does in the lower Worlds of *Yezirah* and *'Assiah*. Despite the formulaic nature of the enrobings, an active exploration of these intersections is necessary because the *parzufim* are not identical in their array, and every rule has its exceptions. In fact, writes Vital, their interfaces are so manifold that "they could not be contained if the heavens were scrolled like a book." This accounts for the diversity of creation and suggests that beyond its pedagogical utility, an ilan of enrobing had creative, generative, and rectifying potential.

performative charts, and Poppers crafted an ilan for his students in Cracow. Poppers introduced and justified his redactional interventions on the basis of the state of Lurianic textual tradition as he found it; in his words, trying to study it "could bring the reader suicidal ideation" ('ad she-yikoz ha-me'ayen be-ḥayav).[105] In addition to their shared sense of duty to re-present Lurianic texts with clarity and order, Ẓemaḥ and Poppers both understood the value and power of images. We have seen Ẓemaḥ thinking with diagrams, even counterfactually, and Poppers lending sufficient epistemic authority to a diagram of Vital's for it to serve as proof of his interpretation of a contested hermeneutical point.

I would not like to give the impression that Lurianic ilanot were about pedagogy rather than practice, however. One might begin one's study of Lurianic Kabbalah with the assistance of an ilan, but distinctions between study and practice, pedagogy and performance, are difficult to maintain in this instance. Acting with Lurianic intentionality—in the form of kavanot and *yiḥudim* (unifications, with a broad variety of applications)—locates the performer in a specific place, at a specific moment.[106] That place and moment exist within an intricate, expansive, and dynamic cosmic structure. The *kavanah* is specific to that place and moment and may involve a variety of operations. Each, in its own way, is to contribute to the *tikkun* of the whole. The "game" environment in which this virtual/virtuous reality is being enacted must be familiar to the player, and familiarity deepens with play. Lurianic ilanot of the enrobings present a diachronic image of this environment. They cannot be studied without being played.

Chapter 4

Ilanot 2.0: The Emergence of the Lurianic Ilan

Classical ilanot present a form of the iconic arboreal diagram on a sheet of parchment. The most ambitious enlarge the scale by joining multiple sheets together without fundamentally changing the nature of the artifact. Patterned symbolic associations and texts of various sorts are presented on the heavenly *yeri'ah*. Like a map, it can be taken in at a glance, although studying its details requires closer examination. One might unroll or unfold such an unwieldy map, but the act would be practical rather than mimetic. This is because the dynamism of classical Kabbalah and its ilanot takes place *within* the sefirotic tree. The infinite complexity of creation arises from ten networked fractal hubs amenable to representation in the form of a single arboreal diagram.

Lurianic Kabbalah is different. The intradivine dynamism it imagines cannot be adequately represented in a single figure, however fractal. The many personae of the Divine, their progressive attenuation through the interlocking operations of enrobing, and the sequential emergence of the Worlds all require a form of visualization—conceptual no less than graphical—that is more akin to a timeline than a map. The structural elements remain, but as moving pictures. Scrolling a Lurianic rotulus is a mimetic act.

The Ẓemaḥ and Poppers ilanot were responsible for rebooting the genre, giving it new life and greater utility than ever before. Their pioneering ilanot proved to be of unrivaled importance and impact, but they were not alone. We are now ready to explore the first wave of Ilanot 2.0, the pioneering Lurianic ilanot of the seventeenth century.

Early Lurianic Ilanot

Few ilanot bear colophons, let alone colophons that date them to the seventeenth century. How, then, can we be certain that a given ilan

dates to the first decades of Lurianic ilanot, and if so, in what form? Enter our unlikely savior: *Kabbala Denudata* (Kabbalah unveiled), a Latin work by Christian Knorr von Rosenroth (1636–1689) that was published in Sulzbach beginning in 1677.[1] Knorr, needless to say, was not a Jew; a staunch Lutheran, he was the leading figure of the second wave in the history of the Christian interest in Kabbalah. Knorr pursued his studies of Jewish Kabbalah with rare scholarly integrity and precision, without the Christological readings and conversionist agendas of earlier generations of Christian kabbalists.[2] His project was largely one of compilation and translation. That said, he was not averse to fashioning original materials when the need arose; the lexicon that occupies the better part of the first volume of *Kabbala Denudata* is the most extensive such creation, but sections that reproduce Knorr's correspondence with the Cambridge Platonist Henry More (1614–1687) also indicate a willingness to share original materials with his readers.[3]

Kabbala Denudata provided Christians with the tools and texts Knorr thought necessary to embark on the study of Jewish Kabbalah. The first volume provides the toolbox, from a comprehensive lexicon of the Kabbalah to an apparatus of five Lurianic ilanot.[4] Knorr's inclusion of the latter testifies to his high estimation of their value. In addition to collecting ilanot, the apparatus provides translations of their texts and demonstrates Knorr's impressive command of the material. His attention to minutiae bespeaks true respect for his readers, who are treated to uncompromisingly complete and painstakingly precise Latin renderings of the Hebrew and Aramaic. Even learned Christian Hebraists would have been challenged by kabbalistic jargon, so Knorr's translations and explanations were invaluable.

Knorr presented the five ilanot as a series of sixteen engravings, each on its own foldout page. Three ilanot required multiple foldouts to present in their entirety; two were elegantly squeezed onto a single foldout each. The story of *Kabbala Denudata*, the man behind it, and its precocious presentation of Lurianic trees with their Hebrew inscriptions precisely translated into Latin deserves telling in more detail than is possible in the present context, but the picture here is supplemented by my discussion of printed ilanot in chapter 7.

For my immediate purpose, Knorr's ilan apparatus is a means to an end: it enables me to identify the Lurianic ilanot that were in circulation in the years leading up to 1677.[5] The *terminus ante quem* of any ilan in Knorr's apparatus would be the mid-1670s, roughly a generation after Ẓemaḥ and Poppers had fashioned their innovative ilanot. By the eighteenth century, these early exemplars—the first Lurianic ilanot—were used as modules within compound rotuli. The numerical preponderance of the latter is such that, without Knorr's apparatus, we might mistake one of the few original ilanot that have survived for a fragment. Knorr's apparatus is thus a time capsule that preserves the pioneering efforts of mid-seventeenth-century kabbalists. In what follows, I refer to the exemplars preserved by Knorr as "single-origin" ilanot. I use the term *Great Tree* to refer to Lurianic rotuli that have been constructed from two or more single-origin ilanot. When they are found in compound Great Trees, I call these single-origin ilanot "modules." I use "elements" for diagrams that recur in Great Trees but did not originate as ilanot.

My presentation of the first Lurianic ilanot is thus keyed to Knorr's collection. Rather than review them in the order in which they appear in *Kabbala Denudata*, however, I begin with the ilan that likely preserves Ẓemaḥ's pioneering efforts. I then present the ilan associated with Poppers, which may be seen as an augmentation and amplification of Ẓemaḥ's. Discussion of two less commonly reproduced early Lurianic ilanot follow, before I conclude this section with a fifth and final

ilan designed by Knorr himself. It would have no place in the present book had it not subsequently been appropriated by Jewish kabbalists for use as an opening component in the modular ilanot explored below, but because it was, I treat it alongside the others.

The Zacuto-Ẓemaḥ *Arikh and the Enrobings* Ilan (Z)

It seems both ironic and appropriate to begin my survey of single-origin Lurianic ilanot with an ilan that splices together two diagrams frequently juxtaposed in the *Oẓrot Ḥayyim* manuscripts copied in Zacuto's atelier (fig. 79). Their fusion was early and remarkably enduring, but hardly absolute.

Even though Zacuto's *Arikh* is never found on a rotulus ilan that does not also include Ẓemaḥ's kaleidoscopic enrobings, the inverse is not the case.[6] Nevertheless, I hope that readers will excuse the imprecision of its categorization as a single-origin ilan, given that it appears as an indivisible unit in nearly every extant modular Great Tree. Knorr acquired it as an independent rotulus and adapted it for publication as the third of five

Figure 79 | Zacuto-Ẓemaḥ *Arikh and the Enrobings* ilan, (*left*) *fig. 13*, 22 × 14.5 cm, (*right*) *fig. 14*, 22 × 17.5 cm, foldout engravings by Johann Christoph Sartorius in Apparatus IV, Christian Knorr von Rosenroth, *Kabbala Denudata* (Sulzbach, 1677). Tel Aviv, GFCT, NHB.136. Photo: William Gross.

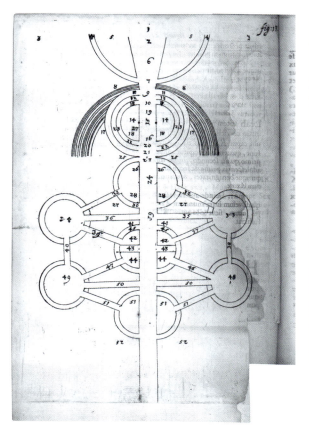
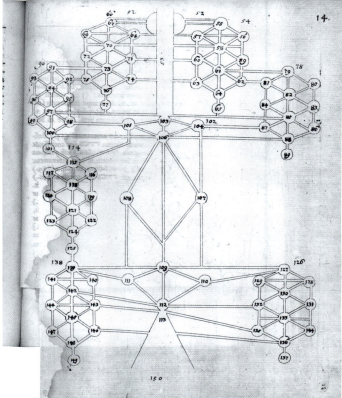

THE EMERGENCE OF THE LURIANIC ILAN | 129

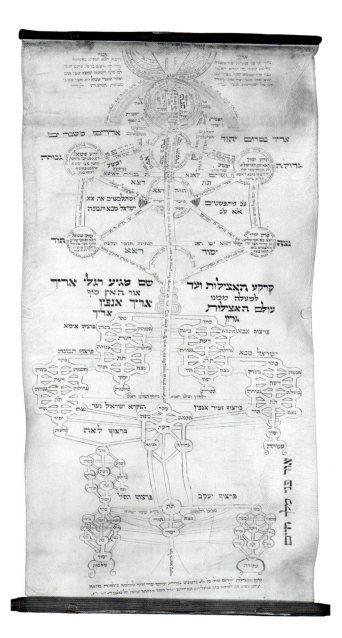

Figure 80 | Zacuto-Ẓemaḥ *Arikh and the Enrobings* ilan, parchment, 70 × 34.5 cm, seventeenth-century Ashkenazi hand. Munich, BSB, Cod.hebr. 449.

Lurianic ilanot presented in his special apparatus. Its length and complexity compelled him to reproduce it over two foldout pages, the engravings *fig. 13* and *fig. 14*—corresponding precisely to Zacuto's and Ẓemaḥ's respective contributions, unintentionally demarcated. (Throughout this book, the italicized *fig. x* refers to Knorr's sixteen figures in the fourth apparatus of *Kabbalah Denudata*.) The dense Hebrew inscriptions of the original rotulus were replaced in the engravings with a continuous key linked to 150 numbered Latin translations. Knorr augmented these translations of the brief Hebrew captions by occasionally referring his readers to the first apparatus, his lexical "Loci communes cabbalistici," as well as the more detailed exposition found in the Poppers ilan, which he had already presented as *figs. 1–7*.[7] Knorr's erudition is evident in his identification of the texts that inspired these visualizations. For example, in a comment on his §13 of Zacuto's *Arikh*, Knorr directs his reader (on page 237) to "Vid. Ez Chaijim Manuscript. Tract. Injam Parzuph *Arich Anpin*, P.II. cap.5."[8] This chapter in Poppers's *Ez Ḥayyim* had, in fact, been incorporated from *Ozrot Ḥayyim*.[9]

At least four extant rotuli, all of seventeenth-century Ashkenazi provenance, preserve the ilan as it was when Knorr obtained it.[10] The witness housed today in Munich bears the closest resemblance to Knorr's engravings, with which it shares distinctive graphical anomalies (fig. 80).[11] Variants in its Hebrew inscriptions are also reflected in Knorr's Latin translations.[12]

What Do We See in the Zacuto-Ẓemaḥ Ilan?

As I argued earlier, Ẓemaḥ's enrobings ilan is singularly responsible for bringing the classical kabbalistic genre into Lurianic modernity. Thanks to its placement following Zacuto's *Arikh* on every Z-only rotulus, Ẓemaḥ's diagram naturally

presented as an elaboration of Zacuto's. If the representational aspirations of this natural pair go far beyond anything attempted by its late medieval and Renaissance precursors, it achieves them with only modest schematic innovations. All its diagrammatic work is accomplished with trees. This ilan has nine of them, each representing a single *parzuf*. Zacuto's *Arikh*, showing the same tower-topped schema found in the *Magnificent Parchment* (fig. 36), dominates the upper frame; the other eight, showing the triangle-topped schema endorsed by Cordovero reproduced in intentionally varied sizes, are arrayed in the lower frame. This reboot of the genre to suit the requirements of the new Kabbalah thus remains true to Cordovero's definition: arboreal diagram wed to parchment. Familiar significations have not been entirely omitted, although the medallions of *Arikh* are so laden with new content that the traditional sefirotic names have been displaced to the margins and internal spaces. They have also been recontextualized, no longer simply *Tiferet* or *Yesod* but, rather, *Tiferet of Arikh*, *Yesod of Arikh*, and so on.

This is the case because Zacuto's tree is now a *parzuf* and Zemaḥ's trees an *ilan ha-parzufim*. In tandem, they visualize the enrobing process at the resolution of twelve *parzufim*.[13] Referring back to our "What You Need to Know" outline, the ilan opens with the titular "Light of *Ein Sof*" but then skips straight to §7, "Reisha de-lo ityada" (The head that is not known), here inscribed as a subtitle. The *Reisha de-lo ityada*, the "soul" or inner dimension of *'Atik*, the Ancient One, is enrobed by *Arikh Anpin*, the first of the *parzufim*. Its lower dimensions are represented by the convex semicircles that provide a chalicelike embrace of the light of *Ein Sof* funneling into the system from above. The nine sefirot beneath them—not all of them visible—represent *Arikh*.[14]

The densely patterned information that Zacuto inscribed in his tree of *Arikh Anpin* is a model of the kind of visual exegesis that a diagram can offer. Sefirotic names, body-part labels (now including facial features), the "thirteen attributes" of Exodus 34:6–7, and the "destination" enrobing coordinates for each element are layered and linked in its medallions, channels, and spaces within them and surrounding them. The attentive reader may wonder why the tree of *Arikh* shows eight rather than ten medallions. First, Zacuto telescoped the pillar of *Keter*, *Ḥokhmah*, and *Binah* from the schema he identified as *Arikh* into a single concentric medallion. Just below it is *Da'at*, which plays a pivotal role in the enrobings even if not quite a sefirah in its own right. I will return to this point, because it is particularly relevant to Zemaḥ's visualization of the enrobings that follow. Finally, the absence of *Malkhut* at the bottom is in keeping with Luria's enigmatic insistence that "the matter of the sefirah of *Malkhut* [of *Arikh*] is not revealed even now."[15]

The Lurianic sources visualized in this ilan were inspired by the zoharic *Idra rabba*. The fountain-like flow emerging from just above the tripartite medallion of *Keter-Ḥokhmah-Binah* (at the top of the ilan) is an image first conjured up in the *Idra*: "Thirteen tresses of hair appear on either side of the skull, toward His face, and within them the hair begins to part. There is no left in this Ancient One; all is right. He is seen and not seen, concealed and not concealed. This pertains to His enhancements [be-tikkunei], all the more so to Him."[16] The fountain flow fashioned of fine lines are the thirteen strands (*nimin*, rendered "tresses" in Matt's translation) on either side of the face of *'Atik*. They are described by Vital as the *peot* (sidelocks) conduits by which the "waters" of the "great sea of *Ḥokhmah* of the concealed brain" flow downward. "This," adds Vital, "is the secret of '[The Lord on high is] mightier than the noise of many waters, yea, than the mighty waves of the sea'" (Ps. 93:4).[17] Zacuto's rationale for inscribing these very words under the

peot in bold, square script is now clear. Although the flow continues its downward journey to engage with the thirteen *tikkunin* (enhancements) of the beard of *Arikh Anpin*, corresponding to the thirteen attributes of compassion, the details of that interface were not Zacuto's concern here. This intentional lacuna would soon be filled by others.[18]

The dominating *parzuf* of *Arikh* invites us to take a closer look. A *parzuf*, often literally translated as *face*, is, in fact, an entire divine body.[19] Zacuto's only graphical gesture to this effect is to be found in the thirteen tresses of hair atop the tree. Zemah, whose efforts were dedicated to exposing the mechanics of the enrobing *parzufim*, understood that a clear presentation called for geometrical rather than anatomical visual language. As a former converso, he may have been all the more reluctant to represent anthropomorphism graphically. The result was the kabbalistic equivalent of the iconic map of the London Underground. From this perspective, the *parzufim* were not so much faces as interfaces.[20] As Lurianic texts typically described the interfaces between the *parzufim* in terms of their respective sefirot, e.g., the triangulated lower sefirot of a higher *parzuf* nesting within the triangular-format higher sefirot of another, the arboreal schema was an ideal choice. It had also long been conflated with the form of the human body.[21] And after all, Zemah was making an *ilan*.

With the exception of the thirteen tresses, Zacuto's body of *Arikh* largely followed in the footsteps of classical ilan makers. The latter routinely listed body parts alongside other sefirotic appellations. Here, however, ten body parts were not simply mapped to ten sefirot. Instead, Zacuto used anatomical inscriptions to reveal the grand structure of this *parzuf* and its implication in the enrobing process. At the intersection of *'Atik*, the tresses, and the concentric circles of the top three sefirot of *Arikh*, inscriptions label "the eye" and "the nose." Reaching the bottom of those circles, we find "the mouth" and even "under the mouth." The bold label at the central medallion associated with *Tiferet* reads "chest of *Arikh Anpin*" and, just below it, "omphalos of *Arikh*." Right and left arms and legs are similarly written in bold inside the circles of *Gedulah* (Greatness, an alternative for *Hesed*), *Gevurah*, *Nezah*, and *Hod*; more circumspect language indicates the organ of *Yesod*. If we zoom in on even one of these, the principle governing Zacuto's work becomes evident.

The *Gedulah* medallion exemplifies the approach (fig. 81). Like the others, it features an inner inscription and an additional text in its encompassing band. "Right arm" headlines the inner circle, but this is just the beginning. The full text reads, "Right arm of *Arikh Anpin*, with half of the right top third of *Tiferet*, enrobes in *Abba*, as *Abba* is dependent upon *Hesed*." Around the circumference we read, "The original [ha-mekori] *Gedulah* in the body of *Abba* becomes the *mohin* [lit., brains] of *Ze'ir Anpin*."[22] I recognize the opacity of these passages to the casual reader—I warned you there was going to be some math!—and all I aim to convey is their patterned discourse of interlocking elements. The body of *Arikh* is methodically mapped to its lower analogues, its "outer" becoming their "inner." Zacuto also added inscriptions in the channels and internal spaces of the tree that convey the extent to which the lower *parzufim* enrobe *Arikh*.

The fusion of Zacuto's and Zemah's ilanot was graphically effected by elegant splicing (fig. 82). The two were seamlessly connected, giving the

Figure 81 | *Gedulah*, detail from Zacuto-Zemah *Arikh and the Enrobings* ilan. Munich, BSB, Cod.hebr. 449 (fig. 80).

Figure 82 | The ground of *Azilut*, detail from *Arikh and the Enrobings* ilan. Munich, BSB, Cod.hebr. 449.

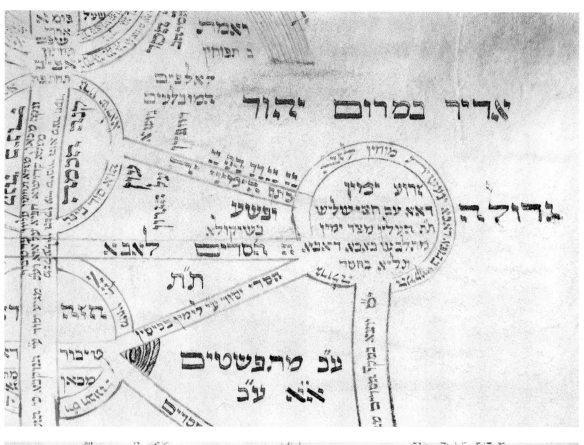

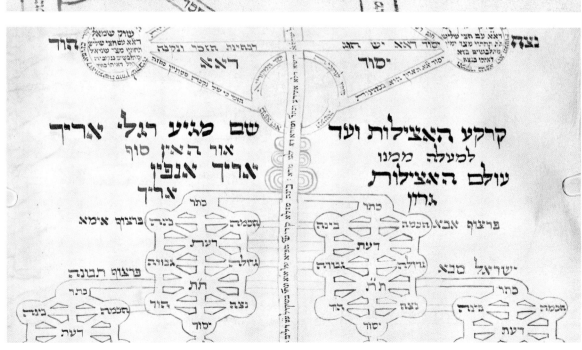

impression of the former flowing and refracting into the latter. A long vertical channel runs unimpeded from the intake funnel for the light of *Ein Sof* at the top of the rotulus to the outtake funnel emerging from *Yesod* at the bottom. Only subtle ripplelike graphical markers and a caption at the seam that labels the transition betray that we have looped back to the beginning and are poised to view the enrobings from a different perspective.

The shift in perspective is so great that the *déjà vu* is subtle. The "legs of *Arikh*" have reached just beyond *Yesod* of *Arikh*. This location is labeled in bold script, "the ground of *Azilut*; above it, the light of *Ein Sof*." Yet just below the inscription, another line of text announces that we are again in the World of *Azilut* beholding *Arikh*. This time, however, from the neck down (captioned "*garon* [neck of] *Arikh*"), the supreme *parzuf* has vanished into the interiority of the eight *parzufim* to which the lower half of the rotulus is dedicated. Among these smaller figures, the tree representing *Ze'ir* is central and more elongated than the others. An oversize vertical inscription, "Or p'nei melekh ḥayyim" ([in the] light of the king's face is life, from Prov. 16:15), runs parallel to it along the lower right margin of the rotulus. The inscription is aligned to begin with the "body" of *Ze'ir*—its *Gedulah* and *Gevurah*. The verse and its placement explain and reinforce the lower positioning of the *parzuf* of *Jacob*, the *Keter* of which may be seen connected by a horizontal channel to the *Tiferet* of *Ze'ir*. "Were *parzuf* 'Jacob' to have emerged from the face of *Ze'ir* above," Vital had written, "the face of *Ze'ir* would be covered and not shining. And it is written, 'light of the face of the living king,' because by the light of his face the judgments are sweetened, as is known, and the power of the external forces is nullified."[23] The inscription of the verse is eminently justifiable, grounded as it is in Vital's exposition in *Oẓrot Ḥayyim*. I wonder, nevertheless, whether the subtext—the sweetening of judgments and nullification of evil—was not what inspired its calligraphic foregrounding.[24]

The focus of the lower half of the ilan is on the interfaces and transpositions between the *parzufim* of *Azilut*. Each is represented by an arboreal figure. These smaller trees bear only the traditional names of the sefirot in their medallions, but they are not quite the trees of old. First, they show eleven rather than ten sefirot, flaunting the axiomatic dictum of *Sefer yezira*, ". . . ten and not nine, ten and not eleven." (SY §4) In an ilan of enrobings, however, the "eleventh sefirah" of *Da'at* is indispensable.[25] *Da'at* plays a crucial role in the interfaces of the *parzufic* system: it is the funnel through which the effluence from *Abba* and *Imma* flows into the body of *Ze'ir* as well as the emanatory connection point between *Ze'ir* and the head of the *parzuf* of *Leah*.[26] These two functions of *Da'at* are part and parcel of the complex networks that govern the enrobings. They are exposed in the diagram by means of channels that connect sefirot from each of the *parzufim* to their next stop on the journey of the great chain. With the elegance and simplicity of the London Underground map, Ẓemaḥ has made plain the network of *Azilut*.

As an homage to our faithful guide, I cite Ẓemaḥ's closing inscription in Knorr's Latin translation:

§150 Hoc loco est fundus Systematis Aziluthici, qui est loco scabelli pedum omnium 12 personarum simul: Et abhinc sit separatio, & siunt tria Systemata, Briathicum, Jezirathicum & Asiathicum; unum infra alterum, in templis & palatiis suis: Dominus autem singularis est absconditus, omnibusque dominatur.

[In this place is the bottom of the system of Azilut, which is the place of the footstool of the feet of all twelve personae together.

Henceforth there is a separation and they become three systems: *Beriah*, *Yeẓirah*, and *'Assiah*—one beneath the other, in their temples and palaces. But the singular Lord is concealed, and rules over them all.]

Pure Poppers: The *Ilan of Adam Kadmon and the Enrobings* (P)

I continue this survey of the first wave of Lurianic ilanot with a second prototype preserved in its singular integrity in *Kabbala Denudata*, figs. 1–7 (fig. 83). One might rightly refer to it as the *Ilan of Adam Kadmon and the Enrobings* if not for the near-certain identity of its famous creator: R. Meir Poppers, the wandering Jerusalemite of the mid-seventeenth century. Poppers, we should recall, wrote that he had drafted an ilan picturing *Adam Kadmon* and its enrobings in all possible detail—a description that fits this ilan perfectly. Philological evidence of Poppers's hand in its creation is also found in the technical terms among its inscriptions that are unique to his lexicon. Although inspired by his teacher's precedent, the Poppers ilan sacrificed Ẓemaḥ's schematic clarity in favor of comprehensive scope. Not only does it add the head of *Adam Kadmon* but it also offers a vastly more intricate treatment of the enrobings.

The Poppers ilan is the first of the five ilanot in Knorr's apparatus.[27] For its presentation in engravings, Knorr divided it into a series of seven figures, each on its own foldout page, and recommended that the reader reconstruct it as a continuous rotulus. He likely chose to open with this ilan precisely for its panoramic presentation. It also had the advantage of beginning with *Adam Kadmon*. Although Knorr never interpolates Christological readings in *Kabbala Denudata*, the equation of *Adam Kadmon* and Christ was presumed in his circle. It was also the subject of a fraught correspondence between Knorr and Henry More.[28] Knorr was sympathetic to the identification, whereas More recoiled from the coarse anatomical and physiological descriptions that accompanied the Lurianic figure.

Adam Kadmon is central to the Lurianic cosmogonic narrative. Understanding the mechanics of the flow of lights that streamed from *AK*'s various orifices (and within its body as a whole) was crucial for every student, which meant that he needed to visualize it accurately. The first order of divine business was to emanate lights that would not be so overwhelming that they would obliterate the very creation they were meant to initiate. The face of Poppers's *Adam Kadmon* appears to be a static image of the divine face. Each component of the face is captioned with the shorthand references to its particular valence in the cosmogonic narrative. Only in contemplative engagement does its dynamism emerge, facilitated by an understanding of the sequential flow of lights from its various openings.[29] In brief, light first emerges through the right and left ears in a kind of fission. This splitting is designed to reduce the intensity of the inner light so that creation can proceed apace outside of *Adam Kadmon*. It is followed by a less dramatic fission in which a second emission flows from *AK*'s right and left nostrils. Only thereafter does a single stream of light emerge from the mouth. Note that these emissions do not proceed from the top down, but zigzag chiastically around the head. Its schematic rendering is captioned with the terminology associated with each phase, but no signposting indicates the sequence to the uninitiated. In this sense, the ilan of *Adam Kadmon* is not an autonomous work. Without some familiarity with the literature it visualizes, its meaning will remain obscure. This interdependence is patently clear in the case of the head of *AK*, but much the same can be said for the rest of this ilan and, to a considerable extent, for its Lurianic peers.

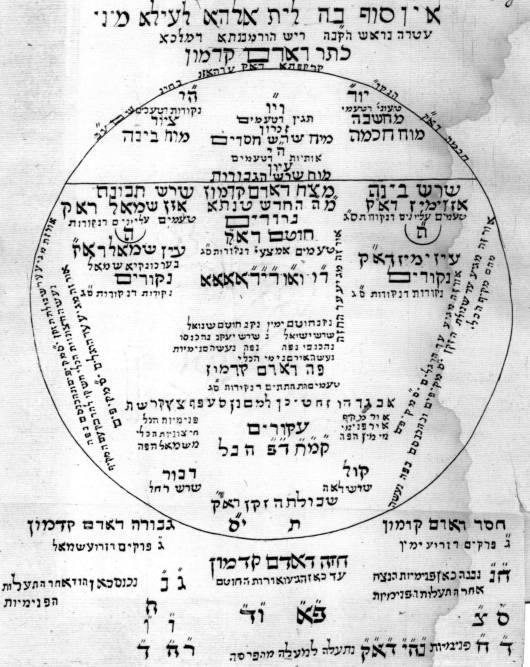

Why all the zigzagging and the stages of fission? It's all about attenuating the power of the lights emanating from the core of *AK*. The first streams must be dimmed just enough to enable their constitution as vessels for the subsequent and higher lights that emanate from the primordial eyes. Informed by his medical background, Vital thought it helpful to explain these various emissions in terms that readers could understand from their own embodied experiences.[30] The stream of the nose is gentle but obvious, that of the mouth the most tangible. The rushing noise heard when ears are plugged was proof that when blocked, their stream, otherwise too fine to be detected, strains to find release. The stream of the eyes is of such a refined and spiritual nature that it finds few expressions in the material world. Among them, he notes a bird known to warm its eggs by gaze alone.[31]

Like the Zacuto-Ẓemaḥ ilan, the Poppers ilan was destined to become a ubiquitous module of Great Trees. Only two copies of the Poppers appear to have reached us in its original form.[32] The two are so different visually that careful examination is required to recognize them as the same ilan reproduced by Knorr in his *figs. 1–7*. For all their stylistic differences, however, a comparison of the textual content of this ilan based on Knorr's engravings and the two Hebrew parchments would show few significant variants. Let us now take a closer look at the two Hebrew manuscripts.

The first is an exquisite ilan held today by the Magnes Collection of Jewish Art and Life at the University of California, Berkeley (fig. 84). This ilan has a colophon signed by R. Behr Eibeschütz Perlhefter (ca. 1650–ca. 1713).[33] Behr, born in Prague, added the surname Perlhefter when he married his learned and illustrious wife, Bella. He was likely in his mid-twenties in 1674 when he and his family settled in Altdorf, near Nürnberg, Bavaria. There he lived in the house of the Lutheran Hebraist Johann Christoph Wagenseil (1633–1705), whom he tutored in Jewish subjects. Wagenseil, a professor at the University of Altdorf, corresponded with Knorr von Rosenroth and served as a censor for some of the books published by the Hebrew press in Sulzbach.[34] Perlhefter seems to have become a Sabbatean prophet after resettling the following year in Modena, Italy, where he had been invited to serve as a rabbi and to teach in the academy of the Sabbatean kabbalist Abraham Rovigo (1650–1713).[35] Perlhefter experienced revelatory "*maggid*" (lit., speaking [angel]) prophecies while in this circle, and he began to study Lurianic Kabbalah, under the direct supervision of Moses Zacuto.[36] In one of his letters, Zacuto provided a kabbalistic curriculum for Perlhefter to follow, urging him to focus his studies on *Oẓrot Ḥayyim*.[37] Perlhefter's stay in Modena, and perhaps his Sabbatean enthusiasm generally, came to an end about six years later, after he rejected Mordechai Eisenstadt—another Sabbatean prophet—as a madman. This happened not long after the latter had arrived in Modena at Perlhefter's personal invitation.[38] In 1687 Perlhefter was serving as scribe in the rabbinical court of Prague; he became one of its judges in 1692.[39]

There is no indication that Perlhefter ever mastered Lurianic Kabbalah. Nothing in his Sabbatean writings of the Modena period reflects real

Figure 83 | Head of *Adam Kadmon, fig. 1*, 22.5 × 18 cm, foldout engravings by Johann Christoph Sartorius in Apparatus IV, Christian Knorr von Rosenroth, *Kabbala Denudata* (Sulzbach, 1677). Tel Aviv, GFCT, NHB.136. Photo: William Gross.

Figure 84 (overleaf) | Perlhefter's Poppers ilan, parchment, 254 × 22.23 cm, Behr Eibeschütz Perlhefter, Altdorf near Nürnberg, 1670s. Museum Purchase, Siegfried S. Strauss Collection, Magnes Collection of Jewish Art and Life, University of California, Berkeley, acc. no. 67.1.11.3. Photo: Sibila Savage Photography.

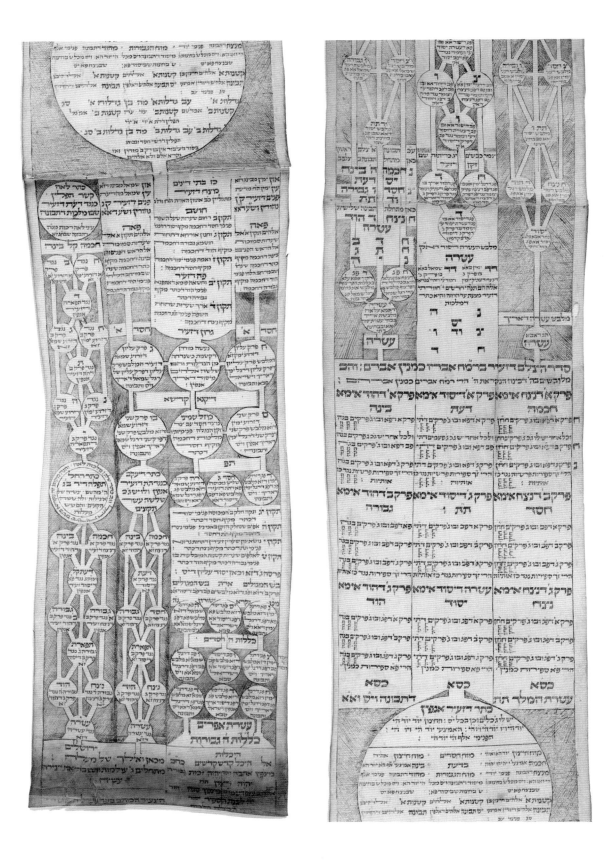

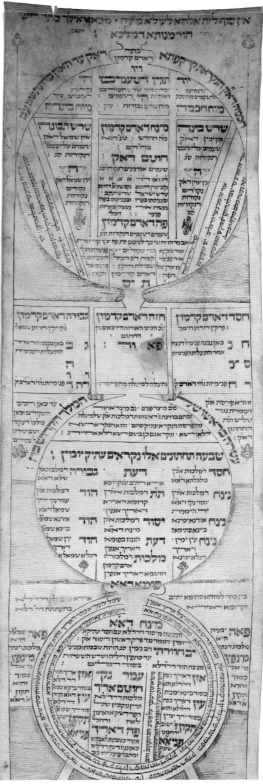
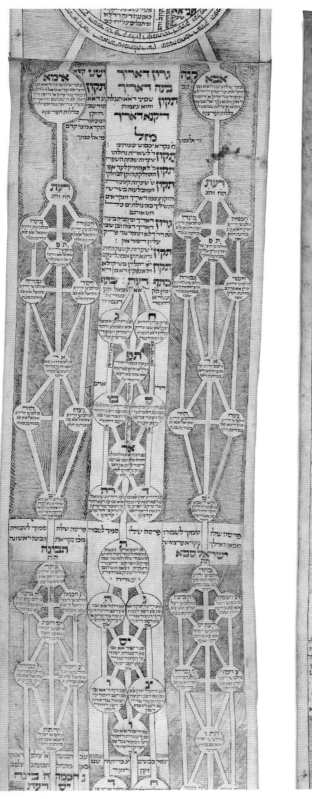

control of the material, and, indeed, the language of Zacuto's letter indicates quite the opposite. Perlhefter's last known work, *Beer sheva* (Well of the seven), also betrays no knowledge of Lurianism.[40] Perlhefter seems to have been a gifted scribe and a learned man, familiar with classical Kabbalah (Zohar and Cordovero) and interested in learning Lurianic Kabbalah but far from expert in its lore. Such a person might have copied the ilan for precisely the reason that Poppers gave for its initial production: to provide a helpful visualization of the Lurianic system for students attempting to master it.[41] He may also have copied it on commission.

When and where did Perlhefter take it upon himself to copy the Poppers ilan? He signed it "Behr Perlhefter *ha-za'ir*" (the youth), but this term was often used as a gesture of modesty and should not be taken literally. The use of the family name Perlhefter provides a *terminus post quem*, after his marriage in the late 1660s. Might he have created it while tutoring Wagenseil, with Knorr's inspiration or even direct involvement? Or in Modena during his period of Sabbatean enthusiasm, as he plunged into the study of Lurianic Kabbalah? Or in Prague, in the very years that a kabbalist whom we will soon meet, R. Nosen Neta Hammerschlag, was working on an *Ilan of Adam Kadmon* of his own not far away?[42] We cannot know for certain, but Perlhefter's autograph correspondence with Wagenseil is preserved, and the script in the earliest letter I inspected (dated February 21, 1676) is closest to that found in the ilan.[43] Given this orthographic similarity, "the youth" appended to the signature, and the indirect connection to Knorr's circle of this period, it seems most likely that Perlhefter produced the ilan in the mid-1670s, the period in which he tutored Wagenseil.[44] Around this time, Knorr was overseeing the preparation of an engraving based on the same model and translating its inscriptions into Latin.

Perlhefter's copy of the Poppers ilan reveals his artistic prowess, a hitherto unknown side of him. He used crosshatching to great effect throughout the ilan to achieve a variety of shadings, making the diagrammatic figures emerge as if in relief. The overwhelming detail that typically lends a chaotic appearance to the Poppers representation of the enrobings is here considerably tamed by Perlhefter's elongated and elegantly rounded lines, and precise lettering. Perlhefter's *horror vacui* is nevertheless palpable; backgrounds are only left blank for a touch of contrast, and decorative elements—manicules, geometric, and floral doodles—often fill spaces. Perlhefter likely took on the (commissioned?) project hoping that it would introduce him to the dauntingly difficult world of Lurianic Kabbalah, and even though its mastery may have eluded him, his efforts produced an ilan of value and beauty that has survived to this day.

GROSS COLLECTION | TEL AVIV, GFCT, MS 028.012.015 | THE *ILAN OF ADAM KADMON AND THE ENROBINGS*

The second extant pure Poppers ilan, today in the Gross Family Collection, lacks a colophon (fig. 85). Paleographic analysis of its scribal hand suggests a German or perhaps Bohemian provenance, ca. 1700. Stylistically it has more in common with the engravings in Knorr's *figs. 1–7* than with Perlhefter's ilan. Might it have been the model for Knorr's engraver, Johann Christoph Sartorius (1656–1739)?[45] Despite the general similarity, specific graphical details belie the possibility. Sartorius copied an ilan in which the head of *Adam Kadmon* was bounded by a circle. We see this in Perlhefter's copy, and in nearly all later incorporations of this ilan within modular artifacts, but not in the Gross Collection witness. That said, the textual inscriptions in all three of these ilanot are nearly identical; they are all versions of one ilan.

More than any other Lurianic single-origin ilan, the Poppers would be subject to cutting and pasting, adaptation, and beautification by later scribes. These mashups, remixes, and repackagings will charm us below; meanwhile, let us appreciate an ilan that likely resembles the one crafted by Poppers in mid-seventeenth-century Cracow. Its rather impoverished appearance is in keeping with what we see in Knorr's *fig. 1*, and I can imagine Knorr pleading with Sartorius, his talented engraver, to resist the temptation to improve his model as he prepared *figs. 1–7*. Poppers had certainly not bothered with decorative niceties when drafting an ilan to help students struggling to comprehend the complex mechanics of Luria's system, so the sober and pragmatic appearance of the Gross Collection ilan is consistent with its origins.

We know that Poppers was aiming for comprehensive detail in his ilan, but what to represent in any ilan is a matter of choice, and selectivity is inevitable. What Lurianic lore did he choose to include, and how did he do so? Let's begin at the top of the parchment, where, in bold square script, we read, "Ein Sof, blessed be He; No God is Above Him." The subtitle in the smaller inscription just below adds, "Crown on the Head of the Holy Blessed One; Beginning of the Will of the King." These Zohar-inspired phrases hover above the head of *Adam Kadmon*. More schematic than representational, the face hints at circularity by the convex inscription labeling the skull of *AK* just below "Crown of *Adam Kadmon*." Brain, ears, eyes, nose and nostrils, mouth—even "torrent of the beard"—are indicated by captions but lack representational elements. Nevertheless, the placement and accented calligraphy of these captions allow

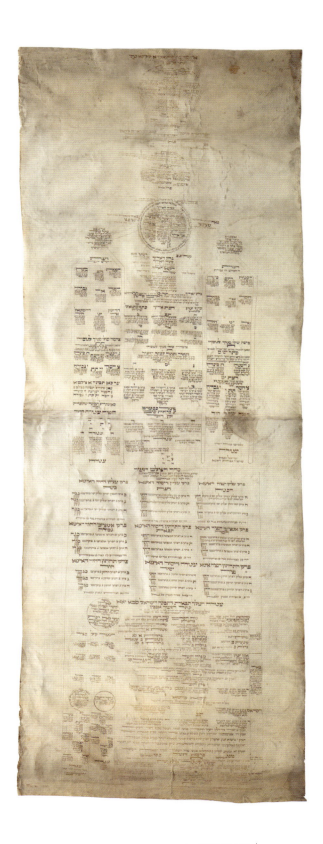

Figure 85 | Poppers ilan, Central Europe, parchment, 152 × 56 cm, Ashkenazi hand, ca. 1700. Tel Aviv, GFCT, MS 028.012.015. Photo: Ardon Bar-Hama.

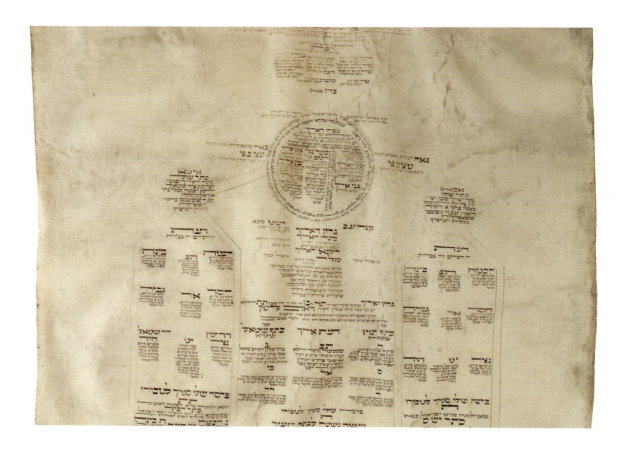

Figure 86 | From *Adam Kadmon* to the *parzufim*, from Poppers ilan (fig. 85).

us to discern a face amid the jumble. These labels do more than identify features, however; they cluster and layer associations drawn from Lurianic teachings. The Tetragrammaton in its many forms is central here, from its basic four letters to its expanded spellings that yield names with the numerical values of seventy-two, sixty-three, forty-five, and fifty-two. To these are added the secrets of the orthography of the letters—particularly *heh* and *alef*—as well as of the cantillation signs and vowel marks that animate them.

The head of *Adam Kadmon* is followed by two large circles aligned vertically (fig. 86). A horizontal line divides the first of these into an upper third (labeled "Reisha de-lo ityada") and lower two-thirds ("'Atik Yomin").[46] The line itself is the *parsah* or diaphragm division within the body of *Adam Kadmon*, now shown enrobed, as promised by Poppers. The *parsah* is the threshold through which the streaming inner lights of *Adam Kadmon* pass en route to their emission via its various porosities as the *'akudim*, *nekudim*, and *brudim* (bound, speckled, and spotted lights). This circle is devoted to the liminal transition from *Adam Kadmon* to the *parzufim*. The lowest sefirah of *Adam Kadmon*, *Malkhut*, has refracted into ten sefirot; the top three remain above the *parsah* as *'Atik*, the bottom seven below are *'Atik Yomin*. The captions relate the specifics of the enrobings: for example, "*Yesod* of *Malkhut*

142 | THE KABBALISTIC TREE

of *AK*" is aligned with the forehead of *Arikh*, and "*Malkhut* of *Malkhut* of *AK*" with the nose of *Arikh*. The second circle—actually an inner circle nested just within an outer one—brings us to the head of *Arikh*. The outer band is *Keter* of *Arikh*, the inner one *Ḥokhmah* of *Arikh*. The medallion labels the face of *Arikh*, from forehead to mouth, but again the captions emphasize these elements as enrobings for their higher analogues in *Reisha de-lo ityada* and *'Atik*.

Although their circularity constitutes a modest representational gesture, these "heads" atop the Poppers ilan are essentially tables in which the cells have been organized from top to bottom and right to left to correspond very roughly with the positions of facial features. They thus set the stage for the remainder of the ilan, which consists primarily of sequential tables and the occasional exposed head of a *parzuf*. Thus, emerging as diagonals from the head of *Arikh* are the smaller heads of *Abba* and *Imma*, their bodies fully concealed by enrobings. From the head of *Arikh* the ilan presents the successive enrobings of the higher *parzufim* in *Ze'ir*, *Israel Saba* and *Tevunah*, *Israel* and *Leah*, and *Jacob* and *Rachel*. The density and complexity of detail in these parchment-and-ink "great chains of being" testifies to the final point in our cosmogonic outline. As Vital wrote in his *Seder ha-azilut be-kizur muflag*, there are irregularities and exceptions in the enrobing process, making it necessary to do more than recognize the generally recurring patterns that govern it. Each of the *parzufim* has its anomalies,

Figure 87 | *Pirkei ha-zelem*, from Poppers ilan (fig. 85).

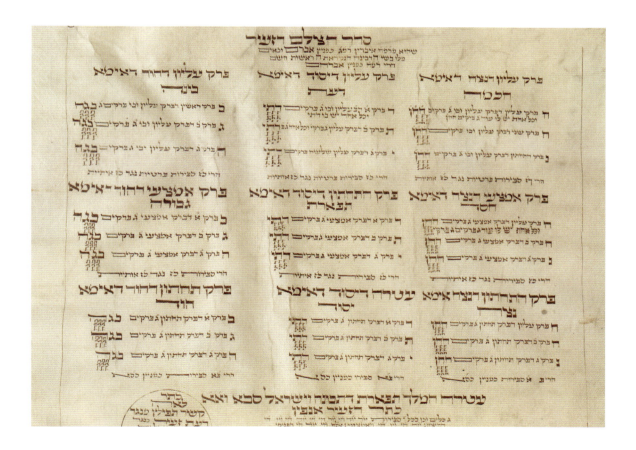

THE EMERGENCE OF THE LURIANIC ILAN | 143

Figure 88 | *Pirkei ha-zelem*, fig. 5, 20 × 18.5 cm, foldout engravings by Johann Christoph Sartorius in Apparatus IV, Christian Knorr von Rosenroth, *Kabbala Denudata* (Sulzbach, 1677). Tel Aviv, GFCT, NHB.136. Photo: William Gross.

variables that give rise to interactions of staggering complexity. The longest rotulus thus represent no more than "chapter headings" (b*Hagigah* 13a).

The lower section of the Gross Collection ilan details these enrobings using three columns, each thrice divided. The general logic of the sefirotic tree is respected and reiterated throughout these tables: right, left, and center. Particular attention is given to the so-called *pirkei ha-zelem* (limbs of the "image"), here presented in 3 × 3 boxlike inscriptions. The significance of this section derives from the stage it visualizes in which the "image"—the term *zelem* denotes something like "astral body" in this literature—of *Ze'ir* is nourished by sublime levels of divine consciousness (*mohin*) critical to the growth and reparation of *Ze'ir* itself. Poppers drew on Zemah's reconstructed *Kehilat Ya'akov* for his presentation of this process in *'Ez Hayyim*.

Zemah had introduced it with the emphatic comment, "Zemah: These discourses must always occupy you."[47] A comparison between the Gross ilan (fig. 87) and Knorr's *fig. 5* (fig. 88) brings home their close relationship. The *pirkei ha-zelem* section exemplifies the density and complexity of the ilan fashioned by Poppers. Clearly inspired by Zemah's efforts, Poppers can fairly be said to have taken the same aspirations to an extreme, if not *ad absurdum*. But absurdity is in the eye of the beholder, and by seventeenth-century standards, the attention to detail in this ilan made it a worthy paragon of divine science.

About Faces

What are faces of God doing in kabbalistic—let alone Jewish—works? Even if the myth of the artless Jew (and Jewish aniconism more generally)

SPECIAL FOCUS | *Jerusalem*

Poppers closed his ilan with a shout-out to his hometown, "Jerusalem," written in bold square script in the lower left corner of the rotulus (fig. 85). That an ilan opening with the head of *Adam Kadmon* ends with Jerusalem should not surprise anyone acquainted with the special status of the city in Jewish cosmology. Jerusalem was long presumed to have a supernal analogue, the ancient rabbinic "Yerushalayim ma'alah" (Jerusalem on high, as in b*Ta'anit* 5a). The earthly city wasn't insignificant either: it was *axis mundi*.[48]

In a comment on the orientation of the *yosher* that descended into the primordial sphere, Ẓemaḥ wrote, "This line corresponds to Jerusalem. From this it is recognized that we who live on this side of the world go straight and those who live on the side below, the opposite."[49] Ẓemaḥ's background would have made him keenly aware of the southern hemisphere, which Portuguese explorers systematically mapped for the first time in the early seventeenth century. The new geography finds its place on the diagram: the channel that carries the light of *Ein Sof* from the "window" that indicates the "top" of the sphere is aligned with Jerusalem. The latest Portuguese discoveries had merely confirmed the earlier cosmic coordinates.

But what exactly was this "Jerusalem" at the bottom of Poppers's rotulus? The answer, not surprisingly, is theosophically precise. We find in *'Eẓ Ḥayyim* that Jerusalem may refer to a state as well as to a place. In the former sense, "Yerushalayim shel ma'alah" refers to the coupling of the *parẓufim Abba* and *Imma*, "Yerushalayim shel matah" (Jerusalem below) to the coupling of *Ze'ir* and *Nukba*. In the latter sense, Jerusalem specifically denotes *Malkhut* of *Nukba*, making it the lowest point in the World of *Aẓilut*.[50] It was in this capacity that it served to conclude Poppers's ilan.

It did not take long, however, for the supernal city to be visualized in the image of its earthly analogue. Poppers's text became the Holy City itself in the stunning Great Tree held in Cambridge's Trinity College library, which I discuss more fully below (fig. 89). The Trinity ilan reproduced the copper engraving found in the Amsterdam Haggadah of 1695, the illustrations of which, according to Yosef Hayim Yerushalmi, were "copied and imitated more than those of any other Haggadah in history" (fig. 90).[51] The latter had been prepared by the proselyte Abraham bar Jacob, who based his engravings on those by the Swiss artist Mattheus Merian (1593–1650) made for bibles printed beginning in 1625 (fig. 91). "As above, so below" was certainly the case—although the stark artistic contrast between this early, austere Poppers ilan (fig. 85) and the luxury Cambridge *Trinity Scroll* (see below, fig. 134) underscores the disparity between the circumstances of their production and intended consumption.

Figure 89 (overleaf) | Jerusalem, from the *Trinity Scroll*, a Great Tree with Delmedigo, Maimon, and Zacuto frame, vellum, 280 × 35 cm, Central Europe, eighteenth century. Cambridge F.18.11, by permission of the Master and Fellows of Trinity College Cambridge.

Figure 90 | Jerusalem, 23a, *Amsterdam Haggadah*, printed by Abraham b. Jacob, Amsterdam, 1695. Tel Aviv, GFCT, B.66. Photo: William Gross.

Figure 91 | Jerusalem, unnumbered page opposite 1 Kings 6, engraving by Mattheus Merian, English Bible, Oxford, 1675. Tel Aviv, GFCT, MS NHB.382. Photo: William Gross.

has long been shattered, how could we not be astonished by seeing a face of God represented on a kabbalistic artifact?[52] The Second Commandment is one thing, but the words of Exodus 33:20 ring memorably in our ears: "You cannot see my face, for no one may see me and live." Yet there they are, these faces of *AK* and the *parzufim*, in the two surviving copies of the Poppers ilan.[53]

It would be hard to avoid an anthropomorphic visualization in the mind's eye of the zoharic *Idrot*–inspired *parzufim* of Lurianic Kabbalah.[54]

Inevitability did not constitute permission to do so, however, and certainly not to render such imaginings graphically. The *Idra rabba* opens with a stern warning voiced by its protagonist and hero, Rabbi Shimon bar Yoḥai, echoing the Second Commandment. Although the teachings about to be revealed were of unprecedented anthropomorphism and plasticity in their representation of the Godhead, the student was not to take them literally or make of them a "graven image" (Zohar III: 127b). Yet images of the faces of God are precisely what we

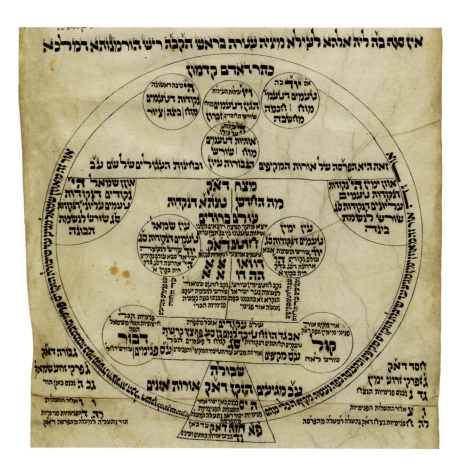

Figure 92 | Head of *Adam Kadmon,* from a Great Tree. Tel Aviv, GFCT, MS 028.012.010 (see fig. 245).

find in Lurianic ilanot. The faces of the Divine—depicted in a spectrum that ranged from schematic abstraction to representational realism—were *de rigueur*. It is sometimes difficult to see that two utterly different images are, in fact, "copies" of the same diagrammatic face of God (figs. 92–93).

Poppers was not the only Lurianic kabbalist to attempt schematic renderings of the head of *Adam Kadmon*. Azriel of Krotoszyn, a seventeenth-century kabbalist from Germany and Poland, diagrammed a head of *AK* that makes for an interesting comparison to the one atop Poppers's ilan (fig. 94). Azriel's was not part of an ilan; it appears in his visual précis of *Ozrot Ḥayyim* entitled *Klalut ve-pratut ha-hishtalshelut me-ein sof 'ad kol ha-'olamot aby"'a"* (General and specific [dimensions] of the emanatory chain from *Ein Sof*, including all the Worlds of *Azilut, Beriah, Yezirah,* and *'Assiah*).[55] Azriel almost certainly composed the brief nine-folio companion, the autograph codex of which is now in Oxford's Bodleian Library (Opp. MS 456), while studying Vital's *Ozrot Ḥayyim* under Zacuto in Mantua. A second, incomplete copy was made by an Italian scribe who was likely Azriel's fellow student in the same academy; it remains in Mantua to this day (fig. 95). The wedding of images and references to *Ozrot Ḥayyim* in the first pages of *Klalut ve-pratut ha-hishtalshelut* reveals Azriel's efforts to draw what he could of its cosmogonic lore. In linking page references to

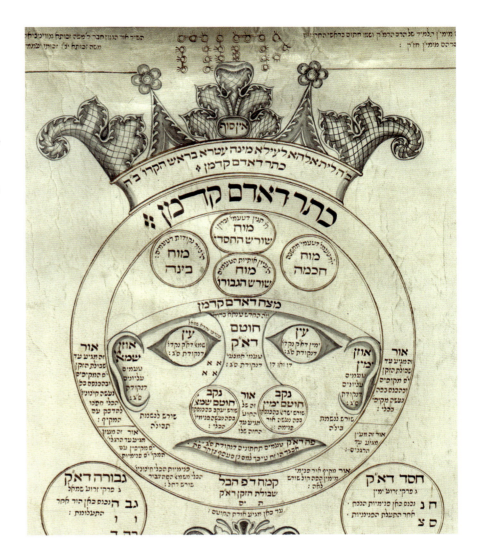

Figure 93 | Head of *Adam Kadmon,* from the *Trinity Scroll,* a Great Tree with Delmedigo, Maimon, and Zacuto frame, vellum, 280 × 35 cm, Central Europe, eighteenth century. Cambridge F.18.11, by permission of the Master and Fellows of Trinity College Cambridge.

such images he was following in the footsteps of Ẓemaḥ and perhaps was even inspired by Ẓemaḥ's description of his large keyed diagrammatic sheet, as well as by the diagrams included in the copies of *Ozrot Ḥayyim* prepared under Zacuto's direction. He was unfamiliar with Poppers's *Ilan of AK and the Enrobings.*

Azriel devoted the first page of his notebook to a bullet-point presentation of the opening cosmogonic sequence, dedicating roughly half the page to a large *'iggulim ve-yosher* diagram. On this first diagram, as we now know to expect, the channel that pierces the circle from above and descends to the lower perimeter of the outermost circle represents *Adam Kadmon.* From this bird's-eye view, *AK* is merely *yosher,* a geometrical abstraction. Viewed from an intimate vantage point, however, the head of *AK* becomes richly detailed. To this graphical accounting Azriel devoted the following page of his keyed précis, shown here both in his own hand and

THE EMERGENCE OF THE LURIANIC ILAN | 149

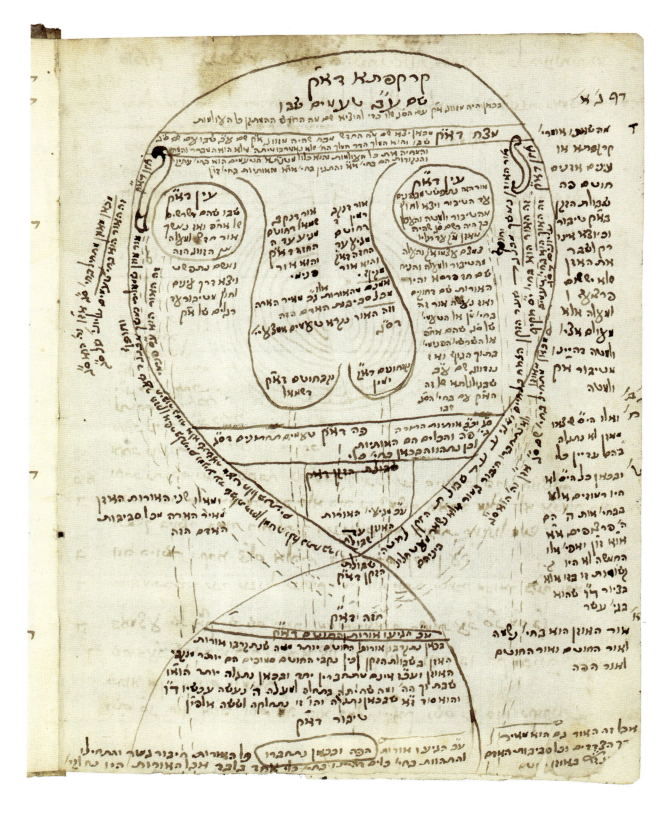

Figure 94 (opposite) | Head of *Adam Kadmon*, fol. 1b, Azriel of Krotoszyn, *Klalut ve-pratut ha-hishtalshelut*, Mantua, late seventeenth-century autograph. Oxford, BL, MS Opp. 456.

Figure 95 | Head of *Adam Kadmon*, fol. 1b, Azriel of Krotoszyn, *Klalut ve-pratut ha-hishtalshelut*. Mantua, Biblioteca della Comunità Ebraica, MS ebr. 109.

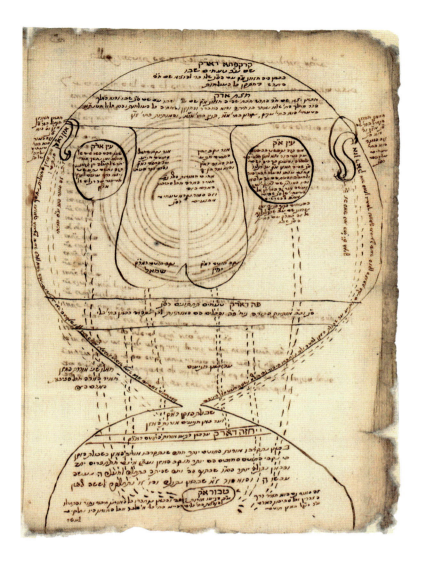

in the copy likely prepared by a fellow student in Zacuto's yeshiva.

The heads of *AK* represented by Azriel and Poppers were both visualizations of the same texts, and they have a great deal in common (e.g., fig. 83). Both outline *AK*'s head and its principal features—forehead, eyes, ears, nose, and so forth, down past the neck and chest to the navel—and inscribe each with key associations. They are, however, fully independent visualizations with quite a few distinguishing differences. In Azriel's diagram, dashed vertical lines trace the flow of the streaming lights from the eyes, nostrils, and ears of *Adam Kadmon* down toward the diaphragmatic *parsah*. Poppers had left this dynamic streaming of lights to the imagination of the contemplative student, who was to conjure it in his mind's eye upon encountering the captions that provided the names associated with each mode. Poppers's captions also betray his own novel modes-of-consciousness

THE EMERGENCE OF THE LURIANIC ILAN | 151

terminology, the "DNA" that points directly to his authorship. Not surprisingly, Azriel's head of *AK* knows nothing of them.

Azriel's brief diagrammatic companion to *Oẓrot Ḥayyim*, with its starkly anthropomorphic image, survived in only two copies, one of them his own. Its reception could hardly have been more different from that of the Poppers ilan, which opened with a strikingly similar representation of *AK*'s head. What fueled its popularity and made the Poppers head of *Adam Kadmon* acceptable, even authoritative, to kabbalists around the Jewish world? It seems likely that the stature of Poppers had a good deal to do with it, although we cannot be certain. Poppers's name, after all, would not appear on an ilan until roughly the mid-nineteenth century. It may be the case that his responsibility for the *Ilan of AK and the Enrobings* was an open secret, an oral tradition, or inferred by erudite kabbalists fully capable of recognizing its use of his distinctive terminology.

The *Ilan of Expanded Names* (*N*)

A third Lurianic ilan is presented in *Kabbala Denudata* as *fig. 15* (fig. 96). As one may infer from the single figure number, it is one of only two ilanot that Knorr and Sartorius managed to fit onto a single foldout page. The Hebrew manuscript versions of this ilan go beyond brief captions to include long passages, many of them in the margins outside the diagram (see below, figs. 100–101). Reproducing them on a single engraving would have been a challenge even for Sartorius. Instead, only the clear outlines of the unusually arrayed circles are retained: three midsize circles in a triangular arrangement on top, one large circle in the middle, and a slightly smaller one just below it. Within these main circles are subcircles and horizontal diameter dividing lines. Knorr devised a sophisticated alphabetical key, assigning Latin cursive characters to the various spaces carved out by the outlines of the diagram and to the diameters, circumferences, and even semicircumferences of the circles. In this instance alone, Knorr did not key the ilan to the Latin translation that accompanied it under the heading "Figura XV." Instead, he explained to readers that the key referred to a section in Apparatus II in the same volume. Why did Knorr divide his presentation of one ilan into two apparatuses? I will return to this curiosity shortly.

The *Ilan of Expanded Names* exhibits an approach to the visualization and graphical presentation of Lurianic lore very different from the *Z* and *P* ilanot I have just analyzed. Rather than focus on the enrobings of the *parzufim* as a kind of interlocking puzzle, *N* emphasizes the patterned layering of its content within a single figure. It is not a sefirotic tree, but the diagram does convey its logic in exploded view—one of the graphic inventions of the Renaissance, deployed to perfection by Leonardo da Vinci in his famous notebooks.[56] The three midsize upper circles are triangulated, followed by a large circle in the middle and a slightly smaller one on the bottom. From a distance one might mistake this array for the typical threefold division of the classical sefirotic tree: *Keter*, *Ḥokhmah*, and *Binah* atop a metonymic *Tiferet*, culminating in *Malkhut*. A closer look, however, reveals how far removed we are from the classical ilan. There are the odd arrays of subcircles and dividing lines, the reiteration of three higher sefirot in the upper third of the central circle, and what would appear to a classical kabbalist to be an extra sefirah in both the middle and bottom circles (in each case, the top-central subcircle). Some of the bold inscriptions also announce our arrival in a new world: *Abba* and *Imma* share top billing with *Ḥokhmah* and *Binah* in their respective medallions in the upper frame. The reason for this admixture of the familiar and the unfamiliar is that this "tree" is, like Ẓemaḥ's and Poppers's, an ilan of enrobings, and its expressions

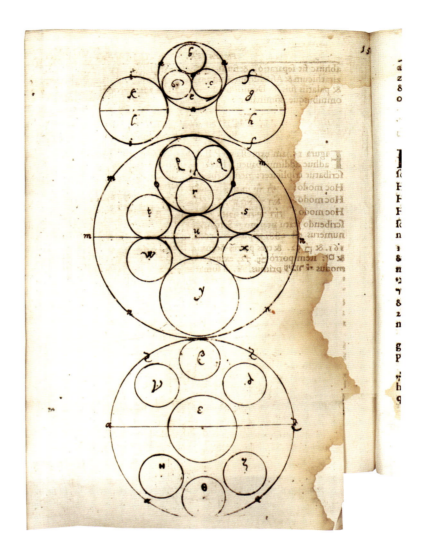

Figure 96 | *Ilan of Expanded Names,* fig. 15, 21.5 × 14.5 cm, fold-out engravings by Johann Christoph Sartorius in Apparatus IV, Christian Knorr von Rosenroth, *Kabbala Denudata* (Sulzbach, 1677). Tel Aviv, GFCT, NHB.136. Photo: William Gross.

of affinity to the iconic tree and its deviation from it are designed accordingly. Yet unlike Ẓemaḥ's and Poppers's ilanot, which are dedicated to visualizing the dynamic enrobing process that governs the emergence of the Lurianic great chain of being, this ilan presents a single synoptic view of the grand structure, recalling the diagrams in early Lurianic manuscripts (e.g., fig. 97), while far exceeding them in graphical detail and textual content.[57] If Ẓemaḥ and Poppers reinvented the ilan as a timeline, with our present ilan we have returned to the ilan as a map.

The texts of *N* share a common theme: divine names. Here too, one discerns echoes of classical ilanot. Other than the sefirotic names, nothing was more common in a medallion of a kabbalistic tree than one of the "unerasable" names of God.[58] As we saw in the *Great Parchment* (fig. 30), the latter might even appear in place of the former. And why not? Gikatilla had opened his *Sha'arei orah,*

THE EMERGENCE OF THE LURIANIC ILAN | 153

בצמצום הראשון אחר שנעשו בחינת עגב פנים לה פן ועל רחם זה היה וקו זה של יושר עגולי אק ולב היושר כנגד עיגול שעולה
העליונה כח אין חותם פה וכולם כלולים מזה מזה בן וב כי לא עגל כן וב אחר ה נמשכים שע של אלוה היינו עגולים ולו
וזה תלוי

של גם עלמאי להמין עד אמצע

ירמוש על העולם היאר היא עד אלין
העילות כי העולם העליונות מנין על הטלמוחות וני טינו
בהרכב אמונה היושר אינו ולא מהאצי וכל וכן הש של כל הפרטים שבונים
לאיכו וכן ב ב י כל הפרטים שבונים כל הפרצופים שעוים היינו שאחורות עולם
כל הפרצופים עעים היינו שאחורות עולם שלמונה הכי האצולה ומלין חמד הכתר של פרצוף נעשים מוח
שלמונה אותן ומלין אבל כאחור היינו עוקריה על הפר הם הוא מוקן ואל כונו של מודר ועלמ והראש כב
איוהל לצמצם כח זה מוד שלמנה הכולל על כן גם רעצ סג
לעצמצום הוא בעני המאורות על האדם ואחב ילא אנו דרך בעני עצמה הכל מה שה היה העולם האל שקריים ומור של אנון
העולם כמהראשך בלב ומלת כה כולה דרך הנקבים וכל אשר תת מל כאני העולם האבל בכל מה כ אח אננו תחינתה ג הרה
גם כי אין האנן בהי וילאני אולא מן הימנית ובן מואחחן ועל פיני אחונו ועש משל ושה שלאל

 ׀ התחילה ׀ הנקודה ׀
 ┌─────────────────────────┐
 │ עתיקא קדישא │
 │ הנקודים אל עצמינו עד סוף האצילות ק ירדים התיקון וההתקון אינו מדרגל │
 │ אלא מתרעם אלן שהיא מצוף אנות כ ים עינא אומרים אק ועולה אומרים כן אינו │
 │ תעולה הן לאנון אחד │
 │ ┌─────────────┐ │
 │ │ אורך אנפין │ │
 │ │ ┌─────┐ │ │
 │ │ │אצי אצי│ │ │
 │ │ │ סוד סוד│ │ │
 │ └──┴─────┴──┘ │
 └─────────────────────────┘

וכל של הפנים על למטה אך כזכרנו והיה צריך עלומים אהדים
להזדית כה זו פרצופים יעקב ורחה לא וה והאל והכלל על
כל הצדק מצמצים אצכחיל מנני ואחד פד אלפריגל

אמר ע של שכזן בכהיא שם עולם כל וכעל חמה ואא
וכי כלם ורהא ש עני ואת הבן צ שלג וכלי כל ואלה של אחת
קצמין אוכהי מראלכתרו ונאחר אבא וא ב ה כאחד של אחד אל מולחין
וחהו קולהה וראמית ב שהי הכי ועולם אבא עולם אל מולחל
טה אם האדר ער א שהוא מ וומר האצל ער השעל הרוב של עולם

האצל מולמונה ואר ב כתרוב אדם ולאוהר שב ב ב ב הגע תב נעב תא
מוקף שעה מוקף כל העושה
מוקף פ חלהי וקב ל הה
מוקף פ חלהי וקב ל כל העושה

זה העעלד היסד שעולה עוצה מעם
הם הכולים של כל כולים מעניתיה
זה כזוצ זה ואת משנתה ונ מנת

לעברגו אלמונה ואחר אהיה כתמו אם שאיי שט ובב כי נקב הוא מלמונה לאך ולך היטח לאספומה אוא אם על ועמים עובר
עשורש והלך עולם ב ובאש הה על פר נואן הבטחה הוא פרק דבר מאר ולא מוק שייך לה אפק
שם האחן שם על החלה שי ואבחלן ומך אמרך שכן אב ו לברינ אה ותבחן ית הבא כנאה אחר לעתה ואחל
ונא

the most popular introduction to the sefirot ever composed, with the assertion that the sefirot were nothing *but* names of God. Kabbalah was, in this view, primarily dedicated to revealing the unique valence of each name, with clear implications for both prayer and study.

Knorr's engraving of *N* clearly labels the overarching structure of the diagram, in keeping with the lengthy Hebrew inscriptions he found on his Hebrew manuscript source. The basic divisions of the *ilan* are linked to the Tetragrammaton. Each of the primary circles is captioned accordingly in Knorr's *fig. 15* (our fig. 96): the uppermost is the "koẓo shel yud" (the thorn of the *yud*); the circles of *Ḥokhmah* and *Binah* are the *yud* and *heh*; the grand central medallion is the *vav*; and the bottom circle, the final *heh*. Classical Kabbalah had established this basic equation by dividing the ten sefirot into four: *Keter*; *Ḥokhmah* and *Binah*; *Ḥesed* through *Yesod* (often represented by their hub, *Tiferet*); and *Malkhut*. In Lurianic Kabbalah, things are no longer that simple: these primary circles are not sefirot but *parzufim*. The ten sefirot are refracted in this *ilan* through the prisms of the many divisions and subdivisions of the *parzufim*. And just as the graphic structure of this *ilan* negotiates the classical arboreal form and its logic with the new world of the *parzufim*, so do its texts, anchoring tens of alphanumeric derivations in the divine names *EHYH* and *YHVH*.

This *ilan* is not merely an *ilan* of names but also of their "expansions"—*miluim*, meaning literally "filled [versions]."[59] Noted briefly above (fig. 64), their starring role in *N* calls for a fuller explanation here. In a *milui* (singular), each Hebrew letter is a word. To spell the letter *A* in English, one simply writes *A*, but the first letter of the Hebrew alphabet, *alef* (א), becomes a word spelled with three Hebrew letters, *alef*, *lamed*, and *peh* (אלף). The Tetragrammaton, *YHVH* (יהוה), can thus be expressed, for example, as *Yud* (יוד) *Hi* (הי) *Viv* (ויו) *Hi* (הי); in that form, it becomes a "new" name of God. Adding up the numerical values of these ten Hebrew letters give us seventy-two, and this is the "Name of Seventy-Two" that governs the World of *Azilut*. Expanding (or "filling") the Tetragrammaton with *alef*s rather than *yud*s, as in *Yud Ha Vav Ha* (יוד הא ואו הא), produces the "Name of Forty-Five" of the World of *Yezirah*. Although these expanded names play a prominent role in the rich associative lore of Lurianism, the logic underlying them would not have struck rabbinic scholars as particularly unusual. It was but one of many implications of ancient Jewish traditions according to which Hebrew was the language of God. Unlike other languages, which were based on people's willingness to agree to call something by a random sound, Hebrew words were thought to capture the essence of their referents. In this view, even Hebrew letters became atom-like building blocks of unique character if not outright semantic value. This broad Jewish background provided all the necessary theoretical support for the unpacking of divine names one finds in Kabbalah. Each name of God tells us something about the Divine and practically has a life of its own. This level of creating meaning is characteristic of classical Kabbalah. When the Tetragrammaton is broken down into its four letters, each spelled out in full, and when each alternative spelling is presumed to capture a distinct and particular dimension of the Godhead, we are in Lurianic territory. The *Ilan of Expanded Names* provides a wealth of such expansions, their numerical values, and their correspondences to the *parzufic* system.

Figure 97 | Synoptic *parzufim* diagram, fol. 28a, Ḥayyim Vital, *Drush Adam Kadmon*, copied and edited by Menaḥem de Lonzano, Damascus, ca. 1600. COL MS X 893 K 11, Rare Book & Manuscript Library, Columbia University in the City of New York.

Fig. 15 and the Quest for Knorr's Elusive Source

A slight difficulty with *Fig. 15* complicates our transition to Knorr's Hebrew ilan source. Knorr was a scholar of antiquarian sensibilities who presented his readers with the most reliable Latin "conversions" of materials he thought essential. Unless he indicated otherwise, each ilan he re-presented in the fourth apparatus of *Kabbala Denudata* was based on a Hebrew manuscript. In the case of *P*, Knorr and Sartorius retained the Hebrew of their source ilan, making the correlation a simple one. For *Z*, they replaced the Hebrew inscriptions of their source with a key to reliable Latin translations. So too for *N*. In this case, however, the keyed Latin translations cannot be fully correlated with the inscriptions in any of the Hebrew ilan manuscripts that are the schematic twins of *fig. 15*, including a rare *N* on parchment (New York, JTS S439) and the foldout paper ilanot bound into the luxury volumes of *'Ez Ḥayyim* to which I will soon turn. Why this discrepancy between the texts of Knorr's Latin and its Hebrew model?

I noted above that Knorr divided his translations of the texts of this ilan into two apparatuses. The translations of the inscriptions found within the diagram were printed in the second apparatus under the title *Clavis Sublimioris Kabbalae, de Ordine Divinorum Nominum pro Resolutione Difficiliorum Aenigmatum Libri Sohar* [Key of the highest Kabbalah, about the rank of divine names for the resolution of the more difficult obscurities in the book Zohar]. The translations include more than just these inscriptions, however; Knorr added sefirotic appellations that are not inscribed in any known Hebrew version.

Knorr is unlikely to have added content to his translations that were not in his source. Realizing that this source may well have been lost, I nevertheless set out to find it. One passage struck me as a possible "fingerprint": "(7.) Tetragrammaton illud, quod protulit Sacerdos Magnus die Expiationum est Tetragrammaton simplex, punctatum per Cholem, Saegol, Kamez & Saegol" [The Tetragrammaton, which the High Priest uttered on the Day of Atonements, is a simple Tetragrammaton, punctuated with [the vowels] Cholem, Saegol, Kamez, and Saegol.][60] Knorr had translated this text as though it were inscribed on his source, but its equivalent was not to be found on the *N* parchment and paper ilanot I inspected. I eventually found the Hebrew passage in *N* ilanot that had been copied into two seventeenth-century Ashkenazi manuscripts now in Oxford's Bodleian Library: MSS Opp. 551 and Opp. 458. In the first, a miscellany copied in Vienna in 1662 by Gabriel Schussberg, the ilan—including this passage—was copied on two consecutive pages, 152a–152b.[61] Alas, the additional sefirotic appellations translated by Knorr were nowhere to be found.

The second codex preserved *N* on a foldout page. Although it contained the "fingerprint," it too lacked the additional sefirotic appellations that Knorr had translated. This time, however, the missing texts were hiding in plain sight: they all appear in a *second* foldout ilan bound into the volume on the very next page (fig. 98). This second ilan is not Lurianic; rather, it is a fine example of the classical ilan in its symbiotic relation to sefirotic commentaries. Although it contains mostly Lurianic works, the miscellany concludes with an anonymous and untitled classical commentary on the sefirot.[62] In lieu of a title the scribe added, "This is related [*zeh shayakh*] to the ilan commentary on ten sefirot" to the header of the first page of the work (313a). The ilan characteristically aggregated the names and appellations of the sefirot in their respective medallions, which is precisely where Knorr found them. In short, even though there is no Hebrew ilan with inscriptions that match Knorr's Latin translations, the first foldout of MS Opp. 458 preserves the single-origin Lurianic ilan as Knorr knew it.

Knorr integrated its inscriptions with those of the classical ilan alongside which it was bound. Their conflation was abetted by the formal similarity of the two trees.[63]

Knorr's synthesis did not produce one harmonized ilan, however, but two. In the *Tabula prima*, the sefirotic names and their unerasable counterparts in Hebrew and Latin are presented in an arboreal array (fig. 99). A mix of texts taken from the inscribed *parzufim* of the Lurianic ilan and the appellations of the classical ilan that followed it in MS Opp. 458 are then presented over the following pages (7–11) and keyed to *fig. 15* of the fourth

Figure 98 | Classical and Lurianic foldouts, Kabbalistic miscellany, Ashkenazi hand, seventeenth century. Oxford, BL, MS Opp. 458.

apparatus. Turning to the latter (fig. 96), we find the keyed schema of the Lurianic ilan and its Latin companion chapter. There, before providing Latin translations keyed to the diagram, Knorr translates the texts, treating the expansions of divine names and their significations that he found on the margins of his Hebrew *N* source. All signs thus point to Knorr's having used MS Opp. 458 and its two foldouts as the source for this enigmatic, idiosyncratic,

Figure 99 | *Clavis Sublimioris Kabbalae*, page 6, foldout engravings by Johann Christoph Sartorius in *Apparatus . . . pars secunda*, Christian Knorr von Rosenroth, *Kabbala Denudata* (Sulzbach, 1677). Tel Aviv, GFCT, NHB.136. Photo: William Gross.

and yet faithful integration of classical and Lurianic content.

GROSS COLLECTION | TEL AVIV, GFC, MS GR.011.012, AND THE ILANOT OF BUCHBINDER

A paper foldout of the *Ilan of Expanded Names* is found at the end of an extraordinary tome produced in 1729, one of the first luxury *'Eẓ Ḥayyim* manuscript codices by the self-described "scribe and artist" R. Israel ben Asher Buchbinder (fig. 100).[64] Buchbinder was originally from Seltz, Lithuania (the birthplace of the Vilna Gaon), but he was a resident of Altona, near Hamburg, when he worked on these volumes. He made a number of lavishly illustrated copies of the work, which was well on its way to achieving canonical status.[65] Six copies have reached us bearing colophons that date them from 1728 to 1749; a seventh, dated 1774, is an exquisite homage to Buchbinder's editions that retains his name on the frontispiece.[66] The different hand and late date, however, lessen the likelihood that Buchbinder himself was behind them. Despite the astounding quality of his work, we know nothing more about Buchbinder than what can be gleaned from these seven volumes. If he copied other works, they have not reached us.[67]

Over the years, Buchbinder's rococo style became progressively bolder and more exuberant. His

very identity was changed by this unique project: from referring to himself as a scribe (*sofer*) in the earliest copy, he came to call himself "ha-sofer ve-ha-ẓayyar" (or *ve-ha-mezayyer*), the scribe and the artist, in subsequent frontispieces. As we might expect, Buchbinder's growing artistic confidence found expression in the foldout *Ilan of Expanded Names* bound into the back of each volume. These ilanot differ from one another primarily in the increasingly rich decorative program on display. As luxury manuscripts these *'Ez Ḥayyim* volumes were treasures rather than working treatises in the hands of common kabbalists. For this reason most are in excellent condition today, with their foldout ilanot intact. The most serious damage is self-inflicted: Buchbinder's ink was not always kind to his paper. Like his slightly older regional contemporary Johann Sebastian Bach, Buchbinder used a form of iron gall ink. As with Bach's musical scores, the corrosion caused by this ink is gradually destroying many of the volumes, its acid slowly disintegrating the paper and its oxidizing iron turning it brown.[68]

Buchbinder's editions of *'Ez Ḥayyim* include finely wrought diagrams, many of which are aestheticized expressions of those found in more prosaic copies of the work. But Buchbinder did not refer to himself as an artist for nothing. His volumes are richly illustrated by any standard, shockingly so in comparison to all other manuscripts of Lurianic works, with the possible exception of a handful of ilanot. Floral motifs, birds and beasts, and elaborate calligraphic chapter titles lavishly adorn the codices. Anthropomorphic images are found as well, especially in the last sections of the volumes, which contain dense diagrammatic material. Here Buchbinder supplemented *'Ez Ḥayyim* with visual material he culled from a variety of sources, including the kabbalistic tree and the human hands associated with R. Jacob Temerles that are examined below.

The copy in the Gross Collection is one of Buchbinder's earliest efforts; only the one in the Bodleian (MS Michael 620), executed a year earlier, predates it. The Jewish Museum in Prague holds a third early copy, dated 1730. It is fascinating to compare the three and see how Buchbinder's artistic

Figure 100 | *Ilan of Expanded Names*, back-matter foldout, paper, 70 × 36.5 cm, in Ḥayyim Vital, *'Ez Ḥayyim* (Poppers ed.), copied and illustrated by R. Israel ben Asher Buchbinder, 1729. Tel Aviv, GFC, MS GR.011.012. Photo: Ardon Bar-Hama.

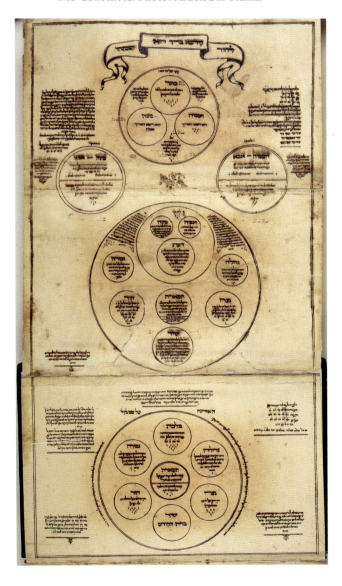

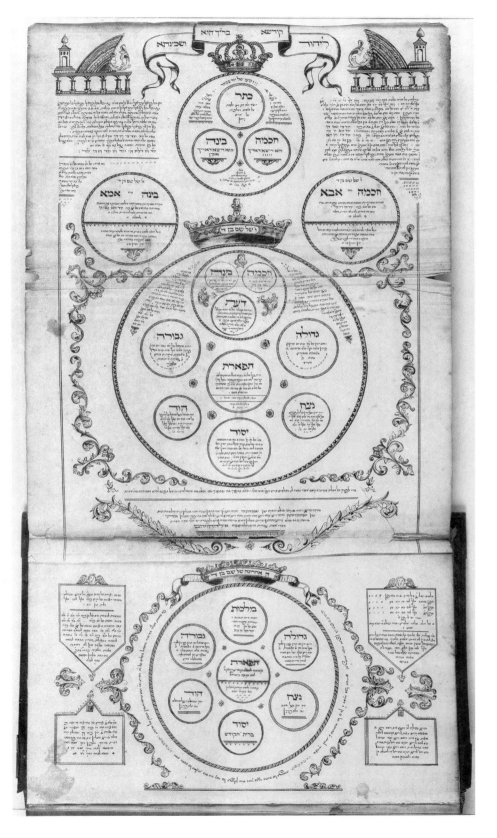

Figure 101 | *Ilan of Expanded Names*, back-matter foldout, paper, 70 × 37 cm, in Ḥayyim Vital, *'Ez Ḥayyim* (Poppers ed.), copied and illustrated by R. Israel ben Asher Buchbinder, 1730. Prague, Jewish Museum, MS 69.

prowess grew from year to year. The 1728 volume in the Bodleian is an impressive calligraphic accomplishment, with charming decorative adornments, but in comparison to what would follow from Buchbinder's pen it is positively austere. The 1730 Prague volume is, in turn, much more richly illustrated than the one in the Gross Collection. Judging from the similarity of the Prague copy to the 1749 Copenhagen Royal Library witness (MS Cod. Hebr. XLIII), Buchbinder's *'Ez Ḥayyim* had attained its mature artistic form with this third known copy. Much of his work closely mimics printed models, as may be seen clearly from the frontispieces that open these tomes, beginning with the Gross exemplar. Elements of Buchbinder's own creation—including a human head inside which sefirot, patriarchs, and the seven doubled letters of *Sefer yeẓirah* are marked—are transformed and elaborated upon freely over the course of his decades-long career creating these manuscripts.

The progressive beautification is particularly evident in the foldout ilan that concludes each volume. Although we cannot know for certain, Buchbinder's selection of this ilan may have been encouraged by its local provenance and structural elegance. In the Oxford copy Buchbinder evidently copied the ilan straightforwardly: the theosophical array is represented with simple circles and stylized calligraphic text. Decorative flourishes make their appearance in the Gross manuscript, from the titular legend, now in an elegant ornamental ribbon atop the diagram, to a miniature image of a peacock beside a bouquet of flowers in the blank space between the higher circles. Just one year later, whether inspired by growing artistic self-confidence or a more lucrative commission, Buchbinder produced the Prague copy, in which the ilan is adorned with spiraling vines, architectural ornaments (complete with carved masks), cherubic heads atop folded angel wings, and regal tiaras crowning its three central circles (fig. 101).

We have not seen the last of the *Ilan of Expanded Names*: it reverberates in a number of extraordinary Great Trees to be explored below.

The *Panoply Tree*

All Worlds, Old and New

A rare and tantalizingly enigmatic Lurianic ilan was engraved by Sartorius as *fig. 16*, the last in Knorr's collection (fig. 102). The complex overall array gives the impression of remarkable novelty, even if many of the individual elements evoke familiar diagrams. In keeping with its totalizing aspirations and schematic diversity, I have dubbed it the *Panoply Tree*. As they did with the densely inscribed *Z* and *N* ilanot, Knorr and Sartorius transformed their Hebrew iconotextual source into an alphabetically keyed figure that preserves the outlines of the original. Given the dimensions of known Hebrew manuscript parallels, that original was likely about half a meter wide and three-quarters of a meter in length. As with *fig. 15*, the use of a key made it possible to present *fig. 16* on a single foldout page. *Fig. 16* may be described as more of a synoptic structural map than a timeline, making the bird's-eye view appropriate and compelling.

Unlike the other ilanot preserved in *Kabbala Denudata*, which are critical to understanding the later history of the ilan genre, *fig. 16* had little currency among Jews in the eighteenth and nineteenth centuries. It is never found as a module in a Great Tree. It survives in its original Hebrew version in three manuscripts that share a common provenance with Knorr's engraving. Like the *Ilan of Expanded Names*, it was produced in a German-Jewish context in the latter half of the seventeenth century. My analysis will highlight its significance as an idiosyncratic Lurianic cosmograph.

Despite its rarity, the ilan adapted for engraving as *fig. 16* was circulating in Knorr's veritable backyard. The three extant Hebrew manuscripts were

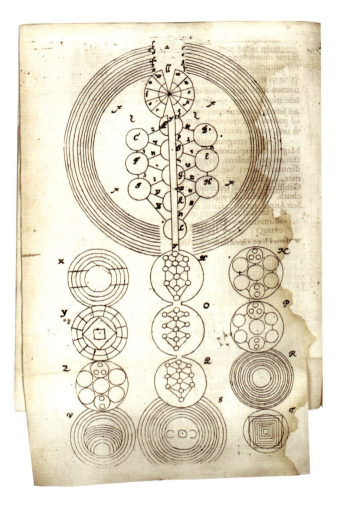

Figure 102 | *Panoply Tree*, fig. 16, 22.5 × 14.5 cm, foldout engravings by Johann Christoph Sartorius in Apparatus IV, Christian Knorr von Rosenroth, *Kabbala Denudata* (Sulzbach, 1677). Tel Aviv, GFCT, NHB.136. Photo: William Gross.

executed by the same scribe in an unusual square script (fig. 103), and that hand has much in common with that of the manuscript ilan that matches Knorr's *figs. 13–14* (fig. 80).[69] Indeed, the fact that two of the three ilanot are now in Munich suggests that they may have been part of a single previous collection. Might that have been Knorr's?[70] The Munich ilanot share a few textual idiosyncrasies with Knorr's—in Latin translation, of course—that distinguish them from the third witness.[71]

Knorr may have chosen to conclude his fourth and final apparatus (and thus the entire volume) with the *Panoply Tree* for its pansophic scope. One can imagine Knorr marveling at the inclusion of so much cosmogonic knowledge on a single page, from *Ein Sof* and the primordial intimations of the sefirot, the *zaḥzaḥot*, through the Lurianic *'iggulim ve-yosher*, to the three teeming Worlds beneath *Aẓilut*. Knorr also would have appreciated its texts, drawn from Bacharach's *'Emek ha-melekh* (Valley of the king, Amsterdam, 1648). This was Knorr's Lurianic Bible,[72] and *Kabbala Denudata* is bursting with translations of long chapters excerpted from its comprehensive presentation of Lurianism. What Knorr may not have fully appreciated, however, was the extent to which its Frankfurt am Main–based author, Naftali Hertz Bacharach (active seventeenth century), had created a work of esoteric fusion. Bacharach did not simply supplant the ancient esoteric traditions of Ashkenazi Jewry with the lore of Luria; he creatively integrated the two.[73] The *Panoply Tree* gives graphical expression to this integration, particularly in its bottom half (fig. 103). Although most of its schemata have no precedents in *'Emek ha-melekh*, instead calling to mind primarily those of the long natural-philosophical tradition, the texts are often traceable directly to a particular chapter of that work.[74] The fact that Lurianic sources inspired the top half of the ilan and ancient Ashkenazi angelology and demonology the bottom is congruent with Lurianism's near-exclusive focus on the World of *Aẓilut*, which left room for pairing with complementary cosmological systems.[75]

Nevertheless, *'Emek ha-melekh* was hardly the only book in the library of the kabbalist who created this ilan. The sources of many of the texts in its lower section have yet to be identified. The array of schemata and textual content in the top section

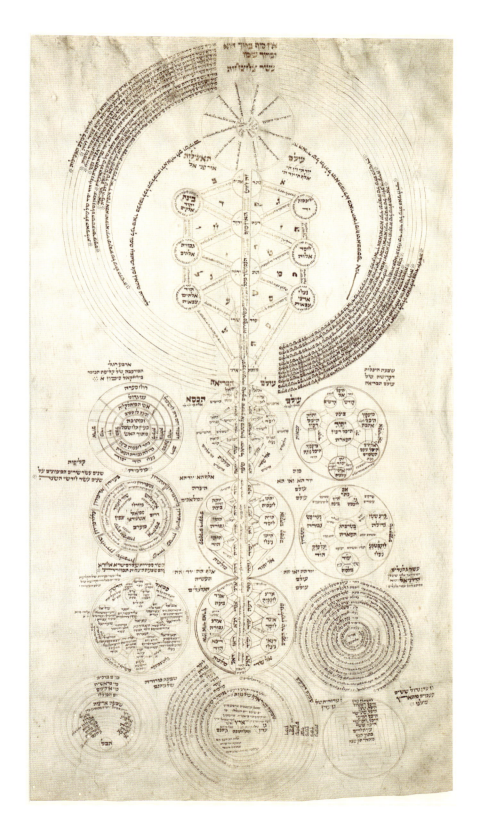

Figure 103 | *Panoply Tree*, parchment, 76 × 41 cm, Ashkenazi square script. Berlin State Library—Prussian Cultural Heritage, Oriental Department, Ms. or. fol. 130, 2.

has no known parallel. Individual elements are also enigmatic, raising the question of their graphical as well as textual sources. To take but one example, the *Panoply Tree* begins with a rare feature: above *Keter*, *Ein Sof* radiates the ten primordial lights known collectively as *'eser zaḥzaḥot*. The beams are labeled with the names of these lights, such as "or mezuḥzaḥ, or mi-zohar" (burnished light, light of brilliance). The *zaḥzaḥot* feature prominently in Cordovero's *Pardes rimonim* and the names of the lights appear in *Maʿayan ha-ḥokhmah* (Fountain of wisdom), a work produced by the early kabbalists associated with the so-called "Circle of Contemplation."[76] The *zaḥzaḥot* do not disappear in Lurianic Kabbalah but undergo a kind of transvaluation. Thus Vital makes reference to *'eser zaḥzaḥot* as the "geonic" nomenclature for the ten sefirot of *Aẓilut*,[77] and this is essentially their role here.

What topography is represented in the *Panoply Tree*? The top half of the ilan shows the World of *Aẓilut*, the bottom the Worlds of *Beriah*, *Yeẓirah*, and *ʿAssiah*. The bold headline reads, "Ein Sof, blessed is He and blessed is His Name; Ten zaḥzaḥot." More than simply title the ilan, these words graphically interrupt the ten concentric circles that range down from the top line. In this way, the words label the passageway that connects the space outside the diagram to that within it, the so-called *ḥalon* (window). The World of *Aẓilut* begins with the circles, labeled hierarchically in the upper left as the principal *parẓufim*, with their relative positions and correspondences duly appended. These inscriptions are repeated on the lower right as well, emphasizing their spherical singularity. The space at the center of the circles is captioned "avir he-ḥallal [aether of the space] . . . filled with the light of Ein Sof."

Returning to the *ḥalon*, we see the emergence of the linear emanation, *yosher*. It begins with the primordial lights of the *zaḥzaḥot*, here figured as a fanlike rota that encroaches on both *Ein Sof* above it and *Keter* below. The tree under the rota is classical, its medallions inscribed with the names of the sefirot, the unerasable names that are their analogues, and, inside their circumferences, the names of all ten sefirot. This clearly reflects the influence of Cordovero's volvelles. The medallions are connected by twenty-two alphabetically labeled channels, honoring the axiomatic dictum of *Sefer yezirah* that divided the thirty-two cosmogonic paths into ten sefirot and twenty-two letters. There is something odd about this sefirotic tree, however; it has eleven sefirot.[78] Although the ilan makes no attempt to diagram the enrobings, it retains the basic structure required by the process—the "eleventh sefirah" of *Daʿat*. One more graphical feature sets this tree apart from its classical antecedents: it is traversed by a central shaft. This "thread of *Ein Sof*" begins in the *zaḥzaḥot* rota and continues its descent until it opens in the band inside the lowermost central figure that represents *Malkhut* of the World of *ʿAssiah*.

The lower half of the ilan features a unique array of a dozen medallions that enclose arboreal forms set alongside concentric circles, nesting squares, and tabular rotae. The general logic of this array is familiar, with higher and center-right positive, lower and left negative. An abundance of lore is layered, correlated, and contrasted in these medallions: divine names and their expansions; angels and demons; heavenly halls, firmaments, and planetary spheres; elements and kingdoms. Much of it is drawn from ancient Jewish esotericism as preserved and developed in medieval Ashkenaz. The top three rows present *Beriah*, *Yeẓirah*, and *ʿAssiah*; the central figure of the fourth row gives an enlarged view of the heavenly firmaments and the "lower world." On either side of it are magnifications of heaven and hell, the locations labeled at its center. These magnifications are of some visual interest because they are exceptional, at least in a kabbalistic context: the "seven rungs of heaven"

[medorei Gan 'Eden] are shown as nesting squares, with the innermost labeled "tree of life—500 years [!] long." A side annotation notes that heaven is sixty times the size of "our earth." The seven rungs of hell, at the far left, use circles and semicircles to represent the waters surrounding the earth and the depths of hell (*Gehennom*), respectively. Hell, it is noted, is sixty times larger than heaven. No doubt the space is needed.

The *Panoply Tree* is maplike, emphasizing overall synoptic structure and the patterned layering of information in meaningful locations. Although the dynamic timelinelike *Z* and *P* ilanot do not have a single order of reading, they intimate forward motion from beginning to end. Is there an intended order of reading in the *Panoply Tree*? I do not believe so. It seems, rather, to be made for exploration and integration. As a diagrammatic tour de force, this ilan has been designed to aggregate a great deal of material, perhaps with an eye to the mnemonic potential of the distinctive schematic settings in which the different traditions are inscribed.

It is fascinating to see how Knorr dealt with this relatively indeterminate visualization. Having shorn the ilan of its inscriptions, he had to present his translations as a continuous, alphabetically ordered text beginning with *A* and ending with *Z*. Knorr assigned *Z* to the far left circle of the penultimate row. A glance at its Hebrew parallels reveals that this medallion is dedicated to classical rabbinic demonology, now transvalued as the "ten sefirot of the *klippot* [shells]" (fig. 104). All the familiar names are there, with Samael the Evil headlining the circle and Lilith the Evil in the position of *Malkhut* in this demonic tree. On either side of Lilith's circle, however, we read "Naḥash ba-mispar mashiaḥ" (*Snake* is the numerical equivalent of *Messiah*). A smaller inscription continues, "for he will uproot her from the world, as it says, 'And death will be swallowed up forever,' speedily and in our days." Knorr chose to conclude his

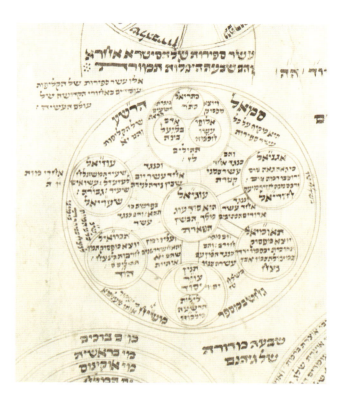

Figure 104 | The Realm of Samael and the Messiah, detail from the *Panoply Tree*, parchment, 76 × 41 cm, Ashkenazi square script. Berlin State Library—Prussian Cultural Heritage, Oriental Department, Ms. or. fol. 130, 2.

presentation of this ilan—and the whole volume—with this text, yet there was no reason for this circle, as opposed, for example, to "our earth" (*S*) or the "rungs of hell" (*V*), to be considered the final cosmological element pictured.

Knorr's Latin translation of the inscriptions ends, "Sed nomen נחש serpens eundem habet numerum cum משיח, qui cortices eradicabit è mundo Iesch. 25,8 . . ." (The word *naḥash*, serpent, has the same numerical value as *Messiah*, who will eradicate the shells from the world, Isaiah 25:8 . . . [the Hebrew words are in Knorr]). The poisonous realm of demonic evil is not where the story concludes but, rather, the locus of a cosmic

SPECIAL FOCUS | *An Ilan for the "Great Elector"*

Tobias Cohen (Metz, 1652–Jerusalem, 1729)—best known as Tuvia *ha-rofeh*, Tuvia the doctor—was a Polish-Jewish physician who authored a Hebrew-language survey of the sciences known as *Ma'aseh Tuvia*. It has never been out of print since it was first published in Venice in 1707. Perhaps the first Jewish medical student in Germany, Tuvia was among the first Jews to respond in print to Nicolaus Copernicus's heliocentrism.[79] Although it is remembered as a work written to bring learned medicine to Jews without access to qualified practitioners, *Ma'aseh Tuvia* was a feast of polymathic proportions. Its readers were exposed to a panoramic survey of the natural world, often illustrated.

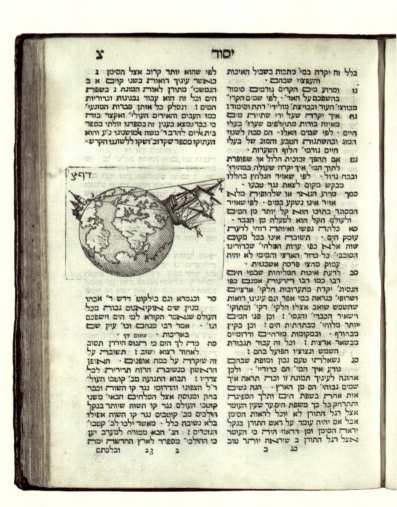

Figure 105 (left) | "That the water is round," 90a, in Tobias Cohen, *Ma'aseh Tuvia*, Venice, 1707. Photo courtesy of Jerusalem, The National Library of Israel, Valmadonna Trust London England 370.

Figure 106 (above) | "That the water is round," page 25, Johannes de Sacrobosco, *Sphaera Ioannis de Sacrobosco Emendata* (Antwerp, 1582). Universitätsbibliothek Augsburg, 02/VIII.3.8.16.

Figure 107 (opposite) | *Tree of Grammar*, parchment, 49 × 34.8 cm, Tobias Cohen and Felix Moschides, 1678. Berlin State Library—Prussian Cultural Heritage, Oriental Department, Ms. or. fol. 130, 3.

Serenissimo ac Potentissimo Domino Domino FRIDERICO WILHELMO ELECTORI BRANDENBURGICO &c.
Domino nobis Clementissimo, hoc Schema arboris quæ repræsentat Epitomen Gramma-
tices, offerebat sacrificium mus Ad. ad Electorales pedes humillime devotus, cui ser-
vi subjectissimi

Gabriel Iehia Jecchides, Eques ab Medina Judæus
Aques à Sebibes

ראיתי והנה נפוצו עם ה' מעל אדמת קדושת הדקדוק והלשון ולא ראי זה כראי זה : זה

One page shows a globe, on the perimeter of which are a large building and a ship connected by lines, captioned, "That the water is round" (fig. 105). Tuvia's image and its accompanying text are borrowed from *De sphaera mundi* of John Holywood, better known as Johannes de Sacrobosco (d. 1256) (fig. 106).[80]

Our story dates to the beginning of Tuvia's studies at the University of Frankfurt an der Oder, which he attended with his friend Felix Gabriel ben Moses (Moschides) of Brody. The two had petitioned Frederick William, Elector of Brandenburg (1620–1688), for admission to the university then under his administration. Frederick William, "the Great Elector," was known for his tolerance of Catholics and Jews despite his strict Calvinist beliefs. He not only admitted the two Polish Jews but also provided them with a stipend. In return, the two were to master the German language and make themselves available as Hebrew teachers, perhaps even to the Great Elector himself.[81] This is the context in which Tuvia and Gabriel produced an ilan in 1678 (fig. 107). It is not a kabbalistic ilan, however, but a grammatical one; we will explore a kabbalistic tree of grammar created in the same decade below (fig. 151). Tuvia and Gabriel's grammatical ilan shares a catalogue number, Ms. or. fol. 130, with the *Panoply Tree* at the Berlin State Library (fig. 103).

The two ilanot were described by Steinschneider as "Pergamentrollen" (parchment rolls)—the first a "Baum der Sefirot" (Tree of the sefirot) featuring a "Porphyriusbaum" (Porphyrian tree) and the second a "Tableau der hebr. Grammatik in Form von Pophyriusbäumen" (Table of Hebrew grammar in the form of Porphyrian trees).[82] Tuvia and Gabriel referred to the diagram as a "Schema arboris" and "dugmat ilan" in their respective Latin and Hebrew dedications. *Dugma* carried the sense of "archetype" in medieval philosophical literature.[83] It was not their common schema that led to their joint cataloguing in Berlin (along with a Scroll of Esther) but, rather, their shared medium.

A year after Knorr published the *Panoply Tree* under the patronage of Christian August, Count Palatine of Sulzbach, Tuvia and Gabriel presented Frederick William with their ilan. The gift was appropriate coming from the new Hebrew teachers in town, a tangible sign that the strange, indeed truly unprecedented newcomers had arrived as representatives of a people and culture with something to offer the local community of scholars.[84] Given that Isaac Newton was at this time exploring the potential scientific contribution that Kabbalah might make to his own enterprise, a *Panoply Tree* would have made a no less suitable gift.[85]

antidote, the secret encoded in the identity of serpent and Messiah. The promise of Isaiah will thus be fulfilled; the Lord "will swallow up death forever." Volume I of *Kabbala Denudata* ends here, with the triumph of the Messiah, the reference to Isaiah's prophecy, and the refrain, invoking Romans 16:27, printed in capital letters, "FINIS—SOLI DEO GLORIA per CHRISTUM" (The End. To God alone [be] the Glory through Christ), would have reassured Knorr's critics that he was a pious Christian. We might nevertheless wonder whether, between the lines or after the ellipse, Knorr meant to allude to something more. He ends by highlighting three Hebrew words from Isaiah 25:8, בלע המות לנצח (bila ha-mavet la-neẓaḥ), inscribed on the inner left of circle Z. But the verse continues: "the

sovereign LORD will wipe away the tears from all faces; and he will remove his people's disgrace from all the earth. The LORD has spoken." Hidden in the ellipse, then, is the implicit subtext of Knorr's entire project: the end of the reproach of the Jews. The choice of a verse that highlights the end of this universal reproach as constitutive of the messianic era could not have been accidental. It was the thoughtful, if slightly veiled statement of a scholar at once occultist and antiquarian, enlightened and messianic.

From Texts to Images, Between Christians and Jews: Knorr's Fifth Ilan

Knorr's fifth ilan (*figs. 8–12*) is both vital to our analysis and *sui generis* (figs. 108–112). Because of the latter, it demands an approach different from what I have taken with the preceding four. Unlike the other ilanot in Knorr's apparatus, these five figures did not originate as a single-origin rotulus. Instead, when Knorr failed to find an ilan that visualized the cosmogonic stages they represent, he took it upon himself to create one. Were it not for the fact that Knorr's original ilan found its way into the compound ilanot that I refer to as Great Trees, this story would not have a place in the present book. But Knorr's ilan *did* become a common opening module of Great Trees, and no history of Jewish ilanot that did not include it would be complete. How did this Christian ilan find its way

Figure 108 | World of the *Malbush*, *fig. 8*, 21 × 19 cm, foldout engravings by Johann Christoph Sartorius in Apparatus IV, Christian Knorr von Rosenroth, *Kabbala Denudata* (Sulzbach, 1677). Tel Aviv, GFCT, NHB.136. Photo: William Gross.

to the top of so many Great Trees, including the 1864 Warsaw printing of the *Great Tree of R. Meir Poppers*?

Before the Beginning

Many Great Trees open with diagrams that visualize the teachings of R. Israel Saruq (or Sarug), the most successful evangelist of Lurianic Kabbalah in Europe at the end of the sixteenth–beginning of the seventeenth century. For all his influence, we know little about Saruq's personal history, especially before his appearance in Europe (fl. 1590–1610).[86] Apparently of Egyptian origin, upon arrival in Italy he presented himself as a former student of the already legendary Luria, ready and willing to teach the great master's lore.[87] Given the tight control over the dissemination of Lurianic writings exercised by Ḥayyim Vital and perpetuated by his son Samuel, Saruq became the initial conduit for the transmission of Lurianism to Europe. He

taught a philosophically inflected Kabbalah that was especially compelling to European scholars but did not align perfectly with that of Vital. This disparity troubled Poppers and would eventually lead modern scholars to question the veracity of Saruq's claim to have studied directly with Luria.[88]

Most relevant to our concerns is Saruq's doctrine of the primordial "divine Garment," the *Malbush*, that was emanated before *Adam Kadmon*—an idea entirely absent in Vital's cosmogonic accounts. Saruq taught (in Luria's name) that creation began with the formation of the letters of the Hebrew language, beginning with a primordial, atomlike point, the letter *yud*. This point began to move, forming a line from which a plane emerged, and this movement initiated the generation of the twenty-two letters. In a teaching indebted to earlier schools of Jewish esotericism, from *Sefer yezirah* to Abraham Abulafia, Saruq described the combination or "weaving" of these letters into a square *Malbush* of 231 paired letters.[89] The rest of the emanation proceeds from this primordial Garment. It cannot do so, however, until space is made for it—and, in the beginning, the *Malbush* filled all the space there was. The *Malbush* folds so that creation may unfold, its lower half rising up to rest on its upper half. Letters from the upper *Malbush* then flow into the newly vacated space to create the lower Worlds. The similar function of Saruq's folding Garment and Vital's *zimzum* has led

Figures 109 (opposite), 110 (left), and 111 (right) | First *zimzum*, fig. 9, 19 × 20.5 cm; World of the folding *Malbush*, fig. 10, 21 × 19 cm; Adam Kadma'ah Setima'ah, fig. 11, 19 × 17 cm, all foldout engravings by Johann Christoph Sartorius in Apparatus IV, Christian Knorr von Rosenroth, *Kabbala Denudata* (Sulzbach, 1677). Tel Aviv, GFCT, NHB.136. Photo: William Gross.

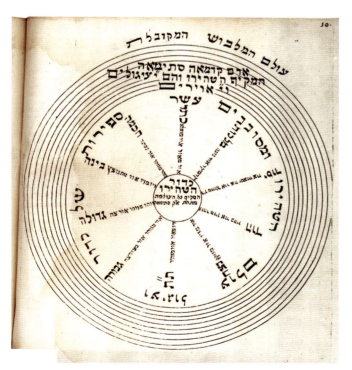
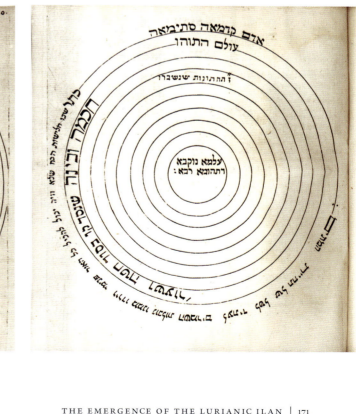

אדם קדמון שני

"ג תקוני דיקנא של א"ן וא"ריך
תיקוני שלאין במילה : תיקוני של א"ריך בשמות
אל א מי אל כמוך
רחום ב נושא עון
וחנון ג ועבר על פשע
אריך ד לשארית נחלתו
אפים ה לא החזיק לעד אפו
ורב חסד ו כי חפץ חסד הוא
ואמת ז ישוב ירחמנו
נוצר חסד ח יכבוש עונותינו
 ט ותשליך במצולות ים וכו' לאלפים
נושא עון י תתן אמת ליעקב
ופשע יא חסד לאברהם
וחטאה יב אשר נשבעת
ונקה יג מימי קדם

קליפות

בריאה

some to argue that Saruq was not so much teaching about an earlier stage as using different language to describe the same divine auto-withdrawal.[90]

Whether or not Saruq actually studied directly with Luria—and scholars increasing believe it plausible that he did while Luria was still living in Egypt—Saruq's version of Luria's teaching was widely embraced on the Continent and soon found its way to print. Among the first printed works based on Saruq's Lurianism was Bacharach's *'Emek ha-melekh*.[91] Its publication in 1648 was viewed by some rabbinic authorities as a lamentable, even tragic breach of secrecy of the most esoteric body of Jewish knowledge.[92] The coincidence of this scandalous publishing event and the Cossack massacres in the eastern territories of the Polish–Lithuanian Commonwealth was not lost on contemporary critics. Printing meant uncontrollable dissemination, and even if *'Emek ha-melekh* was hardly a popularization of Lurianic Kabbalah, it did provide access to hitherto almost unobtainable material.[93] Bacharach's book was relatively orderly and comprehensive, which cannot be said about most Lurianic manuscript sources.[94] Knorr was particularly indebted to Bacharach's work for its lucid presentation, and he endeavored to bring much of it to his Latin readership.[95] Yet our concern here is Knorr's original ilan. What does it have to do with *'Emek ha-melekh*?

Knorr was committed to introducing his readers to a diverse selection of Lurianic ilanot, but as a student of *'Emek ha-melekh*, he was keenly aware that none he had acquired visualized the cosmogonic *Malbush*. Rather than accept the lacuna, Knorr chose to fill it with an ilan of his own design, informed by texts and diagrams he found in Bacharach's book. Knorr presented his original ilan in a unique way, devoting the accompanying discussion to an explanation of its textual and iconographic derivations.

Knorr's *Malbush* ilan speaks in a distinctive visual language that to some extent reflects his cultural background. This visual-language gap is most vividly on display in *fig. 12*, with its exquisitely engraved profile view of the bearded head of *Adam Kadmon* (fig. 112). Other than the magnificent engraving of *Kabbala Denudata*'s title page, *fig. 12* is Sartorius's finest work in the volume. For all its representational realism, the engraving was crafted to capture precise theosophical alignments. The beard, which seems to flow realistically over the side of the sefirotic tree below it, has not petered out naturally but, rather, at the dividing line separating the higher and lower dimensions of *Arikh*. The "flow of the beard" reaches "ad foveam pectoris," [lit., to the pit of the chest], Knorr's rendering of the contested Lurianic term *tibbura de-liba*.[96] Knorr and Sartorius managed the challenging task of putting a representational image into diagrammatic duty with aplomb. The image is utterly unlike anything found in even the most anthropomorphic ilanot produced by Jews. Not surprisingly, it was not reproduced when, early in the nineteenth century, Knorr's *figs. 8–11* began to appear as the opening frames of Great Trees. *Fig. 12* would have been redundant in any case, given that *figs. 8–11* were always followed by the Poppers ilan, which begins with the head of *Adam Kadmon*.

How might the Jewish scribe who first incorporated Knorr's diagrams in a Great Tree have come across them? Perhaps more easily than we might have thought. In the early 1820s, while in Berdichev, Isaac Baer Levinsohn (1788–1860) saw *Kabbala Denudata* for sale at a local fair.[97] He wrote: "Not long ago, all the books of the *Zohar*—translated into Latin and printed in a handsome old edition—were brought for sale in the city of Berdichev. The body of the *Zohar* was in the original [Aramaic]

Figure 112 | *Adam Kadmon Sheni*, fig. 12, 22.5 × 19 cm, foldout engravings by Johann Christoph Sartorius in Apparatus IV, Christian Knorr von Rosenroth, *Kabbala Denudata* (Sulzbach, 1677). Tel Aviv, GFCT, NHB.136. Photo: William Gross.

language and alongside this a [Latin] translation was also printed, on one side in the language of the *Zohar* and on the other in Latin. These [volumes] are currently in Korets, Volhynia district." Although his description fits the second volume (the ilanot were published at the end of the first), Levinsohn's use of the plural may indicate that the full set was for sale.[98] Thanks to this report, we know that the Jews of early eighteenth-century eastern Europe had opportunities to discover Knorr's work. The foldout pages may have circulated on their own, reaching the first Jew to incorporate them in a Great Tree long after having been torn out of the volume. The small figure labels on each foldout page, in Latin and Arabic numerals, should have betrayed their "foreign" provenance to a scribal "importer." We can only assume that, knowingly or not, the transfer from Sartorius's engravings to the opening of Jewish Great Trees was undertaken with the presumption that these exclusively Hebrew-inscribed and *'Emek ha-melekh*–inspired diagrams were perfectly kosher. And, in truth, they were.

Understanding Knorr's Method

To understand how Knorr created an original ilan from Bachrach's *'Emek ha-melekh*, I will use the first of his five figures—fig. 8—as a case study (fig. 108). What do we see? Within the rectangle delineated by the edges of the black vignette are three circles, the outermost represented only by its upper arc, in which the darkness is labeled as such. The inscription, in the reserved white space, is taken word for word from the opening of the *'Emek ha-melekh* summary chapter that inspired Knorr: "Master of [or, perhaps better, "One who has"] the Will [*ba'al ha-razon*], who is absolute darkness, concealed from the eye of all the living." The black is thus the visualization of this cosmogonic bed of creation.

The accompanying Latin chapter does not translate the Hebrew inscribed in the diagram. Instead, Knorr explains each of its elements with a translation or paraphrase of the section of *'Emek ha-melekh* on which it is based. Thus, §2 of the chapter provides a Latin translation of the first four lines of the final chapter of *'Emek ha-melekh*; Knorr had used the third line for the title. He devotes the remainder of the chapter to unpacking the dense encoding at the center of the figure. The Hebrew inscription, in bold letters along the inner perimeter of this inner circle, was borrowed directly from the last chapter of *'Emek ha-melekh*: "The World of the *Malbush* from the *Roshem* [trace or residue] [remaining from] when he vacated space for the Worlds." Knorr took the smaller inscription beneath it, "the first World in the Worlds of the *Ein Sof*," from the subtitle of the extensive cosmogonic discussion in *'Emek ha-melekh*'s first chapter, "Sha'ashu'ei ha-melekh" (the King's [auto-] amusements).[99]

At the center of the third circle, at the heart of the figure, is Knorr's summary visualization of the *Malbush*. The economical presentation is visually akin to one deployed by Bacharach himself (fig. 113). Knorr has embellished Bacharach's simple triadic tower of couplets with added captions, sefirotic names, and a scalelike balance that places the frontal combinations and associations on the right and the rear ones on the left.[100] What we see is a condensation of the critical elements of the full combinatoric tables of *'Emek ha-melekh* I, chapters 6–28 (4a–6b), which provides the key associations that link sefirot, letters, and expansions of the Tetragrammaton that constitute the *Malbush*. Understood in light of the accompanying chapter, this modest embedded table provides the algorithm for the derivation of the "231 Gates" (times two, for its "front" and "back") that are the warp and weft of the primordial Garment. The full tables of the couplets formed by successive letter combinations, the scheme of which is implicit in the diagram and its source in *'Emek ha-melekh*, are presented in the Latin chapter that accompanies *fig. 8*.[101]

Figure 113 | Garment algorithm, 10b, Gate 1:60 of Naftali Hertz Bacharach, *ʿEmek ha-melekh*, Frankfurt am Main, 1648. Photo courtesy of Jerusalem, The National Library of Israel, Valmadonna Trust London England 7596.

Knorr did not sacrifice precision to concision, and he supplemented his précis of the tables with two short texts that extend the sixth and seventh lines of the rear columns. These are anomalous elements in the *ʿEmek ha-melekh* tables (5d), correspondences unobtainable through the application of the basic algorithm. Knorr drew attention to this odd feature of the diagram when he concluded his explication of *fig. 8* in §6 of the accompanying Latin chapter. The inclusion of these short texts—at the cost of compromising the diagram's visual balance—meant that the reader could fully reconstruct the content of five dense pages of combinatory tabulations without losing a single detail. The act enabled by the mnemonic is unlikely to have been intended merely to allow for the reconstruction of the complete tables; rather, it allowed for active contemplative participation in the weaving of the primordial Garment.

Fig. 9 and the Disappearing *Tav*

How can we be certain that the opening frames of Jewish ilanot in the subsequent centuries can be traced back to Knorr's ilan? Knorr took credit for *figs. 8–12* and explained, over eleven detailed pages, precisely how he derived each of them from Bacharach's *ʿEmek ha-melekh*. We need not rely exclusively on this evidence, however. A careful comparison of Knorr's diagrams and their parallels in Great Trees confirms that the former are unquestionably prior to the latter. I can demonstrate this with relative ease by looking at Knorr's *fig. 9*, a visualization of a text that treats the folding of the *Malbush* (fig. 109).[102] Rather than comparing the central elements of this visualization, I propose a Morellian focus on a seemingly negligible detail.[103]

Suspended in the upper right corner, just below the Arabic numeral 9, is the Hebrew letter *tav* (ת). If this were not an engraving, one might think the *tav* was a printer's accident, a loose letter that has floated away, a mistake. But no copyist could have

appreciated the significance of the *tav* without an awareness of the text from *'Emek ha-melekh* that inspired the entire image, and no Jewish ilan has ever included it.

The *tav* was an indispensable component of Knorr's visualization—so much so that here too he compromised the symmetry and geometrical purity of his image rather than omit it. The scribe who first copied Knorr's figures, launching their circulation in the Jewish world, was unaware of the source in *'Emek ha-melekh* or the Latin companion text to *fig. 9*. In the latter, Knorr explains the significance of the floating *tav*. After opening with a classic "Figurâ hâc repraesentatur"—"With this figure is represented," in this case continuing "mundus vestimenti" (world of the Garment)—and translating the Hebrew inscription that titles *fig. 9*, he immediately draws attention to the *tav*:

> In summitate Figurae autem repraesentatur litera ultima ת׳, quasi extremitas personae כת, quae est Malchuth mundi vestis, cujus pedes extenduntur in Aerem primum pro necessitate mundi: de quibus vide latiùs Emek hammelech sect.2.c7 [Hebrew in the original].[104]

> [In the top portion of the figure is shown the final letter ת׳ [*tav*], as it were, end of the *parzuf* כת [khaf tav], which is *Malkhut* of the World of the Garment, whose legs extended into the Primordial Aether for the sake of the world, concerning which see at length in *'Emek ha-melekh*, Gate 2, chapter 7.]

In addition to Knorr's direct reference to the treatment in *'Emek ha-melekh* II:7, the extensive tables presenting the combinations that form the *Malbush* (subsequently abridged at 10c) are introduced in the work as being bounded lengthwise by the *tav*: "The Primordial Torah is built of doubled 231, front and back, and they go and expand downward (*ba-orekh*, lit., lengthwise) until the *tav* of the *Malbush* reaches the bottom end of the circle, to the place where it returns to being Infinite."[105] The *tav* (and the inscription "*ha-Ein Sof*" beside it) label the background of *fig. 9*; that background, in turn, is equivalent to the innermost circle of *fig. 8*. The *tav* and the *Ein Sof* are the carry-overs that link the two images. Descending to the inner depth of *fig. 8*, we arrive at *Malkhut* and its couplet, *khaf tav*. This *tav* is carried over as the *tav* of the upper right corner of *fig. 9*.

It is tempting, but perhaps too fanciful, to imagine Knorr's visualized Godhead as evocative of cutting-edge mid-seventeenth-century technology, but it does bring to mind Blaise Pascal's calculator and its most amazing feature: a mechanism for carrying numbers.[106] In any case, the carry-over signals that *fig. 9* zooms beyond the limits of *fig. 8* to reach the next stage of the cosmogonic sequence. By inscribing "*ha-Ein Sof*" alongside the *tav*, Knorr underscored that the ground of this secondary development remained the Infinite. The inner circle of *fig. 9* is described in *'Emek ha-melekh* as an engraved circle of somewhat diminished light carved out of *Ein Sof*.[107] This light at one degree of separation from the light of *Ein Sof* has a name—*Tehiru*—a technical term based on the Aramaic for "shine." In the same chapter *Ein Sof* is also referred to as "the paper" on which the letters of the *Malbush* are inscribed. The infinite would engulf and obliterate these letters were they not protected by the circumference of the circle surrounding them. By simply inscribing "*ha-Ein Sof*" on the blank paper background of *fig. 9*, Knorr stunningly closed the semiotic gap between referent and reference.[108]

The originality of the diagrammatic image in *fig. 9*, and by extension *figs. 8–11*, is thus demonstrated by the fact that only the engraving designed by Knorr shows full agreement in all its details

SPECIAL FOCUS | *Knorr's Kabbalistic Tree Rings*

Knorr's original ilan has a visual language all its own. Rather than cutting the cosmic tree vertically to show its inner structure from root to branch, which is not a bad description of Z (e.g., fig. 76), Knorr's horizontal slices show us its rings. And if the kabbalistic tree has its roots above and branches below, Knorr's rings offer a parallel inversion, with the "oldest" at the periphery and the "newest" at the center. If the visual language is novel, the concept is not; this is the logic of *'iggulim*, the concentric-circle schema that went back to the emergence of Kabbalah and got a full reboot in Lurianic cosmogony.

Knorr has transformed the *'iggulim* into hypermedia in which forward movement is effected by repeatedly enlarging the center. As we have already seen in *fig. 9* and its carry-over from *fig. 8*, the innermost circle of each figure becomes the outermost circle of the one that follows. Rather than flow, the sequence zooms from the dark, undifferentiated infinite to the evacuated void and beyond. Like time-lapse photographic images, each figure captures a moment of this cosmic plunge. Knorr's visualization may have been inspired by the microscope, introduced to Europe earlier in the seventeenth century and the topic of extensive interest and discussion throughout the period.[110] Robert Hooke's *Micrographia* and its descriptions of "minute bodies" had been published just over a decade before *Kabbala Denudata*.[111] If my speculation has merit, Knorr's cosmogonic deep dive offers an extraordinary example of the affinities in this period between the discursive worlds of natural philosophy and Kabbalah in a visual key.[112]

Knorr's original ilan thus differs substantially from other ilanot, notwithstanding its roots in the texts and paratexts of *'Emek ha-melekh*.[113] It was the "Jewish" ilan of a Christian kabbalist. This odd formulation is meant to distinguish Knorr's ilan from the vast majority of diagrammatic images created by Christian kabbalists, which often include Christological elements, from interpolated Pentagrammatons to hovering Marys.[114] It also meant that Knorr's diagrams (at least *figs. 8–11*) could be incorporated into compound ilanot by Jews without raising any eyebrows. With the exception of the head in profile of *fig. 12* (fig. 112), Knorr's diagrams exhibit what might be termed geometrical neutrality.

Giordano Bruno seems to me the most likely influence on Knorr's distinctive visual language.[115] Bruno expressly voiced the conviction implicit in Knorr's approach. In his prefatory epistle to *La cena de le ceneri* [The Ash Wednesday supper, 1584], Bruno instructed his readers, "you are to read and visualize [*leggete e vedrete*] what I have to say."[116] Bruno's conviction that even simple circle diagrams bore tremendous power and meaning led him to his "Hermetic mathesistical" readings of the sun-centered concentric circles of Copernicus.[117] In her groundbreaking treatment, Frances Yates—who did not analyze the diagrams but emphasized their importance to Bruno—wrote, "I believe that the crazy [!] diagrams in Bruno's works are what he calls 'mathesis,'" meaning a way "to insinuate profound and difficult things by mathematical means" that he associated with Pythagoras and Plato.[118]

Bruno believed that geometrical diagrams were central to his project, but this conviction did not oblige him to explain their every detail to the reader. The most important were published without a word of explanation. This is the case with the "Geometra" diagram in his *Articuli* [160 articles against the mathematicians and philosophers of our times] (fig. 114).[119] By remaining silent, Bruno seems to attempt "to force the reader to participate ... to fill in what has been left out" and to read "within, around, between, and beyond" his

diagrams.[120] Knorr invested tremendous effort in translating the embedded texts of the ilanot he collected and explaining the derivations of his original ilan, yet much remains unsaid in his presentation. In his ilan sequence of cosmogonic figures, Knorr had created a series of Brunoesque emblems to conjure the earliest stages of creation.

Figure 114 | Geometra diagram, page 66r, woodcut by Giordano Bruno from his *Articuli Centum et Sexaginta Adversus huius Tempestatis Mathematicos atque Philosophos*, Prague 1588. Munich, BSB, ESlg/P.o.lat. 259#Beibd.1.

with the text that inspired it. The appropriation of this sequence by a Jewish ilan maker to open a Great Tree was likely the result of a search for a Saruqian *Malbush* prequel to the visual narrative found in Poppers's ilan, which began with the head of *Adam Kadmon*. Although there is no way to know whether this initial Jewish appropriation was undertaken with full cognizance of its provenance, once the sequence opened a Great Tree it achieved full independence. Kabbalists accustomed to the modular construction of Great Trees had no compunctions about snapping this Saruqian sequence off one and adding it to another. The equivalent of Knorr's *figs*. 8–11, which I refer to as *K* in its capacity as a module, became the most common prologue to *P* in Great Trees. The fact that earlier rotuli retain more of the distinctive details of *K* as it originally appeared in Sartorius's engravings suggests that Jewish scribes were copying from other ilanot. Had scribes returned repeatedly to Knorr's book, we would expect an occasional display of fidelity rather than incremental modifications and departures from the source over time.[109]

Lurianic Elements

Having completed our survey of single-origin Lurianic ilanot—of which four out of five were destined to have a busy afterlife as modules of compound Great Trees—I turn now to an exploration of other diagrammatic materials found in the kabbalistic repertoire. Here too I emphasize those visualizations that would be drawn upon over centuries by the kabbalists who creatively crafted rotuli blending the old and the new. Any kabbalistic diagram going back to those found in thirteenth-century manuscripts could be incorporated in a Great Tree. That said, those in Lurianic codices—whether intended to elucidate a particular concept ("detail" diagrams) or to provide

a comprehensive image of the system as a whole ("synoptic" diagrams)—were ideally suited for ilan redeployment.[121] To reiterate, I refer to these secondary diagrammatic materials as "elements," reserving "modules" for the single-origin ilanot when they reappear in Great Trees.

The *Grand Circles* of Vital (*V*)

In exploring the origins of complex Lurianic diagrams, I highlighted the importance of the pair of ambitious images found in early copies of Ẓemaḥ's *Mevo she'arim* (fig. 75). Reduced versions of what were originally oversize foldouts, these diagrams are found on facing pages, one attributed by Ẓemaḥ to Vital and the other captioned as Ẓemaḥ's own attempt to visualize the same ideas and text that inspired Vital's image. It is instructive to compare these diagrams to another early synoptic Lurianic image fashioned by R. Menaḥem de Lonzano (active late sixteenth–early seventeenth century), a contemporary and neighbor of Vital's in Damascus.[122] Although at first glance Lonzano's diagram looks very different, it visualizes essentially the same content (fig. 115). To create a cleaner and clearer diagram, Lonzano dispensed with cumbersome concentric circles, leaving only an inscription in the upper right corner in which he explains that each *parzuf* had ten inner and ten surrounding circles. The hierarchic revealed heads of the *parzufim* are captioned within the broad linear channel of *Adam Kadmon*, each text aligned with one of the narrow channels that flank it right and left. The tops of these narrow channels represent the exposed heads of the *parzufim*. Within each one, Lonzano has inscribed its basic role in the enrobing process, which is to enrobe the *parzuf* above it. One can easily see that even though their heads reach different heights, their feet all stand as one. "Kan raglei kulam" (here are the feet of all) is inscribed just above the highest horizontal line in the broad channel of *AK*. The rest of the Worlds are labeled in the continuation of this channel until the concentric circles are reached. Just above them is inscribed "'aseret ha-galgalim" (the ten orbs). Then follow, each inscribed twice in the three inner bands, "esh ruaḥ yam" (fire wind sea). At the very center, a small solid-black circle marks the fourth element, earth. As in Ẓemaḥ's copy of Vital's diagram, Lonzano indicates the tibbura de-liba, drawing attention to its contested status in the inscriptions in the upper left part of the circle.[123]

Vital's diagram, which likely approximated the "drawn page" that opened his *'Ez Ḥayyim* autograph, was salvaged from oblivion by Ẓemaḥ. Its importance was not lost on kabbalists, as Lonzano's early diagrammatic response indicates. Roughly a century later, thanks to the circulation of *Mevo she'arim* manuscripts, Vital's diagram found its way into manuscripts of *Oẓrot Ḥayyim*, where it often replaced the simple *'iggulim ve-yosher* found in opening homilies on *Adam Kadmon* (fig. 116).[124] Like Vital's original, the more schematic version presents a ramified image of *'iggulim ve-yosher* in which the concentric bands are captioned in succession as the encompassing and internal lights of *Adam Kadmon* and the *parzufim*. The titular inscription reads, "Simple [i.e., undifferentiated] *Ein Sof* encompasses all the circles and the Worlds, from which all the Worlds were emanated."[125] Unlike Ẓemaḥ, who thought it best to draw ten circles rather than rely on captions, the bands of these circles are inscribed "the ten circles" of *Adam Kadmon*, *'Atik*, *Arikh*, *Abba*, *Imma*, *Ze'ir*, and *Nukba*, followed by those of the lower worlds of *Beriah*, *Yezirah*, and *'Assiah*. As in Vital's diagram, labels note their dual aspects as encompassing light (*makif*) and inner light (*pnimi*). The two stand-alone inscriptions of Vital's diagram locating the source of the *'akudim* lights and the tibbura of *Adam Kadmon* are retained in the adaptation seen in the upper right bands of the figure, at roughly

one o'clock. The *yosher* of the first figure, however, features an inscription that is not to be found in the antecedents: "This is the linear channel and within it extends a thread [ḥut] of *Ein Sof*, may He be blessed. It expands from one end [ha-kaẓeh] to the other of all the Worlds, to the base of the circles of 'Atik." The inspiration behind this formulation will shortly be apparent.

This *Ozrot Ḥayyim* version of the Vital circles was soon paired with a new partner.[126] The two diagrams were included in a number of North African and European ilanot beginning in the 1720s. The second diagram was not Ẓemaḥ's alternative from *Mevo she'arim* but, rather, a seemingly new, structurally oriented synoptic diagram (fig. 117). The inscription in the outermost band begins: "In the beginning the world was primordial aether

Figure 115 (opposite) | Synoptic *parzufim* diagram, fol. 10a, Ḥayyim Vital, *Sefer ha-drushim*, copied and edited by Menaḥem de Lonzano, Damascus, 1610. Jerusalem, NLI, MS Heb. 28°7991. Photo courtesy of The National Library of Israel.

Figure 116 | Enhanced *'Iggulim ve-yosher*, fol. 2b, Ḥayyim Vital, *Ozrot Ḥayyim*. Parma, BP, Cod. Parm. 3547, by concession of the Ministry for Cultural Heritage and Activities from the Biblioteca Palatina. Photo: author.

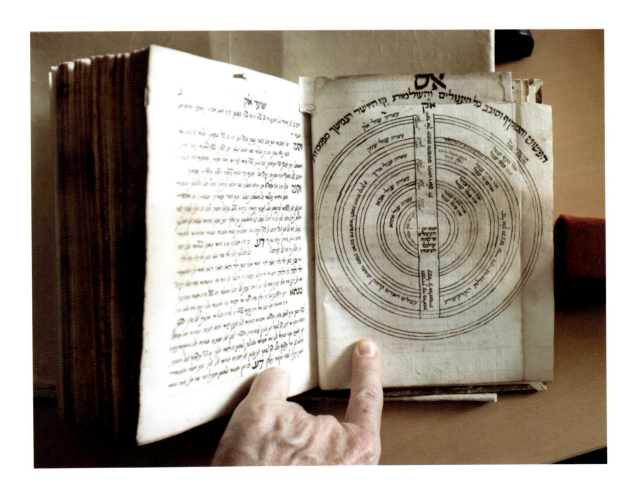

THE EMERGENCE OF THE LURIANIC ILAN | 181

יגעתה ולא מצאתה אל תאמן
שאו מרום עיניכם וראו מי ברא אלה
אין סוף יושר ועגולים דאדם קדמון:

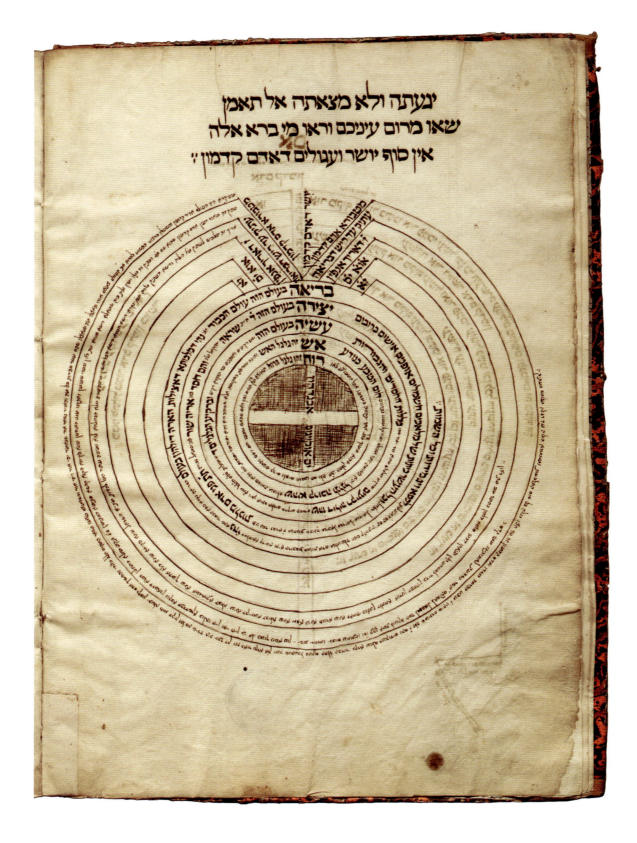

[avir kadmon]; when it arose in its simple will to create the world, it evacuated [ẓimẓem] its light and those that were emanated were emanated, these being the ten immaterial [blimah] sefirot." The five outer bands of the circle represent the *parẓufim*. Each cuts sharply downward upon convergence with the *yosher* of *Adam Kadmon* before terminating at the band of *Beriah*. The result is an elegant alternative visualization of their relative positions as seen in Lonzano's diagram (fig. 115). The texts on the circles emphasize the relational aspect of the *parẓufim*, noting basic enrobings. The lower Worlds are also brought into higher resolution than in the first figure, down to the four elements in the space beneath the lunar sphere. The sublunar realm is represented in a manner that recalls medieval T-O maps, even including the label "*Okeanos*" commonly found on the latter encircling the divided earth.

To the best of my knowledge, the earliest instance of this second diagram is found in a manuscript copied by the kabbalist R. Isaac Coppio (ca. 1680–ca. 1730). Coppio, who traveled extensively throughout his life, was a prolific producer of Lurianic ilanot; I discuss his Great Trees below. Coppio either copied a source unknown to me or designed the second figure to create a striking diagrammatic duo with which to open the Lurianic miscellany he copied in 1709. Empowered by the precedent set by Ẓemaḥ in *Mevo she'arim*, Coppio (or his source) fashioned a twin of his own to complement Vital's diagram (fig. 117). Inscriptions in square script introduce the second figure in this early version: "You have labored and not found? Do not believe" (an odd misquotation of the first-person expression in b*Megillah* 6b); "Lift up your eyes and see who created these" (from Isa. 40:26, but here thanks to Zohar I:1b); and "*Ein Sof*; *'iggulim ve-yosher* of *Adam Kadmon*."

Ẓemaḥ has not disappeared, however; the inspiration of his commentary on the *Idra rabba* on the second figure is evident. We might recall Ẓemaḥ's expression of pride in his ilan making in the introduction to his *Kol be-Ramah*, which could hardly have been lost on Coppio.[127] Expressions from Ẓemaḥ's *Kol be-Ramah* echo in both, from the captions in the *yosher* of the first figure to the texts and structure of the second.[128] In the *Kiẓur drush ha-melakhim* (Abridged teaching on the [deaths of the seven] kings [of Edom]),[129] integrated by Ẓemaḥ into *Kol be-Ramah* from *Oẓrot Ḥayyim*, Vital taught that "*Malkhut* of *Adam Kadmon* is *Keter* of *Aẓilut*; understand this. . . ."[130] Thus if the contemplative sees fit to delve deeply into our words here he will see that *Ein Sof* is within all Worlds and encompassing all Worlds and the legs of *AK* that enrobe *Ein Sof* extend from edge to edge and extend to all the Worlds and encompass all the Worlds of *ABY'A*."[131] This formulation recalls the texts in the *yosher* of the first figure. In his comment on Vital's passage, Ẓemaḥ uses a rare locution that describes the light of *Ein Sof* that enters the spheres as a *ḥut dak* (fine thread). This language is echoed in an inscription on the second figure:

> Ẓemaḥ: "*Ein Sof* is within all Worlds"—all of that fine thread that is within the circles, which is in *yosher*, as mentioned in the homily of *Adam Kadmon*. . . . "And the legs of *AK* enrobe"—that very thread of *Ein Sof*. "The legs of *AK* that enrobe *Ein Sof* extend from the limit to the end"—extending from the topmost edge where begins the thread of *yosher* to the edge of the bottom of the circle of *'Atik Yomin*, as is known from the drawing of the circles [ẓiyyur ha-'iggulim]. He said *ABY'A* because they too, the Worlds of

Figure 117 | Augmented circles of Vital, fol. 2b, Lurianic miscellany, copied by Isaac Coppio in Salonica, 1709. Moscow, RSL, MS Guenzburg 543.

Figure 118 | Frontispiece, Moses ibn Ẓur, *Me'arat sdeh ha-makhpelah*, copied by Isaac Coppio in Morocco, 1720. New York, JTS, MS 2187, courtesy of The Jewish Theological Seminary Library. Photo: author.

Figure 119 (opposite) | Augmented circles of Vital, front matter, in Moses ibn Ẓur, *Me'arat sdeh ha-makhpelah*, copied by Isaac Coppio in Morocco, 1720. New York, JTS, MS 2187, courtesy of The Jewish Theological Seminary Library. Photo: author.

ABY'A, are included in this principle, for the Worlds are circles, as is known.[132]

The congruence between these texts and the *V* element often used in Great Trees is evident. Ẓemaḥ tellingly reinforces the structural point central to his comment by invoking the authority of the "drawing of the circles."

Coppio probably copied the 1709 miscellany that opened with these diagrams in Salonica.[133] Roughly a decade later he was in Morocco, in the circle of R. Moses ibn Ẓur (active early eighteenth century), and the spread of his diagrammatic duo then began. On the one hand, the duo was chosen in 1720 to adorn luxury manuscripts of *Me'arat sdeh ha-makhpelah* (The cave in the field of Machpelah,

from Gen. 23:19), ibn Ẓur's recently completed poetic paraphrase of Vital's *Oẓrot Ḥayyim*; these manuscripts were created by Isaac Ḥajaj (figs. 118–119). On the other hand, Coppio introduced the duo as the opening element of his own ilanot, wedding them to excerpts from ibn Ẓur's poetry (fig. 120). Coppio's marketing savvy, his peripatetic life, and, perhaps above all his final stop in Jerusalem likely contributed to the broad reception of his *V* element by kabbalists from the Maghreb to Mezhbizh (today Medzhybizh, Ukraine). As we will see, *V* would find its way to the beginning (as

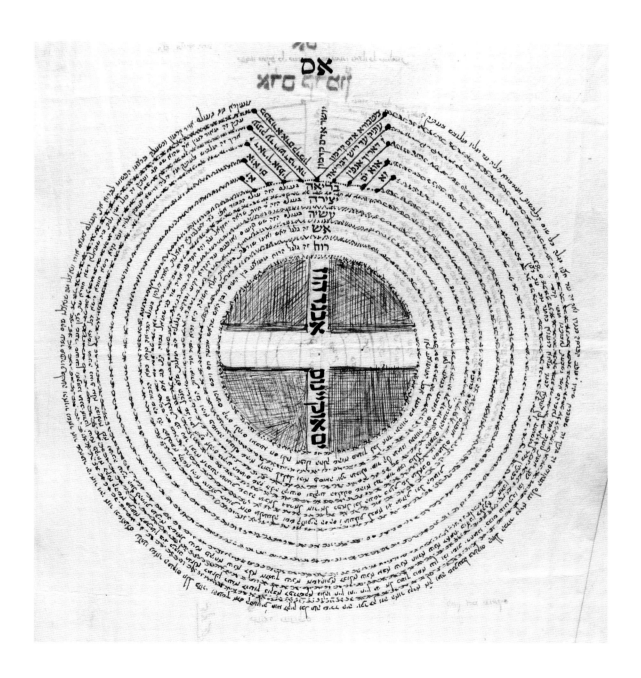

THE EMERGENCE OF THE LURIANIC ILAN | 185

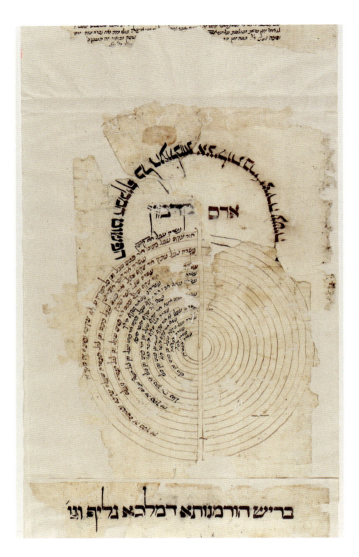

Figure 120 | Augmented circles of Vital, detail from a Great Tree, paper, 409 × 32 cm, copied by Isaac Coppio, Fez, Morocco, early eighteenth century. Tel Aviv, GFCT, MS 028.011.004 (fig. 170). Photo: Ardon Bar-Hama.

well as to the end) of Great Trees produced over a wide geographic range. Such synoptic, all-encompassing pictures of the cosmos could open *or* close an ilan equally well.

How might users of such ilanot have understood the relationship between the pair of diagrams? As we saw in *K*, in a sequence of cosmological circle diagrams, a progressive zooming-in, may be implied (figs. 108–111). Some ilan makers modified *V* in order to establish a visual connection between its two parts. In these ilanot, the elongated vertical channel traverses the first set of circles before plunging to the core of the second. Given the perspective of these circle diagrams—more akin to

Figure 121 | Augmented circles of Vital, detail from a Great Tree, parchment, 348.5 × 22.7 cm, Germany, ca. 1750. Tel Aviv, GFC, MS 028.012.025. (fig. 147). Photo: Ardon Bar-Hama.

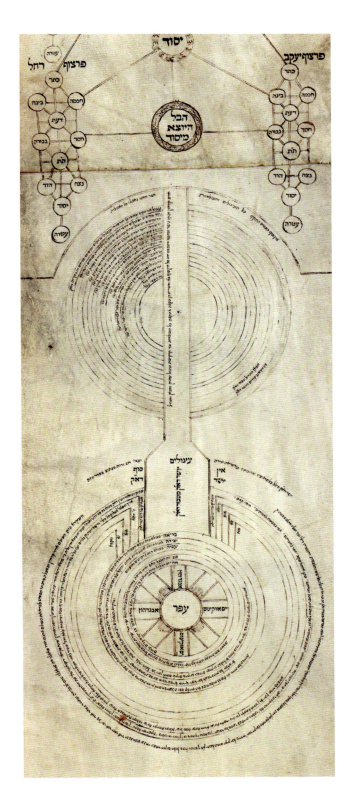

planar (from above) than landscape (from the side) views—such connections must, like the circles more generally, be converted in the mind's eye to three dimensions. The connection between the two figures is, at least in this sense, telescopic, and it was pictured accordingly. In a beautiful rotulus in the Gross Collection, we see the channel that flows through the upper circles continue and broaden as it meets the second set of circles (fig. 121). As in Coppio's early codex diagram (fig. 117), the bands that intersect this wider channel all take a ninety-degree downward turn that bring them, together with the "linear *Adam Kadmon*," to the edge of *Beriah*. Reaching the center of the second diagram, vertical and horizontal radials surrounding the element (not the planet) earth are each inscribed "sea *Okeanos* אבגדהוז," with the first seven letters of the Hebrew alphabet. *Okeanos*, the mythic sea surrounding the earth, is thus the element of water. It is unclear what the seven letters sandwiched between the elements of earth and air were meant to number, as the seven planetary spheres and the seven firmaments belong in very different locations on the map. Perhaps they indicate the seven rungs of *Gehennom*, here linked to the depths (*tehom*) of the mythic sea.

The *Temerles Tree* (*T*)

A rather surprising element that appears in some Lurianic Great Trees testifies to the inclusivity typical of the kabbalists' visual repertoire (fig. 122). The classical sefirotic tree associated with R. Jacob Temerles (d. 1666) would seem to be misplaced in a review of Lurianic diagrams—and indeed it is. It

THE EMERGENCE OF THE LURIANIC ILAN | 187

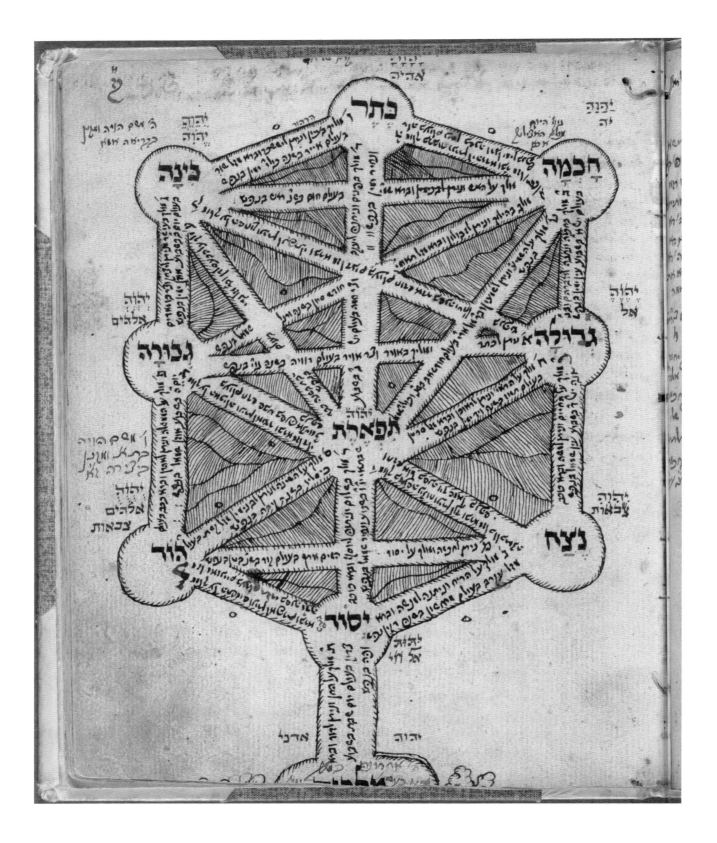

is attributed to Temerles, who served as a rabbi in Kremenets (now in Ukraine) after his expulsion from Worms. Temerles authored a Lurianic commentary to the zoharic *Sifra de-zniyuta* (Book of concealment) called the *Sifra de-zniyuta de-Yaakov* (Jacob's book of concealment).[134] The tree was not part of that work but, rather, appeared in a short treatise entitled *Perush mahalakh ha-otiyot* (Commentary on the pathways of the letters). What distinguishes the arboreal sefirotic diagram in the Temerles treatise from most others is its fidelity to the apodictic assertion of *Sefer yezirah* that the thirty-two pathways of Wisdom by which the cosmos was formed consisted of the ten sefirot and the twenty-two Hebrew letters. As in *Sefer yezirah*, the letters were divided into three mothers, seven doubles, and twelve simples. In Temerles's kabbalistic visualization, the ten sefirot are the medallions of the tree; this, of course, is standard. The ten are interconnected by precisely twenty-two channels, the corridors between any two medallions. This is much less standard, as a perusal of the images in this book will demonstrate. The *Temerles Tree* goes even further, however. There are precisely three horizontal channels, seven vertical channels, and twelve diagonal channels. The texts in the channels make this explicit: the Hebrew mother letters *alef*, *mem*, and *shin*, for example, are found at the beginning of the inscriptions of the three horizontal channels. The rest of the texts are adapted from passages in the third, fourth, and fifth chapters of *Sefer yezirah*, in which the letters of each group are described as having dominion over various aspects of creation. The three mothers rule spirit, water, and fire; air, earth, and sky; and the human chest, belly, and head. The seven doubles rule the seven planets, days of the week, and orifices of the face. The twelve simples rule the signs of the zodiac, the Hebrew months, and the primary human organs.

The structural parallel between the channels of a sefirotic tree and the twenty-two letters in their threefold division was not as simple to establish as it might seem. The channels of the *Temerles Tree* are top-heavy and asymmetrically—one might even say arbitrarily—arranged. The iconic schema, with its descended tenth sefirah of *Malkhut*, was to blame; the channels could not be distributed symmetrically when one of the ten medallions was literally off the chart. The rare diagram in which the ten sefirot are arrayed evenly shows how much easier the parallel might have been (fig. 123).[135] Yet diagrams like this one, for all their appealing balance, did not honor the kabbalistic axiom according to which *Malkhut* was utterly unlike the other sefirot: it received and reflected light but generated none of its own.

The *Temerles Tree* is most commonly found in manuscripts following a short treatise. In these cases, the tree is preceded by another drawing, in which right and left hands are portrayed from the perspective of one reading one's own palms (fig. 124). Lines are not the subject of this apparent palmistry, however, but rather the jointed segments of the fingers and thumbs. In most manuscripts, these are keyed to the letters of the Hebrew alphabet. A copy in the Gross Collection (Tel Aviv, GFCT, MS EE.011.021) supplements the alphabetical key with captions that specify the sefirotic path governed by each joint. For example, the letter *bet* "goes in the channel from *Ḥokhmah* to *Tiferet*" (fig. 125).

The two diagrams, the tree and the palms, are thus intimately related. To understand their combined message, we need to consider the short treatise that they follow. It is untitled and referred to by its opening words, "The judgment of a person

Figure 122 | *Temerles Tree*, fol. 26a, kabbalistic miscellany, paper, 18 × 14 cm, eighteenth-century Ashkenazi hand. COL MS X893 Se3, Rare Book & Manuscript Library, Columbia University in the City of New York.

THE EMERGENCE OF THE LURIANIC ILAN | 189

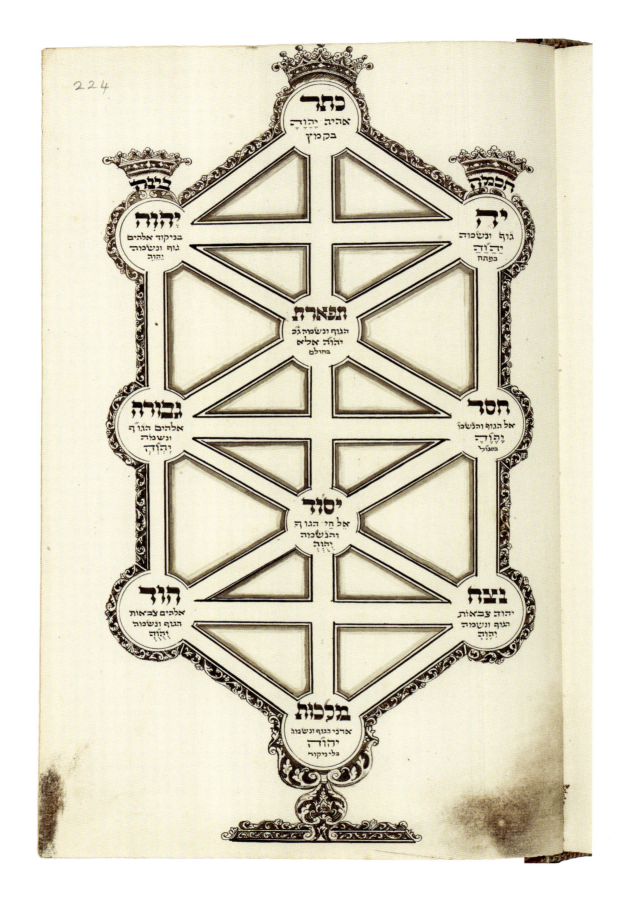

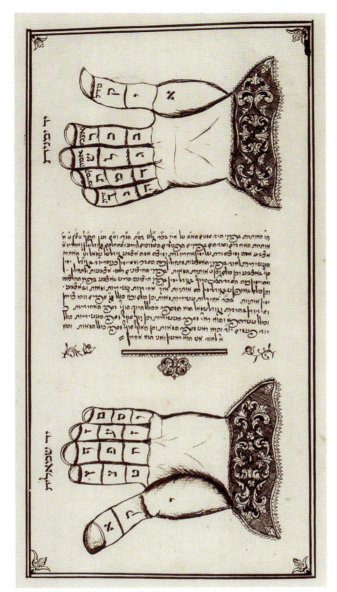

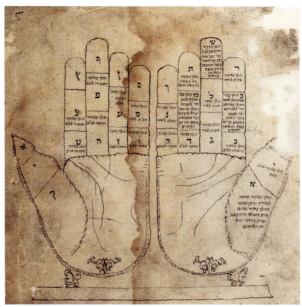

Figure 123 (opposite) | Symmetrical tree of "Thirty-Two Paths of Wisdom," fol. 224a, in Ḥayyim Vital, *'Eẓ Ḥayyim* (Poppers ed.), copied and with illustrations by Israel ben Asher Buchbinder in 1728. Oxford, BL, MS Opp. Add. Fol. 32.

Figure 124 (left) | Hands opened like a book, page 179a, paper, 37 × 23 cm, in Ḥayyim Vital, *'Eẓ Ḥayyim* (Poppers ed.), copied and with illustrations by Israel ben Asher Buchbinder in 1730. Prague, Jewish Museum, MS 69.

Figure 125 (above) | Hands opened like a book, fol. 5a, kabbalistic and magical miscellany, paper, 20.4 × 24.6 cm, Eastern Europe, ca. 1800. Tel Aviv, GFCT, MS EE.011.021. Photo: Ardon Bar-Hama.

[after death] begins with [an inquiry regarding] words of Torah" (b*Kiddushin* 40b; b*Sanhedrin* 7a). It continues with a simple question: "Do you know the *alef-bet*?" The response is not to be verbal, but gestural: one must show one's hands. The letters are inscribed on them and may be read like a book—specifically, *Sefer toldot ha-adam* (The book of the history of the [hu]man).[136] "We find that when one opens one's hands, it is like an open book; when one closes one's hands, it is like a closed book." The author then abandons any literary pretenses and proceeds to list the *Sefer yeẓirah*–inspired associations of each segment of the hands, asserting in the first lines that the reading of the hands is best

THE EMERGENCE OF THE LURIANIC ILAN | 191

assisted by juxtaposing them to the sefirotic tree: "and you will understand from the drawing of the array of the sefirot [mitokh ẓiyyur ha'amadat ha-sefirot]."

The first section of this work is generally attributed (spuriously) to R. Isaac Luria, with Temerles receiving credit for the "Commentary on the Pathways of the Letters," of roughly equal length, that follows it. The simple explanation for the lack of Lurianic content in the treatise and its sefirotic tree is that the R. Jacob Temerles who wrote it lived two generations before his namesake, the Lurianic kabbalist who died in 1666. The earlier, Lublin-born Temerles was not a Lurianic kabbalist at all.[137]

The treatise, commentary, and two diagrams are found together in a large number of kabbalistic manuscripts, many of them miscellanies with a practical orientation. Lurianic Kabbalah was frequently referred to as *kabbalah ma'asit* (practical Kabbalah) by kabbalists and early academic scholars alike. This was not meant to suggest that Lurianism taught grimoire-style magic but, rather, that it prioritized praxis over theology. Before the vogue of mythical and theological readings of Lurianism was established in modern scholarship, the consensus was that Lurianic theory was a means to an end, providing preparatory background to performance.[138] This perception is consistent with the frequent use of the term *hakdamot* (introductions) to refer to discussions of a theoretical nature. As practical Kabbalah, Lurianism centers around its enactment in kavanot and yiḥudim. Seen from this perspective, the ascription of a treatise and commentary on kabbalistic chiromancy to Luria and a Lurianic kabbalist who shared the name of its probable author becomes easier to understand.

The treatise-commentary-diagrams ensemble appears in a seventeenth-century Hamburg miscellany alongside *Pri 'ez Ḥayyim*, a Poppers redaction of Vitalian writings that present Lurianic explanations of the commandments, as well as at the end of the kabbalistic prayer book fashioned by R. Nosen Neta Hammerschlag of Moravia.[139] In the early eighteenth century, it was included in the extraordinary illustrated *'Ez Ḥayyim* volumes crafted by Buchbinder, preceding the *Ilan of Expanded Names* foldouts sewn into the bindings of these weighty tomes.[140] Around this time it was also incorporated into several ilanot that are explored below: the *Tree of Holiness* and, by the end of the century, the ilanot produced by the Baghdadi kabbalist R. Sasson ben Mordekhai Shandukh.[141]

The manuscript of the *Temerles Tree* in the Gross Collection prefaces the treatise with a necromantic technique—a juxtaposition that suggests something about the perception of the work by the scribe responsible for the miscellany: "This tradition is also from the aforementioned Rav [Luria]: at the time when one prostrates oneself on the graves of the dead, one should place one's hand on the grave upon which one is prostrating oneself and say this verse, 'Thy dead shall live, my dead bodies shall arise; Awake and sing, ye that dwell in the dust; For Thy dew is as the dew of light, And the earth shall bring to life the shades' [Isa. 26:19]. One will be assured he will awaken the dead [interred there], whose soul will come upon his so that his prayers be received—for there are sixteen words in the verse, corresponding to the sixteen parts [lit., limbs] of his hand."[142] This practice is unlikely to have been formulated or even endorsed by Luria. When considered in its context, however, it further illustrates the tendency to associate materials of a practical, divinatory, or diagnostic orientation with Vital. It fit the *image* of Luria very well, even if it had nothing to do with his Kabbalah.

The Gross manuscript is not altogether lacking in authentic Lurianic material. Following this necromantic technique, we find a one-page chart of the four *miluim* of *YHVH*; for each one, it provides twelve "rungs" (*madregot*) or expressions. The page

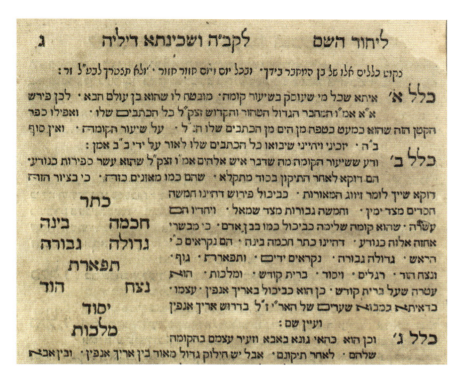

Figure 126 | Twenty-two principles, page 3a, by Eliezer Temerles, in Jacob Temerles, *Sifra de-zni'uta de-Ya'akov* (Amsterdam, 1699). Photo courtesy of Jerusalem, The National Library of Israel, Valmadonna Trust London England 5648.

thus offers assistance to the kabbalist seeking to craft homilies based on such computations. Next follows a two-page composition that lists twenty-two general principles of Lurianic Kabbalah. These principles, here anonymous, were published in the 1699 edition of a Lurianic work by the younger Temerles, the *Sifra de-zni'uta de-Ya'akov*. The book was brought to press in Amsterdam by R. Eliezer Temerles, the son of the author. Eliezer introduced the printed work with the principles, which he himself had authored. He opens his list with the declaration that his father had studied and taught nothing less than *shi'ur komah* (lit., the measurement of the height), thus guaranteeing his place in the World to Come.[143] The second principle states: "Know that this *shi'ur komah* . . . is the ten sefirot, as is known, after the *tikkun*, in the secret of the *mitkalah* [cosmic scale], when they are like a scale, *like this*; for it is precisely with regard to this drawing [*ziyyur*] that one can speak of the coupling of the lights." "*Like this*" refers to a simple kabbalistic tree adjacent to the text in the printed edition (fig. 126).[144] Although the *parzufim* are central to his presentation, the message of R. Eliezer is clear: for all its complexity, Lurianic Kabbalah still boils down to the tree of ten sefirot.

The Thirteen Enhancements of the Beard (E)

The most striking Lurianic diagram is, to my eye, one that visualizes the so-called thirteen enhancements of the beard.[145] Its earliest attestation is in a manuscript of *Derekh 'ez Ḥayyim* copied in Jerusalem in 1679 based on Poppers's own copy.[146] By the end of the century, the manuscript was in the renowned library of R. David Oppenheim of Prague (1664–1736) (fig. 127).[147] The long afterlife of this

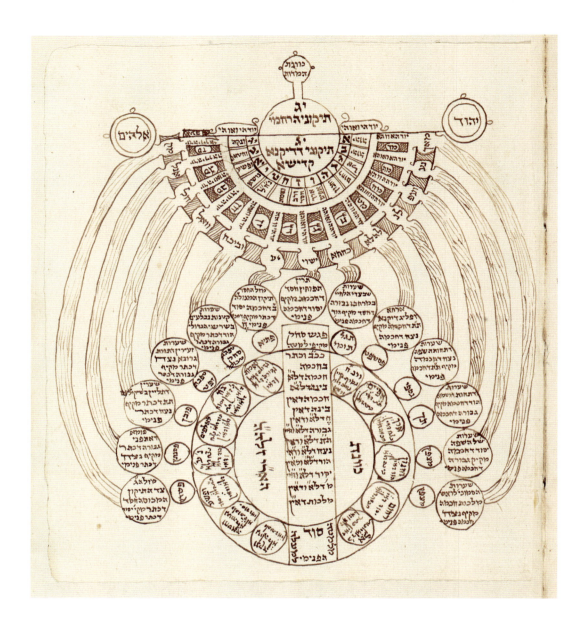

Figure 127 | *Thirteen Enhancements of the Beard*, fol. 328a, in Ḥayyim Vital, *Derekh ʿez Ḥayyim*, Ashkenazi script, copied in Jerusalem in 1679. Oxford, BL, MS Opp. 105.

Figure 128 (opposite) | *Thirteen Enhancements of the Beard*, pages 32b–33a, *Va-yakhel Moshe* (Dessau, 1699). Tel Aviv, GFC, B.433A. Photo: William Gross.

diagram began in Oppenheim's home, where the young R. Moses Graf (Prager) (1650–1705) lodged as he prepared his book *Va-yakhel Moshe* (Moses assembled) for publication.[148] Graf must have been very taken by this image, as his work presented it in a faithful woodcut reproduction over two pages at its center (fig. 128).

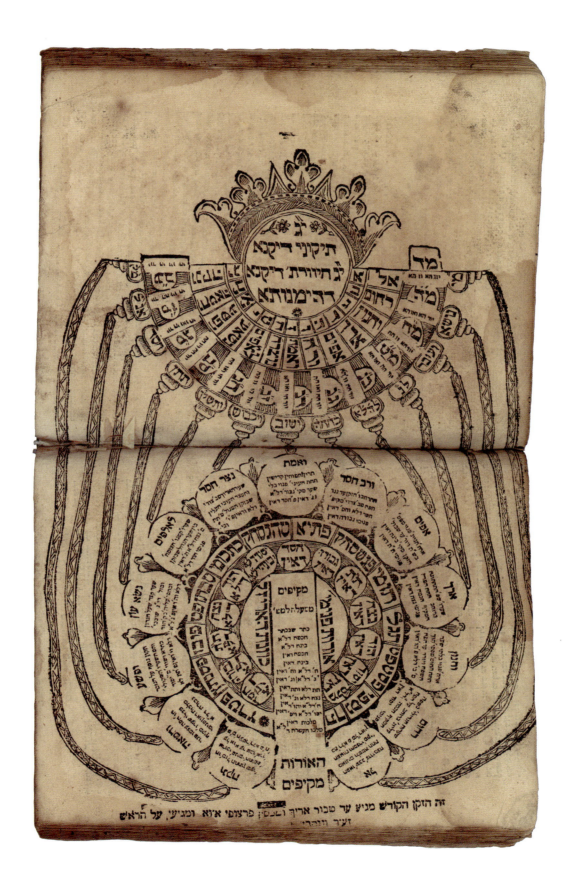

The role of this diagram in the 1679 manuscript codex is not entirely clear. From a codicological standpoint, its placement does not appear to be meaningful: it is glued to a blank page at the end of the book and written in a hand unlike that of the scribe responsible for the pages that precede it. Those pages present unrelated material from "Gate of the *klippot* (demonic shells)," the forty-eighth section of Poppers's *'Ez Ḥayyim*. The meaning of the diagram on its own can nevertheless be ascertained on the basis of its texts. It is a detailed mapping of the thirteen *tikkunin* (enhancements) of the beard of *Arikh Anpin*. This beard flows from *Arikh* to *Ze'ir* and corresponds to the thirteen attributes of compassion.[149] The latter are found in two sources, Exodus 34:6–7 and Micah 7:18–20. The *Idra rabba* teaches that the higher beard of *Arikh* expresses the verses in Micah, which then modulates into the lower beard of *Ze'ir*, which is connected to those in Exodus. *Arikh* is pure love, but *Ze'ir* is a discerning divine persona with the capacity to judge. The integration of their beards is thought to catalyze the opening of the "gates of compassion" (Zohar III:131a). The thirteen streams, representing the dreadlocks-like beard of *Arikh*, are seen in the diagram as if in flow. A closer examination reveals their source in thirteen hubs labeled with the acrostic abridgments of the Micah verses. They culminate in the thirteen medallions below, which are inscribed with the verses in Exodus.

Trees of the Worlds (W)

The *Trees of the Worlds* element is found exclusively at the end of Great Trees and never on its own. Unlike the other elements in this section, it was not an existing diagram in the visual repertoire of kabbalists that was subsequently incorporated into ilanot; nor was it ever an ilan in its own right, unlike the modules examined above. Without troubling too much about its exceptionalism (the categories it does not quite fit are, after all, my own inventions), I treat *Trees of the Worlds* as an element developed specifically to augment Lurianic ilanot. The augmentation brought the Lurianic ilan closer to the totalizing, pansophic ideal of visualizing the entire great chain of being rather than merely its most sublime extremity.

The earliest dated ilan that includes—or, better, concludes (like all ilanot that contain it)—with this element was executed by David Montpellier in London in 1663 (fig. 129). Montpellier seems to have been an Ashkenazi Jew who was just passing through, not a member of the fledgling Spanish and Portuguese (*Nação*) community that had been officially established recently.[150] Had Montpellier found an ilan in the library of a Sephardi community member and undertaken the task of reproducing it on the spot? This seems likely; a century earlier, David Darshan, another wandering Ashkenazi scholar, made a copy of the *Magnificent Parchment* during a sojourn in Modena.[151] The opportunity to reproduce a rare treasure was not to be missed.

Montpellier, writing in an Ashkenazi hand that shows Italian influence, added a colophon at the very bottom of the rotulus. It reads, "I wrote in London the capital; I (am) David *ha-katan* [the small] Montpellier of the order and the count [le-seder u-li-frat] '*I will inscribe* on the tablets [*ha-luḥot*] the words.'" Using a highlighted word or words within a biblical verse to indicate the Hebrew year—a chronogram—was commonplace. Montpellier nevertheless deserves kudos for cleverness. He used the opening of Deuteronomy 10:2, in which Moses refers to copying the first tablets (*luḥot*) of the covenant, to date his production as well as to allude to its generic classification. The date is indicated by paratextual marks above four letters in the apt first word of the verse, *ekhtov* (I will write); together, they have the numerical value of [5]423, the Jewish year corresponding to

1662/63.¹⁵² The verse is part of the weekly Torah portion *'Ekev* and would have been read in late August 1663.

Montpellier's dating verse continues with the prepositional phrase "on the *luḥot*," alluding to genre. In this period, as we saw in the writings of Isaac Wanneh, *luaḥ* could mean board, chart, tablet, or ilan.¹⁵³ In the sense of chart, it could also denote a diagram, a usage found, for example, in presentations of Gikatilla's stick-figure sefirotic tree.¹⁵⁴ Even more instructive is the entry *luaḥ* found in the first printed Hebrew bibliography, *Siftei yeshenim* (Lips of those who sleep), prepared by Shabtai Bass of Prague and printed by him in Amsterdam in 1680.¹⁵⁵ In his alphabetical listing of titles that had appeared up to the time of its printing, Bass included *luaḥ* under the letter *lamed*—first defining it as a medium or format, and then providing a number of examples of works in its category. His first examples are kabbalistic: "§15 *Luaḥ* (or ilan) [parenthesis in the original] of the kabbalistic science, R. Joseph Gikatilla,"¹⁵⁶ and "§16 *Luaḥ* (or ilan) [parenthesis in the original], the preacher [ha-darshan] Abraham ben Moses Brod, which is a very large *luaḥ* of all the general principles of kabbalistic science anthologized [melukat] from all the writings of the AR"I [Ashkenazi Rabbi Isaac (Luria)] of blessed memory. Nothing was omitted, including all the sefirot and the *parzufim* and the Worlds and the channels—with wonderful concision. [Seen in] Manuscript, Prague."

It would seem that ca. 1680, Bass had seen one Lurianic rotulus that had much in common with Montpellier's. Its ascription to Brod (d. 1677), a distinguished rabbi and kabbalist about whom only meager biographical details are known, is

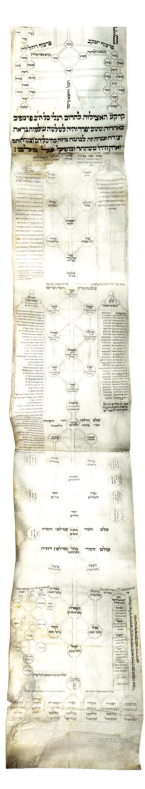
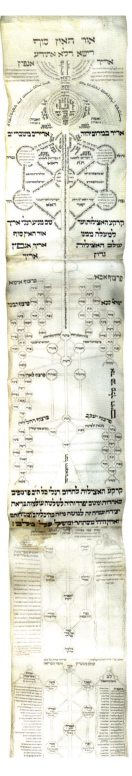

Figure 129 | Great Tree, parchment, 313.7 × ca. 30.5 cm, copied by David Montpellier in London, 1663. New York, JTS, MS S436, courtesy of The Jewish Theological Seminary Library. Photo: author.

THE EMERGENCE OF THE LURIANIC ILAN

tantalizing in itself.[157] Was this otherwise unknown figure responsible for one of the single-origin ilanot? We may never know. Bass's definition of *luaḥ* is, in any event, my central concern here: "§14 *Luaḥ*—or ilan or *map* . . . is a large chart [*luaḥ gadol*] made up of several pages glued together. Upon it is inscribed in the form of circles all the principles and keys and introductions required for every subject and study of a given science. For every science, there is such a chart [*luaḥ ka-zeh*]."[158] Bass's revealing lexical entry captures the sense of *luḥot* in Montpellier's compounded double entendre: on the week Jews read about Moses copying the tablets, he had copied the ilan.

And now to the ilan itself: the top half of the Montpellier rotulus presents Z, which concludes with the inscription I quoted in Knorr's Latin above. Here I translate the Hebrew (thus the modest variance from my translation of the Latin): "This is the ground of *Azilut*, the footstool of all twelve *parzufim* as one; from there they divide and become three Worlds: *Beriah*, *Yezirah*, and *'Assiah*—one beneath the other, in their palaces and castles. The one Lord hides and rules over them all." The designer of the *Trees of the Worlds* seems to have taken this as an invitation to continue the visualization to the end of *'Assiah* (fig. 130).

Whoever created this sequence of diagrams concluded that for the representation of these lower Worlds, classical, pre-Lurianic sources were ideal. For all of its totalizing cosmological ambitions, as I suggested above, Lurianic Kabbalah was disproportionately preoccupied with the world of *Azilut* and had remarkably little to say about the rest.[159] Beneath the heading announcing the beginning of the bottom half of the rotulus, an inscription in small print refers the user to Gikatilla's *Sha'arei orah* and Cordovero's *Pardes rimonim* for further reading. The latter was the model for the overall mapping of the Worlds, the former for many of the basic correspondences of divine names, vowels, angels, and more, which populate the medallions of the sefirotic trees that immediately follow.

In the Montpellier ilan, all Four Worlds receive this classical treatment rather than only those below *Azilut*, as is the case in many other ilanot.[160] Each large tree represents a World, from *Azilut* (now without reference to *parzufim*, as it had been represented in the Zemaḥ module that preceded it) to *'Assiah*. Their medallions pair standard sefirotic appellations with designations unique to each World: in *Azilut* with unerasable divine names, in *Beriah* with the names of the vowels and angels associated with Metatron, in *Yezirah* with the ten classes of angels, and in *'Assiah* with the spheres of the intellect, the zodiac, and the planetary orbs. This lowest frame also adds a sefirotic tree of the demons, akin to that found on the verso of the *Grand Venetian Parchment* (fig. 32), and a tower representing the seven rungs of the netherworld. In Montpellier's ilan, the first two trees are flanked on either side by towerlike columns in which lists are inscribed under various headings. Among them are the "Fifty Gates of Understanding" alluded to in God's response to Job (to the left of the tree of *Azilut*) and the "Thirty-Two Paths of Wisdom" (to the right of the tree of *Beriah*). The margins to the right and left of the lower two trees highlight other associations. The seven lower medallions of *Yezirah* branch out laterally to its seven *heikhalot* (palaces)—an example of a feature of ancient Jewish esotericism incorporated into the kabbalistic world picture.[161] The name of each *heikhal* and its associated angel is featured in a circle inscribed in a square, and each square has seven circles around its perimeter, perhaps meant to suggest its fractal

Figure 130 | *Trees of the Worlds*, detail from a Great Tree, parchment, 313.7 × ca. 30.5 cm, copied by David Montpellier in London, 1663. New York, JTS, MS S436, courtesy of The Jewish Theological Seminary Library.

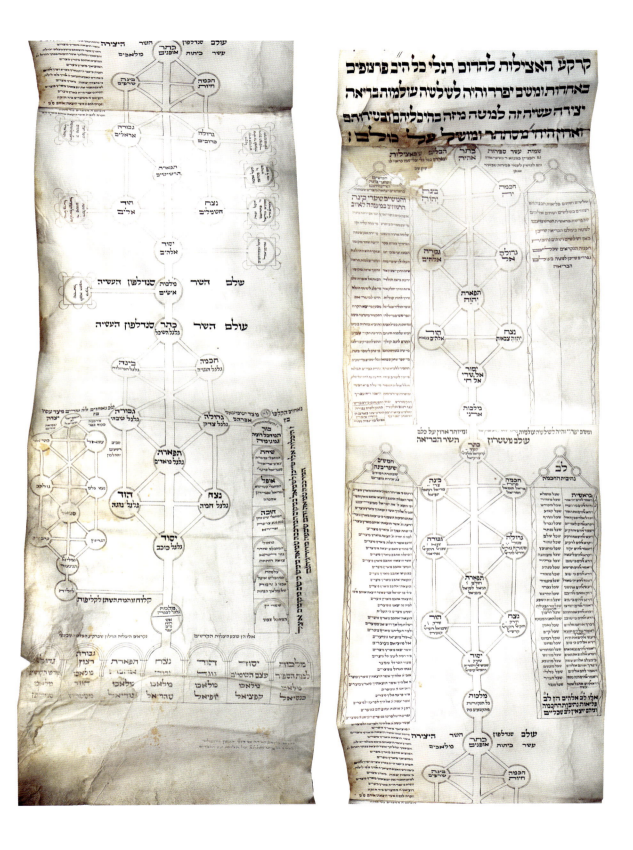

nature. The final tree of *'Assiah* is flanked on the right by a tower of stacked archways representing the seven levels of hell—the "palaces of *temurot*" (exchanges)—and on the left by a demon tree. The seven holy palaces, in a horizontal row of arches, anchor the lowermost central tree. This early copy of the *Trees of the Worlds* is exceptionally rich in content, as even this cursory survey suggests. With rare exceptions, it was reproduced in rather impoverished versions.[162]

Montpellier's ilan also serves to establish that by 1663, kabbalists had begun to make their way toward compound ilanot. At this first stage, the single-origin Lurianic ilan—always devoted chiefly to *Azilut*—was complemented by a diagrammatic series based on classical sources. Rather than compounding Lurianic visualizations of *Azilut*, as would be the case when P and Z modules were joined to form the core of the Great Trees soon to emerge, the Montpellier ilan preserves a pioneering attempt to map the kabbalistic cosmos from top to bottom. It also demonstrated a harmonious perception of Kabbalah in which the new Lurianic system took pride of place atop the hierarchy, as it stood (almost) literally on the shoulders of giants, in this case, Gikatilla and Cordovero.

Chapter 5

Luria Compounded

The New Normal

By the second half of the seventeenth century, a number of ambitious diagrammatic representations of Lurianic cosmogony and cosmology were circulating among kabbalists: oversize foldouts, poster-size parchments, and the first rotuli dedicated to the diachronic representation of the enrobing process. Each had a distinct genealogy: Vital's circles, Ẓemaḥ's interlocking trees, Poppers's head of *Adam Kadmon*, and the anonymous Ashkenazi synoptic *Ilan of Expanded Names* among them. Today they would be marketed as artisanal single-origin products, each idiosyncratic notwithstanding family resemblances born of their common aspiration to visualize Lurianic lore.[1] As we saw in chapter 4, when Knorr gathered the Lurianic ilanot for his diagrammatic apparatus in the 1670s he found four such artifacts for engraving. Kabbalists of the time did not consider these materials as sacrosanct in their independent individuality; instead, they were tools. Whether synchronic structural maps of the divine topography or diachronic timelines of the Divine unfolding, their significance lay in their utility. And just as one might combine various tools to get a particular job done, or consult different maps to better understand a specific locale, kabbalists thought it sensible to combine the diagrammatic visualizations of Lurianism as they saw fit. There were two ways of doing so, and they were not mutually exclusive: assimilative integration and sequential splicing. In the former, parts or all of an originally independent ilan were incorporated into a more comprehensive visualization. In the latter, parts or all of an originally independent ilan were spliced before or after parts or all of another.

Lurianic ilanot from a later period should nevertheless not be dismissed as purely derivative, because kabbalists of the eighteenth and nineteenth centuries produced quite a few novel creations. As a rule,

however, even these innovative ilanot incorporated older elements alongside fresh visualizations. Yet the older elements were not slavishly reproduced. The head of *Adam Kadmon* that opened *P* was copied with textual variations and in an artistic range that spanned from schematic abstraction to shocking representationalism. The impression of the early nineteenth-century Galician maskil Elyaqim Hamilzahgi (1780–1854), who reports having seen over twenty ilanot, emphasizes their diversity: "They were on parchment and on paper, ranging in length from six to twenty or more cubits,[2] which had been acquired at considerable expense by their owners. Among them all there were hardly two or three that presented the same picture, [sefirotic] names, and *parzufim*; the appearance of one was not like the appearance of another, and each held its own teaching."[3] Hamilzahgi may not have spent enough time with these ilanot to realize just why they presented with such diversity. Rather than representing a plethora of unica, these rotuli were the parchment equivalents of Lego-brick towers. Like their click-and-snap counterparts, their bricks—ilan modules and other diagrammatic elements—could be arranged and rearranged at will. The metaphor is imperfect, however; unlike Lego towers, the modules of Great Trees are not connected but, rather, arranged paratactically, thanks to the flexibility of a structure that facilitates free combination.

Indeed, the long rotuli that quickly became the new normal were all Great Trees, a terminology with emic roots that I have appropriated to refer to compound ilanot. Every Great Tree pairs a form of *P* and *Z*, at the very least.[4] The Poppers and Zacuto-Ẓemaḥ ilanot—now "modules"—mapped much the same cosmological terrain and diachronic processes. Poppers had offered something truly innovative in his representation of the head of *Adam Kadmon* before turning his attention to providing more densely intricate visualizations of the enrobing *parzufim* than had his teacher, Ẓemaḥ. Put another way, Poppers increased the resolution of the map (below *AK*) without changing the terrain.

When *Z* follows *P*, the former retaining its titular "*Ein Sof*" now just centimeters below the "Jerusalem" inscribed at the bottom of Poppers, we may be forgiven for feeling as if we've entered an infinite loop.[5] The major *parzufim* now unfold before us once again, this time as what the classical rabbis of antiquity called "chapter headings." Their compounding could hardly have been accidental, given the widespread acceptance of Great Trees by erudite kabbalists no less capable of noticing their internal redundancy than I am. What might have been their motives? Was this redundancy welcomed for its potential pedagogical benefit, allowing a student to review the material from a different angle? Was there an appreciation of the value of multiple approaches? After all, *P* and *Z* each brought a unique perspective to bear on the impossibly complex task of visualizing the Lurianic system.

Although these two ilanot, *P* and *Z*, may be found in some form in every Great Tree, few rotuli preserve these two alone and in their entirety. One such Great Tree is held by the Library of Agudas Chasidei Chabad in Brooklyn, New York (fig. 131).[6] Around 1925 this exquisite parchment rotulus was given as a gift to the sixth *rebbe* of the Lubavitch dynasty, R. Yosef Yitzchak Schneersohn (1880–1950). The ilan is embellished with floral, geometric, and architectural elements; winged cherubs, jewel-encrusted crowns, birds, peacocks, deer, lions, and oxen—the Ashkenazi bestiary—enhance the beauty of this luxury manuscript. The artistry of its execution, which mimics fine engravings, brings to mind the Buchbinder codices with which it shares a common provenance (figs. 100–101).[7] The *Frierdiker Rebbe*, as he is now called, personally inscribed the details of this gift on a sticker that still

Figure 131 | Great Tree, parchment, 230 × 29 cm, late eighteenth century. Brooklyn, Library of Agudas Chasidei Chabad, Megillah 4902 ל.
Photo: Avrohom Perl.

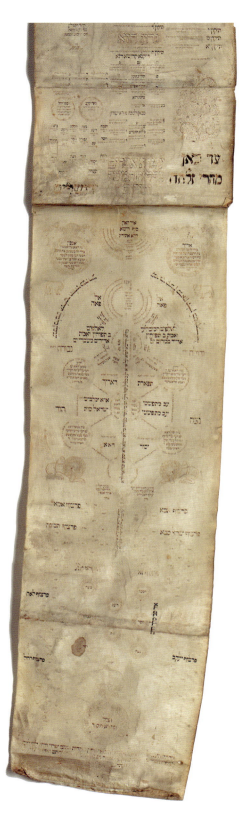
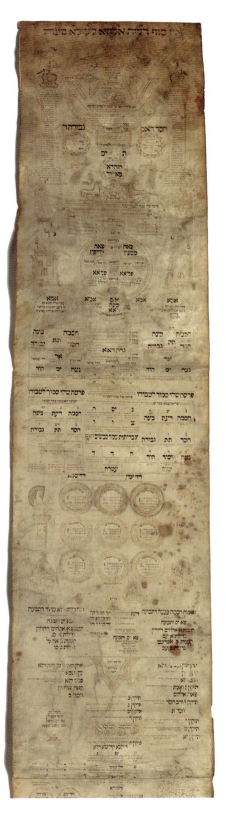

adheres to the verso of the parchment: it was a gift of a certain "Mr. Rubenstein of Königsberg, who received it as an inheritance, [passed down] from [the time of] his great-great grandfather over 130 years ago." Schneersohn thus dated the ilan to the late eighteenth century, a dating consistent with its script, decorations, and content. The top roughly three-fifths of the roll presents a magnificent witness to the Poppers ilan in its complete form, including a scribal gloss treating the contested question of the precise location of the *parsah* of *Adam Kadmon* that "requires further consideration."[8] Unlike most copies, in which this gloss is compressed alongside the inscription captioning this feature of the diagram, the ilan's master scribe placed it in elegant towers that rise up on either side of the opening frame. At the bottom of the *P* module an important disclosure is written in large square lettering: "to this point, from the R. I[saac Luria], may the memory of the righteous and holy be a blessing for life in the World to Come." This rare inscription demonstrates a clear awareness that the rotulus combined ilanot of distinct origins.[9]

The *Chabad Library Ilan* presents *P* and *Z* sequentially. With its head of *Adam Kadmon*, *P* has the more primordial beginning but then proceeds to offer a more ramified mapping of the enrobing process than found in *Z*. By the time a reader reaches the latter, it's a veritable walk in the park. Would it have made more sense pedagogically to have inverted the order? To keep the head of *Adam Kadmon* on top, such an ilan would have to open with the beginning of *P* before the segue to *Z*. Having traversed the schematic adumbration of the enrobing process offered by *Z*, the student would then proceed to the advanced exposition found in the remainder of *P*.

This eminently sensible proposition was in fact deployed in a few ilanot that preserve *P* and *Z* exclusively and in their entirety. I am aware of three such rotuli, all made in late eighteenth-century Ashkenaz. The first is an ilan drafted with economy and skill; the diagrammatic elements are drawn in doubled lines with fine-tooled precision (fig. 132).[10] Decorative embellishment is sparse but elegant. The texts have been inscribed with similar care using a combination of so-called Ashurite square script and the semicursive typical of Ashkenazi provenance. A second ilan of this type has reached us in a manner that is simultaneously suggestive and amusing: it was clumsily sewn onto the bottom of another ilan written by a different scribe.[11] The widths of the top and bottom pieces differ, making the splice immediately apparent (fig. 133). The top is an extraordinary ilan in its own right and will be discussed in due course below. The bottom is a well-made ilan that nevertheless appears somewhat chaotic in comparison to its peers. Unlike the first ilan (fig. 132), which used scripts of one size throughout, this one is written with square, cursive, and semicursive scripts of all shapes and sizes. An examination of its use of large, bold inscriptions for particular words and phrases reveals that it is closely related to the third rotulus of this type, the extraordinarily sumptuous *Trinity Scroll* in Cambridge, Trinity College Library (fig. 134, gatefold following page 206).[12] A common source likely accounts for their shared traits. One is the workmanlike, accurate copy made by a kabbalist and the other a luxury copy made by a professional scribe.

The *Trinity Scroll* makes an indelible impression at first sight. It begins with a shamelessly anthropomorphic head of *Adam Kadmon* and ends with an elegant engraving of Jerusalem, both of which we have already seen.[13] Framing the entire ilan on all four margins are kabbalistic poems by R. Abraham Maimon, a student of Cordovero's in Safed ("El mistater be-shafrir ḥevyon") and Moses Zacuto ("Or ganuz").[14] Although from a modular point of view the *Trinity Scroll* includes exclusively *P* and *Z*, the latter features a significant external element: a textual frame evoking the *mise-en-page*

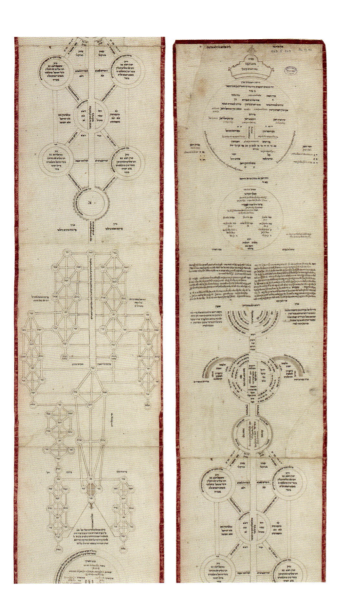
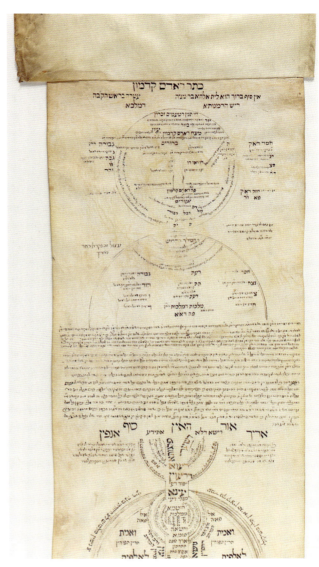

of a traditional commentary.[15] One hoping to find a commentary explaining Z is in for a disappointment, however. The text is the *Kizur 'olam ha-tikkun* (Abridged world of rectification) by R. Joseph Solomon Delmedigo.[16] He composed it as a summary of the extended treatment of the enrobing process he had presented earlier in *Ta'alumot ḥokhmah* (Mysteries of wisdom). This précis was

Figure 132 | Great Tree, top section, parchment, 380 × 27 cm, late eighteenth century. Jerusalem, NLI, MS Heb. 8°963. Photo courtesy of The National Library of Israel.

Figure 133 | Great Tree, top section of part 2, parchment, 181 × 24.5 (part 2 only), Eastern Europe, eighteenth century. Tel Aviv, GFCT, MS 028.012.005 (for part 1, see fig. 198).

LURIA COMPOUNDED | 205

intended to accompany the diagrammatic presentation appended to the end of the companion volume, *Novelot ḥokhmah* (Fallen fruit of wisdom), which was published after some delay in 1631. It is to these back-matter diagrams, printed on both sides of a foldout sheet, that he referred in the closing words of the text: "and before you, all of this is drawn and established [meẓuyar u'metukan]."[17] I will examine Delmedigo's diagrams below under the rubric of printed ilanot; for now, I merely point out that the text must have suggested itself as a useful complement to the austerely inscribed Z. The combination certainly had its merits, as the text provided a linear, progressive narrative account of the structural dynamics visualized in the ilan. As a static chart, labeled but not numbered, these dynamics could not be inferred from the image alone, even if its implicit hierarchy and the act of scrolling implied forward movement.

A deeper complementarity may have been intended. Delmedigo's *Ta'alumot ḥokhmah* presented Lurianism on the basis of the literature available to him in early seventeenth-century Europe, which meant extensive reliance on the teachings of R. Israel Saruq.[18] The image and the text framing the ilan were thus products of different schools. Saruq did not *only* teach about the primordial *Malbush* that preceded Vital's cosmogonic starting point, however, and Delmedigo's text gives it short shrift. He had written it to review the enrobing process of the World of *Tikkun* and only needed to provide a modest Saruqian background before turning his attention to the subject at hand. If not a perfect match from the beginning, the ilan and Delmedigo's text were not a clumsy couple after the fact.

I cannot fail to comment on the high level of artistic execution of the *Chabad Library Ilan* and the *Trinity Scroll*; both embrace an unusually representational iconography. From a purely modular perspective, they are simply $P + Z$, one sequential, one spliced. In a survey of Lurianic trees they would have few peers in the second generation, the first generation populated by the single-origin ilanot themselves. Both are luxury manuscripts, however, not the first modular ilanot or Great Trees that sired all the successors. They are deluxe versions of the basic models that sufficed for everyday kabbalists. Moreover, unlike those simpler ilanot, the *Trinity Scroll* is riddled with elementary textual errors whose nature and number point to it having been executed by a talented artist unable to fathom the content of the Great Tree that he was tasked with embellishing.[19] That said, the unusual beauty of these ilanot surely contributed to their survival long after most of the heavily used rotuli that kabbalists made for themselves were consigned to genizot, repositories of sacred trash.[20]

Great Trees consisting exclusively of the two core modules P and Z are thus exceedingly rare; as a rule, they include additional modules and elements. The rationale for such augmentation is clear when the components are complementary. If P and Z present largely overlapping emanatory timelines, they also share common limitations. They present neither visualizations of processes the kabbalists imagined occurring prior to the emergence of the light streams from the face of *Adam Kadmon*, nor the Worlds below *Aẓilut*. A visualization of Saruqian teachings that treated the *Malbush* thus perfectly complemented the PZ core.[21] Similarly, W, the sequence that visualizes the Worlds below *Aẓilut*, was crafted expressly to supplement the presentation of Lurianic enrobings in the first of the Four Worlds.

The compound nature of almost every ilan in circulation over the past three hundred years demonstrates that the modular approach was the norm. Although the *Chabad Library Ilan* included the rare signpost signaling the transition from one module to the next, the use of the singular *ilan* in such titles as *Ilan ha-kadosh* (Holy tree) and *Ilan ha-gadol* (Great tree) points to indifference toward

The *Trinity Scroll* (*overleaf*)

Figure 134 | The *Trinity Scroll*, a Great Tree with Delmedigo, Maimon, and Zacuto frame, vellum, 280 × 35 cm, Central Europe, eighteenth century. Cambridge F.18.11, by permission of the Master and Fellows of Trinity College Cambridge.

their amalgamated character. This indifference is particularly evident in the mid-nineteenth-century *Great Tree*—in the singular—*of R. Meir Poppers*, the parchment rotulus that served as the basis for the 1864 printed edition (see below, fig. 226). Did the kabbalist who crowned it with that title truly believe it was a single ilan composed by a single author, namely Poppers?[22] Perhaps, although the attribution should probably be taken as a calculated attempt to confer the authority of Poppers upon the artifact; I doubt that it attests to a considered view of its provenance.[23] As we will see, the *Great Tree of R. Meir Poppers* was reissued in 1893 as a bound book that divided the rotulus into thirteen frames. When he discovered a Great Tree that included an additional module, N, the editor of the new edition simply added a fourteenth frame. N (the *Ilan of Expanded Names*) became §9 of the (still singular) Great Tree still bearing the attribution to Poppers in its title. Although this editorial decision may reflect the intensifying aspiration "laẓet le-khol ha-deʿot" (to fulfill all opinions), it clearly expresses what had become the standard approach to these artifacts.[24]

Kabbalists were hardly committed to the endemic redundancy of the full PZ. They had another option: the modular method could be applied to the modules themselves. The *Trinity Scroll* presented a full Z spliced into a full P just after the diaphragm of *Adam Kadmon*. This approach seems to have precipitated the emergence of an abridgment that quickly became the most reproduced Great Tree of its time. Ilanot of this type begin with the head of *Adam Kadmon*, but continue only as far as the *parsah* diaphragm (Pa).[25] They then continue with Z and its treatment of *Arikh* and the enrobing of the major *parẓufim*.[26] Rather than return to the Poppers module to see it through to its end ($P7$), they skip directly to the visualization of the lower Worlds (W). Judging by the number that have reached us, the $PaZW$ ilan was a great success. Not only was it more widely copied that the Great Tree that ultimately made its way to print but it also became the basis of the most popular ilan amulet.

We have, at this point, analyzed almost every ingredient that goes into the making of a Great Tree: the major Lurianic ilanot (modules), the broader diagrammatic repertoire (elements), and the common heart ($P + Z$) that is at the core of these compound artifacts. The rest, as they say, is commentary. I continue my analysis of the Lurianic ilan by building on these foundations to survey the forest of Great Trees. Despite sharing so many common building blocks, the diversity of Great Trees is undeniable. My goal in what follows is to unpack this diversity, account for it, and analyze it. This means telling the stories of trees in their individual idiosyncrasies, reconstructed to the greatest extent possible from direct and indirect evidence. I highlight the added value that scribes contributed to their copying and compounding of "off-the-rack" components. What does this tell us about the people who produced these ilanot, their beliefs and taboos, their ritual practices and aesthetics, the books in their libraries, and how they read them? The answers will also illuminate broader communal, geographic, and historical settings, individual quirks excepted.

I begin this investigation of Great Trees by presenting a number of ilanot that illustrate the range of combinations produced without going significantly beyond what was in widespread circulation. Even these yield surprises and fascinating backstories. I then treat Great Trees that exhibit the intervention of a bold creator in a section all their own. These kabbalists created distinctive ilanot, their indebtedness to stock elements notwithstanding. The four ilan makers I highlight were, to varying degrees, gifted scribal artists with a talent for rendering their visual thinking in this genre; each was responsible for drafting a number of important graphic kabbalistic artifacts. Finally, I conclude my

GREAT TREE COMPONENTS KEY

To reiterate: a Great Tree is a rotulus composed of more than one single-origin Lurianic ilan. When they are found in Great Trees, I refer to such originally single-origin ilanot as modules. The ubiquitous modules in Great Trees are versions of the Poppers and Zacuto-Ẓemaḥ ilanot analyzed above. Additional kabbalistic diagrams were often added to the mix; I refer to these as elements. The outlier in this classification is Knorr's Saruqian ilan (K); although it was conceived by Knorr as a stand-alone ilan, it is found in Hebrew manuscripts exclusively as the opening module of Great Trees.

The following key was developed to identify the major Great Tree manuscript families. It is meant to be heuristic rather than exhaustive. Although additional details could be added, doing so would neither clarify the principal features of these artifacts nor meaningfully alter the results of my genealogy. The single textual element whose presence or absence proves to be a significant family trait is the scribal gloss on the uncertain position of the *parsah* of *Adam Kadmon*.[27] It is found exclusively on versions of the Poppers module and is keyed below accordingly.

MODULES

K—Knorr's Saruqian ilan (adapted from *Kabbala Denudata*, figs. 8–11)

N—the *Ilan of Expanded Names* (represented in *Kabbala Denudata* as *fig. 15*)

$P/Pa/P7/Pr/Pu$—Poppers
 P—*Ilan of Adam Kadmon and the Enrobings* (corresponding to *Kabbala Denudata*, figs. 1–7)
 Pa—an abridged version of the *Ilan of Adam Kadmon and the Enrobings* up to the head of *Arikh* (corresponding to *Kabbala Denudata* fig. 1 and the top of fig. 2)
 $P7$—the continuation of P (from where Pa left off to the end of the section corresponding to *Kabbala Denudata*, fig. 7, ending with "Jerusalem")
 Pr—*Ilan of Adam Kadmon and the Enrobings* with corrupt structure (the section corresponding to *Kabbala Denudata*, figs. 6–7, has been spliced into the section corresponding to *Kabbala Denudata*, fig. 3)
 Pu—single-column redesign

$Z/Z13/Z14$—Zacuto/Ẓemaḥ
 Z—*Arikh and the Enrobings* ilan (represented in *Kabbala Denudata* as figs. 13–14)
 $Z13$—Zacuto's *Arikh* only (*Kabbala Denudata*, fig. 13)
 $Z14$—Ẓemaḥ's *Ilan of the Enrobings* only (*Kabbala Denudata*, fig. 14)

The modules are easy to distinguish. A glance at this four-module Great Tree from a bird's-eye view should suffice to illustrate the phenomenon (fig. 135, gatefold following page 210).

ELEMENTS

E—*Thirteen Enhancements of the Beard*

T—*Temerles Tree*

V—*Grand Circles of Vital*

W/Wy—*Trees of the Worlds* (*Wy* concludes with *Yeẓira*)

treatment of Great Trees with two outliers, each of which opens with a novel visualization based on a (different) specific book. Just as Knorr von Rosenroth transformed key texts and paratexts of ʿEmek ha-melekh into the Saruqian ilan that would ultimately open so many Great Trees as *K*, two later kabbalists fashioned alternative Saruqian openings for Great Trees based on their readings of other works. This phenomenon—the conversion of book to ilan—deserves attention for what it has to teach us about the ongoing perception of the Great Tree as a fundamentally open (icono)text, as well as about the visualization of knowledge more generally. The diverse artifacts explored below were produced over centuries and continents; for all their differences, they tell us about kabbalistic practice and pedagogy, the persistence of manuscript esoterica and scribal arts in the age of print, and the transfer of knowledge and its visualization.

Great Trees

I begin my detailed exploration of Great Trees with examples of ilanot that illustrate the range that could be produced by varying combinations of modules and elements that are now familiar to the reader. Although I hesitate to offer a statistical analysis based on such a small sample, I would like to offer a few insights based on what the extant rotuli suggest.[28] Nothing would please me more than to add a Tree of Ilanot diagram to show the genealogical relationships among the various manuscript families, but this has proved elusive. According to my analysis, even though all Great Trees are indebted to common modules and elements, they did not neatly branch out from a common source. In short, there is no "ur" Great Tree.

I can nevertheless share some provisional insights gleaned from my analysis of the entire corpus. In these mix-and-match, off-the-rack Great Trees, the most significant variations within a given module are seen in *P*. We thus find manuscript families in which *P* has undergone abridgment (*Pa*) as well as reordering (*Pr*). The scribal gloss treating the location of the *parsah* of *Adam Kadmon* ("requires further consideration"), which is not found in the single-origin ilan, became a universal component of Great Trees except for amulets and those that underwent reordering (*Pr*). The *P* module also reveals the most artistic variation, with graphical features largely correlating with other manuscript family markers. We see schematic circular faces of *Adam Kadmon* within which the *moḥin* are in a triangular format; representational faces of *Adam Kadmon* in which the right and left ears are gracefully outlined in the circle or boldly protrude from either side of it; and tabular as well as anthropomorphic representations of *Zeʿir*'s face.[29] An elegantly streamlined version, *Pu*, is also occasionally found among the Great Trees.

Looking at the larger patterns that emerge from my analysis, I would add the following observations. First, the great majority of Great Trees (amulets excepted) present *P* after a prologue of some kind. By far the most common is based on Knorr's figures (*K*). We find *K* introducing a handful of full sequential *PZ* compounds, the latter akin to the *Chabad Library Ilan* (fig. 131); some of these end with the lower Worlds (*W*). Most Great Trees that open with *K*, however, show a reordered—indeed, corrupt—version of *P*, namely *Pr*. The explicit attribution to Poppers is found exclusively in a subset of this family that includes the source of the printed 1864 edition. Other prologues to *P* include Vital's *Grand Circles* (*V*) as well as the more idiosyncratic openings discussed below in the sections on artisanal and book-visualization ilanot.

To this point we have encountered Lurianic ilanot in their earliest single-origin forms and as minimal, two-module (*PZ*) Great Trees. Before turning to the more idiosyncratic ilanot, I want to provide

a sense of the Great Trees that combine three, four, and even five components. Although I probe their backstories whenever possible, my approach here overall is gallerylike and impressionistic.

I begin with a beautiful ilan that augments *PZ* with a visualization of the lower Worlds (*W*); the very popular abridged version (*PaZW*) will follow. I then present the work of an anonymous scribe who made a number of particularly elegant diminutive ilanot. His most ambitious Great Tree features the slender *Pu* redesign followed by stylishly drawn versions of the *Ilan of Expanded Names* (*N*) and the *Thirteen Enhancements of the Beard* (*E*). Great Trees that open with prologues to *P*—Vital's *Grand Circles* (*V*) and Knorr's visualization of the Garment (*K*)—round out this survey. Additional variations may be found in the brief appendix of the Gross ilanot collection at the end of the book.

GREAT TREE TYPE *PZW* | TEL AVIV, GFCT, MS 028.011.006 (FIG. 136, GATEFOLD OPPOSITE)

This elegant paper ilan was written by an experienced, professional hand. The facial features of *Adam Kadmon* and *Arikh Anpin* are depicted primarily through micrographic text layout. The geometrical precision and balance achieved by the scribe is more conspicuous than any human features. Scribal prowess is on display from the very beginning, with a heading in grand, cross-hatch-filled lettering:

> BS"D [be-sayata de-shmaya, with the help of heaven]
> This ilan ha-kadosh, may its merit protect us, and so may it be His will, amen.
> The Light of *Ein Sof* blessed be He and blessed be His Name. . . .

The self-referential "holy tree" (*ilan ha-kadosh*) in the title is reminiscent of the openings of most ilan amulets and may point to a common lineage. As we shall see, the family of Great Trees that spawned these amulets is an abridgment of this type, but the abridgments do not carry this title.

The *Trees of the Worlds* (*W*) element that supplements the *PZ* core of this ilan begins with *Beriah* (forgoing what would otherwise have been a third representation of the World of *Azilut*) and reaches all the way to the World of *'Assiah*. The representation of this lowest of the Four Worlds presents the four sublunar elements, the planetary spheres, and those of the fixed stars and the intellect in the medallions of a sefirotic tree. Other versions of *W* represent *'Assiah* with the concentric-circle schema. Why does this ilan use an arboreal schema to represent a reality that everyone agreed was spherical?

This representation had deep roots. It may be seen, for example, in the *Magnificent Parchment* of ca. 1500 (fig. 36). In that work, however, the astronomical spheres are shown in the bottom third of the parchment in its elaborate zodiac rota. A secondary diagram in the *Magnificent Parchment* presents a tree of planetary spheres that associates the planets with the sefirot. That an indexical rather than an iconic sign was intended is further suggested by the fact that the bottom of this secondary diagram itself shows a representative pie-slice of the spheres when they are pictured in their actual place in the cosmos (fig. 137).

The presentation of the universe as a tree asserted that a common, underlying sefirotic structure was shared by all levels of creation. In the spheres-as-sefirot tree, we see a mapping of the celestial spheres of *'Assiah* that associates each with its analogue sefirah. Nevertheless, the arboreal structure should not be dismissed as purely instrumental. At least implicitly, the enrobings of *Adam Kadmon* that began in the highest World still demanded that structural analogues in lower registers recur to the very bottom of the great chain of being. Rather than providing an astronomical view

Four Great Tree Modules and Great Tree detail (*overleaf*)

Figure 135 | Four Great Tree modules. Tel Aviv, GFCT, MS 028.012.012 (see fig. 146).

Figure 136 | Great Tree, top section, paper, 455 × 22.3 cm, Land of Israel (Jerusalem), ca. 1900. Tel Aviv, GFCT, MS 028.011.006 (detail). Photo: Ardon Bar-Hama.

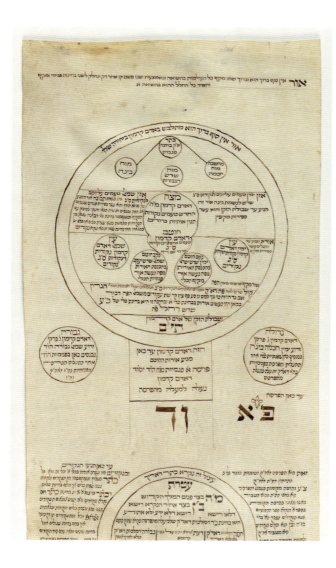
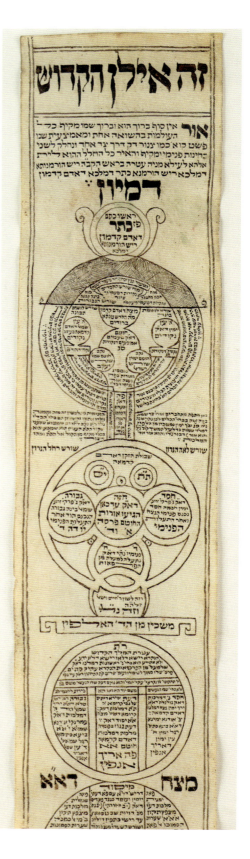

Figure 138 | Opening *P* detail from a Great Tree, parchment (goat), 344 × 26 cm, Morocco, mid-nineteenth century. Tel Aviv, GFCT, MS 028.012.022. Photo: Ardon Bar-Hama.

Figure 139 | Opening *P* detail from a Great Tree, parchment (sheep), 262 × 8 cm, Eastern Maghreb (Tunisia, Libya) or Land of Israel, late nineteenth century. Tel Aviv, GFCT, MS 028.012.016. Photo: Ardon Bar-Hama.

ha-kadosh]." Thereafter follows a paraphrase of the Lurianic teaching on the beginnings of emanation following the *zimzum* that is so often accompanied by the simple *'iggulim ve-yosher* diagram.[33] It reads, "The light of *Ein Sof*, may He and His Name be blessed, surrounding all Worlds in perfect balance [hashvaah aḥat]. From its center it extended [pashat] a single line [kav aḥat] like a fine channel from one side. It split into two aspects, inner and surrounding, and illuminated all of that space. There is no God above Him, Crown on the head of the Blessed Holy One, 'at the head of the potency of the King,'[34] beginning of the will, Crown of the King of *Adam Kadmon*." Next, on a line of its own, is a single, headline-size word: *dimyon* (likeness). It is both unique and unexplained, but the context indicates that it serves as something of an apology for everything that will follow: a stunning visualization of the divine realm, from top to bottom. Although its heads of *Adam Kadmon* and *Arikh* could hardly be more schematic, with no hint of representational elements, the ilan remained a spatialization of the Divine—which was, after all, the place of space and not subject to spatial conceptualization, let alone representation. It is fascinating that the kabbalist who crafted this ilan thought to open with this bold disclaimer.

The ilan is distinctive in a number of respects. First of all, it presents an uncommon and highly

Figure 140 | *Thirteen Enhancements of the Beard*, detail from a Great Tree (fig. 139). Photo: author.

LURIA COMPOUNDED | 213

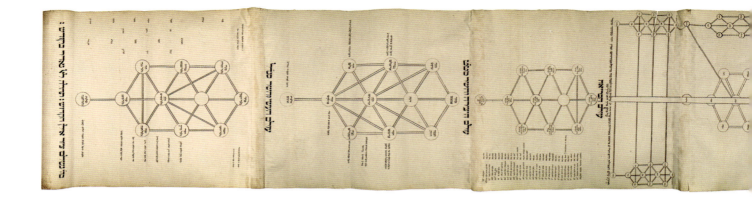

Figure 141 | *Kitzes Ilan*, parchment, 430 × 52.5 cm, obtained by S. An-sky during his expedition to Volhynia and Podolian governorates in 1912–14, Eastern Europe, late nineteenth–early twentieth century. St. Petersburg, Russian Museum of Ethnography, inv. no. 6396-101.

stylized aesthetic. Given its late nineteenth-century dating, its clean lines and rounded figures seem appropriately modernist. Yet for all its apparent modernism, the appearance of this ilan is indebted to a venerable tradition of representation, the streamlined *P* variant *Pu*.[35] Adding to its striking appearance are its odd proportions: it is roughly one-third the width of typical ilanot that bear comparable content. Although some streamlining and editing abetted this miniaturization, it is primarily the result of clever graphical devices and modest reordering. The fact that the ilan opens with *P* may not be immediately apparent because the circular figure atop the rotulus hardly resembles the faces of *Adam Kadmon* we have seen thus far. A simple comparison, however, confirms that its content is nearly identical to theirs.

Although this beautiful ilan includes no instructions for use, one need only hold it to appreciate its natural ergonomics (fig. 140). It is a truly personal, handheld ilan that scrolls with ease. Its miniaturization is not a liability thanks to the precision of its lettering and graphical execution. Yet its intended uses were unlikely to have been limited to study and meditation, given the substantial empty area at the bottom of the rotulus. The blank space was intended to be filled with an inscription to a dedicatee. A comparison to three other closely related ilanot, all of which end with directives for using the ilan as an amulet to be worn in a pure silver case, confirms this impression. I will return to this ilan and its unusual siblings below when considering the ilan amulet.

GREAT TREE TYPE *VPaZW* | THE *KITZES ILAN*—ST. PETERSBURG, RUSSIAN MUSEUM OF ETHNOGRAPHY, INV. NO. 6396-101 (FIG. 141)

This imposing ilan was collected by S. An-sky (Shloyme Zanvl Rappoport, 1863–1920) in the course of his prescient 1912–14 expedition to Volhynia and Podolia. It passed from the An-sky collection to the Russian Museum of Ethnography in 1926.[36]

Great Trees of type *VPaZW* were produced from eastern Europe to northwestern Africa, but this late nineteenth-century Hasidic expression is one of only two with a European provenance; the rest were copied in North Africa between the early eighteenth century and the late nineteenth.[37] The first remarkable thing about this Great Tree

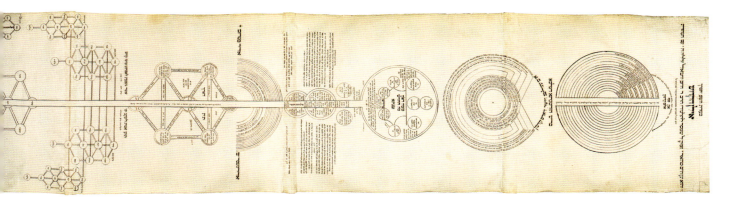

in St. Petersburg is its size: it is literally twice the length and width of its siblings. Such a generous width would be fully exploited by the makers of the artisanal ilanot explored in the next section, but here the scribe has simply enlarged the contents without additions or interventions, as the ample white space of the parchment testifies. This redwood of Lurianic ilanot is best appreciated when displayed from top to bottom, as it is in the museum today in a special glass cabinet.

The second distinction of this ilan is its claim, in the third and fourth lines, to include the comments (*hagahot*) of "the great rabbi, famous in his name, in his deeds, and in his place: R. Zev Kitzes (or Kuẓis, ca. 1685–ca. 1770) of blessed memory." Kitzes was the leader of the circle of kabbalist-pietists of Mezhbizh when the Ba'al Shem Tov (the Besht, ca. 1700–1760) arrived in the village; he initially opposed the latter before becoming a disciple. Kitzes is primarily remembered for his piety and proximity to the Besht, alongside whom he was buried. The claim about Kitzes's comments may have added luster to the grand parchment, but apart from this, the ilan's contents do not differ from other Great Trees of its type.

The *Kitzes Ilan* is titled "Ilan ha-kadosh." Its unusual subtitle features an apt play on words: "And it is the tree of life ['eẓ ḥayyim] of the AR"I

that he transmitted [she-masar] to his student, the rabbi Ḥayyim Vital." The ilan is the "tree of life" and, at the same time, a précis of the canonical book of the same name. The assertion may also allude to the "pure fine flour" position, according to which only Vital's version of Luria's teachings were to be studied.[38] Given the widespread use of prologue modules that visualized the *Malbush* of Saruq's teachings, the subtitle may also allude to a principled decision to replace it with *V*, the circles of Vital.

GREAT TREE TYPE *KPaZP7* | THE *GRUPA ILAN*—
CINCINNATI, HUC, KLAU LIBRARY, SCROLLS 69
(FIG. 142)

We will probably never know who initiated the use of the first four frames of Knorr's original Saruqian ilan atop a Great Tree. A comparison between Knorr's *figs. 8–11* and the *K* modules that open so many Great Trees nevertheless leads to a clear conclusion: Cincinnati, Scrolls 69 preserves the earliest *K* to have reached us. The presumption underlying this identification is that the retention of detail—and especially what seems to be meaningless

Figure 142 (overleaf) | *Grupa Ilan*, parchment, 309 × 26 cm, early eighteenth century. Cincinnati, HUC, Klau Scrolls 69.

LURIA COMPOUNDED | 215

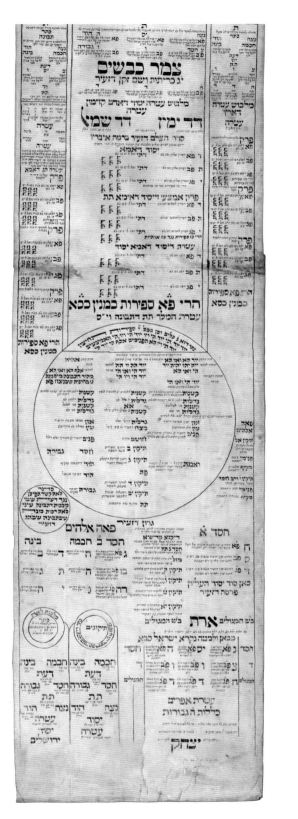
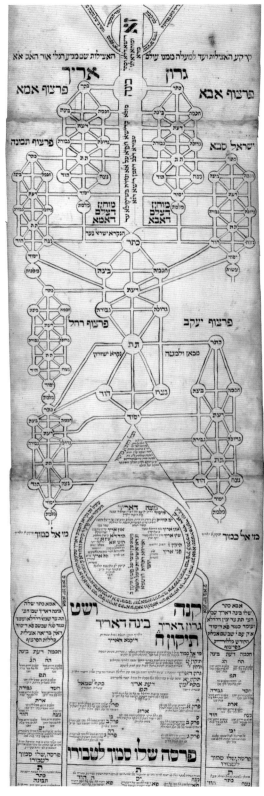

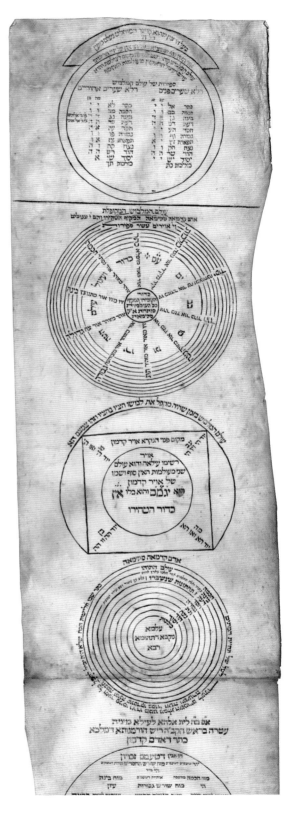
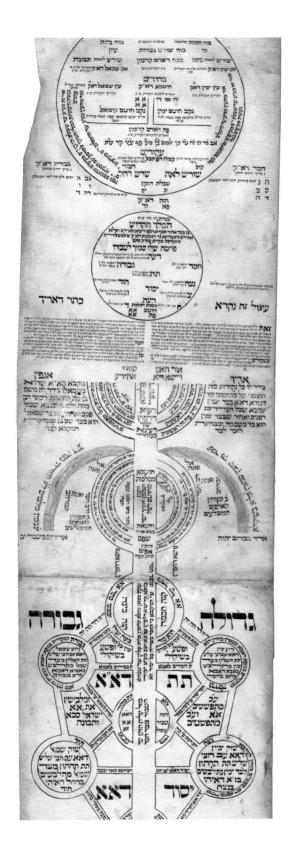

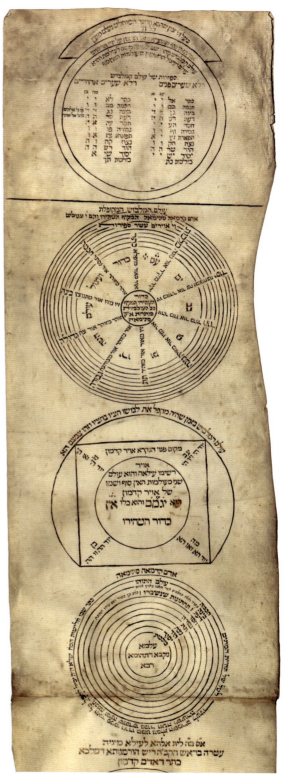

Figure 143 | Colophon, detail from the *Grupa Ilan* (fig. 142).

Figure 144 | *K*, detail from the *Grupa Ilan* (fig. 142).

detail—attests to the close relationship between this *K* and Knorr's engravings.[39]

This ilan also stands out by virtue of having a rare colophon at the very bottom of the rotulus. The colophon consists of two parts that are ostensibly, although not necessarily, related. The first is written in the clear Rashi script (a kind of faux-Sephardi semicursive) used throughout the ilan. It proclaims in rhyming Hebrew couplets, partly in bold square script: "I made this neither out of genius nor pride, for it is not for the desire of the eyes / but only for the glory of the Lord, who dwells in the heavens, to learn within it His deep secrets / and the covenant of ISAAC he will fulfill with me" (fig. 143). These touching lines expose the intentions of the scribe of this precocious rotulus: Isaac has made an ilan that is attractive even though he insists that its beauty is

accidental rather than essential. His intention was to plumb the depths of God's secrets, for God's glory. As is so often the case with the language of scribes, Isaac's "I made this" might attest with equal plausibility to reproduction or authorship; the latter might point to his role in pioneering this modular combination. The third line, featuring his enlarged first name, is his blessing to himself. Apropos modularity, the blessing grafts two biblical verses (Gen. 26:3 and Lev. 26:42) to create one novel expression of hope.

Under the formal colophon is a cursive signature that is difficult to decipher. Bearing in mind the deteriorated state of the parchment and relatively obscure place-names, I hazard the following reading: "Isaac son of the honorable R. Leib of Grupa (Dolná Krupá), here in Schlaining."[40] Alas, Isaac Grupa is an unknown figure. Was he the scribe of the ilan, or perhaps a grandson of the Isaac in the formal colophon? The name turns up in an anonymous manuscript of Talmudic novellae on b*Beizah* and b*Ketubot* dated ca. 1830.[41] In that text, Grupa is described as "the rabbinic perfect sage, our teacher, the rabbi Isaac Grupa," and is credited with sharing with the anonymous author a teaching of the Vilna Gaon on the importance of being content with one's lot.[42]

If it cannot be said with certainty whether Isaac of Grupa was the first scribe to incorporate *K* in a Great Tree or merely the faithful copyist of an even earlier rotulus, his *K* is truest to Knorr's originals (fig. 144). Here I urge the reader to refer to figs. 108–11 above. The hanging *tav* of Knorr's *fig. 8* has not been preserved, but R. Isaac's *K* retains details of Knorr's figures that other copyists presumed insignificant and omitted. Despite the unmatched fidelity of this *K* to the details of

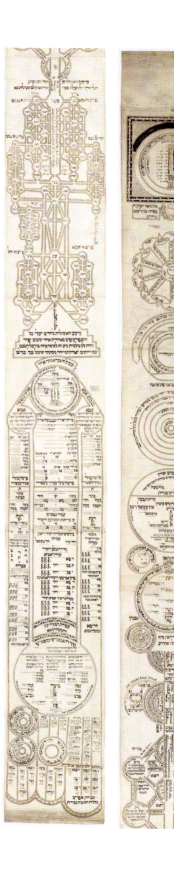

Figure 145 | Great Tree, parchment, 28.6 × 426.4 cm, eighteenth century. Amsterdam, Ets Haim Bibliotheek, Livraria Montezinos, MS 47 E 53.

בעל הרצון שהוא המוליך
מעין כל חי

אור האן סוף שהוציא בעל הרצועי ברשם
עולם המלבוש מהרושם שפנה מוקום
לעולמות והוא עולם ועצילות הוא מעולמות אס בה

ספירות של עולם המלבוש

רלא שערים	כתר אל עב סג	מהבן כהר לא רלא שערים	פנם
חכמתהבמי י		יי חכמה מב	אחור
בינה בן ו		וו בינה נ ג	
דעת דם ד ד		דדעת סד	
גדולה הע ה ה		ההגדולה עה	
גבורה ופ י י		אגבורה פו	
תת זך ו ו		ו ת ת צ	
נצח חך יא		אונצח כח	
הוד שך יו		וה הוד רע	
יסוד יש הה		הה יסוד שי	
מלכיות כת י		א מלכות דך	
פוג אלהים		עזו אל אדני	

עולם המלבוש בזמן שהי' נקפל לבושיו בתוכו זה הנועם

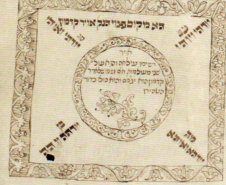

המקום פניו הנך אויר קדמון
הי רשימן עולה וחוזה על
שני מעולמות תם ושמו שלאויר
קדמון הול ינפס והוא כול כדור
העתירו

אמחמאה המקוה העהירו והם עציל ואיבוש
מופלא כתר
נסתר חכמה
אוהר בינה
מטיצץ גדולה
צח גבורה
מצוחצח תת
גלוי נצח
מעוררצח הוד

Knorr's figures, the ilan presents the sequence out of order, placing *fig. 10* before *fig. 9*. This reshuffle may attest to a scribe having copied from sheets that had been separated from Knorr's volume, with the "incriminating" Latin-Arabic figure numbers perhaps torn from their corners. A more likely (and less conspiratorial) explanation is that scribes felt free to intervene and reorder material within a component, as they did with *P*.

I have yet to comment on the basic structure of the *Grupa Ilan*. In short, *K* is followed by *PaZP7*—the spliced integration of Poppers and Zemaḥ, represented above by the Cambridge *Trinity Scroll*. The *KPaZP7* Great Tree is a rare breed; only one other complete rotulus in this family is known to me, a highly artistic ilan in the collection of the Ets Haim Library in Amsterdam (fig. 145).[43] The *Ets Haim Ilan* seems likely to have been based on the *Grupa Ilan* or an unknown common source: both share the same anomalous reordering of *K*. In his quest for elegance, the scribe of the *Ets Haim Ilan* has sacrificed only the familiar "requires further consideration" gloss. Though he may have lacked R. Isaac's fidelity to detail, the unknown scribe has, at least for the kabbalist aesthete, provided ample compensation in his stunning enhancement of this small family of ilanot.

GREAT TREE TYPE *KPZWY* | TEL AVIV, GFCT, MS 028.012.012 (FIG. 146)

This Great Tree, produced in eastern Europe in the late eighteenth century, could be described as an augmented version of the *Chabad Library Ilan*. To the full *PZ* sequence at its heart, however, a prologue, *K*, and an epilogue, *Wy*, have been added. Like the *Chabad Library* rotulus, this one contains fine decorative elements and is the work of a master scribal craftsman. The square script is penned in black ink in the Ashkenazi style; the semicursive, an imitation of Rashi script, is executed in light brown.

The scribe has adorned the two opening figures of *K* with rich, vine-filled frames and added a bouquet of flowers to their central medallions. The faces of *Adam Kadmon* and *Arikh Anpin* were treated to similar enhancements. Anthropomorphic allusions to their facial features are muted, although the elaborate crowns on their heads could hardly have been drawn in a more ornate representational style.

Figure 146 | *K*, detail from a Great Tree, parchment, 354.8 × 22.7 cm, Eastern Europe, late eighteenth century. Tel Aviv, GFCT, MS 028.012.012. Photo: author.

GROSS COLLECTION | TEL AVIV, GFC, MS 028.012.025 | GREAT TREE TYPE *KPZV* (FIG. 147; SEE ALSO FIG. 121)

This expertly executed Great Tree in the Gross Collection features fine cursive and square calligraphy and decorative ornamentation. A comparison between it and the ilan just described provides an opportunity to make a general point: Great Trees are more than the sum of their modules. To put it a different way, even though I have relied primarily on these modules to group Great Trees into "families," there is considerable difference *within* the modules themselves. These intramodule variants, whether textual, iconographic, or both, can be quite substantial. Viewed at low granularity, the present ilan would thus appear to differ only in its final section, where we see *V* rather than *W*. Viewed at a higher granularity, we discover considerable textual variants in their respective *K* openings. The version of *P* in the present ilan also shows a number of relatively rare iconographic variants. The bold anthropomorphism of the head of *AK* is accentuated by large protruding ears; an architectural element rather than a circle separates the heads of *Adam Kadmon* and *Arikh*; medallions rather than square tables detail the *pirkei ha-ẓelem*; and, just below them, we see a tabular rather than

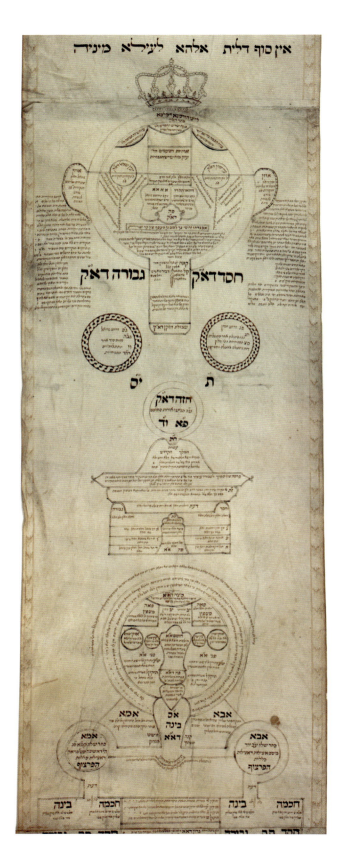

Figure 147 | *P*, detail from a Great Tree, parchment, 348.5 × 22.7 cm, Germany, ca. 1750. Tel Aviv, GFC, MS 028.012.025. Photo: Ardon Bar-Hama.

an anthropomorphic presentation of *Ze'ir*. The fact that this ilan is boldly anthropomorphic in presenting *AK* (and, to a lesser extent, *Arikh*) but tabular with *Ze'ir* would seem to indicate that such choices were not based on principled aniconism. Yet for all their interest, intramodular variants do not contribute meaningfully to the determination of manuscript families. Indeed, at this resolution, every Great Tree is a unicum, in accord with Hamilzahgi's impression.

Returning to the macro level, this ilan concludes with *V* rather than with a form of *W*. *V* was hardly a rare element to find in a Great Tree, and at least a half-dozen surviving examples begin with this pair of concentric-circle diagrams, but this ilan is the only one that closes with them. Their synoptic nature—meaning that they effectively capture the cosmological structure at a glance rather than present it developmentally or sequentially—seems to have been fully appreciated by the scribe, who demarcated them from the rest of the ilan with a clear dividing line.

Why put the circles at the bottom of the ilan rather than at the top? Because it didn't really matter. Representing the whole cosmos as they do, they are redundant whether they precede or follow the timeline of a Great Tree. Redundancy was, in any case, hardly off-putting to the makers of modular ilanot, who seem to have reveled in the different emphases and perspectives of alternative diagrammatic visualizations of cosmogonic processes and cosmological topography. Indeed, the choice to present these *'iggulim ve-yosher* diagrams as a pair—even on their own, let alone above or below a full mapping of the cosmic chain—demonstrates this tendency.

This particular ilan does not merely present the circle diagrams of *V* in succession, as we find elsewhere, but connects them in order to assert their continuity and the distinct realms signified by each. A broad channel flows through the first figure, from top to bottom, widening before penetrating the circles of *Aẓilut* of the second figure (fig. 121). This channel is the linear light of *Adam Kadmon*, and it culminates, with the rest of the *parẓufim*, at the edge of *Beriah*, which it does not penetrate. The structural continuity of the cosmos then continues through *Beriah*, *Yeẓirah*, and *'Assiah*, the last including the four elements. Our scribe has done a lovely job with the innermost band of water that surrounds earth, inscribed to indicate its association with the seven firmaments and the mythical sea. By connecting the two figures as he has, the kabbalist/scribal artist has given us the key to their contemplation. The student of the ilan is to understand the second figure as a telescopic zoom into the core of the first. Separated for heuristic reasons, given the limitations of diagrammatic representation in this medium, they are in fact the outer and inner facets of one synoptic diagram.

GREAT TREE TYPE *KPrZW* | TEL AVIV, GFCT, MS 028.011.003 (FIG. 148)

This well-executed Great Tree opens with the word אילן (*ilan*) inscribed in large, hollow faux-Sephardi square letters filled with delicate crosshatching and adorned with floral decorations. It is otherwise austere but not unattractive. Except for the text-laden table, the ilan inscriptions are in square Ashurite script. The heads of *Adam Kadmon*, *Arikh Anpin*, and *Ze'ir* are rendered schematically, with lines reminiscent of human facial features complementing the suggestively arrayed micrography.

There is more to say about this workmanlike ilan in the Gross Collection than one might suspect at first glance. Let me begin with the family it represents, *KPrZW*.[44] By all appearances, it is an augmentation of a closely related family from which it differs only at its very beginning and end.[45] The two related families, taken together, share a common variant of *P* that is found nowhere else. In this variant (*Pr*), the lower section has been shifted well up the chain of being. The motivation underlying this rearrangement is unknown to me; it is indefensible in emic terms and should be considered a corruption.[46] That said, one struggles to imagine just how such a reshuffling could have happened accidentally. I initially suspected that Knorr's *figs. 1–7* might have something to do with it, but the division of the ilan seen in Knorr's engravings is incompatible with such a rearrangement.

To the beginning of the common core shared by the two families (*KPrWy*), this ilan adds a textual preamble that attributes the Great Tree to R. Meir Poppers and highlights its form and function. (See the "Special Focus" immediately below.) To the end, it adds a representation of the lowest World of *'Assiah*, rather than ending with *Yeẓirah* like the ilanot in the family upon which it builds. Furthermore, unlike the representations of *'Assiah* found in *W* that use an arboreal schema to show the spheres, these ilanot represent them as concentric circles. In this Gross Collection ilan, the four elements of the sublunar realm are also inscribed in the central circle; the lowest, *ereẓ* (land), is encompassed by its own decoratively styled circle. These two features—the preamble and the geocentric circles of *'Assiah*—are always found together.

The attribution to Poppers that is unique to this small family was probably a significant factor in its having been selected as the basis of the 1864 printed *Great Tree of R. Meir Poppers*.[47] *'Ez Ḥayyim* had been printed in 1782, initiating a concomitant elevation in the author's status. As his redaction was the canonical expression of the Lurianic text, his ilan would be presumed the canonical expression of the Lurianic image. The attribution was likely embraced as a validation of

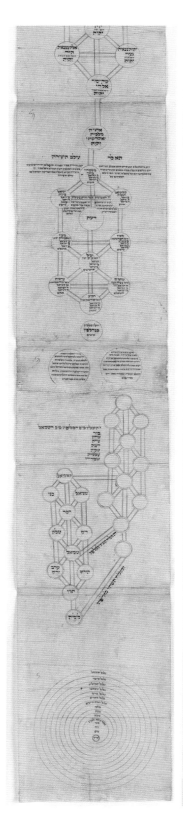
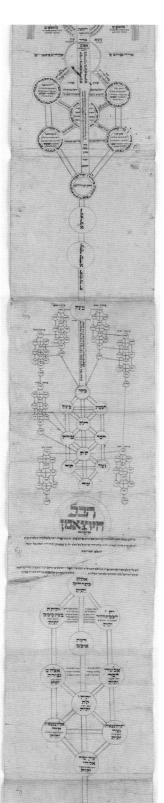
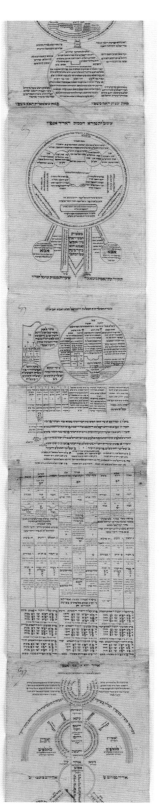
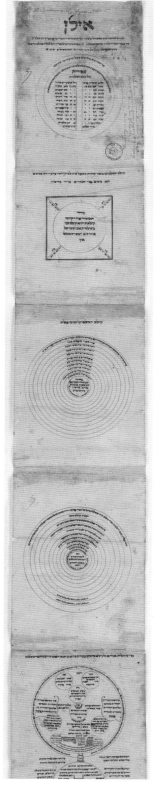

Figure 148 | Great Tree, paper, 519 × 24.5 cm, Eastern Europe, ca. 1850. Tel Aviv, GFCT, MS 028.011.003. Photo: Ardon Bar-Hama.

the unimpeachable authority and, dare we say, the orthodoxy of the ilan in the eyes of the rabbi who assented to its publication.

Apropos of publication, the comments of the censor who approved the printing of this specific ilan, dated immediately before its publication, are found to the right of the first figure of *K*:

> B. Cymerman, styczeń 1864
> Wolno drukować z warunkiem złożenia w Komitecie Cenzury prawem przepisanej liczby wydrukowanych egzemplarzy.
> Warszawa, dnia 4/16.02.1864
> Cenzor B. Cymerman

> [B. Cymerman, January 1864
> It is permissible to print on condition that the proper number of copies are delivered to the Censorship Committee.
> Warsaw, February 4 [Julian calendar]/ February 16 [Gregorian calendar]1864
> Censor B. Cymerman][48]

The censor approved each frame of the ilan, initialing every diagram from the *Malbush* on top to the planetary spheres at the bottom.

Artisanal Ilanot

We are now ready to take a walk on the wilder side of Lurianic ilanot. As opposed to the Great Trees just surveyed, the ilanot explored in this section were fashioned by identifiable creators for whom off-the-rack modules were merely a starting point. Their additions and interventions are substantial, their hands and heads (by which I mean their individual points of view) entirely distinct. They are the ilanot of confident, if not necessarily prominent, kabbalists. The stories of their lives and thought are impossible to separate from the ilanot they produced, and in what follows, I shall try to weave these elements together to the extent possible.

My treatment of these artisanal artifacts and their creators is roughly chronological. I begin with the astounding ilanot of a Moravian kabbalist active in the late seventeenth century, R. Nosen Hammerschlag, who deserves a separate monograph (which I hope to write). I move on to the ilanot of one of the most famous kabbalists of the eighteenth century, R. Moses Ḥayyim Luzzatto. From Italy I venture to Amsterdam, where R. Joseph Siprut de Gabay, known primarily as a poet and painter, crafted a series of fascinating single-frame synoptic ilanot. Next I examine the enigmatic ilanot of R. Isaac Coppio, an international kabbalist of mystery, before concluding with the Baghdadi craftsman-kabbalist R. Sasson Shandukh. Credited with the ability to inscribe Deuteronomy 8:8, "A land of wheat and barley," on a stalk of wheat, Shandukh proved no less capable of inscribing Lurianic cosmological iconotexts over eleven meters of parchment. Shandukh's Lurianic ilanot were qualitatively and quantitatively great, but he stands apart from the other artisans I treat in this section. He was unfamiliar with Great Trees, so his ilanot were unique amalgamations of texts and images culled from his own eighteenth-century kabbalistic library.

The Ilanot of Nosen Neta Hammerschlag

Nosen Neta "Ḥazen" ben Moses Naftali Hirsh Hammerschlag, artist and provocateur, was the R. Crumb of seventeenth-century kabbalists.

SPECIAL FOCUS | *Features and Functions of the* Great Tree of R. Meir Poppers

The *Great Tree of R. Meir Poppers* opens with a fascinating preamble. It reads: "The *Great Tree* composed by the rabbi, the kabbalist, the holy lamp, our teacher the rabbi Meir Katz Poppers . . . one of the "cubs" of the AR"I [the acrostic, as a word, means "lion"]. . . . [It is] in small signs [simanim ketanim], to know with wisdom, and to be for a memorial. [With it] one will be able to climb the ladder, the top of which reaches heaven, [as it] comprises all of the writings of the R. Isaac Luria. And the enlightened will understand."

The attribution of the entire ilan to Poppers, here intimately linked with Luria, gave it an immediate and immanent authority. But to what end? As a rule, ilanot did not come with operating manuals; the kabbalists generally neglected to leave us instructions. We *infer* their uses, basing our speculations on what we can learn from the artifacts themselves and their broader contexts. Here, however, a rare text documents an insider's perception of the ilan. At the risk of over-reading this brief passage, which suggests at least a modicum of marketing savvy, I will unpack each of its points.

- "To know with wisdom" (*layda be-ḥokhmah*): The ilan provides an entrée to the study of Lurianic Kabbalah, the divine science (*ḥokhmah*) par excellence.
- "To be a memorial": The ilan offers mnemonic benefit to the student, providing a structural matrix in which knowledge is inscribed *in loco*.
- "To enable one to ascend the ladder": The "ladder"—Jacob's, of course (Gen. 28)—refers to the occult pathways that ascend to the heavenly realms. The Great Tree was not simply to be studied but also performed. An image of the Divine in its dynamic unfolding, it was no less a tool in the service of its restoration, its *tikkun*.
- "Comprising all of the writings of the R. Isaac Luria": The Great Tree is an iconotext wedding image and text that visualizes the cosmogonic and cosmological system of Lurianic Kabbalah. We know, perhaps more clearly than did the author of the preamble, that this ilan is indebted to Saruq, Zacuto, Ẓemaḥ, and Poppers. In this sense, it was indeed a précis of "*all* the writings of [i.e., inspired by] R. Isaac Luria."

Although it is wise to take anything written by this kabbalist, cantor, and delightful doodler with a grain of salt, the colophons and marginalia of his various codices and ilanot announce Prosnitz, Moravia, as his place of birth in 1624; his appointment as ḥazen (cantor, here transliterated in keeping with Nosen's likely pronunciation) in 1642; and his employment as "scribe to the four lands of Poland."[49] Nosen completed his magnum opus, the *Ilan of Adam Kadmon*, in Nikolsburg (today Mikulov), Moravia, in 1691. The last we hear of him is in 1694, when he crafted—and this is the correct verb to describe the bricolage of the codex—a Lurianic prayer book.[50] My efforts to locate archival records that would shed more light on his life (and the date of his death) have so far come to naught, but his voice may be heard clearly in the iconotexts he crafted on scrolls and codices alike.

Hammerschlag's most ambitious and, indeed, outrageous work is the *Ilan of Adam Kadmon* (Munich, BSB, Cod.hebr. 450) (fig. 149, gatefold opposite). This extraordinary artifact is what drew

226 | THE KABBALISTIC TREE

Ilan of Adam Kadmon (overleaf)

Figure 149 | *Ilan of Adam Kadmon*, vellum, 336 × ca. 68 cm, Nosen Neta Hammerschlag, Nikolsburg (Mikulov), 1691. Munich, BSB, Cod.hebr. 450.

me into his world. Dated 1691, it was completed when Nosen was sixty-seven years old. The rotulus is sufficiently colorful to have attracted the attention of scholars of Jewish art; not surprisingly, it was utterly incomprehensible to them.[51] The ilan is preserved today in the Bavarian State Library in Munich. It is one of a number of kabbalistic manuscripts transferred to Munich in 1804 from the library of the Mannheim court. They probably arrived in Mannheim from the library of Christian August (1622–1708), Count Palatine of Sulzbach, when one of his successors, Karl Theodor, became Elector of the Palatinate in Mannheim in 1742.[52] Christian August was the patron of Knorr, and Sulzbach was the place of publication of the first volume of *Kabbala Denudata*, as well as many important Hebrew publications. A second ilan drawn by Hammerschlag, almost certainly executed in the same period, is also in the Munich, BSB, collection. Entitled *Ilan dikduk ha-torah* (Tree of the grammar of the Torah), it is a kabbalistic diagrammatic visualization of Hebrew grammar (fig. 150).

The flamboyant *Ilan of Adam Kadmon* had a long period of gestation, as might be expected given the expense of its materials and the scale of the effort involved in its execution. A codex study was completed by Hammerschlag in 1684, much of which would be copied to parchment to create his masterpiece.[53] The codex has some gems of its own, including an inscribed pop-up tongue that resists photographic reproduction (fig. 151).

Hammerschlag's ilan is bursting with references to the works of Ḥayyim Vital. In the colophon he asserts that Vital's ilan served as his model, but a cursory glance suffices to call that claim into question. Nothing like Vital's circles—or any concentric circles at all—are found in Hammerschlag's ilan. This particular tree of *Adam Kadmon* does not have a single arboreal schema, either. Hammerschlag's ilan was truly unlike any that preceded it.

Hammerschlag says much the same himself just after claiming to have copied Vital's ilan: "that which has never been seen until this very generation, *this tree*, with its enlarged branches (Ezek. 31:5); happy is the eye that has seen its great power and grandeur!" Here, at least, Hammerschlag spoke the truth: he had produced an ilan that was like nothing else in the history of the genre.

Even if Vital's ilan was not Hammerschlag's source, the claim was an understandable exaggeration given that much of his own ilan's content was drawn from others circulating in his environment. These he would naturally have associated with Vital, Poppers's *P* foremost among them. Admittedly, it is not easy to see Poppers's schematic face of *Adam Kadmon* in the cartoony visage staring straight out from the center of the first vellum sheet. An examination of the inscriptions nevertheless reveals the assimilation of *P* amid new texts, all within a strikingly different representational framework. Even verbatim cut-and-pastes were subject to Hammerschlag's interventions. Look carefully at this head of *Adam Kadmon*: at its eyes and eyebrows, its ears. According to their captions, right and left have been reversed. This is the case with *AK*'s arms and legs as well. Hammerschlag frequently cites the *Minḥat Yehudah* of Judah Ḥayyat in the ilan; was he inspired by Ḥayyat's story of the ilan in Reggio, "made by a great man," in which the right and left of the sefirotic tree had been reversed?[54] Did he seek to present *Adam Kadmon* intersubjectively, eye to eye, as it were? Adding to the intrigue is the exceptionalism of this inversion of perspective: the rest of the ilan, including even other parts of the head, is presented in the conventional perspective.

Hammerschlag freely used the tabular enrobings of *P* as well, thoroughly cannibalizing and arraying them with creative license throughout the parchment. The *Reisha de-lo ityeda* (The head that is not known) that follows the head of *AK* on *P*—here

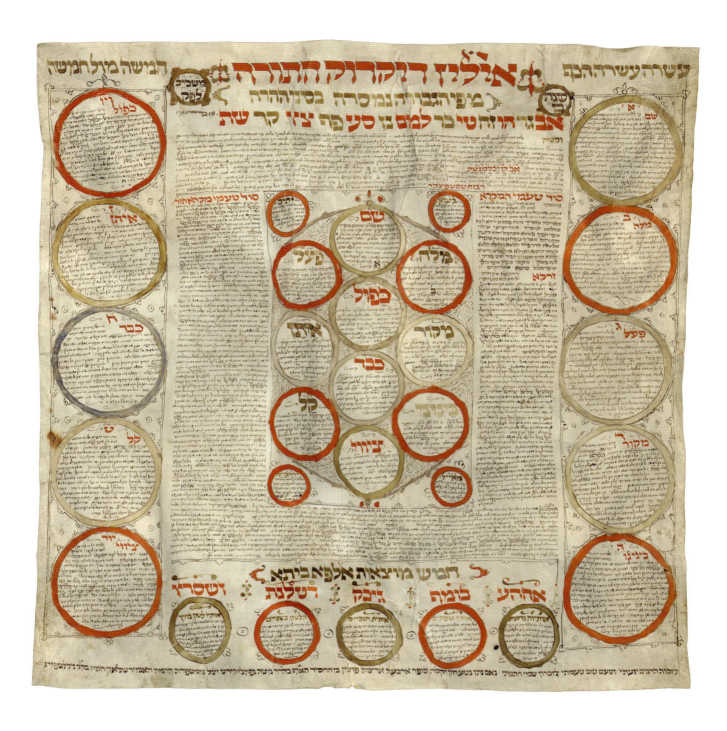

Figure 150 | *Ilan dikduk ha-torah*, vellum, 74 × 75 cm, Nosen Neta Hammerschlag, Nikolsburg (Mikulov), 1692. Munich, BSB, Cod.hebr. 451.

featuring the "requires further consideration" gloss—may thus be seen just below the flared bottom of the figure's doublet, the latter filled with the triplets of the divine seventy-two-letter name. The bottom half of *fig. 2* has been shunted just beneath the figure's right hand. Subsequent enrobings show clear affinities to the variation of *P* we saw in a beautiful Great Tree amulet in the previous section (fig. 139).[55] The streamlined *Pu* presentation of this still-conventional Great Tree made it ideally suited to Hammerschlag's novel serpentine layout (fig. 152). The two ilanot also have in common their inclusion of the rather less popular *Ilan of Expanded Names* (*N*). In this case, Hammerschlag, now on the fourth of his five parchment sheets, has introduced the module atop the second column and continued it throughout the third (fig. 153).

This serpentine layout marked a departure from the *mise-en-page* of his sources, in which columns retain their integrity—center, flanked by right and left—from top to bottom, thereby respecting the symbolic significance of those placements in kabbalistic theosophy. Hammerschlag has not done away with that symbolic significance; it is retained within each column.

These, however, are truly details that ought not distract from the big picture: the audacious representation of *Adam Kadmon*. Its anthropomorphism is bested in this era only by the profile of *AK* in *fig. 12* of Knorr's fourth apparatus (fig. 112). Might

Figure 151 | Head of Adam Kadmon, 86b–87a, *Ilan of Adam Kadmon* codex reduction, Nosen Neta Hammerschlag, 1684. Oxford, BL, MS Michael 88.

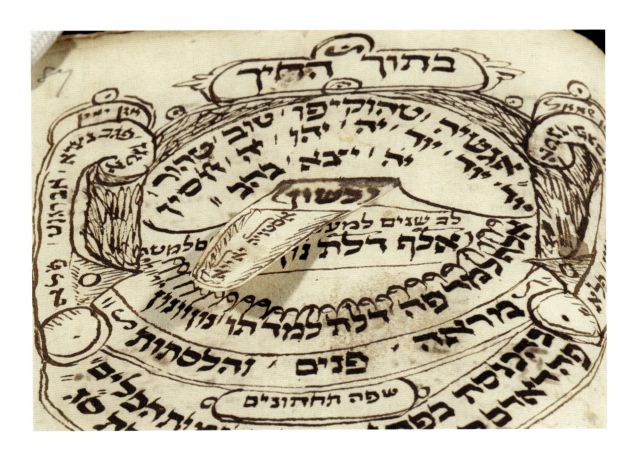

LURIA COMPOUNDED | 229

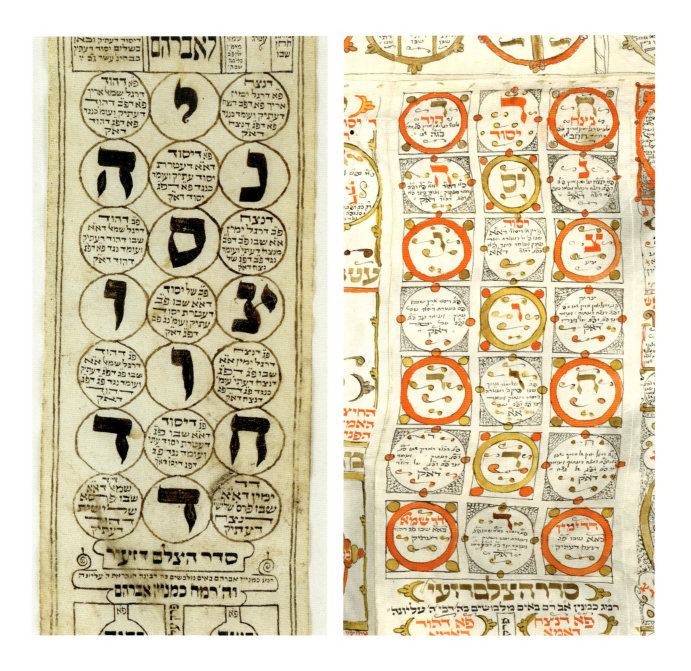

Figure 152 | *Pu*, from Tel Aviv, GFCT, MS 028.012.016 (*left*, detail of fig. 139) and Munich, BSB, Cod.hebr. 450 (*right*, detail of fig. 149).

Figure 153 (opposite) | *Ilan of Expanded Names*, from Tel Aviv, GFCT, MS 028.012.016 (*left*, detail of fig. 139) and Munich, BSB, Cod.hebr. 450 (*right*, detail of fig. 149).

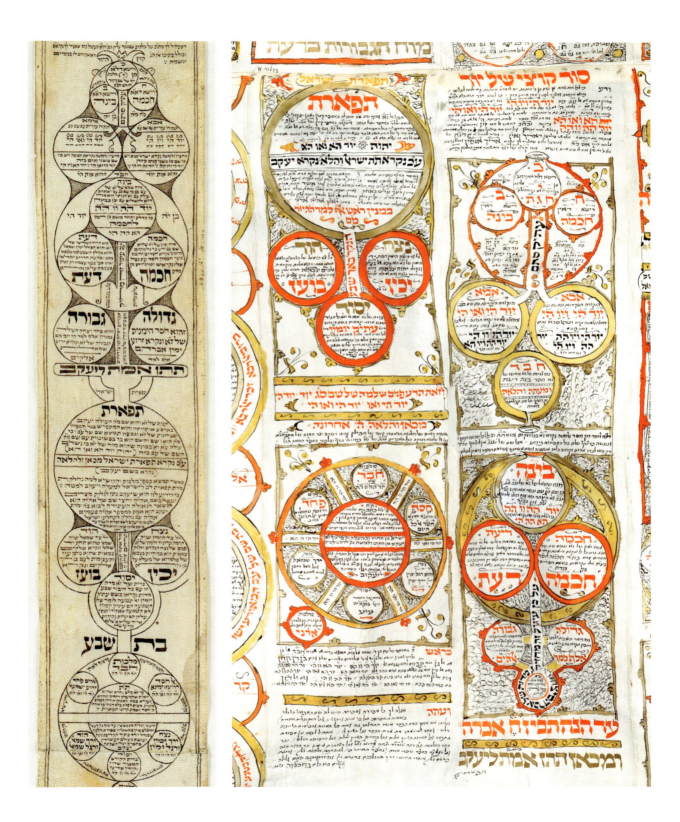

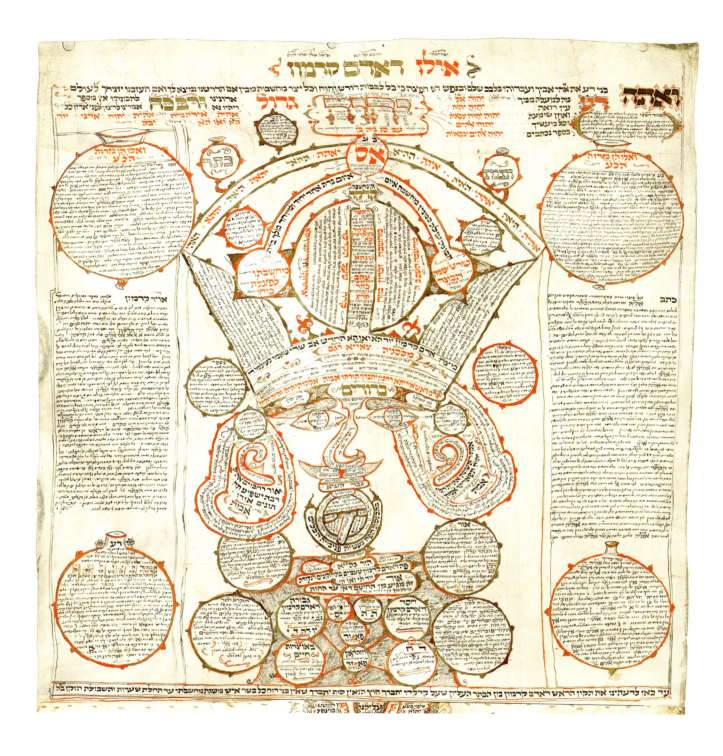

Figure 154 | Head of Adam Kadmon, from *Ilan of Adam Kadmon*, vellum, 336 × ca. 68 cm, Nosen Neta Hammerschlag, Nikolsburg (Mikulov), 1691. Munich, BSB, Cod. hebr. 450.

these two very human images of *Adam Kadmon* from the last quarter of the seventeenth century have something in common? The syncretists in Knorr's circle saw *AK* as the Christ by another name.⁵⁶ Who or what was *AK* for Hammerschlag?

This *Adam Kadmon* was a composite figure. First, he was a Habsburgian emperor, from imperial crown to curled mustache (fig. 154). His tripartite crown is unmistakably modeled on the solid-gold masterpiece made in 1602 by Jan Vermeyen in Prague to be the personal crown of Rudolf II. The crown, now housed in the Kaiserliche Schatzkammer in Vienna, was a symbol of the beloved monarchy that was embraced by its Jewish subjects. This may be seen in its prominence in ritual artifacts, from Torah *tassim* (breastplates) to *rimonim* (ornamental stave finials) and Hanukkah menorahs (fig. 155).⁵⁷ The image of *Adam Kadmon* also bears an uncanny resemblance to Leopold I, the reigning Holy Roman Emperor (b. 1640, r. 1658–d. 1705) (fig. 156). He had been emperor for a generation and was the iconic ruler of his age when Hammerschlag began work on his great ilan. Leopold I is remembered by Jewish historians today chiefly for his consent to the expulsion of Jews from Vienna in 1670. One might have imagined that the expulsion would ruin him as an object of Jewish veneration, but his rule was not without its moments of benevolence toward the Jews, and the very fact that he reigned for such a long time, and survived the Ottoman threat of the 1680s, paved the way for him to become an object of obsession and devotion.⁵⁸

Second, Hammerschlag's *Adam Kadmon* was Shabtai Zevi, the "mystical messiah" of 1666.⁵⁹ Nosen was in his early forties when the movement was in its heyday, in the 1660s. He may have participated in processions carrying a printed portrait of Shabtai, forming the image in his mind's eye that ultimately would fuse with the popular icon

Figure 155 | Torah shield, Vienna, 1805, by Franz Lorenz Turinsky. Tel Aviv, GFC. Photo: Ardon Bar-Hama.

Figure 156 (*overleaf left*) | "Leopoldus I," etching on paper, 24.7 × 17 cm, Hendrik Cause (1648–1699), author's collection. Photo: author.

Figure 157 (*overleaf right*) | "Sabetha Sebi: Vermeynden Messias der Ioden," page 237, engraved copperplate based on 1667 portrait, paper, 29 × 19 cm, from Thomas Loenen, *Ydele verwachtinge der Joden* (Amsterdam, 1669). Tel Aviv, GFCT, MS 117.011.055. Photo: Ardon Bar-Hama.

of Emperor Leopold I to create his *Adam Kadmon* (fig. 157).⁶⁰

Zevi's enormously popular messianic movement was aborted by his conversion to Islam. The theoretician of the movement, Nathan of Gaza, developed

LEOPOLDUS I.
Romanorum Imperator Semper Augustus,
Germ. Hung. Bohem. etc. Rex, Arch. Austriæ,
Dux Burg. Com. Habs. etc.

Hon. Cause sculp.

SABETHA SEBI
Vermeynden Meſſias Der Ioden

fol. 237.

Figure 158 | "Nathan Levi van Gaza: Propheet van den Ioodschen Messias," page 243, engraved copperplate based on 1667 portrait, paper, 29 × 19 cm, from Thomas Loenen, *Ydele verwachtinge der Joden* (Amsterdam, 1669). Tel Aviv, GFCT, 117.011.055. Photo: Ardon Bar-Hama.

a messianism that fit Zevi, before and after his apostasy, grounded in Nathan's creative fluency in Lurianic Kabbalah (fig. 158).[61] His Lurianism was so eloquent that it was often difficult to spot its "heresies."[62] Largely devoid of direct references to Shabtai himself, Nathan's unusually poignant and poetic writings proved resilient enough to survive the demise of the messianic movement and, to a considerable extent, to be assimilated into the Lurianic corpus.[63] The historical Shabtai was largely irrelevant to this doctrinal afterlife. Some Jews, though, had little interest in matters of doctrine and maintained a personal devotion to the "mystical messiah" as they awaited his return.[64]

On what basis do I claim that Hammerschlag's *AK* is, among its other referents, Shabtai? Scholars have often asserted the Sabbateanism of an author on the basis of their own astonishment when unable to find the source of a striking teaching. Such an approach has clear methodological flaws.[65] Does Hammerschlag's unrestrained anthropomorphism point to Sabbatean proclivities? Anthropomorphism on its own is certainly not a reliable indicator; Poppers, after all, was willing to draw the head of *AK* decades before the rise of Sabbateanism (fig. 83). Nathan of Gaza used a geometrical visual language akin to that found in Vital's manuscripts to diagram his cosmogonic innovations,[66] and other leading Sabbatean theorists were known to oppose any corporealization of the Divine.[67]

Anthropomorphism may not mark Hammerschlag's ilan as Sabbatean, but a close inspection of its textual content leaves no room for doubt. Take, for example, the Tetragrammaton fashioned of large hollow letters, filled and surrounded by inscriptions, just beneath the title and subtitle (fig. 159). Its decorative, roughly rectangular frame has a small opening in the center of the lower horizontal line; this opening leads into the crown jewel of *Keter*, the Habsburg crown—here dominated by the initials of *Ein Sof*, the infinite. Before treating its inscriptions, however, we need to appreciate the significance of the crown more fully. According to Nathan of Gaza, the messianic shift sees *Malkhut*, the lowest sefirah—notwithstanding its associations with majesty—having risen to the level of the crown, *Keter*.[68]

The unerasable divine name associated with *Keter*, the highest of the sefirot, is *EHYH*: "I

will be who I will be," a name used by God self-referentially in Exodus 3:14 that is the first-person future-implying imperfect tense of *to be*. This divine name was traditionally associated by the kabbalists with the Crown sefirah, which topped the constellation of the sefirot. The Tetragrammaton, by contrast, was associated with *Tiferet*, the central sefirah associated with *Ha-kadosh barukh hu*, the Holy One, Blessed be He. The inscribed Hapsburg crown made the visual claim that *YHVH* was the *source* of *Ein Sof* and *Keter*. The statement would not be missed by anyone with an inkling of Shabtai Ẓevi's "secret of the Godhead."[69] The secret holds that *Ein Sof* is religiously irrelevant; in some formulations, as we literally see on this parchment, *Ein Sof* is even paradoxically cast as a kind of "embodiment" of *YHVH*. *YHVH* is the true and personal God first and foremost of Shabtai ("elohei Shabtai Ẓevi," as he often referred to him), but also, in principle, of anyone who understands the secret. This is the sense of Hammerschlag's subtitle, "And you, my son, know the God of your father [elohei avikha] . . . for *YHVH* demands all hearts. . . ."[70] And there is yet another layer: *YHVH* is the name of the Messiah who is thus named by his Crown. As Nathan wrote, "Is it not the level of the messiah to rectify the lower World and to be a Chariot for the light of life? Therefore his name is *YHVH*, for he comprises the Chariot of the three Worlds."[71]

Hammerschlag added a manicule just under this *YHVH* that points to the larger, framed

Figure 159 | Tetragrammaton, *Ein Sof*, and Crown, from *Ilan of Adam Kadmon*, vellum, 336 × ca. 68 cm, Nosen Neta Hammerschlag, Nikolsburg (Mikulov), 1691. Munich, BSB, Cod.hebr. 450.

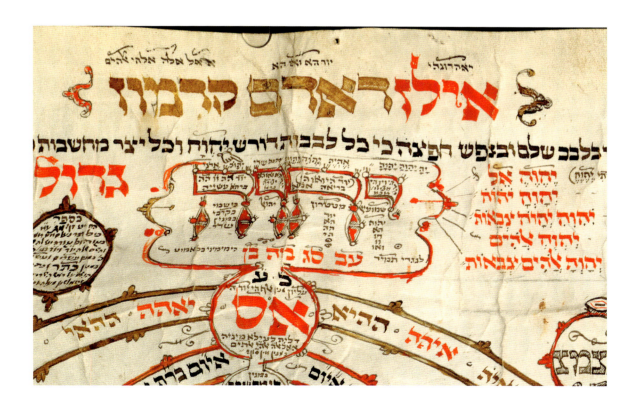

LURIA COMPOUNDED | 237

Tetragrammaton atop the crown. There, a knowing reader was to find more clues. Suggestions of apotheosis—a conflation of Shabtai with God—abound in the adjacent inscriptions. In the final *heh* of the large Tetragrammaton, Hammerschlag has written, "'For My Name *is within Me* [be-kirbi]' (*sic*), the numerical equivalent of *Shaddai*." The numerical value of *be-kirbi*, 314, is also that of Metatron, of whom God says in the Talmud, "My Name is within *him*" (b*Sanhedrin* 38b).[72] For all the subversive intimation of this meaningfully located intentional misquotation, it stands beside the most ubiquitous of Sabbatean gematrias: the three letters that make up the name *Shaddai*. When rendered individually as *shin, dalet, yud,* their numerical value—814—is equivalent to that of the two words *Shabtai Ẓevi*.[73] Again, in Nathan's words, "the manifestation of the light of the name *Shaddai* will be disclosed through the messianic king. Through him, the light of *'Atika Kadisha* will be manifest in *Ze'ir Anpin*. By means of this [manifestation], the souls of this generation will be rectified."[74]

Hammerschlag's visual language is part and parcel of the quirky, gamelike teasing that characterizes his creations. He delights in the whole palette of colors at his disposal, the connotations of images, visual argumentation, and subversive mis- and pseudocitations. A fine example of the last is found in a text balloon just below *AK*'s Habsburg jaw (fig. 154). "In *Ozrot Ḥayyim* page 12b, I found this, verbatim—see on the right, under 'And these are his words.'" Looking to the right, a parallel text balloon carries an ostensible quotation that links the highest lights of *Adam Kadmon*, again equated with *YHVH*, with the name *Shabtai*, the latter said to be central to the culmination of the cosmic restoration (*tikkun*). The codex study for this parchment scroll, which may have been impounded by the great heresy hunter R. Jacob Emden (1697–1776), has an even more extensive and suggestive passage.[75] It combines a "lady-doth-protest-too-much" insistence on precise citation, enthusiasm, and equations that include the term *mashiaḥ* (Messiah). Needless to say, the passage is not in *Ozrot Ḥayyim*.[76]

More oblique references to the Messiah are scattered across the ilan, including two at the very bottom of the rotulus (fig. 149). At the end of the second column from the right, we find a hierarchical list of the *parzufim* from top to bottom, culminating in "Father, Mother, Son, and Daughter." The last, a reference to the lowest sefirah, is glossed in red ink in the final line: "She is called 'the Orchard of Holy Apples of All the Field.'"[77] "The Field" is emphasized above with a horizontal squiggle and explained in smaller black script underneath as being equivalent numerically to *Shaddai*, which, as noted, is easily converted to *Shabtai Ẓevi*. In the column immediately to left, above the red bar that curves up at its ends, is an even more dramatically encrypted wink: "The fourth *parzuf* and its completion; from here begin the 390 Worlds [S″Ẓ 'olamot]." This sounds very kabbalistic, except that there is no precedent for the notion of 390 Worlds in the literature. Instead, as early as Mishnah *'Okẓin* (3:12), the rabbis speak of the 310 Worlds (S″Y 'olamot) that God will bequeath to the righteous in the future. This classical eschatological teaching was subtly updated to 390, which happens to be the numerical total of the S and Ẓ in *Shabtai Ẓevi*. S″Ẓ is also the traditional abbreviation for the cantorial leader of communal prayer, *shaliaḥ ẓibbur* in Hebrew. It is unlikely that this was lost on Hammerschlag; the colophon adjacent to this reference (one column to the left) emphasizes his position as a cantor: he refers to himself as "Nosen Neta Ḥazen who was appointed as *ḥazan* in the year 420 [1660]." We may well wonder to what extent Hammerschlag's obsession with Shabtai Ẓevi entailed personal identification with this divine Messiah. At the very least, both were singers.[78]

Figure 160 | Frontispiece, paper, pages 12.3 × 7.5 cm, *Seliḥot* (penitential prayers), ed. David de Castro Tartas (Amsterdam, 1666). Tel Aviv, GFCT, MS B.52. Photo: Ardon Bar-Hama.

Hammerschlag's Sabbateanism is Shabtai-centric, and his iconotextual compositions reveal no clear structural or ideational traces of Nathan of Gaza's kabbalistic innovations. He was probably unaware of Shabtai's dismissal of Lurianic Kabbalah. For all its adoration, the *Ilan of Adam Kadmon* remains a Lurianic cosmograph. Hammerschlag's other works reveal unabated interest in Lurianic kavanot as well. In short, Shabtai Ẓevi was the focal point of a religious life that does not otherwise reveal signs of having changed dramatically. In this respect, Hammerschlag could have been the subject of Gershom Scholem's description of R. Mordechai Ashkenazi, the Zolkiew-born Sabbatean prophet whose personal dream notebook of the 1690s was analyzed by the great scholar in one of his earliest publications on Sabbateanism: "We see [in Ashkenazi] the whole spiritual orientation [mahalakh ruḥo] of a true pietist [ḥasid] for whom the transformation of the world that came with the appearance of Shabtai Ẓevi was the determining event in his inner life—notwithstanding the fact that the world of halakha and commandments remained fully binding for him."[79] It is intriguing that Mordechai Ashkenazi recorded in his notebook that the "secret of the *Godhead*"—which he referred to as *shi'ur komah*—was explained to him by a revelatory *maggid*. He described the secret in terms of *Tiferet* and its enrobing in the *parzufim*; he understood it upon "his having gazed upon a drawing that the *maggid* had drawn by his own hand [biroti ha-ẓiyyur she-ẓiyyer be-yado]."[80]

Through texts *and* images, Hammerschlag expressed his undying devotion to Shabtai Ẓevi.

LURIA COMPOUNDED | 239

Even the gematria of Shabtai's name thrilled him. The ilan visualizes this devotion nowhere more clearly than in its conflation of the iconic Emperor Leopold I and the beloved King Messiah in the figure of *Adam Kadmon*, now—in keeping with the "secret"—the personal God of Nosen. Sabbatean iconography from the height of the movement's activity shows Shabtai as a crowned king seated on Solomon's throne, but Hammerschlag thoroughly divinized him (fig. 160).[81] For all its seeming audacity, this was a fantasy that could survive the death of the divine Messiah. Those in his thrall could even go on living as Jews among Jews. Hammerschlag's visualization of Shabtai as Messiah, emperor, and *Adam Kadmon*—crafted a generation after the historical Shabtai's conversion (1666) and death (1676)—testifies to this form of devotion and its stubborn capacity for persistence.[82] Scholem notes that Shabtai often cited 2 Samuel 23:1 in reference to himself: "the man exalted by the Most High, the man anointed by the God of Jacob." An old Polish rabbi who encountered Shabtai in 1666 realized that the numerical value of this verse was equal to "Shabtai Zevi YHVH EHYH."[83] Hammerschlag's reimagined Great Tree expressed precisely that.

GROSS COLLECTION | TEL AVIV, GFC, MS 028.011.009 | THE HAMMERSCHLAG *POPPERS* (FIG. 161, GATEFOLD OPPOSITE)

Most of this book had been written when I received an e-mail from Sharon Liberman Mintz telling me that Sotheby's had an ilan coming up for auction, and they were keen to know what they were selling. The attached cell-phone snapshots more than sufficed to enable me to identify the hand of Nosen Ḥazen. There was another Hammerschlag ilan. Given that my impression of him had been based on works that he composed after 1666, what was particularly interesting about this new ilan was its (relative) normalcy. Hammerschlag, it turns out, had taken a stab at copying a Poppers ilan. Although it mostly remained true to its source, Hammerschlag saw fit to add a few special touches before its beginning and after its end.

Two bold headlines open the rotulus. They are not the lines typically found atop Poppers ilanot, which are here compressed into the odd crown atop *Adam Kadmon*, but, rather, a good-luck phrase followed by Psalm 71:16. A passionate, polemical, but ultimately elusive introduction then follows, seven crowded lines penned by Hammerschlag himself. The boilerplate expressions of messianic expectation lack the barely veiled references to Shabtai Zevi found in every one of his Oxford and Munich manuscripts. Hammerschlag instructs those who study his ilan to transmute its "shades, colors, and circles" to their true signification as "great lights and names." He claims that Luria's teachings were intentionally obscure, designed to keep unworthy interlopers at bay, yet suggests that his ilan facilitates access to their secrets. Then follows an attack on abusers of secrets, whom he chastises for their ignorance of the Torah and their "false writings." They have "not served the scholars," and they "steal the hearts of Israel, those hypocrites who have obstructed the channels, darkened the lights, and destroyed the created Worlds." Who were these people who so upset him? Itinerant preachers? Saruqians?[84] Sabbateans? Might Hammerschlag have been an opponent of the Sabbateans before he had a vision of Shabtai Zevi on his proverbial way to Damascus? For all his caustic censure of would-be abusers of the holy ilan, it is impossible to know the target of Hammerschlag's critique.

Near the end of his distinctively rendered copy, Hammerschlag drew a double line. Under it, he filled the space that remained at the bottom of the eleventh sheet with three additional diagrams that he evidently thought might be useful (fig. 162). These were, from right to left, an *Ilan of Expanded*

Hammerschlag *Poppers* (*overleaf*)

Figure 161 | Hammerschlag *Poppers*, paper, ca. 398 × 47 cm, Nosen Neta Hammerschlag, ca. 1660. Tel Aviv, GFC, MS 028.011.009. Photo: Ardon Bar-Hama.

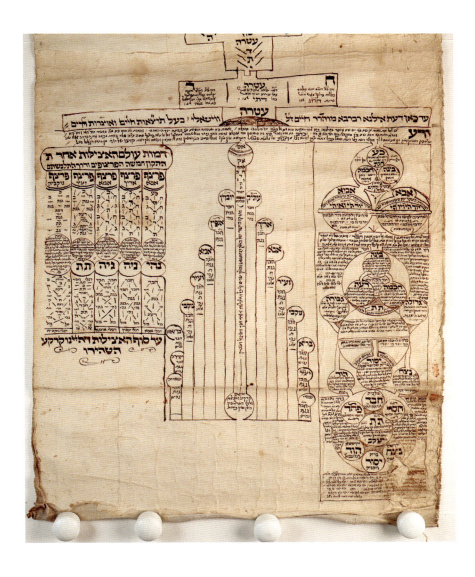

Figure 162 | Supplemental diagrams, bottom detail from Hammerschlag *Poppers* (fig. 161).

Names; a "Steps to Infinity" diagram, as I call it; and a dense tabular chart of the enrobings of the five principal *parzufim*.[85] We have already discussed the first of these, *N*, and noted its presence in Ashkenazi codices of the period as well as in Hammerschlag's *Ilan of Adam Kadmon*.[86] The "Steps to Infinity" is commonly found in copies of Vital's *Oẓrot Ḥayyim* written in an Ashkenazi hand (fig. 163).[87] This diagram is a synoptic snapshot of the entire *parẓufic* structure of the Godhead. The "steps" are the major *parẓufim* of *Aẓilut* followed by the three lower Worlds; at the top of this stepped pyramid is the Infinite, *Ein Sof* above and *Adam Kadmon* below. The diagram exhibits a striking formal similarity to a schema prevalent in medieval mathematical treatises in the Latin West. In these works, it was used to visualize the measurement of qualities "in cases in which the quality was infinite."[88] The schema was, in John E. Murdoch's words, "[a] frequent medieval technique . . . [to]

LURIA COMPOUNDED | 241

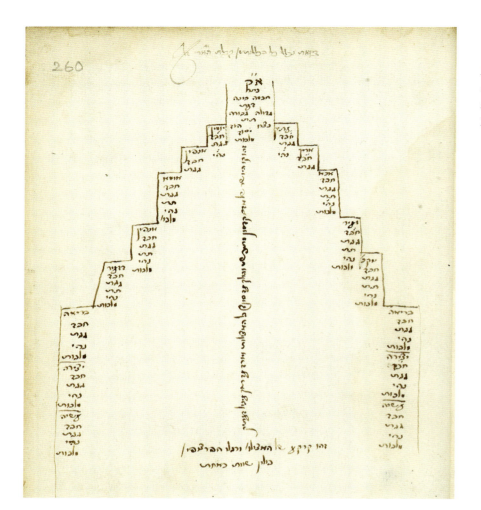

Figure 163 | Steps to Infinity, fol. 260a, *Ozrot Ḥayyim*, Ashkenazi script, 1702. Oxford, BL, MS Mich. 134.

diagram anything infinite."[89] The fact that the kabbalistic diagram could be described in this manner makes intentional appropriation a real possibility, although each could have arisen independently as a visualization inspired by their common theme.[90]

Hammerschlag left his Poppers ilan undated. Since it lacks even oblique references to Shabtai Ẓevi, it almost certainly predates his obsession with the Messiah. It is hard to imagine that he had a change of heart in the late 1690s, when he was already a man in his seventies, and it could hardly have been undertaken in the preceding decades, during which he produced works that are saturated with testimonies to his devotion. Therefore, Hammerschlag likely made this ilan in the early 1660s, when he was around forty and the Poppers ilan was quickly establishing itself as *the* Lurianic ilan. If my assessment is correct, Hammerschlag's copy represents one of the earliest extant specimens of both the Poppers ilan and the *Ilan of Expanded Names*.[91]

With Hammerschlag, though, there was no such thing as a simple copy. In addition to the tantalizing opening paragraph, the visual language of this Poppers is like none other. The face of *Adam Kadmon*

242 | THE KABBALISTIC TREE

might have been the work of Crumb. Overall, the ilan suggests affinities to the stylized *Pu* and to Perlhefter's rotulus (fig. 139); the fact that a number of ilanot show signs of this redesign indicates a family tie. Hammerschlag's graphical revision preserved the lion's share of content even as it wove it into elegant, rounded, and flowing forms, making *Pu* a bit easier to follow.[92]

Hammerschlag ca. 1660 was already the man we know, at least in formation. Shabtai Ẓevi had not yet obsessed him. A quirky eccentric incapable of slavishly copying any manuscript, from his rambling rants to his cartoonish *Adam Kadmon* and *parzufim*, he is instantly recognizable.

The Ilanot of R. Moses Ḥayyim Luzzatto

R. Moses Ḥayyim Luzzatto (1707–1746) is today counted among the greatest kabbalists who ever lived.[93] In the contemporary Orthodox world, he is also the paragon of *mussar*, or ethical piety, having authored the classic of this tradition, *Mesilat yesharim* (Path of the straight). Lithuanian yeshiva students still read the work with liturgical regularity to this day. Luzzatto's preeminent status now stands in stark contrast to the tenuous position in which he often found himself. In his lifetime, Luzzatto, better known by the acrostic *Ramḥal*, was a figure of some controversy. A scholar and kabbalist of undeniable gifts and erudition, he was nevertheless suspect in the eyes of many senior rabbis of his day. The seeming contradictions of his character were hard for them to reconcile, and if they were better known among his later Orthodox lionizers, they might very well react similarly. Luzzatto was not only a scholar and kabbalist but also a visionary prophet who claimed to enjoy revelatory visitations by an angelic *maggid*. In the aftermath of Sabbateanism, such claims to prophecy were not casually dismissed.[94] He was also something of a dandy, who trimmed his beard and didn't take on the usual signs of ascetic piety, such as regular immersion in a ritual bath. These were expected of a kabbalist, and a prophet could hardly fall short of this standard.[95]

Luzzatto must be included among the ilan makers of the early modern period. As Eliezer Baumgarten has shown, his ilanot should be understood in light of his understanding of the primacy of vision (*mareh*) in kabbalistic contemplation.[96] The fact that Luzzatto considered most kabbalistic texts to be secondary reflections upon these visions—they are their *pitaron* (lit., solution, the strong term also used for dream interpretations)—lends a special valence to his ilanot and their visualizations of the Divine.

Until recently, only one of Luzzatto's ilanot was known to have reached us: an impressive sheet found in the library of the Jewish Theological Seminary in New York of ca. 1729 (fig. 164). A few years ago, however, I discovered a second ilan by Luzzatto, dated 1739, among the uncatalogued oversized materials in that collection.[97] It too appears to be written in Luzzatto's own hand.[98] For all their superficial resemblance, however, the sheets in fact present different texts and images.

The earlier effort (K106) shows a condensed version of Z at its heart. The middle figure is *Arikh* of Z13, and the variously sized arboreal figures arrayed to its right and left are the *parzufim* of Z14. Although the central figure of *Arikh* bears shorthand inscriptions that caption its medallions both as enrobings of *'Arik* and in and of themselves, such as *Nezaḥ* of *'Arik* / *Ḥesed* of *Arikh*, it seems that Luzzatto was satisfied with providing a rough snapshot of the Godhead. The ilan pictures the constellation of *parzufim* and their relative positions and sizes without the granularity of the Ẓemaḥ ilan (Z14) (fig. 78). The crude superimpositions of the *parzufim* of *Leah*, *Rachel*, and *Jacob* on the tree of *Ze'ir* in the bottom right—where the spatial

[Hebrew kabbalistic manuscript page with diagrams of the sefirot (Tree of Life) — text too faded/handwritten to transcribe reliably]

limitations of his frame forced Luzzatto to shift them—are as close as he comes to showing their points of connection. The "thirteen enhancements" are inscribed to the left of the upper sefirot of *Arikh* but not keyed to the diagram.

Framing the simplified Ẓemaḥ diagram is a short work Luzzatto wrote especially for this ilan. In it, he condenses his kabbalistic worldview into ten laconic chapters that begin with "the intention of creation" and proceed to "the nature of the sefirot," "the expansion of the sefirot," "the enrobing of the *parzufim*," "the emergence of the branches," "operation," "awakening from below," "evil and its suckling," "exile and redemption," and "reward and punishment." One must rotate the sheet as one reads, as the chapters are inscribed in all four orientations around the diagram.[99] Given the chapter headings, it goes without saying that this work is not an explication of the diagram at the center of the sheet; indeed, it makes no reference to it. "Root" and "branch" are central metaphors, but the term *ilan* is not in the text. Luzzatto's first (known) ilan thus presents his kabbalistic view in both graphical and textual shorthand but without formally connecting the two. In their telegraphic brevity, both images and text participate in the *mareh*, the vision/visualization that Luzzatto was attempting to transmit.

Luzzatto was particularly proud of this text and regarded it as revolutionary and profound. Like the visual image, it required extensive unpacking and decoding—the *pitaron*. Thus his disappointment upon receiving the lukewarm appraisal of his teacher, R. Isaiah Bassan (1673–1739), to whom he had sent a copy of the ilan. In September 1729 Luzzatto wrote Bassan to appeal the latter's assessment: "I was amazed by your words [in a letter] regarding the ilan that I sent you, to the effect that you found in it nothing new. In fact it is mostly new, things never known before or understood at all, for which reason many have erred with regard to them. It is, however, true that it is highly abridged, each word demanding extensive deliberation. This was the point: to include in it all the principles of the [kabbalistic] science [ha-ḥokhmah] with great brevity."[100] Luzzatto was disheartened that his teacher failed to appreciate his achievements. Given the fact that the diagrammatic center of the ilan was derivative, it is not surprising that Luzzatto's pride focused on the surrounding text, in which he had condensed "all the principles" of Kabbalah from a novel perspective. He believed that Bassan had given the text short shrift and written it off as insignificant without having grasped its profundity. To give his teacher a better sense of his accomplishment, Luzzatto continued the letter with an example of how to understand one of the opaque statements in the text. Bassan may have remained skeptical of its merits, but he did come to Luzzatto's defense when the rabbis of Venice bizarrely mistook his ilan for a magical parchment of demonic seals and incantations. In a letter on behalf of his student, Bassan insisted that the suspect artifact was "a drawn ilan based on [kabbalistic] science, the principles of which are around it."[101]

Luzzatto's recently identified 1739 ilan is more ambitious than his earlier effort, in text and image alike (fig. 165). Close inspection helps us appreciate Luzzatto's renewed efforts to craft a more perfect *mareh*. He has again written a text for the occasion, this one denser and more lyrical than the "principles." This poetic text runs horizontally along the top and bottom of the ilan, divided by columns into five sections each. Rather than use the frame to summarize a broad spectrum of kabbalistic topics, Luzzatto here opts to focus on the core structures and processes of Lurianic cosmogony. The ten numbered chapters may be regarded as a poetic

Figure 164 | Luzzatto ilan I, paper, 76.5 × 55 cm, Moses Ḥayyim Luzzatto, ca. 1729. New York, JTS, MS K106, courtesy of The Jewish Theological Seminary Library.

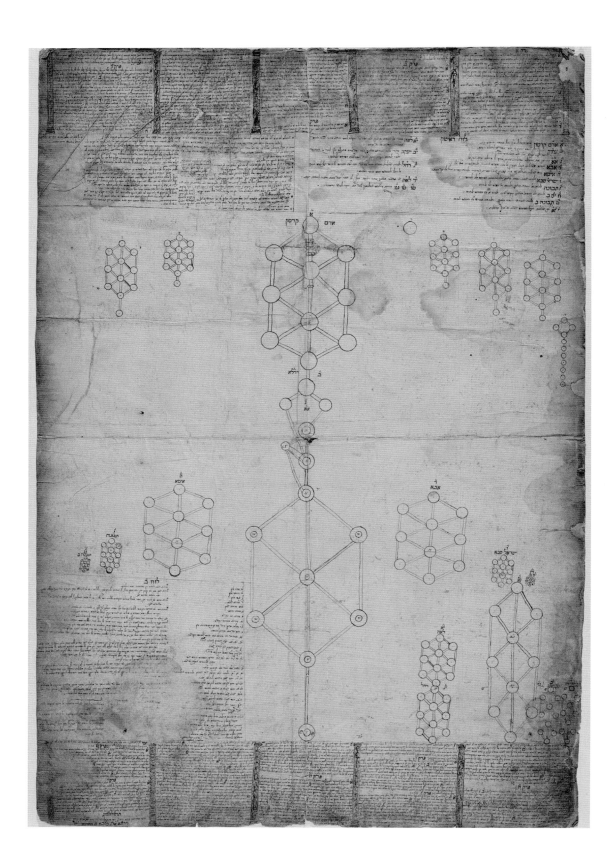

précis of *Ozrot Ḥayyim*.¹⁰² They are subdivided into units evoking Mishnaic passages; indeed, when circulated on its own, this text was referred to as *Pirkei Mishnah* (Mishnaic chapters). Luzzatto himself referred to it as the "*Asarah perakim*" (Ten chapters) summarizing his "*ilan ha-kadosh*." He wrote that they were to be committed to memory, like the Mishnah, for ritual recitation. Like the images they surround, these texts were part and parcel of the *mareh* rather than a secondary reflection.¹⁰³ As such, they relate directly to the diagrammatic centerpiece of the ilan in a fashion more oracular than explanatory.

Another innovation of this iteration of Luzzatto's ilan is found in the additional texts just inside the columned sections. These provide keys to its diagrammatic figures. The major structural elements are keyed in square script in the upper right section, under the title "*Luaḥ rishon*" (first chart); in the lower left, under the title "*Luaḥ sheni*" (second chart), the internal subdivisions are keyed in cursive script. Luzzatto has added asterisks to the keys that direct the reader to dense annotations beside each. The square and cursive letters of the keys are easily found throughout the roughly twenty diagrams arrayed in the central space.

The diagrams in this 1739 ilan remain indebted to Ẓemaḥ's image of the enrobing *parzufim*. Rather than offer a condensation, however, Luzzatto has enhanced and augmented this visualization of the Godhead. The lower half of the frame retains the image of his first ilan, now executed with greater precision. The upper half may be characterized as Luzzatto's answer to Poppers. Poppers, we recall, did not shy away from anthropomorphic schematizations of *Adam Kadmon* and the *parzufim* in his ilan even as he replaced the simple clarity

Figure 165 | Luzzatto ilan II, paper, 77.5 × 53 cm, Moses Ḥayyim Luzzatto, 1739, New York, JTS, MS K103, courtesy of The Jewish Theological Seminary Library.

of Ẓemaḥ's interlocking trees with dense, text-filled tables. Luzzatto moved away from Poppers's anthropomorphic representation in favor of a return to the traditional visual language that was put to novel use by Ẓemaḥ. He added a large tree of *Arikh*—not obviously indebted to Zacuto's—to the bottom of the frame joined by an original interface to a smaller tree of *Adam Kadmon* hovering above it. The ovals that overlay the channel connecting *Keter* of *AK* to *Da'at*, inscribed with cursive letter keys, locate the ears, nose, and mouth of *Adam Kadmon*; the disconnected, free-floating medallion to the right signals the lights of the seventy-two-letter name, sublime beyond description. The smaller trees floating to the right and left of *AK* signify, in order of proximity to the central figure, the lights of the ears, the nose, and the mouth. To the far right is a figure that we have seen before, representing the lights of the eyes of *Adam Kadmon*—the about-to-shatter *nekudim*. All of these were treated as sefirot at different stages and formations, so the arboreal schema was an entirely appropriate choice.

The *Z14* schema is not the only one that Luzzatto's ilan brings to mind. He has truly followed in Ẓemaḥ's footsteps, fashioning a large paper sheet with a *mise-en-page* that is fully in keeping with the one Ẓemaḥ described in the introduction to his *Kol be-Ramah*. Especially with his later effort, Luzzatto made an ilan that tightly integrated text and image. Was his work an homage to Ẓemaḥ, inspired by the latter's description of his ilan and/or the *Z14* diagrams included in so many Italian copies of *Ozrot Ḥayyim*? A more interesting question is what role ilanot played in their respective kabbalistic agendas. Ẓemaḥ, the meticulous editor, educator, and exegete, understood the power of images and the need to think visually. As he describes it, his ilan served primarily to provide a graphical, iconic anchor for his indexed aggregation of the critical texts pertaining to the complex enrobing process.

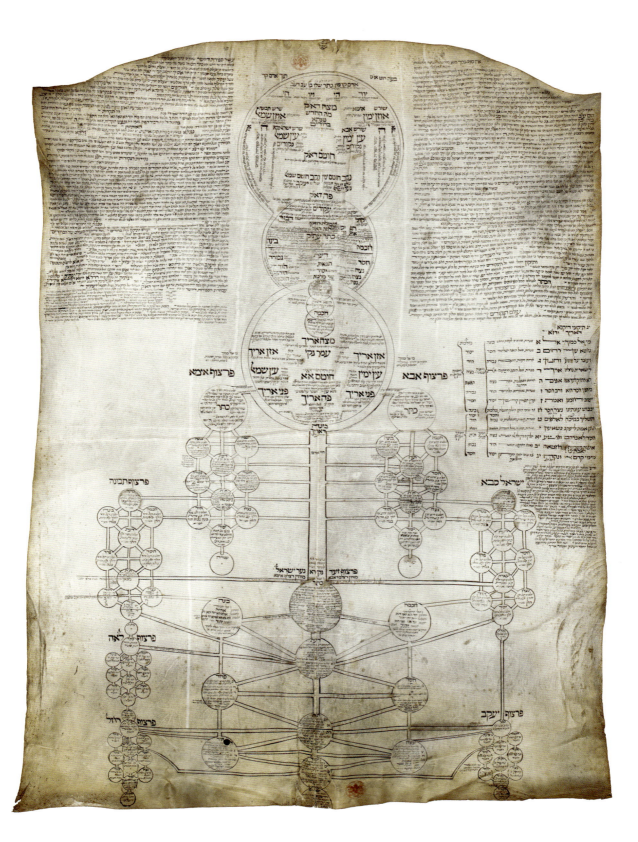

Ẓemaḥ's revival of the ilan in the Lurianic age makes him a central figure in our story. His ilan is representative of Ẓemaḥ's humanistic engagement with the Lurianic corpus but not central to *his* story. By contrast, Luzzatto's poetic-visionary approach, coupled with his frequent use of the term *ilan* as a metonym for the Lurianic cosmos, gave his original ilanot heightened significance in his oeuvre. Moreover, rather than wed *mareh* and *pitaron* in one ilan, as Ẓemaḥ had done, Luzzatto created an integrated *mareh* that communicated the vision of God by means of poetry and picture: two channels that bypassed the discursive reasoning of the *pitaron*. If the hostility of the Venetian rabbis and the reserve of his teacher Bassan are any indication, Luzzatto's efforts were unappreciated in his own time. To judge by the proliferation of publications, quite the opposite may be said about their fortunes today.

Apropos of Luzzatto's homage to Ẓemaḥ's ilan, I should like to draw attention to another parchment that does much the same thing: a Great Tree that presents the equivalent of *PaZ14* on a large parchment sheet (fig. 166). Normally such a Great Tree would be found on a rotulus just broad enough to frame the diagrammatic figures. The very different ratio of a full parchment sheet provided the scribe with a generous blank background that could easily accommodate extensive accompanying text. On this example in the British Library, the text was excerpted from *Mishnat ḥasidim*, published in Amsterdam in 1727.[104] This popular introduction to Lurianic Kabbalah was written by Luzzatto's slightly older contemporary, R. Immanuel Ḥai-Ricchi (1688–1743), an Italian kabbalist who studied Lurianic Kabbalah in the Land of Israel.

Figure 166 | *Mishnat ḥasidim* ilan, parchment, 100 × 75 cm, Eastern scripts, eighteenth century. London, BL, MS Or. 6996. © The British Library Board.

Selections from the introduction flank the heads of *Adam Kadmon* and *Arikh*.

The *Tree of Circular and Linear Emanations* by R. Joseph Siprut de Gabay

GROSS COLLECTION | TEL AVIV, GFC, MS 028.012.024 (FIG. 167)

This ilan is the ambitious work of R. Joseph Siprut de Gabay (1695–1766), an erudite scribal artist in the Portuguese Jewish community of Amsterdam.[105] It is one of three nearly identical copies to have reached us; the others are held in the Lehmann Hebrew Manuscript Collection in New York (K85) and the National Library of Israel in Jerusalem (MS 1045).

Siprut's ilan is a Great Tree, but entirely reformatted. Using my shorthand it could be categorized as *VPaZ14W*, but it would look out of place alongside its Great Tree siblings and cousins. Rather than stitch these components one after another lengthwise to create a rotulus ilan, Siprut has taken the synoptic circles of *V*—ramified *'iggulim*—and pieced them with a *yosher* consisting of a slightly condensed version of a Great Tree. The result is a single, expertly wrought parchment sheet that I call the *Tree of Circular and Linear Emanations*.

The head of *Adam Kadmon*, whose anthropomorphic facial features are muted and gracefully stylized, sits largely beyond the circles in the infinite ground of *Ein Sof*. The band representing *Malkhut* of *Adam Kadmon* intersects with the top of *Arikh*, as it should. Siprut has a bit of trouble with the kaleidoscopic trees of *Z14*, which extend past *Azilut* into the circles of *Beriah*. Likewise, the *Beriah* and *Yezirah* of *W* would ideally have their corresponding circles intersect a few bands above

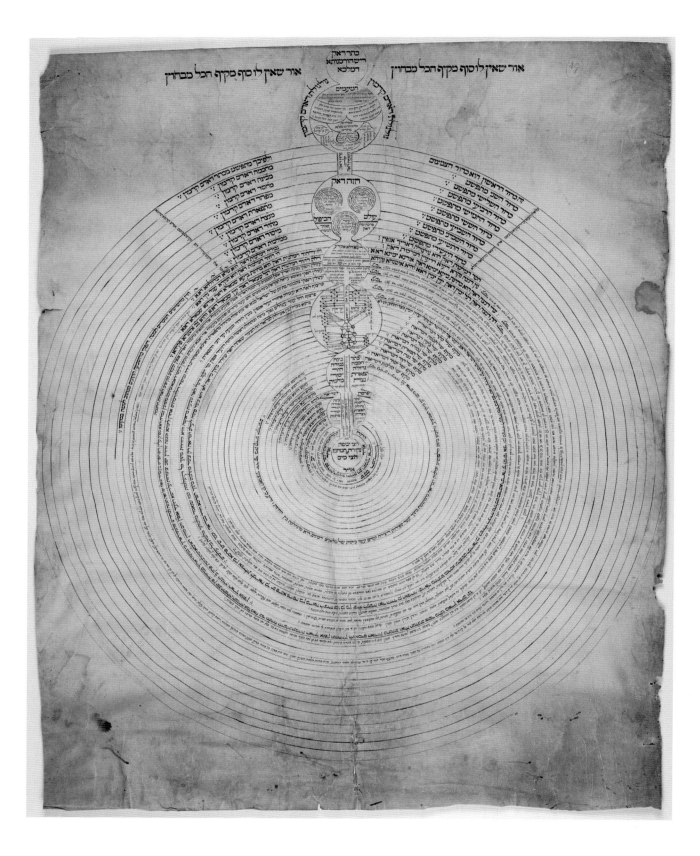

their current placement. ʿAssiah is given short shrift visually at the center of the circles, where it is inscribed in keeping with the geocentric, four-element medieval scientific tradition. When examined closely, the three nearly identical copies of this ilan evince Siprut's incremental efforts to remedy the placement issue. The problem is most extreme in the Gross exemplar and only slightly improved in the Lehmann parchment. By shrinking Z_{14}, Siprut nearly overcame the issue in the Jerusalem, NLI, witness; he also made a bit more space for himself by condensing ʿAssiah. It is hardly surprising that Z_{14} caused him trouble; Siprut has shrunk Ẓemaḥ's ilan into a circle only eight centimeters in diameter. Siprut has strained to retain its every detail: even the vertical inscription from Proverbs 16:15 running alongside Zeʿir, "When a king's face brightens, it means life," is in its proper place.

The Siprut ilan represents a creative attempt, albeit not entirely successful, to juxtapose ʿiggulim ve-yosher, the two modes of emanation in Lurianic cosmogony. In its simple form, this is the diagram found among the opening paragraphs of so many Lurianic cosmogonic accounts. We have also seen the more detailed ʿiggulim of synoptic diagrams going back to Vital, Ẓemaḥ, and Lonzano. None of these excelled when it came to detailing the yosher, however, or to clarifying the juxtaposition of the two modes. Siprut's extraordinary parchment represents far more intricate and inscribed networks. His adaptation of a $PaZ_{14}W$ Great Tree as the yosher traversing over forty ʿiggulim aspires to align the two with unprecedented precision. I have already noted the graphical challenges that thwarted its implementation. The difficulties were more than simply spatial, though. Vital identified the "juxtaposition issue" as a lacuna in Luria's instructions. "I have another doubt [safek] with regard to the ʿiggulim ve-yosher of Adam Kadmon, as the manner of their connection [aikh hem mitḥabrim yaḥad] was not clarified for me by my teacher of blessed memory."[106] Siprut was thus trying to come to terms with a real difficulty faced by those who attempted to visualize the contiguities of the circular and linear emanations in any detail. Siprut's innovation—though it does bring to mind Knorr's enigmatic fig. 16 (fig. 102)—was to design a Great Tree that did not simply splice the Vital circles before or after but, rather, "around" it.

Only the Lehmann copy of this ilan bears a colophon, signed by the self-described "artisan" (maʿaseh yedei oman) Joseph Siprut de Gabay in the year 1734.[107] Siprut was a particularly learned artisan, having studied in the highest class of the Ets Haim yeshiva fifteen years earlier.[108] He is remembered primarily as the calligrapher of a handful of occasional poems he composed in Amsterdam in the first half of the eighteenth century.[109] One of these, the only document that ties him in any way to the Kabbalah, is a lamentation honoring his late father, "the divine kabbalist, the perfect sage ... R. Abraham," who had emigrated to Amsterdam from Constantinople via Belgrade.[110] A year after his death in 1733, in the year that Joseph fashioned his ilan, Abraham was remembered by the Hebrew-language poet David Franco Mendes (1713–1792) as his master in the kabbalistic mysteries.[111] Joseph also enjoyed composing and illuminating complex riddles, as may be seen on a beautiful parchment that he crafted as a wedding gift in 1743 (fig. 168).[112] Happily for the bride and groom, he was kind enough to clear up all enigmas (in the central column) before concluding with a series of poetic blessings.

Figure 167 | Tree of Circular and Linear Emanations, parchment, 87 × 69.5 cm, Joseph Siprut de Gabay, Amsterdam, ca. 1734. Tel Aviv, GFC, MS 028.012.024. Photo: Ardon Bar-Hama.

Was Joseph inspired to create an ilan as a memorial to his recently deceased father? Might the project have originated as a collaboration between kabbalist father and artist son? Joseph referred to himself simply as an "artisan," but the integration and harmonization of perspectives that he achieved required some degree of kabbalistic literacy.

If the *Tree of Circular and Linear Emanations* was a clever reformatting of familiar components, it nevertheless holds a surprise. Siprut copied most of the texts inscribed on the parchment from his Great Tree sources, but the texts not found in those Great Trees share a common feature: they betray the influence of Sabbatean theology. The Sabbatean ideas in Siprut's ilanot influence may have their origins in 1713 when, roughly twenty years before Siprut began work on them, R. Neḥemiah Ḥayyun (ca. 1650–ca. 1730) arrived in Amsterdam. Ḥayyun had just printed his *'Oz le-Elohim* (Power to God) in Berlin and hoped to find buyers in the vibrant community. *'Oz le-Elohim* presented a core text—unidentified in the publication, but attributed to Shabtai Ẓevi by Abraham Cardozo, from whom Ḥayyun obtained it—and a running commentary by Ḥayyun. His request for permission to sell the book sparked a controversy that engulfed many leading rabbis of the day.[113] Despite the audacious nature of the publication and all the rancor of the controversy, Ḥayyun had the support of the Portuguese community led by R. Solomon Ayllon (1660/64–1728), a rabbi of sterling reputation who was nevertheless associated with Sabbateanism throughout his life.[114] Siprut was a young man of eighteen when Ḥayyun arrived and a student of Ayllon, who lent his support to the wandering charismatic figure. Moreover, Siprut's father was one of four Amsterdam-based *belogrados* who testified that Ḥayyun had behaved impeccably when residing in Belgrade years before.[115] The family thus had a direct connection to Ḥayyun. The Sabbatean passages in Siprut's ilan suggest that he, perhaps with his father, adopted the more subtle and theological approach of Ayllon, which studiously avoided direct references to Shabtai Ẓevi.

The boldest of Siprut's Sabbatean expressions are found in the first two densely inscribed *'iggulim*, the twelfth and thirteenth ones in; the eleven outermost bands bear only square-script labels identifying them as the "spheres of *Adam Kadmon*." In the thirteenth band, we find the phrase "or she-ain bo maḥshavah" (light containing no thought).[116] Coined by Nathan of Gaza, this locution is the philological equivalent of Sabbatean DNA (fig. 169). It was also close to Ayllon's heart: in the words of Yael Nadav, "the matter of 'light containing thought' and 'light containing no thought' traverses [Ayllon's kabbalistic] treatise like a scarlet thread, from beginning to end."[117]

The inscription in the twelfth band "quotes" the sages to the effect that "the Son of David will not come until feet will incline to feet." This invented quotation, recalling the phrasing of eschatological speculation found in b*Sanhedrin* 97a, is closely related to a teaching in Nathan's *Drush ha-teninim* (Homily on the sea monsters):[118]

> Know that *Ein Sof* emanated ten circles, one within another, spherical as the skins of onions. In the center of these circles, the linear channel [kav ha-yashar] emerges from *Ein Sof* and becomes the secret of the *yosher*, which is *Adam Kadmon*. These circles are the measure of the width of the head of *Adam Kadmon*. From his tabur onward, from the beginning of the World of *Azilut*, the first [parẓuf] is *'Atik*. He too has circles surrounding his head like a hat that a person

Figure 168 | Wedding riddle, parchment sheet, 46.7 × 39.8 cm, Joseph Siprut de Gabay, Amsterdam, 1743. Amsterdam, Ets Haim Bibliotheek, Livraria Montezinos, MS EH Pl. A-7.

Figure 169 | "Light containing no thought," detail from the *Tree of Circular and Linear Emanations* (fig. 167).

places on his head. They are not spherical, but concentric like onion skins. So too, in this manner, with regard to the rest of the *parzufim*. And when the World of *Azilut* ends, the legs of *AK* end. Thereafter, the Worlds of *Beriah* and *Yezirah* and *Assiah* [are structured] in this manner. At the end of *'Assiah*, an abyss [*tehom*] is below. What is the secret of this *tehom*? It is the secret of the *Tehiru*. For this *Tehiru* begins at the very beginning of the linear channel. This *Tehiru* is not yet clarified: it will not be clarified by any other than the King Messiah, when the feet of *AK* descend and stand upon the Mount of Olives. Then, an aspect of the linear channel will also be below Him and "feet will incline to feet."[119]

Even as he subtly subverts it, Nathan's passage makes brilliant use of the traditional repertoire: Vital's *Sha'ar ha-gilgulim* (Gate of reincarnation), which refers to the messianic redemption of souls that, with Adam's sin, fell to the bottom of the feet of the anti-Adam of evil (*Adam ha-beli'al*, cf. 2 Sam 16:7). Vital's text invokes Zohar II:258a as its source: "When the exile will end at the extent of the feet, then 'On that day His feet will stand' [Zech. 14:4] . . . and Israel will resume dominion alone, as is fitting." In Nathan's account, the messianic moment is identified as the extension of the feet of *Adam Kadmon* to the abyss below the lowest World, the unclarified realm of the *Tehiru* that stems from the source of the linear channel itself. As the *Tehiru* is also home to the soul of the Messiah—whose mission is to overcome the anti-Adam—the feet of this soul will then incline to the feet of *Adam Kadmon*.[120] The setting in which this drama unfolds is, to phrase it baldly, a concentric-circle diagram; Nathan *twice* uses the astronomical metaphor of onion skins to describe it. Thinking about Siprut's ilan in this light is fascinating. He has not merely juxtaposed the linear and circular but also mapped the extension of *Adam Kadmon* to the end of *'Assiah*. Yet unlike Nathan's own diagrams and an exceptional ilan to which I will turn shortly, Siprut did not include the *Tehiru* in his cosmograph. Even though there is no sign of the *Tehiru*, the cosmic structure is still profoundly implicated in the messianic moment. The *yosher*,

i.e., *Adam Kadmon*, has become the timeline of a divine history that will culminate upon convergence with its analogue in the realm of primordial spheres. Siprut's inscription reads,

> The light of the linear channel cleaves [boke'a] all the way to the end of these spheres. By "cleaves," I refer to the light of the linear channel rather than to the channel itself. By "to the end," I mean that it descends, extending the splendor of the light of the linear channel, to the beginning of the round sphere, being the aspect of *Malkhut* of *'Atik Yomin*. For if it cleaved all the spheres of *'Atik* and touched the sphere that is drawn from *Malkhut* of *Adam Kadmon*, it would constitute the redemption of Israel. And of this our sages, may their memory be a blessing, said that the son of David will not come until "feet will incline to feet," i.e., the feet of the light of the ten surrounding [lights] of *Adam Kadmon* toward the feet of the spheres of *Adam Kadmon*. Then Israel will return to its land and the beautiful crown to its former glory.

In the thirteenth band, Siprut's inscription had stated that the *yosher* was "light containing thought," as opposed to the spheres of *Malkhut* of *Adam Kadmon* that were "light containing no thought." In the fourteenth, their convergence is identified by Siprut as redemption itself. It is difficult to know just what to make of this *Tehiru*-less take on Nathan's diagrammatic eschatology. The substitution of the primordial spheres for the *Tehiru* may have been an attempt to veil Siprut's indebtedness, but it could just as easily reflect a text or oral teaching that derived from his studies with Ayllon or even Ḥayyun.[121]

Is the *Tree of Circular and Linear Emanations* a Sabbatean ilan? Except for these two lines, little deviates from the content of Siprut's mid-seventeenth-century, pre-Sabbatean sources.[122] Siprut has not found a place in his ilan for the characteristic Sabbatean *Tehiru*, but he has extracted its essence—the "light without thought" that was the source of unimaginable messianic possibility—and reinscribed it in the primordial spheres of *Adam Kadmon*. Was this the misunderstanding of a fine draftsman who was only a middling kabbalist? Or was it Siprut's own considered interpretation of a notion indebted to his studies with the preeminent Sabbatean teachers—including his communal rabbi—with whom he had studied?

Given their proximity to *Ein Sof*, it is scarcely possible to differentiate the outermost primordial spheres from the infinite and undifferentiated ground of existence. Vital had put it bluntly: Luria's teachings treat *yosher*, the *'iggulim* being beyond the limits of the mind to comprehend.[123] Siprut's conflation of the outer spheres with Nathan's notion of the *Tehiru* is thus defensible. The *yosher* is creation, the expression of the latent potential of the thought in primordial light. The *'iggulim*, in particular those spheres that abut *Ein Sof*, are unfathomable potential. Without disrupting the contours of the cosmic circles to carve out a location for the *Tehiru*, Siprut has nevertheless found a place on the map for the primordial light that gave no thought to creation. For all its unfathomable potential, once unlocked, "feet inclining to feet," the Jewish people will return home and live in peace. If this is a Sabbatean ilan, it above all reveals the domestication of radical Sabbatean cosmology in genteel eighteenth-century circles. It seems only appropriate that it was left to us by a known riddler.

The Ilanot of R. Isaac Coppio

R. Isaac ben Michael Coppio was a wandering kabbalist, scribe, and book trader active in the first

decades of the eighteenth century.[124] A number of his ilanot have reached us, as have later copies and amulets modeled on them. Coppio was likely raised in Salonica before spending much of his life in North Africa.[125] If he is the "Isaac Coppio" whose tombstone was recently discovered on the Mount of Olives, he died in Jerusalem.[126]

The peripatetic kabbalist may have encountered Great Trees during the time he spent in Italy or in the possession of the European kabbalists he met as he traveled elsewhere. Although fashioned distinctively, Coppio's ilanot are Great Trees. All feature an opening module anchored in the Vital tradition before continuing with abridged forms of *P*, *Z*, and *W*. If most of the components of Coppio's ilanot are familiar, he—and they—nevertheless tell a compelling story. The artifacts offer a rare glimpse into the world of a man who made his living finding, trading, copying, and creating kabbalistic manuscripts. His need to seek and to sell took him far, literally and figuratively.

Coppio created eclectic works, often intentionally blurring his relationship to their content: author, copyist, or "collector" (*measef*, his preferred self-designation).[127] Thanks to the perspicacious acquisitions of William Gross and the pioneering research of Eliezer Baumgarten, Coppio is finally receiving scholarly attention. In his recent book *'Over la-sofer* [Paid to the scribe], Moshe Hillel surveys Coppio's oeuvre and portrays him as a charlatan who sought financial gain through the commodification of the Kabbalah. Hillel also alleges that Coppio consistently and conspicuously misrepresented the Kabbalah he was selling. This jaundiced view is supported by evidence, but a somewhat less judgmental posture nevertheless seems prudent.[128]

Coppio's colophons tell of his many travels. He writes extensively of two journeys in particular: the first, in 1709, to Libya, Tunisia, and perhaps Italy, and the second to the valley regions of Drâa and Sous in southern Morocco. From his description of the first, we learn that his plan was to acquire kabbalistic works for subsequent resale: "Since wandering from my home as a flying bird, as a wandering swallow, God has brought me here to the city of Ṭarābulus (Tripoli), may God protect her, a city of wise men and of scribes. And I found that which my soul loves, i.e., the *Idra rabba* [Great Assembly] with Luria's commentary, and an additional commentary by the Rabbi, the all-comprehending, the divine kabbalist, our honorable teacher, our rabbi, the rabbi R. Jacob ben Ḥayyim Ẓemaḥ, may he be protected and redeemed by the Merciful One."[129] Ẓemaḥ, we recall, had described the ilan he made in the introduction to *Kol be-Ramah*, his commentary on the *Idra*. Coppio, as we will see, was unlikely to have needed to visualize an ilan based on Ẓemaḥ's description alone.

Coppio's second trip, which lasted three years, was to southern Morocco. The Drâa and Sous valleys preserved unique kabbalistic traditions. Sources that reached Safed in the sixteenth century describe them as regions in which the Zohar was preserved from antiquity in its complete form. Their sages were also known as masters of *zeruf* (combination), a kabbalistic technique of letter manipulation. Coppio reports bartering for texts, including *Brit menuḥa* (Covenant of serenity) and *Sefer ha-nekudot* (Book of vowels), the latter an unknown work. These works were not to be found in large Moroccan cities and could be traded for Lurianic writings.

The academy of R. Moses ibn Ẓur in Fez played a critical role in Coppio's creative development. Ibn Ẓur, a member of one of the prominent families of Spanish exiles, was an eminent kabbalist and the author of *Meʿarat sdeh ha-makhpelah*, mentioned above (figs. 118–119). His academy maintained ties with Zacuto's in Mantua; recall that Zacuto's atelier produced scores of copies of *Ozrot Ḥayyim* for

distribution around the Jewish world. The diagrammatic materials in these codices were an important source of Coppio's visual inspiration. Coppio copiously copied Zacuto's works and the Ẓemaḥ recensions of Vital's writings that reached ibn Ẓur's academy. The connection to Ẓemaḥ is evident in Coppio's works and is explicit in his ilanot. His insistence that his ilanot are *solet nekiah* (pure fine flour)—Zacuto's term—proclaims Coppio's loyalty to Vital's lineage, via Ẓemaḥ.[130] Unlike most European ilanot of the early eighteenth century, Coppio's contain no Saruqian elements.

There are four extant expressions of Coppio's ilan:

1. Coppio's Great Tree with ibn Ẓur opening (Tel Aviv, GFCT, MS 028.011.004).
2. Coppio's *"Headline" Ilan* (Tel Aviv, GFCT, MS 028.011.005).
3. Coppio's *"Two-Column" Ilan*, the left diagrammatic and the right a running text.[131]
4. Amulets based on the left column of Coppio's *"Two-Column" Ilan*.[132]

The Gross Collection has six Coppio ilanot in these diverse iterations.[133] Let us take a closer look at the series.

GROSS COLLECTION | TEL AVIV, GFCT, MS 028.011.004 | COPPIO'S GREAT TREE WITH IBN ẒUR OPENING (FIG. 170)

This Great Tree, written in Coppio's hand, may have been made during the time he spent in Fez at ibn Ẓur's academy.[134] The date on its colophon, written on the bottom in bold script, is perplexing: "This holy ilan was written in the city of Fez in the year "בש׳ש׳מ׳ח׳ לפ״ק" (fig. 171). The most straightforward reading corresponds to the Jewish year 5348 (1588). Was Coppio trying to pass off his rotulus as a sixteenth-century ilan? Its indebtedness to seventeenth-century materials from the Great Tree was not likely to have been noticed by most potential buyers, but what about its inclusion of a section of ibn Ẓur's well-known—and recent—work?

Putting aside this enigma, Coppio's early ilan is a stylish example of a type of Great Tree that circulated widely in the period: *VPaZW*. Examples include a North African ilan now in Amsterdam (fig. 172) and the eastern European *Kitzes Ilan* in St. Petersburg, which we admired above (fig. 141). Both are undoubtedly later than Coppio's Great Tree. Were they directly or indirectly based on Coppio's artifact? Circumstantial evidence points to the possibility that Coppio introduced *V* atop *PaZW* to create this Great Tree type (see fig. 117).

Coppio's autograph ilan, unlike these two younger parallels, opens with ibn Ẓur's poem from *Me'arat sdeh ha-makhpelah*:

Concealed light will lift and gather
Yearning to surround itself with repose
The center of its light vacated to expose
The great luminary called Infinite Light[135]

Me'arat sdeh ha-makhpelah is ibn Ẓur's poetic paraphrase of Vital's *Oẓrot Ḥayyim*; it includes a commentary in which ibn Ẓur unpacks his poetic allusions. Coppio copied a bit of that autocommentary at the top of his ilan as well (fig. 170). Then follows the bold inscription, "[*Ein Sof*],[136] the Simple, encompassing all the Worlds of *Aẓilut, Beriah, Yeẓirah*, and *'Assiah*."[137] Great Tree components *Pa, Z*, and *W* follow.

Just above the colophon at the end of *W*, Coppio added three small diagrams (fig. 171). Entirely forthcoming about the fact that these additions were *not* part of the ilan, he captioned each one. On the right is a unique sefirotic tree bearing divine and angelic names which, he asserts, he copied from the book *Brit menuḥa*, acquired during his travels to southern Morocco. In the middle we see the venerable nested letters that are simultaneously

Figure 170 | Ibn Ẓur opening of a Great Tree, paper, 409 × 32 cm, Isaac Coppio, Fez, Morocco, early eighteenth century. Tel Aviv, GFCT, MS 028.011.004. Photo: Ardon Bar-Hama.

Figure 171 (opposite left) | Colophon and supplemental diagrams, bottom detail from Tel Aviv, GFCT, MS 028.011.004 (fig. 170).

Figure 172 (opposite right) | V opening of a Great Tree, parchment, 250 × 14.5 cm, North Africa, ca. 1800. Amsterdam, Embassy of the Free Mind, Bibliotheca Philosophica Hermetica Collection, MS M 474.

acrostic sefirotic "circles." On the left, Coppio drew a chiromantic hand, captioned, "the science of the lines [ḥokhmat ha-sirtutin] [of the hand] . . . 'He seals up the hand of every man'" (Job 37:7).[138] Between the second and third figures, Coppio added another puzzling caption: "This picture and the chiromantic hand [ḥokhmat ha-yad, lit. science of the hand] I copied from the book *Ha-gvulim ve-ha-ʿiggulim* (The limits and the circles) of RḤ″V [R. Ḥayyim Vital], may his memory be for

258 | THE KABBALISTIC TREE

everlasting life." No book by this name is known, and Coppio was probably referring to a work that never existed.

GROSS COLLECTION | TEL AVIV, GFCT
MS 028.011.005 | COPPIO *"HEADLINE"* ILAN
(FIG. 173)

The first thing one notices about Coppio's second autograph ilan are its bold, oversized inscriptions. In the first third of the ilan, Coppio, who refers to himself throughout as *"ha-measef,"* the collector, wrote certain words (including the introductory words of the paragraphs) in large square lettering, roughly ten times larger than the cursive lettering used in the rest of the scroll. There is no obvious rationale for emphasizing most of these texts; nor is there a precedent for using a rotulus to present texts in this manner.[139]

Roughly a third of the ilan is devoted to a recognizable but quirky Z. The drawings are exaggeratedly elongated and presented with minimal square-letter captioning (fig. 174). After this Coppio returns to his text-only presentation. Mostly in bold headline script, Coppio lifts titular

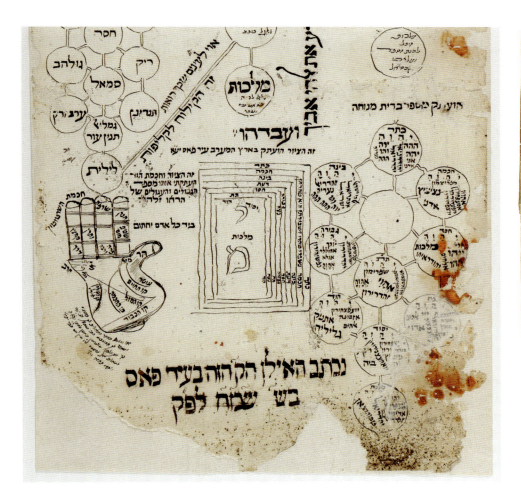

LURIA COMPOUNDED | 259

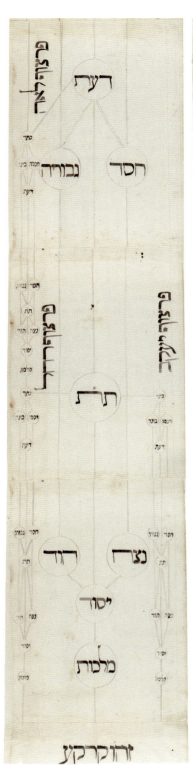
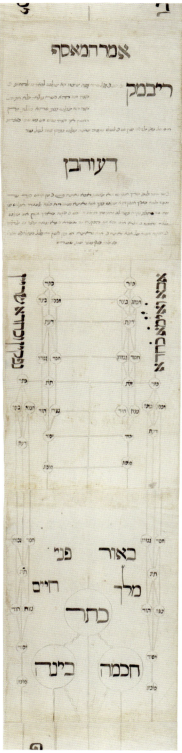

Figure 173 | "Headline" detail from a Great Tree, paper, 1,080 × 31.3 cm, Isaac Coppio, North Africa, early eighteenth century. Tel Aviv, GFCT, MS 028.011.005. Photo: Ardon Bar-Hama.

Figure 174 | Z14 from Tel Aviv, GFCT, MS 028.011.005 (fig. 173).

inscriptions from *W* without bothering to copy their diagrammatic trees. From the towerlike presentation of the "Thirty-Two Paths of Wisdom" found to the right of the Tree of *Beriah* in typical *W* modules of compound ilanot, he has hurriedly extracted the thirty-two occurrences of *Elohim* in Genesis as well as thirty-two kinds of *sekhel* (intellect), inscribing them in cursive script on either side of the bold writing that occupies the space normally taken by a large arboreal diagram (fig. 175).

There are numerous mistakes, such as the spelling of *ḥanoch* (teach), the first word in Proverbs 22:6, as *ḥanof*, or the substitution of *mesutar* for *mistater* (is concealed) in the inscription that typically separates *Aẓilut* from *Beriah* in modular ilanot that splice *W* after *Z*. Such errors, written in enormous, bold script, are perplexing, to say the least. The most likely explanation for the oddities of this ilan is that Coppio prepared it quickly. A customer wanted an ilan; the dealer had nothing in stock. "Come back tomorrow" might well have given Coppio all the time he needed.

GROSS COLLECTION | TEL AVIV, GFCT, MS 028.012.002 | COPPIO'S "TWO-COLUMN" ILAN (FIG. 176)

This manuscript—the first ilan acquired by William Gross some fifty years ago—presents a different, seemingly later ilan presumably designed by Coppio, to whose moniker "the collector" has been added "the late. . . ." Like his autograph ilanot, it is a modified Great Tree (type *VPaZW*). In this iteration, however, *V* has been significantly modified and about a third of the rotulus width dedicated to a column of text. Despite appearances, the latter is not a running commentary on the diagrammatic timeline to its left. In fact, it contains scarcely any reference to it. It is, rather, a digest of texts cobbled primarily from two works by Vital: *Adam yashar*, edited by Ẓemaḥ, and *Sefer ha-drushim* (Book of homilies), edited by R. Efraim Penzieri.[140]

Figure 175 | "Thirty-Two Paths of Wisdom," from Tel Aviv, GFCT, MS 028.011.005 (fig. 173).

The *V* with which this ilan opens retains a version of the first concentric circles of the diagrammatic duo but presents them after a few familiar elements. Atop the ilan are the acrostic sefirotic "circles" we first saw in fig. 7 and more recently in fig. 171. Originally intended to suggest that the structure of the sefirot was comparable to that of the astronomical spheres, the figure has been transvalued to represent the preexistent sefirot in *Ein Sof*. The emanation of the primordial sefirot as a pillar is visualized as a channel descending from the bottom of the *kaf* of *Keter*, the outermost letter. Coppio—if he is indeed responsible for this redesigned ilan—borrowed these elements and their meaning in this context from *Va-yakhel Moshe* by Moses Graf. According to Graf, the acrostic circles represent the "World of *ʿAkudim*" (the "bound"

LURIA COMPOUNDED | 261

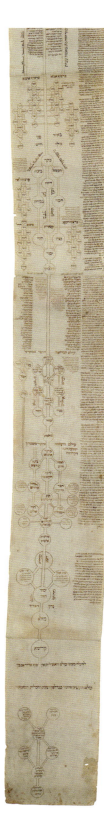
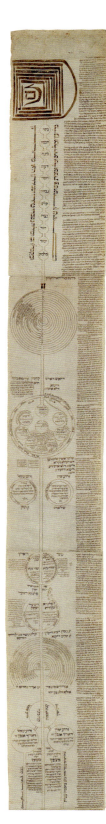

Figure 176 | Coppio's *"Two-Column" Ilan*, parchment (sheep), 366 cm × 23 cm, Morocco, ca. 1800. Tel Aviv, GFCT, MS 028.012.002. Photo: Ardon Bar-Hama.

lights) in which the sefirot "were one within the other like circles, a small circle within a large circle, like onion skins."[141] The tower image of primordial sefirot follows shortly thereafter in Graf's work.[142] In this ilan, the two are linked. The two vertical inscriptions flanking the tower of sefirot read, "Vessels of wood, vessels of pottery, vessels of glass: If they are simple [flat] they are pure, if they form a receptacle, et cetera. If they were broken they become pure again; their breaking is their purification." In its original Mishnaic context (*Kelim* 2:1), this statement refers to the susceptibility of various materials to impurity and the ways they may be purified for Temple use. In this kabbalistic context, the phrase foreshadows the "shattering of the vessels."

The channel that began at the bottom of the *kaf* continues its downward plunge, first combining with "the linear [channel] of *Adam Kadmon*"— bringing us to the first set of concentric circles based on *V*. The second set dispensed with, the channel continues its descent via *Pa*, *Z*, and *W*. This unique common denominator, traversing the roughly three-meter ilan nearly from top to bottom, visualizes the entirety of emanation as enrobing the light of *Ein Sof*.[143]

The Ilanot of R. Sasson ben Mordekhai Shandukh

One of the earliest Baghdadi kabbalists known to us by name is R. Sasson ben Mordekhai Shandukh (1747–1830).[145] Shandukh was a prolific author who composed works of commentary, poetry, and Kabbalah. In addition to his literary activities, he held several positions in the Jewish community of

SPECIAL FOCUS | *Coppio on the Role of Images*

It makes a great deal of sense to add a running commentary to a Great Tree (fig. 177). If one were to do so, most of the width of the rotulus would be allocated to the diagrammatic presentation, with the text in the remaining margin used to clarify the meaning of the images and their sources. The *"Two-Column" Ilan* just discussed seems to have been designed accordingly, its *mise-en-page* signaling that the text column is a running commentary. Yet one expecting an explanation of the drawings will be disappointed. The text opens with a smattering of cosmogonic clichés, beginning with the ancient Mishnaic proscription against asking what was before the beginning or will be after the end (bḤagigah 11b). The pastiche continues: as the lights that flowed from the face of *Adam Kadmon* and the four emanated Worlds all have beginnings, their study—through the writings of Vital and this ilan, which is based on them—approaches the limits of possible knowledge without violating this prohibition. At this point Coppio, the presumed author, refers directly to his drawings:

> Indeed, I have drawn drawings before you so that you may become enlightened; so that you might discern, understand, and clearly understand [ve-ta'amid davar 'al burio; see, *Sefer yezirah* §4] the secrets and mysteries of the holy and perfect Torah. Its secrets and deep mysteries are, after all, hidden from the eyes of the living, as our Sages of blessed memory said, "I have seen those [who are spiritually] eminent, and they are few"[144] [bSukka 45b]. And the drawings that I have arranged before you and drawn are from R. Vital, of blessed memory, who received [she-kibel] them from R. Luria, of

Figure 177 | Coppio's comment on the role of images, from Tel Aviv, GFCT, MS 028.012.002 (fig. 176).

blessed memory; pure fine flour, with no combination or admixture whatsoever of other sciences [ḥokhmot]. Let this comment suffice! And in the merit of the living God, our portion, He will speedily advance our redemption and say "enough!" to our travails. These are the words of a servant of the smallest servants of servants, who seek and investigate this true, deep science: I, the lowest of men, I[saac]B[en]M[oshe] C[oppio].

The rarity of such writing on an ilan by its maker merits our attention. Making ilanot might have been a good business for Coppio, but we do not have to dismiss this earnest reflection as pure salesmanship. Even if it were, what did he think would make for a good sales pitch? The product, as he frames it, is all about enlightenment. He claims that the ilan is a tool to be used by one seeking a lucid grasp of cosmic secrets as they are esoterically encoded in the Torah. It is worth stressing this perception of the ilan, even by a person who made a living from the sale of manuscripts. In the era that saw the printing of *Raziel ha-malakh* (Raziel the angel) (Amsterdam, 1701) for the express purpose of functioning as an amulet in the home of its buyer, Coppio makes no allusion to the potential benefits that a buyer of the ilan might accrue beyond enlightenment itself.

Coppio also emphasizes that his ilan is based exclusively on Vital's writings. In the only direct reference to a specific diagram in the faux-commentary, Coppio claims that his towerlike drawing of the primordial sefirot visualizes "Vital's commentary on the *Idra rabba*." What he has in mind is the allegorical understanding of the "deaths of the seven kings of Edom" (Gen. 36:31–43). To the perennial question of "why would God have bothered writing about Edomite kings in the Torah?," kabbalists could answer that the story was nothing less than an account of cosmogonic secrets of the "World of *Tohu*" (chaos). The seven kings are the seven lower sefirot of this first emanation. They shatter only to reconfigure as the *parzufim* in the subsequent phase of creation, the "World of *Tikkun*." Here again the ilan is framed in exclusively kabbalistic terms: it is an artifact that can be proudly certified as "pure fine flour"—Vital's Luria alone—and a visualization meant to serve kabbalists.

Baghdad, serving as a cantor as well as a scribe of Jewish marriage contracts—the latter a role he passed on to his descendants. The Jews of Baghdad delighted in the outstanding artistic craftsmanship of their beloved rabbi. His micrographic calligraphy was so refined that he could inscribe "a land of wheat and barley" on a single stalk of wheat. He built a scale model of the Tabernacle "fashioned of small boards," which it was his custom to display once a year, on the Sabbath of the Torah portion *Terumah* (Exod. 25:1–27:19). Shandukh even embroidered a parokhet, an ornamental curtain to cover the front of the holy ark, which depicted the Third Temple according to Ezekiel. The Jews of Baghdad long maintained a tradition to display it once a year at the end of the High Holidays.[146]

As befits a kabbalist-scribe-artist, Shandukh crafted ilanot that leveraged both his artistic talent and his scholarly expertise. In these works, the plethora of kabbalistic doctrines then circulating in Baghdad find their place. Shandukh's distinctive style and gifts as a visual artist make his ilanot

unique, but their imaginal qualities are not the only things that put them in a class of their own. His ilanot include lengthy passages from kabbalistic works, giving them a textual richness that has few if any equals since the parchments of the Renaissance. Such prolixity is rare in Lurianic ilanot, which typically make do with captions and relatively brief passages. Furthermore, although he made contributions to many genres of Jewish literature, Shandukh exclusively used the ilan genre for the study and practice of kabbalistic cosmology. Although he reformatted one of his ilanot into a small book for convenience, he explained its rationale apologetically.[147] He knew that for simple study, skipping to a page to check something at a distant remove on the cosmic timeline was easier than tediously scrolling ten meters down a rotulus.

Shandukh lived in a period of economic growth in the Baghdadi Jewish community. Its communal leaders were instrumental in establishing trade relations between Europe and the East. As Baghdad rose in stature as a hub of international commerce, kabbalistic books from around the Jewish world began to arrive there. It was no simple task to wade through these voluminous treatises, much less attempt to synthesize their often irreconcilable teachings. Shandukh used the ilan as a means of enacting precisely such amalgamations. Each of his ilanot assembles puzzle pieces that represent a diverse range of sources to achieve a harmonious integration. A comparison between his earlier and later efforts reveals his unflagging efforts to keep his comprehensive cosmograph a state-of-the-art reflection of the best and most authoritative material available to him. The arrival of a new kabbalistic book in Baghdad engendered a need to assess its authority relative to the works with which he was already familiar and to determine whether it deserved a place in the vast, intricate picture. For Shandukh, an ilan constructed of disparate and at times dissenting sources nevertheless had to tell a coherent story. This required creative ingenuity on his part.

Four ilanot crafted by Shandukh have reached us. All are autographs in his own hand:

1. A complete ilan produced around 1780, the earliest extant one (Tel Aviv, GFC, MS 028.012.009).
2. An ilan severely damaged by fire (Tel Aviv, GFC, MS 028.011.007; fig. 178). Most of

Figure 178 | Tree of *Heikhalot* from Shandukh ilan (pre-restoration), paper, major fragments 362 × 32 and 385 × 32 cm, Sasson ben Mordekhai Shandukh, Baghdad, ca. 1790. Tel Aviv, GFC, MS 028.011.007 (see also fig. 251). Photo: Ardon Bar-Hama.

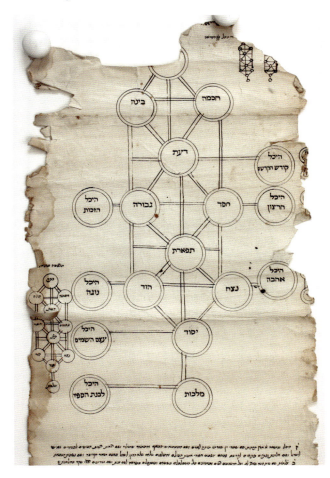

Shandukh's literary estate was destroyed in a fire that consumed his nephew's home in 1861; this ilan seems to have been pulled from the ashes. It appears to have been a preparatory study for Tel Aviv, GFC, MS 028.001.008.

3. A complete ilan, dated 1793, the greatest of the Shandukh ilanot to have reached us. In addition to its rich content, both graphical and textual, its colorful decorative elements distinguish it as one of the most beautiful of all ilanot (Tel Aviv, GFC, MS 028.011.008).

4. A codex dating to the same period as the 1793 rotulus (Tel Aviv, GFC, MS IQ.011.011).[148]

With their extensive texts and eclectic range of images drawn from far and wide, Shandukh's ilanot express the creative autonomy of a kabbalist on the periphery. They also give us a sense of the kabbalistic library of Baghdad in the second half of the eighteenth century. On its bookshelves, the latest European printings sat beside Kurdish manuscripts—as, in a sense, they do in the ilanot. Nearly all of the works anthologized by Shandukh will by now be familiar to the reader: Vital's *Oẓrot Ḥayyim*, rescued by Ẓemaḥ (the likely source for *Z14*); Poppers's *Derekh 'eẓ Ḥayyim* and *Pri 'eẓ Ḥayyim*; Delmedigo's *Novelot ḥokhmah*; Bacharach's *'Emek ha-melekh*; Graf's *Va-yakhel Moshe*; Ḥai-Ricchi's *Mishnat ḥasidim*; and the Kurdish ilan (fig. 52). Every element in Shandukh's ilanot can be traced to one of these works. Were we to pin each of these sources onto a map, the cosmopolitan character of early modern Kabbalah would be immediately apparent. The Vitals, father and son, were active in Safed, Jerusalem, Damascus, and Cairo; Ẓemaḥ, the Portuguese converso turned kabbalist, was responsible for the work copied in large numbers by the scribes of Zacuto's Mantuan workshop for distribution among the kabbalists of Poland, Morocco, and Iraq; and printed books from Dessau, Zolkiew, and Amsterdam quickly reached every corner of the Jewish world. Individual and local cultural factors always color the absorption, integration and re-expression of these shared resources. Some of these works aspired to harmonize local esoteric lore with the "universal" Kabbalah associated with Luria, as Bacharach's treatment of medieval Ashkenazi traditions in *'Emek ha-melekh* demonstrates.[149] When Shandukh uses *'Emek ha-melekh* as part of his mosaic, the integration is thus all the richer. Furthermore, both *Va-yakhel Moshe* and *'Emek ha-melekh* present Saruqian cosmogonic teachings. In a manner uncommon among kabbalists of the East, Shandukh blended the traditions of the two dominant exponents of Lurianic lore: Vital and Saruq. Shandukh distinguished among his different sources, even noting instances in which the traditions did not align with one another, but he resolutely persisted in his program of comprehensive harmonization.

Shandukh also integrated diagrammatic material from closer to home, in particular from the Kurdish ilan. The most striking example is his appropriation of its Chariot (fig. 55). Why did Kurdish kabbalists place such an emphasis on the Chariot? Presumably because esoteric traditions in Kurdistan had long centered around the Chariot, and with the arrival of the new Kabbalah, local sages would naturally have sought to harmonize the two.[150] Kabbalistic works were primarily devoted to the emanation of the sefirot and the rectification of the Worlds; the fact that the Chariot was peripheral to kabbalistic speculation made it easier to integrate creatively, to splice it into the flow. The high esteem in which Shandukh held the scholarship of Kurdish rabbis—whose ilan was classical rather than Lurianic—is expressed in his incorporation of the Chariot into these Baghdadi ilanot.

Shandukh made good use of the sources at his disposal, but as new works arrived he reassessed their significance and authority, and a work long on his "top shelf" might lose its place to a compelling

alternative. Such was the case with Graf's *Va-yakhel Moshe* and its fortunes in Shandukh's ilanot. His earliest ilan contains long excerpts from Graf's texts and adaptations of its diagrams, beginning with the very first frame. The beautifully drawn *Thirteen Enhancements of the Beard*, found roughly at its midpoint, is also borrowed from Graf's book (fig. 128). In Shandukh's later ilanot, however, almost all of this is gone. It seems that, upon receiving a copy of *'Emek ha-melekh*, Shandukh judged it a more authoritative and reliable source upon which to base his work. The striking "thirteen enhancements" nevertheless remained central in all of Shandukh's ilanot.

One final remark on the sources of Shandukh's ilanot is in order: he was unfamiliar with Great Trees.[151] The Kurdish classical ilan seems to have been his only model in this genre. It follows, then, that Shandukh's ilanot are more Lurianic augmentations of their Kurdish inspiration than they are idiosyncratic Great Trees. Perhaps because of his unfamiliarity with Great Trees, Shandukh was free to roll his own.

The Shandukh Ilanot Compared

The Shandukh ilanot share much material, graphical as well as textual, so I begin by reviewing their common elements (fig. 179). When looking at each individually, I highlight only their exceptional features.

A. THE OPENING SEQUENCE

A major question faced by makers of Lurianic ilanot was where to begin. Those who regarded only Vital's writings as authoritative might begin with *'iggulim ve-yosher*, as Vital had done in his own diagrammatic introduction to *'Ez Ḥayyim*, or with *Adam Kadmon*. Saruq's teachings, which were known to Shandukh, added the *Malbush* to the picture. Most kabbalists, as well as modern academics, understand the *Malbush* as a cosmogonic stage

Figure 179 | Shandukh ilanot compared: Tel Aviv, GFC, MSS 028.012.009 (*left*), 028.011.007 (*center*); 028.011.008 (*right*).

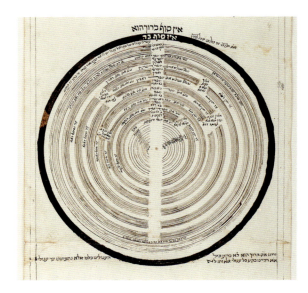

preceding those treated by Vital. This encouraged the addition of a component visualizing the *Malbush* at the top of Great Trees. Shandukh, unfamiliar with these trees, attempted to harmonize Vital and Saruq. Shandukh incorporated Saruqian texts at the opening of all of his ilanot but added *visualizations* of the *Malbush* only in his later ilanot.

B. ẒEMAḤ'S ʿIGGULIM VE-YOSHER (FIG. 180)

The first diagram common to all the ilanot produced by Shandukh is a version of the Ẓemaḥ circles diagram in *Mevo sheʿarim*. Shandukh's grandfather, R. Mordechai Moshe, was in touch with R. Samuel Laniado of Aleppo, the scribe responsible for the *Mevo sheʿarim* copy I highlighted above (fig. 75). Shandukh enhanced Ẓemaḥ's figure with additional encompassing circles—those of *Adam Kadmon*—as well as with the ten internal circles of *Nukba*, the lowest of the *parzufim*. He preserved most of Ẓemaḥ's inscriptions, including such details as the labeled "windows and openings" between the *parzufim*.

C. THE PRIMORDIAL SEFIROT (FIG. 181)

Shandukh represents the primordial sefirotic states using different schemata. The ʿakudim are a pillar of hovering medallions. In the *nekudim*, the top of this tower has been triangulated. Just below, we see the concentric acrostics figure of nested letters. The adjacent texts explain that the two schemata represent the *nekudim* from two perspectives: as vessels (*kelim*), they appear as a tower; as the lights that filled the vessels, they appear as the concentric

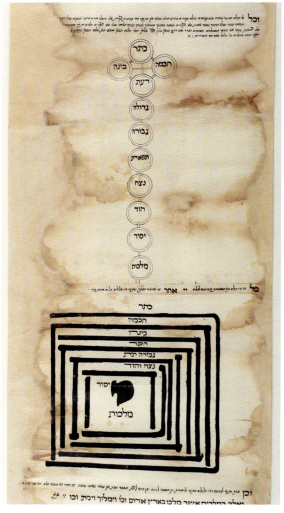

Figure 180 | Ẓemaḥ's ʿIggulim ve-yosher, in *Tofes ilana deḥayei*, paper, 1100 × 21 cm, Sasson ben Mordekhai Shandukh, Baghdad, 1793. Tel Aviv, GFC, MS 028.011.008. Photo: Ardon Bar-Hama.

Figure 181 | Primordial sefirot. Tel Aviv, GFC, MS 028.011.007 (fig. 178). Photo: Ardon Bar-Hama.

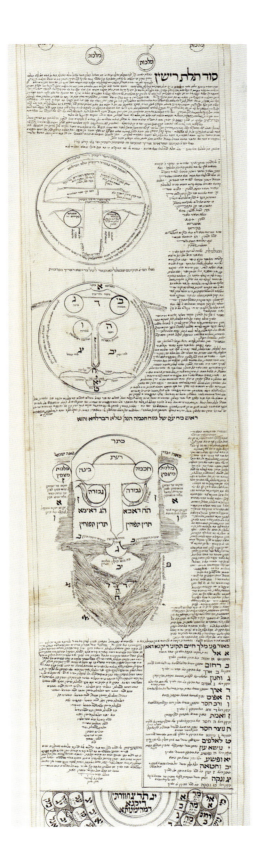

acrostics. Coppio, we recall, had used these same two schemata to represent the primordial sefirot, albeit reversing their order of appearance and with rather simpler referents (top of fig. 177). Both Coppio and Shandukh were indebted to Graf's *Va-yakhel Moshe* here. Shandukh's use of a triangle-topped tower also reveals the influence of the diagrams he encountered in Lurianic codices. The schema is found in Laniado's copy of *Mevo she'arim* as well as in Buchbinder's copies of *'Ez Ḥayyim*.

D. "THE SECRET OF THE THREE HEADS" (FIG. 182)

Anthropomorphic representations of the Divine always come as something of a surprise when found in traditional Jewish sources, all the more so when those sources were produced in an Islamic rather than a Christian context. The visual surprise of the Shandukh ilanot, produced in Baghdad, is therefore the "three heads." These are visualizations based on a teaching in the *Idra zuta*, according to which "The three heads of 'Atika are one inside the other, one over the other, and yet they are one head, the head of all heads that is not a head, for no one knows what is in that head" (Zohar III:288b). The zoharic text was mediated by Ḥai-Ricchi's discussion in *Mishnat ḥasidim*, from which Shandukh excerpted liberally and which, as Baumgarten has shown, influenced his renderings of their expressions.[152]

The series begins with a schematic image before becoming incrementally more representational. The third head is particularly noteworthy for its hair. Looking a bit like a latter-day hipster, *Arikh*'s facial hair has been rendered in accordance with Lurianic teachings. This third face varies somewhat in appearance over Shandukh's ilanot, but it always

Figure 182 | Secret of the three heads, in *Tofes ilana de-ḥayei*. Tel Aviv, GFC, MS 028.011.008 (fig. 180).

LURIA COMPOUNDED | 269

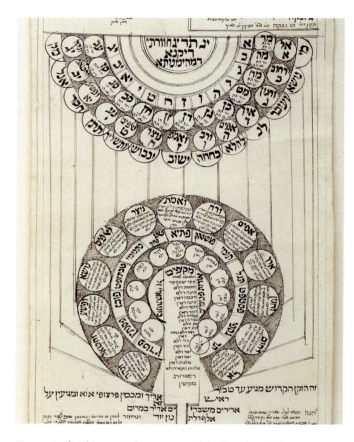

Figure 183 | *Thirteen Enhancements of the Beard*, in *Tofes ilana de-ḥayei*. Tel Aviv, GFC, MS 028.011.008 (fig. 180).

Figure 184 (opposite) | *Z14* in *Tofes ilana de-ḥayei*. Tel Aviv, GFC, MS 028.011.008 (fig. 180).

has long sidelocks, an extended mustache, and a full beard.[153]

E. THE *THIRTEEN ENHANCEMENTS OF THE BEARD* (E) (FIG. 183)

The last of the three faces of *Arikh*, with its ample beard, sets up the next component found in all of Shandukh's ilanot: the *Thirteen Enhancements of the Beard*, which he discovered in the woodcut printed in *Va-yakhel Moshe*. In the third face, Shandukh located the source of each of these enhancements. This diagram below it represents the enhancements

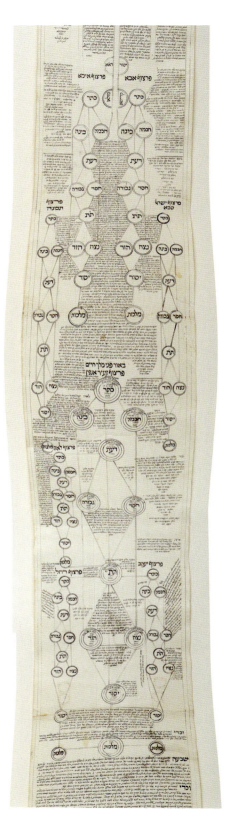

as a process, using an inventive, arresting, and precisely patterned geometrical design. Dynamism is implied by the lines that connect the higher to the lower element.

F. ARIKH ANPIN, ZE'IR ANPIN, AND THEIR ENROBINGS IN LOWER PARẒUFIM (Z14) (FIG. 184)

The next sections of these ilanot are impressively drafted adaptations of *Z14*. Shandukh almost certainly encountered it in a copy of *Oẓrot Ḥayyim* prepared in Zacuto's Mantuan atelier.

G. THE TEMERLES TREE (FIG. 185)

Among the European kabbalistic works that reached Shandukh was the *Temerles Tree* (fig. 122).[154]

H. TREES OF THE FOUR WORLDS AND THE MERKAVAH (FIG. 186)

These elements of Shandukh's ilanot reflect the influence of the Kurdish ilan (fig. 53).

I. THE HIGHER LOWER REALMS (FIG. 187)

Once again inspired by the Kurdish ilan, Shandukh ends his ilanot with a sequence of four figures: three cosmological rotae and a schematic "world" map. All four figures feature an inner circle that represents the cosmic pillar that connects them all. The first of these follows a title caption that describes the Garden of Eden as surrounded by a "highly refined firmament, for it is [formed] of fire and water of the *Ḥasadim* [plural referring to the qualities of the sefirah *Ḥesed*] and *Gevurot* [plural

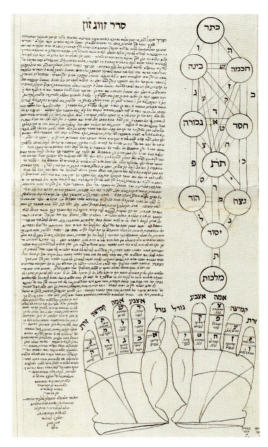

Figure 185 | *Temerles Tree*, in *Tofes ilana de-ḥayei*. Tel Aviv, GFC, MS 028.011.008 (fig. 180).

Figure 186 | Trees of the Four Worlds and the *Merkavah*, in *Tofes ilana de-ḥayei*. Tel Aviv, GFC, MS 028.011.008 (fig. 180).

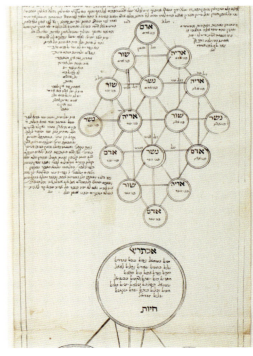

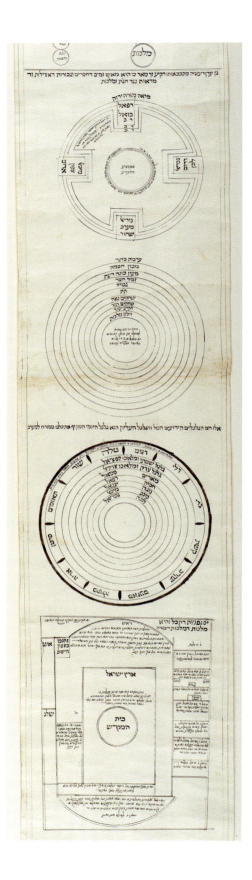

referring to the qualities of the sefirah *Gevurah*] of *Azilut* and four mirrors [*marot*] corresponding to *Ḥesed*, *Gevurah*, *Tiferet*, and *Malkhut*." It is depicted in the first of the frames in a manner that recalls medieval wind diagrams.[155] The top rectangular indentation, one of the four mirrors, is labeled "east green Rafael." This pattern (direction, color, angel) continues around the rota. Its inner circle is inscribed "center of the firmament," and the caption around its perimeter reads, "This is a pillar, bearing the likeness of the rainbow, and it emerges from *Yesod* of *Da'at* [and extends] until the ground of the Garden; through it souls ascend and descend."

From this angelic dimension, Shandukh telescopes to the drawing below, the concentric circles of which depict the seven firmaments and their sefirotic associations.[156] According to the inscription in its innermost circle, "the nine celestial spheres I will draw below are located here." The following rota indeed presents a zodiac, complete with astrological signs, planets, and their associated angels. *Levanah* (moon) is the last caption before the uninscribed center—which again becomes the subject of the next, final frame. With the transition from rota to rectangle, we have reached earth, represented in a manner that brings to mind medieval T-O figures or Rashi's maps of the Holy Land.[157] Just beneath the dome that abuts the top (east) of the rectangular schema, Shandukh tells us that "the Garden . . . is in the south of the inhabited [world], at the omphalos [*tabur*] of the earth, as it suckles from the omphalos of *Ze'ir Anpin* that is at the center of its body."[158] The inner rectangle of this last figure, captioned "Land of Israel," has but one feature: the Holy Temple. *Beit ha-mikdash* is duly inscribed in the circle at its midpoint.

Figure 187 | The Higher Lower Worlds, in *Tofes ilana de-ḥayei*. Tel Aviv, GFC, MS 028.011.008 (fig. 180).

The Shandukh Ilanot

GROSS COLLECTION | TEL AVIV, GFC, MS 028.012.009 | SHANDUKH'S FIRST ILAN

"This ilan, the largest in the forest (?), sun and moon, I wrote in the year 55[4]1 of creation."[159] So reads the colophon of this heterogeneous ilan that measures over ten meters in length. As I have already described the common features of Shandukh's ilanot, all that remains is to point out the unique features of this ilan and the others that follow it.

A. OPENING AND *ADAM KADMON* (FIG. 188)

The header of this ilan reads: "One and unique, *Ein Sof*, may He be blessed, God, God of gods, and ruler of rulers, cause of causes, may His Name be blessed forever and ever, the creator [*yozer*] of all." Thereafter *Adam Kadmon* is represented by a flurry of miniature arboreal diagrams and described as being formed of "ten complete *parzufim*."

Each of the ten sefirot of the first figure then becomes a tree in its own right. Amid this fractal multiplication of figures Shandukh commented, "each and every sefirah is composed of ten, endlessly." He dedicated two sheets of parchment to this representation before running out of room at the bottom of the second. Rather than continuing on another sheet, he chose to relocate the tenfold multiplication of *Malkhut* of *Adam Kadmon* to an empty space beside *Hod*. Shandukh's inspiration for this sprawling diagram may have been the modest sefirotic tree found in Graf's presentation of *Adam Kadmon* in *Va-yakhel Moshe* or one found in the margins of a Lurianic manuscript of Baghdadi provenance.[160]

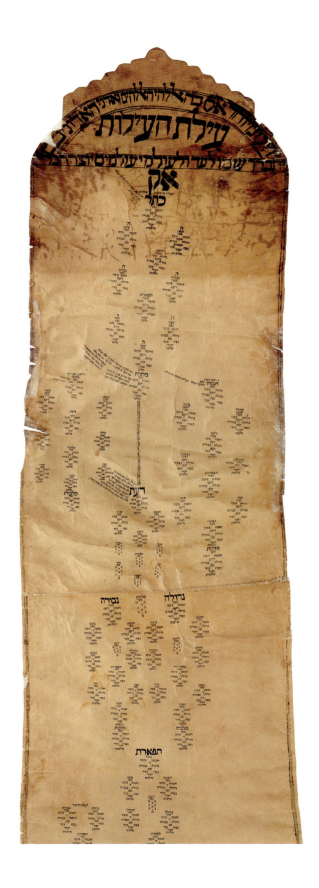

Figure 188 | Opening of Shandukh's first ilan, parchment, 1058 × 29.5 cm, Sasson ben Mordekhai Shandukh, Baghdad, 1781. Tel Aviv, GFC, MS 028.012.009. Photo: Ardon Bar-Hama.

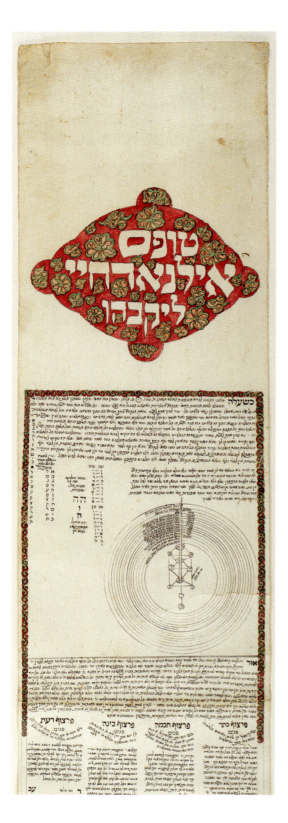

B. THE WORLD OF POINTS ('OLAM HA-NEKUDOT)

The third parchment sheet of this early ilan begins with a return to the uppermost sefirah of *Keter*: "In the beginning, *Keter* began in the 'secret of the point' [sod ha-nekudah]." The reference is to a cosmogonic teaching of Saruq that describes a fissionlike process in which the originary primordial point splits. Shandukh's visualization can charitably be described as chaotic. It draws from the opening of *Va-yakhel Moshe* (10d) and copies the acrostic sefirot diagram twice alongside the cruciform tower of sefirot. Shandukh returns to this material later in the ilan, just before the "three heads," with somewhat greater success. It does not appear in his later ilanot.

C. AẒILUT AGAIN

Shandukh compactly recapitulated the first section, beginning with the title inscription. It is unclear why he did so, but his subsequent ilanot forgo this entire visualization of *Aẓilut* in favor of a new approach.

GROSS COLLECTION | TEL AVIV, GFC, MS 028.011.008 | SHANDUKH'S *TOFES ILANA DE-ḤAYEI* (FIG. 189)

The full name of this extraordinary ilan—one of the most stunning and intricate ever produced—is *Tofes ilana de-ḥayei lykbh"v* (Image of the tree of life, for the unification of the Holy Blessed One and his *Shekhinah*). A bright red, roughly oval form bursting with orange flowers outlined in green hovers atop the uppermost diagrammatic element of the rotulus. The title, in hollow square-script letters, declares the ilan to be the image (*tofes*) of the tree of life and its *raison d'être* nothing less

Figure 189 | Opening of *Tofes ilana de-ḥayei*. Tel Aviv, GFC, MS 028.011.008 (fig. 180).

than the unification of the Holy Blessed One and the *Shekhinah*.

From a terminological standpoint, Shandukh has made an eminently sensible choice in the word *tofes*. It was used by early modern rabbis to describe the archetypal blueprint consulted by God as he created the world. So wrote R. Isaac Abravanel (1437–1508): "the Torah was drawn [*mezuyeret*] in His supernal wisdom, and Moses's words were the image [*tofes*] of that divine drawing [*ziyyur*]" (*Mif'alot Elohim* 1:2). Cordovero's usage is no less pertinent: he used *tofes* to refer to the microcosmic reflection of the divine form in the physical realm.¹⁶¹ Indeed, the term is so apt that it is striking that it was not used to refer to ilanot either before Shandukh or after him. So too with regard to the rest of the title: despite the popular perception of the iconic sefirotic tree as "the tree of life," this phrase was not used by kabbalists to refer to ilanot. Shandukh used the Aramaic equivalent, *ilana de-ḥayei*, which was a technical term for the tree of life in the highest of the Four Worlds, not the one in the biblical Garden of Eden. The combination of *tofes* and this phrase, with its specific connotation, accurately captures Shandukh's conception of his ilan. Under the title, the acrostic "For the Unification of the Holy Blessed One and His *Shekhinah*" signals the telos of the ilan: its creation, and undoubtedly its use, was intended to bring about the unification of the Godhead.¹⁶²

The significant novelties of this ilan are found in its first frames. In Shandukh's first ilan, relying chiefly on *Va-yakhel Moshe*, he attempted to harmonize the cosmogonic teachings of Saruq and Vital. This aspiration is still evident in this later ilan, but his primary source has changed. Graf's work has not been entirely expunged but is now peripheral; Bacharach's *'Emek ha-melekh* is front and center.

The *Tofes ilana de-ḥayei* opens with a text on the *Malbush* but quickly pivots to present a diagram that Shandukh says he found in "another ilan, made in abridged form without the World of the *Malbush*." Its tree-centered concentric circles bring to mind the upper section of the Lurianic ilan presented in *fig. 16* of Knorr's apparatus (fig. 102), although it is also indebted to the circles of Vital and Ẓemaḥ. Perhaps Shandukh was using the term *ilan* to refer to a foldout diagram in a codex along the lines of the *Mevo she'arim* in his library. Whatever the case, Shandukh obviously thought the image was an ideal way to launch the ilan that was to be his *magnum opus*. It was never quite finished; the elegant red and green border that frames the top of the ilan quickly petered out, but the scoring for it goes the full length of the rotulus.¹⁶³

Shandukh opens with his own take on Saruq's *Malbush*, the primordial fabric of creation woven from the twenty-two letters of the Hebrew alphabet. The tables of the 231-letter combinations, the "Gates," had been published in full in *'Emek ha-melekh* and conveyed in a kind of shorthand formula at the center of Knorr's *fig. 8* (fig. 108), the model for the first frame of *K*. The shorthand approach was surely sensible in the context of an ilan. Rather than squander precious parchment, the practitioner is challenged to carry out the combinatory gymnastics in his mind's eye. Shandukh, however, reproduced the full tables of *'Emek ha-melekh* in this ilan.¹⁶⁴ He may have believed that the contemplative exercise was best performed using the tables, and perhaps the decision was easier for him given that his ilan was on paper rather than costly parchment. His inclusive approach doubtless had something to do with this ilan reaching eleven meters in length.

Shandukh next introduces a complex diagram that had not been part of his early ilan. He had reached the point in Saruq's cosmogonic narrative at which a discrepancy in the balance of the letters results in a free *yud*—an unpartnered letter that

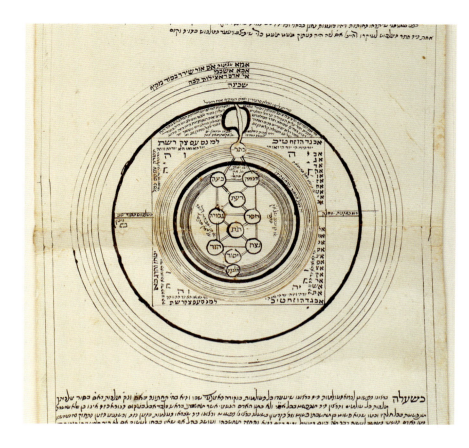

Figure 190 | Descent of the *yud*, in *Tofes ilana de-ḥayei*. Tel Aviv, GFC, MS 028.011.008 (fig. 180).

Figure 191 | Ẓemaḥ's circles, page 47a, paper, 15.5 × 10.5 cm, Sasson ben Mordekhai Shandukh, *Tofes ilana de-ḥayei* (pages 25a–87b of codex), Baghdad, 1793. Tel Aviv, GFC, MS IQ.011.011. Photo: Ardon Bar-Hama.

undergoes a cosmic descent reminiscent of the ancient rabbinic myth of the diminished moon.[165] The descent of the *yud* is artfully visualized in this second diagram, which captures it piercing concentric circles to contact the highest of the ten sefirot of *Adam Kadmon* (fig. 190). The *yud* is thickly outlined in the space between the similarly contoured inner circle and the square nestled within it. As is often the case with kabbalistic appropriations of astronomical-cosmological diagrams with ancient pedigrees, the meaning of the square in the circle has been given novel meaning. In accord with Saruqian theory, it is here deployed to represent the primordial fabric woven of alphabet combinatorics. The alphabet is inscribed on all four sides, representing the moment before the "folding" that will generate further creative combinations and open up a space for the next phase of emanation.

GROSS COLLECTION | TEL AVIV, GFC, MS IQ.011.011 | SHANDUKH'S *TOFES ILANA DE-ḤAYEI* CODEX (FIG. 191)

This codex contains a frame-by-frame reduction of the ilan just described. The deconstructed ilan is the last of three works Shandukh included in the volume. The first, *Marpeh la-nefesh* (Cure for the soul), treats the rectification of the supernal worlds in terms that correlate with human anatomy, at least as the latter was understood in the rabbinic tradition. The second, *Eileh ha-miẓvot* (These are the commandments), is a work devoted to the provision of kabbalistic rationales for

the commandments that remain binding in the post-Temple era. Through them one was to better the cosmos as well as one's own spiritual state.

The three parts of the small codex were meant to be studied as a series; the first two tracts are preparatory, and the reformatted ilan is their culmination. On the verso of the title page, Shandukh describes each as a successive stage in an individual's spiritual progress. Reaching the third, he writes:

> And then [after studying and applying the lessons of the first two works], journey in paradise [tetayel be-pardes]! Indeed, in former years, I saw a copy of an ilan written by R. Ḥayyim Vital zlh"h, without any commentary.[166] And I myself made two ilanot, with a commentary and explanation, from the [cosmogonic] beginning to the end.

From the "231 Gates," front and back, and the *Malbush*, to the end of the rungs.

> Still, one sometimes wants to see something at the end of the ilan. He is then compelled to roll it from beginning to end, involving great exertion. For this reason, I have formatted the ilan—its commentary and other wondrous components—as a book. Thus one will be able to see easily anything one may want to see.[167]

Shandukh's emphasis on the "commentary" that is so central to his ilanot project makes it easier to understand his decision to reformat the rotulus. His ilan placed a premium on textual learning, and even though he was committed to the ilan genre as singularly appropriate for its subject matter, he was not oblivious to its practical shortcomings. After

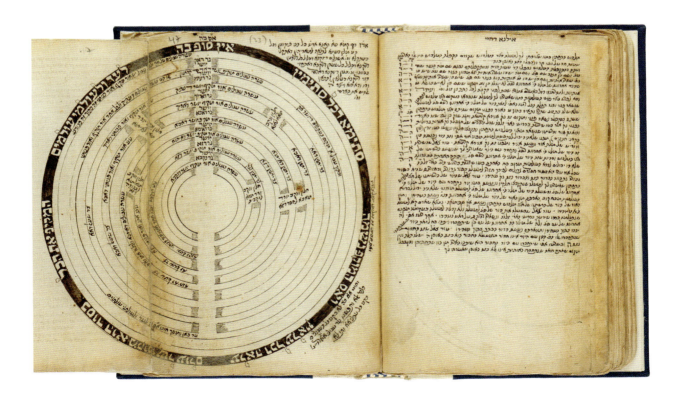

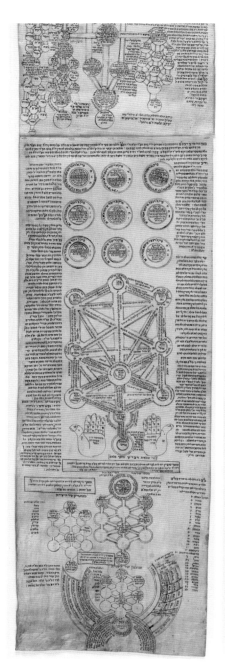 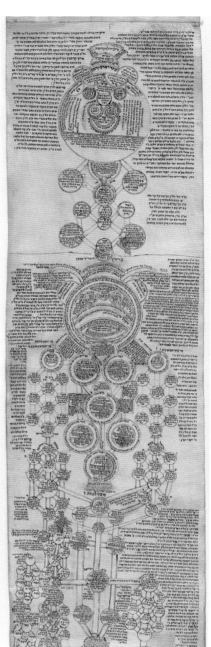 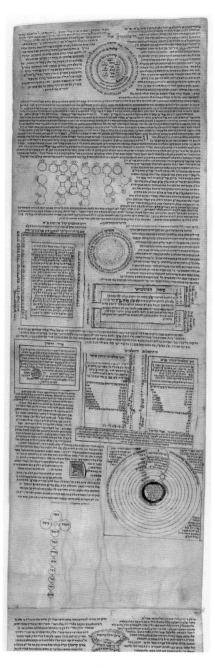

Figure 192 | *Tree of Holiness*, parchment, 185 × 20 cm, Eastern Europe, ca. 1700. Tel Aviv, GFCT, MS 028.012.003. Photo: Ardon Bar-Hama.

Figure 193 (opposite) | *Trees of Holiness* compared: Tel Aviv, GFCT, MS 028.012.003; Cincinnati, HUC, Klau Scrolls 65.2 (paper, 345 × 35 cm); Katsh Scroll (first of three fragments: opening of the ilan, 232.4 × ca. 37 cm; images of other fragments unavailable), Katsh Family Judaica Collection, Needham, MA, and Pawtucket, RI.

all, Jews study the Pentateuch from books rather than from Torah scrolls for a reason. The scrolls are performative objects to be ritually enacted rather than simply read. If the codex format is ideal for study, the implication is that the value of the rotulus original cannot be expressed in exclusively pedagogical terms. The performance of an ilan may include the reading of its texts but cannot be reduced to it.

Once at work on the codex version, Shandukh realized that the format freed him to make additions—"wondrous things"—that space did not allow him to include in the rotulus. "I have added the *heikhalot* mentioned in the Zohar *Pikudei*, just as they are written in *'Emek ha-melekh*, and other matters, as your eyes will straightaway see, from the first to the last of the grades [madregot]. It is called *Ilana de-ḥayei*, which is one's life and the length of one's days, for which every person was created 'that he might eat and live forever'" (Gen. 3:22).[168] If the reformatting invited the generous augmentation of these texts, the page size—only half the width of the narrowest of his ilanot—made it difficult for Shandukh to retain his most ambitious images. For the diagrams of the descending *yud* and Ẓemaḥ's synoptic circles, he therefore added roughly fifty percent to his available real estate by using foldout pages. Everything else could be accommodated on the modest pages of his codex, which, at least by the standards of a stalk of wheat, must have seemed ample.

The *Tree of Holiness*

GROSS COLLECTION | TEL AVIV, GFCT, MS 028.012.003 (FIG. 192)

All Lurianic ilanot are visualizations of ideas first encountered in books. This ilan—as well as the others in this subsection—is nevertheless exceptional for its sustained visualization of one work in particular.[169] I have dubbed it the *Tree of Holiness*

Gross
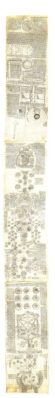

Klau
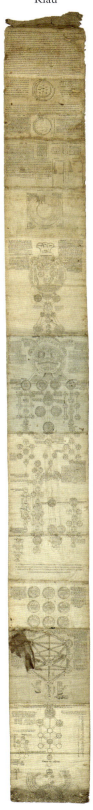

Katsh
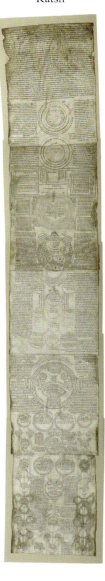

because of the prominence of these words in the crown atop the head of its *Adam Kadmon*. It may not compare visually to the most skillfully drafted ilanot we have explored, but the ideational content of the *Tree of Holiness*, conveyed in text and image, shows exceptional creativity and thoughtfulness.

The Gross rotulus is one of three known extant witnesses of the *Tree of Holiness* (fig. 193). The other two are held by Hebrew Union College in Cincinnati (Klau Library, Scrolls 65.2) and the Katsh Family Judaica Collection.[170] Each was executed by a different unknown scribe. Although the Gross witness is by far the smallest in scale (roughly half the width of the other two) and the least professional as a work of scribal art, it exhibits the most accurate integration of text and image. In a number of cases, its versions of individual diagrammatic elements also demonstrate a greater understanding of the notions they are meant to visualize.

The *Tree of Holiness* rotuli open with an original visualization of the first half of *Maamar Adam de-Azilut* (Discourse of Adam of *Azilut*), the poetic core of Graf's *Va-yakhel Moshe*.[171] No book could be visualized on a single rotulus, of course, but it is fascinating to see the graphical expression of one kabbalist's reflection upon a specific treatise.[172] More broadly, the *Tree of Holiness* shows its maker's profound grasp of the Lurianic system. As a Great Tree, it features novel representations of core components (*Pa* and *Z*) as well as additional elements (*T* and a form of *W*). Great Trees rarely display this degree of intentionality: each element, textual and pictorial, has been thoughtfully modified for inclusion. What truly sets the *Tree of Holiness* apart, though, is its opening: a visualization of an incantatory Aramaic presentation of Saruq's *Malbush* teaching. Yehuda Liebes has speculated that the composition was intended for ritual recitation. As he put it, "According to his writing style, it seems safe to presume that the author of *Maamar Adam de-Azilut* . . . intended to provide people with a short text that constituted a précis of the entire Lurianic-Saruqian myth, in a form apt for memorization and appropriate for daily ritual recitation."[173] If Liebes is correct, the choice of this text for visualization and adaptation to the performative ilanot genre is especially interesting to ponder.

Like *'Emek ha-melekh*, *Maamar Adam de-Azilut* and its commentaries present Saruq's *Malbush* teaching as the cosmogonic prequel to Vital's treatment of *Adam Kadmon* and the enrobings. *'Emek ha-melekh* had fired the imagination of Knorr, whose visualizations were the basis of *K*. The kabbalist responsible for the *Tree of Holiness* nevertheless produced a very different visualization of the teaching. His presentation of the formation and folding of the *Malbush*—particularly in the Gross ilan—is dense, almost chaotic. An inordinate amount of text has been inscribed in and around its schemata with no clear order of reading indicated.[174]

The creative freedom of the author-designer is already apparent in this first section (fig. 192). Rather than launch directly into the visualization of *Maamar Adam de-Azilut*, he opens with an independent prologue. The text, in the upper right corner of the rotulus—precisely where the Hebrew reader would think to begin—raises the age-old question of why, if God always knew that creation was to be, he initiated the process when he did and not before. Rather than offer any of the hackneyed responses to this philosophical conundrum, our kabbalist overcomes it by asserting the primacy of God's will over his knowledge. As Menachem Kallus was the first to realize, this idiosyncratic answer is found nowhere else except in a teaching attributed to the Ba'al Shem Tov, the founder of Hasidism.[175]

Most of the diagrammatic figures in the opening section of the *Tree of Holiness* are indebted to those in *Maamar Adam de-Azilut*. Among them are the representation of *avir kadmon* (primordial ether),

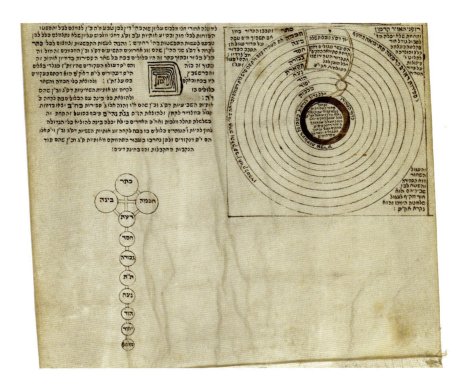

Figure 194 | Descent of the *yud*. Tel Aviv, GFCT, MS 028.012.003 (fig. 192).

the acrostic circles of preexistent sefirot, and the unstable tower of first-emanated sefirot. *Maamar Adam de-Azilut* also included the "Tetragrammaton of Eyes," the second diagram in our ilan, as well as the rudimentary elements that were developed into the vertically oriented rectangular figure just below it.[176] As for the combinatory tables that set out the warp and weft of the *Malbush*, our designer opted not to reproduce the charts in their entirety but, rather, to fashion a figure that would provide the ilan user with the algorithm that produces them.[177] This is akin to what Knorr did in his *fig. 8* (fig. 108).

Two images in this first section stand out for their novel ingenuity (fig. 194). On the right, a diagram shows the letter *yud* penetrating ten circles. This is the "free" *yud* released when the *Malbush* was folded. Two of its edges—formed of the *milium* of *YHVH* that use *yud/alef* and *heh*, respectively (יוד הי ואו הי and יוד הה וו הה)—did not align perfectly due to the disparity between the ten letters of the former and the nine of the latter; the unpartnered *yud* was left a cosmic orphan looking for its place.[178] In this figure, the *yud* has penetrated the realm of primordial ether, spanning its ten concentric sefirot from circumference to core. These are the circles of *Adam Kadmon*, and at their center, drawn as a thick black circle, is the *kadur ha-Tehiru* (sphere of brilliance), "the large space within which to create all the Worlds of *ABY'A*."[179] The internal caption explains that within it "were made the circles of *'Arik, Arikh Anpin, Abba, Imma, Ze'ir* and *Nukba* of the Four Worlds." In other words, all of creation exists within that little black circle. This diagram, which our ilan maker did not find in *Maamar adam de-Azilut*—and which was not in *'Emek ha-melekh* or other Saruqian works, for that matter—has an undeniable elegance. Scholem famously interpreted the "shattering of

LURIA COMPOUNDED | 281

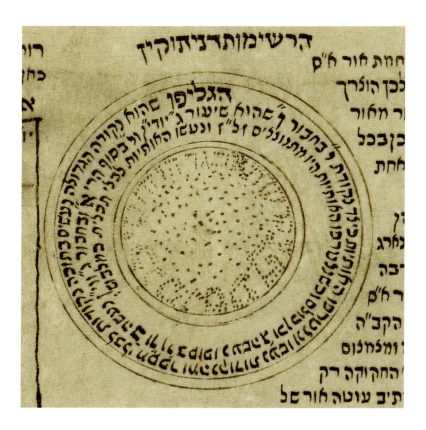

Figure 195 | "The impressions of the withdrawals." Tel Aviv, GFCT, MS 028.012.003 (fig. 192).

Figure 196 | "The impressions of the withdrawals." Katsh Scroll, Katsh Family Judaica Collection, Needham, MA, and Pawtucket, RI.

Figure 197 | "The impressions of the withdrawals." Cincinnati, HUC, Klau Scrolls 65.2.

the vessels" as the cosmic expression of the Jewish historical experience of exile.[180] The fact that, according to the cosmogonic narrative visualized here, creation was born of the plight and flight of the orphaned *yud* offers some measure of consolation: all's well that ends well.

Perhaps the most fascinating visualization in this first section of the ilan is roughly at its center (fig. 195). Two concentric double-banded circles may be seen under the caption "ha-reshimot de-nitukin" (the impressions of the withdrawals). In the space between the outer and inner circles, the inscription explains that the figure represents the *gelifu* (engraving), a vacated space in which innumerable impressions were made by the penetrations and withdrawals of the light of *Ein Sof*. Each left behind a point, seen clearly in the inner circle.

The image conveys not only the pointillist chaos of these primordial marks but their centrifugal coagulation into the letters of the Hebrew alphabet in the surrounding perimeter. Comparison with the same element in the two other known witnesses underscores the care invested in the Gross manuscript (figs. 196–197).

With the Saruqian prequel complete, the ilan continues with its novel representation of the core modules of the Great Tree: the heads of *Adam Kadmon* and *Arikh* (*Pa*) and the kaleidoscopic arboreal enrobings of the *parzufim* (*Z*). The common (*K*)*PaZP7* ilan, which we encountered in the *Grupa Ilan* above, has been thoughtfully reimagined (fig. 142).[181] The heads of *Adam Kadmon* and *Arikh* in all three witnesses share a family resemblance that sets them apart from all others. Rather

than present the two elements of *Z* sequentially (*Z13* + *Z14*), the scribal artist has adapted and embedded *Z13* as the core of *Z14*, a move so efficient and effective that one wonders why no one else thought to do so. Of the full version of *P* he had at his disposal, he selected only the *pirkei ha-zelem*

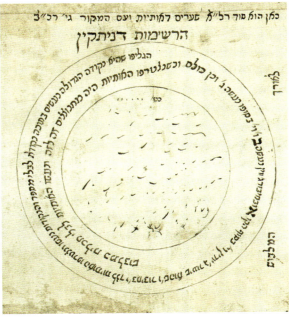

of *Ze'ir* for inclusion in the following section. He then introduced *T*, the arboreal and open-palm diagrams from Temerles's *Commentary on the Pathways of the Letters*.[182] Here too he did not copy slavishly; the inscriptions of the arboreal diagram have been enriched to include angel names, vocalizations, and colors that were not in Temerles's original, which was principally concerned with correlating the sefirot with the joints of the hands. That said, the ilan does not reproduce the Temerles commentary. Instead, its creator used this section to return to some of the general questions with which he began, including the nature of the divine will, and to highlight the centrality of *Sefer yezirah*. The cosmological teaching of *Sefer yezirah* binds this new framing text to the *Temerles Tree* and the hands, bringing into play a range of sources that includes Ḥayyat's commentary on the *Ma'arekhet*, Joseph ben Shalom Ashkenazi's commentary on *Sefer yezirah*, and works by ibn Gabbai. Our creative kabbalist then concluded his work with a final integrative abridgment, drawing selectively from the Tree of the Four Worlds (*W*) and adding a flourish at the base—the half-dome "translucent shell" (*klippat noga*) encasing the bottom of *'Assiah*—of his own inspiration.[183]

The *Gates of Eden Ilan*

GROSS COLLECTION | TEL AVIV, GFCT, MS 028.012.005 | PART I—SARUQIAN UNICUM; PART II—*PaZP7* (FIG. 198)

The scribal arts on display in the Saruqian ilan that has been sewn atop a Great Tree are nothing short of breathtaking. The result is terribly unfair to the Tree onto which it has been rather clumsily grafted.[184] The latter is a fine example of the rare type *PaZP7*: a complete Poppers into which a complete Ẓemaḥ has been spliced, as in the magnificent Cambridge *Trinity Scroll* (fig. 134). Rarity, though, is no match for beauty.

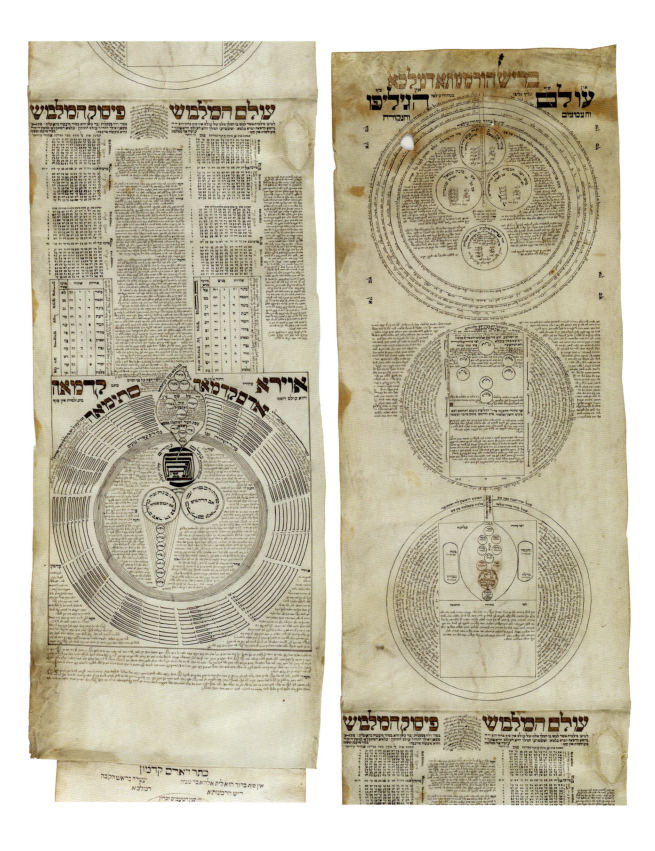

The beauty, in this case, is no less rare: the Saruqian *Gates of Eden Ilan* is a visualization of *Sha'arei Gan 'Eden* (Korets, 1803), authored by the Mezritsh (today Mezhirichi, Ukraine) kabbalist R. Jacob Koppel Lifshitz (d. 1740). Like *Maamar Adam de-Azilut*, *Sha'arei Gan 'Eden* presents Saruq's teachings as the prelude to its treatment of Lurianic cosmogony. And like the *Tree of Holiness*, the *Gates of Eden Ilan* visualizes specifically this Saruqian material. Unlike the *Tree of Holiness*, however, the scribal prowess required to copy it all but ensured that it would remain a unicum.[185] The wedding of the Saruqian ilan to the Great Tree likely took place well after their respective executions, but once consummated, the result was a Great Tree featuring an alternative to the common *K*-form Saruqian opening. This opening was almost certainly crafted originally as a stand-alone rotulus. In this respect, it has no peers. Knorr's figures originated as printed foldouts, only subsequently becoming a module of Great Trees, whereas the *Tree of Holiness* was conceived as one ilan from start to finish.

My focus here is exclusively on the *Gates of Eden Ilan*. *Sha'arei Gan 'Eden* was an eclectic synthesis of Lurianic materials, including Saruqian elements, that also integrated older Ashkenazi esoteric traditions; in this it was akin to *'Emek ha-melekh* and *Va-yakhel Moshe*.[186] Yet unlike those works, *Sha'arei Gan 'Eden* incorporated Lurianic teachings associated with Nathan of Gaza.[187] It is not possible to say whether Lifshitz knew that he was presenting Nathan's ideas, particularly because they were often attributed to Luria in contemporary manuscripts.[188] Lifshitz might have been among those scholars who believed that Nathan's brilliance could still be appreciated, albeit selectively; the peel was to be discarded but not the fruit.[189] Such men found meaning and inspiration in Nathan's literary legacy without fundamentally undermining their commitment to normative Jewish life. Nevertheless, what is at issue here is not the book but, rather, the ilan it inspired.

Atop the ilan, large, crosshatched square letters are used to inscribe the kabbalistic version of "In the beginning": "be-reish hurmanuta de-malka" (At the head of the potency of the King). This zoharic phrase continues just underneath in smaller letters, "galif glifu be-tehiru 'ilaah" (He engraved engravings in luster on high). The bold black subtitle locates us in "'olam ha-glifu," the "World of the Engraving," followed, in smaller lettering by, "and the *zimzum* and the point." Rather than one caption of *Ein Sof* atop the ilan, the scribe has multiplied the inscription no fewer than six times, above and to the right and left of the first large circular diagram. There can be no mistaking that the Infinite is the ground of intradivine structure and process being visualized in this frame.

In a sequence of extraordinary diagrams, the *Gates of Eden Ilan* then presents the Saruqian Malbush narrative. We have by now encountered three other approaches to the visualization of this lore: the diagrams based on Knorr's readings in *'Emek ha-melekh* (fig. 146), the opening of Shandukh's late Baghdadi ilan (figs. 189–190), and the densely inscribed visual reduction-transformation of *Maamar Adam de-Azilut* in the *Tree of Holiness* (top of fig. 192). The similarities among these imagings of Saruq's teaching are not immediately obvious, but they all emphasize its geometrical elements and letter combinations. Overall, we see the primordial sphere within which the *Malbush* is to be woven of letters; the four-cornered divine Garment within that sphere; the combinatory tables (or the algorithm by which they are derived); and the first-emanated sefirot, the lower seven of which shattered.

Figure 198 | *Gates of Eden Ilan*, parchment, 134 × 29 cm, (part 1 only), Eastern Europe, ca. 1800, Tel Aviv, GFCT, MS 028.012.005 (for part 2, see fig. 133). Photo: Ardon Bar-Hama.

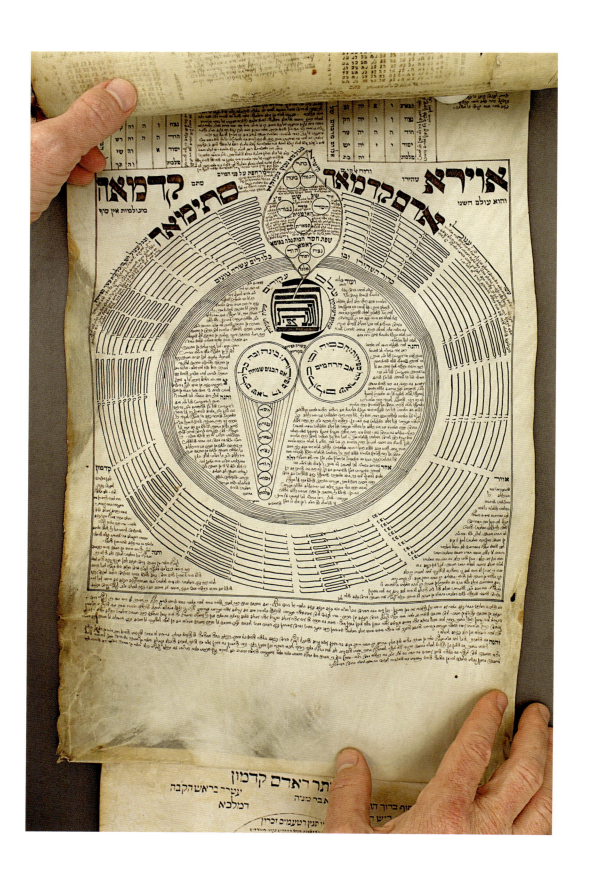

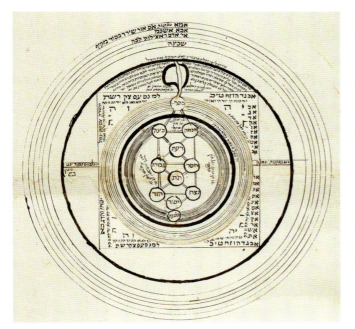 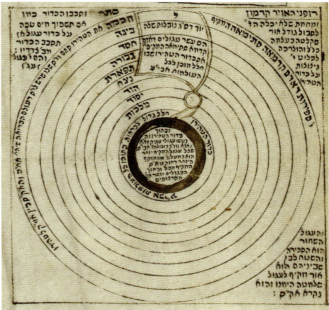

The *Gates of Eden Ilan* is at its most ingenious in visualizing the descent of the "extra" *yud* of the sixty-three-letter name into the *Tehiru* (fig. 199). Its presentation is incomparably more sophisticated than the visualization of the teaching in Shandukh's late ilan and the *Tree of Holiness* (figs. 200–201). The comparison is not entirely fair, as the *Tree of Holiness* devotes multiple diagrams and texts to cover the same ground that the *Gates of Eden Ilan* integrates in a single image. Shandukh also presents an integrative albeit less comprehensive image.

The *Gates of Eden Ilan* does most of its visual magic with letters. Other than a bit of decorative crosshatching in the large letters atop each section and a sparing use of compass-drawn circles and ruled lines, the scribe has worked primarily with two eastern European scripts, one a basic square lettering and the other a flowery cursive. These are complemented by an unusual horizontally elongated square script adopted in the second figure to write the expanded divine names to the right and

Figure 199 (opposite) | "Descent of the *yud*." Tel Aviv, GFCT, MS 028.012.005 (fig. 198). Photo: author.

Figure 200 | "Descent of the *yud*." Tel Aviv, GFC, MS 028.011.008 (fig. 180).

Figure 201 | "Descent of the *yud*." Tel Aviv, GFCT, MS 028.012.003 (fig. 192).

left of the *Tehiru*. It is used to greatest effect in the final figure, where the ten concentric sefirot of the *Tehiru* sphere are composed of the sefirotic names written in this uncommon calligraphic style.

Beyond its tremendous visual appeal, the *Gates of Eden Ilan* gives us another opportunity to explore how Sabbateanism might find expression in the genre of ilanot. Lifshitz's book represents the integration of Nathanic Sabbateanism into the eighteenth-century mainstream. There is no evidence that Lifshitz's Sabbateanism went beyond an appreciation of aspects of Nathan's Lurianic

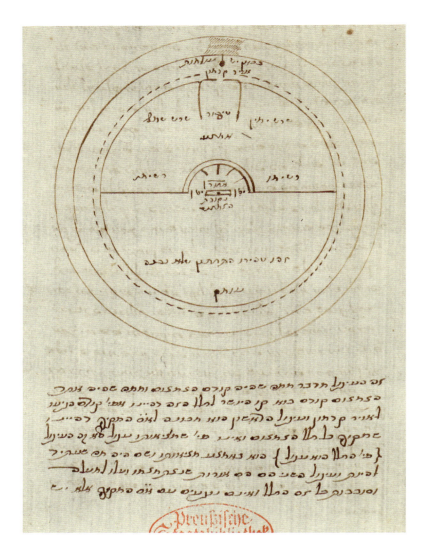

Figure 202 | Circle before the *zimzum* showing lower *Tehiru*, fol. 1r, in Nathan of Gaza, "Discourse of the Circles." Berlin State Library—Prussian Cultural Heritage, Oriental Department, Ms. or. oct. 3078.

Kabbalah that he may or may not have known were Nathan's.

The ilan maps a Nathanic signature concept in a manner reminiscent of Nathan's own diagrams in his "Discourse of the Circles" (fig. 202).[190] In the image reproduced here, the inner circle has been divided into upper and lower halves. The lower is labeled "Zehu Tehiru ha-taḥton she-lo nivnah" (This is the lower *Tehiru* that was not built). In the second and third figures of our ilan (fig. 198), the area of the *Malbush* is outlined. Unlike the comparable images in Knorr's series and the *Tree of Holiness*, however, the diagram in the *Gates of Eden Ilan*, like Nathan's, is divided horizontally into two equal sections. The upper part is the *Tehiru*, as we see it in Knorr and in the *Tree of Holiness*, but beneath it is the "lower half of the *Tehiru*, realm of the *klippot* [demonic shells], *nukba de tehoma raba* [female of the great depths], place of darkness and the shadow of death, evil waters, a place of wilderness

and desolation" (fig. 203).¹⁹¹ This is the epicenter of evil—located very high on the map. And as they say, "location, location, location."

The broader question, of course, remains: How fundamentally different is this sort of Sabbatean theology from other Lurianic ideas that were not "pure fine flour"? Is the consideration of the unexpressed potential of the *Tehiru* and the deep roots of evil in the divine structure (Sabbatean) intrinsically more heretical than the notion of a primordial *Malbush* that preceded the emergence of *Adam Kadmon* (Saruqian)? Indeed, the ontological priority of evil was hardly a Sabbatean invention. For example, Bacharach's 1648 *'Emek ha-melekh* opens with a cosmogonic narrative in which evil makes a precociously early entrance. Already on page 1a, the originary sphere is said to have contained everything that would ever be created, including evil, as per Isaiah 45:7. According to Bacharach, man's sin amplified evil but did not initiate it.

In short, I see no reason to believe that the creator of the *Gates of Eden Ilan* knew that he was visualizing specifically Sabbatean cosmogony. Not everyone is a philological heresy hunter, after all. We should recall that in 1664, at the age of sixty-six, Samuel Vital—the guardian of his father's authoritative Lurianic writings—traveled from Damascus to Cairo at the invitation of the leader of its Jewish community, the wealthy ascetic Raphael Joseph (d. 1669). There, like his host, Vital lauded Nathan of Gaza as "the legitimate heir and representative of the Lurianic tradition."¹⁹² Samuel found Nathan's Lurianic teachings compelling and absolutely genuine. If Vital's heir considered Nathan an authentic exponent of his father's legacy, how were men like Siprut, Lifshitz, and the maker of the *Garden of Eden Ilan* to have known better?

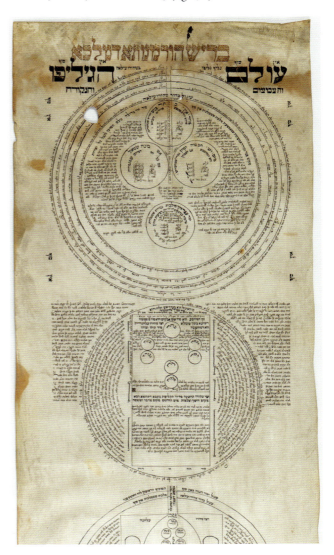

Figure 203 | Lower *Tehiru*, the *Gates of Eden Ilan*. Tel Aviv, GFCT, MS 028.012.005 (fig. 198).

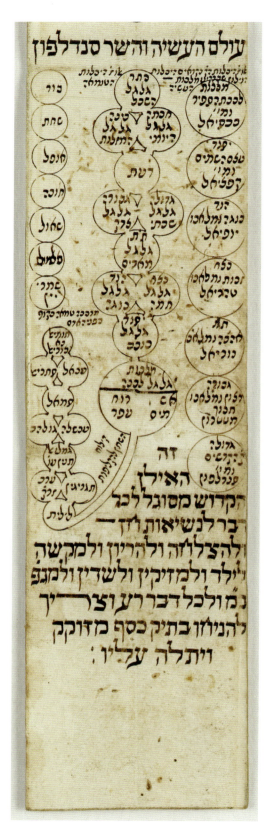

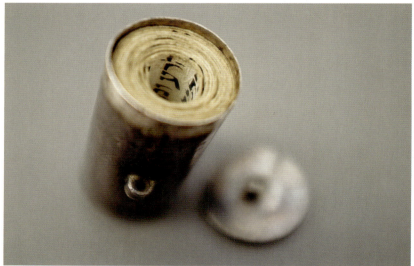

Figure 204 (left) | Amulet addendum on ilan amulet, parchment, 85 × 4.5 cm, Near East or North Africa, ca. 1900. Tel Aviv, GFCT, MS 028.012.017. Photo: Ardon Bar-Hama.

Figure 205 (above) | Ilan amulet in silver case, parchment, 88 × 5 cm, Near East or North Africa, ca. 1900. Tel Aviv, GFCT, MS 028.012.001. Photo: author.

Chapter 6

Ilan Amulets

"This holy tree [zeh ha-ilan ha-kadosh] is a charm [useful] for everything [mesugal le-khol davar]: to find favor, and for success, and for pregnancy, and [to ease] the complications of labor, [against] harmful spirits and demons and plague (may it never happen to us), and [against] everything bad. One must place it in a pure silver case and hang it upon him[self]" (figs. 204–205). Were it not for these opening words about its use, this amulet would never give away its unusual character. It is, generically speaking, a rotulus amulet made up of a few parchment strips sewn together. Such amulets have been used by Jews throughout the diaspora for centuries, and a sizable number were found in the Cairo Genizah.[1]

The notion that an encased parchment could be an effective amulet is an ancient one. According to the rabbinic reading of the Bible, there were commandments to install a mezuzah (pl. mezuzot) —an inscribed parchment scroll—on the doorpost of one's home and to bundle small scrolls inside the leather boxes of tefillin to be strapped upon one's head and arm.[2] Mezuzot and phylacteries—from the Greek *phulaktērion*, derived from the verb *phulassein* (to guard)—have been in constant use among Jews for millennia, certainly qualifying them for the approbation "tried and tested" (*baduk u'menuseh*) so common in the Hebrew grimoire literature.

Until their disappearance in the Middle Ages, magical *charaktêres* typically amplified the apotropaic potency of these Jewish doorpost amulets.[3] Ultimately, however, it was the scriptural text inscribed on the parchment, rolled in its case and installed on a doorframe, that made the mezuzah what it was in the eyes of Jews (and often gentiles, who occasionally sought to procure them to protect their own houses).[4] I do not think it is going too far to suggest that in this case, the text has itself become an apotropaic image. Numerous ancient rabbinic teachings, in particular cosmogonic fantasies, imbue the

letters of the Hebrew alphabet with morphologically determined potencies. Mastering their combinations as words and names was the characteristic forte of a Jewish magus, a *ba'al shem* (name master), to use the term employed by Jews for the past millennium.[5] Consider also the well-known Jewish talismanic artifact known as the *Shiviti*, often seen as a plaque on the eastern synagogue wall; the word means "I set" or "keep," from Psalm 16:8, "I keep my eyes always on the Lord [*YHVH*]." Many examples of the *Shiviti* include supplemental magical paratexts, but their distinguishing

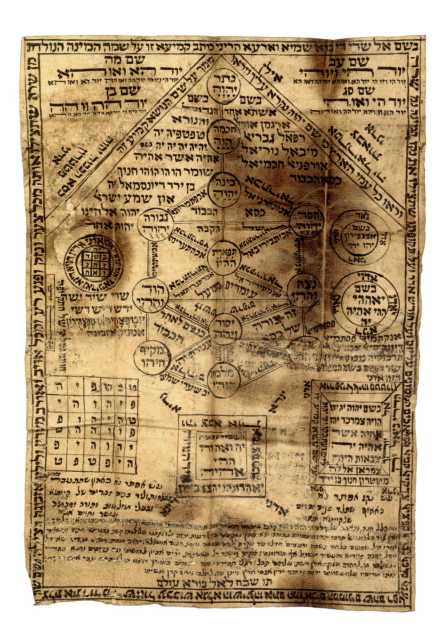

Figure 206 | Woman's amulet with kabbalistic tree, deerskin, 30.5 × 20 cm, Iraq, nineteenth century. Tel Aviv, GFC, MS 027.010.009. Photo: Ardon Bar-Hama.

feature remains the magnified inscription of the Tetragrammaton.⁶

Jewish amulets were not purely textual, of course. Frequently reproduced amulets of the past few centuries, including those designed to defend new mothers and children against the attacks of Lilith, feature images thought to terrify or confound demons. Among them are the birdlike creatures popularized in the 1701 printing of *Raziel ha-malakh* (Raziel the angel) and the simple six-pointed *Magen David* (Shield [now typically Star] of David). The latter was a popular apotropaic image for centuries before its modern transvaluation.⁷ Given their subject matter and pedigree, it would have been strange if amulet makers had not used kabbalistic diagrams to lend added gravitas to their wares.⁸ And use them they did. Consider, for example, a rare nineteenth-century Iraqi amulet that features angelogical appropriation of the sefirotic tree (fig. 206). The tree is presented as the image of the structural matrix responsible for the array of guardian angels required by its bearer, in this case a woman struggling to conceive.⁹ The tree, or at least intimations of it, found its way into antidemonic amulets as well (fig. 207).¹⁰ My concern in the present discussion, however, is exclusively with the use of ilanot—Great Trees in particular—*as* amulets.

A Great Tree is more than a collection of schemata that radiates kabbalistic mystique; it is an image of the divine cosmos in its ideal state. From *Ein Sof* to the bottom of *ʿAssiah*, a Great Tree pictures the entire chain of being, with everything in its proper place. Understood in this way, the "inherent" magic of the ilan is evident. The Great Tree may therefore signify the will to maintain (and, if need be, to restore) that ordered cosmos in the face of innumerable threats. From the standpoint of sympathetic magic, with a touch of theurgy thrown in for good measure, the ilan amulet was a sensible, powerful defense against the disruptions of life, large and small. Nevertheless, such an analysis, as

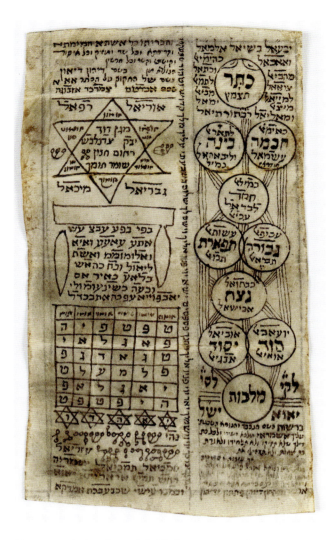

Figure 207 | Amulet with kabbalistic tree, parchment, 16.5 × 9.5 cm, Land of Israel (?), ca. 1900. Tel Aviv, GFCT, MS 027.012.048. Photo: Ardon Bar-Hama.

compelling as it may be from an etic anthropological standpoint, is unlikely to have been a conscious motivating factor for buyers of ilan amulets. For them, simple kabbalistic mystique did the trick.

I return to the artifact with which I opened this chapter: it proclaims itself to be "a holy tree." That is not to say it is *not* an amulet, but that its

ILAN AMULETS | 293

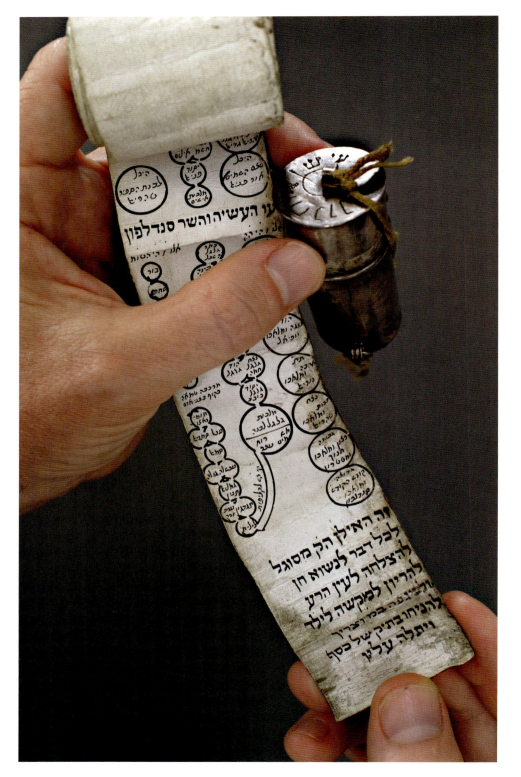

Figure 208 | Ilan amulet with silver case, parchment, 85 × 4.5 cm, Near East or North Africa, ca. 1900. Tel Aviv, GFCT, MS 028.012.018 (see also fig. 258). Photo: author.

distinctiveness—its particular genealogy—justifies labeling it as an ilan rather than as a *kamea*, the generic term for an amulet. Kabbalists might study or contemplate an ilan; the buyers of an ilan amulet wore it rolled up in a silver case (fig. 208). My analysis has highlighted the performative enactment of ilanot and the sympathetic magic implicit in their imaging of the divine topography. Nevertheless, if "practical Kabbalah" is used to denote magical activity that is concerned primarily with this-worldly objectives, such as finding lost objects, curing ailments, and preventing all manner of misfortunes, then most ilanot clearly do not belong in that category.[11] Note that I do not distinguish the ilanot of kabbalistic practice from the ilanot amulets of "practical Kabbalah" on an *a priori* analytical basis; the latter are, with very few exceptions, clearly labeled. Ilan amulets begin or end with inscriptions like the one that opens this chapter.

A great many ilan amulets were produced, and roughly one-quarter of the rotuli in the database of the Ilanot Project are ilan amulets. This ratio belies their actual numerical preponderance: common models were reproduced by a few industrious scribes in commercial quantities. Most undoubtedly remain in the possession of families that have passed them down over the past few generations.

There are two common models for ilan amulets. The first is based on the *"Two-Column" Ilan* associated with R. Isaac Coppio (fig. 176). The nested acrostics that open this ilan make it instantly recognizable. The reader will recall the story of Coppio's peripatetic life in search of kabbalistic manuscripts to buy, sell, and copy. His original ilanot were certainly made with sales in mind, but there is no indication that Coppio sold them as amulets. The rationale he provided for their production was purely devotional. None of his ilanot carry dedicatory inscriptions, promises to ward off harm and evil, or instructions to carry in a pure silver case. Some buyers may have hoped to use them for study and contemplation, whereas others were likely captivated by their alluring aura. A purchaser may have hoped to benefit from simply possessing an image of the Divine. Such a conception reflects a type of natural magic, based on the notion of sympathies and resemblance, but does not make the ilan an apotropaic amulet. Given Coppio's commercial proclivities, if the thought had occurred to him, he might well have produced ilan amulets himself. Yet such a redeployment was a later innovation.

At least a century would pass after Coppio's death before a scribe in Jerusalem took the *"Two-Column" Ilan* as his model for the novel amulets he produced in considerable numbers. To make the amulet version of Coppio's ilan, the scribe streamlined its content and stripped away the text column (fig. 209).[12] This was sensible, given that the amulets would be doing their work from within silver cases, rolled up and hidden from human eyes; why add to the cost of production if the ilan is to be worn rather than read? In addition, these amulet ilanot open with inscriptions above the nested acrostic circles. The bearer—a man or woman referred to by "X [name] son/daughter of Y [mother's name]"—is promised success in all endeavors, rescue from harm, and the blessings of the Torah "by the merit of these holy and pure and awesome names written in great holiness and purity in Jerusalem."

The Coppio-based ilan amulets were not the most popular to emerge in the late nineteenth century. Judging from the quantity that have reached us, the most ubiquitous amulet was based on a Great Tree of type *PaZW* (fig. 210). This ilan type was the one most widely circulated over the eighteenth and nineteenth centuries,[13] but amulet adaptations were produced exclusively in North Africa and in Jerusalem in the late nineteenth and early twentieth centuries.[14] These ilan amulets retain most but not all of the captions found in the type of ilan from which they derive. It is likely that

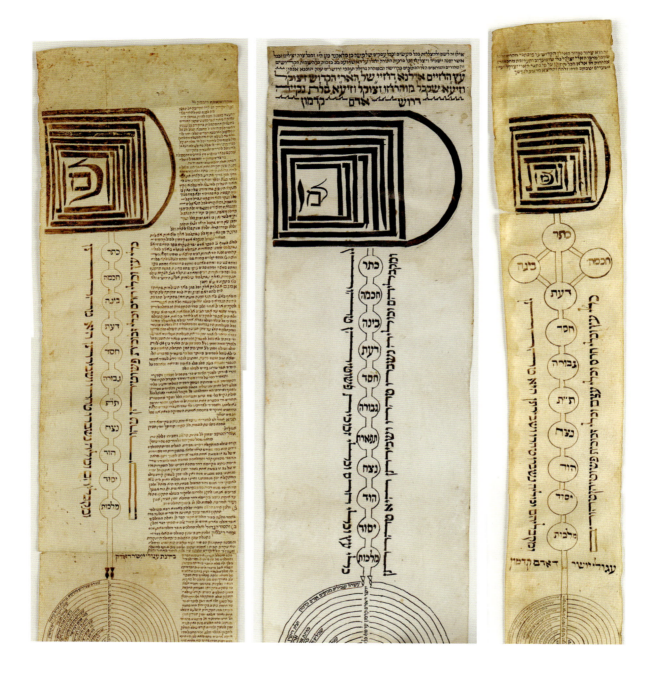

Figure 209 | From ilan to ilan amulet: Tel Aviv, GFCT, MSS 028.012.002 (*left*; original ilan, fig. 176); 028.012.006 (*center*; amulet, fig. 218); 028.012.008 (*right*; amulet, fig. 252). Photos: Ardon Bar-Hama.

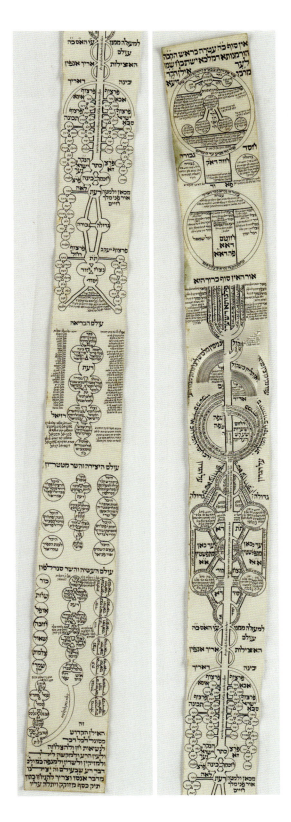

once an initial adaptation was made from a full ilan, the resulting amulet became the common source of most subsequent copies.[15] Promised benefits and instructions for use are found at the bottom of these rotuli (fig. 204).

Ilan amulets could be subject to further abridgments and modifications. Although most exhibit fidelity to their Great Tree ancestor, some were corrupted almost beyond recognition. The narrow rotulus seen here is a good example, retaining as it does just a smattering of key elements (fig. 211). "Ilan ha-kadosh" is inscribed in bold black letters above the circle that normally represents the head of *Adam Kadmon*. Not much of that head remains, even though "chest of *AK*" is also inscribed in bold just under the circle. Little more has been copied from an ilan of any kind; figures and inscriptions culled from other amulets have taken their place. Even the promises and instructions with which the rotulus concludes are abridged. This artifact is titled "The holy ilan," but it is almost indistinguishable from typical North African amulets of its time.

When crafted to serve as amulets, ilanot are streamlined and miniaturized—with a few notable exceptions. We have encountered one of these already in the survey of Great Trees, as it lacks an amulet inscription and presents exceptionally rich visual and textual content (figs. 139–140).[16] The import of the blank space at the bottom of that rotulus as *awaiting* inscription became clear only upon comparison with an ilan amulet in the same hand that recently came to light when it was put up for sale.[17] Two additional rotuli, one in the Gross Collection and the other in the Columbia University Library, round out the picture of this unique family of manuscripts. The ilan amulets in question

Figure 210 | Ilan amulet, parchment, 72 × 4.5 cm, Near East or North Africa, ca. 1900. Tel Aviv, GFCT, MS 028.012.013 (fig. 254). Photo: Ardon Bar-Hama.

ILAN AMULETS | 297

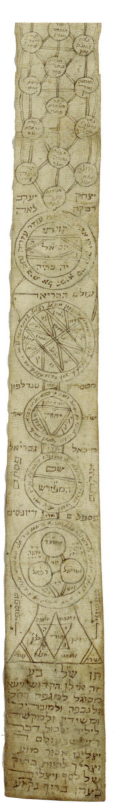
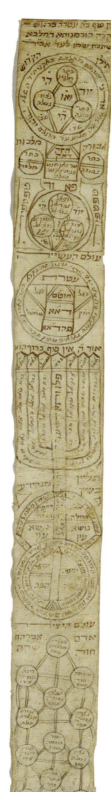
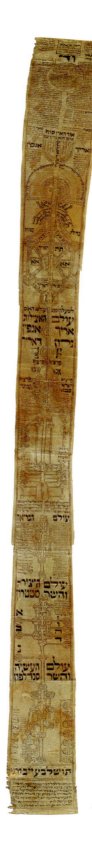

Figure 211 (far left) | Ilan amulet, parchment, 76.8 × 4.7 cm, Near East or North Africa, ca. 1900. Tel Aviv, GFCT, MS 028.012.020. Photo: Ardon Bar-Hama.

Figure 212 (left) | Ilan amulet, parchment (goat), 104.6 × 7.8 cm (upper section missing), Near East or North Africa, ca. 1900. Tel Aviv, GFCT, MS 028.012.021 (fig. 262). Photo: Ardon Bar-Hama.

do not contain precisely the same content, but they all augment rather than abridge complete Great Trees. Two are nearly identical: a Gross rotulus (fig. 212) and the amulet currently on the market are both *PuNZ14EWy* ilanot that conclude with touted benefits and instructions. The stunning ilan explored above and Columbia MS General 247 are close cousins (figs. 213–214). Although the artistry of *Pu* in the former is unique, the two rotuli nonetheless share the module in common, as they do *N*, *Z14*, *E*, and *Wy*. This inclusivity translates into rotuli that are over twice the length of their *PaZW* cousins.[18] Although the scribal hand of Columbia appears to be different from that seen in the three others, comparing their common content reveals an intimate relationship.

All four of these impressive works of scribal art so faithfully preserve their Great Tree content that it comes as a surprise to find them concluding with inscriptions—in one case, a space for an inscription—that betray their intended function. Although the market generally favored simpler and cheaper ilan amulets, these artifacts demonstrate that luxury ilan amulets could appeal to affluent clients who wanted only the best. This seems an opportune moment to reiterate that ilanot should never be subject to a reductionism that limits them to a single function, whatever that may be. These exceptional ilanot included apotropaic elements, but presumably that did not make them objectionable to those who sought an ilan for study and contemplation. Their integrity may also reflect the principled stance of their producers, who may have considered bowdlerization of an ilan sacrilegious.

As an apotropaic artifact, the Columbia manuscript stands out. Rather than end with a few lines promising protection, it concludes with a full-fledged amulet (fig. 215).[19] A clear perception of the functions of ilanot may have encouraged this addition. The final product was required to protect its bearer—something that a Great Tree

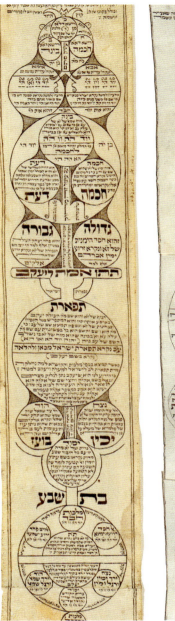
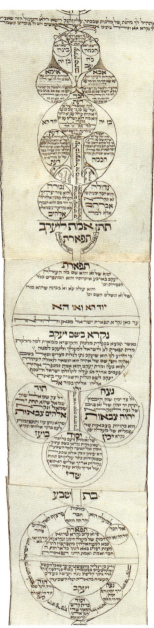

Figure 213 | *N* details compared: (*left*) Tel Aviv, GFCT, MS 028.012.016 (fig. 139); (*right*) ilan amulet, parchment, 390 × 12.5 cm, Near East or North Africa, ca. 1900. New York, COL General MS 247, Rare Book & Manuscript Library, Columbia University in the City of New York.

ILAN AMULETS | 299

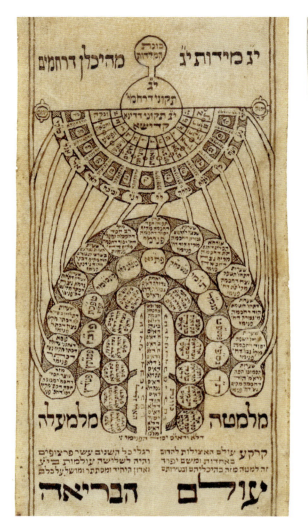 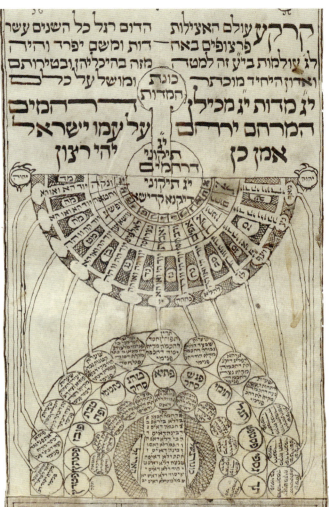

Figure 214 | *E* details compared, (*left*) Tel Aviv, GFCT, MS 028.012.016 (fig. 139); (*right*) ilan amulet, parchment, 390 × 12.5 cm, Near East or North Africa, ca. 1900. New York, COL General MS 247, Rare Book & Manuscript Library, Columbia University in the City of New York.

Figure 215 (opposite) | Amulet ilan bottoms: (*left*) dedicated space of Tel Aviv, GFCT, MS 028.012.016 (fig. 139); (*middle*) boilerplate inscription of Tel Aviv, GFCT, MS 028.012.021 (fig. 261); (*right*) amulet at end of ilan amulet, parchment, 390 × 12.5 cm, Near East or North Africa, ca. 1900. COL General MS 247, Rare Book & Manuscript Library, Columbia University in the City of New York.

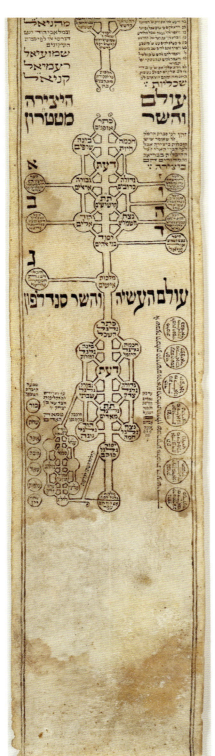
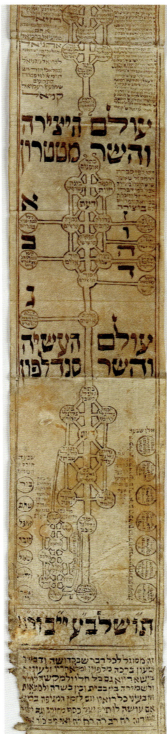
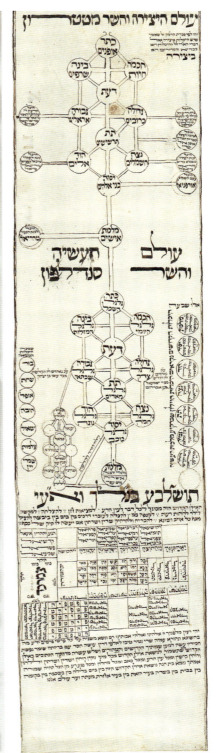

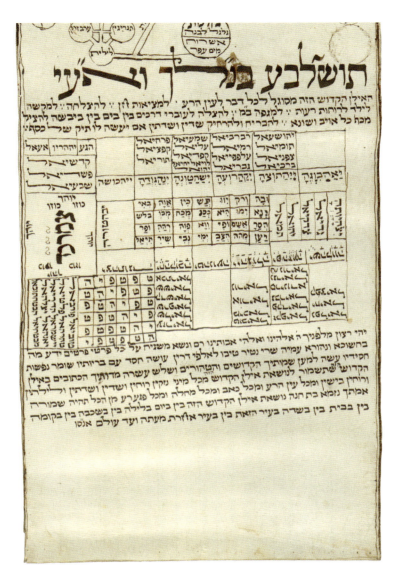

Figure 216 | Amulet addendum, in ilan amulet, parchment, 390 × 12.5 cm, Near East or North Africa, ca. 1900. COL General MS 247, Rare Book & Manuscript Library, Columbia University in the City of New York.

was never intended to do. The ilan "proper" ends with the concluding acrostic ואע״י תושלב״ע בנל״ך, which stands for "finished and completed, praise for the creator of the world; blessed is He who gives strength to the weary and increases the power of the weak." As in typical ilan amulets, the formulaic lines then follow, here somewhat amplified; the promised benefits now include travelers' insurance, whether by land or sea, and protection from enemies human and demonic.

Thereafter we find the unique element: a complex amulet grid composed of squares and rectangles in which various divine names are inscribed in all directions (fig. 216). The magical names it contains are familiar to students of Jewish magic: ZMRKhD, צמרכד, formed from the last letters of the first five verses of Genesis; another divine name consisting almost entirely of triplet sequences, based on Numbers 10:35, is arrayed in twenty-eight squares; and *Taftafia*, טפטפיה, one of the seventy names

of Metatron, is spelled forward and backward, up and down across a square divided into thirty-six mini-squares, each of which contains one of the six letters of the name.[20] The thirty-six squares can also be seen in fig. 206, just below and to the left of the sefirotic tree.

At the very end of the Columbia amulet we find a prayerful dedication to the intended bearer of this substantial rotulus: Nazmah (Nedjma) bat Ḥannah. Paleographic analysis suggests that she lived in the eastern Maghreb (Tunisia, Libya) or in the Land of Israel.[21] In a manner typical of Jewish magical writing, the passage seamlessly weaves devotional second-person supplications to God with emphatic reminders of the significance of the holy names written on the ilan to be worn by Nazmah. God is implored to act on the merit of these names and the virtues of the ilan itself rather than on the basis of Nazmah's merits:

> May it be your will, Lord our God and the God of our fathers, high and lofty, who providentially observes even the smallest details, knows what is in the darkness and with whom light dwells (Dan. 2:22). . . . Act for the sake of your holy and pure names and the thirteen attributes written on this holy ilan. Protect the [female] wearer of [this] holy ilan from all manner of misfortunes. . . . From everything may your handmaiden Nazmah bat Ḥannah, carrier of this holy ilan [noset ilan ha-kadosh ha-zeh], be protected: whether day or night, lying down or rising up, at home or in the field, in this city or in another city, from now and forever, amen!

An inspection of this last section of the rotulus gives the impression that, like its close kin in the Gross Collection, it was prepared without a particular buyer in mind, up to the end of the amulet grid and the beginning of this inscription. The general declaration of the virtues of the ilan just before the grid is generic, and the verbs use the presumptive male form, i.e., "he should make himself a silver case [for it]." The seven-line inscription after the amulet grid, beginning with "May it be your will," uses the female form throughout, referring to the one who is to carry the amulet in the silver case as a woman. Would kabbalists, with their historic propensity for embracing stringencies surrounding female impurity, have been bothered by a woman using an ilan?[22] It depends; if Nazmah had asked to study the ilan, she probably would have been rebuffed. Bearing it rolled up in a silver case was a different story.

A recently discovered cache of letters provides a behind-the-scenes picture of the ilan-amulet business in the early twentieth century. The letters, written in 1926 and included in the published correspondence of R. Joseph Messas (1892–1974), document ilan-amulet transactions between Messas, then a rabbinic scribal artist, and Jacob Soffer of Marseille.[23] Messas was born in Meknès, Morocco, served as chief rabbi of Tlemcen, Algeria, for seventeen years, and immigrated to Israel in 1964, where he was quickly installed as rabbi of Haifa. Today he is remembered as an enlightened moderate with ties to the Alliance Israélite Universelle.[24] Soffer went to Marseille in 1920 from Oran, Algeria; he would eventually study rabbinics and scribal arts in Palestine. Even though Soffer was the one commissioning ilan amulets from Messas, he too became a talented calligrapher, and his works of micrography are found today in several museums.[25]

In the first of his letters mentioning the commission, Messas writes of having received a faded "holy ilan amulet" (kamea ilan ha-kadosh) from Soffer, along with a request "to make two or three akin to it on fine white parchment and in the finest Ashurite script [used in writing Torah scrolls, etc.], with all the drawings [ẓiyyurim] and with great precision."[26] Messas does not subsequently use the term *amulet* when referring to the ilanot,

referring to them exclusively as "holy trees" (ilanei [sic] kodesh). There is no mention of names to be inscribed; Soffer was fully capable of adding them at the point of sale. The correspondence shows that Messas produced a half-dozen rotuli based on the model that Soffer had provided.

The letters also offer a unique opportunity to discover the economics of ilan production. Soffer's initial payment of 200 French francs for the first two ilanot—roughly $600 US dollars today—fell short of Messas's expectations. "Thank you very much, my friend," he responded to Soffer, "even though this is not fitting payment for my precise and clean work, as his honor will see." In Messas's next letter to Soffer, the following month, we discover that Soffer graciously sent a supplemental payment.[27] A few months later, Soffer paid Messas 250 francs for two additional ilanot, a sum that satisfied him.[28] For the sake of comparison, Soffer paid Messas 100 francs to fix two damaged Torah parchment sheets and 300 francs to fix five small, damaged Esther scrolls and to make two new, smaller ilanot.[29] The wholesale price of a beautifully executed ilan amulet in the 1920s was therefore about $375 US.

The correspondence confirms that the scribes who copied ilanot need not have been kabbalists. I suggested as much above on the basis of howlers—mistakes that expose ignorance. It is no coincidence that some of the most beautiful ilanot are rife with them: the Cambridge *Trinity Scroll* comes immediately to mind (fig. 134). I cannot say whether Messas fell prey to such blunders, as I have yet to positively identify one of his ilan amulets. Although he studied Kabbalah, it was not his forte. Soffer's commission was based on Messas's scribal prowess. During the same period, Soffer also paid him to restore an old parchment Pentateuch with Rashi's commentary, likely of Iberian origin; its first pages were torn and half missing, including its opening illuminated carpet page. Messas was asked to re-create the missing half of the illumination and the texts on aged parchment that matched the original.[30] He was thus more than capable of copying ilanot with precision, even if he lacked a real understanding of their content. Might he have been responsible for the neatly executed ilan amulet seen here, with headings in Ashurite script, as ordered by Soffer (fig. 217)?

Attending to their magical dimensions, I have divided the ilanot genre into two broad categories: talismanic and apotropaic. By talismanic I refer to the work an ilan was presumed to do intrinsically, owing to the presumed resemblance between signifier and signified. By apotropaic I refer to the repurposing of these very objects as amulets; rolled up and encased in silver, they were to provide protection and deter the misfortunes that deferentially kept their distance. A comparison may be made to the two kinds of Psalms that can be purchased today from every purveyor of Jewish holy books. One is sized normally, the other miniaturized.[31] The former is for study and recitation; the latter, too small to be read comfortably, is to be hung from one's rear-view mirror or stored in a handbag. It might be fairly asked: Are they one and the same book? Mapped onto a Venn diagram, we would undoubtedly see overlaps. The multivalence of these expressions reminds us that a book may be studied by its owner one day and carried as a charm the next. An ilan in a silver case could one day be removed and unrolled by its curious owner, its telos transformed in an instant.

GROSS COLLECTION | TEL AVIV, GFCT, MS 028.012.006 | COPPIO ILAN AMULET (FIG. 218)
This goatskin ilan amulet begins with the following dedication:

This ilan is for the sake of Moses son of Malakand Cohen, may God preserve him,

Figure 217 (*left*) | Top of ilan amulet. Tel Aviv, GFCT, MS 028.012.001 (fig. 205). Photo: Ardon Bar-Hama.

Figure 218 (*right*) | Top of ilan amulet, parchment (goat), 254 × 17.5 cm, Jerusalem, ca. 1900. Tel Aviv, GFCT, MS 028.012.006. Photo: Ardon Bar-Hama.

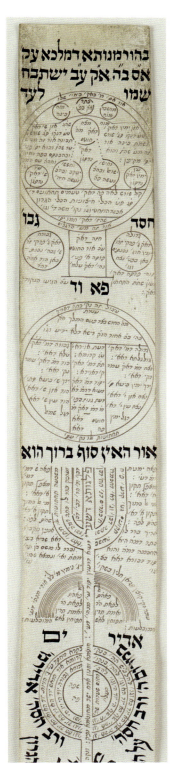
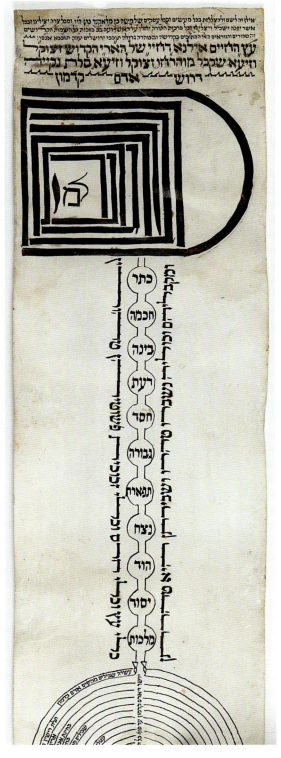

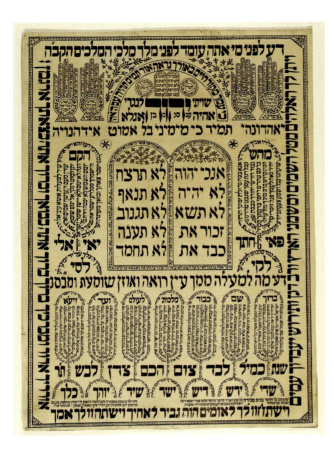

Figure 219 | Bukharan *Shiviti*, paper, 63.4 × 46.3, Nissim Sejera, Jerusalem, 1905. Tel Aviv, GFCT, MS 058.011.011. Photo: William Gross.

and for the success of all his actions and enterprises.[32] And he will be saved from every hardship, succeed and prosper in all his endeavors, and all the blessings of the Torah will be bestowed upon his head and upon all the members of his household by virtue of these holy, pure, and awesome names, written in great holiness and purity in Jerusalem, the Holy City, may be it rebuilt and established speedily in our days, *amen, nezaḥ, selah, va'ed.*

This optimistic header was the only element added to the Coppio *"Two-Column" Ilan* in the process of transforming it into an ilan amulet. The redeployment enabled the scribe to forgo the entire right column and its miscellany of texts. The scribe also omitted numerous inscriptions embedded within the diagrams of his source.

According to William Gross, the scribe in question was likely Nissim Sejera, a Bukharan scribal artist living in Jerusalem. Sejera was a well-known *sofer*, whose works, including a number of Torah scrolls, were commissioned by Jews in Bukhara and are found in synagogues there to this day. Sejera was also in the business of making *Shiviti* amulets, from large stone lithograph posters to handwritten pocket-size versions (fig. 219).

Whoever made this ilan amulet made more than one. A twin can be found in New York, in the collection of the Jewish Theological Seminary, MS S435. The only difference between them is the name of the client, in this case Mordekhai Ḥayyim son of Rachel. According to the captions, both were made in Jerusalem—perhaps on the basis of an ilan brought to the holy city by Coppio himself.

Chapter 7

The Printed Ilan

We have reached the final chapter of this history of the ilanot genre. Readers will recall that a particular medium—parchment—was constitutive of its generic definition in the earliest sources that refer to the ilan as such. Even so, we have seen that paper would do in a pinch, if funds were scarce or if the ilan was a draft that would later be committed to more precious sheets. Did it matter whether an ilan was written by hand? Jewish law mandates that the parchments of Torah scrolls, tefillin, and mezuzot be handwritten by carefully trained and pious scribes; if such items were mechanically reproduced, they would be unfit for use.[1] The question arose relatively late in Jewish historical terms, of course, after the advent of modern printing. In a responsum by R. Yair Ḥayyim Bacharach (1638–1701), written expressly to find a way for a couple who lived in a single room to have intercourse in close proximity to their bookcase, a metaphysical distinction was posited between handwritten and printed materials:

> The sanctity of a Torah scroll derives from the writing of a man in whom there is a soul of life, part of God above, [conferred] by means of his intentions and his forming of the holy letters. All of Israel are presumed to cleave spiritually to our God, and because of this, holiness is drawn down into the Torah scroll, tefillin, mezuzot, books, and the sanctity of every sacred object.... Were mezuzot, tefillin, and Torah scrolls to be printed, no one would even consider the possibility that they might be valid.[2]

The ontological divide between anything written by hand—not only the halakhically mandated scrolls but all books and even the vague "every sacred object"—and printed material made a difference. Because the books in the couple's library were printed, the taboo did not apply, and they were permitted to have sex in their modest home.

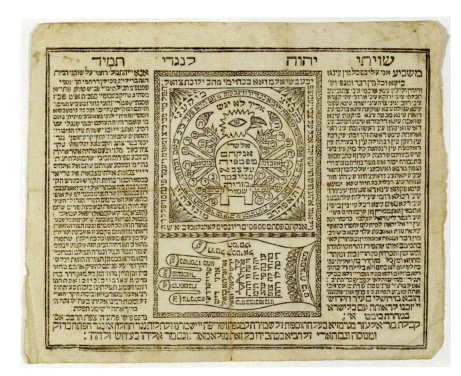

Figure 220 | *Shiviti* amulet, paper, stone lithograph, 23.3 × 27.7 cm, Safed, ca. 1865. Tel Aviv, GFCT, 027.011.214. Photo: William Gross.

En route to giving the green light, Bacharach articulated a broad, talismanic view of manuscript as vessel: the scribal object was charged with the holiness channeled by the scribe in the act of writing it. Printed works were mundane by contrast and lacked this charge. If Bacharach's view is at all representative, we can easily understand why ilanot, which resonated more immediately with Torah scrolls, mezuzot, and tefillin than with typical printed books, continued to be reproduced by hand well into the twentieth century.

Like ilanot, amulets—other than tefillin and mezuzot—were not required by Jewish law. That did not mean, however, that the details of their production were not without legal consequence. Ancient rabbinic sources made a distinction between amulets written by experts and those of amateurs, allowing the former to be carried in the public domain on the Sabbath because of the greater likelihood that they were going to work.[3] In addition to expertise, piety and preparation were presumed to factor into the efficacy of an amulet. Medieval sources often stipulate that amulets be written only after lengthy ascetic preparations by the scribe. Nevertheless, by the eighteenth century Jews began to produce printed amulets without evident concern over such niceties. Production ramped up markedly in the mid-nineteenth century, with a plethora of printed amulets demonstrating the presumed efficacy of lithographs printed on paper as well as typeset versions of perennial favorites, the *Shiviti* and the Lilith repeller foremost among them (fig. 220).

This spike in printed amulet production overlapped, not coincidentally, with the emergence of ilan amulets. The scores of extant examples indicate that most were reproduced from boilerplate templates by a small number of copyists.

Still, they were prepared by hand rather than by the printing press. The market would finally have its way, though, and 1864 saw the appearance of an ilan that was fully typeset and printed on paper. The publishers promised that it would keep its buyers safe from all manner of harm, a guarantee reminiscent of one made by the publishers of the first printed amulet-bearing Hebrew grimoire, *Raziel ha-malakh*.[4] The 1864 printed ilan certainly has a fascinating story, but it attests more to the commodification and marketing of magical artifacts in its day than to the venerable mores of the genre.

Did the fact of mechanical reproduction matter? Did an ilan require handwritten holiness to do its work? Were those who opposed the printing of ilanot concerned that mechanical reproduction would wither their "aura," to invoke Walter Benjamin?[5] Was the performance of an ilan thought by kabbalists to be related in any way to its mode of reproduction? It is tempting to presume such concerns, but I have yet to find evidence for them in the sources. When we hear of opposition, it seems grounded in the conviction that ilanot were esoteric artifacts ill-suited for the public eye. According to an undated ban against the printing of kabbalistic works that circulated in Italy in the late 1550s, plans were in the works, in the words of R. Moses Basola (1480–1560), "to print [la'asot be-dfus] an ilan with manifold branches and roots—from which great troubles would come."[6] There is no evidence for such a printed ilan aside from this reference, and it was probably never published.[7] Rabbis who shared such concerns, or who wished to avoid the ire of those who did, were probably reluctant to lend their approbation to printed editions of ilanot until R. Isaiah Muskat (1783–1868), an infirm and elderly Hasidic rabbi based just outside of Warsaw, consented to do so some three hundred years later. Resistance, if not outright opposition, to the printing of ilanot over the centuries does not mean that the printed ilan does not have a tale to tell, one that deserves its own chapter. In the next pages, I explore the precocious printings of the seventeenth century before taking a closer look at two printings in Warsaw of 1864 and 1893.

The "Tree of Kabbalistic Science"— Venice, 1608

Lipa Schwager and David Fränkel's bookshop in Husyatin (now Husiatyn, Ukraine), "Dovev Sifsei Yeshenim" (Moving the Lips of Sleepers),[8] was a mecca for connoisseurs of rare Judaica. These Galitzianer booksellers were known for the detailed catalogues they regularly produced during their partnership, which lasted through the end of the First World War.[9] In 1907, the fourteenth "L. Schwager & D. Fränkel" sale catalogue was published.[10] It opened with a very special item— so important, in fact, that it was given top billing and priced many times higher than the other listings that followed it (fig. 221).[11] Under the heading "Unica. Einblattdruck" appeared: "*1. Kol sasson* [voice of gladness], *Ha-apiriyon* [the palanquin] *part II*. And this is a 'tree of the science of the Kabbalah' [*ilan ḥokhmat ha-kabbalah*], drawn [*meẓuyar*] with a commentary according to deep Kabbalah [*kabbalah 'amukah*]. At its end is a poem of eighteen verses in praise of the aforementioned 'ilan' by the *gaon* our teacher the rabbi Judah Aryeh [Leon] Modena.[12] It is one of a kind and no other copy is known to exist in the world."[13]

As anyone familiar with his life and work would have expected, Gershom Scholem was a careful reader of these catalogues, even years after the books on offer had been sold.[14] He combed them thoroughly, always on the lookout for volumes he had yet to acquire. In his copy of the 1907 catalogue, Scholem marked an *X* beside this unicum.[15] *X* meant that an item was desired—but not (yet)

in his collection. Such a "single-page print" never resurfaced during his lifetime, and nor has it since.

The 1907 catalogue used the term *Einblattdruck*, a single-sheet printing. The circulation of such a single-sheet printed ilan is corroborated by two entries in Bernhard Friedberg's bibliographical lexicon of 1928. *Apiriyon Shlomo* (Palanquin of Solomon) is there described as a work of "Kabbalah treating the calculation of the redemption" that was printed "in duodecimo (12°) format *and one folio (2°) page*" [italics added]. *Kol sasson*, in its own lexicon entry, is described as "an ilan of the science of the Kabbalah, drawn, with an explication and poem in praise of the ilan by our teacher, rabbi Judah Aryeh Modena: Venice, 1608, single-sheet folio."[16]

In late 2019 a copy of *Kol sasson* was put up for sale by Jerusalem's Refaeli Auction House. The auctioneers touted it as "unknown to any bibliographers" and having a "fold-out page" in its back matter.[17] Thanks to Eliezer Baumgarten's vigilant eye, the sale was spotted and its significance clocked. William Gross bid with enthusiasm and became its proud owner.[18] One hundred and twelve years after its last sighting, the first printed ilan had been recovered and acquired by the visionary patron of the Ilanot Project. It *was* an oversize page, attached to the book of which it was originally and

Figure 221 (opposite) | Top billing for *Kol sasson* in Lipa Schwager and David Fränkel, eds., *Reshima mi-sfarim yeshanim yekirei ha-meziyut (Incunabeln) ha-'omdim le-mekhirah ezel L. Schwager & D. Fränkel, Husiatyn (Oesterreich)—Nr. 14* (German and Hebrew) (Husiateyn, 1907). Tel Aviv, GFC, B.2545. Photo: William Gross.

Figure 222 | *Kol sasson* ilan, paper foldout, 17.6 × 27.8 cm, in Abraham Sasson, *Apiryon Shlomo: hu kol sasson ḥelek sheni* (Venice, 1608). Tel Aviv, GFC, B.2521. Photo: William Gross.

intrinsically a part: Rabbi Abraham Sasson's *Kol sasson* (fig. 222).

We know next to nothing about Sasson himself. The rare references to him describe him merely as "an Italian rabbi." He claimed descent from King David's fifth son, Shefatia ben Avital, and, appropriate to that lineage, messianic matters were very much on his mind. In 1605 he published *Kol mevasser* (Voice of the herald)-*Kol sasson*, a two-part work devoted to the eschatological prophecies of Daniel and messianism. The 1608 volume continued *Kol sasson*, the messianic treatise. Its date of publication was given on the frontispiece as "the year 'I ordered a lamp for MY MESSIAH'" (MShYHY has the numerical value of [5]368, the Hebrew year corresponding to 1608).[19] Sasson's messianic calculations come at the end of this second volume: his expectation was that the great day would come in 1648, forty years later. As we know, 1648 would not be one of "the blank pages of history," in Hegel's memorable phrase, but one that told a rather different story than Sasson had hoped.[20]

Inclined to harmonize differences of opinion, Sasson was nevertheless a gutsy interpreter of texts. In his introduction, Sasson laments the fact that confusion reigns among students of the Kabbalah. The most fundamental questions concerning the nature of God are a matter of dispute, with irreconcilable contradictory positions expressed in the literature to which earnest students turn for answers. The result is that "They do not know who they are to bless and to whom they are to bow."[21] The introduction frames the issue in terms of *'azmut ve-kelim* (essence and vessels), whether the sefirot are rightly understood as one or the other. This question had been considered implicitly since the emergence of Kabbalah but became problematized in these terms in the sixteenth century, as the discussion in the fourth gate of Cordovero's *Pardes rimonim* exemplifies. Cordovero's discussion, as well as Menaḥem Azariah da Fano's abridgment of and commentary on it in *Pelaḥ ha-rimon*, were central to Sasson's thinking. Yet Sasson remained concerned that the issue was anything but resolved. Drawing inspiration from the zoharic interpretation of Solomon's cedarwood palanquin as an archetype of the tree of sefirot, as we see in Zohar II:127b and its parallels, his mission was to achieve decisive clarity.[22] Although it is not entirely clear whether the closing lines of his introduction refer literally to the foldout ilan at the end of the book or metaphorically to the book as a whole, they are worthy of citation. Referring to the palanquin, Sasson writes (fol. 4a), "I have drawn it and made it solidly [miksha], the image of the most supernal structure [dmut tavnit gavoha me'al gavoha], compared to a tree [ilan] whose branches are many and whose root is one, united in its branches. For I said, 'for it is time to be gracious unto her, for the appointed time has come' [Ps. 102:14] and 'it is time to do something for the Lord . . .' [Ps. 119:126], to uproot and to plant." As we will see, the ilan that concludes the work is a visual expression of the attempted harmonization of disparate schools of thought to which the book is dedicated. As for the *'azmut ve-kelim* debate, Sasson thought it possible to reconcile the issue by applying the monist assertion that 'azmut is the "soul," kelim the "body," and the distinction merely a matter of perspective.

Because Sasson's book has not been treated by scholars, a brief analysis is needed to contextualize the first printed ilan that concludes it. The main sources for the first half of the work were *Ma'ayan ha-ḥokhmah* (Fountain of wisdom) and Cordovero's *Pardes* (along with its commentary-abridgment *Pelaḥ ha-rimon*).[23] The former (mentioned above in the section on Knorr's *Panoply Tree*) was regarded as what we would today call a "primary source," and its doctrine of primordial lights, taken as ur-sefirot, was gospel to Sasson.

These lights found their way to the very top of the ilan, graphically ringing *Ein Sof*. Looming large throughout Sasson's chapters is the Zohar, which he regarded as the ultimate authority. Cordovero was Sasson's principal "secondary source" throughout the first half of the book, but even though he was revered by Sasson, he was not considered infallible. Roughly halfway into *Apiryon Shlomo*, Sasson suddenly invokes R. Isaac Luria, whom he refers to as "Ha-AR"I el." A lack of familiarity with the name is assumed by the author, who takes pains to add one of the book's rare printed marginal notes beside this line to explain the reference. The note reads simply, "Ha-elohi Yiẓḥak Ashkenazi Luria" (The divine Isaac Ashkenazi Luria). It is difficult to assess the extent of Sasson's familiarity with Luria's teachings or whether his cryptic remarks in the introduction about contradictory opinions were made with Luria in mind. Without mentioning a particular work, Sasson merely says, "in the name of Ha-AR"I el, may the memory of the righteous be a blessing, we have received [the tradition] that *Ḥokhmah* and *Binah* are two *parzufim* and considered part of *Arikh Anpin*."[24] Cordovero, by contrast, had defined *Zeʿir Anpin* as a complex of eight sefirot beginning with *Ḥokhmah* and culminating with *Yesod*.[25] Sasson regarded his reconciliation of this apparent contradiction—the task to which he devoted the remainder of the work—to be his greatest exegetical accomplishment.[26]

Sasson, the harmonizer, settled the matter by asserting that the upper (*Arikh*) could be regarded as the soul of the lower (*Zeʿir*). Yet regardless of how obvious it seems in light of his similar approach to *ʿazmut ve-kelim*, he did not arrive at this solution without first embarking on a surprising hermeneutical journey. It was this journey that prompted my description of Sasson as a "gutsy interpreter." Having laid out the problem, Sasson explains that the Cordovero-Luria contradiction is rooted in their different readings of the zoharic *Sifra de-zniʿuta*. He opines that "after *Maʿayan ha-ḥokhmah*, which was transmitted by [the angel] Michael to Moses our Rabbi, of blessed memory, and which expounds the essence of the cause of everything," the work of the greatest profundity is the *Sifra de-zniʿuta*.[27] He credits Luria with bringing unprecedented illumination to what was previously a "closed" book, in his words. There was, however, a problem: "collection after collection" of Luria's teachings written by "his students" displayed contradictions and inconsistencies so great that they jeopardized the reader's strength and sanity.[28] As it was impossible to know what Luria actually taught, Sasson made his brave move: he would study *Sifra de-zniʿuta* and figure out who was right.[29]

Kol sasson concludes with the "most excellent of the cedars" (Song of Songs 5:15): the ilan. The sheet—roughly four times larger than the pages of the book to which it is bound—is divided into three columns.[30] The center is devoted to the ilan, the sides to a short kabbalistic exposition that provides some sense of what Sasson was trying to achieve in the diagram. An eighteen-line poem in praise of the ilan by Leon Modena fills the bottoms of both marginal columns. Modena, hardly averse to taking on the odd side job, likely composed the panegyric on commission.[31]

Below the title *Ha-apiryon*, two square-script lines of text open the diagram in the center column. The first says, "Cause of Causes, Soul of Souls"—an interesting but hardly uncommon wedding of philosophical and kabbalistic language. Found occasionally in early kabbalistic sources, the epithet "Soul of Souls" expressed Sasson's preferred perspective on the entire complex constellation of divinity, as it established the oneness underlying apparent multiplicity. The second line—"Ten Supernal Lights [ẓaḥẓaḥot] spring forth from the darkened light"—captions the single nontextual

pictorial element in Sasson's ilan, a black sunlike figure labeled at its center "*Ein Sof*."³² From it radiate ten dark wavy rays, each one labeled with the names and derivations of these supernal lights: "Marvelous Light; light from light. Hidden Light; radiance from radiance. Sparkling Light; luster from luster. Bright Light; radiance from light. Brightened Light; light from radiance. Illuminating Light; luster from light. Refined Light; light from luster. Bright and Brightened Light; luster from radiance. Clear Light; radiance from luster. Splendorous Light; flaming fire from flaming fire."³³ Sasson's reverence for *Ma'ayan ha-ḥokhmah* found apt expression atop his ilan in this striking figure.

Beneath the dark star of *Ein Sof*, the ilan continues with a presentation of the primary *parzufim* from top to bottom. Here too Sasson shows no sign of having been inspired by the diagrams of Lurianic manuscripts; the first Lurianic ilan rotuli had yet to be drafted. The array of *parzufim* is conveyed exclusively by the arrangement and style of terms and typefaces. Major structural features use a bold square typeface that clearly emphasizes the two dominant interrelated elements: the Tetragrammaton and the ten triangulated sefirot. Between the four demarcated strata, the finer details of each *parzuf* are listed and labeled in a smaller semicursive typeface associated with Rashi's commentary on the Torah.³⁴ The idiosyncratic final product is indeed a kind of Lurianic ilan, although it seems primarily indebted to his own reading of the zoharic sources of Lurianic inspiration. For Sasson, the key elements of the top stratum are expressed with terms borrowed from the opening of *Sifra de-zni'uta*: "a single skull filled with crystalline dew. Membrane of air, purified and sealed; those strands of clean fleece hanging evenly. Will of Wills is revealed through prayer of those below. . . ."³⁵ The lower strata represent their respective *parzufim* as ten sefirot, mostly in the same array seen in the overall structure. The only divergence among them is that the ten sefirot of *Arikh* begin with *Keter*, whereas those of *Ze'ir* and *Nukba* (here labeled "Shekhinat 'uzo") do not; the latter insert *Da'at* to make up for the lost sefirah.

Sasson's commentary, which flanks the diagram on both sides, returns to his consistent theological claim and exegetical master key: the soul may be heuristically distinguished from that which it ensouls, but they are truly one. In human terms, the *zelem* is the soul, the *d'mut* the body; together, they embrace all Worlds as one "Adam." So too for God: "So the Holy One, Blessed be He, and blessed in the mouths of all who live, in the secret of His Name." On the one hand, God is the "Holy Blessed One," which corresponds to *Ze'ir Anpin* and to "*parzuf V* [ו] of the name YHVH." But of course there is more to God than that: the *Shekhinah* is equated with *'Assiah* of *Azilut* and the "final *parzuf H* [ה] of the name of YHVH"; *Binah* with *Yezirah* of *Azilut* and the first *heh*; *Ḥokhmah* with *Beriah* of *Azilut* and *parzuf Y* [י]; and *Keter* with the thorn of the *yud*.³⁶ All of these levels of the hierarchy are mere garments of the ultimate Soul, however.³⁷ So to whom do we bow? In his introduction, Sasson laments that the differences of kabbalistic opinion had left people wondering.

> With a flesh-and-blood king, say that people bow to the countenance [*parzuf*] of his soul and not to the countenance of his body. No! That is demonstrably false. So say that people bow to the countenance of his body and not to the countenance of his soul. No! After all, the soul is what makes a person who s/he is [ha-neshamah hi 'ikar ha-adam]! How, then? To this and to that in union [be-yiḥud] people bow. So too is the secret of divinity [sod ha-elohut]: say that we bow to the emanator who is the soul and cause of emanation and not to the emanation, which

is his name and his garment? No! For it can be demonstrated that the opposite is the case, as "we thank and bow before you, Lord our God" of *Aẓilut*, whose name is YHVH. But the emanator has no letter or name that refers to it. Say we bow before the emanation and not the emanator? No! For the emanator is the cause, root, and soul of emanation. How, then? To the emanator *and* to the emanation—his name—praised and marvelous in unity, we bow and pray.

If Sasson's theology gave him a certain license to diagram God's body as he has, it also dovetailed neatly with his messianic fervor. The year 1648—the Hebrew year [5]408—is the time of the redemption, of which it is said, "[On that day,] YHVH will be one, and his name one [YHVH eḥad u-shmo eḥad]." If one adds up the numerical value of those four Hebrew words, they equal 408 (1648).[38]

The Delmedigo *Novelot ḥokhmah* Foldout

After the aborted efforts of the late 1550s and Sasson's unicum of 1608, we know of no attempt by Jews to print an ilan until the late nineteenth century. There is one exception worth noting: a diagrammatic foldout page near the end of the second volume of Joseph Solomon Delmedigo's *Novelot ḥokhmah*.[39] Delmedigo, a polymath whose complex intellectual profile has long challenged scholars with a preference for what they perceive as consistency, wedded an impressive training in rabbinic, mathematics, and astronomy—which he studied with Galileo—with a profound interest in Kabbalah.[40] Delmedigo amassed a truly incredible kabbalistic library, much of which he shared with his student R. Samuel Ashkenazi, who was the editor of *Novelot ḥokhmah*. Ashkenazi's interest in book collecting and printing is on display throughout his lengthy introduction and in the fascinating booklist on its last page. In *Novelot ḥokhmah* Ashkenazi collected a variety of texts composed by Delmedigo and others.[41] Bacharach's 1648 *'Emek ha-melekh* is often described as the first book to print Lurianic kabbalistic materials, but *Novelot ḥokhmah* had done so roughly a generation before. Both books include the writings of Vital and Saruq as well as overviews by their respective authors.[42] These overviews, of undeniable and understandable appeal to students, were written with them in mind. Having studied them, one was better equipped to tackle the sprawling and disorganized Lurianic corpus.

Lurianic ilanot have an interesting relationship to such efforts. We know that Ẓemaḥ's ilan, which was crafted during the reboot of the genre around the time that *Novelot ḥokhmah* was published, was pedagogically keyed to his own redactions. Knorr von Rosenroth found inspiration in the succinct overview printed at the end of *'Emek ha-melekh* for the Saruqian ilan that became a common opening module of Great Trees. Delmedigo's paraphrastic abridgment from the first volume of *Novelot ḥokhmah* and long sections from Immanuel Ḥai-Ricchi's *Mishnat ḥasidim* can be found framing Great Trees.[43] Delmedigo (or his pupil Ashkenazi) anticipated this phenomenon by appending an ilan of sorts to the end of his Lurianic compilation.

The foldout is referenced as "*temunot*" (pictures) rather than as an ilan. The genre had not yet been revived and redeployed to represent the timeline of Lurianic cosmogony; the arboreal schema of interconnected medallions were not used; and it was printed on paper. The possibility of printing the foldout so it would begin with the first line parallel to the vertical spine of the book, as did the foldout ilanot in several Lurianic codices noted above, seems not to have been considered.[44] Instead, the recto displays confusing arrays of text in two broad

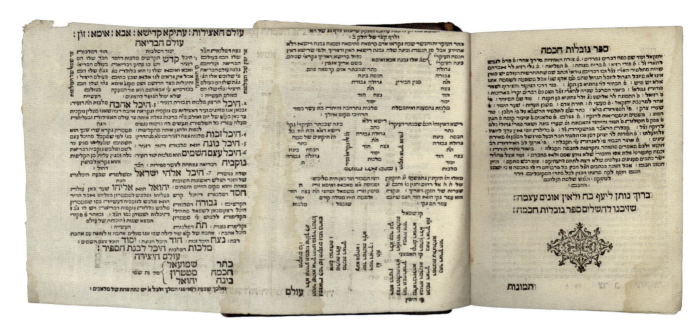

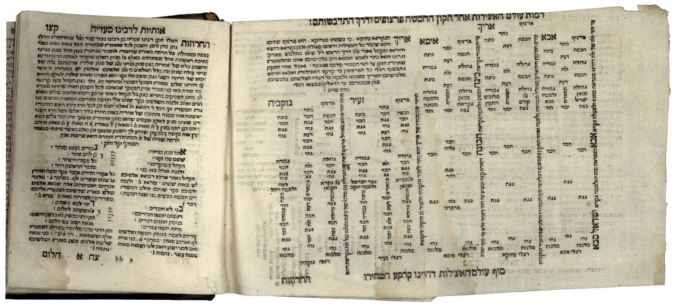

Figure 223 (top) | Lurianic *parzufim* diagram, foldout *a*, in Joseph Solomon Delmedigo, *Novelot ḥokhmah* (Basel [Hanau], 1631). Tel Aviv, GFCT, B.2493. Photo: William Gross.

Figure 224 (bottom) | Lurianic *parzufim* diagram, foldout *b*, in Joseph Solomon Delmedigo, *Novelot ḥokhmah* (Basel [Hanau], 1631). Tel Aviv, GFCT, B.2493. Photo: William Gross.

columns, each the size of a standard page (fig. 223). On the right, we find a Saruqian outline of the proto-sefirot and *parẓufim* of the "Adam Kadma'ah Setima'ah" (Recondite *Adam Kadmon*)—a precursor of Vital's *Adam Kadmon*—and on the left, the briefest adumbration of the palaces of the World of *Beriah* and the angels of *Yeẓirah*.[45] The verso takes a more expansive approach, dedicating the double page in its entirety to a stepped horizontal presentation of the five major *parẓufim* in the World of *Aẓilut* (fig. 224).

Atop the right side of the recto is not so much a title as a reference: the reader is simply alerted to the fact that "these pictures are for the understanding of the World of *Tikkun*," and they are to be studied in conjunction with the texts published on page 53 of part 1 and page 134 of part 2. Page 53 marks the beginning of Delmedigo's abridgment of the Saruqian "Kiẓur 'olam ha-tikkun" (The abridged World of Rectification), so named because it picks up the story only at the tail end of the *Malbush* account. Page 134 (actually page 133b) presents a recapitulation of the enrobing process, to which the verso of the foldout is dedicated. In short, the abridged treatises and the diagrams were a two-pronged pedagogical initiative meant to be studied together.

The Delmedigo ilan may not be pretty, but its *mise-en-page* is not without interest. The diagrammatic presentation is achieved exclusively through the arrangement of texts; there are no lines or circles and nothing representational, let alone anthropomorphic. As his 1629 Amsterdam *Sefer Elim* amply demonstrates, Delmedigo was quite capable of making an elegant diagram, which raises the question: Was the impoverished imagery of *Novelot ḥokhmah* intentional, due to its subject matter? Might Ashkenazi be to blame? Or was it an accident born of the already formidable publication expenses? On the page that precedes the foldout, Ashkenazi appended an impressive list of manuscripts that he hoped to publish along with a request for the financial support of his readers. Whatever the motivation, the typesetter, presumably with Ashkenazi or Delmedigo nearby, did his best to squeeze as much as possible onto each side of the double page. Entirely in square typeface, with minimal use of larger bold lettering for emphasis, the structure of the Godhead is represented exclusively by word placement.

The first page (the right half of the recto of fig. 223) is roughly divided horizontally into three zones. The top third presents the supernal precursors of *Adam Kadmon* and the *parẓufim*, the initial emanated pillar of the soon-to-be-shattered lower sefirot, and the emergent *Adam Kadmon*. The middle and bottom thirds attempt to represent *Arikh* and *Ze'ir* as well as the "thirteen enhancements." With space running low, the bottom continues the textual flow along a vertical orientation. After an initial three-column sefirotic-style division, the second page (the left half of the recto) forgoes diagrammatic layout for an enumerated list of the seven palaces of *Beriah*. These more ancient esoteric realms are here correlated with their Lurianic equivalents. This is the sense of the hint to the composition of *Yeẓirah* squeezed into the remaining space under the "sapphire brick palace" that, we are told, is "*Malkhut* within *Malkhut* of *Beriah*." The third—and double—page, the verso (fig. 224, right), is more ambitious in its diagrammatic presentation of "the image of the World of *Aẓilut* after the rectification of the five *parẓufim* and their path of enrobing [dmut 'olam ha-aẓilut aḥar tikkun ha-ḥamisha parẓufim ve-derekh hitlabshutam]." Were the medium more forgiving or the publication budget more ample, this figure would rightly have immediately followed the first page, preceding the presentation of the lower Worlds. Yet *Aẓilut* was not only a challenge to present as a synoptic figure with its five *parẓufim* but also nearly impossible to capture as the *process* of their enrobing. As

we have seen, the visualization of this process was the central task of the Lurianic ilanot emerging around this time, the mid-seventeenth century, and this, I believe, is what inspired the return to the rotulus. The graphical representation of the process, a cosmogonic timeline, required a good deal of vertical space. Delmedigo's precocious enrobing diagram gives us a sense of the problem. Framed in terms of latitude and longitude, over the broad double page, the typesetter has tried to use the former to show higher and lower elements, as we would expect, and the latter to show their sequential succession (from right to left) and conjunctions. None of this works very well, as each *parzuf* requires roughly the same amount of room on the page, but one thing does work: we can see that the five *parzufim* emerge in a graduated hierarchy and end as one. After all the enrobings, one within another, their feet stand on the same ground. "We find that the feet of all are equal," concludes the summary paragraph squeezed above *Ze'ir* and *Nukba* at the upper left; "the end of the World of *Azilut*, being the ground of the *Tehiru*" announces the bold inscription at the bottom, below the five feet (*raglei 'Atika, raglei Abba, raglei Imma*, etc.) that terminate each column.

The Delmedigo foldout makes an interesting companion diagram to consult alongside the discussions that it was intended to clarify. Although we should not discount the possibility of putting it to contemplative uses, the explicit intention of the foldout was to make it easier to follow particular texts. Pedagogy was always a factor in the production and consumption of ilanot, but they were not designed to elucidate texts; on the contrary, texts were adduced to elucidate the figures and features of ilanot. Half a century later, this was crystal clear to Knorr, who was intimately conversant with the genre and understood its nature. A comparison of the final frames of his original visualization of "Adam Kadma'ah Setima'ah" (fig. 112) and the treatment of parallel material by Delmedigo makes this clear. The remarkable anthropomorphic realism of his *Adam Kadmon* aside, the pictures in Knorr not only speak a thousand words but also call for a thousand words of elucidation—which he happily provided.

The Lurianic Ilanot of Christian Knorr von Rosenroth's *Kabbala Denudata*

For a work of scholarship to come to completion, it must be manageable. Temporal, geographic, and thematic limits also provide for greater context and coherence, but they are guides rather than blinders. In the present case, I have confined myself to writing on the genre of ilanot produced by Jews from London to Maragheh over some five centuries. The iconography and novel graphical creations of Christian Kabbalah have not been within my purview, but it has long been clear to me that the story of Jewish ilanot could not be told without Christian Knorr von Rosenroth.[46] In the words of Gottfried Wilhelm Leibniz (1646–1716), Knorr was "perhaps the cleverest man in Europe concerning the knowledge of the most esoteric matters of the Jews."[47] Knorr's *Kabbala Denudata* provided me with an inventory of the single-origin Lurianic ilanot in circulation in the late seventeenth century. His sixteen foldouts obviated the need for considerable speculation; they not only facilitated the telling of this first history of the ilan genre but also entered its history when Knorr's original ilan became a module that frequently opened Great Trees, including the one chosen for publication in Warsaw in 1864. Because of its unique relationship to the history of ilanot, a short reflection on the printed ilanot of *Kabbala Denudata* is in order.[48]

Kabbala Denudata emerged in the ecumenical environment of late seventeenth-century Sulzbach(-Rosenberg), under the patronage of

Prince Christian August of Sulzbach.[49] Knorr published his "unsurpassed description of the Kabbalah in Latin" in Sulzbach and Frankfurt in 1677–78 and 1684, respectively.[50] His presentation of the Lurianic system was comprehensive, uncompromising, and unadulterated.[51] Knorr offered far more than an anthology of sources in translation, crafting new and largely (but not exclusively) synthetic works. Presenting an eclectic range of kabbalistic texts supplemented by the contributions of Knorr's contemporaries Francis Mercury van Helmont (1614–1698) and Henry More, *Kabbala Denudata* represents the summa of the seventeenth-century second (and less tendentiously conversionary) wave of Christian Kabbalah. Between the lines of its myriad pages and occasionally in its texts and paratexts is the conviction that the true identity of Judaism and Christianity is to be found in the *prisca theologia* of Kabbalah. Knorr aimed to provide learned Christians with the keys to this ancient wisdom; keys dangle from the wrist of Lady Wisdom on the frontispiece engraving by Sartorius (fig. 225). In the first volume, Knorr published background and reference materials that would support readers' engagement with the primary sources that followed in the later volumes. The kabbalistic lexicon alone, "Loci communes kabbalistici," spans 740 pages.[52]

Epistemic images were another tool used by early modern educators. Kabbalistic diagrams were not merely pedagogical tools, however; they were perceived as "hieroglyphs" with the potential to express energetic qualities and cosmic secrets.[53] This view resonates in the images created by Knorr's predecessors and contemporaries, including Giordano Bruno (1548–1600), Heinrich Khunrath (ca. 1560–1605), Robert Fludd (1574–1637), and Athanasius Kircher (1602–1680).[54] The kabbalistic tree in particular was seen as the heart of Jewish esotericism by many Christians who took an interest in these matters. In 1678, Johann Benedict Carpzov II (1639–1699), a professor of Oriental languages at Leipzig, wrote a letter on the subject to Johann Jakob Schütz (1640–1690), a pious Lutheran hymn composer.[55] Carpzov explains that the recondite speculations of the Kabbalah have been all but impenetrable in the past, not only to Christians but also to Jewish rabbis.[56] Why? "Because most of them know nothing about its kabbalistic tree, which is the foundation of the whole doctrine." Carpzov notes that Theodor Hackspan (1607–1659) had written in his *Miscellaneorum Sacrorum* that he had given up on his plan to provide an explicated kabbalistic tree because of the great difficulty of the subject matter.[57] Recently, however, Carpzov reassures Schütz, "a highly illustrious man has undertaken it in a truly heroic way, far beyond the reasonable hopes of Christians." This letter is a celebration of Knorr's "Arbores seu Tabulas Cabbalisticas Universales," as his fourth apparatus is called on the title page of the second half of the first volume of *Kabbalah Denudata*.[58]

Knorr understood the ilan as a means to provide comprehensive, brief, and clear summary presentations of all key points of kabbalistic cosmogony and cosmology. So he introduces them: "Apparatus on the Book of the Zohar, *Part IV*, which contains an explanation of Trees, which are also five universal kabbalistic tables with the shortest and most perspicacious representation of all the complete and supreme headings of Kabbalah, along with various hypotheses" (Apparatus in Librum Sohar *Pars Quarta*, quae Continet Explicationem *Arborum* seu Tabularum Quinque Cabbalistarum Generalium cum Repraesentatione Omnium & Summorum Totius Cabbalae Capitum Brevissima & Perspicua, Juxta Diverse Hypotheses).

As the reader will recall, Knorr managed to find four Lurianic ilanot and added a fifth of his own. The five were presented as sixteen engravings, interspersed and bound into the sixty-two-page apparatus. In the "Unterricht für die Buchbinder"

Figure 225 | *Kabbala Denudata* frontispiece, 20 × 17.5 cm, foldout engraving by Johann Christoph Sartorius in Apparatus IV, Christian Knorr von Rosenroth, *Kabbala Denudata* (Sulzbach, 1677). Tel Aviv, GFCT, NHB.136. Photo: William Gross.

that follows the apparatus, Knorr provided clear directions for the binder to ensure that each figure would be inserted in its proper place. Knorr also encouraged readers to undo his work: the ilanot that had been split into a sequence of figures by the exigencies of printing could be restored to their original unbroken wholeness. Following his seven-figure presentation of the Poppers ilan (*P*), Knorr suggests making an ilan rotulus out of the engraved foldouts: "And so ends the Tree, or the first Cabbalistic table, which abundantly and accurately enough represents the most recent hypothesis from the manuscripts of R. Isaac Luria; and for the convenience of the beholder it can be joined as one great table, with all seven figures glued together" (Atque sic finita est Arbor, vel Tabula Cabbalistica prima, quae prolixè & accuratè satis repraesentat Hypothesin recentissimam è Manuscriptis R. Jizchak Lorjensis: & pro commoditate inspectionis in unam Tabulam magnam, conglutinatis omnibus septem figuris, concinnari potest). As if foldout pages didn't get enough normal wear, Knorr here recommends that his readers tear them out.

Foldouts are invariably separated and lost over time, but Knorr's encouragement may have accelerated this process; many extant copies of *Kabbala Denudata* lack them.[59] Knorr would have certainly found it intriguing that among the most popular ilanot in subsequent centuries would be one that spliced together, end to end, *figs. 8–11* (*K*) followed by *figs. 1–7* (*P*) and *figs. 13–14* (*Z*). With the addition of the *Trees of the Worlds* (*W*), an ilan nearly identical to the paper rotulus printed in Warsaw in 1864 would result.[60] The second edition of that ilan in 1893 would splice *N*, Knorr's *fig. 15*, between *P* and *Z*.

Knorr's closing note to "the beholder" encourages us to highlight terminology once again, as he uses the terms *tree* (*arbor*, ilan) and *table* (*tabula*, luaḥ) interchangeably. Shabtai Bass had characterized the *luaḥ*-ilan format as several pages glued together on which are "inscribed in the form of circles all the principles and keys and introductions required for every subject and study of a given science."[61] Bass captured the scientific evocation intrinsic to the ilan genre. Knorr's appreciation of ilanot, and indeed of Kabbalah more generally, was due in part to his own appraisal of their application of scientific rigor to the divine realm. This was to be the kabbalistic contribution to the scientific revolution of Knorr's own age.[62] And although quite a few prominent scientists and intellectuals thought this prospect was reasonable, the enthusiasm did not last long. The occult sciences would soon be reclassified as "supernatural" and, from the standpoint of the new science, rejected knowledge.[63] *Kabbala Denudata* weathered the storm surprisingly well, however. It was widely read in learned—and not only occultist—circles for centuries.[64]

The *Great Tree of R. Meir Poppers*— Warsaw, 1864

Knorr's engravings remained the only printed ilanot in circulation for more than two hundred years. A Jew in Berdichev could, after all, have purchased a copy of *Kabbala Denudata* in the early 1820s.[65] Around that time, the first Great Tree was compounded with a new opening module consisting of four of the figures that made up Knorr's original Saruqian ilan (*figs. 8–11*, i.e., *K*; figs. 108–111).[66] In 1864, just such a rotulus was selected for publication in Warsaw by two brothers-in-law, Efraim Fischel Geliebter and Josef Asher Zelig Weinryb.[67] From the A. Bomberg press in Warsaw, Geliebter and Weinryb commissioned the printing of a paper roll consisting of six sheets of paper glued end to end; the resulting three-and-a-half-meter rotulus reproduced its manuscript source with impressive fidelity (figs. 226–228).

Figure 226 (right and opposite) | *The Great Tree of R. Meir Poppers*, paper, 343 × 20.9 cm, Efraim Fischel Geliebter and Josef Asher Zelig Weinryb, eds., *Ilan ha-gadol* (Warsaw, 1864). Tel Aviv, GFCT, MS 028.011.001. Photo: Ardon Bar-Hama.

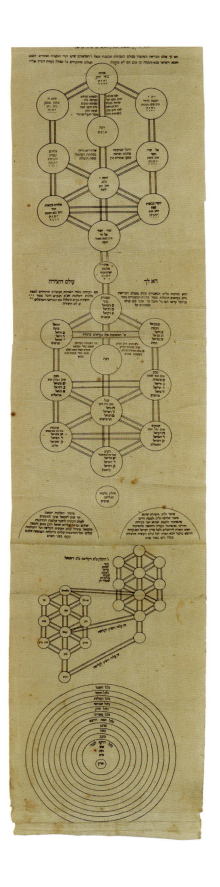

The 1864 printed ilan is so true to its source that I need not delve here into its content; my previous analysis of its model can be applied here without reservation. What is new is the "front matter" atop the printed ilan. Like nearly all Jewish religious books, it opens with an approbation. It was written by a venerable figure, R. Isaiah Muskat (1783–1868), a Hasidic rabbi who headed the rabbinic court in the Praga suburb of Warsaw.[68] Obtaining his approbation may not have been simple. Jews had never before printed a Great Tree. Opposition could be expected, and rabbinic cooperation in the enterprise was far from guaranteed. Muskat, however, was an ideal choice.[69] Over eighty and long infirm, he was a kabbalist with a sterling lineage, having been a disciple of the famed R. Yisroel Hopstein (1737–1814), the so-called Maggid of Kozhnitz.[70] Although many Hasidic luminaries distanced themselves from "hard-core" Lurianism and the practice of prayer kavanot in particular, Muskat took a less doctrinaire approach. Typically, Hasidic teachers encouraged Jews to pray simply and in accordance with the plain meaning of the liturgy lest the technical demands of Lurianic kavanot inhibit *devekut*, the clinging to God that is the object of Hasidic prayer. Muskat, by contrast, embraced a two-tiered approach: praying with the plain meaning of the liturgy in mind was good, but praying with Lurianic kavanot better.[71] In short, Muskat was the relatively rare Hasid who thought it worthwhile to acquire a true knowledge of the Lurianic system, something the ilan could reasonably claim to facilitate. He was the right rabbi to ask for permission to publish.

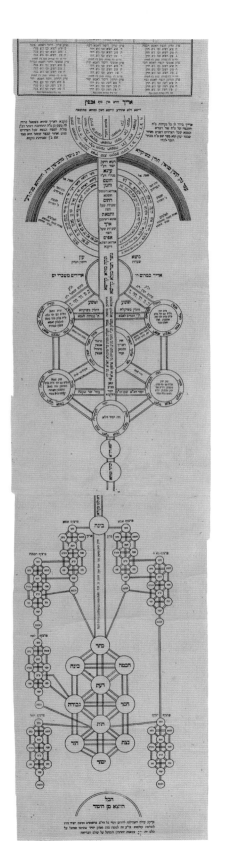
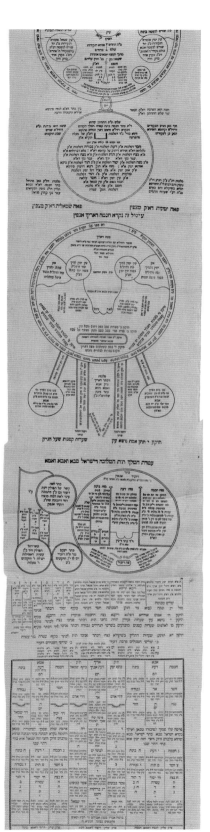
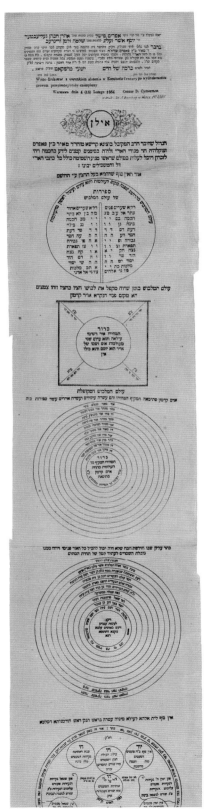

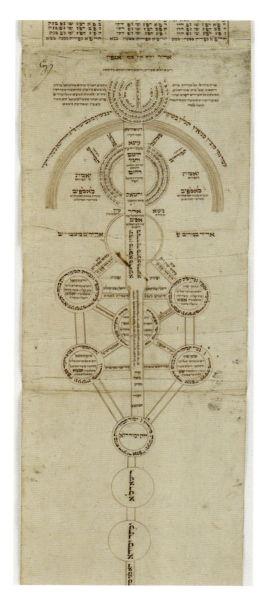
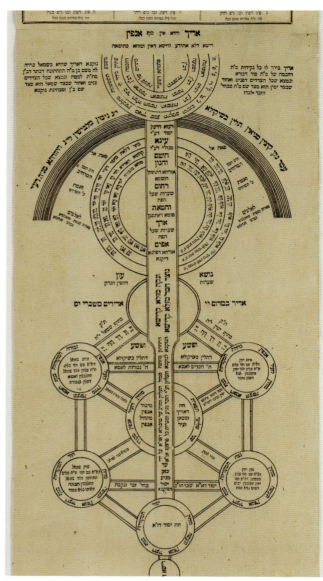

Figure 227 | *Z13* detail in Tel Aviv, GFCT, MS 028.011.003 (fig. 148).

Figure 228 | *Z13* detail in the *Great Tree of R. Meir Poppers* (fig. 226).

Muskat's approbation reads as follows:

The religious high court of the holy community of Warsaw queried me with regard to the publishing of the book of the holy ilan that was composed by the holy and righteous rabbi, R. Meir Katz Poppers, may

324 | THE KABBALISTIC TREE

the memory of the righteous live on in the World to Come. I am of the opinion that its publication should be permitted, since it contains holy words more precious than gold and pearls, which include all the writings of the AR"I, may his memory be a blessing in the World to Come. One who is expert in its holy words can easily engage in the science of Kabbalah.

From the phrasing, it seems that Geliebter and Weinryb had first approached the supreme rabbinical court of Warsaw for permission to print, as would be expected for any Hebrew book being brought to press in the city. Yet this case was anything but ordinary. Despite the opening of the floodgates to the printing of Lurianic works a century earlier, this was a Rubicon that had yet to be crossed. The rabbis in central Warsaw must have been reluctant to give their permission without the approval of their revered elder, and it seems that they left the decision to him. Muskat's statement of approval paraphrased the preamble found in the ilan that accompanied the query (Tel Aviv, GFCT, MS 028.011.003; fig. 148), reproduced in this printed edition as well.[72] The three factors that prompted his consent were the attribution of the ilan to Poppers, the fact that it constituted a précis of the entire Lurianic corpus, and its pedagogical utility. The ilan was the ideal entrée to the study and practice of Lurianic Kabbalah.

The publishers clearly understood the commercial potential of a printed ilan. Students of Kabbalah who could not afford to buy a handwritten one would be interested in such an acquisition, and others, perhaps many others, might be enticed into buying one as an amulet. In this regard, Geliebter and Weinryb anticipated the market for ilan amulets—or, more accurately, they attempted to create such a market in eastern Europe. The publishers of the 1864 Warsaw ilan soft-pedal the point, appending promises that the ilan will protect "from any pain or damage" and serve "as a charm to raise children" in small print just beneath the approbation. Three lines in Polish—the consent of the censor, B. Cymerman—then follow.[73] With that, the first mechanical reproduction of a Great Tree begins.

The *Great Tree of R. Meir Poppers*— Warsaw, 1893

After seeing what a good job the publishers did with the printed ilan of 1864, which bore the blessing of the venerable Hasid Muskat, it is tempting to frame the 1893 "second edition" as the bowdlerized *misnagdic* edition—*misnagdic* referring to the constellation of anti-Hasidic Orthodox groups whose collective name means "against." Indeed, at first glance the 1893 Warsaw printing seems primarily to have been intended to destroy anything ilanlike about the work titled *Ilan ha-gadol* atop the 1864 paper rotulus and *Sefer ilan ha-gadol* in its 1893 codex format. The violence done to the ilan is obvious: the roll has been chopped into pages and a comprehensive impoverishment of its already austere visual elements effected. It would be a mistake to leave our characterization of this edition at that, though, because these deficits are offset by several virtues. The backstory of the edition is also of interest.

The *Chabad Library Ilan* (fig. 131), the *Kitzes Ilan* (fig. 141), and the *Tree of Holiness* (fig. 192) all point to ongoing interest in ilanot in the Hasidic world. Yet eastern European Kabbalah did not belong exclusively to the Hasidim. At least in its first generations, the *misnagdic* opposition was not directed against the study of Kabbalah per se but against Hasidic populism and its reordering of traditional values.[74] The founder of this anti-Hasidic force, R. Elijah of Vilna (1720–1797), the Vilna Gaon, was himself a towering kabbalist, as were some of his

greatest disciples. Over the generations, Lithuanian interest in Kabbalah flagged but was never completely extinguished.

Enter R. Aryeh Leib Lipkin (1840–1903), nephew of Rabbi Yisrael of Salanter (1810–1883).[75] Lipkin was born in Žagarė and served as rabbi of Kretinga, Lithuania. A kabbalist in the Lithuanian tradition, he was profoundly engaged by its giants, foremost among them the "adopted" Luzzatto, the Vilna Gaon, and R. Ḥayyim of Volozhin (1749–1821).[76] Lipkin, who maintained a lifelong friendship with the eminent kabbalist and fellow Žagarėan Shlomo Eliashiv, was interested in ilanot. It was at Lipkin's initiative that the *Great Tree of R. Meir Poppers* was published in a revised edition in 1893. He was also singularly responsible for the acts of commission and omission that changed the Great Tree almost beyond recognition. Concern befitting one who is revealing secrets made Lipkin ask that his name be suppressed in the publication, but his authorship was an open secret among his contemporaries.[77]

I must say a word about what is in plain sight (figs. 229–230). First, the ilan has been printed as a book. Lipkin presents the Great Tree as fourteen *simanim* (signs), each given its own page.[78] Unlike Knorr, who suggests that his readers detach and glue his figures together to re-create the rotulus experience, the Warsaw publisher's introduction simply informs the reader that the ilan has been reformatted in this way because otherwise, "it would be impossible to bind the book as is appropriate."[79] Second, and more significant, the new Great Tree shows little fidelity to the ilanot on which is it based. It is graphically bowdlerized: any suggestion of representationalism has been removed. Particularly in its presentation of *P*, even the simplest geometrical diagram elements—lines and circles—have been almost entirely expunged, leaving an anemic array of texts. Finally, this 1893 edition is not simply a reformat of 1864, but something (almost) entirely new: it is an eclectic edition of two Great Trees. And here we return to the backstory.

Lipkin's partner in this publication project was Aharon Meir Altshuler. Altshuler collaborated with Lipkin on another work that was published the same year as something of a companion volume to the ilan, featuring introductory works by Lipkin; a classical commentary on the ten sefirot, "The Commentary on the Ilan" by R. Shlomo Luria, the illustrious ancestor of the AR"I; and Lipkin's glosses on the Great Tree, which had been published separately.[80] The division of work between the two men seems fairly clear: Lipkin provided the content, and Altshuler did everything else. In his own words, he was "the copyist [ha-maʿatik], the proofreader [ha-magiah], and the publisher [ha-moẓi la-or]." A native of Mogilev in White Russia, Altshuler was also—and most salient to our story—the grandson of one of the great kabbalists of the Vilna Gaon's era (recognized as such by the Gaon himself), R. Kalonymus Kalman of Chavusy.[81] It so happens that Kalonymus Kalman had a Great Tree of his own that was now in Altshuler's possession.[82] Although never stated explicitly, it seems likely that the stimulus for the eclectic 1893 edition was Altshuler providing his grandfather's ilan to Lipkin, perhaps as the latter worked on the commentary that was to accompany the reissue. In Lipkin's opinion, the Kalonymus Kalman ilan was, on the whole, superior to the one published in 1864. In innumerable cases, he judged its readings as more accurate and worthy of inclusion in a new edition.[83] Furthermore, this "new" old ilan included an entire section "missing" from the 1863 rotulus. Although Lipkin's work presumes Poppers's authorship of the 1863 ilan in its entirety, he is circumspect about the missing section, which seemed "not to have been composed by the author of the rest of the *Sefer ha-ilan*."[84] This section, referred to by Lipkin as "another order of ten sefirot,"

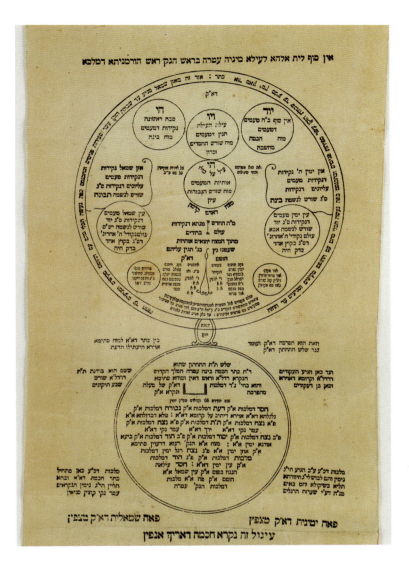

was spliced into the new edition as §9, in keeping with its position in the Kalonymus Kalman ilan. If it had retained even a trace of its distinctive schema, we would recognize it at a glance: it is the *Ilan of Expanded Names* (N).

For all his erudition, Lipkin did not suspect that the *Great Tree of R. Meir Poppers* was a compound artifact composed of multiple ilanot. Yet his comments demonstrate an awareness of precisely those

Figure 229 | Head of *Adam Kadmon* in the *Great Tree of R. Meir Poppers* (fig. 226).

Figure 230 | Head of *Adam Kadmon*, §5, paper, pages 39.5 × 20 cm, Aryeh Leib Lipkin and Aharon Meir Altshuler, eds., *Sefer ilan ha-gadol* (Warsaw, 1893). Tel Aviv, GFC, B.265. Photo: William Gross.

elements that might have led him to deduce this: the four opening frames "are not in *ʿEz Ḥayyim* but based on books by other students of the AR"I z"l,"[85] and the section that now begins with §10, i.e., Z, reiterates much that has already been presented earlier. In his commentary, Lipkin uses Luzzatto, and, to a lesser extent, the works of R. Menaḥem Azariah da Fano and Lifshitz, to explain *K*, which was designed by Knorr and inspired by Bacharach's *ʿEmek ha-melekh*. The fact that *K* was clearly Saruqian might have led him to question the plausibility of Poppers's authorship of the entire ilan, but it did not. Lipkin provides no explanation for the redundancy problem. At the same time, he acts as if the modular nature of ilanot is self-evident. How else could he justify the inclusion of an element that he understood to be of different authorship—§9, our *N*—in the very heart of the *Great Tree of R. Meir Poppers*? The Kalonymus Kalman ilan would not have carried the attribution to Poppers, which is only to be found atop the rotuli of the small subfamily of Great Trees to which Tel Aviv, GFCT, MS 028.011.003, belongs (fig. 148). This "omission" made it that much easier for Lipkin to excise a section for inclusion in the new edition, especially in view of his overall higher estimation of the Kalonymus Kalman ilan. As we will see, he was also well aware that the particular *Great Tree of R. Meir Poppers* that he was reissuing in a new edition was a poor witness.

The visual poverty of the Warsaw 1893 edition was intentional; its conversion to something approaching a text-only artifact was undertaken on principle. A number of major kabbalistic works published in Warsaw in this period, including Luzzatto's *KL"Ḥ pitḥei ḥokhmah* (138 openings of wisdom, 1888) and a new edition of *ʿEz Ḥayyim* (1890), shared a common supplement with *Sefer ilan ha-gadol*: the so-called "Hodaʿah ve-azharah" (announcement and warning).[86] Its sole point was to convey to students that everything they were about to read was a *mashal*, a term that here means "allegory" or simply "metaphor." That, we might say, was the announcement. The warning was to avoid *hagshamah* (corporealization) of the Divine at all costs. Notwithstanding the language of Jewish religious texts, from the Bible through classical rabbinic literature and culminating in the Kabbalah, there was no divine body. Every language of space in these sources—up, down, left, right, circle, and lines—was no more than a *mashal*; to confuse it with the *nimshal*, its referent and real meaning, was tantamount to idolatry. Much of the "announcement and warning" was borrowed from works by Luzzatto and the Vilna Gaon, and it seems that Lipkin had something to do with its distillation and distribution.[87] These editions were all published by Lithuanian scholars deeply engaged in the Kabbalah of Luzzatto and the Gaon who understood this legacy as demanding the very highest level of intellectual abstraction and aniconism.[88] From the historian's point of view, there is a touch of irony in the fact that Lithuanian kabbalists living in the Russian Orthodox world were more stringent on this point than was Shandukh in Islamic Baghdad. If these contexts played a role in determining Jewish attitudes toward graphical representation of the Divine, they apparently did so in terms of reactive rejection as well as identification and internalization.

Another point made in Lipkin's introduction put the matter succinctly, at least with regard to the ilan: "We have ordered [the ilan] with a minimum of drawings [ẓiyyurim] in accordance with the opinions of those of scientific understanding [mevinei madʿa], this being the best way for many great and true reasons with regard to which there is no need to expound at length. [Presentation in] this manner is also easier to understand." The graphical impoverishment could not have been more intentional or more fully justified. There was one exception, though. In the final section of

the ilan—from *Z14* through the end of *W*, here §11–14—the new edition retained the arboreal diagrams just as they appeared in the 1864 paper rotulus (fig. 226) and its manuscript model (fig. 148). The final frame also retains the geocentric concentric circles representing the planetary orbs at the bottom of *'Assiah*; Copernicus had yet to arrive in Warsaw. Although the use of these schemata is never justified by Lipkin, he used them and therefore presumed them to be kosher. We know, and perhaps Lipkin did as well, that Luzzatto himself made ilanot displaying interlocking trees.

Lipkin's ideological recoiling from the graphical visualization of the Godhead may have produced an impoverished ilan, but his methodical work as the editor of a protocritical edition of the Great Tree deserves admiration. He might have insisted that it was preferable to publish the Kalonymus Kalman ilan, given his assessment of its merits. He might have omitted its "faulty" readings and created an eclectic edition without an apparatus flagging his interventions. To his credit, however, Lipkin blended the two ilanot in an utterly transparent manner. When the two ilanot were not in agreement, each was presented as a clearly demarcated variant. When he felt that the newly available ilan offered a correction to what he regarded as a mistake in the 1864 printing, Lipkin wrote as much in an adjacent note. Of even greater value is his sourcing of so much of the content visualized in the ilan. Although it is true that his analysis of the Knorr-Saruqian opening frames is off the mark, beginning with §5 (the beginning of *P*), Lipkin provides a valuable collection of source references that, as Altshuler noted in the publisher's introduction, allows one "to know and to understand there [in *'Ez Ḥayyim*, for the most part] on the basis of the ilan and the ilan on the basis of what is there."[89]

One final question deserves our consideration with regard to the 1893 edition: Has the Kalonymus Kalman ilan reached us? At present I am unaware of any extant ilan that is its perfect match. Nevertheless, its overall structure is clear: it was a Great Tree of the type *KPNZW*. The closest ilan I have found is a Great Tree preserved in the National Library of Israel.[90] Of the tens of variants in the 1893 edition that I checked, this Jerusalem Great Tree was a near-perfect match with the Kalonymus Kalman ilan. To give a particularly vivid example, I show a variant from §5, the first frame of the Poppers (*P*) module. In the anodyne textual representation of the head of *Adam Kadmon*, Lipkin notes a significant difference between the 1864 edition and the Kalonymus Kalman ilan. The 1864 edition (fig. 231), like the manuscript on which it was based (fig. 149), shows the outline of the ears of *Adam Kadmon* gracefully delineated by bowed lines attached at their bottom ends to the inner ring of the large circle. At the point where they curve upward, they intersect medallions situated at roughly four o'clock and eight o'clock. These are the eyes of *Adam Kadmon*. As Lipkin reads this image, the ears of *Adam Kadmon* are above the eyes, contradicting *'Ez Ḥayyim*, Gate of *Arikh Anpin*, chapter six. The Kalonymus Kalman ilan, however, got it right, he believed, and so it is followed in the text-only adaptation of 1893. We can understand why Lipkin thought as much with a glance at the Jerusalem, NLI, ilan (fig. 232).

Most of the textual variants between this head of *Adam Kadmon* and the one featured in the 1864 printing are of minor consequence (although consistently in accord with the Kalonymus Kalman–ilan variants), but from a visual point of view, the picture is very different indeed. The Jerusalem, NLI, ilan has an anthropomorphic plasticity compared to which the 1864 head looks downright schematic. Each facial feature is positioned as we would expect on a human face. The nose even features a certain "Jewish nostrility," to use a memorable phrase from the *Jewish Encyclopedia*.[91] But it is the ears that concern us here, and rather than turn

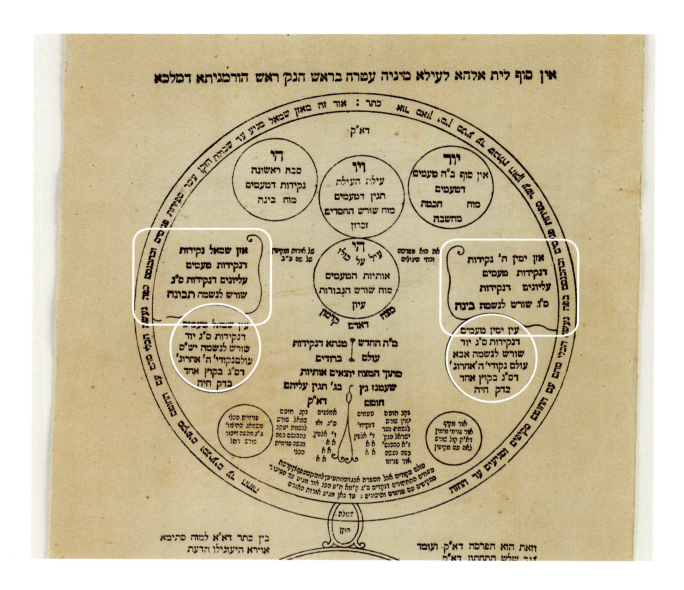

Figure 231 | Eyes and ears of *Adam Kadmon*, from the *Great Tree of R. Meir Poppers* (fig. 226).

in unnaturally over the eyes, they grace either side of the circle, complete with suggestions of helix and lobe. Their wavy lines emerge from the circle encompassing of *Adam Kadmon*'s head at roughly three and nine o'clock, intersecting with the eyes before curving upward.[92]

In addition to establishing the family resemblance between the lost Kalonymus Kalman ilan and the extant one in Jerusalem, this comparison affords us the opportunity for a few broader reflections. For all his principled aniconism, Lipkin did not mind using an ilan that exhibited boldly anthropomorphic representations of *Adam Kadmon*, and in fact he deemed it superior to the far more schematic presentation in the subfamily of

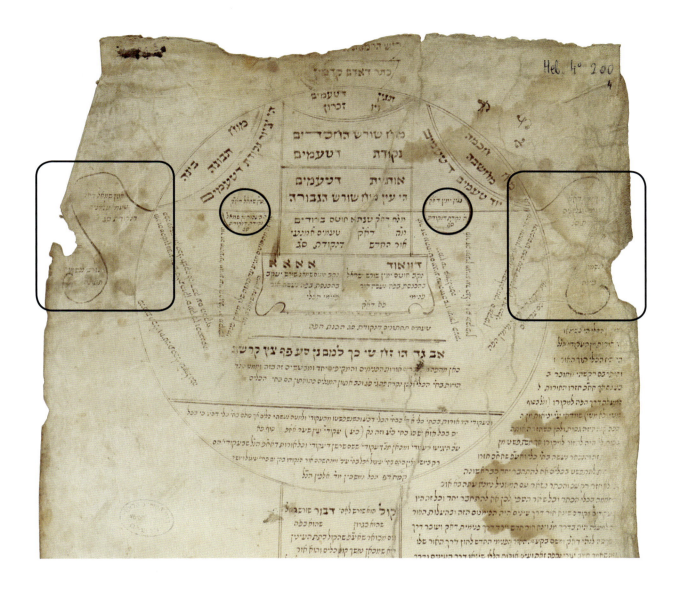

Great Tree rotuli represented in the 1864 printing. Furthermore, Lipkin understood the "reading" of an ilan to be determined principally by its visual order from top to bottom. It was, however, possible to view the image of *Adam Kadmon*'s head without such a presumption. Indeed, the clearest example is to be found in Knorr's Latin guide to his equivalent to §5, *fig. 1* (fig. 83). Knorr presents the lights flowing forth from the face of *Adam Kadmon* in the

Figure 232 | Eyes and ears of *Adam Kadmon*, from a Great Tree, parchment (top missing), 334 × 24 cm, Eastern Europe. Jerusalem, NLI, MS Heb. 4°200.4. Photo courtesy of The National Library of Israel.

order in which they are given in Vital's *'Eẓ Ḥayyim*. This invariably involves a chiasmic reading, as described in chapter 4, zigzagging up and down, as, according to that text, the lights flow from the

THE PRINTED ILAN | 331

mouth of *AK* before they do from the forehead. We may infer from Lipkin's reading of the schematic image of 1864—which is closer to Knorr's engraving than to the Jerusalem, NLI, ilan—that our editor thought it preferable to give the ilan a linearity that no figurative image could provide. The elimination of images was, Lipkin claimed, both ideologically and pedagogically warranted. By the latter, he seems to have meant that it foreclosed possible "misreadings."

Ilanot may have lost their aura in the age of mechanical reproduction, but, as we have seen, printed ilanot still have intriguing stories to tell. Their contexts, origins, and appearances raise fascinating questions that include—and often combine—theological, aesthetic, economic, and hermeneutical issues. Manuscript-to-print transitions also invited a more public voicing of tensions around the genre, giving us a sense of how these artifacts were perceived by various authorities. If the history of printing kabbalistic works reveals conflict and controversy, ilanot were the embodiment of what concerned the naysayers. They were liminal artifacts that pushed the boundaries of the (at least publicly) permissible in their graphical visualization of the Divine, but the protracted opposition to their printing and their eventual visual bowdlerization betray broad consensus with regard to their esoteric classification.

Conclusion

We have, by now, seen very many trees. It seems only appropriate in these final pages to bring the forest back into view. One way to do so might be to revisit big questions, such as "who made ilanot . . . and why?" Big questions, though, often elicit small answers. In the case studies that fill this book we have encountered pedagogical kabbalists, creative contemplatives, scribal artists, and commodifying copyists as makers of ilanot. What is more, the ilanot they produced ranged from quick ink sketches on paper to parchments illuminated with gold leaf. It goes without saying that very different reasons prompted the production of such eclectic artifacts. Throughout this book, I have tried to avoid reductionist analyses that presume any given function to be definitive for a specific ilan, let alone for the genre writ large. An ilan may serve as any and all of the following: pedagogic précis, mnemonic matrix, meditative mandala, mimetic mechanism, talismanic attractor, apotropaic amulet, and objet d'art. If cornered, I might concede that underlying all these eclectic functions is one common denominator: the iconotextual signification of the divine order. The image of the Divine delivers its presence. This presence facilitates its performative diversity and distinguishes the ilan as a cornerstone of kabbalistic practice, even as it endows it with apotropaic power that can be leveraged by anyone who wears it rolled up in a silver case.

Another way to bring the forest back into view would be to summarize our journey. Allow me, then, to do so very briefly. To tell the story of the ilanot genre, I began by exploring the background of its emergence in the fourteenth century. Even though the earliest kabbalistic manuscripts communicated with diagrammatic images, the distinguishing feature of ilanot has always been their materiality, their medium—the (sc)roll, almost always made of parchment. It was this medium that imbued classical ilanot with their maplike character and Lurianic Great Trees with their mimetic timeline dynamism.

The first ilanot were austere sheets dominated by large arboreal diagrams. Their medallions featured sefirotic names and appellations, a network of channels indicating their flow and function. Elaborations, explanations, and derivations could be added to proximate blank spaces. The ilanot of the Italian Renaissance, ambitious upgrades of these basic models, maintained generic conventions even as they augmented and enhanced them. Italy may have been the epicenter of classical ilanot production, but kabbalists elsewhere in the Jewish world fashioned ilanot of their own in which local traditions—including traditions of representation—were integrated with teachings only recently arrived.

The genre was revived and reinvented for the Lurianic age by R. Jacob Ẓemaḥ, a former converso. His humanist background, keen interest in visual thinking, and intimate familiarity with the occult literature of his era found expression in the many facets of his distinctive career as a kabbalist. His *Ilan of the Enrobings* exemplified these aspects of his profile. It also demonstrated the ongoing relevance of the genre and its great potential to contribute to the study and practice of Lurianic Kabbalah. Ẓemaḥ's ilan was soon wedded to a parẓufic diagram crafted by R. Moses Zacuto, which it seemed to unpack and elaborate. Together on a parchment sheet, they fused to form the earliest Lurianic ilan to have reached us. Other single-origin ilanot followed, including the vastly more detailed and comprehensive effort of Ẓemaḥ's student, R. Meir Poppers. These were blended and compounded so universally that their distinct genealogies were soon forgotten. The overwhelming majority of ilanot produced by kabbalists since the late seventeenth century were, as we saw, Great Trees constructed chiefly of two or more such ilanot.

The redeployment of Great Trees as amulets and their reproduction in printed editions were late nineteenth-century developments. Ilan amulets bearing apotropaic inscriptions were only then produced in large numbers, to be rolled up inside silver cases and worn by those in need of protection. As we saw, among the virtues touted by the publisher of the *Great Tree of R. Meir Poppers* was its efficacy as a good-luck charm and protective amulet. Apotropaic prowess proved to be the most durable selling point of that 1864 edition. As I first observed at a kosher fast-food joint in Houston, the typeset rotulus can now be obtained as a large golden engraving in a gilded frame. Hung on the wall behind the cash register, *K*, *P*, *Z*, and *Wy* wielded their hieroglyphic magic on behalf of the proprietor. If one wonders whether size matters in such things, I offer yet another telling anecdote. As I was putting the finishing touches on this book, the Sephardi ultra-Orthodox party *Shas* (the acrostic for "*Shomrei* [guardians of] *Sepharad*") distributed the 1864 printed ilan as a wallet-size political party favor in the spring 2021 Israeli election (fig. 233).[1] "The Holy *Ilan*, the Great, [and] the Complete—on Microfilm," as it is titled, is flanked by golden columns of seventy-two-letter name triplets and, in a romantic flourish, features fake fire damage. "Microfilm" is the declared medium of this Great Tree, although it is actually a cardboard reproduction of a doctored photograph of a photo-offset of the printed edition. The quaint invocation of this medium presumes an electorate for whom "microfilm" has not lost its aura. Modern politics has answered Walter Benjamin unequivocally.

One thing has been decisively demonstrated in *The Kabbalistic Tree*: the persistent determination of kabbalists to create ilanot. Imagining the emanations—mental diagramming—was necessary but not sufficient; their graphical inscription was required for the practice of Kabbalah. Furthermore, the emulation of the divine process of autogenesis associated with the contemplation of the sefirotic emanations, whether imaginatively or

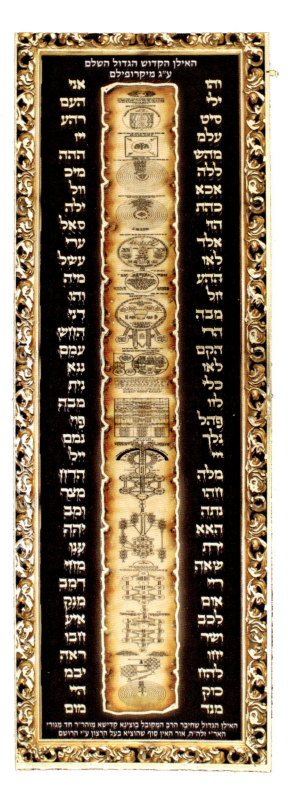

in the mimetic act of scrolling down an ilan, was only part of the work done by and with ilanot.[2] Texts were no less important to their makers, who appear to have been driven in equal measure by Jewish bibliophilia and *horror vacui* to inscribe them in every available space in and around the images. Contemplating an ilan without these texts would have struck kabbalists as absurd, akin to reading the Bible without Rashi.[3] Finally, there was the third dimension of an ilan: its medium. Substitutions might do in a pinch, but an ilan was ideally a *yeri'ah*, a parchment sheet. It was this medium that established the ilan as a ritual object, an appurtenance of kabbalistic practice, and, later, an apotropaic amulet.

Traditional Jewish kabbalists continue to engage with historical ilanot to this day. Scribbled diagrams in the spiral notebooks of students in kabbalistic yeshivot might well have been drawn centuries ago. An erudite teacher in one such institution showed me an ilan of his own making not long ago; it would not have looked out of place on the pages of this book. The visual Kabbalah of today is not limited to these persistent traditions of representation, however. Recent years have witnessed a veritable explosion of new editions of kabbalistic treatises augmented by extensive diagrams. Entire publications are devoted to such images.[4] The visual language of these publications is scarcely indebted to the diagrammatic repertoire of historical kabbalists. Just as the latter appropriated arboreal and concentric-circle schemata from the prestigious scientific disciplines of natural philosophy and astronomy, today's kabbalists are fond of the infographics and flow charts of our age (fig. 234). The underlying motivation seems to be

Figure 233 | Shas Party election amulet, 2021, cardboard, 17.7 × 6 cm. Photo: author.

CONCLUSION | 335

Figure 234 | Diagram of *'Eẓ Ḥayyim* Gate 29:7, page 24a, in David Kapashian, ed., *'Eẓ ha-hayyim she-ba-gan* (Jerusalem, 2009). Photo: author.

the same: their appropriation implicitly asserts the scientific status of kabbalistic knowledge. Such an assertion was, of course, a different matter when made in the seventeenth century rather than in the twenty-first. And unlike many of their predecessors, modern kabbalists give scant consideration to the aesthetics of their diagrammatic expositions.[5] The diagrammatic turn in kabbalistic publishing has so far resulted exclusively in the production of images that are not art.

Some of the most compelling contemporary works of visual Kabbalah—if not exactly ilanot—are being produced in the studios of artists rather than in the study halls of kabbalists. I cannot claim any special expertise in this area, but neither can I resist the temptation to consider a few of these latter-day expressions before bringing our journey to a close. (That said, for extended reflections on the Kabbalah and its iconography in modern art, the reader is advised to look elsewhere.[6]) Sandra

Valabregue is the rare and perhaps unique contemporary artist whose work has been inspired by historical ilanot. Valabregue, a Kabbalah scholar whose doctoral dissertation treated conceptualizations of *Ein Sof* in kabbalistic thought, has borrowed elements from Shandukh ilanot in some of her recent paintings (fig. 235).[7] Her scholarship and artistic integrity help her avoid the kitschiness that often inflects such borrowings. Shandukh's faces of the Divine have proved themselves sources of playful inspiration for this contemporary artist and scholar of infinity.

Figure 235 | *Up the Palm Tree I* and *II*, Sandra Valabregue, pastel and ink on wood panel, 40 × 120 cm (each), 2018. Photo: Yaal Herman.

In what follows, I celebrate artists whose work evokes constitutive characteristics of the ilan genre without making any attempt to borrow explicitly from its historic iconotextual traditions. Some practice their craft within traditional Jewish environments. Two contemplative artists who have worked in the old city of Safed for decades, Avraham Loewenthal and David Friedman, bring novel visual languages to their creative kabbalistic visualizations.[8] Both visualize kabbalistic ideas diagrammatically, although neither consciously aspires to continue the historical ilanot tradition per se. The works by Loewenthal that are most evocative of historic rotuli are, ironically, text-free. His tall, vertical canvases convey a sense of emanation and the concatenation of Worlds. In one painting, Loewenthal uses colorful microgeometric shapes to render the iconic arboreal schema, lending a modern fractal aesthetic to his visualization of the enrobings at the heart of Lurianic ilanot (fig. 236). In another, he maps the sound of the shofar, the ram's horn associated with the Jewish New Year and the coronation of the Divine, to create what is, to my eyes at least, an abstract synesthetic homage to the traditional ilan (fig. 237).

Friedman's work is at once more playful and more scholarly, the product of his own extended study especially of *Sefer yezirah* and the works of Luzzatto.[9] He tends to use texts sparsely, one exception being a piece that I find extraordinary: an ambitious visualization of *Sefer yezirah* (fig. 238).

Figure 236 (far left) | *Ilan*, Avraham Loewenthal, giclée on canvas, 146 × 17 cm, 2021.

Figure 237 (left) | *Seeing the Sounds*, Avraham Loewenthal, giclée on canvas, 146 × 26 cm, 2015.

Figure 238 (opposite) | *Sefer Yetzirah Motherboard*, David Friedman, opaque watercolors and pen and ink, 55 × 74 cm. David Friedman (www.kosmic-kabbalah.com), 1990.

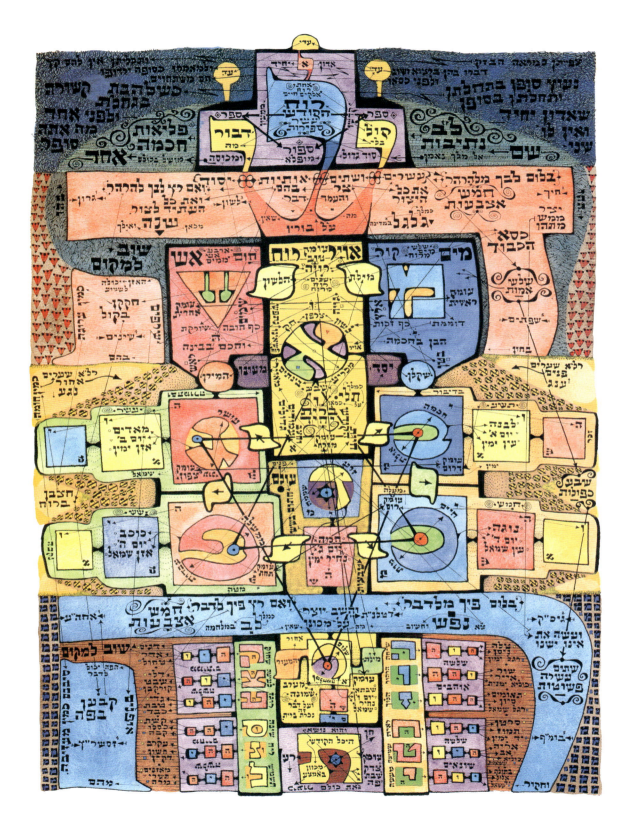

Figure 239 | *Family Tree of Life*, David Friedman, opaque watercolors and pen and ink, 36 × 51 cm. David Friedman (www.kosmic-kabbalah.com), 1995.

Friedman's fidelity to the text is evident in this sophisticated diagrammatization. The busy image deploys the conventions he uses in many works that represent particular teachings of *Sefer yezirah* without the totalizing aspiration seen here: the systematic conversion of its basic concepts—the three elements and mother letters—into the primary colors (red, yellow, and blue) and geometric plane

340 | THE KABBALISTIC TREE

shapes (circle, triangle, and square). Friedman has also produced a number of works that represent the enrobing of the *parzufim*. Strikingly, he does not eschew anthropomorphism. His images of *'Atik*, the ancient one, and the successive embraces of *Abba*, *Imma*, *Ze'ir*, and *Nukba*—father, mother, son, and daughter—present the "pamalia shel ma'alah" (the family of above, a phrase originally from b*Sanhedrin* 38b) with rare clarity and warmth (fig. 239). The concept of enrobed *parzufim* is conveyed in Friedman's oeuvre in human rather than mechanistic terms, free of the aspiration to realize the interlocking precision of a Lurianic ilan.

A self-described "esoteric cartographer" and mystic, New York–based David Chaim Smith practices his own special blend of Jewish Kabbalah and Hermetic Qabalah. Smith's visionary images are fashioned with consummate skill and sophistication (fig. 240). He insists that his works are not "forms of 'personal expression' nor do they belong to the domain of 'art' in the conventional sense." Familiar elements of kabbalistic iconography are subsumed within a vivid and intricate alchemical matrix. Even though Smith operates at a greater remove from traditional Jewish Kabbalah than Loewenthal and Friedman, his images more consistently fulfill a core function of the historical ilan: the intricate iconotextual encoding of cosmological topography. In Smith's words, the images and symbols that arise upon the return of consciousness from its "immersion within non-conceptual territories" are at the heart of the "visual documents" that he fashions "so they can be studied and contemplated by practitioners."[10]

No contemporary iconotexts have struck me as more ilanlike than those produced by Suzanne Treister (fig. 241). Treister's work has fascinated me since I stumbled upon her "Alchemy" series in the exhibition "Mutatis Mutandis" curated by Catherine David at Vienna's Secession in 2012. "Alchemy" presented "a series of 82 works which transcribe front pages of international daily newspapers into alchemical drawings, reframing the world as a place animated by strange forces, powers and belief systems."[11] Treister's creations array extensive texts in meaningful locations in and around various traditional kabbalistic schemata, often giving the tree pride of place. At their most frenetic, these iconotexts give the densely inscribed ilanot of the past a run for their money. Like ilanot, Treister's images are devoted to the visualization of esoteric knowledge. Rather than kabbalistic cosmology, however, the esotericism she exposes often depicts relationships among technology, society, and alternative belief systems, illuminating the forces at play in the modern world. Treister's art is driven by the aspiration to make these powers and correspondences visible and, in so doing, to foster potentially transformative understanding and positive action. She describes the "ilan" seen here in the following manner:

> HEXEN 2.0/*Historical Diagrams/From* MKULTRA *via the Counterculture to Technogaianism* is one of many works from the project HEXEN 2.0 (2009–11) which looks into histories of scientific research behind government programmes of mass control, investigating parallel histories of countercultural and grass-roots movements. HEXEN 2.0 charts, within a framework of post-WWII U.S. governmental and military imperatives, the coming together of scientific and social sciences through the development of cybernetics, the history of the internet, the rise of Web 2.0 and increased intelligence gathering, and implications for the future of new systems of societal manipulation towards a control society.[12]

Treister's ambitious work is something of a bahiric All-Tree for our age.

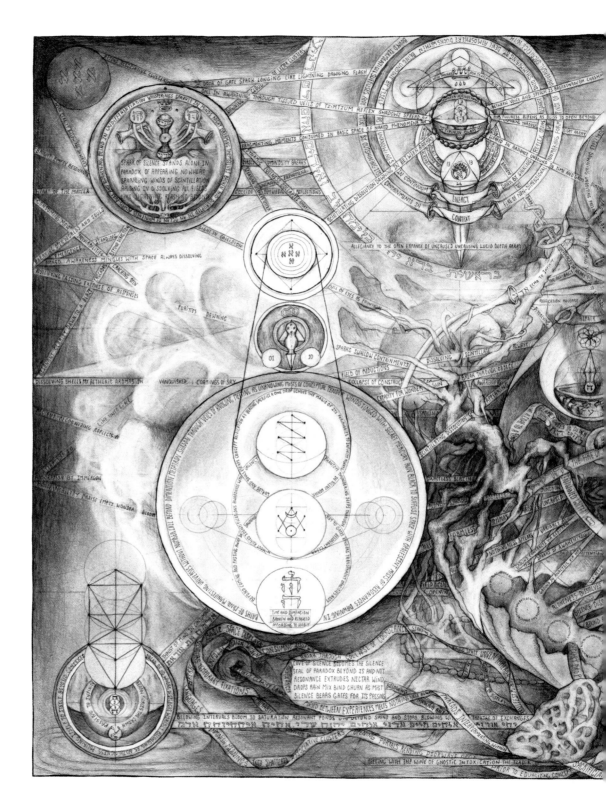

Figure 240 | *Lightning Flash of Alef*, David Chaim Smith, graphite, ink, 51 × 84 cm. David Chaim Smith, 2011–15.

HEXEN 2.0: From MKULTRA via the Counterculture to Technogaianism

One ilan has been left out of this book. It is so enigmatic that I felt unable to treat it at all, and I remain uncertain of its meaning, let alone its proper place in the narrative. It may be the unicum of a madman, for all I know. I will return to study it again and, with a bit of grit and grace, perhaps discover its secret (fig. 242). This "last ilan" is emblematic of my reluctance to part with this typescript, but part with it I shall, in the knowledge that even though *The Kabbalistic Tree* may be the first book on the subject, it is *only* the first book on the subject. A line I came across recently in Alan Walker's remarkable biography of Fryderyk Chopin struck me as impossibly apt: "This is the sort of book that should first appear in a second edition."[13] Its encyclopedic ambition alone guarantees that, not long after I surrender *The Kabbalistic Tree* to the "altar of the press,"[14] new ilanot will come to light and more thorough understandings of those already known will surely emerge.

Figure 241 (opposite) | HEXEN 2.0 / *Historical Diagrams / From* MKULTRA *via the Counterculture to Technogaianism,* Suzanne Treister, archival giclée print on Hahnemuhle bamboo paper, 29.7 × 42 cm, 2009–11. Courtesy the artist, Annely Juda Fine Art, London and P.P.O.W. Gallery, New York.

Figure 242 (overleaf) | Ilan, ink and watercolors on parchment, 640 × 23 cm, The Netherlands (?), eighteenth century. Jerusalem, IM, B50.02.1945; 180/40 [received through Jewish Restitution Successor Organization]. Pictured: Menachem Kallus; Eliezer Baumgarten. Photo © J. H. Chajes, Courtesy of The Israel Museum, Jerusalem.

APPENDIX: CATALOGUE OF THE GROSS FAMILY ILANOT COLLECTION

William Gross has perspicaciously curated his ilanot collection for more than forty years (fig. 243). The result is a nearly *A* to *Z* treasury of the ilan genre, beginning with a gorgeous sixteenth-century fragment and culminating in silver-cased amulets from the early twentieth century. His collection also includes a wealth of related manuscripts and printed books. William and I long ago agreed that I would prepare a catalogue of his collection with Dr. Eliezer Baumgarten and only thereafter write a comprehensive monograph on the genre.[1] However, I soon realized that the history of ilanot could be told to a remarkable extent through the Gross Collection, which also had the distinct advantage of being entirely at my disposal. There was no need to write two books after all.

 William's vision was responsible for building a collection of ilanot the likes of which exists nowhere else. No less important, his curiosity and generosity made it unthinkable for him to treat them as his own private treasure, investments to be locked away in a vault. In a very literal sense, William catalyzed this book and the study of the genre.[2] The great research libraries of the world are the bedrock of scholarship, but the contribution to the advancement of knowledge made by private collectors who make their distinctive collections available to the community of scholars is inestimable. As an homage to this great collection and collector, every Gross Collection ilan not featured in the body of this book is described briefly in the appendix that follows. If a related ilan has been treated in the monograph, the reader will find a reference to the relevant discussion.

 The Gross Family Collection (Trust) (Tel Aviv, GFC/GFCT) distinction need not concern the reader. Regarding the numbering system, the first three digits refer to the classification of the object; 028 are ilanot. The next three digits refer to the medium; 011 and 012 are

paper and parchment, respectively. The final three digits reflect the order of acquisition.

Classical Ilanot

Tel Aviv, GFC, MS 083.012.001 | The *Magnificent Parchment* (fragment): see above, pp. 73–74.

Tel Aviv, GFCT, MS KU.011.009 | Deconstructed Prayer Ilan: see above, pp. 80–82.

Tel Aviv, GFCT, MS YM.011.035 | R. Isaac Wanneh—*Rekhev Elohim* (Vehicle of God): see above, pp. 82–88.

Lurianic Ilanot

SINGLE-ORIGIN ILANOT

Tel Aviv, GFCT, MS 028.012.015 | *Ilan of Adam Kadmon and the Enrobings*: see above, pp. 140–44.

Tel Aviv, GFC, MS 028.011.009 | The Hammerschlag *Poppers*: see above, pp. 240–43.

GREAT TREES

Tel Aviv, GFCT, MS 028.011.003 | Great Tree type κΡrzw: see above, pp. 223–25.

Tel Aviv, GFCT, MS 028.011.002 | Great Tree type κΡrzw (fig. 244)
This ilan, amateurishly drawn by Judah Leib ben Asher Anshel Katz, is the rare specimen that contains a colophon noting the name of the scribe and its date of completion in 1896. The ilan is almost identical to Tel Aviv, GFCT, MS 028.011.003, and to the first printed edition. The latter may have been Katz's source, although his hand and lettering mimic the style of the manuscript more than the printed edition. Katz preserved the suggestively anthropomorphic images of his source, particularly in the representation of the eyes, nose, and ears of

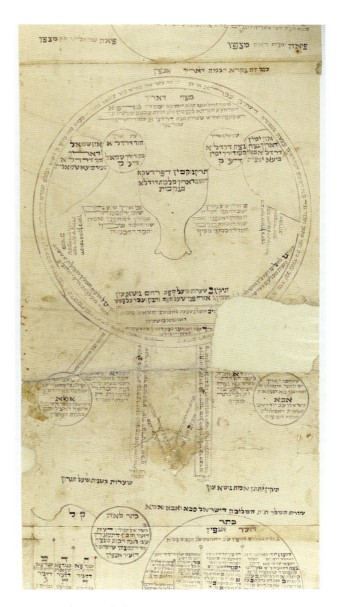

Figure 243 (opposite) | William Gross with ilan, 2009. Photo: author.

Figure 244 | Head of *Arikh* from a Great Tree, paper, 539 × 274 cm, Eastern Europe, 1896. Tel Aviv, GFCT, MS 028.011.002. Photo: Ardon Bar-Hama.

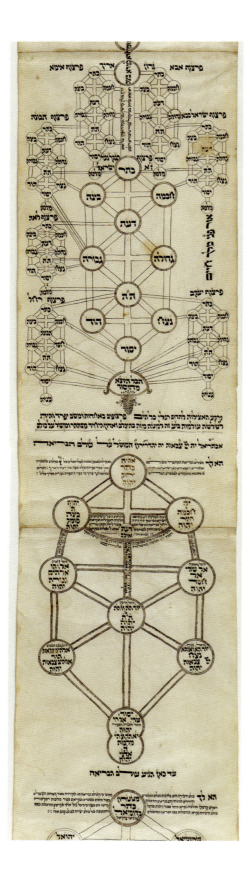

Adam Kadmon. He also did his best to reproduce its text placement as well as its emphases on particular words and lines.

Tel Aviv, GFCT, MS 028.012.010 | Great Tree type *KPZWy* (fig. 245)

The scribe of this Great Tree produced a beautiful rotulus using lettering reminiscent of that found on a Torah scroll. The schemata were executed with no less impressive precision. At the bottom is the proud inscription, "Joshua Segal Kagan—Seven sheets of parchment." Two comments are inscribed in the name of "Israel," a kabbalist who was the ostensible owner of the ilan at some point in its transmission. One treats how the different sections of the ilan relate to one another; the other addresses the relationship between the Kabbalah of Luria and that of Cordovero.[3] The first comment is found at the top of the ilan, in an area difficult to read due to extensive wear and tear. From the intelligible fragment of the second comment, we can make out the author's assertion that Cordovero's Kabbalah treated the World of *Tohu* (Chaos), whereas Luria's treated the World of *Tikkun* (Rectification)—making them complementary bodies of knowledge. Luria's was, of course, of higher rank.

At the end of *K*, written in the margins of the parchment in the same handwriting, we read:

> Said young Israel:
> From here forward is the World of *Tikkun*
> based on the exalted writings
> of the Holy Ari, may his memory live on in
> the World to Come.

Figure 245 | *Z14* and the beginning of *Wy*, from a Great Tree, parchment, 470 × 28 cm, Germany, early eighteenth century. Tel Aviv, GFCT, MS 028.012.010. Photo: Ardon Bar-Hama.

> Missing here are the ten circles of the *Ein Sof*,
> blessed be He,
> as explicated in his pure book by his faithful
> student
> the *'Ez ha-Ḥayyim* [*sic*]; see there.

Israel knew that *K* was not based on the writings of the AR"I, by which he meant Vital, and he was also correct about *P* treating the "World of *Tikkun*." He laments the absence of the *'iggulim* in the cosmogonic presentation of *P*. He would have certainly preferred Tel Aviv, GFCT, MS 028.012.023 (fig. 247, below).

Tel Aviv, GFCT, MS 028.012.012 | Great Tree type *KPZW*: see above, p. 221.

Tel Aviv, GFC, MS 028.012.025 | Great Tree type *KPZV*: see above, pp. 221–23.

Tel Aviv, GFCT, MS 028.011.006 | Great Tree type *PZW*: see above, pp. 210–11.

Tel Aviv, GFCT, MS 028.012.007 | Great Tree type *KPrZWy* (fig. 246)
This orderly *KPrZW* Great Tree is missing the first membrane of the rotulus. At the top of the ilan in its current state, we see the bottom of the circle that always appears under the head of *Adam Kadmon*, referred to as *Keter de-Arikh* (crown of *Arikh*). The circle represents the lower third of *Adam Kadmon* and the "seven *tikkunim* . . . called *'Atik Yomin* [Ancient of Days]." It is situated between the two anthropomorphic faces of *Adam Kadmon* and *Arikh Anpin*. If the ilan were complete, it would be nearly identical to Tel Aviv, GFCT, MS 028.012.010 (figs. 92, 245). Even though they were written by different scribes, artistic details such as the cleft noses with articulated nostrils of the *parzufim* betray their common origins.

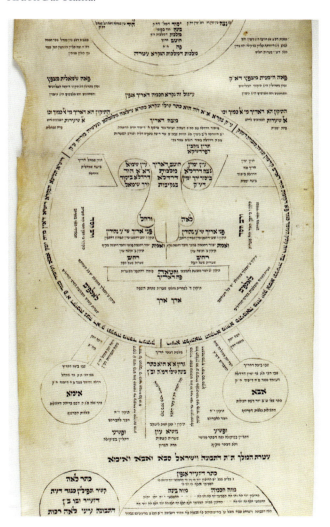

Figure 246 | Head of *Arikh* from a Great Tree, parchment, 384 × 31 cm, Germany, early eighteenth century. Tel Aviv, GFCT, MS 028.012.007. Photo: Ardon Bar-Hama.

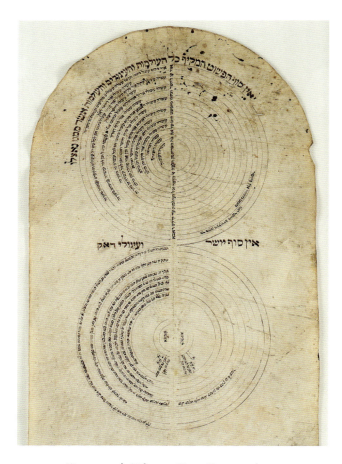

Figure 247 | *V* from a Great Tree, parchment (sheep), 180 × 26 cm, Morocco, ca. 1850. Tel Aviv, GFCT, MS 028.012.023. Photo: Ardon Bar-Hama.

Figure 248 (opposite left) | Great Tree with Delmedigo framed *Z*, parchment, 211 × 22.8 cm, Eastern Europe, mid-eighteenth century. Tel Aviv, GFCT, MS 028.012.011. Photo: Ardon Bar-Hama.

Figure 249 (opposite right) | Opening of two-column Great Tree, parchment (sheep), 254 × 17.5 cm, Shlomo Mordekhai Ish Yemini ben Aharon of Ḥutin, Morocco, ca. 1825. Tel Aviv, GFC, MS 028.012.026. Photo: Ardon Bar-Hama.

Tel Aviv, GFCT, MS 028.012.023 | Great Tree type *VPaZW* (fig. 247)

This mid-nineteenth-century Moroccan ilan is noteworthy for its *V* opening and the thoughtful rounding of the upper edge of the rotulus to match it. The two circular diagrams are connected by a vertical channel that entirely traverses them both. There is otherwise little of visual interest in the ilan; it is free of decorative elements and presents highly schematized heads of *Adam Kadmon* and *Arikh Anpin*.

Tel Aviv, GFCT, MS 028.012.016 | Great Tree type *PuNZ14EWy*: see above, pp. 211–214.

Tel Aviv, GFCT, MS 028.012.022 | Great Tree type *PaZW*: see above, p. 211.

Tel Aviv, GFCT, MS 028.012.011 | Great Tree with Framed *Z* + *PaZP7* (fig. 248)

This enigmatic ilan is distinguished principally for having preserved the work-in-progress of its earnest copyist. It is not merely unfinished, though; it seems that the scribe had not entirely worked out his plan at the outset. The rotulus opens with the Zacuto-Ẓemaḥ ilan, framed by the text of Delmedigo, as we encountered it in the second module of the Cambridge *Trinity Scroll* (fig. 134). Judging from appearances, it was necessary to sew another parchment sheet to the bottom of the first in order to finish the *parzufim* of Jacob and Rachel. When that was done, the scribe drew two horizontal lines, perhaps to guide a cut. Rather than cut, however, he kept writing, beginning with the head of *Adam Kadmon* (*P*). He likely planned to create an ilan akin to the *Trinity Scroll*, type *PaZP7*, but after beginning *P7*, he seems to have run out of steam. The diagrammatic lines are partially drawn but incomplete. *Z* is thus reproduced twice over the course of the two-meter rotulus.

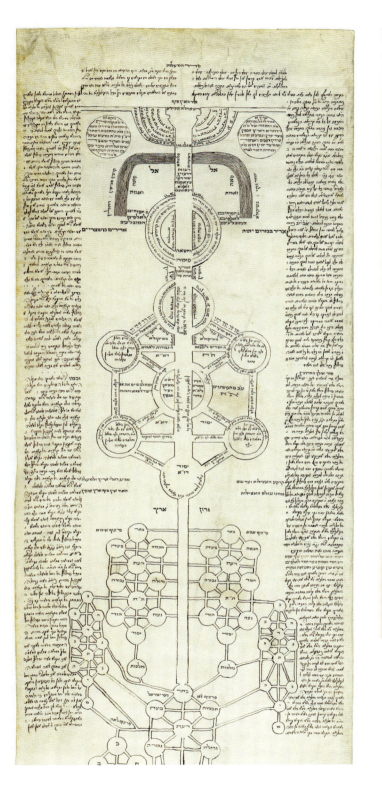
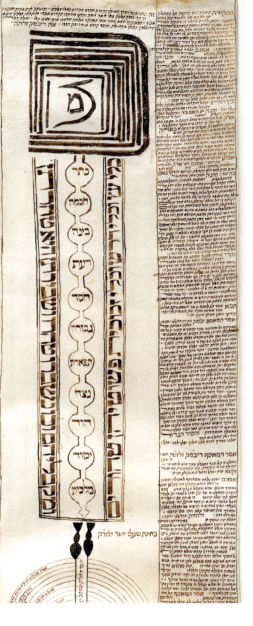

The second presentation of *Z* shows some minor improvements; the scribe had made better use of his ruler. A new text now surrounds the diagram: this time, it is the "requires further consideration" gloss. To it was added a short passage containing various affirmations and words of encouragement to the student.

Artisanal Ilanot

COPPIO ILANOT

Tel Aviv, GFCT, MS 028.011.004 | Coppio Great Tree with ibn Ẓur Opening: see above, pp. 257–59.

Tel Aviv, GFCT, MS 028.011.005 | Coppio *"Headline" Ilan*: see above, pp. 259–61.

Tel Aviv, GFCT, MS 028.012.002 | Coppio *"Two-Column" Ilan*: see above, pp. 261–62.

Tel Aviv, GFC, MS 028.012.026 | Coppio *"Two-Column" Ilan* (fig. 249)
This ilan is based on Tel Aviv, GFCT, MS 028.012.002 (fig. 176), or its equivalent, reduced in size by about thirty percent. Toward the bottom, the scribe, Shlomo Mordekhai Ish Yemini ben Aharon of Khotyn, added an arboreal diagram that does not appear in the model. In the right column above it he explained, "This drawing [ẓiyyur] is not one of the drawings of the holy tree, as I copied it from elsewhere."⁴ In the narrow space the scribe copied a tree featuring standard sefirotic names and their associated unerasable names of God. This addition, probably born of *horror vacui*, takes advantage of one of the empty spaces in the Coppio ilan created by the concentration of texts in the upper levels of emanation. A bit of spatial miscalculation related to this augmentation forced Shlomo Mordekhai to complete the "tree of the *heikhalot*" at the very bottom of the rotulus.

Tel Aviv, GFCT, MS 028.010.001 | Great Tree type *VPaZW* with Coppio Additions (fig. 250)
This ilan is a variation on the "ibn Ẓur" Coppio rotulus, Tel Aviv, GFCT, MS 028.011.004 (fig. 170).⁵ Both open with long texts before presenting the first diagrammatic image. In this case, we find an excerpt from Vital's *Adam yashar*, which also appeared in the "commentary column" of Tel Aviv, GFCT, MS 028.012.002, as well as in Coppio's copy of *Meʿarat sdeh ha-makhpelah*. Tel Aviv, GFCT, MS 028.011.004, opens with an excerpt from *Meʿarat sdeh ha-makhpelah*.

Like Tel Aviv, GFCT, MS 028.011.004, this one follows the opening text with *V*. It follows the ibn Ẓur ilan in its lower section as well, including two unusual images. The first shows the palm with its various lines and the caption "the science of palmistry" (*ḥokhmat ha-sirtutim*). This diagram is less densely inscribed than the one found in the ibn Ẓur ilan, however, and its inscriptions differ. For example, the "line of speech" (*kav ha-dibbur*) here appears there as the "line of glory" (*kav ha-kavod*). The second illustration differs from that found in the ibn Ẓur ilan. It is a rather coarse illustration of a human face with several inscriptions referring to the lines of the forehead, the shape of the nose, and the mouth under the title of "the science of chiromancy" (*ḥokhmat ha-parzufim*).

Why were the "science of palmistry" and the "science of chiromancy" added to an ilan that was ostensibly intended to present the order of emanation according to Lurianic Kabbalah? These sciences were understood to pertain to the lower Worlds of ʿ*Assiah*, but they were also thought to have a special connection to Kabbalah (often under the rubric of "practical Kabbalah"). *Horror vacui*

Figure 250 | Opening of Great Tree with prefatory text and *V*, leather (gevil), 186 × 13.2 cm, Morocco, ca. 1850. Tel Aviv, GFCT, MS 028.010.001.

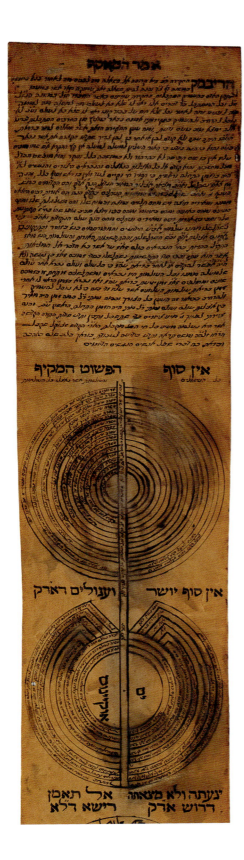

also dictated that every centimeter of the parchment rotulus was to be utilized.

SHANDUKH ILANOT

Tel Aviv, GFC, MS 028.012.009 | Shandukh Ilan (early version): see above, pp. 273–74.

Tel Aviv, GFC, MS 028.011.008 | Shandukh Ilan *Tofes ilana de-ḥayei* (Image of the Tree of Life): see above, pp. 274–76.

Tel Aviv, GFC, MS IQ.011.011 | *Tofes ilana de-ḥayei* (Image of the Tree of Life) Codex: see above, pp. 276–79.

Tel Aviv, GFC, MS 028.011.007 | Shandukh Ilan (fragments) (fig. 251)

The colophon at the end of the rotulus is damaged, leaving only the second half of the bottom four rows readable: "Sasson ben ha-meruḥam / . . . [wri]tten in the month of Elul / . . . 32." The most plausible reading of the date, 5532 (1772), is difficult to reconcile with the content of this ilan: it bears all the signs of having been fashioned, like Tel Aviv, GFC, MS 028.011.008 (fig. 180), in Shandukh's later period. Indeed, apart from the reading of the damaged colophon, the parallels between these two ilanot suggest the strong possibility that the former served as a study for the latter ca. 1790. In addition to the damaged bottom, the rotulus was discovered in a fragmentary state. Nevertheless, the two largest fragments together extend over seven meters. They were stored along with many smaller fragments, and all show signs of fire damage. Our attempted reconstruction produced an impressive but incomplete ilan.

Before becoming part of the Gross Collection, this ilan was held by the Panigel family, best known in contemporary Israeli culture for their legendary Angel Bakery in Jerusalem. According to family tradition, the ilan was in the personal collection of R. Elijah Moshe Panigel (1850–1919), who was

CATALOGUE | 355

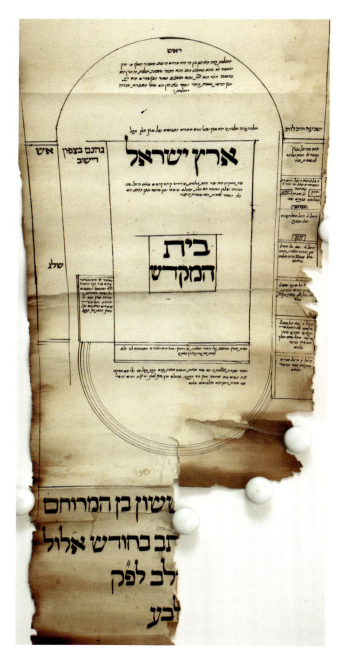

Figure 251 | Temple and colophon detail, from Shandukh ilan fragment, pre-restoration. Tel Aviv, GFC, MS 028.011.007 (fig. 178).

the Sephardi Chief Rabbi (Rishon le-Ẓiyyon) and the Chief Rabbi of Jerusalem from 1907 to 1909. He long served as an emissary of Jerusalem to the diaspora, and in this capacity he established relations with many communities. It seems likely that this ilan came into his possession during one such mission to Baghdad.

The distinguishing feature of this ilan, when compared to Shandukh's other ilanot, is its relatively sparse use of texts. The emphasis on the ordering and arrangement of graphical elements was evidently the main objective of what seems to have been a study for his most elaborate rotulus. Copying out extensive texts was less important for such a preparatory study.

Tel Aviv, GFC, MS 028.012.024 | Joseph Siprut de Gabay, *Tree of Circular and Linear Emanations*: see above, pp. 249–55.

Tel Aviv, GFCT, MS 028.012.003 | The *Tree of Holiness*: see above, pp. 279–83.

Tel Aviv, GFCT, MS 028.012.005 | The *Gates of Eden Ilan*: see above, pp. 283–89.

Ilan Amulets

ILAN AMULETS BASED ON COPPIO ILAN TYPE
TEL AVIV, GFCT, MS 028.012.002

Tel Aviv, GFCT, MS 028.012.008 | Coppio Ilan Amulet (fig. 252)
Strictly on the basis of its miniaturization and minimalism, we can assume that this rotulus was prepared to serve as an amulet rather than for study and contemplation. That said, it carries neither a dedication nor instructions for use. At the top of the ilan, a caption notes its adherence to Lurianic doctrine, but this assertion is also found on amulets based on the Coppio ilan, including Tel Aviv, GFCT, MS 028.012.006 (fig. 218). The emphasis on

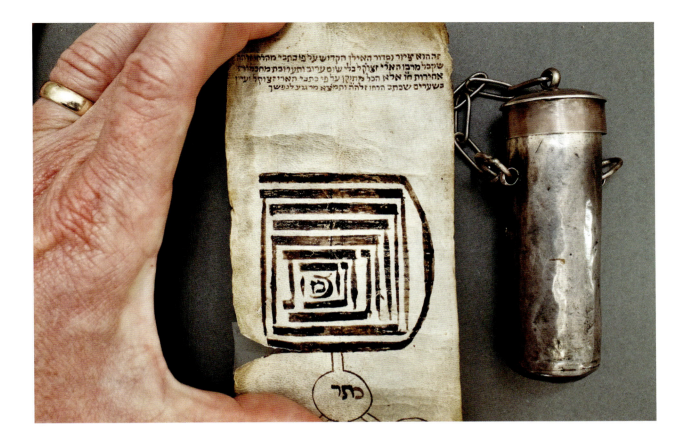

the Lurianic lineage of what is effectively an amulet should be considered part of its marketing strategy. If Lurianic Kabbalah in all its intricate theosophical complexities was understood by very few, Luria's reputation as a wonder-working saint was well known from widely read hagiographical literature. To link the ilan to Luria was thus to assert its unassailable origins and concomitant virtues. The caption reads:

> This is the image and order of the holy ilan according to the writings of our teacher, the Rabbi, R. Ḥayyim Vital, may his memory be for everlasting life, which he received from his teacher the AR"I, may the memory of the righteous and the holy be a blessing, without any mixing or mixture from other teachings, God forbid. Rather, all is constructed according to the writings of the AR"I, may the memory of the righteous and the holy be a blessing, and see in the *She'arim* [Gates] written by R. Ḥayyim Vital, may his memory live on in the World to Come and your soul shall be calmed.

Figure 252 | Opening of ilan amulet with silver case, parchment (sheep), 198 × 7.6 cm, Morocco, ca. 1875. Tel Aviv, GFCT, MS 028.012.008 (see also fig. 209, right). Photo: author.

Tel Aviv, GFCT, MS 028.012.006 | Coppio Ilan Amulet: see above, pp. 304–6.

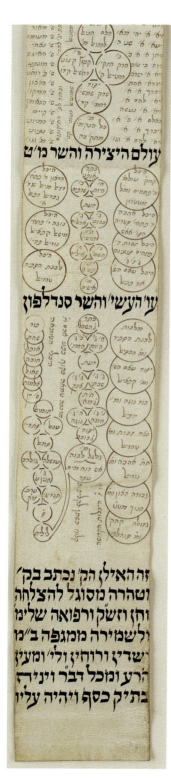
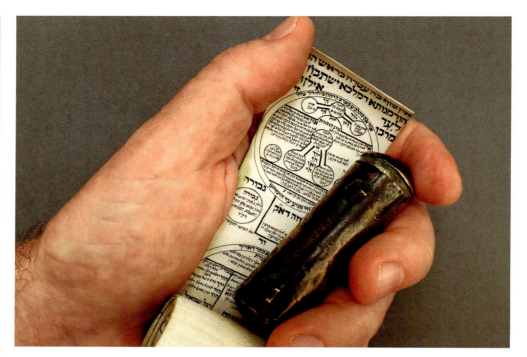

Figure 253 | Bottom of ilan amulet. Tel Aviv, GFCT, MS 028.012.001 (fig. 205). Photo: Ardon Bar-Hama.

Figure 254 | Bottom of ilan amulet with silver case, parchment, 72 × 4.5 cm, Land of Israel, ca. 1920. Tel Aviv, GFCT, MS 028.012.013. Photo: author.

ILAN AMULETS BASED ON GREAT TREE TYPE *pazw* TEL AVIV, GFCT, MS 028.012.022

Tel Aviv, GFCT, MS 028.012.001 | Ilan Amulet (fig. 253)

This early twentieth-century ilan amulet is a well-crafted reduction of a Great Tree akin to Tel Aviv, GFCT, MS 028.012.022 (fig. 138). The copyist was not stingy about including the texts typical of this type of tree, although he did so with a rather hurried cursive script. Calligraphic embellishments were reserved for section headers and the amulet inscription at the very bottom of the narrow rotulus. Lacking any personal dedication, this amulet seems to have been made for purchase "off the rack."

Tel Aviv, GFCT, MS 028.012.013 | Ilan Amulet (fig. 254)

This ilan amulet is a deluxe model of Tel Aviv, GFCT, MS 028.012.001 (fig. 217). The content is

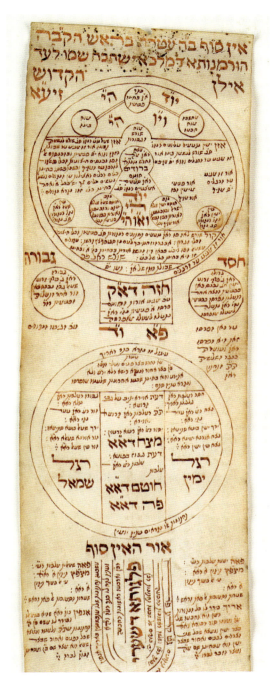

virtually identical, but this scribe has invested more time and skill in its preparation. The difference is seen in the execution of the drawings as well as in the texts, the latter here displaying more use of a formal square script.

Tel Aviv, GFCT, MS 028.012.004 | Ilan Amulet (fig. 255)

This ilan amulet is an older sibling of those just discussed. It is likely among the earliest amulets fashioned on the basis of the paZw Great Tree model. The rotulus has reached us in its simple silver case.

Tel Aviv, GFCT, MS 028.012.014 | Ilan Amulet (fig. 256)

This ilan amulet, prepared for one Elazar ben Ezekiel, was passed down over the last few generations in a pure silver case. The requirement to keep the parchment in such a case was a standard part of the inscription found on every such artifact. Not all silver cases were created equal, however, and the one that carried this ilan was a beauty. Its attractiveness was apparently irresistible to one of William Gross's innumerable guests. Its whereabouts are currently unknown.

Tel Aviv, GFCT, MS 028.012.017 | Ilan Amulet (fig. 257)

An ilan amulet akin to Tel Aviv, GFCT, MS 028.012.001 (fig. 217).

Figure 255 | Opening of ilan amulet, parchment (goat), 119 × 8.7 cm, Near East or North Africa, ca. 1900. Tel Aviv, GFCT, MS 028.012.004. Photo: Ardon Bar-Hama.

Figure 256 | Silver case for ilan amulet (stolen). Tel Aviv, GFCT, MS 028.012.014.

CATALOGUE | 359

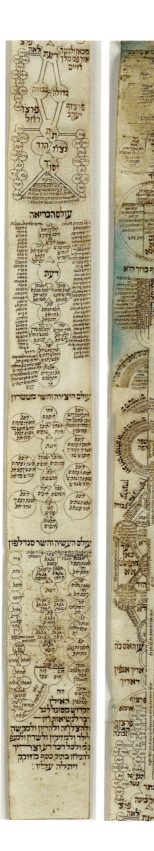
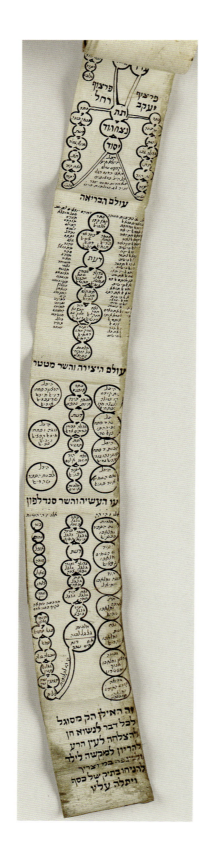
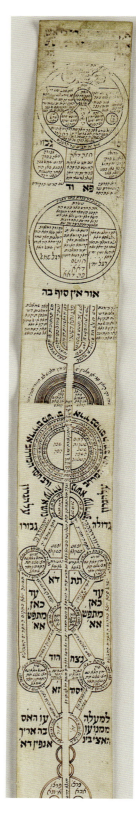

Tel Aviv, GFCT, MS 028.012.018 | Ilan Amulet (fig. 258)
An ilan amulet akin to Tel Aviv, GFCT, MS 028.012.001.

Tel Aviv, GFCT, MS 028.012.019 | Ilan Amulet (fig. 259)
This ilan amulet is terribly worn at the top and bottom. Otherwise it is identical to Tel Aviv, GFCT, MS 028.012.018 (fig. 258), and is doubtless the work of the same scribe.

Tel Aviv, GFCT, MS 028.012.020 | Ilan Amulet (fig. 260)
Although most ilan amulets were copied boilerplate style, resulting in a pronounced lack of variation within a given type, the present artifact is an exception to this rule. Rather than simply reproduce a Great Tree amulet like the rest, the scribe

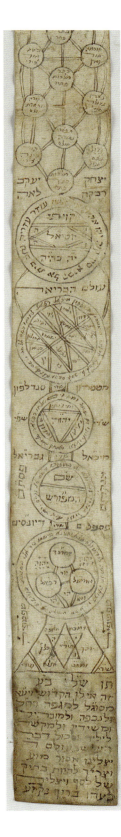

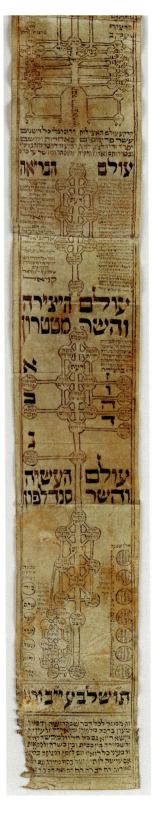

Figure 257 (opposite left) | Ilan amulet, 85 × 4.5 cm, parchment, Land of Israel, ca. 1920. Tel Aviv, GFCT, MS 028.012.017. Photo: Ardon Bar-Hama.

Figure 258 (opposite center) | Bottom of ilan amulet, 85 × 4.5 cm, parchment, Land of Israel, ca. 1920. Tel Aviv, GFCT, MS 028.012.018 (see also fig. 208). Photo: Ardon Bar-Hama.

Figure 259 (opposite right) | Opening of ilan amulet, 85 × 4.6 cm, parchment, Near East or North Africa, ca. 1900. Tel Aviv, GFCT, MS 028.012.019. Photo: Ardon Bar-Hama.

Figure 260 (right) | Bottom of ilan amulet, Tel Aviv, GFCT, MS 028.012.020 (see also fig. 211).

Figure 261 (far right) | Bottom of ilan amulet, parchment (goat), 104.6 × 7.8 cm, Near East or North Africa, ca. 1900. Tel Aviv, GFCT, MS 028.012.021. Photo: Ardon Bar-Hama.

has opted for something like a visual paraphrase. The familiar figures and modules of *Pa*, *W*, and perhaps even *Z* are schematically reduced to the point of near disappearance, although someone familiar with this material would notice vestigial signs of their ancestry. The scribe has also added visual and textual elements taken from the world of non-ilan Hebrew amulets. Many have the appearance of magical "seals," but so does the schematic rendering of *Adam Kadmon*, in fact.

The scribe is unlikely to have been much of a kabbalist, and the elements are in disarray. The Worlds of *'Assiah*, *Yeẓirah*, and *Beriah* are accentuated by bold inscriptions but with *'Assiah* coming first, directly after the head of *Adam Kadmon*. In addition to magical-looking seals with their various inscribed circles and triangles, we find the famously apotropaic "shield of David" at the very bottom, beside the divine name *Taftafia*. Still, at the end of the day—or at least at the end of the rotulus—the scribe reinforces the identity of this amulet: it is "the holy ilan, may its merit protect us, Amen!" and so forth.

Tel Aviv, GFCT, MS 028.012.021 | Ilan Amulet (fig. 261)

This ilan amulet was analyzed and compared to its parallels above (figs. 202–205). Although still fundamentally akin to others of its type—amulets based on the *PaZW* framework—it shows greater affinity to their common model, Tel Aviv, GFCT, MS 028.012.022, or its equivalent. The model includes considerable supplementary texts, particularly in the lower section of *Pa*.

Were it not for the inscription at the bottom, we would scarcely suspect that this rotulus was made to serve as an amulet. The precision and comprehensiveness of this copy demonstrate that not every artifact destined to remain rolled up in a silver case was devoid of the detail found in the original. As Steve Jobs related, his father "loved doing things right. He even cared about the look of the parts you couldn't see."[6] The present ilan was made in keeping with a similar ethos, or, at the very least, it was commissioned by a customer who thought that a complete copy would make for a better amulet, regardless of the extra expense.

COLLECTOR'S AFTERWORD, BY WILLIAM GROSS

When I saw my first ilan, the complex sets of circles and forms arranged in various combinations were an instant source of fascination to me. While I had heard of sefirot and seen simpler representations of them, this was the first time I had ever seen an authentic kabbalistic scroll decorated with different arrangements of this symbol. To me it appeared to be a magical presentation of something that I did not understand but found to be incredibly appealing. I was enchanted.

So the first ilan entered the Gross Family Collection more than forty years ago. While at that time I had no idea of what this parchment scroll represented in Jewish tradition, I did know that such scrolls seldom appeared in the marketplace. I understood that they were rare. Their form and appearance simply radiated beauty and significance to me. As examples appeared over the decades, one every few years, I acquired them when I could. Quite frankly I was always very pleasantly surprised at the almost total lack of competition for these manuscripts when they appeared at auction. The catalogue descriptions were almost always short and vague, devoid of meaningful context. At least in the Judaica-collecting world, it was clear to me that virtually no one understood the significance of the ilan. I cannot say that I understood it either, but my instincts told me that such scrolls were of major importance in addition to being visually fascinating. I continued to acquire these manuscripts, learning that they appeared in different versions. The variety of visual presentations appealed to my sense of aesthetics. I continually sought examples that were different from one another. It was increasingly obvious to me that there existed some sort of typology; I simply did not know how to arrange it and interpret its significance.

Then there began the more frequent appearance of small ilanot on offer in the Judaica marketplace. These scrolls were narrow, about one meter long, and so similar in appearance that it seemed likely that the

majority were done by the same hand. They almost all carried a text at the bottom indicating their use as an amulet; they served as a shield against all sorts of injurious threats and were to be carried in a silver case by the owner for protection. The use of these seemed to be centered in *Erez Yisrael* and Morocco.

 These amuletic scrolls emphasized that the larger ilanot were made to serve a different purpose. They contained much larger quantities of legible script and naturally, because of their size, a more detailed and varied presentation of the diagrams that visually represented aspects of the sefirot. These larger scrolls were generally from three meters in length to over ten meters. The scribal investment in writing them was immense.

Another phenomenon that struck me was the lack of scholarship explaining these scrolls. It seemed to be a field that was neither well known nor explored. Since I have always enjoyed collecting material that other collectors ignore, my continued acquisition of ilanot afforded me great pleasure. But the unanswered questions, at least for me, of how they were utilized, when they were written, and by whom they were composed remained open.

In 2005 a serendipitous event occurred. Because of the planning of a museum exhibition in New York that was to include Hebrew mystical art, I was contacted by Dr. Menachem Kallus about whether I might lend some ilanot to the museum. Menachem is an erudite scholar of Kabbalah working in Jerusalem. That phone call was the genesis of the first-ever scholarly exploration of the ilan, by Menachem, using my collection as his source material. He began examining the ilanot then in the collection, mining the texts and images; he started working out a preliminary typology of the ilan. He also worked on text analysis, seeking and finding sources in Jewish textual tradition. Menachem was the Johnny Appleseed of scholarly ilan research.

In 2008 Menachem's research came to the attention of Prof. J. H. (Yossi) Chajes, a cultural historian and scholar of Kabbalah in the Department of Jewish History at the University of Haifa. Yossi's realization that the ilanot constituted a virtually forgotten genre of Judaica led quickly to the establishment of the so-called Ilanot Project under his direction. With the support of the Israel Science Foundation and the Volkswagen Foundation, Yossi and his postdoctoral collaborators— Menachem for some half-dozen years, as well as Dr. Eliezer Baumgarten and, more recently, Dr. Uri Safrai and Dr. Hanna Gentili—have been pursuing wide-ranging, in-depth research, attempting to locate, identify, classify, analyze, and present the history of the ilan genre and visual kabbalah more generally.

 Although the recovery of a forgotten genre and its study provides rich material for lifetimes of exploration, with roughly a decade of research now behind him Yossi has produced the book before you. He has created a framework that plumbs the depths of the subject, establishing an entirely new field of scholarship informed by broad cultural-historical sensibilities. He also shares my appreciation of the beauty of these manuscripts. His efforts have been dramatically expanded and assisted over the past few years thanks to the unflagging efforts of Eliezer Baumgarten, a Kabbalah scholar with vast knowledge and an uncanny memory for everything he has seen. As Yossi is the first to admit, the present work would not have been possible were it not for Eliezer's indefatigable assistance.

I am not a scholar, and, unfortunately, traditional Jewish sources are largely unknown to me. I have always viewed my collecting efforts and my role in the field of Jewish Studies to be mainly that of a supplier, not an interpreter. It has been my infinite pleasure to gather Jewish material that I thought was important, to try to organize it, and then to make it available to all: scholars, museums,

publishers, and anyone else who expresses interest. It has always been my feeling that Jewish material from the Gross Family Collection that remains only in drawers or on shelves in my home is moribund. The only thing that gives it life is its exposure. Only when people see it can an artifact have the effect of conveying aspects of Jewish life and tradition. In the best and most desired case, the exposure will even stimulate someone to further explore Jewish culture.

So it is now with the ilanot in the Gross Family Collection, my favorite section of my Jewish material. Not only are the scrolls themselves being illustrated and well described, but this book also represents, as it were, the debut of the entire subject in print. It is truly a privilege and an honor to be a part of this event. The publication and consequent exposure of the scrolls make all the decades of collecting efforts completely worthwhile. My true gratitude is extended to Prof. Chajes and to Dr. Baumgarten for the efforts that have produced this volume and also for their friendship. It is my fervent hope that this book will be the first of many that will emerge from the Ilanot Project and that this work will reach both scholars and the general public, illuminating an important manuscript tradition in all its beauty and mystery.

NOTES

Introduction

1. Wilkinson, *Orientalism, Aramaic, and Kabbalah in the Catholic Reformation*, 119n82; and J. Weiss, *Kabbalistic Christian Messiah in the Renaissance*, 92n274, 100n324. Postel designed the Christological ilan in the Syriac New Testament published by Johann Albrecht Widmannstetter (1506–1557); see Wilkinson, *Orientalism, Aramaic, and Kabbalah in the Catholic Reformation*, plate xvi and discussion on 47n63, 182–85. See also De Molière, "Studies in the Christian Hebraist Library," 231–68. Postel's lost work *L'arbre des noms divins* may have been conceptualized as an ilan.

2. Scholem, "Index to Commentaries"; Abrams, "Commentary to the Ten *Sefirot* from Early Thirteenth-Century Catalonia"; Lachter, "Anonymous Commentary on the Ten *Sefirot*"; and see below.

3. Scholem's panoramic essay in the original *Encyclopaedia Judaica* was richly illustrated with diagrams chosen by Scholem but not referenced in the text. Scholem, "Kabbala"; and Chajes, "Kabbalistic Trees of Gershom Scholem."

4. Scholem, *Major Trends in Jewish Mysticism*; Idel, *Kabbalah: New Perspectives*; and Wolfson, *Through a Speculum that Shines*.

5. Drucker, *Graphesis*, 16–17. The situation began to change with the publication of Evans, "Geometry of the Mind," and Murdoch, *Antiquity and the Middle Ages*. On the neglect of visual materials by historians of Kabbalah, see Busi, "Beyond the Burden of Idealism."

6. Elkins, "Art History and Images."

7. Busi, *Qabbalah visiva*. Other studies of kabbalistic diagrams—but not ilanot—include Segol, *Word and Image in Medieval Kabbalah*; Abrams, "New Study Tools from the Kabbalists of Today"; Abrams, "Kabbalistic Paratext"; Abrams, *Kabbalistic Manuscripts and Textual Theory*, 618–26; and Wolfson, "Metaphor, Dream, and the Parabolic Bridging of Difference."

8. I use these terms to refer to the kinds of relations that signs can have to their objects: an icon bears a resemblance; an index an actual connection (like an "Exit" sign with an arrow); and a symbol a learned association. Associated with the semiotics of Charles Sanders Peirce, the art-historical usage of these terms is not responsive to the complexity of Peirce's system. See Elkins, "What Does Peirce's Sign Theory Have to Say."

9. Verboon, "Medieval Tree of Porphyry," 95–116, esp. 109–13; and Drucker, *Graphesis*, 98. See also the speculative remarks in Scholem, *Origins of the Kabbalah*, 446–47. On the diagrammatic turn in the twelfth century, see A. Cohen, "Diagramming the Diagrammatic," esp. 390–92.

10. Bynum, "Avoiding the Tyranny of Morphology." See also Lüthy and Smets, "Words, Lines, Diagrams, Images," esp. 405–11; Chajes, "Imaginative Thinking," 40–42; and Drucker, *Graphesis*, 40–42.

11. Tirosh-Samuelson, "Kabbalah and Science."

12. Chajes, "Kabbalah and the Diagrammatic Phase."

13. Kemp, "Vision and Visualisation," 19–20.

14. Chajes, "Spheres, *Sefirot*," 249.

15. Schadt, *Die Darstellungen der Arbores consanguinitatis und der Arbores affinitatis*.

16. This phytomorphic sefirotic tree is found in "The Booklet of Kabbalistic Forms," a source of the *Magnificent Parchment* that I discuss below.

17. See Klapisch-Zuber, "Genesis of the Family Tree"; and Klapisch-Zuber, *Stammbäume*. On the potential tensions between diagrammatic structure and direction of

reading, see also Verboon, "Medieval Tree of Porphyry"; Norbye, "*Arbor genealogiae*"; and Drucker, *Graphesis*, 87, 95–105.

18. See Busi, "'Engraved, Hewed, Sealed.'" On *Sefer yezirah*, see Meroz, "Cosmology *Sefer yezirah* of"; and T. Weiss, *Sefer Yeṣirah and Its Contexts*. References to *Sefer yezirah* follow the numbering in Hayman's edition, but translations are my own.

19. Hayman, *Sefer Yeṣira*, §7, at 76–77, and §11, at 82–83.

20. Chajes, "Spheres, *Sefirot*."

21. Hayman, *Sefer Yeṣira*, §4, at 69–70.

22. I allude here to the notion of the rhizome developed in Deleuze and Guattari, *Thousand Plateaus*, 3–25. My thanks to Peter Cole, who suggested the salience of their work to my argument.

23. Wolfson, "Metaphor, Dream, and the Parabolic Bridging of Difference," 7.

24. On the "mystification" of the Kabbalah, see Huss, *Mystifying Kabbalah*. On the aversion of kabbalists to subjective presentations of their knowledge, see Scholem, *Major Trends in Jewish Mysticism*, 15–16; and Chajes, "Accounting for the Self."

25. Wolfson, "Metaphor, Dream, and the Parabolic Bridging of Difference," 8.

26. On diagrams and their affordances, see Krämer, *Figuration, Anschauung, Erkenntnis*.

27. I paraphrase Drucker, *Graphesis*, 3, 65.

28. Cordovero, *Or yakar*, 190a. See also Chajes, "Spheres, *Sefirot*," 259.

29. On the use of scrolls by medieval authors to use length to represent time, see T. Kelly, *Role of the Scroll*, 75–99. See also Rosenberg and Grafton, *Cartographies of Time*.

30. Nerlich, "Qu'est-ce qu'un iconotexte?," 268. Sybille Krämer's notion of "Schriftbildlichkeit"—referring to the diagram as an independent hybrid between writing and image—seems to me less well suited than "iconotext" to this text-heavy genre. Krämer, "'Schriftbildlichkeit' oder."

Chapter 1

1. For a thorough and up-to-date review of the scholarship on diagrams, see Worm, *Geschichte und Weltordnung*, 16–18.

2. See Abrams, "Divine Multiplicity." For Henry More's critique of the different ways of representing the sefirotic array, see Coudert, "Cambridge Platonist's Kabbalist Nightmare," 650.

3. See Idel, *New Perspectives*, 112–22.

4. Chavel, *Kitvei Rabbeinu Moshe ben Naḥman*, 2:296. On the term *ilan* in zoharic literature, see Liebes, "Perakim be-milon sefer ha-Zohar," 107–33.

5. On the conflation of the human form and the arboreal schema, see Verboon, "Einen alten Baum verpflanzt man nicht," 262.

6. b*Brachot* 40a–b; and b*Sanhedrin* 70a.

7. Salonius, "Tree of Life in Medieval Iconography."

8. Chajes, "Durchlässige Grenzen."

9. *Contra* Parpola, "Assyrian Tree of Life."

10. The 1284 codex (Paris, BnF, MS hébr. 763) and the 1286 codex (Parma, BP, Cod. Parm. 2784) were discussed in Idel, *R. Menaḥem Recanati*, 33–46. On the diagrams, see Busi, *Qabbalah visiva*, 125–36; and see also Segol, *Word and Image in Medieval Kabbalah*, 65–87.

11. The last refers to an ancient rabbinic tradition that counts the "let there be" speech acts of God in Genesis 1. See, e.g., Mishnah *Avot* 5:1; and Chajes, "Spheres, *Sefirot*," 250–51.

12. Wallis, "What a Medieval Diagram Shows."

13. On circles as spheres in the work of Giordano Bruno, see Lüthy, "Centre, Circle, Circumference," 317–18; and Lüthy, "Bruno's *Area Democriti*," 74. See also Idel, *Mystical Experience*, 113 and 401n68.

14. Chajes, "Spheres, *Sefirot*," 253n80.

15. The same diagram appears in Paris, BnF, MS hébr. 763, fol. 34b. See Busi, *Qabbalah visiva*, 128–30; and Segol, *Word and Image in Medieval Kabbalah*, 71–80.

16. Rather than connote something without substance—*bli-mah* as "without what[ness]"—it may have been intended to refer to the cosmic pillar upon which the earth stands. See Meroz, "Between Sefer Yezirah and Wisdom Literature," 103.

17. Hayman, *Sefer Yeṣira*, §16, at 91–92, and §47, at 149–50. Here and throughout I modify Hayman's translations as necessary.

18. This formulation is indebted to Mary Carruthers, who was kind enough to share her work in progress on geometries in motion.

19. Carruthers, *Craft of Thought*, plates 1–2.

20. On the Hereford *mappa mundi,* see Kline, *Maps of Medieval Thought*; and Kupfer, *Art and Optics.*

21. The use of blue and red for the inscriptions "water" and "fire," respectively, in the Parma manuscript was likely intentional.

22. The seven branches with their doubled nodes suggest this referent; additional indexical features of these branches, e.g., the precise number of nodes on each branch, presumably exist.

23. Busi (*Qabbalah visiva*, 130) suggested that the tree visualized the "phytomorphic metaphor" of the *Bahir*. Segol (*Word and Image in Medieval Kabbalah*, 75) rightly inferred from the precise copying of the seven branches that they were "indexical," referring to the seven "doubles."

24. In Hebrew manuscripts, such marks indicate that a word is to be emphasized, that it is an acrostic, or that its numerical value is to be calculated.

25. The primary meaning of the term ḥokhmah in this period was scientific knowledge. See Pines, *Guide of the Perplexed*, 632 (III:54). See also Klatzkin, *Ozar ha-munaḥim ha-filosofiyim*, 2, pt. 1: 290–99, s.v. ḥokhmah. See also Septimus, "What Did Maimonides Mean."

26. The content of these miscellanies is also revealing in this regard: *Sefer yezirah* materials, Maimonides, and al-Farabi. On Llull's *Arbor scientiae*, see Badia, "*Arbor Scientiae*"; and Blanco Mourelle, "Every Knowable Thing," 127–48.

27. Ladner, "Medieval and Modern Understanding of Symbolism," 252–53.

28. On Llull's relationship with contemporary Spanish kabbalists, see Idel, "Ramon Lull and Ecstatic Kabbalah"; and Hames, *Art of Conversion*.

29. Abrams, *Sefer ha-bahir*, §14, at 125. On this passage, see Wolfson, "Tree That Is All"; and Meroz, "Tree That Is an Angel."

30. Abrams, *Sefer ha-bahir*, §85, at 171.

31. See, e.g., Leon, *Ha-nefesh ha-ḥakhamah*, 5, 10; and Greenup, *Sefer Shekel ha-kodesh*, 69.

32. See Liebes, "Perakim be-milon ha-Zohar," §11, at 108.

33. The lineup in fig. 10 is found in a commentary on the sefirot by Shem Tov ibn Shem Tov (1380–1440). It was published, albeit with mistaken attribution, in Scholem, "Seridei sifro." Ibn Shem Tov's authorship was established in Gottlieb, "Regarding the Kabbalistic Orientation." See also Ariel, "Shem Tob ibn Shem Tob's Kabbalistic Critique," 14–18, 41–42. For additional examples of such lineups, see Oron, *Sefer ha-Shem*, 59–60 and note 48; Paris, BnF, MS hébr. 798, fol. 5b.

34. Goldreich, "*Sefer meirat 'einayim*." Goldreich's edition is based on London, BL, MS Or. 12260, a fourteenth-century Spanish manuscript. The Erlanger edition is based on Parma, BP, Cod. Parm. 3515. See also Fishbane, *As Light Before Dawn*, 183–84, 240–41.

35. Chavel, *Perushe ha-torah*. Nachmanides is the subject of three recent book-length studies: Halbertal, *Nahmanides*; Pedaya, *Nachmanides*; and Yisraeli, *R. Moses b. Naḥman*.

36. Abrams, "Orality in the Kabbalistic School of Nahmanides," 89; reissued in Abrams, *Kabbalistic Manuscripts and Textual Theory*, 203.

37. Abrams, "Orality in the Kabbalistic School of Nahmanides," 93–97; Abrams, *Kabbalistic Manuscripts*, 204–16; and Yisraeli, *R. Moses b. Naḥman*, 184–90.

38. Eizenbach et al., *Supercommentaries and Summaries*, presents *Meirat 'einayim* alongside the supercommentaries of Shem Tov ibn Gaon and Joshua ibn Shuaib.

39. *Pericope* refers to a weekly reading of the Pentateuch in the Sabbath synagogal service. Many Jewish books were structured—or reorganized—according to pericopes because of the immediate, quotidian utility of this manner of organization.

40. The structural-visual instruction is reiterated at the end of the chapter: "See and make their structures, which you are seeing on the mountain" (Exod. 25:40). These verses inspired rabbinic legends in which Moses's inability to follow God's verbal descriptions prompts the Divine to offer pictures. See, e.g., Numbers Rabbah 15:4 and 15:10.

41. See Nachmanides on Exodus 25:1 in Chavel, *Perushe ha-torah*, 1:453. The Hebrew word *nistar* connotes hiddenness and might also be translated as "occult."

42. Eizenbach et al., *Supercommentaries and Summaries*, 233–34. Medieval astro-magical talismanic views of the Tabernacle/Temple implements are discussed in Schwartz, *Studies on Astral Magic*, 18–19, 106–13. On images of the implements on carpet pages of illuminated Spanish bibles from this period, see Kogman-Appel, "Messianic Sanctuary in Late Fifteenth-Century Sepharad"; and Frojmovic, "Messianic Politics in Re-Christianized Spain." On the term

ziyyur, see Lelli, "Osservazioni sull'uso del termine *siyyur*."

43. Chavel, *Kitvei Rabbeinu Moshe ben Naḥman*, 2:296. See also Halbertal, *Concealment and Revelation*, 91; Halbertal, *Nahmanides*, 126, 302; and Wolfson, "By Way of Truth," 146–47.

44. See R. Shem Tov ibn Gaon and R. Isaac on Nachmanides's discussion of Exodus 25:30, in which Nachmanides characterizes the secret of the menorah as "particularly obscure" (neʿelamah meod). Both insist that the secret remains restricted to oral transmission. See Eizenbach et al., *Supercommentaries and Summaries*, 237; and Chavel, *Perushe ha-torah*, 1:463.

45. Ibn Shuaib is most forthcoming. See Eizenbach et al., *Supercommentaries and Summaries*, 237–38. The passages under discussion here display a mixture of kabbalistic and astro-magical interpretations, on which see Schwartz, *Studies on Astral Magic*, 77–84. See also the pertinent considerations in Wolfson, "Sacred Space and Mental Iconography," esp. 600n18.

46. Idel, "*Binah*, the Eighth *Sefirah*." Examples of early images of the Temple implements juxtaposed with the sefirotic tree are found, e.g., in the front matter of a fifteenth-century Sephardi manuscript of Gikatilla's *Shaʿarei orah* (Paris, BnF, MS hébr. 819, front matter) and in a fourteenth-century Ashkenazi miscellany (Moscow, RSL, MS Guenzburg 82, fols. 100b–101a). See figs. 11 and 12.

47. See Nachmanides on Exodus 26:17 in Chavel, *Perushe ha-torah*, 1:468. See also Pedaya, "*Ẓiyyur* and *Temunah*."

48. Eizenbach et al., *Supercommentaries and Summaries*, 238.

49. ʿAmidah (standing) was a term for existence in medieval philosophical Hebrew that was also used in astronomical treatises in the sense of "position," as in the position of the planets. See Chajes, "Spheres, Sefirot," 239.

50. Goldreich, "*Sefer meirat ʿeinayim*," 118–20; and Eizenbach et al., *Supercommentaries and Summaries*, 239–43. London, BL, MS Or. 12260, fols. 38b–40b.

51. Beker, *Maʿarekhet ha-elohut*, 101.

52. Abrams, *Sefer ha-bahir*, §122, at 204–5, but Abrams's transcription of the term is faulty.

53. See the classic treatment of Foucault in *Order of Things*, 17–50.

54. Goldreich, "*Sefer meirat ʿeinayim*," 119; and Fishbane, *As Light Before Dawn*, 240n168.

55. Goldreich, "*Sefer meirat ʿeinayim*," 120.

56. Maimonides, *Mishneh torah* (Repetition of the Torah), Laws of Prayer 5:11; cf. *Shulḥan ʿarukh*, *Oraḥ ḥayyim* §123:1. See Wolfson, "Sacred Space and Mental Iconography," 601–2 and note 23.

57. Goldreich, "*Sefer meirat ʿeinayim*," 121; and Fishbane, *As Light Before Dawn*, 241. Fishbane does not consider the issue of perspective.

58. Pines, *Guide of the Perplexed*, 26–27 (I:3). The quotation is from Rudavsky, *Jewish Philosophy in the Middle Ages*, 79.

59. See Nachmanides on Exodus 25:1 in Chavel, *Perushe ha-torah*, 1:454.

60. See, e.g., in the kabbalistic commentary on *Sefer yeẓirah* in Sendor, "Emergence of Provencal Kabbalah," 2:4–5. Its attribution to Isaac the Blind of Provence (ca. 1165–ca. 1235) is contested in Bar-Asher, "Illusion Versus Reality in the Study of Early Kabbalah."

61. Goldreich, "*Sefer meirat ʿeinayim*," 212.

62. See Morlok, *Rabbi Joseph Gikatilla's Hermeneutics*.

63. Saverio Campanini suggested the plausibility of the Paulus Riccius identification in Campanini, "Aperçu sur la représentation," 52–54.

64. This image is found in a rare manuscript that contains texts of Porphyry, Aristotle, and Boethius. Verboon, "Lines of Thought," 67–70.

65. Gikatilla, *Shaʿarei orah*, 63a (on the *vav*), 63b (on the trunk of the tree).

66. Ibid., 63b. On the valence of the term *figure*, see Auerbach, "Figura."

67. On Delacrut, who also wrote a Hebrew commentary on Sacrobosco's astronomy, see Stillman, "Printed Primer of Kabbalistic Knowledge," 7–14. See also Fishman, "Rabbi Moshe Isserles," 575–76; and Scholem, *Sabbatai Ṣevi*, 77.

68. *Daʿat*—the liminal eleventh sefirah—is not typically represented in kabbalistic trees, although we will see exceptions to this rule below. Whether or not shown, it is typically positioned between *Keter* and *Tiferet* on the central line, triangulated below *Ḥokhmah* and *Binah*.

69. Gikatilla, *Shaʿarei orah*, end of Delacrut's introduction, before 1a. See also his general remarks on

the ideal curriculum for those embarking on a study of Kabbalah.

70. Ibid., 63b.

71. This passage is also found near the end of Delacrut's introduction, before 1a. For the passage—including his diagram—in an Italian manuscript of the commentary dated ca. 1600, see Oxford, BL, MS Opp. 599, fol. 2b.

72. Beker, *Maʿarekhet ha-elohut*. See L. Chajes, "On the Discourse of Unity"; Gottlieb, "Kabbalah in the Writings"; and Elqayam, "On the Architectonic Structure."

73. Beker, *Maʿarekhet ha-elohut*, 94–100.

74. *Maʿarekhet* is also used in medieval Hebrew astronomical texts to mean constellation. Chajes, "Spheres, Sefirot," 239–40.

75. The array is reproduced consistently in early manuscripts. See, e.g., Warsaw, Jewish Historical Institute, MS 155, fol. 41b. By the fifteenth century, the influence of ilan parchments is evident, with the sefirot shown as medallions and the top half of *Keter* blackened. See, e.g., Paris, BnF, MS hébr. 825, by an Italian scribe.

76. Beker, *Maʿarekhet ha-elohut*, 101–3.

77. Ibid., 109.

78. Idel, *Kabbalah in Italy*, 213–14.

79. Ibid., 212–26. See also Huss, *Like the Radiance of the Sky*, 107.

80. Ḥayyat denoted triangulations with the names of particular paratextual symbols used in the cantillation and vocalization of the Torah: here, a *segolta* above two *segol*s. Their shapes may be compared, respectively, to the Greek letter *delta* and its inverted harplike shape, the *nabla*.

81. Beker, *Maʿarekhet ha-elohut*, 98. The zoharic translation is from Matt, *The Zohar*, 8:264.

82. For Ḥayyat's discussion, see Beker, *Maʿarekhet ha-elohut*, 103–4.

83. The zoharic passage is from Matt, *The Zohar*, 1:163–65; for additional references, see esp. 164n452.

84. See b*Yoma* 53b for the talmudic inspiration of this solution.

85. Beker, *Maʿarekhet ha-elohut*, 103.

86. Paris, BnF, MS hébr. 857, fol. 9r, an Italian manuscript dated 1526. See also Greenup, *Iggereth Hamudoth*, 29. Greenup's edition preserves the telling misreading of *yeriʿah* as *yediʿah* (knowledge). See also Lelli, *Eliyyah Hayim ben Binyamin of Genazzano*; and Idel, *Kabbalah in Italy*, 173–76.

87. See Elqayam, "Issues in the Commentary."

88. See Scholem, "Commentaries on the Ten *Sefirot*," §28, at 502, and §52, at 504. In Scholem's notes on Ṣarfati, he described the "Commentary on the *Great Parchment*" as "one of the most widely distributed kabbalistic books in Italy in the fifteenth and sixteenth centuries that was copied many times." Jerusalem, NLI, Scholem Archive ARC. 1599. See also Busi, *Great Parchment*, 21–27; and Dan, "Great Parchment." The attributions to Ṣarfati were made by Gottlieb in "Regarding the Identity of the Author," 360, 365–68.

89. For a late fourteenth-century usage (albeit in a mid-fifteenth-century Italian copy in an Ashkenazi hand), see Jurgan and Campanini, *Gate of Heaven*, 1:12n2.

90. Munich, BSB, Cod.hebr. 58, 386a.

91. Cordovero, *Pardes rimonim*, 34c. On Cordovero's review of the arrays, see Chajes, "Spheres, Sefirot."

92. Menaḥem Azariah da Fano, *Pelaḥ ha-rimon*, 26b. See Dweck, *Scandal of Kabbalah*, 146–47; Avivi, "Kabbalistic Writings of R. Menaḥem Azariah"; Bonfil, "Halakhah, Kabbalah and Society"; Lev El, "Organization, Clarification, and Reception of Kabbalistic Knowledge"; and Lev El, "On the Editions."

93. Here again we find *yeriʿah* misread as *yediʿah*, indicating that the former term was no longer understood. This misreading is found in manuscripts including Mantua, Jewish Community of Mantua, MS ebr. 127, 54a, as well as in the Korets 1786 printed edition (16b).

94. Drucker, *Graphesis*, 107–11. On volvelles in classical Kabbalah and more broadly, see Chajes, "Kabbalistic Tree as Material Text"; and Crupi, "Volvelles of Knowledge."

95. Cordovero, *Pardes rimonim*, 42d–43a.

96. Menaḥem Azariah da Fano, *Pelaḥ ha-rimon*, 29b.

97. New York, JTS, MS 1990, fols. 102b–111b; its parallel is found in New York, JTS, MS 2030, fols. 9a–18a. A manual without this introduction is in Oxford, Christ Church, MS 188, fols. 218a–222b. A study and critical edition of this fascinating text is in preparation.

98. Deleuze and Guattari, *Thousand Plateaus*, 3–25.

99. Here I invoke D. F. McKenzie, spelling *effect* with an *e* (meaning *to produce* rather than *to influence*). McKenzie, *Bibliography and the Sociology of Texts*, 10–18.

100. The classic work is Yates, *Art of Memory*; and see also Bolzoni, *Gallery of Memory*.

101. For a fascinating study treating the creative manipulation of mnemonic images, see Carruthers, "Moving Images in the Mind's Eye."

102. Vital, *Sha'ar ha-hakdamot* (Gate of introductions), 4a. Vital did not have the Zohar in mind, as he considered it a classical rabbinic text.

103. Stallybrass, "Books and Scrolls," 46.

104. Beit-Arié, *Hebrew Codicology*.

105. Olszowy-Schlanger, "Cheap Books in Medieval Egypt." See also Bohak, "Magical Rotuli." One *heikhalot* manuscript written on a rotulus has been discovered in the Cairo Genizah; see Bohak, "Dangerous Books," 322.

106. See Worm, *Geschichte und Weltordnung*; and Worm, "*Arbor autem humanum genus significat*."

107. On terminology, see T. Kelly, *Role of the Scroll*, 7–8. The Hebrew term *megillah* refers to both vertical and horizontal (sc)rolls. "Scroll" is a Middle English derivation from "roll" (*scrowle* from *rowle*) or "rotulus."

108. Jews in Italy and the Land of Israel produced rotuli pilgrimage maps known as *yihusei avot* (lineages of the patriarchs). See Sarfati, *Florence Scroll*.

109. Herva, "Maps and Magic," 336.

110. Ibid.; and Melion, "*Ad ductum itineris*."

111. The parchments of the Italian priest Opicinus de Canistris (1296–ca. 1351), fashioned in the 1330s, make for an interesting comparison. See Harding, "Opening to God"; and Whittington, *Body-Worlds*.

Chapter 2

1. On "Commentaries on the Ten Sefirot" as "one-volume libraries" that circulated among scholars "who would add and subtract texts in the process of copying them," see De Molière, "Studies in the Christian Hebraist Library," 110.

2. Beker, *Ma'arekhet ha-elohut*, 53–82. Elqayam, "On the Architectonic Structure," 22–29, takes a semiotic rather than historical approach to this section, which he regards as a "symbol dictionary."

3. On the Torah as divine names, see Idel, *Absorbing Perfections*, 321–24.

4. Beker, *Ma'arekhet ha-elohut*, 65–66.

5. The odd name of this work stems from Judah Ḥayyat's reference to it as such, i.e., the "other" commentary, in his *Minḥat Yehudah* commentary on the *Ma'arekhet*.

6. Parallels between *Perush zulati* and the "Commentary on the *Small Parchment*" are adduced in Gottlieb, "Regarding the Identity," 365–69.

7. A copy in a fourteenth-century Italian kabbalistic miscellany dominated by the *Ma'arekhet ha-elohut*—Warsaw, Jewish Historical Institute, MS 155 (now lost)—appears to be the oldest copy based on this template. Notably, the ilan directly follows the *Ma'arekhet* and concludes the codex. Other codices include Moscow, RSL, MS 302, and Munich, BSB, Cod.hebr. 448.

8. The bibliographical complexities of this circulation are formidable. See Jurgan and Campanini, *Gate of Heaven*, 1:11–17; 2:3*–12* for a survey of the manuscripts noting which ones contain diagrammatic elements.

9. Modest classical ilanot remained useful to students acquiring the rudiments of the Kabbalah. See, e.g., Tel Aviv, GFCT, MS 083.011.002 (fig. 1); Jerusalem, IM, MS 171/165b; and Vatican City, BAV, MS Borg.ebr. 21.

10. London, BL, MS Or. 9045, fols. 1a–42b.

11. Munich, BSB, Cod.hebr. 119, fols. 25b–26a. This manuscript, dated 1404, contains the notes of Egidio da Viterbo and Johann Albrecht Widmanstetter. See De Molière, "Studies in the Christian Hebraist Library," 395–96.

12. A similar diagram is found in Parma, BP, Cod. Parm. 2601, fol. 13b.

13. The composition in codex format appears in Scholem, "Commentaries on the Ten *Sefirot*," §76, at 506, and §115, at 510. Idel ascribed the commentary to Gikatilla in "World of the Angels," 39n145. See Farber-Ginat and Abrams, *R. Joseph Gikatilla's Commentary*, 16n23.

14. The seven divine names that are forbidden to erase are identified in b*Shavuot* 35b. See *Shulḥan 'arukh, Yoreh de'ah* 276:9. For their kabbalistic codification, see Cordovero, *Pardes rimonim*, 108c–117b (Gate 20).

15. The option to copy an ilan over a page—or preferably two—at the end of a codex was perhaps less elegant but compelling for its better preservation of the telos of the artifact. See above, on Munich, BSB, Cod.hebr. 119, fols. 24b–25a (fig. 25).

16. I thank Dr. Evelien Chayes for bringing this important uncatalogued ilan to my attention. An ilan with a version of this text (Jerusalem, IM, MS B87.0579b

171/165b) was copied in nineteenth-century western North Africa (Morocco or Algeria). My thanks to Rabbi Gabriel Hagaï for his paleographical assessment of the latter.

17. *Ein Sof* is not inscribed atop the Vatican ilan for the same reason.

18. The schema as well as the principal sefirotic names and appellations are found in the copies of *Sefer ha-peliyah* made by Ḥayyim Gatigno in Rome in 1548 and 1555. See Paris, BnF, MS hébr. 794, 95a; and Munich, BSB, Cod.hebr. 96, fol. 172b. These copies are discussed in De Molière, "Studies in the Christian Hebraist Library," 114–19. A manuscript copied in Safed in 1554 by a Spanish scribe presents this schema on a full codex page with richer inscriptions. See Jerusalem, NLI, MS Heb. 28°613, fol. 122b.

19. Esmeijer, *Divina Quaternitas*, 38–39, 151n58; and Obrist, "Wind Diagrams and Medieval Cosmology," 64–65. Note that the "Ilan ha-ḥokhmah," though lacking theosophical sefirotic names, is amenable to a similar reading.

20. *Ein Sof* is typically inscribed on the parchment "background" atop Lurianic rotuli, not encircled as in classical ilanot.

21. See Copenhaver, *Magic and the Dignity of Man*.

22. For a summary and bibliography, see Ruderman, "Italian Renaissance and Jewish Thought."

23. Compare, e.g., the approach of Barzilay in *Yoseph Shlomo Delmedigo* with that of Idel in "Magical and Neoplatonic Interpretations." See also Idel, *Kabbalah in Italy*.

24. Chajes, "Kabbalistic Trees (*Ilanot*) in Italy."

25. On the Judaica library of Egidio, see Abate, "Filologia e Qabbalah."

26. Busi, Bondoni, and Campanini, *Great Parchment*, is an edition of the text translated into Latin in the fifteenth century by Flavius Mithridates (1450–1489) for Giovanni Pico della Mirandola (1463–1494). No surviving ilan was thought to have preserved the text in its original setting until I observed it in Oxford, Bodleian Library, MS Hunt. Add. E.

27. See Sed-Rajna, "Un diagramme kabbalistique"; Grafton and Weinberg, "*I Have Always Loved the Holy Tongue*," 83–85; and Wilkinson, *Orientalism, Aramaic and Kabbalah*, 47n63.

28. Idel, "*Prisca Theologia* in Marsilio Ficino"; and Ruderman, "Italian Renaissance and Jewish Thought," 397–404.

29. See Grafton and Weinberg, "*I Have Always Loved the Holy Tongue*," 85, and the bibliography in 85n78. Thanks to Dr. Cis van Heertum and Dr. Carlos Gilly for their invaluable assistance in locating this exceedingly rare engraving.

30. The self-reference found on the *Virga Aurea* clears up the uncertainty noted in ibid., 84n69.

31. In the Bible, the four four-headed *kruvim* (cherubs, angelic beasts) guard the liminal zone between creation and creator. Cherubs guard the gates of Eden (Gen. 3:24) and their images adorn the tent tapestries of the Tabernacle and the Ark of the Covenant.

32. See Ruderman, "Mental Image of Two Cherubim," 293–95; and Lawee, "Graven Images, Astromagical Cherubs," 766–67. Images of cherubs are not found in early ilanot, despite having been bundled together in Nachmanides's commentary. On early kabbalistic notions of cherubs, see Abrams, "Special Angelic Figures."

33. By Hepburn's time, the heart symbol was well established. See Kemp, "The Heart." Among Hepburn's many possible sources of inspiration, the colorful alchemical "Ripley" scrolls come to mind. See T. Kelly, *Role of the Scroll*, 63–67.

34. The insertion of the Hebrew letter *shin* made the Tetragrammaton into something like "Yeshuah." This innovation of Johannes Reuchlin (1455–1522) appeared in his 1494 work of Christian Kabbalah, *De Verbo Mirifico*. This "Pentagrammaton" remained a favorite of Christian kabbalists and may be seen in the diagrams of Athanasius Kircher. See Stolzenberg, "Four Trees, Some Amulets," 150–58.

35. Giuliano de' Medici had one in Palazzo Strozzi; more modest throne chairs resembling the one pictured in the ilan could be found in synagogues. A "synagogue throne" from Siena in the Berlin Kunstgewerbemuseum did not survive the Second World War. For an image, see Bode, *Die italienischen Hausmöbel*, 19.

36. For a cube represented in two dimensions using the same technique, see, e.g., Gerbert of Aurillac, *Geometria* (ca. 980), e.g., Oxford, BL, MS Selden sup. 25, fol. 119v (an English manuscript probably made in Canterbury ca. 1200). For a diagram of the Chariot using a similar technique to convey three-dimensionality, see *Sefer ha-temunah*, 35b.

37. On Molcho, see Benmelech, *Shlomo Molcho*; Sonne, "I dati biografici"; Busi, *Qabbalah visiva*, 385–86; and Lelli, "Albero sefirotico." A scientific edition of

this ilan may be found on the "Maps of God" platform, www.ilanot.org.

38. Versions of the commentary are found in London, BL, MS Or. 9045, 1a–42b (fig. 23), as well as in Cambridge, University Library, Add. MS 651, 2, fols. 1a–45a. Scholem noted its presence in the *Grand Venetian Parchment* and erroneously presumed it to be Ḥalfan's original composition. Scholem, "Commentaries on the Ten *Sefirot*," §10, at 100; and Lelli, "Albero sefirotico," 272n5.

39. For a recent summary of scholarship on the Special Cherub, see Ben-Shachar, "Ms. Stadtbibliothek Nürnberg," esp. 95n145.

40. For a summary of scholarship, see Sweeney, "Dimensions of the Shekhinah."

41. Hepburn's copy of the *Great Parchment* pictures the Garden as two trees in an arched architectural frame, the serpent coiled around the Tree of Knowledge of Good and Evil. The original *Great Parchment* likely included a representation of the Garden that was enhanced by Hepburn and the makers of the Venetian ilan.

42. *Pirkei de-rabbi Eliezer*, 13. Prof. Marc Michael Epstein identified the creature pictured on the ilan as a "hybrid wingless unicorn wyvern"; Elchanan Baumgarten thought it more likely that the image depicts a Cerberus. Personal communications, October 2020.

43. Although we do not know who executed the illuminations, Lelli ("Albero sefirotico," 283–84) suggested that the iconography recalls the illuminated bibles of the Franco-Catalan area.

44. Ḥalfan and Ṣarfati's representation of a higher tree atop a lower one may have been inspired by an influential kabbalistic tradition going back to the early thirteenth century, according to which they were both literally at "the center" of the Garden of Eden. See Vajda and Gottlieb, *Sefer meshiv devarim*, §26, at 52. No text on the ilan confirms this hypothesis, however.

45. The classic study remains O'Reilly, *Studies in the Iconography*.

46. These were transcribed and published by Sonne, "I dati biografici," 202–4. For an Italian translation of Ḥalfan's testimony, see Lelli, "Albero sefirotico," 273–74. Sonne's approach led to an unwarranted emphasis on Molcho and messianism in subsequent scholarship.

47. On the signification of *du parzufin*, see Idel, *Kabbalah and Eros*, 73–77; his discussion includes pertinent reflections on kabbalistic visualization.

48. The edition may be viewed on www.ilanot.org.

49. See Rebecca Lawton, "A Useless Letter," on the British Library's *Medieval Manuscripts Blog*, https://blogs.bl.uk/digitisedmanuscripts/2018/12/a-useless-letter.html. See also Carey, "What Is the Folded Almanac?"

50. See, e.g., the Jerusalem, NLI catalogue titles for Parma, BP, Cod. Parm. 2486, and Munich, BSB, Cod. hebr. 58. The persistent error was noted in Busi, Bondoni, and Campanini, *Great Parchment*, 22n5.

51. See Hayman, *Sefer Yeṣira*, §1 and his discussion of the various readings, 59–64.

52. Jurgan and Campanini, *Gate of Heaven*, 2:273–74. A student of Ṣarfati's may have authored this text; see 1:11–17.

53. Hebrew text in ibid., 2:32*, my translation.

54. The presence of an ilan parchment before the commentator is evident in the opening passage: "The top of the ilan [some manuscripts read "*yeri'ah*" here] is one circle. One half is black. Within the other half, which is white, is written *Ein Sof*." Hebrew in ibid., 2:30*, my translation.

55. See, e.g., Idel, "Magical and Neoplatonic Interpretations"; Ogren, *Beginning of the World in Renaissance Jewish Thought*. These translations had been read and quoted by earlier kabbalists as well, most notably by Abraham Abulafia and Joseph Gikatilla. Regarding Gikatilla, see Morlok, *Rabbi Joseph Gikatilla's Hermeneutics*, 156–60.

56. Fidora, Hames, and Schwartz, *Latin-into-Hebrew*, 306–7. See also Campanini, "*Receptum est in recipiente per modum recipientis*."

57. The parchment does not have an official title, though it does refer to itself as a *yeri'ah*; here again, I have taken the liberty of giving it a name.

58. Little has been written beyond the catalogue entry in Margoliouth, *Catalogue of the Hebrew and Samaritan Manuscripts*, no. 829, at 129–30; the lines in Busi's monograph (*Qabbalah visiva*, 387–88); and my own modest summaries. See Chajes, "Kabbalistic Trees (*Ilanot*) in Italy," 180–83. The present discussion supersedes my treatment in Chajes, "Kabbalistic Tree," 463–68.

59. Dr. Emma Abate inspected the extant copies of the *Magnificent Parchment* at my request and graciously provided paleographic assessments. The earliest extant witness appears to be Cincinnati, HUC, Scrolls 65.1. Vatican

City, BAV, MS Vat.ebr. 598 may have been copied as late as the eighteenth century, according to Richler, *Hebrew Manuscripts in the Vatican Library*, 493.

60. Alberti's "avowed architectural aim," according to Joan Kelly, was "to schematize in the spatial form of the church the immanent, harmonious order of the world." See her *Leon Battista Alberti*, 135.

61. Handwritten note in the Scholem archives, Jerusalem, NLI, file 92.4.

62. See "*Special Focus | Be as Rabbi Akiva*," below. A recently discovered witness (private collection, Tel Aviv and London) does not include representations of rabbis in its illustrations. New York, JTS, K105—a fragment of the upper section of the ilan—replaces the "eye" *Ein Sof* with a crown atop *Keter*. "*Ein Sof*" is inscribed in relief just above it.

63. See Baumgarten and Safrai, "'Wedding Canopy Is Constituted by the Being of These Sefirot'"; and Idel, "Wedding Canopies for the Divine Couple." See also the text published in Abrams, "Commentary to the Ten Sefirot."

64. Five witnesses of the *Booklet* are extant, including Vatican City, BAV, MS Vat.ebr.441, fols. 110r–117v, an Italian manuscript dated to the early sixteenth century. This is the basis of the critical edition in Chajes and Baumgarten, "Visual Kabbalah in the Italian Renaissance."

65. These examples are drawn from the openings to §3, §11, and §12 in the Chajes and Baumgarten edition. Ibid.

66. By the term *luxury manuscript* I mean one with illuminations and/or other indicators that it was prepared—on commission—at considerable expense. Unlike the Ḥalfan-Ṣarfati ilan, which was likely illuminated by an unknown artist, each copy of the *Magnificent Parchment* appears to have been executed by a single scribal artist.

67. Goldberg, *Jews and Magic in Medici Florence*, 120–21.

68. See Foucault, *Order of Things*, 17–50.

69. Darshan's copy—the only with a colophon—is preserved as London, BL, MS Or. 6465. Confusion with regard to the parchment reigns in Elbaum, "Rabbi David Darshan," 282n4; and Darshan, *Shir haMa'alot l'David*, 14–15.

70. Darshan, *Shir haMa'alot l'David*, 18. Darshan also wrote an essay on amulets, noted by Perelmuter in his introductory chapter (ibid.). On Darshan's library, see Bar-Levav, "What Could be Done with Four Hundred Books?"

71. On this circle, see Idel, *Kabbalah in Italy*, 194–226.

72. Fidora, Hames, and Schwartz, *Latin-into-Hebrew*, 307. Abulafia quoted from *Liber de causis* extensively; his incorporations were known to such figures as Alemanno and Pico. See Ogren, *Beginning of the World in Renaissance Jewish Thought*, 31–33; and Campanini, "*Receptum est in recipiente per modum recipientis*," 456–63.

73. See Ogren, *Beginning of the World in Renaissance Jewish Thought*, 177.

74. These arches are referred to as *gesharim* (bridges). The *Shem 'ayin bet* is formed by combining the three verses from Exodus 14 that contain seventy-two letters to form seventy-two triads. References and an early passage that spells out the name in full are in Matt, *The Zohar* 4:258–262.

75. A study of Abulafian diagrams, used for letter meditation rather than cosmological representation, remains a desideratum. For now, see Michelini Tocci, "Una tecnica recitativa"; and Busi, *Qabbalah visiva*, 141–55. On Abulafian Maimonideanism, see Afterman, "*And They Shall Be One Flesh*," 151–70.

76. The asterisms are also featured on the cosmograph of the legendary *Catalan Atlas* executed by Elisha Cresques of Majorca in 1375. See Sansó and Casanovas, "Cosmografía, astrología y calendario"; and Kogman-Appel, *Catalan Maps and Jewish Books*.

77. See Sela, *Abraham ibn Ezra's Introductions to Astrology*. Ibn Ezra discussed the asterisms in a number of works. In *Kli neḥoshet* (Brass vessel), he drew them alongside their Arabic names, with Hebrew translations. See, e.g., Mantua, Jewish Community of Mantua, MS 10, fols. 45r–v; this Spanish manuscript of the fifteenth century likely made its way to Italy with the exiles.

78. In their divinatory context, the configurations were formed by calculating the number of lines drawn between points; sixteen four-line figures could be generated. These were linked with the twelve signs of the zodiac to create an integrated divinatory system. Of the twenty-eight lunar mansions, only sixteen were put to geomantic use.

79. See Skinner, *Terrestrial Astrology*.

80. See Kogman-Appel, "Role of Hebrew Letters."

81. Thanks to Eliezer Baumgarten and Uri Safrai for providing the initial inspiration for this section.

82. The work was partially published in Idel, "Commentary on the Entering of the Orchard."

83. The phrase "use of the crown" goes back to Hillel's dictum in m*Avot* 1:13 (referred to there by the Aramaic *taga*), where it meant the Torah, deployed inappropriately. The sense here is in keeping with that of *Heikhalot zutarti*. Schäfer, *Hidden and Manifest God*, 71; and Scholem, *Jewish Gnosticism, Merkabah Mysticism*, 54, 80.

84. This is in keeping with his role as described in the *heikhalot* macroform 574 of *Ma'aseh merkavah*. This detail is not, however, in *Roshei prakim mi-ma'aseh merkavah*.

85. These words are in the version of the account in the Jerusalem Talmud *Ḥagigah* 9a.

86. William's identification of the matching fragments was subsequently confirmed in Abate, "Cabalistic Diagram."

87. See Liebes, "Sabbetai Zevi's Religious Faith."

88. For a fuller discussion of this material as well as extensive background bibliography, see Baumgarten, "From Kurdistan to Baghdad"; and Baumgarten, Safrai, and Chajes, "'See the Whole World in the Likeness of a Ladder.'"

89. Benayahu, "R. Samuel Barzani," 81.

90. Ibid., 83.

91. For the diagrams drawn from the rotulus, see Jerusalem, NLI, MS 6247, fols. 39b–43a. The miscellany may reflect R. Joshua's compliance with his teacher's request, although it is written in the hand of his associate, R. Joshua Sidkani.

92. See Baumgarten, "From Kurdistan to Baghdad," 85–86; and Baumgarten, Safrai, and Chajes, "'See the Whole World in the Likeness of a Ladder,'" 858–61.

93. On the adaptions in the ilan, see Baumgarten, Safrai, and Chajes, "'See the Whole World in the Likeness of a Ladder,'" 862–65. On Aldabi's work, see Schwartz, "Towards the Study of the Sources."

94. The language is originally Gikatilla's. On this notion in Kabbalah, see Idel, *Ascensions on High in Jewish Mysticism*, 187–92.

95. R. Joshua's immediate inspiration seems to have been Zohar III:154a–155a.

96. See Halperin, *Faces of the Chariot*. For kabbalistic transvaluations, see Wolfson, *Through a Speculum that Shines*.

97. On this diagram, see Busi, *Qabbalah visiva*, 89–91.

98. Arboreal diagrams need not resemble trees. See Verboon, "Einen alten Baum verpflanzt man nicht," 258.

99. R. Joshua equates *kruv* with human, following Gikatilla's commentary and b*Ḥagigah* 13b.

100. See below, "The *Ilanot* of Shandukh." For a comparison between Kurdish and Iraqi ilanot, see Baumgarten, "From Kurdistan to Baghdad," 88–92.

101. On magical uses of the sefirot, see Harari, "'Practical Kabbalah' and the Jewish Tradition," 58–60. The manuscript briefly described by Harari (Jerusalem, NLI, MS 151) does not include a graphic representation of a full ilan, but its language makes it clear that such an artifact was to be before the user.

102. The meaning of the final two italicized terms is unclear to biblical scholars. In a baraita adduced in b*Eruvin* 54a, the sages opine that, "Wherever it states *nezaḥ*, *Selah*, or *va'ed*, the matter will never cease."

103. For a more thorough treatment of Wanneh and his sources, see Baumgarten, "Kabbalistic *Ilan* of Yitzhaq Wannah."

104. Wannah, *Rekhev Elohim*, 4–5.

105. For more on the term *luah*, see below, chapter 4, note 158.

106. Wannah, *Rekhev Elohim*, 9.

107. Ibid., 84.

108. In the first printed edition it may be found on 53a. See also above.

109. I have in mind primarily passages such as 2 Samuel 22:11: "He mounted the cherubim and flew; he soared on the wings of the wind."

110. He drew inspiration from *Midrash konen*, a work published as part of the book *Arzei Levanon* (Venice, 1601), 5a. This image is missing from the copy in the Gross Collection.

111. Wanneh, *Rekhev Elohim*, 5.

112. This may be compared to the fifteenth-century Italian introduction to the Kabbalah discussed above that concludes with directions for drafting a complex ilan. Unlike Wanneh's richly diagrammed codex, the two extant manuscript copies of this earlier Italian treatise are entirely without illustration. See above, chapter 1.

113. The copy of *Rekhev Elohim* in the Gross Collection is incomplete and bound out of order. Where the Gross witness is faulty, I rely on Jerusalem, NLI, MS 2126.

114. He would also have seen them in *Kol bokhim* (Voice of the weepers), a kabbalistic commentary on Lamentations written by Cordovero's disciple R. Abraham Galante.

115. The descriptions of the levels is taken from Zohar I:38a–45b. Wanneh here uses the zoharic material, rather than the very different descriptions found in Cordovero's *Pardes rimonim*, because he received the *Pardes* only after completing the composition of this work.

Chapter 3

1. For an intellectual biography of Luria, see Fine, *Physician of the Soul*. For a recent, reliable, and concise overview of sixteenth-century Safed Kabbalah, see Garb, *History of Kabbalah*, 30–66. See also Necker, *Einführung in die lurianische Kabbala*.

2. The two sections of the *Idrot* are Zohar III:127b–145a (*Idra rabba*) and Zohar III:287b–296d (*Idra zuta*). On the former, see Matt, "Idra rabba"; Hellner-Eshed, *Seekers of the Face*; and Sobol, *Transgression of the Torah and the Rectification of God*. These sections received a diagrammatic commentary by R. David ben Judah he-Ḥasid in the early fourteenth century, *Sefer ha-gvul*, on which see Busi, *Qabbalah visiva*, 197–335.

3. Meroz, "Faithful Transmission Versus Innovation"; and see also Tamari, "Body Discourse of Lurianic Kabbalah." On the bibliographical thicket that resulted from Vital's extended writing and rewriting, see Avivi, *Kabbala Luriana*.

4. For more technical details, see below, "Lurianic Cosmogony: What You Need to Know."

5. I refer obliquely to the pioneering study on visual exegesis, Esmeijer, *Divina Quaternitas*.

6. In Hebrew, the name with the numerical value of 72 is: יוד הי ויו הי. I will discuss these names and their significance in the next section, on the *Ilan of Expanded Names*. See also Magid, *From Metaphysics to Midrash*, 31.

7. Tishby, *Doctrine of Evil*. See also Idel, *Primeval Evil in Kabbalah*, 261–316.

8. On this central concept, see Fine, *Physician of the Soul*, 187–258.

9. Necker, *Einführung in die lurianische Kabbala*, 54.

10. *Derekh ʿez Ḥayyim* was one of three large works of Vital's writings redacted by Meir Poppers. It is the most famous and generally referred to as *ʿEz Ḥayyim*, as I do throughout this book. The Vital autograph of *ʿEz Ḥayyim* is extant but privately owned and inaccessible. Yosef Avivi was allowed to inspect it and offered a description in *Binyan Ariel*, 26–30. See also Avivi, *Kabbala Luriana*, 61, at 1:121. In an oral communication to Dr. Menachem Kallus in 2012, Avivi reported that the autograph no longer includes the front-matter diagram.

11. See Poppers, *Or zaruʿa*, 34b: "on the drawn page [daf ha-ẓiyyur] of the Rav (Vital), written and inscribed at the beginning of *ʿEz Ḥayyim*." See also Avivi, *Kabbala Luriana*, 1:50.

12. See Hamburger, "*Haec figura demonstrat*."

13. *Zimzum* often connotes concentration, but in Lurianic teachings the primary sense is that of evacuation. For a study of the term and its long reception history, see Schulte, *Zimzum*. See also Bielik-Robson and Weiss, *Tsimtsum and Modernity*.

14. The terms *circle* and *sphere* are used interchangeably in the sources, although the latter is always intended. See Lüthy, "Centre, Circle, Circumference."

15. See Chajes, "Spheres, Sefirot."

16. See Pachter, "Circles and Straightness."

17. Vital may have been inspired by the discussion and diagram in R. Joseph ben Shalom Ashkenazi's commentary on *Sefer yeẓirah*. Scholem's marginal comment on 18a of his personal copy of the standard edition makes this claim explicitly. Barak Hoffman and Dr. Jonnie Schnytzer suggest this indebtedness in unpublished work that they kindly shared with me.

18. See the introduction and studies in Krämer and Ljungberg, *Thinking with Diagrams*.

19. See Chajes, "Imaginative Thinking."

20. Vital, *ʿEz Ḥayyim* (2011), 23. The expression recurs with some frequency in Vital's works but is hardly unique to him. Maimonides used the metaphor, a commonplace in astronomical literature, in his *Mishneh torah*, *Hilkhot yesodei ha-Torah* (Laws) [which are] the foundations of the Torah), 3:2. See Chajes, "Spheres, Sefirot," 253–60.

21. Vital's statement, "we do not deal with the *'iggulim* at all but exclusively with the *yosher*," may be found, for example, alongside the diagram of *'iggulim ve-yosher* in *Ozrot Ḥayyim*.

22. Diagrams of later kabbalists that place a tree within the circles are discussed below. See, e.g., the opening frame of Tel Aviv, GFC, MS 028.011.008 (fig. 189), and Tel Aviv, GFC, MS 028.012.024 (fig. 167).

23. *Sefer ha-ḥezyonot* is a collection of Vital's notes, recorded in the first person. Written neither as memoir nor autobiography, I prefer to refer to it with the broad term *egodocument*. See Chajes, "Accounting for the Self," 5–8.

24. Vital's usage here of *segol* is borrowed from Ḥayyat. See above, chapter 2, note 80.

25. Vital, *Sefer ha-ḥezyonot*, part 2, §45, at 73–74; my translation. See Vital and Safrin, *Jewish Mystical Autobiographies*, 103–4.

26. Ẓemaḥ's participation in R. Samuel Vital's Sabbath readings is discussed in Avivi, *Kabbala Luriana*, 1:49. My thanks to Prof. Claude B. Stuczynski and Dr. Javier Castaño for their guidance with regard to the Jewish community and conversos of Viana de Caminha. Ẓemaḥ's autobiographical introductions to two works that he composed in Jerusalem in the 1640s are our primary sources for reconstructing his life story. Ẓemaḥ, *Kol be-Ramah*; and Ẓemaḥ, *Tiferet Adam*.

27. The precise years of his migrations from Portugal to Salonica, Salonica to Safed, and Safed to Damascus are also unknown.

28. Isaia Sonne advanced a similar speculation with regard to Shlomo Molcho in Sonne, "Place of Kabbalah." See, however, Moshe Idel's carefully worded characterization, "There can be no doubt that Tzemah was well acquainted with tenets of Christianity from his former period as a converso in Portugal, and he knew much about Christian Kabbalah, but he insisted that there are impure things in those Kabbalistic treatises." Idel, "Jewish Thinkers Versus Christian Kabbalah," 57.

29. Scholem's harsh dismissal is found in his rejoinder to Sonne's essay, "On R. Jacob Ẓemaḥ," which it immediately followed. Idel concurred with Scholem's critique in "Swietlicki's *Spanish Christian Cabala*." Sonne subsequently attempted to strengthen his speculative argument by means of a broader survey of Christian missionary work based on the sanctioned study of "banned" materials, including the Talmud and Kabbalah. He also pointed to the awareness of threats from these quarters as evidenced in Ẓemaḥ's references to Christian Kabbalah and in a dream recorded by Vital. See Sonne, "Place of Kabbalah," 65–66. Idel adduces the same dream of Vital, to the same end, in "Jewish Thinkers Versus Christian Kabbalah," 62.

30. Salamanca is identified with bloodshed in a demonological teaching recorded by Vital. Roni Weinstein speculated that the unexpected invocation bespoke the central role of the university—and its converso faculty and students—in Catholic religious reforms. Weinstein, *Kabbalah and Jewish Modernity*, 157.

31. See Saraiva de Carvalho, "Fellowship of St Diogo." António Homem's trial record is preserved in the Portuguese National Archives and viewable online at https://digitarq.arquivos.pt/details?id=2315530. The trial mentions related inquisitorial investigations done in Viana. My thanks to Dr. José Carlos Vieira of the University of Coimbra for his assistance with this material.

32. See the recent review of this question with regard to Molcho in Benmelech, *Shlomo Molcho*, 127–42.

33. Ibid., 136–37, and bibliography in notes 77–81.

34. In addition to this search for his Jewish background, scholars have tended to emphasize the importance of Ẓemaḥ's Christian background when assessing his influence on the history of Kabbalah. I take a different approach to this question below, but see the suggestive comments in Idel, *Messianic Mystics*, 205–6; and Magid, *From Metaphysics to Midrash*, 262n27. See also the summary of scholarship in Weinstein, *Kabbalah and Jewish Modernity*, 142–65.

35. Ẓemaḥ's humanism was instilled by late Portuguese humanists, but his methods are characteristic of humanism in general. See, e.g., Blair, *Too Much to Know*, 117–72; and Grafton, *Inky Fingers*, 152–85. On late Portuguese humanism, see the introduction and essays collected in Berbara and Enenkel, *Portuguese Humanism*.

36. Avivi, "Writings of R. Ḥayyim Vital," 69–71. Other editors of Vital's writings, from R. Samuel Vital to R. Meir Poppers, felt no compunction about creating eclectic redactions.

37. Sonne ("On R. Jacob Ẓemaḥ," 98) characterized Ẓemaḥ's editorial practices as reminiscent of the Iberian

scientific style of the early seventeenth century and referred specifically to the popular scientific or literary compilations of the time known as *florilegia*.

38. This point, stressed by Sonne, is greatly amplified in Idel, "Differing Conceptions of Kabbalah." Apropos, Idel notes (169n159) that he became interested in *Tiferet Adam* upon hearing from Yosef Avivi that the work contained "Christian names."

39. On this term, see Hanegraaff, "Esotericism."

40. For an overview of the history of this assertion, see Melamed, *Myth of the Jewish Origins*.

41. Ẓemaḥ, *Tiferet Adam*, 1. The passage was highlighted by Sonne in "On R. Jacob Ẓemaḥ," 97, and first published in the appendix to the same article, 99.

42. Ẓemaḥ, *Tiferet Adam*, 101. That said, he continues by citing the position of R. Yom Tov ben Avraham Asevilli (the Ritva, ca. 1260–1320) on b*Bava Batra* 98b that validates the study of "the external books" (typically translated as "Jewish apocrypha," but here intended to carry a broader valence) as long as the study was irregular. The reference to these *novellae* on this difficult talmudic tractate may also be taken, *en passant*, as evidence of Ẓemaḥ's broad rabbinic erudition. Serendipitously, a copy of Ritva on b*Bava Batra* made in Salonica in 1619—coinciding with Ẓemaḥ's time there—is extant in London, Montefiore Library, MS 86 (Jerusalem, NLI, MS F 4601).

43. Because of the significant variations among the manuscripts, there is no critical edition. The scholarly consensus today seems to be that it is more a genre than a book. See Mathiesen, "Key of Solomon." On the circulation of a Spanish vernacular translation in late sixteenth-century Portugal, see Leitão, "Very Handsome Book," 56.

44. Ẓemaḥ, *Tiferet Adam*, 102 (IV:11). It is unlikely that Ẓemaḥ knew of the Hebrew versions that began to circulate in the seventeenth century, on which see Sofer, "Hebrew Manuscripts." On the zoharic roots of some of these Solomonic traditions, see Liebes, *Cult of the Dawn*. On the lost works of King Solomon as they were imagined in Spanish and Italian Jewish contexts, see also Idel, "Shlomo's Lost Books."

45. Ẓemaḥ, *Tiferet Adam*, 103. The strange Greek title is written in two vocalized Hebrew words in Ẓemaḥ's autograph (Jerusalem, Benayahu Collection, MS K109, fol. 37b). On the title page of the book, it appears as one: *Ropicapnefma*.

46. See the fifth unnumbered page of the opening dedication. On the title, see Ramalho, "Ropicapnefma."

47. Boxer, *João de Barros*, 59.

48. See, e.g., Révah, "'Antiquité et christianisme.'" Révah published a facsimile reproduction accompanied by a modernized text, introduction, and notes under the title *João de Barros: Ropica Pnefma* (Lisbon, 1983). A contemporary edition was published by Círculo de Leitores in 2019 as part of the Pioneering Works of Portuguese Culture book series. See http://id.bnportugal.gov.pt/bib/bibnacional/2031883.

49. This description of A. J. Saraiva is quoted by Boxer, *João de Barros*, 59.

50. Boxer adds that *Ropicapnefma* was also indebted to Heinrich Cornelius Agrippa's *De Incertitudine et Vanitate Scientiarum atque Artium Declamatio Invectiva* (Antwerp, 1530)—another work on Ẓemaḥ's bookshelf with an Erasmian background. For a broader contextualization of the issues raised here, see Mulsow, "Antiquarianism and Idolatry." In 1540 Barros published *Dialogo de preceitos morães cõ prática delles, em módo de iogo*, in which he presented an exposition of the virtues using an *arbor moralis* inspired by Ramon Llull. At the very least, this serves to remind us of the prominence of generative images in the intellectual culture within which Ẓemaḥ was educated. See Blanco Mourelle, "Every Knowable Thing," 128.

51. Here too his approach differs from that of Menasseh ben Israel, for example, who lavished each "small" question with comparisons drawn from his worldly erudition. Moreover, most such comparisons were devoted to pointing out parallels, "testimonies of authors who are not of our nation," as he was wont to call them. See the discussion in Chajes, *Between Worlds*, 124–26.

52. His discussion is found in the fourth section of *Tiferet Adam*, chapter 14.

53. Weinstein, *Kabbalah and Jewish Modernity*, 159.

54. Ẓemaḥ, *Tiferet Adam*, 109. Sonne thought Ẓemaḥ's interest in the nuances of *Ein Sof*–infinity expressed in the introduction to *Tiferet Adam* and echoed in this passage reflected his developed philosophical sensibilities. Here too, however, Scholem categorically rejected

Sonne's reading. See Sonne, "On R. Jacob Ẓemaḥ," 98–99; and Scholem, "Notes to Sonne's Article," 108–9.

55. See his development of this critique below.

56. Ẓemaḥ may have been speaking on the basis of his experience with the Christian Hebraists whom he encountered as a university student. For a sober assessment of the Hebrew skills of Portuguese Christian Hebraists of Molcho's generation, see Benmelech, *Shlomo Molcho*, 131.

57. The appellation "master of the prophets" (*adon ha-neviim*) was used in the popular *'Avodat ha-kodesh* (4:22), the systematic kabbalistic work completed in 1531 by Meir ibn Gabbai, in the context of his hierarchical presentation of the grades of prophecy.

58. Even though the particular topics, e.g., the soul of the proselyte, are not unique to Ẓemaḥ's presentation, his framing of them is distinctive.

59. Idel criticized the 1983 printed edition for its errors, but his own transcriptions are neither error-free nor entirely intelligible. See Idel, "Differing Conceptions of Kabbalah," 169–70nn 159, 161, 163, and 164. Although all annotations, additions, and corrections are in Ẓemaḥ's hand, the body of the text was written by his scribe, David Nachmias *ha-rofeh* (the physician). Rabbi Moshe Hillel identified the latter (personal correspondence, November 26, 2020).

60. Ẓemaḥ's translation of *umbra* (shadow) as *zelem* (image) reflects a common rabbinic etymology based on the fact that the first two of its three letters spell *zel* (shadow). See, e.g., the biblical commentary *Malbim*, by R. Meir Leibush Wisser (1809–1879), on Genesis 1:26; and Idel, "Differing Conceptions of Kabbalah," 169n161.

61. This line was crossed out in the original draft and not as part of the subsequent revision.

62. For an attempt to assess the influence of Kabbalah on Bruno's work, see DeLeón-Jones, *Giordano Bruno and the Kabbalah*; and Bolzoni, "Giulio Camillo's Memory Theatre."

63. On the arts of memory in Portuguese Jesuit education in Ẓemaḥ's time, see Hosne, "'Art of Memory' in the Jesuit Missions." On Soarez and the textbook likely studied by Ẓemaḥ in his youth, see Flynn, "*De arte rhetorica* of Cyprian Soarez."

64. For a thorough review of the mnemonic diagrams of the work featuring many reproductions, see Bruno, *Corpus Iconographicum*, 3–103.

65. See Saiber, "Ornamental Flourishes," 730 and 730n2.

66. Two charming working volvelle "machines" complement the deluxe boxed edition of Bruno, *Corpus Iconographicum*.

67. Idel ("Differing Conceptions of Kabbalah," 197–98) mistakenly read the entire passage as referring to Bruno's *De Umbris Idearum*. Gerard Mercator, the most prominent cartographer of the sixteenth century, also dealt with chronology in a 1569 work. His famous, posthumously published (1595) atlas was subtitled *Cosmographicae Meditationes de Fabrica Mundi et Fabricati Figura*. See Shalev, *Sacred Words and Worlds*. I thank Dr. Shalev for his guidance.

68. See Grant, "Celestial Orbs," 159–60. On the empyrean sphere and its fortunes in the early modern period, see Randles, *Unmaking of the Medieval Christian Cosmos*.

69. Idel regards the page citation as evidence of Ẓemaḥ having "had the book before his eyes." See Idel, "Differing Conceptions of Kabbalah," 198.

70. The discussion of Agrippa is found in Ẓemaḥ, *Tiferet Adam*, 110. Idel treats Agrippa at length in "Differing Conceptions of Kabbalah," 168–76.

71. Scholem, who only had access to the introduction of *Tiferet Adam*, was certain that the circles and charts to which Ẓemaḥ referred were those in Heinrich Khunrath's *Amphitheatrum Sapientiae Aeternae* (Hamburg, 1595). See Scholem, "Notes to Sonne's Article," 108.

72. *De Occulta Philosophia Libri Tres* (Book 1 printed Paris, 1531; Books 2 and 3 in Cologne, 1533); and *De Incertitudine et Vanitate Scientiarum atque Artium Declamatio Invectiva* (Antwerp, 1530).

73. Ẓemaḥ, *Tiferet Adam*, 110. The authors—Cocles, Tricasso, Taisnier, and Pietro Diabolos—are identified by Idel in "Differing Conceptions of Kabbalah," 170n163. I would add that the works familiar to Ẓemaḥ included Tricasso da Cerasari Mantuano, *Esposizione sopra il cocle* (Venice, 1531), and Johannes Taisnier's *Opus Mathematicum* (Cologne, 1562), a compilation in eight books on chiromancy, astrology, and physiognomy indebted to Cocles. Ẓemaḥ lauded Abraham ibn Ezra's expertise in geomancy and provided references to geomantic passages in the Zohar in *Tiferet Adam*, 102–3 (IV:11).

74. These subjects were treated in IV:11. See Ẓemaḥ, *Tiferet Adam*, 101–3.

75. Ibid., 110–11. I am unaware of his having engaged the Christological interpolations characteristic of the Christian Kabbalah with which he was familiar.

76. The "points" to which the definition referred were not mathematical but, rather, more akin to atoms or monads. This issue is also addressed in Idel, "Differing Conceptions of Kabbalah," esp. 181–82.

77. For all its legendary aura, the fundamental historicity of the episode is accepted by scholars and recounted in Avivi, *Kabbala Luriana*, 1:40–47.

78. Ẓemaḥ, *Kol be-Ramah*, 27. Like Vital, Ẓemaḥ routinely referred to Luria as "the Rav."

79. See the final asterisked note in Sonne, "On R. Jacob Ẓemaḥ," 106.

80. Vital likely consigned his writings to the genizah in Safed, where, after his departure, they were disinterred by R. Abraham Azulai and eventually brought to Ẓemaḥ in Jerusalem, in 1640. See *Kitvuni le-dorot*, 37n36; Avivi, *Kabbala Luriana* 2:600–605; and Avivi, "Writings of R. Ḥayyim Vital."

81. See Hillel, "Rashash's Meditation Prayer Books," 237n5. Ẓemaḥ's bet midrash was also a scribal workshop and should be studied in light of kabbalistic manuscript reproduction in the early modern period. See, e.g., Abate and Mottolese, "La Qabbalah in volgare"; De Molière, "Studies in the Christian Hebraist Library," 79–121; and Steimann, "Jewish Scribes and Christian Patrons."

82. With the exception of *Ozrot Ḥayyim*, Ẓemaḥ's editions were marginalized until the recent resurgence of interest.

83. Ẓemaḥ's page-specific references to his own redactions enable us to identify the precise manuscripts he was using. See, e.g., Avivi, "Writings of R. Ḥayyim Vital," 68–71.

84. Ramat Gan, Bar-Ilan University Library, Moussaieff Collection, MS 1095, fol. 1b. On this manuscript, see Avivi, *Kabbala Luriana*, 2:621–23. The diagram in *Mevo she'arim* I:2, 2 may be seen in Vital, *Mevo she'arim*, 22.

85. See Vital's discussion, invoked in Idel, "Visualization of Colors," 53.

86. Goodman, "Problem of Counterfactual Conditionals."

87. New York, COL, MS X 893 V 837, presents the diagrams on pages measuring 29 × 22 centimeters in the front matter, following Ẓemaḥ's indices. Cf. Jerusalem, Benayahu Collection, MS K 71, fols. 30b–31a.

88. Although composed some twenty years later, the lost opening foldout page of the *'Ez Ḥayyim* autograph may have featured a similar diagram.

89. Ẓemaḥ, *Kol be-Ramah*, 29.

90. According to Avivi, the older of the two is London, BL, Add. MS 26997, written in an eastern script. New York, JTS, MS 1996 is written in an Italian hand. Many of its readings are superior to those found in the older manuscript. See, e.g., Avivi, *Kabbala Luriana*, 2:594. Scholem based his transcription on London, BL, Add. MS 26997. The printed edition is based on a manuscript akin to this last witness. For the passage in question, see Ẓemaḥ, *Kol be-Ramah*, 29.

91. Author's transcription from the manuscript:

ואח״כ כתבתי בנייר א׳ גדול אילן הפרצופים מסודרים בציורים כפי הנז׳ בספרים מחולקין הפרצופים והפרקים (ב ע״א) המתלבשים מזה לזה וכל ביארו מסביב במורה מקום דף הספר שהעתקתי אותו משם.

On this passage, Scholem perceptively noted, "This, therefore, is the first model for the *ilan ha-parzufim* of his student R. Meir Cohen Poppers that was perhaps accomplished according to its plan." Scholem, "On the Biography and Literary Activity," 191n32.

92. Author's transcription from the unpublished section of the manuscript:

ואח״כ כתבתי בנייר גדול אחד האילן של הפרצופין כסדר הכתוב בספרים ובירדתי כל דבר ודבר והחמשה פרצופים צייירתי בפרקים הנחלקים מזה לזה ומפרצוף לפרצוף ומספירה לספירה וכל דבר ודבר כתוב ביארו סביב כל ענין במורה מקום שהוצאתי אותה משם.

93. While in Safed, Ẓemaḥ annotated a manuscript—Jerusalem, NLI, MS 537, noted above—that included elaborate instructions for drafting an ilan.

94. Although not my concern here, recent printed editions of *Ozrot Ḥayyim*—particularly those edited by Isaac Ẓror—testify to a long-standing diagrammatic approach to the work.

95. Warsaw, Jewish Historical Institute, MS 293. Although it is possible to consult on microfilm, the manuscript was brazenly stolen from the Institute some decades ago.

96. Formerly Warsaw, Jewish Historical Institute, MS 293, fol. 163a. I am grateful to Dr. Eliezer Baumgarten and Dr. Uri Safrai for bringing this text to my attention and for inviting me to unpack it with them in greater depth in a forthcoming article, Baumgarten, Chajes, and Safrai, "Rabbi Moses Zacuto's Tree."

97. According to Yosef Avivi, Zacuto's project to spread *Ozrot Ḥayyim* though a concerted copying effort produced more than eighty copies: thirty-eight in Italian script, thirty-two in Ashkenazi, nine in "eastern" (e.g., Iraqi) script, and four in "western" (e.g., Moroccan) script. Avivi, *Kabbala Luriana*, 2:728.

98. The first printed edition, brought to press by the *maskil* Isaac Satanow, appeared only in 1782.

99. On this subject more generally, see Norman, *After Euclid*.

100. As noted above, even though Vital's autograph *'Ez Ḥayyim* has survived, this opening diagrammatic page has been lost. Neither of two sophisticated diagrams based on Vital's originals and devoted to the same subject matter can be identified with confidence as this "drawn page" because each diverges in some significant way from Poppers's description. For a detailed analysis, see Chajes, "Kabbalistic Diagram as Epistemic Image," 260–72.

101. Poppers, *Or zaru'a*, 12b.

102. The distinctive terms are used by Poppers in his *Torah or*, 86, as noted by Kallus, "Historical Background and Methodological Considerations."

103. The passage, Poppers, *Or zaru'a*, 83, is analyzed in Hillel, "New Information on the History," 89n215. Unlike Vital, Poppers had great respect for classical kabbalists. On the hierarchy posited by many kabbalists, according to which Cordovero provided *peshat*, the simple or contextual meaning of the Zohar, and Luria its *sod* or secret meaning, see Tishby, "Confrontation Between Lurianic." Zacuto's transvaluation of Cordovero's rejected schemata is also salient here and will be treated in the co-authored article noted above, note 96.

104. See the revealing recollections of Vital about his early experiences as a student of Luria in Ẓemaḥ, *Tiferet Adam*, 27–28 (I:7).

105. See Poppers's introduction to Vital, *'Ez Ḥayyim* (1988), 2b.

106. This point is related to the one made a generation ago by Yehuda Liebes in his critique of the theological orientation of the scholarship on Lurianic kabbalah. See Liebes, "New Directions."

107. For the quintessential statement, see Scholem, *Major Trends in Jewish Mysticism*, 261. See also Scholem, *Sabbatai Ṣevi*, 22–44; Fine, *Physician of the Soul*, 124–49; and Magid, *From Metaphysics to Midrash*, 16–33. This last opens with two images: the first from Lipkin and Altshuler, *Sefer ilan ha-gadol*, §11 (equivalent to module Z14 below), and the second from Vital, *Ozrot Ḥayyim* (1907), fol. 1a, featuring the *'iggulim ve-yosher* diagram. The captions of two figures have been reversed. Magid laudably refers to the *'iggulim ve-yosher* diagram when discussing *Adam Kadmon* (23) and to the ilan when discussing the *parzufim* (26).

108. Delmedigo, *Ta'alumot ḥokhmah*, 55a–56a; and Avivi, *Kabbala Luriana*, 1:141–42.

109. The unknowable head (*reisha de-lo ityeda*, or RDL"A in its typical Lurianic abridgment) is a concept rooted in the zoharic *Idra zuta* (III:288b–289a) and greatly amplified in Lurianic discussions.

110. Delmedigo, *Ta'alumot ḥokhmah*, 56a.

Chapter 4

1. I return to Knorr below when discussing printed ilanot. For a recent summary, see Schmidt-Biggemann, *Geschichte der christlichen Kabbala*; and see also Coudert, *Impact of the Kabbalah in the Seventeenth Century*. I treated Knorr's ilanot in Chajes, "Durchlässige Grenzen." Atton and Dziklewicz, *Kabbalistic Diagrams of Rosenroth*, is riddled with errors.

2. See, however, Coudert, *Leibniz and the Kabbalah*," 44–45; and Coudert, "Kabbala Denudata," 79. I regard Knorr's conversionary statements as the requisite lip service of someone whose profound investment in Jewish learning endangered him. Knorr's position on this matter notwithstanding, it has been claimed that his work "served as a scholarly basis for the massive use of the Kabbala in missionary activity among the Jews in Germany and later in Poland." Kalik, "Christian Kabbala and Polish Jews," 493.

3. On Knorr's reluctance to take authorial credit, see Zeller, "Paratext der *Kabbala Denudata*," 143–45; and Schmidt-Biggemann, "Knorr von Rosenroths missionarische Intentionen," 195. Knorr employed two Polish Jews to work with him on *Kabbala Denudata*, and a Christian,

Johann Peter Spaeth (1644–1701), who subsequently became a Jew through conversion and distanced himself from Knorr's project. Schmidt-Biggemann, "Knorr von Rosenroths missionarische Intentionen," 193.

4. Scholem's characterization of this section (in *Kabbalah*, 241) is tellingly inaccurate. He writes that it contained a "detailed explanation of the kabbalistic 'Tree' according to the teachings of Luria, after the manner of Israel Sarug. The 'Tree' itself (which he possessed in manuscript form) he printed separately in 16 pages." See Chajes, "Kabbalistic Trees of Gershom Scholem."

5. The ilanot collected by Knorr are not in the Herzog August Bibliothek in Wolfenbüttel, although one of Knorr's manuscripts there, Cod. Guelf. 157.1 Extrav., does contain kabbalistic diagrams. Two (on fols. 43v and 51v) are reproduced (the former upside down) in Zeller, "Der Nachlaß Christian Knorr von Rosenroths," and may also be viewed online at http://diglib.hab.de. The second is based either on London, Beth Din, MS 109, dated 1593, or a manuscript very like it.

6. Ẓemaḥ's enrobings appear without Zacuto's *Arikh* in roughly twenty percent of Great Trees, including Oxford, BL, MS Opp. 128 (fig. 66), the *Tree of Circular and Linear Emanations* (fig. 167), the Shandukh ilanot (fig. 179), the *Tree of Holiness* (fig. 192), and Tel Aviv, GFCT, MS 028.012.016 (fig. 139). With the exception of the first, these are all idiosyncratic unica—artisanal ilanot, as I refer to them in this book.

7. References to the lexicon are found in the Latin to *fig. 13* in §§2 and 5, to Poppers in §17. On the lexicon, see Kilcher, "Lexikographische Konstruktion der Kabbala."

8. Poppers's edition of Vital's *'Ez Ḥayyim* is cited from manuscript; it would be over a century until its first print edition (Korets, 1782). On its publication, see Stillman, "Living Leaves."

9. See Vital, *Oẓrot Ḥayyim ha-shalem*, 128.

10. Munich, BSB, Cod.hebr. 449 (fig. 80); New York, JTS, MS S441—in an amateur cursive hand, with square-script *parzuf* names and biblical texts; Jerusalem, NLI, MS Heb. 28°4414—similar to JTS S441 but more professionally executed, using a semicursive rabbinic hand and square script for emphasis; and a parchment rotulus in Jerusalem, Benayahu Collection (fig. 76), showing Ashkenazi and Sephardi square scripts. Judging by their common textual corruptions, this ilan (or its twin) served as the basis for one of the most beautiful Great Trees, the Cambridge *Trinity Scroll* (fig. 134). Jerusalem, IM, MS HF 0778, and an uncatalogued ilan in the archives of the Jewish Museum of Vienna are incomplete, ending with *parzuf Ya'akov* and *parzuf Raḥel*. Finally, as noted, the ilan was preserved in codices of *Oẓrot Ḥayyim*.

11. The scribe's use of green ink to draw the diagrams is highly unusual; the inscriptions in Ashkenazi square script are in black. The hand resembles that found in Munich, BSB, Cod.hebr. 446 and 447, which preserves the Hebrew equivalent of Knorr's *fig. 16*.

12. Knorr occasionally refers his readers to more expansive explanations of terms and concepts in his preceding lexical apparatus. See Apparatus IV, 235–36 (§3 and §5 of *fig. 13*). Of particular interest is his choice to forgo translating §17–29 and redirect his readers to the more thorough treatment found in §5 of *fig. 6*, i.e., the Poppers ilan visualizing the same concept.

13. The bold inscription at the base of the ilan says this explicitly. The twelve are named in Vital, *Oẓrot Ḥayyim ha-shalem*, 29, among other places.

14. Ibid., 124. The appearance of this element in some ilanot brings to mind a candelabrum, although the inscriptions *in loco* make no mention of this association. Morphological interpretations of diagrams presume that schemata carry fixed meaning, but such essentialism is a recipe for projection on the part of the interpreter. See Idel, "*Binah*, the Eighth *Sefirah*," 129.

15. Vital, *Oẓrot Ḥayyim ha-shalem*, 125.

16. Zohar III:129a; see Matt, "Idra rabba," 334.

17. Vital, *Mevo she'arim*, 166, 178. See the pertinent discussion in the context of prayer in Vital, *Sha'ar ha-tefilah*, 243.

18. See Matt, "Idra rabba," 349–53; and below, "*Thirteen Enhancements of the Beard (E)*." Knorr, in this instance, rightly refers his readers to Poppers's detailed treatment presented in *fig. 6* of his fourth apparatus, along with his explanation in the accompanying Latin, §5. See *Kabbala Denudata, Partis Quarta* §17, at 1:238.

19. Knorr uses the Latin *Persona*, which is closer to the mark. See above, chapter 3, note 9.

20. Magid, *From Metaphysics to Midrash*, 24.

21. See above, chapter 1, note 5. See also Chajes, "Spheres, *Sefirot*," 243–45.

22. The notion of "original" sefirot is explained in Vital, *Oẓrot Ḥayyim ha-shalem*, 125.

23. Ibid., 84.

24. This is nowhere more evident than in the Benayahu Collection ilan (fig. 76), where the inscription is exceptionally large and written in a discordant medieval Ashkenazi square script. On the sweetening of judgments and the magical side of Lurianic Kabbalah, see Chajes, "Judgments Sweetened."

25. On the unique status of *Da'at*, the sefirah described as a "neshamah beli kli" (soul without a vessel), see Vital, *'Ez Ḥayyim*, Gate 23, Chapters 5 and 8. These discussions also explain why, in certain contexts, *Da'at* rather than *Keter* is counted as one of the axiomatic ten sefirot.

26. Magid, *From Metaphysics to Midrash*, 27.

27. In order to lessen the possibility of misunderstanding, I refer to the original single-origin ilan by this name and to the later compound ilanot that include it (or parts of it) as Great Trees.

28. I refer to "Quaestiones et considerationes paucae brevésque in Tractatum primum libri Druschim." See Knorr von Rosenroth, *Kabbala Denudata*, 1:2, 63–65. See also Coudert, "Cambridge Platonist's Kabbalist Nightmare," 650; Coudert, *Impact of the Kabbalah in the Seventeenth Century*, 127; and Schmidt-Biggemann, "Christliche Kabbala oder Philosophia Hebraeorum."

29. No keys to the translation were added to the engravings of this ilan. The sequence of the Latin does, however, demonstrate Knorr's full understanding of the sequence I outline here, which is anything but obvious.

30. See Tamari, "Body Discourse of Lurianic Kabbalah."

31. See Kemp, "Science in Culture." On the long presumption of extramission from the eyes and its influence on Jewish thought, see Chajes, "Re-envisioning the Evil Eye."

32. Three, if we include Jerusalem, NLI, MS Heb. 4°8644. This rotulus, unfortunately, is a fragment in very degraded condition, and it cannot be ruled out that it was a section of a compound ilan.

33. The basic chronology of Perlhefter's life was established in Tishby, "First Sabbatean 'Maggid,'" 86–87. The most recent treatment of Perlhefter is Riemer, *Zwischen Tradition und Häresie*; the dates here reflect Reimer's refinement of Tishby's chronology. See also Wolfson, *Venturing Beyond*, 176–83; and Carlebach, *Divided Souls*, 80–81, 204–5. Perlhefter's ilan has not previously been discussed, even in the lengthy footnote documenting his lost works in Tishby, "First Sabbatean 'Maggid,'" 296–97n43.

34. Huss, "Text and Context," 134–37; and Coudert and Corse, *Alphabet of Nature*, xxxv.

35. On Sabbatean "enthusiasm," see Goldish, *Sabbatean Prophets*; Perlhefter is mentioned in passing (165).

36. Tishby, "First Sabbatean 'Maggid,'" 87–88; and Elqayam, "Rebirth of the Messiah," 91n18.

37. Zacuto, *Sefer Igrot ha-Remez*, 42b. Zacuto obtained a copy of *Ozrot Ḥayyim* in 1649, while still in Venice—only six years after Ẓemaḥ had recovered and edited it in 1643. Avivi, *Kabbala Luriana*, 2:727.

38. So Scholem conjectured in *Kabbalah*, 276.

39. This biographical outline not only brings him into the orbit of Knorr but also to another scribal artist with some strikingly similar lines on his *curriculum vitae*, Nosen Neta Hammerschlag. Ironically, Perlhefter has been studied intensively by Jewish historians even though little of his work is extant; Hammerschlag, whose ilanot are explored in the next section, speaks to us from multiple extant autograph manuscripts, but until now no historian has taken notice.

40. Riemer attempts to read Perlhefter's later work *Beer Sheva* as crypto-Sabbatean but offers no evidence for his use of Lurianic sources. See Riemer, "Mystery of *Adam, David, Messiah*."

41. See above, chapter 3, note 105.

42. Hammerschlag's earlier ilan, Tel Aviv, GFC, MS 028.011.009 (fig. 161), is based primarily on the Poppers model. It is roughly twice the length and width of Perlhefter's copy.

43. See Leipzig, Universitätsbibliothek, MS B. H. 18, fol. 135r. Many thanks to Prof. Riemer for sharing with me his scans of these materials.

44. I doubt that he would have copied it while under Zacuto's tutelage, given the latter's known affinity for *Ozrot Ḥayyim*, which often featured Ẓemaḥ's ilan in its diagrammatic pages.

45. The frontispiece as well as *fig. 8* are signed "J. C. S. Sculp" (*Sculpes* = engraver). Sartorius worked in Nuremberg between 1679 and 1697, producing religious images as well as portraits. On the symbolism of the frontispiece etching, see Zeller, "Der Paratext der *Kabbala Denudata*."

46. The line seen clearly in *Kabbala Denudata*, fig. 2, is faded and difficult to discern on the Gross Collection parchment.

47. Vital (here Ẓemaḥ), *Kehilat Ya'akov*, 24. Cf. Vital, *'Eẓ Ḥayyim* (2011), Gate 8 (part I, 110a, at 219).

48. See Sperber, "Jerusalem: Axis Mundi"; and Alexander, "Jerusalem as the *Omphalos*." On its symbolic import in medieval Kabbalah, see Idel, "On Jerusalem as a Feminine and Sexual Hypostasis." For Lurianic invocations of this notion, see, e.g., Vital, *'Eẓ Ḥayyim*, Gate 32:5.

49. Ẓemaḥ, *Tiferet Adam*, 13.

50. Vital, *'Eẓ Ḥayyim*, Gate 16:1 and Gate 35:3. See also the treatment of Jerusalem in the *Idra rabba* (Zohar III:137b) as well as Ẓemaḥ's commentary in *Kol be-Ramah*, 296–99.

51. Yerushalmi, *Haggadah and History*, plate 59. On this Haggadah, see now A. Cohen, *Signs and Wonders*, 98–105, esp. 102–3 for the Jerusalem image.

52. See, e.g., Bland, *Artless Jew*.

53. Although the focus here on the ilan genre accounts for my emphasis on the "Poppers" head of *Adam Kadmon*, which became a ubiquitous element in the eighteenth- and nineteenth-century artifacts, it was not the first graphical-diagrammatic treatment of this notion. See esp. Busi, *Qabbalah visiva*, 197–335.

54. Were we to include mental and not only graphical visualization, there would be a great deal more material to consider. See, e.g., Wolfson, "Iconic Visualization and the Imaginal Body of God," 152; Wolfson, "Body in the Text"; and Wolfson, "Metaphor, Dream, and the Parabolic Bridging of Difference."

55. The Oxford booklet appears in the National Library of Israel catalogue under the title *Kiẓur (Abridged) Oẓrot Ḥayyim* and not under the title that appears atop the first page of both extant copies. The Mantuan witness is not in the National Library catalogue. Around the time of Zacuto's death, Azriel, laden with manuscripts, relocated to Prague, where he worked closely with the city's chief rabbi, David Oppenheim. See Avivi, *Kabbala Luriana*, 2:766–69; and Teplitsky, *Prince of the Press*, 30.

56. See Ferguson, *Engineering and the Mind's Eye*, 82.

57. See, e.g., New York, COL, MS X893 K11, fol. 28a; and Jerusalem, NLI, MS Heb. 799128, fol. 10a. For close analyses of these images, see Chajes, "Imaginative Thinking"; and Chajes, "Kabbalistic Diagram as Epistemic Image."

58. See above, chapter 2, note 14.

59. For a more detailed and cosmologically contextualized explanation, see Magid, *From Metaphysics to Midrash*, 31.

60. The passage in Latin is in the fourth apparatus, §5 of *fig. 15*.

61. The ilan, found in a kabbalistic miscellany written by an Ashkenazi scribe in the seventeenth century, follows the "Exaggerated Abridgement of Emanation." See above, "Lurianic Cosmogony: What You Need to Know." Gabriel Schussberg was a student of R. Jacob Temerles, about whom see below.

62. Scholem, "Commentaries on the Ten *Sefirot*," §21, at 501.

63. The Lurianic ilanot of the two Oxford, BL, manuscripts (Opp. 458 and 551) as well as a third, London, Beth Din, MS 109, all preserve an anomalous presentation of the sefirotic array in which the sefirot of the right and left columns have been reversed. Although Knorr used MS Opp. 458 (or its unknown twin), he has "righted" the array in accordance with the standard positions and in keeping with the second, classical ilan with which he synthesized it. All other presentations of this diagram, including Buchbinder's foldouts and the various integrations into more complex ilanot, use the conventional right–left presentation.

64. According to Avivi ("Notes on *Sefer 'Eẓ Ḥayyim*"), the text of *'Eẓ Ḥayyim* copied by Buchbinder is not identical to that of the first printed edition (Korets, 1782), and would appear to be based on an earlier draft by Poppers. Buchbinder would have had access to it through his father-in-law, R. Jospe Pozna of Altona. See Avivi, "Notes on *Sefer 'Eẓ Ḥayyim*."

65. This impression is based on the steadily growing number of manuscript copies over the early decades of the seventeenth century. See Stillman, "Living Leaves."

66. The earliest is Oxford, BL, MS Mich. 620, and the latest is Oxford, BL, MS Opp. Add. fol. 32. From most catalogue entries, one would have no idea that these were fabulously illustrated volumes. See, e.g., Neubauer, *Catalogue of the Hebrew Manuscripts*, 582, on MS Opp. Add. fol. 32. I hope to explore this unique series elsewhere in greater depth.

67. He appears in the database of the Institute of Microfilmed Hebrew Manuscripts exclusively as the scribe of this series of ʿEz Ḥayyim volumes.

68. Some of the manuscripts are in considerably worse shape than others due to changes in the composition of the ink and/or paper used. This catastrophic combination of ink and paper is associated particularly with northern and central German manuscripts of the eighteenth century. See Hooper, "Poison Pen is Eating Away Bach's Manuscripts"; and Ault, "Words Will Eat Themselves."

69. One copy is in Berlin, Staatsbibliothek–Preußischer Kulturbesitz, Ms. or. fol. 130, 2 (fig. 103). Two are in Munich: BSB, Cod.hebr. 446 and 447, the former parchment and the latter, perhaps a preparatory study, on paper. Róth, *Hebräische Handschriften*, 252–53, describes 446 as a Sephardi script and 449 as "German square hand"; the Jerusalem, NLI, online catalogue asserts that both are Ashkenazi hands. Dr. Emma Abate suggested that 446 is "a Sephardi script with hybrid elements" and that 449 is Ashkenazi. My suspicion is that the scripts in these ilanot are works of artifice, a faux-Sephardi style adopted by scribes whom I assume were Ashkenazim. See https://www.nli.org.il/he/manuscripts/NNL_ALEPH000128496/NLI#$FL47904293 and https://www.nli.org.il/he/manuscripts/NNL_ALEPH000128499/NLI#$FL50420663.

70. The Bayerische Staatsbibliothek does not have records that go back far enough to allow me to confirm or refute this hypothesis. Munich, BSB, Cod.hebr. 448 could well have served Knorr as he prepared his *Clavis Sublimioris Kabbalae* along with the second foldout ilan in Oxford, BL, MS Opp. 458. Munich, BSB, Cod.hebr. 448 was copied by Francesco Parnas around 1537 for Johann Albrecht Widmanstetter. See De Molière, "Studies in the Christian Hebraist Library," 59–61, 82–103.

71. Berlin, Staatsbibliothek–Preußischer Kulturbesitz, MS Or. fol. 130 (fig. 103). See Steinschneider, *Die Handschriften Verzeichnisse*, 6–7.

72. See Chajes, "Durchlässige Grenzen," and below.

73. See Baumgarten, "Notes on R. Naftali Bacharach's Treatment."

74. See, e.g., Bacharach, *ʿEmek ha-melekh* XVII:1 (168a) for the texts of the World of *Beriah*; XVIII:1 (178a–b) for the names of the angels; the "four kingdoms" in XIV:9 (83b); the demonology of the "shells" XIV:15 (84d–85a) and XX (179c–d). The roman numeral refers to the Gate, followed by the chapter; the Arabic numerals and letters in parentheses indicate the page and column, with a–b on the recto and c–d on the verso.

75. Chajes, "Kabbalah and the Diagrammatic Phase," 111–17.

76. *Pardes*, Gate 11 (*Shaʿar ha-zaḥzaḥot*), chapter 7. See also Idel, "*Sefirot* above the *Sefirot*," 248–49; Verman, *Books of Contemplation*; and Porat, "Founding of the Circle."

77. See Vital's statement in *ʿEz Ḥayyim*, Gate I, Branch 4. As *Maʿayan ha-ḥokhmah* was attributed to the geonim, Vital surely had it in mind as his source. In the Saruqian cosmogony of Bacharach's *ʿEmek ha-melekh*, they are assigned to the sphere of the *Tehiru* (lit. brilliance) and even represented in a wheel-like diagram (14b). This latter usage does not seem evident in our ilan, however. See the representation atop the foldout ilan printed in Sasson, *Apiryon Shlomo*, to which I will return under the rubric of "printed ilanot."

78. On trees with eleven sefirot, see above, chapter 4, note 25.

79. See, e.g., Neher, "Copernicus in the Hebraic Literature"; H. Levine, "Paradise Not Surrendered"; Zinger, *Baʿal Shem and the Doctor*; and Ruderman, *Jewish Thought and Scientific Discovery*.

80. The thirteenth-century work was published in innumerable editions; Hebrew translations were also available and included its classic images. See Buda, "At the Crossroads of Cultures."

81. Richarz, *Der Eintritt der Juden*, 223.

82. Steinschneider, *Die Handschriften Verzeichnisse*, 6–7.

83. Klatzkin, *Ozar ha-munaḥim ha-filosofiyim*, 2, pt. 1: 132, s.v. *dugma*. The term was used in this sense in the Grand Venetian Parchment.

84. Tuvia recounted the disparagements of his Frankfurt an der Oder professors in the introduction to *Maʿaseh Tuvia*.

85. On Newton's kabbalistic interests, see Goldish, *Judaism in the Theology*.

86. For a thorough review, see Meroz, "Saruk School." For a brief English summary, see Meroz, "Contrasting Opinions Among the Founders."

87. The legend of Luria spread far and wide in the Jewish world well before his Kabbalah. For the legends, and a sense of their broad circulation and reception, see Benayahu, *Toledot ha-AR"I*. See also Chajes, *Between Worlds*, 92; and Yassif, *Legend of Safed*.

88. See Meroz, "R. Israel Sarug"; and Scholem, "R. Israel Sarug."

89. Drawings of such squares may be seen in a few ilanot, such as the *Gates of Eden Ilan*, Tel Aviv, GFCT, MS 028.012.005, part 1 (fig. 198).

90. Such an opinion still has its advocates today. See, e.g., Avivi, *Kabbala Luriana*, 1:242.

91. *'Emek ha-melekh* reflects the Saruqian teachings of his *Limmudei azilut*, a work first published in 1897. Delmedigo's *Novelot ḥokhmah* is the other early printed work indebted to Saruq's teachings.

92. For a consideration of the critique of *'Emek ha-melekh* by various rabbinic contemporaries, see Liebes, "Towards a Study of the Author."

93. On the question of popularization, see Scholem, "Zehn unhistorische Sätze über Kabbala," 210; and Liebes, "Towards a Study of the Author," 109n75. On the scarcity of Lurianic texts in circulation in the seventeenth century, see Idel, "'One from a Town,'" 86–87.

94. This point is emphasized in Avivi, *Kabbala Luriana*, 2:557–64.

95. Nearly a century later, Isaiah Bassan complained to M. Ḥ. Luzzatto about the numerous translations of chapters from *'Emek ha-melekh* in Latin, referring to the *Kabbala Denudata* by Knorr von Rosenroth, "which were among the important causes of prolonging our exile" (*Iggerot Shadal*, 29). Cited in Scholem, *Kabbalah*, 394–95; cf. Theisohn, "Zur Rezeption." I am unconvinced by Theisohn's claim (235) that Knorr's lack of engagement with the Saruqian origin of the *Malbush* concept and his Latin translations of its key terms represent "crucial modifications" of the material and reflect Knorr's Christian Kabbalah agenda. See also Burmistrov, "Die hebräischen Quellen," 359–60.

96. On the *tabur* of *Adam Kadmon*, see above, chapter 3, note 100. See also Avivi, *Kabbala Luriana*, 1:248–52.

97. See Levinsohn, *Beit Yehudah*, 2:127. The work was written in 1837. My thanks to Avinoam Stillman for this invaluable reference. See now Meir, "Haskalah, Kabbalah and Mesmerism," 152.

98. Other Latin translations of the Zohar were then in circulation—specifically Andreas Norrelius's *Phosphoros Orthodoxae Fidei Veterum Cabbalistarum* (Amsterdam, 1720) and Gottfried Christoph Sommer's *Specimen Theologiae Soharicae* (Gotha, 1734)—but, unlike *Kabbala Denudata*, neither their content nor their *mise-en-page* matches Levinsohn's description. See Huss, "Translations of the Zohar."

99. The phrase is reiterated at the very end of Gate I, Chapter 61.

100. This impression is reinforced by the selections chosen by Knorr for the accompanying Latin chapter. In §4 Knorr reproduces a single complete combinatoric table (the first of twenty-two, taken from Bacharach, *'Emek ha-melekh* I:6 [4a]), with a literal translation of Bacharach's introduction to the tables at I:5 (4b).

101. *Sefer yeẓirah* is the source for the cosmogonic tradition in which the newly hewn twenty-two letters of the Hebrew alphabet combine sequentially. See Hayman, *Sefer Yeṣira*, 92–108; in traditional editions, see chapter II, mishnah 5. On the discourse of creation through letters in late antiquity, see T. Weiss, *Letters by Which Heaven and Earth Were Created*, 109–15 for discussion of *Sefer yeẓirah*.

102. Bacharach, *'Emek ha-melekh* I:60 (10c–11a); II:5 (11d).

103. See the memorable discussion in Ginzburg, "Clues," 273–80.

104. *Kabbala Denudata*, Apparatus IV, 227–28.

105. Bacharach, *'Emek ha-melekh* I:5 (4b).

106. See Dear, "Divine Illumination, Mechanical Calculators." Leibniz was captivated by the calculator and managed to invent a version with some nifty features of his own.

107. Bacharach, *'Emek ha-melekh* I:57 (10a).

108. In *'Emek ha-melekh* I:58 (10b), Bacharach writes that all letters begin as the letter *yud* (יוד), which when reversed is *dyo* (דיו), ink, and that this ink is equivalent to the black fire of the classic rabbinic metaphor describing the Torah as "black fire on white fire."

109. For a visual demonstration of these incremental transformations, see Chajes, "Durchlässige Grenzen," 134–41.

110. See Wilson, *Invisible World*.

111. Knorr refers to the study of optics and the telescope in *Kabbala Denudata* 2:8: "Suo tempore, cum

ultimata Christianismi instaret consummatio, inter exercitatiores feliciore praxi animos cum Christi traditis in ordinem pro facilitanda Animae contemplatione redigendum: Ita ut non alio opus sit studiosis istius Optices Telescopio." Under the pseudonym of Christian Peganium, Knorr also translated Giambattista della Porta's *Magia Naturalis* and thus was intimately acquainted with its contents. Among the various topics covered in the work that are relevant to the current discussion is the author's extensive consideration of optics in Book 17 of the second edition. He also translated Thomas Brown's *Pseudodoxia Epidemica*, a best-selling work of popular science of the period.

112. See Chajes, "Kabbalah and the Diagrammatic Phase"; and Chajes, "Spheres, *Sefirot*."

113. I use the term *paratexts* here to denote the two nontextual elements from Bacharach, *'Emek ha-melekh* I:60 (10c) and V:6 (14b), that Knorr adapted for his figures.

114. See above, chapter 2, note 34.

115. The diagrams of Jakob Böhme would likely have been familiar to Knorr. Rosmarie Zeller ("Böhme-Rezeption") has argued that Böhme's influence is indetectable in the works of Knorr and Van Helmont, despite the sympathy toward him in the Sulzbach environment in which they worked. It may be worth reexamining this question from the perspective of visual materials.

116. Saiber, *Giordano Bruno*, 119. See also the discussion in Selcer, "Mask of Copernicus and the Mark of the Compass."

117. Yates, *Giordano Bruno*, 324; 296 on Bruno's "mathesis."

118. Ibid., 235–56; quote at 324. Yates was a precocious critic of the treatment of diagrams by modern editors. She chastises Tocco and Vitelli for their "thin and staid" nineteenth-century replacements of Bruno's own diagrams, woodcuts produced by Bruno himself in which his geometrical figures were "enlivened with queer floral and other designs" that Yates believed bore meaning (313). Her critique and intuition were eventually explored by Arielle Saiber, though without proper acknowledgment of Yates's anticipation of her position. Saiber, "Ornamental Flourishes," 735n18.

119. Bruno, *Articuli Centum et Sexaginta*.

120. Saiber, "Ornamental Flourishes," 742. Saiber follows up (742n31) on a suggestion by Edward Gosselin and Lawrence Lerner.

121. For "detail" vs. "synoptic" Lurianic diagrams, see Chajes, "Kabbalah and the Diagrammatic Phase," 115–17.

122. Among early Lurianic kabbalists, only Lonzano displays a critical humanist methodology that may be compared with Ẓemaḥ's. Lonzano was an active critic in a broad variety of fields, including biblical Masorah and musicology. See, e.g., Seroussi, "Rabbi Menaḥem de Lonzano," 597n2.

123. Poppers would later assert that its unequivocal location in Vital's diagram made the text-based exegetical question moot. See Chajes, "Kabbalistic Diagram as Epistemic Image," 260.

124. We find some variation in early manuscripts of *Ozrot Ḥayyim* that include this more complex *'iggulim ve-yosher*. See, e.g., New York, JTS, MS 1615, fol. 4b— a seventeenth-century Italian manuscript featuring comments in the hand of R. Moses Ḥayyim Luzzatto. Another seventeenth-century Italian manuscript includes the diagram in yet another variation in its diagrammatic end matter: London, BL, Add MS 27006, fol. 226a; on the following page (227a), Z14 has been copied as well. See also the copy made in 1707 by Azriel of Krotoszyn: Oxford, BL, MS Mich. 194, fol. 10a.

125. There is some variation in this title, particularly in its second half. In addition to reversing the order of Circles and Worlds, some simply conclude, "from it were emanated all the emanations."

126. This second diagram is found on its own in Ramat Gan, Bar-Ilan University Library, Moussaieff Collection, MS 1098, an eastern manuscript of *Ozrot Ḥayyim* dated to the eighteenth century. It is used in the homily on *Adam Kadmon* as the *'iggulim ve-yosher* diagram, as was the first diagram in the earlier *Ozrot Ḥayyim* manuscripts mentioned above.

127. See above, chapter 3, around note 90.

128. Coppio copied this commentary in 1721 but could have been familiar with it earlier.

129. Referring to Genesis 36:31–43. These kings were taken as allegories for the shattered primordial sefirot. The idea is first explored in the zoharic *Idra* and then greatly elaborated in Lurianic teachings. See Fine, *Physician of the Soul*, 135–38.

130. This is the basic transpositional logic of the Worlds and *parẓufic* enrobings in a nutshell. Each of the Worlds is akin to a sefirotic tree. Interlocking, the lowest sefirah of *Adam Kadmon* (*Malkhut*) becomes the highest (*Keter*) of *Aẓilut*.

131. Ẓemaḥ, *Kol be-Ramah*, 252.

132. Ibid., 252.

133. Moscow, RSL, MS 543. See Hillel, *'Over la-sofer*, 95–97. The miscellany included treatises by Vital, Zacuto, and Lonzano.

134. Zohar II:176b–179a. For an annotated English translation, see Matt, *The Zohar* 5:543–88.

135. The illustrating diagram is in the Bodleian copy of a Buchbinder *'Ez Ḥayyim*. See above, "The *Ilan of Expanded Names*."

136. Hands were central to medieval mnemonics. See Murdoch, *Antiquity and the Middle Ages*, 84. On the divinatory encodings sketched on the hands in the esoteric teachings of medieval German Jewish pietists, see Dubrau, "Physiognomy in the Esoteric Treatises." See also Sherman, *Writing on Hands*.

137. The elder Temerles was likely the author of the first section as well.

138. A renewed appreciation for this characterization of Lurianic Kabbalah began with Liebes, "New Directions."

139. See Hamburg, State and University Library Carl von Ossietzky, MS Levy 89, fols. 114a–116a; and Oxford, BL, MS Mich. 139, fols. 197a–200b. Foldout diagrams of the *Temerles Tree* are found in Prague, Jewish Museum, MS 28 (sewn-in end matter after 58b) (sixteenth- or seventeenth-century Ashkenazi); and Warsaw, Emanuel Ringelblum Jewish Historical Institute, MS 244 (eighteenth-century Ashkenazi).

140. See e.g., Tel Aviv, GFC, MS GR.011.012; Oxford, BL, MS Mich. 586, fols. 300b–302a; and Prague, Jewish Museum, MS 69.

141. Tel Aviv, GFCT, MS 028.012.003; and Tel Aviv, GFC, MSS 028.012.009, 028.011.007, 028.011.008, and IQ.011.011. On these *ilanot*, see below.

142. Tel Aviv, GFCT, MS EE.011.021, fol. 2b. On Lurianic grave prostration, see Chajes, *Between Worlds*, 20n51.

143. Such a notion is found frequently in Bacharach, *'Emek ha-melekh*, e.g., X:12 (55b).

144. Temerles, "Twenty-Two Principles," 3a.

145. The Hebrew, *tikkunei dikna*, is often rendered as "rectifications" or "fixings," but I here follow Matt's use of "enhancements" for its sensitivity to the jewelry-like aspect of the descriptions in the sources.

146. Oxford, BL, MS Opp. 105. See Avivi, *Kabbala Luriana*, 2:641–42.

147. See Teplitsky, *Prince of the Press*.

148. Graf (Prager), *Va-yakhel Moshe*.

149. Zohar III:131a–134a (Matt, "Idra rabba," 349–53). The same notion is visualized by Knorr and Sartorius in *fig. 12* as the flowing beard of *Adam Kadmon* in profile. See above.

150. The scribe's name is not to be found in the minute-book of the London community covering the years 1663–1681. The name Montpellier indicates the Provençal origins of the family but nothing more. Bearing in mind his Ashkenazi (Italian-inflected) hand, orthography (לונדן rather than as לונדריש, Londres), and Hebrew literacy, we can presume that he was an (Italian?) Ashkenazi temporarily in London. I thank Dr. Alex Kerner, Dr. Noam Sienna, and Ton Tielen for their helpful contributions to these admittedly modest findings.

151. See above, chapter 2, note 69.

152. The number of thousands in the year (here 5,000) is generally omitted from the calculation and indicated here by "and the count," an abridgment of "by the small count."

153. See above, "Visual Kabbalah in Yemen."

154. Gikatilla's diagram was presented as a *luaḥ* in a copy of *Sha'arei orah* executed for the Vatican in 1547 by the converted Jew Fabio Ranucci of Mantua (born Elisha de Rossi), Vatican City, BAV, MS Vat.ebr.193, fol. 56r. See Richler, *Hebrew Manuscripts in the Vatican Library*, 135–36. The diagram is introduced in bold script: וזו היא הצורה אשר תמצא כתוב בזה הלוח ("and this is the form that you will find written on this table"). On the term, see below, chapter 4, note 158.

155. See Bar-Levav, "Religious Order of Jewish Books"; and Idelson-Shein, "Shabbethai Bass."

156. Likely referring to a classical *ilan* featuring a text associated with Gikatilla, if not to the figure in *Sha'arei orah* noted just above, note 154.

157. Hock, *Die Familien Prags*, 48.

158. Bass, *Siftei yeshenim*, 35. See the largely—though not complete—derivative *luaḥ* entries of Benjacob, *Oẓar ha-sefarim*, 257.

159. See above in this chapter, note 75.

160. Many instances of this element in Great Trees also forgo *ʿAssiah* and conclude with *Yeẓirah*.

161. The integration of the *heikhalot* may be seen already in the Zohar (I:38a–45b, II:244b–262b). Cordovero treated the *heikhalot* from a kabbalistic perspective in Gate 24 of *Pardes rimonim*.

162. For an exception, see Tel Aviv, GFCT, MS 028.012.016 (fig. 139).

Chapter 5

1. Not all were aimed at visualizing the same concepts, however, and I am reluctant to make too much of family resemblance in this graphical corpus, as there are simply too many exceptions.

2. We may presume roughly fifty centimeters per cubit, meaning that he had seen ilanot ranging from three to over ten meters in length.

3. This extraordinary testimony is adduced in Meir, "Haskalah and Esotericism in Galicia," 296.

4. The only exceptions to this rule are New York, JTS, MS S436 (fig. 129), which pairs *Z* with *W*; and Jerusalem, NLI, MS 38°7403, which pairs *N* and *Z*.

5. On Jerusalem at the bottom of *P*, see above. For this juxtaposition, see, e.g., Tel Aviv, GFC, MS 028.012.025; Tel Aviv, GFCT, MSS 028.012.012 and 028.011.006; and Jerusalem, NLI, MS Heb. 4°200.4.

6. The ilan is catalogued as "4902 ל" in the Library of Agudas Chasidei Chabad catalogue and was featured in S. Levine, *Mibeis HaGenozim*, 279. I thank Rabbi Levine for allowing me to photograph the ilan and publish it here.

7. Buchbinder was active in Altona, which became part of Prussia in 1867. Königsberg is a historic Prussian city.

8. The significance of this "requires further consideration" (*zarikh ʿiyyun*) passage was first highlighted in Kallus, "Additional Witnesses to *Dapei Tziur* of RH Vital."

9. Moreover, parchment gluing in the *P* and *Z* sections, respectively, was accomplished with a subtlety that cannot be said of the splice point that connects the two. The impression given by the latter is that of two separate ilanot that have been joined.

10. Jerusalem, NLI, MS Heb. 8°963, is housed in a Scroll of Esther–style box with a wooden stave, likely added by a recent owner. A line at the very bottom reads, "Rabbi Moses of Bialystok, son-in-law of Rabbi Simcha Halevi." According to Yitzchack Gila, Joseph Chasanowich (1844–1919), a founder of the National Library in Jerusalem, likely added this line to record the name of the man from whom he had acquired it.

11. I refer to part 2 of Tel Aviv, GFCT, MS 028.012.005, to be discussed below (fig. 133).

12. Except for a brief entry in Loewe, *Catalogue of the Manuscripts*, 100–101 (cat. no. 112), the *Trinity Scroll* has remained unstudied until now.

13. The head of *Adam Kadmon* on the *Trinity Scroll* represents a significant departure from (or beautification of) what the scribe found in his source. We may presume that its peers, Jerusalem, NLI, MS Heb. 8°963 (fig. 132), and part 2 of Tel Aviv, GFCT, MS 028.012.005 (fig. 133), show us the likely original. For all their differences, these last two present the head of *Adam Kadmon* using the same schema. On the Jerusalem image that concludes the *Trinity Scroll*, see above.

14. Both poems may be found in English translation in Cole, *Poetry of Kabbalah*, 162–64, 218–20. Cole points out (212) that the two poems were often sung to the same tune. See also the analysis of Maimon's poem, 380–84.

15. The Delmedigo framing text is also found on Tel Aviv, GFCT, MS 028.012.011 (fig. 248), and on an ilan held by a private New York collector who has asked to remain anonymous. The latter is *Z* only and thus not a Great Tree as defined here. It may thus be considered an attempt to frame *Z* with an alternative to Ẓemaḥ's original commentary. The *Trinity Scroll* was likely copied from a *PaZP7* with the Delmedigo frame rather than from an ilan akin to Jerusalem, NLI, MS Heb. 8°963, or Tel Aviv, GFCT, MS 028.012.005, part 2 (fig. 133).

16. The short work was published in Delmedigo, *Taʿalumot ḥokhmah*, 53b–55a.

17. Delmedigo's references to other discussions in *Taʿalumot ḥokhmah* were deleted from the text in its ilan adaptation.

18. See Idel, "'One from a Town,'" 86. Delmedigo's suggestion (*Taʿalumot ḥokhmah*, 55a) that his reader

study a handful of named Lurianic treatises "if you have merited to [obtain] these works" says it all. The passage is found on the Cambridge *Trinity Scroll* just to the left and below the sefirah of *Gevurah*.

19. Errors include misreading common acrostics and misplacement of captions within the schema.

20. See Hoffman and Cole, *Sacred Trash*.

21. See above, "From Texts to Images, Between Christians and Jews."

22. The subtitle uses a verb associated with literary authorship to describe Poppers's work (*she-ḥiber*).

23. The attribution to Poppers is found only atop five rotuli of the type *KPrZW/Wy*. One—Tel Aviv, GFCT, MS 028.011.003 (fig. 227)—was the basis of the printed edition. The other four appear to be copies of the printed edition.

24. The aspiration to act in accordance with all opinions lies behind much Jewish customary practice. Sperber, *Minhagei Yisrael*, 1:39–59.

25. In terms of Knorr's figures, this takes us to the middle of *fig. 2*. No versions of *P* show any signs of having been influenced by Knorr's division into seven figures (*figs. 1–7*).

26. As noted, *Z14* is also occasionally found on its own, presumably having been extracted from *Z*—though the possibility certainly exists that *Ozrot Ḥayyim* codices also may have served as a source for its independent afterlife.

27. I noted this passage above and will discuss its significance further below.

28. After eliminating tens of ilanot that were produced in large numbers for the express purpose of serving as amulets—which I discuss separately in chapter 6 below—I based my assessment on some sixty Great Trees currently known to me.

29. These graphical traits closely correlate with core elements used to identify manuscript families. Additional graphical *P* variations include representations of the *pirkei ha-zelem* of *Ze'ir* and the variation in the nomenclature and placement of the "breasts" (*dadei adam*, *dadei behemah*, etc.) from which the lower *parzufim* suckle as they grow.

30. Amsterdam, Braginsky Collection, scroll 70-BCS; thanks to Prof. Emile Schrijver for providing me with a scan of this ilan. Additional members of this family include Amsterdam, Embassy of the Free Mind, Bibliotheca Philosophica Hermetica, MS M475; and Jerusalem, IM, MS 103/389, this last a fragment.

31. The recapitulation of *Arikh* within *Z* excepted; see above.

32. New York, JTS, MS 9411, is a fragment of a similar ilan. Another was sold in December 2019 by Kedem Auction House in Jerusalem, and yet another is currently on the market. The last is a condensed expression of Tel Aviv, GFCT, MS 028.012.016 (fig. 139), with an amuletic postscript.

33. See *Sha'ar ha-hakdamot* 6a for one example.

34. This phrase opens many Lurianic ilanot and is drawn from Zohar I:15a. See Matt, *The Zohar* 1:107; and also Liebes, "Zoharic Story."

35. See, e.g., Tel Aviv, GFC, MS 028.011.009 (fig. 161).

36. Thanks are due to Sharon Liberman Mintz, who first brought this ilan to my attention, and to Prof. Shimon Iakerson and Anna Nikolaeva of the Russian Museum of Ethnography for their assistance.

37. An ilan copied by Aharon Ḥayyim ben David Mordekhai of Zinkov is the other Hasidic copy; it is held by one of his direct descendants. Tel Aviv, GFCT, MS 028.011.004, an ilan of this type from early eighteenth-century North Africa, will be discussed below in my treatment of Coppio's ilanot (figs. 120, 170–171). Tel Aviv, GFCT, MSS 028.010.001 (fig. 250) and 028.012.023 (fig. 247); and Amsterdam, Embassy of the Free Mind, Bibliotheca Philosophica Hermetica, MS M474 (fig. 172), are North African Great Trees of this type. The last two show a variation in *V* and date to the second half of the nineteenth century.

38. See Avivi, "Pure Fine Flour"; and Baumgarten and Safrai, "Rabbi Moses Zacuto."

39. See above, "From Texts to Images, Between Christians and Jews."

40. Based on a reading of יצחק בן כ״ר ליב יצ״ו מגרופא פה שלאוד[י]|?|[נ]|ג, Elli Fischer identified the place-names as Dolná Krupá and Stadtschlaining, although the latter is more speculative. Both towns were then part of the same cultural region of western Hungary. My thanks to Rabbi Fischer for his generous assistance.

41. Budapest, Jewish Theological Seminary–University of Jewish Studies, Hungary, MS K 16.

42. The teaching is found in the first book of the Vilna Gaon ever published: his commentary on Proverbs (Shklov, 1797), 40a. Thanks again to Rabbi Elli Fischer.

43. The fragment Jerusalem, NLI, MS 5264, was also an ilan of this type; it too has the unique rearrangement of *K*.

44. Other family members include Tel Aviv, GFCT, MS 028.011.002 (fig. 244); Jerusalem, NLI, MS 4°200.2; Jerusalem, IM, MS 180/41; and an ilan in the Moussaieff personal collection. This last appears to have been copied by the scribe responsible for our ilan. The others are amateurish and likely copied from the 1864 printed rotulus.

45. Four ilanot from this related family have reached us: Tel Aviv, GFCT, MSS 028.012.010 (fig. 245) and 028.012.007 (fig. 246); Jerusalem, NLI, MS 4°200.1; and Montreal, Jewish Public Library (*Rosenberg Ilan*).

46. This was the position of the editor of the second Warsaw printed edition, as we shall see below; he corrected the order of the ilan accordingly.

47. Most of the manuscripts in this subfamily appear to be copies of the printed edition.

48. Thanks to my dear cousin, Dr. Anna Roth Stępień, for providing the translation from Polish. The opening January date likely refers to the manuscript submission to the censor and the closing February date to the granting of permission. It was customary to include both Julian and Gregorian dates, in that order, on official Polish documents in this period, hence the 4/16 of the final date. Prof. Marcos Silber was kind enough to clear up that confusion for me.

49. He provides birth information on the frontispiece of Oxford, BL, MS Mich. 139. All of Hammerschlag's extant codices are in the Bodleian Library collection. Despite the generous guidance provided by Prof. Michael Miller and Lenka Uličná, I have not found external sources that corroborate Hammerschlag's appointments. According to Alexander Beider, "Nosen Ḥazen" is the most plausible pronunciation of Hammerschlag's name in seventeenth-century Moravia (personal communication, September 4, 2015).

50. Based on the colophon in Oxford, BL, MS Mich. 139. The mistaken bibliographical claim that an edition of the Psalms with his commentary was published in Prostitz (Prostějov/Proßnitz) in 1605 is based on the conflation of the edition used by Hammerschlag for his collage and the date of his composition. See Heller, "Often Overlooked," 120 and the references in 120n9.

51. Cohen-Mushlin, *Selected Hebrew Manuscripts*, 495. The material description of the manuscript is accurate.

52. The details were kindly provided by Dr. Paul Gerhard Dannhauer, Hebraica specialist at the Bavarian State Library in Munich (personal communication, April 2009).

53. Oxford, BL, MS Mich. 88, fols. 81a–103b.

54. See above, chapter 1, note 82.

55. Tel Aviv, GFCT, MS 028.012.016, as we saw, is of the type *PuNZ14EWy*. For all his indebtedness to an ilan of this type, Hammerschlag seems to have used only *Pu* and *N*. See also below, fig. 213.

56. Spector, *Francis Mercury van Helmont's*, 37. On the identification of the Trinity with kabbalistic *parzufim* by Helmont and Knorr, see Coudert, *Impact of the Kabbalah in the Seventeenth Century*, 125–29, where the author makes an *a fortiori* argument regarding the plausibility of such identifications based on Scholem's descriptions.

57. The Jewish Museum in Prague has more than 1,200 pieces of Viennese silver in its collection, and the Israel Museum and Jewish museums in Vienna, Budapest, and New York have extensive collections as well. My images and information are thanks to the generosity of William Gross, who has a number of extraordinary pieces of rare Alt-Wien (pre-1866) Jewish ritual silver in his collection.

58. See, e.g., Kaufmann, *Die letzte Vertreibung der Juden aus Wien und Niederösterreich*, 65–166. For a contemporary Jewish work that regarded Leopold I as a messianic figure, see Springer, *Derekh ha-nesher*. David Oppenheim's copy in Oxford's Bodleian Library may be the only one extant. Apropos ilanot, Leopold I also conferred the title of "Baron" upon Christian Knorr von Rosenroth.

59. The classic account of this movement is Scholem, *Sabbatai Ṣevi*. For a sourcebook with up-to-date introductions, see Maciejko, *Sabbatian Heresy*. Here and elsewhere in the present book where I interrogate the nexus of Sabbateanism and ilanot, the analyses supersede those published in Chajes, "Diagramming Sabbateanism."

60. Scholem (*Sabbatai Ṣevi*, 597) notes the documentation of such processions in the Lviv archive.

61. See Elqayam, "Mystery of Faith."

62. On R. Samuel Vital's high regard for Nathan, see below, chapter 5, note 192.

63. Assimilation by way of copying or incorporating Nathan's writings without attribution or under different names. See also chapter 5, note 188.

64. The best-known case of such ongoing devotion is that of the Ottoman Turkish *dönmes*, on whom see Sisman, *Burden of Silence*.

65. See, e.g., Tishby, "Between Sabbateanism and Hasidism," 219, where the author admits that although he could find no source for a particular idea in Sabbatean works, its very audaciousness was sufficient to "incriminate."

66. Busi, *Qabbalah visiva*, 416–19; and Chajes and Baumgarten, "Nathan of Gaza's 'Discourse of the Circles.'"

67. See, e.g., Yosha, *Captivated by Messianic Agonies*, 197–215. Idel ("Perceptions of Kabbalah," 59) has pointed out that Sabbatean interpretations of Lurianism were commonly viewed as anthropomorphic. Idel also contrasts (76) Luzzatto and R. Joseph Ergas's allegorical interpretations of Lurianism with the "plain meaning" stressed by R. Immanuel Ḥai-Ricchi. The fact that Luzzatto created ilanot—albeit not anthropomorphic ones—further complicates any attempt to correlate views on corporealization and the production of ilanot.

68. Wolfson has argued that the "coronation" of the Messiah, "the critical metaphysical change" in the Sabbatean doctrine of redemption, "is linked to the symbol of the crown." Wolfson, "Engenderment of Messianic Politics," 217, 236.

69. This tenet of Sabbateanism—an innovation of Shabtai's elaborated upon by both Nathan of Gaza and Abraham Michael Cardoso—was explored most thoroughly in Elqayam, "Mystery of Faith." For Shabtai's own formulation, see Liebes, "Shabbetai Zevi's View of His Conversion."

70. On the centrality of this verse in Sabbatean thought going back to Shabtai himself, see Elqayam, "Mystery of Faith," 310–13.

71. Wolfson, "Engenderment of Messianic Politics," 246n144.

72. Nathan of Gaza is reported to have explained the numerical equivalence between *Shabtai Zevi* and *shin, dalet, yud* by invoking the description of Metatron on that same talmudic page: "his name is that of his master"

(shmo ke-shem rabo). See Elqayam, "Mystery of Faith," 326; and Wolfson, "Engenderment of Messianic Politics," 218.

73. On these substitutions for Shabtai Zevi, see Liebes, "Vilner Gaon School," 267. *Shaddai*, with each letter spelled individually (*shin, dalet, yud*), adds up to 814 [תתי״ד].

74. My translation is adapted from Wolfson, "Engenderment of Messianic Politics," 245.

75. Oxford, BL, MS Michael 88, fols. 88b–89a. Thousands of volumes from the library of Heimann Joseph Michael (1792–1846) were acquired by the Bodleian and the British Library in 1848; many of these originated in Emden's library. The suggestion that the Hammerschlag manuscripts may have been "sequestered" by Emden was made by Dr. Menachem Kallus in "Graphic Representation in Kabbalah."

76. In his 1683 work *Or ha-ganuz* (bound with the ilan codex in Oxford, BL, MS Mich. 88), Hammerschlag covers much of the same ground, but with an added emphasis on revealing terms including 814 [תתי״ד] and *Shaddai* that could be converted numerically to the equivalent of Shabtai Zevi.

77. Zohar I:224b (Matt, *The Zohar* 1:350). Matt notes there that "the apple orchard of *Shekhinah* drips with dew emanating from *Tif'eret*, who is known as heaven."

78. Scholem, *Sabbatai Ṣevi*, 158; and Papo, "'Meliselda' and Its Symbolism."

79. Scholem, *Ḥalomotav shel ha-Shabtai*, 37. See also his trenchant remarks (52) on "the mistake of R. Jacob Emden," who failed to understand how "true *ḥasidim* and *ẓaddikim* could also be Sabbateans." In the 1690s it was possible to express belief in Shabtai Zevi within certain rabbinic circles without inevitably generating condemnation and charges of heresy. Scholem's claim (39) is based on the case of R. Abraham Rovigo, whose belief was so unremarkable in the 1690s that it left insufficient traces for the heresy hunters of the next generation to have heard about it. Two of three extant manuscripts of Nathan's "Discourse on the Circles" were copied by Rovigo's scribe.

80. Scholem, *Ḥalomotav shel ha-Shabtai*, 43. Scholem also notes (61) a reference in the notebook to a "*Sefer shi'ur komah* written by *ploni* that is not to be studied"— which he was unable to identify.

81. The frontispiece of the penitential *Seliḥot* prayer book published in Amsterdam by David De Castro Tartas in 1666 features Shabtai Ẓevi seated on King Solomon's throne.

82. For a contemporary parallel, consider the most common placard in the State of Israel: an image of the last Lubavitcher rebbe, R. Menachem Mendel Schneerson (1902–1994), upon which the slogan "King Messiah" is emblazoned, hung everywhere by his otherwise conventionally Orthodox devotees. On the visualization practices of contemporary believers in the messiahship of the Rebbe, see Bilu, "'With Us More than Ever Before.'"

83. Scholem, *Sabbatai Ṣevi*, 607.

84. In this same introduction, he endorses *Kanfei yonah*, a Saruqian work by Menaḥem Azariah da Fano that Zacuto specifically forbade Perlhefter from studying.

85. "Steps to Infinity" may be an adaptation of the tabular representation of the *parzufim* found in Jerusalem, NLI, MS Heb. 28°7991, fol. 180b. Earlier in the same manuscript, the *parzufim* are shown as steplike tubes on both sides of the broad channel of *AK* (fig. 115). See above, chapter 4, between notes 122 and 123.

86. On the Ashkenazi codices, see above, "*Fig. 15* and the Quest for Knorr's Elusive Source."

87. The diagram also appears in nineteenth-century North African copies.

88. Murdoch, *Antiquity and the Middle Ages*, 159.

89. On the kabbalistic appropriation of schemata from the sciences, see Chajes, "Spheres, Sefirot."

90. The third diagram at the bottom of the rotulus presents a tabular chart with a summary of the enrobings; it too has been adapted from the diagrammatic materials in *Oẓrot Ḥayyim* codices. See, e.g., Oxford, BL, MS Opp. 551, fol. 155b.

91. I do not regard this as a compound *ilan* because the second is clearly presented as an independent figure rather than as the second of a sequence.

92. It is a fascinating but challenging exercise to compare the standard Poppers ilan with Tel Aviv, GFCT, MS 028.012.016 (fig. 139), and Tel Aviv, GFC, MS 028.011.009 (fig. 161). Doing so confirms that nearly everything has been preserved in the latter.

93. A considerable literature has been devoted to Luzzatto in the past decades. The most recent and comprehensive treatment is Garb, *Kabbalist in the Heart of the Storm*. See also Carlebach, *Pursuit of Heresy*.

94. On the centrality of prophecy and "enthusiasm" in Sabbateanism, see Goldish, *Sabbatean Prophets*.

95. Carlebach, *Pursuit of Heresy*, 206, 221.

96. See Baumgarten, "Visualization of Knowledge."

97. Both New York, JTS, MSS K106 and K103, are absent from the Jerusalem, NLI, catalogue.

98. I compared the hands in the two ilanot to each other as well as to autograph letters signed by Luzzatto held in New York, JTS, MS 4022/8520a, a box of 131 items.

99. The work has been published under the titles *Pitḥei ḥokhmah ve-da'at* (Openings of wisdom and knowledge) and *Klalei* (General principles) *pitḥei ḥokhmah ve-da'at* in *Da'at tevunot*. It also opens *Pitḥei ḥokhmah ve-da'at* (Warsaw, 1884).

100. According to a label pasted on New York, JTS, MS K106, the original letter was preserved together with the ilan sent to Bassan. It is now stored in New York, JTS, MS 4022/8520a. The letter was published in Luzzatto, *Igrot Ramḥal*, §4, at 14–18.

101. Baumgarten presumes that only the text was sent to Bassan, but both the wording of Luzzatto's letter and Bassan's defense suggest otherwise. Baumgarten, "Visualization of Knowledge," 308–10; and see also Garb, *Kabbalist in the Heart of the Storm*, 155.

102. The "Shoresh ha-ilan" (Roots of the tree) commentary in Ẓror, *Sefer ilan*, usefully links the cryptic pronouncements of Luzzatto's text to *Oẓrot Ḥayyim*.

103. Luzzatto, *Sha'arei Ramḥal*, §74–76, at 63–64, identifies the short text as the *mareh*, referring to it as "klalut kol ha-ilan ha-kadosh" (the sum of the entire holy tree), to be ritually recited in *Maamar ha-vikuaḥ*.

104. The Israel Museum copy of this ilan—Jerusalem, IM, MS B87.0579A (171/165a)—includes additional texts.

105. My thanks to Bart Schuurman (Stadsarchief Amsterdam) for his help navigating the archival materials to find key dates and other family data on Siprut. My meager findings were substantially augmented by the information in Levie Bernfeld, "Confrontation Between East and West," 335–38, 345n57, 352n81, and 354.

106. Vital, *Sha'ar ha-hakdamot*, 9a. See also Vital, *'Eẓ Ḥayyim* I:4.

107. Scholem recorded having seen this ilan in the collection of "Ben Zwi (Jerusalem)," adding that Yitzhak Ben-Zvi—the historian who was also president of Israel from 1952 to 1963—believed that it reflected a Baghdadi tradition. The note is in Jerusalem, NLI, Scholem Archive Arc.4* 1599 03 92.4.

108. Levie Bernfeld, "Confrontation Between East and West," 354, where the author notes Joseph's having published an edition of Moses Almosnino's ethical work *Regimiento de la vida* in 1729, "perhaps to criticize the licentious way of life of the western Sephardim." She also mentions (355n88) his primary contribution to a collection of Hebrew poems, *Shirei hilulim*, published in Utrecht in 1745.

109. Siprut illuminated his poem celebrating the 1753 marriage of Jacob Teixeira De Mattos and Sarah Ximénes in a manner akin to the loveliest contemporary ketubot. Joseph himself married Ester Ẓemaḥ in 1716.

110. See entry 22, page 15 in Jerusalem, NLI, digital object NNL_ALEPH000171951. Abraham de Gabay is referred to as a kabbalist in Amsterdam, Ets Haim Library, MS 47 B 03, fol. 17.

111. The poem dedication is cited in Michman, *David Franco Mendes*, 130n25, which Tim Franks was kind enough to bring to my attention.

112. See Fuks and Fuks-Mansfeld, *Catalogue of the Manuscripts of Ets Haim*, 169, no. 317; for other works by Siprut, see pp. 134–37, 148–49. I am grateful to Heide Warncke, executive curator of the Bibliotheek Ets Haim, for her attentive responses to my queries.

113. Maciejko, *Sabbatian Heresy*, 87–113.

114. Nadav, "Rabbi Shlomo Ayllon," 312.

115. Levie Bernfeld, "Confrontation Between East and West," 335–36n27.

116. Wirszubski, *Ben ha-shittin*, 157–59. See also Liebes, *Sod ha-emunah*, 154–56; and Lefler, "'When They Came to Take Her,'" 213–15.

117. Nadav, "Rabbi Shlomo Ayllon," 312.

118. The text was published in Scholem, *Be-'ikvot mashiaḥ*, 14–52; my translation.

119. Ibid., 18; and Vital, *Sha'ar ha-gilgulim*, 46 (*hakdamah* 15). The teaching, apropos Ḥayyun, also features the phrase *'oz Elohim*.

120. On the anti-Adam and the Messiah, see Barnai, "'Sabbateanism after the Death of Sabbatai Ṣevi,'" 213. The translation of Zohar II:258a is from Wolski and Hecker, *The Zohar*, 12:141.

121. Further study of the works of Ayllon and Ḥayyun may shed light on Siprut's sources and intentions.

122. References elsewhere in the inscriptions to the emergence of the divine configuration known as "Timna" from the rear of "Leah" and to the proliferation of demonic shells in the World of Creation (*Beriah*) known as "the great sea dragons" are likely indebted to a Nathanic source as well.

123. See above, chapter 3, note 21.

124. Hillel, *'Over la-sofer*, 39–48. Dr. Eliezer Baumgarten's study of Coppio's ilanot is forthcoming.

125. A 1709 manuscript copied by Coppio was written in the local script associated with Salonica rather than in the formal script he subsequently adopted. Ibid., 95.

126. The discovery was reported online at https://mountofolives.co.il/he/news/-סיפור-שיברי-המצבה-של-החכם-השלם-המקובל/#gsc.tab=0.

127. Hillel, *'Over la-sofer*, 15, 23.

128. The vast literature on the fluid notions of authorship should give us pause before casting judgment. See, e.g., Mazzeo, *Plagiarism and Literary Property*.

129. He refers here to Ẓemaḥ, *Kol be-Ramah*.

130. See Avivi, "Pure Fine Flour"; and Baumgarten and Safrai, "Rabbi Moses Zacuto."

131. These reach us in the copies made in the early nineteenth century by Shlomo Mordekhai Ish Yemini ben Aharon of Khotyn. In 1807 Shlomo Mordekhai was in Salonica, whence he later continued to the Land of Israel. Examples of copies that belong to this family are Tel Aviv, GFCT, MS 028.012.002 (fig. 176); Tel Aviv, GFC, MS 028.012.026 (fig. 249); Jerusalem, Benayahu Collection, MS NA 155; and New York, Lehmann Hebrew Manuscript Collection, MS NL 138.

132. These are treated below under the rubric "Ilan Amulets."

133. I know of seven additional Coppio ilanot in libraries and other private collections; many more are likely to exist.

134. Known autographs of Coppio include Moscow, RSL, MS 543 (fig. 117); Jerusalem, NLI, MS 2044; and Jerusalem, Benayahu Collection, MS K 88.

135. See New York, JTS, MS 2187, fol. 7a.

136. The top of the ilan underwent significant reconstruction due to its condition, and a large portion of it was lost. In its parallels, including Tel Aviv, GFCT, MS 028.010.001 (fig. 250), *E"S* or *Ein Sof* is written above

Adam Kadmon. The remains of that caption are visible above the letter *kuf* of *Kadmon*.

137. This phrasing is not identical to that found in *Me'arat sdeh ha-makhpelah* (New York, JTS, MS 2187, fol. 64a), which reads, "*E"S* (*Ein Sof*), the Simple, encompassing all the circles (*'iggulim*) from which all the Worlds emanated." The latter language is identical to that found in the St. Petersburg ilan and in a later copy of a Coppio ilan. See Tel Aviv, GFCT, MS 028.010.001, below.

138. The chiromantic hand also appears at the bottom of Tel Aviv, GFCT, MS 028.010.001.

139. The scroll resembles Jerusalem, NLI, MS 40 6067; the latter was copied in 1806, in either Turkey or the Land of Israel, by Shlomo Mordekhai Ish Yemini ben Aharon of Khotyn. It is likely that he had in his possession either this ilan or a copy of it, to which he made additions that were not part of the original.

140. The text column includes the "requires further consideration" gloss.

141. Graf (Prager), *Va-yakhel Moshe* (1699), 10b (diagram omitted in 2005 ed.).

142. Ibid., 13a (2005 ed., 64).

143. The last section of this ilan was left incomplete by the scribe. Complete copies include Tel Aviv, GFC, MS 028.012.026 (fig. 249); and New York, Lehmann Hebrew Manuscript Collection, scroll 138, the latter copied by Shlomo Mordekhai Ish Yemini.

144. These words, attributed in the Talmud to R. Shimon bar Yoḥai, were often applied to kabbalists.

145. My treatment of Shandukh is indebted to Eliezer Baumgarten's work. See also Busi, *Qabbalah visiva*, 427–36.

146. The wheat and model Tabernacle have not survived, but the parokhet, now extremely fragile, is preserved in a private collection in Jerusalem.

147. See below on Tel Aviv, GFC, MS IQ.011.011 (fig. 191).

148. An additional codex of this kind, no longer complete, was until recently held in Jerusalem, Benayahu Collection, MS B12. The Benayahu codex may have been copied by his son. If so, it is the only copy of a Shandukh ilan.

149. See above, chapter 4, note 72.

150. See Baumgarten, "From Kurdistan to Baghdad."

151. In his late ilan, Shandukh opened with a figure that resembles the upper half of Knorr's *fig. 16*, the *Panoply Tree*, even glossing it as inspired by an ilan he had seen.

152. Baumgarten, "Faces of God," 104–6. On the zoharic passage, see Giller, *Reading the Zohar*, 109.

153. Horowitz, "Early Eighteenth Century Confronts the Beard," 97–98.

154. See above, "The *Temerles Tree* (*T*)."

155. Obrist, "Wind Diagrams and Medieval Cosmology."

156. On the identification of the biblical firmaments with the planetary spheres and orbs of the fixed stars, see Chajes, "Spheres, *Sefirot*," 254–55.

157. Rubin, *Portraying the Land*, 19–37.

158. On locating the Garden of Eden, see, generally, Scafi, *Mapping Paradise*. For kabbalistic traditions, see Bar-Asher, *Journeys of the Soul*.

159. The translation reflects my reconstruction and reading of the damaged colophon.

160. Graf (Prager), *Va-yakhel Moshe*, 21a; Hamburg, State and University Library Carl von Ossietzky, MS Levy 94, a 1680 manuscript of Lurianic commentaries on the zoharic *idrot*, 98b.

161. Although I cannot confirm that Shandukh had access to the work, the usage is found in Cordovero's *Ilema*, *'Ein ha-bedulaḥ*, 3:21.

162. Though not invoked here, a well-known gematria demonstrated this very unification: YHVH (26) + ADNY (65) = ILAN (91) [יהוה + אדני = אילן].

163. The ornamental frame was left unfinished; the scoring, however, goes the full length of the rotulus.

164. Bacharach, *'Emek ha-melekh* I:6–28 (4a–6b).

165. See, e.g., b*Rosh ha-shanah* 23b. See also below, "The *Tree of Holiness*."

166. "Vital's ilan without a commentary" may refer to a foldout circle diagram, e.g., *Mevo she'arim* or *V*, or to Z14.

167. Shandukh, *Tofes ilana de-ḥayei*, Tel Aviv, GFC, MS IQ.011.011, 1b.

168. Ibid.

169. An extended analysis and close reading will be provided in an edition of this ilan. See also Busi, *Qabbalah visiva*, 437–41.

170. The collection now belongs to Ethan Katsh (Needham, Massachusetts) and Shelly Katsh (Pawtucket, Rhode Island), who kindly provided images of

their ilan. Their copy will receive closer scrutiny in the critical edition.

171. As the designer of the *Tree of Holiness* was relatively free in his adaptation of materials both textual and visual, it is difficult to know with certainty which edition of *Maamar Adam de-Azilut* he used. The earliest known copy of the treatise and commentary is found in a kabbalistic miscellany dated 1653, Oxford, BL, MS Mich. 446. The ilan précis reflects the treatise as well as the two commentaries that appeared in the printed editions brought to press by R. Moses Graf as *Va-yakhel Moshe* (Dessau, 1699), reprinted in Zolkiew in 1741.

172. Knorr's *figs. 8–12* were of this nature: visualizations of key passages in Bacharach's *'Emek ha-melekh*.

173. Liebes, "Towards a Study of the Author," 114 (my translation). Liebes speculates (113–20) that the author of *Maamar Adam de-Azilut* and its auto-commentary was none other than R. Naftali Bacharach, author of *'Emek ha-melekh*.

174. The other witnesses of the *Tree of Holiness* took steps to clarify the order of reading in this section.

175. The parallel teaching attributed to the Ba'al Shem Tov is recorded in the eighteenth-century anthology edited by Schochet, *Keter shem tov ha-shalem*, §348. Our kabbalist may have discovered the teaching there. Kallus's assessment will be published online as part of the digital critical edition of this ilan on www.ilanot.org.

176. The "Tetragrammaton of the Eyes" has ancient Jewish magical roots and made its way into medieval kabbalistic manuscripts, including Florence, Biblioteca Medicea Laurenziana, MS Plut.2.41, fol. 211a. See Busi, *Qabbalah visiva*, 122–24. Saruq incorporates it into his cosmogony in his *Limmudei azilut*, 35c. See Meroz, "An Anonymous Commentary," 313–14. The explanation of its derivation and place in the narrative is distinctive in *Maamar Adam de-Azilut*, chapters 4–5, 3d–4a. See Bacharach, *'Emek ha-melekh* I:43 (8c); and Menaḥem Azariah da Fano, *Sefer shiv'im ve-shtayim yedi'ot*, chapters 28–29. In the forthcoming critical edition, see §2.1.

177. The full charts of *Maamar Adam de-Azilut* and *'Emek ha-melekh* are reproduced *in extenso* in the *Gates of Eden* and Shandukh ilanot.

178. On this development of the "diminished moon" midrash, see above.

179. The Nathanic *Tehiru* discussed in Sabbatean sources emerged from this earlier notion of the *Tehiru*.

180. See, e.g., Scholem, *Major Trends*, 261–68.

181. As a feature of P7, the *pirkei ha-zelem*, appears after Z. Our ilan designer likely modified a Great Tree of type KPaZP7 akin to the Cincinnati, HUC, Klau Library, Scrolls 69 (fig. 142), substituting his novel Saruqian opening for K and freely adapting the rest of the components.

182. See above, "The *Temerles Tree*" (T).

183. For a possible source of inspiration, see Jerusalem, Benayahu Collection, MS K 133, fol. 17b.

184. The two ilanot that comprise this long rotulus were inscribed on parchment sheets of different widths, the work of different scribes. It is unknown when the two were sewn together

185. The only known copy was made in 1928 by the Lithuanian-trained rabbi Yehudah bar Abraham Getzel Falk, who was then in Sydney, Australia. The copy was auctioned by Kestenbaum & Company on November 13, 2014 (auction 63, lot 296).

186. On this phenomenon, see Baumgarten, "Notes on R. Naftali Bacharach's Treatment."

187. See Stillman, "Nathan of Gaza."

188. Recall that the Temerles "Commentary on the Pathway of the Letters," which has no Lurianic source, was often incorporated into Lurianic collections solely on the basis of the erroneous attribution. Nathan's work, which is fundamentally Lurianic, would be an *a fortiori* case of the same phenomenon.

189. See Kahana, "Allure of Forbidden Knowledge."

190. See Chajes, "Diagramming Sabbateanism"; and Busi, *Qabbalah visiva*, 416–19. For an introduction to this work by Nathan of Gaza and a scientific edition of the text, see Chajes and Baumgarten, "Nathan of Gaza's 'Discourse of the Circles.'"

191. The term is meant to parallel *nukba de-Ze'ir* in the realm of holiness, the lowest of the five principal *parzufim*.

192. On Raphael Joseph, see Scholem, *Sabbatai Ṣevi*, 177–79; 276 and 279 on the meeting between Samuel Vital and Nathan.

Chapter 6

1. The classic English-language survey is Schrire, *Hebrew Amulets*. For a recent, beautifully illustrated volume, see Bohak and Hoog, *Magie*, which also includes

up-to-date scholarly essays. Portions of this chapter incorporate and substantially revise Chajes, "Kabbalah Practices / Practical Kabbalah."

2. See Bohak, "Mezuzoth with Magical Additions"; Bar-Ilan, "Writing *Torah Scrolls*"; and Yisraeli, "Mezuzah as an Amulet."

3. *Charaktêres* are letter-shaped characters lacking semantic or phonetic correlations used as magic signs. By *apotropaic* I mean the presumed ability of an object to avert evil and protect its bearer from harm. See Bohak, "*Charaktêres* in Ancient and Medieval"; and Trachtenberg, *Jewish Magic and Superstition*, 145–52. Maimonides's caustic denunciation of the apotropaic view of the mezuzah is in *Mishneh torah*, *Laws of Mezuzah* 5:4. Maimonides's position was not normative, however. See b*Menahot* 33b and Rashi's comments there.

4. Trachtenberg, *Jewish Magic and Superstition*, 271n4.

5. Widely associated with early modern eastern European wonder-workers, *ba'alei shem* are mentioned in Jewish literature as early as the eleventh century. See the responsum of Rav Hai Gaon (939–1038) published in Levin, *Ozar ha-geonim*, 16.

6. On these artifacts, see Juhasz, "'*Shiviti*-Menorah'"; and Wolfson, "Sacred Space and Mental Iconography," 603–4.

7. See Scholem, *Magen David*.

8. E.g., Baumgarten, "Homilies on the Kabbalistic *Ilan*," 115.

9. Chajes, "Kabbalistic Tree as Material Text," 168–69.

10. Harari, "'Practical Kabbalah' and the Jewish Tradition," 60–64.

11. Ilanot might be perceived as artifacts of harmful magic as well, though such a perception primarily points to the ignorance of the perceiver. Thus, the charge made by the rabbis of Venice in 1794 that a "large sheet [written by R. Moses Ḥayyim Luzzatto] was covered with demonic adjurations."

12. New York, JTS, MS 435, is written in the same hand as Tel Aviv, GFCT, MS 028.012.006 (fig. 218).

13. See above on Tel Aviv, GFCT, MS 028.012.022 (fig. 138). If one regards *PaZW* trees to which a prologue has been added, e.g., *V* or the acrostic sefirot as subtypes, the quantitative dominance of this type emerges with even greater clarity. See, e.g., Tel Aviv, GFCT, MS 028.012.023 (fig. 247), the *Kitzes Ilan* (fig. 141), and even the Coppio ilanot (figs. 120 and 170).

14. William Gross has five of these amulet ilanot in his collection: Tel Aviv, GFCT, MSS 028.012.001 (fig. 205), 028.012.013 (fig. 254), 028.012.014 (fig. 256), 028.012.018 (fig. 258), and 028.012.019 (fig. 259). Many more can be found in museums, libraries, and private collections.

15. This is suggested by the fact that, aside from the exceptions discussed just below, ilan amulets of this type lack the "requires further consideration" gloss that is always found in the *Pa* section of *PaZW* Great Trees.

16. See above, "Great Tree type *PuNZ14EWy* | Tel Aviv, GFCT, MS 028.012.016."

17. As I write, it remains for sale by a private dealer and is therefore impossible to publish here.

18. The Columbia parchment rotulus measures 390 × 12.5 centimeters (fig. 213). It may be viewed online at https://archive.org/details/ldpd_15196031_000 or https://tinyurl.com/2pm2m7f6. Tel Aviv, GFCT, MS 028.012.016, which does not include all the elements found in the Columbia artifact, measures 262 × 8 centimeters (fig. 139). The two standard *PaZW* members of the family reach barely over one meter in length (Tel Aviv, GFCT, MS 028.012.021, is missing the top of *Pa*; the ilan for sale by a private dealer is unavailable for measurement.)

19. Tel Aviv, GFCT, MS 028.012.021 and the ilan for sale end with closely related inscriptions that begin, "This is a charm (davar zeh mesugal) for everything holy." In the case of the ilan for sale, the inscription is preceded by a poem, roughly five times longer, inspired by a poetic approbation by the rabbis of Jerusalem to *Sha'ar Yoseph* (Livorno, 1756), the first published work of R. Ḥayyim Yoseph David Azulai (1724–1806).

20. The amulet appears to be an aggregate of eclectic and unrelated apotropaic elements rather than a copy of an established amulet. Unfilled spaces and unvocalized names indicate that less care was taken in its preparation than in the copying of the ilan. On the name *Taftafia*, see Idel, "R. Neḥemiah ben Shlomo on the Shield of David."

21. Thanks again to Rabbi Gabriel Hagaï for his paleographical assessment. Nazma/Nedjma (lit. star, نجمة), a common name in the Muslim world, was also used by Jews.

22. See Koren, "Kabbalistic Physiology."

23. The correspondence was discovered by my student, Rabbi Asaf Fromer, in Messas, *Ozar ha-mikhtavim*, 172–203. The letters in which the ilanot commissions

feature are on pp. 182–93. Messas's calligraphic prowess may be seen in his copy of North African *piyyutim* (liturgical poetry) in Jerusalem, Benayahu Collection, MS NA 63, viewable online at https://www.nli.org.il/en/manuscripts/NNL_ALEPH000067769/NLI#$FL30655257.

24. See, e.g., Biton, "Law, Intellect, and Time"; and Zohar, "Halakha as a Non-Fundamentalist Religious Language."

25. The grandson of Soffer, Prof. Jacques Soffer of CNRS Marseille, kindly provided me with the biographical details known to him.

26. Messas, *Ozar ha-mikhtavim*, §347, at 182.

27. Ibid., §348 and §349, at 182–83.

28. Ibid., §352, at 183.

29. Messas took a number of additional commissions from Soffer, including Torah-scroll repairs and mezuzah scrolls, making fifty of the latter. Ibid., §363 and §365, at 188–90; §370, at 193; and §394, at 200.

30. Ibid., §357, at 185.

31. The same can be said of *Raziel ha-malakh* and the Hasidic best-seller *No'am Elimelekh* [Pleasantness of Elimelekh], which preserves the teachings of Rebbe Elimelekh of Lizinsk. Chajes, "'Too Holy to Print.'"

32. The name Malakand is common among Bukharan Jews.

Chapter 7

1. *Shulḥan 'arukh*, *Oraḥ ḥayyim* §39 and §791:2; and *Yoreh de'ah* §181:1.

2. Bacharach, *Ḥavot Yair*, §184, at 171b–172b. Thanks to Dr. Yakov Z. Meir for suggesting the salience of this responsum to my discussion.

3. b*Shabbat* 61a.

4. See Ben Abraham, *Raziel ha-malakh*. The famous amulets are on 41b–42a and 43b–45a. See also Chajes, "'Too Holy to Print.'"

5. "Was im Zeitalter der technischen Reproduzierbarkeit des Kunstwerks verkümmert, das ist seine Aura." Benjamin, "Das Kunstwerk im Zeitalter," 477.

6. London, Montefiore Library, MS 113, fol. 182a. See Tishby, "Controversy Regarding the Zohar," 159–60.

7. Tishby speculates that the intention may have been to print the *Grand Venetian Parchment*. Ibid., 160n102. See above, "Renaissance Ilanot."

8. This clever name for a bookshop is based on Song of Songs 7:10, understood in light of a recurring talmudic teaching according to which "Anyone in whose name a halakha is stated in this world, his lips move in the grave." See, e.g., b*Sanhedrin* 90b.

9. The partnership was in place from 1906 to 1913; the shop had been opened by Schwager in 1902. At least thirty-seven catalogues were printed during these years.

10. Schwager and Fränkel, *Reshimah mi-sefarim yeshanim*.

11. The price, twenty-five marks, would have bought nine grams of gold in 1907—an amount that would cost approximately $550 in late 2020. Most of their rare books sold for between one and three marks.

12. Modena's involvement is hardly shocking given his wide-ranging professional occupations. Chajes, "'Too Holy to Print,'" 255.

13. The description was cited in Tishby, "Controversy Regarding the Zohar," 160n102.

14. Scholem was an avid book collector who went so far as to publish a list of eighty works that he sought to acquire for his library. See Scholem, *Kuntress 'alu le-Shalom*.

15. Scholem's copy is in the eponymous Scholem Library in Jerusalem, NLI.

16. See Friedberg, *Bet 'eked sefarim*, 1:98–99, §2482; 3:901, §542. Actual sizes vary, but a folio page is roughly four times the size of a duodecimo. See fig. 222.

17. Heller, *Seventeenth Century Hebrew Book*, 208–9, references discussions in publications by Meir Benayahu and Gershom Scholem.

18. If my historical currency conversion is correct, its value was roughly four times greater in late 2019 than it had been in 1907.

19. The quotation takes the liberty of removing the preposition *for* before the Hebrew term for Messiah that is found in the original verse, Psalm 132:17.

20. Hegel, *Lectures*, 79; and Sasson, *Apiryon Shlomo*, 31a–32b.

21. Sasson, *Apiryon Shlomo*, 2a.

22. On the term *apiriyon*, see also Fishbane, *As Light Before Dawn*, 183n14.

23. On *Ma'ayan ha-ḥokhmah*, an early kabbalistic text associated with the so-called '*iyyun* school, see Porat, "Aimed Inquiry and Positive Theology." The work was highly regarded by Cordovero, who cited it at length in

the *Pardes* and recommended it to all students of Kabbalah in *Or neʾerav*. It also features prominently in *ʿEmek ha-melekh* and *Shaʿarei Gan Eden*. See Dan, *History of Jewish Mysticism and Esotericism*, 47. Other works quoted by Sasson include the *Kuzari* and R. Joseph Karo's *Maggid mesharim*.

24. Sasson, *Apiryon Shlomo*, 18a.

25. Cordovero, *Pardes rimonim*, 19b (Gate 3, Chapter 7).

26. Sasson, *Apiryon Shlomo*, 31a. See also above, chapter 3, note 103.

27. Ibid., 20a.

28. Ibid., 20b. His remarks recall those of Poppers cited above, chapter 3, note 105.

29. This autodidactic approach may perhaps be taken as circumstantial corroboration of the otherwise undocumented identification of Sasson as an Italian rabbi. See Idel, "Particularism and Universalism," 331. Sasson also exhibits a consistently positive regard for gentiles, including their philosophers and historians. See, e.g., Sasson, *Apiryon Shlomo*, 12a–b.

30. Although well preserved, the page has lost about one line of text along the seam of its lower horizontal fold.

31. M. Cohen, *Autobiography of a Seventeenth-Century Venetian Rabbi*, 160.

32. On the *zaḥzaḥot*, see Nadav, "Epistle of the Qabbalist."

33. Adapted from the translation of *Maʿayan ha-ḥokhmah* in Verman, *Books of Contemplation*, 59.

34. Just above *Zeʿir* we see the three sefirot of *Ḥokhmah*, *Binah*, and *Daʿat* in a smaller square typeface that is also used in the lowest parẓufic tree of the diagram.

35. Matt, *The Zohar* 5:535.

36. Sasson adds more detail, including the associations between God's head and the higher sefirot of *Ḥokhmah* and *Binah*, his arms to *Gedulah* and *Gevurah*, chest to *Tiferet*, and so forth.

37. Sasson uses the term *levush* (garment) in a manner consistent with its usage in classical Kabbalah. He does not, however, use *hitlabshut*, the quintessentially Lurianic term we have translated throughout as "enrobing." This latter process, typically central in Lurianic ilanot, is not reflected in Sasson's structural or synoptic diagram.

38. The four words have the numerical value of 404, to which 4 is added for the words themselves.

39. Delmedigo, *Novelot ḥokhmah*, unpaginated foldout between 195b–196a. In 1629, the first section of *Novelot ḥokhmah* was published as the second part of *Taʿalumot ḥokhmah*; the first part was the controversial *Mazref le-ḥokhmah*, Delmedigo's response to the critique of the Kabbalah voiced by his ancestor Elijah Delmedigo in the latter's 1591 *Beḥinat ha-dat*.

40. Although dated, the major study remains Barzilay, *Yoseph Shlomo Delmedigo*. For an important contribution toward a reassessment, see the treatment in Ruderman, "Science, Medicine, and Jewish Culture."

41. Ashkenazi also wrote a long introduction to the first volume. The staggering kabbalistic booklist may be found on 195a–b of the second (1631) volume.

42. Bacharach, *ʿEmek ha-Melekh*, 180b–c; and Delmedigo, *Taʿalumot ḥokhmah*, 53b–55a. Note that Vital's own attempt to provide such an abridgment—used above in "Lurianic Cosmogony: What You Need to Know"—appears just after Delmedigo's in *Taʿalumot ḥokhmah*, 55a–56a.

43. See above, e.g., Tel Aviv, GFCT, MS 028.012.011, and Cambridge *Trinity Scroll*. The text appears in Delmedigo, *Taʿalumot ḥokhmah*, 53b–55a. Ḥai-Ricchi's texts are found in London, BL, MS Or. 6996 (fig. 166), and Jerusalem, IM, MS B87.0579A (171/165a).

44. See, e.g., the early Oxford, BL, MS Opp. 128 (fig. 66), as well as the later Buchbinder volumes, including Tel Aviv, GFC, MS GR.011.012 (fig. 100).

45. Knorr's *fig. 11* is also dedicated to *Adam Kadmaʾah Setimaʾah*, who precedes the *Adam Kadmon* to which the Poppers ilan is dedicated. On this figure, see Meroz, "An Anonymous Commentary," 326n84.

46. This treatment of Knorr in the context of the printed ilan complements my discussion in chapter 4.

47. Cited in Coudert, *Leibniz and the Kabbalah*, 42.

48. Chajes, *Kabbalistic Trees of Christian Knorr von Rosenroth*, will include a full facsimile of the fourth apparatus and a new English translation of Knorr's Latin keys to each of the sixteen figures.

49. Andreas Kilcher and Boaz Huss have suggested that the production of *Kabbala Denudata* was part of a late seventeenth-century Sabbatean-inspired circle of Jews and Christians. See Huss, "Text and Context"; and Kilcher, "Kabbalistische Buchmetaphysik."

50. Dan, *Christian Kabbalah*, 221. Volume 1 was published in two instalments in Sulzbach; the second, which contains the collection of diagrams, was actually printed in 1678. Schmidt-Biggemann, "Knorr von Rosenroths missionarische Intentionen," 193.

51. Kilcher has recently argued that *Kabbala Denudata* "is to a large extent a philological project in the modern sense." Kilcher, "Philology as Kabbalah," 16.

52. See Kilcher, "Lexikographische Konstruktion der Kabbala."

53. On hieroglyphs and Kabbalah, see Idel, "Kabbalah, Hieroglyphicity and Hieroglyphs"; and Idel, "Perceptions of Kabbalah," 62n34.

54. The kabbalistic diagrams of Kircher were influenced by a Christological ilan prepared by Philippe d'Aquin (born Mordecai Crescas, 1578–1650). D'Aquin's ilan also found its way back to Jewish Kabbalah when it was copied without Christian interpolation by Benjamin Senior Godines in 1675 on the manuscript of Abraham Cohen de Herrera's *Sha'ar ha-shamayim* (Gate of heaven), Amsterdam, Ets Haim Library, MS HS.EH 48 A. See Stolzenberg, "Four Trees, Some Amulets"; and Campanini, "Aperçu sur la représentation."

55. Wolfenbüttel, Herzog August Bibliothek, Cod. Guelf. 157.1 Extrav., fols. 42r–v. The letter is dated October 18, 1678. Carpzov was a classmate of Knorr's; see Schmidt-Biggemann, *Geschichte der christlichen Kabbala*, 63.

56. Knorr was himself a hymn composer and a personal friend of Schütz. Telle, "Knorr von Rosenroth," 528; and Deppermann, *Johann Jakob Schütz*, 222–42.

57. Hackspan published a simple sefirotic tree at the end of the treatise. Hackspan, "Cabbalae Judaicae," 454. See also Campanini, "Aperçu sur la représentation," 64.

58. This section of volume 1 was printed separately in Sulzbach in 1678 but typically is found bound with the first section, which had been printed in 1677.

59. See, e.g., the digitized copy available via the National Library of Jerusalem website, in which all figures from *fig. 8* forward are missing. Recall too the reordering of frames in early witnesses of *K*, as seen in fig. 144.

60. *Nearly* identical, as the Warsaw ilan presents a corrupt version of *P*.

61. On Bass's terminology (*luaḥ*), see above, chapter 4, note 158.

62. See Chajes, "Kabbalah and the Diagrammatic Phase."

63. See Hanegraaff, *Esotericism and the Academy*.

64. See, e.g., Magee, *Hegel and the Hermetic Tradition*; and Franks, "Rabbinic Idealism and Kabbalistic Realism." With regard to the impact of *Kabbala Denudata* on the subsequent history of "western esotericism," see Kilcher, "Verhüllung und Enthüllung des Geheimnisses." On its role in conversionary efforts directed against Jews in subsequent centuries, see Kalik, "Christian Kabbala and Polish Jews."

65. See above, chapter 4, note 97.

66. See above, "*Grupa Ilan*."

67. That rotulus has reached us: Tel Aviv, GFCT, MS 028.011.003 (fig. 148). The printed rotulus based upon it is Geliebter and Weinryb, eds., *Ilan ha-gadol* (Tel Aviv, GFCT, MS 028.011.001, fig. 226).

68. I have found little information on Muskat. His obituary in *Ha-maggid* of 2 Nissan 5628 (1868) is online at https://isheiisrael.wordpress.com/2018/01/19/רבי-ישעיה-מושקט/ and https://tinyurl.com/yccygamk.

69. An earlier approbation by Muskat may be found in *Kol simḥa*, the collection of teaching of Simcha Bunim of Peshischa (Warsaw, 1859). It appears alongside an approbation by Yitzchak Meir Rotenberg-Alter (1799–1866), the founder of the Ger dynasty, who was a personal friend of Muskat.

70. Hopstein, in turn, was a student of the Maggid of Mezerich, the founder of Hasidism and disciple of the Ba'al Shem Tov.

71. See Jacobs, *Hasidic Prayer*, 81. Muskat's commentary, *Harei besamim* [Hills of spices], may be found in *Seder tefilot* (Warsaw, 1934).

72. For the preamble, see above, *Special Focus | Features and Functions of the Great Tree of R. Meir Poppers*. The preamble is found in only one subfamily of Great Trees.

73. The censor's approval is reproduced from Tel Aviv, GFCT, MS 028.011.003, as well.

74. E.g., Garb, *History of Kabbalah*, 129–33.

75. On Lipkin, see Kamenetsky, "From the Depths of the Heart"; and Peleg, "On the Kabbalistic Literary Activities."

76. For Lipkin's dedication to the publication of the kabbalistic works of Luzzatto and the Gaon, see Kamenetsky, "From the Depths of the Heart," 139–50.

77. Ibid., 136n16.

78. Later editions in smaller formats present each *siman* over two facing pages. See, e.g., the A. B. Sefarim Jerusalem edition of 2005.

79. Publisher's introduction, §3, at 1.

80. Luria's "Commentary on the Ilan" has nothing to do with Lurianic Kabbalah, which he did not live to see. It offers explanations of the appellations of the sefirot that were common to classical ilanot.

81. The meager biographical data on Kalonymus Kalman is presented in Kamenetsky, "From the Depths of the Heart," 151–56.

82. The last lines of the edition, following §14, relate that the copying of the ilan—i.e., the Kalonymus Kalman ilan—was completed on 9 Kislev 5652 (December 10, 1891) in Mariupol by Altshuler. The book passed the censor in St. Petersburg on February 28, 1893. Most of Lipkin's work must therefore have been carried out during 1892.

83. See, e.g., Lipkin's strongly worded introduction to §7, in which he explains his rearrangement of the presentation of the enrobings in accordance with the Kalonymus Kalman ilan, as the order of presentation in the 1863 printing was "demonstrably wrong." He provides references to *'Ez Ḥayyim* to prove his point.

84. Lipkin and Altshuler, *Sefer ilan ha-gadol*, §9 (p. 10).

85. Ibid., §1 (p. 1).

86. The supplement appears at the end of *KL"Ḥ pitḥei ḥokhmah* (80a–b) and on 3b–5a of Menachem Mendel Halperin of Grodno's *'Ez Ḥayyim* edition.

87. The credit is given to Lipkin explicitly in *KL"Ḥ pitḥei ḥokhmah*. Lipkin's authorship of this tract was reasserted in Peleg, "On the Kabbalistic Literary Activities," 147–49.

88. See, however, the very important nuances of Baumgarten, "Visualization of Knowledge."

89. Publisher's introduction, §4. Although I have not thoroughly reviewed these references, doing so will be among the first tasks undertaken as the Ilanot Project creates critical editions of the Great Trees. They will be published online at www.ilanot.org.

90. Jerusalem, NLI, MS 4°200.4. This Great Tree of type *PNZ* is damaged at both ends but likely opened with *K*.

91. Fishberg, "Nose."

92. Other *P* heads of *Adam Kadmon* with extruding ears include Hammerschlag's early effort in Tel Aviv, GFC, MSS 028.011.009 and 028.012.025 (fig. 147).

Conclusion

1. The use of amulets in Shas political campaigns has been a matter of controversy and legal battles going back to 1996. Bohak, "How Jewish Magic Survived," 8.

2. See above, introduction, around note 25.

3. Chajes, *Between Worlds*, 133.

4. For an example of the former, see, e.g., Turg'eman, *Even ha-shoham*; for the latter, see the nearly four hundred diagrams in Kapashian, *'Ez ha-ḥayyim she-ba-gan*.

5. Even schematic anthropomorphisms are strictly avoided, thus continuing the "tradition" established in the 1893 edition of the Great Tree.

6. See, e.g., Akrap, Davidowicz, and Knotter, *Kabbalah* קבלה; and Goldman-Ida, "Kabbalah and Art."

7. Compare fig. 235 with fig. 182. Her dissertation was published as Valabregue-Perry, *Concealed and Revealed*. More of her work may be seen at www.valabregue.com.

8. More of Loewenthal's work may be seen at www.kabbalahart.com.

9. See Friedman's work at www.kosmic-kabbalah.com and his meditative coloring book at www.thekabbalah coloringbook.com. On Luzzatto's ilanot, see above.

10. Smith's images are central to the transmission of his teachings; he has unpacked them in a series of fascinating and beautifully produced publications, e.g., *Deep Principles of Kabbalistic Alchemy*. The quoted phrases in this paragraph are taken, with Smith's permission, from personal correspondence with the author (March 9, 2021).

11. So Treister described it in a text she prepared for the exhibition, which she shared with me in a personal communication (March 9, 2021). For images from the exhibition, see www.suzannetreister.net/ALCHEMY/ALCHEMY.html.

12. Excerpted from Treister's description of the image; provided in a personal communication (March 9, 2021).

13. Walker, *Fryderyk Chopin*, front matter.

14. This phrase has been used on thousands of Hebrew frontispieces to denote print publication since

the age of incunabula. See https://amhasefer.wordpress.com/2016/03/17/הדפוס-מזבח or https://tinyurl.com/brfck83t.

Appendix

1. I thank Dr. Eliezer Baumgarten for his contributions to what was then merely a catalogue. He revised Dr. Menachem Kallus's initial descriptions.

2. Although the study of ilanot specifically is uniquely indebted to William Gross, his contributions to scholarship go far beyond this genre. See, e.g., Harari and Chajes, "Practical Kabbalah." For a sense of the diverse fields of study that have been enriched by William's collections, see Sabar, Schrijver, and Wiesemann, *Windows on Jewish Worlds*.

3. See above, chapter 3, note 103.

4. The same addition can be found in New York, Lehmann Hebrew Manuscript Collection, MS 138.

5. Another copy of this ilan is preserved as Jerusalem, NLI, MS Heb. 8°5808.

6. Isaacson, *Steve Jobs*, 6.

BIBLIOGRAPHY

Abate, Emma. "Cabalistic Diagram: An Ultramundane Representation / Diagramma cabalistico: Una rappresentazione ultramondana." In *La menorà: Culto storia e mito*, edited by Francesco Leone, 348–49. Milan: Skira, 2017.

———. "Filologia e Qabbalah: La collezione ebraica di Egidio da Viterbo alla biblioteca Angelica di Roma." *Archivio italiano per la storia della pietà* 26 (2014): 409–46.

Abate, Emma, and Maurizio Mottolese. "La Qabbalah in volgare: Manoscritti dall'atelier di Egidio da Viterbo." In *Umanesimo e cultura ebraica nel Rinascimento italiano: Convegno internazionale di studi ISI, Florence, Palazzo Rucellai, Firenze, 10 marzo 2016*, edited by Stefano U. Baldassarri and Fabrizio Lelli, 15–40. Florence: Angelo Pontecorboli, 2016.

Abrams, Daniel. "A Commentary to the Ten *Sefirot* from Early Thirteenth-Century Catalonia: Synoptic Edition, Translation and Detailed Commentary." *Kabbalah: Journal for the Study of Jewish Mystical Texts* 30 (2013): 7–63.

———. "Divine Multiplicity: The Presentation of Differing Sefirotic Diagrams in Kabbalistic Manuscripts." *Kabbalah: Journal for the Study of Jewish Mystical Texts* 50 (2021): 81–152.

———. *Kabbalistic Manuscripts and Textual Theory: Methodologies of Textual Scholarship and Editorial Practice in the Study of Jewish Mysticism*. 2nd rev. ed. Jerusalem: Hebrew University Magnes Press; Los Angeles: Cherub Press, 2013.

———. "Kabbalistic Paratext." *Kabbalah: Journal for the Study of Jewish Mystical Texts* 26 (2012): 7–24.

———. "New Study Tools from the Kabbalists of Today: Toward an Appreciation of the History and Role of Collectanea, Paraphrases and Graphic Representations in Kabbalistic Literature." *Journal des Études de la Cabale* 1 (1997). http://jec2.chez.com/artabrams.htm.

———. "Orality in the Kabbalistic School of Nahmanides: Preserving and Interpreting Esoteric Traditions and Texts." *Jewish Studies Quarterly* 3, no. 1 (1996): 85–102.

———, ed. *Sefer ha-bahir: ʿAl pi kitve ha-yad ha-kedumin*. Los Angeles: Cherub Press, 1994.

———. "Special Angelic Figures: The Career of the Beasts of the Throne-World in *Hekhalot* Literature, German Pietism and Early Kabbalistic Literature." *Revue des études juives* 155, nos. 3–4 (1996): 363–86.

Afterman, Adam. *"And They Shall Be One Flesh": On the Language of Mystical Union in Judaism*. Leiden: Brill, 2016.

Akrap, Domagoj, Klaus Davidowicz, and Mirjam Knotter, eds. *Kabbalah* קבלה. Bielefeld: Kerber, 2018.

Alexander, Philip S. "Jerusalem as the *Omphalos* of the World: On the History of a Geographical Concept." In *Jerusalem: Its Sanctity and Centrality to Judaism, Christianity, and Islam*, edited by Lee I. Levine, 104–19. New York: Continuum, 1999.

Ariel, David S. "Shem Tob ibn Shem Tob's Kabbalistic Critique of Jewish Philosophy in the *Commentary on the Sefirot*: Study and Text." PhD diss., Brandeis University, 1981.

Atton, Christopher, and Stephen Dziklewicz, trans. *The Kabbalistic Diagrams of Rosenroth*. Edited and introduction by Adam McLean. London: Hermetic Research Trust, 1987.

Auerbach, Erich. "Figura." In *Scenes from the Drama of European Literature*, 11–76. Minneapolis: University of Minnesota Press, 1984.

Ault, Alexandra. "Words Will Eat Themselves." *British Library, Untold Lives Blog*, July 28, 2016. https://blogs.bl.uk/untoldlives/2016/07/words-will-eat-themselves.html.

Avivi, Yosef. *Binyan Ariel: Introduction to the Homilies of R. Isaac Luria* [in Hebrew]. Jerusalem: Misgav Yerushalayim, Institute for Research on the Sephardi and Oriental Jewish Heritage, 1987.

———. *Kabbala Luriana* [in Hebrew]. 3 vols. Jerusalem: Ben-Zvi Institute, 2008.

———. "The Kabbalistic Writings of R. Menaḥem Azariah da Fano" [in Hebrew]. *Sefunot: Studies and Sources on the History of the Jewish Communities in the East* 19 (1989): 347–76.

———. "Notes on *Sefer ʿEz Ḥayyim* by R. Yiẓḥak of Pozna" [in Hebrew]. *Moriah* 13, nos. 1–2 (1984): 33–37.

———. "Pure Fine Flour: The Sieve of R. Moses Zacuto" [in Hebrew]. *Peʿamim* 96 (2003): 71–106.

———. "The Writings of R. Ḥayyim Vital Found in Jerusalem and Their Editing by R. Yaʿakov Ẓemaḥ" [in Hebrew]. *Ha-maʿayan* 18 (1978): 61–77.

Bacharach, Naftali ben Jacob. *ʿEmek ha-melekh*. Amsterdam, 1648.

Bacharach, Yair Ḥayyim. *Ḥavot Yair*. Frankfurt am Main, 1699.

Badia, Lola. "The *Arbor Scientiae*: A 'New' Encyclopedia in the Thirteenth-Century Occitan-Catalan Cultural Context." In *Arbor Scientiae: Der Baum des Wissens von Ramon Lull; Akten des Internationalen Kongressus aus Anlass des 40-jährigen Jubiläums des Raimundus-Lullus-Institutes der Universität Freiburg. 29. September–2. Oktober 1996*, edited by Fernando Domínguez Reboiras, Pere Villalba-Varneda, and Peter Walter, 1–19. Turnhout: Brepols, 2002.

Bar-Asher, Avishai. "Illusion Versus Reality in the Study of Early Kabbalah: The Commentary on *Sefer Yeẓirah* Attributed to Isaac the Blind and Its History in Kabbalah and Scholarship" [in Hebrew]. *Tarbiz* 86, nos. 2–3 (2019): 269–384.

———. *Journeys of the Soul: Concepts and Imageries of Paradise in Medieval Kabbalah* [in Hebrew]. Jerusalem: Hebrew University Magnes Press, 2019.

Bar-Ilan, Meir. "Writing *Torah Scrolls*, *Tefilin*, and *Mezuzot* on Deer Skin" [in Hebrew]. *Beit Mikrah* 30, no. 102 (1985): 375–81.

Bar-Levav, Avriel. "The Religious Order of Jewish Books: Structuring Hebrew Knowledge in Amsterdam." *Studia Rosenthaliana* 44 (2012): 1–27.

———. "What Could be Done with Four Hundred Books?: A Proposal for a Jewish Library, Krakow 1571" [in Hebrew]. *Zmanim* 112 (2010): 42–49.

Barnai, Jacob. "'Sabbateanism after the Death of Sabbatai Ṣevi': Gershom Scholem's Lectures from the Hebrew University, 1960–1961 from the Notebooks of Zalman Shazar" [in Hebrew]. *Kabbalah: Journal for the Study of Jewish Mystical Texts* 35 (2016): 205–26.

Barzilay, Isaac. *Yoseph Shlomo Delmedigo (Yashar of Candia): His Life, Works and Times*. Leiden: Brill, 1974.

Bass, Shabtai. *Siftei yeshenim* [Lips of those who sleep]. Amsterdam, 1680.

Baumgarten, Eliezer. "Faces of God: The *Ilan* of Rabbi Sasson ben Mordechai Shandukh." *Images: A Journal of Jewish Art and Visual Culture* 13 (2020): 91–107.

———. "From Kurdistan to Baghdad: Transitions of Visual Knowledge During the Early Modern Period." *Ars Judaica* 14 (2018): 79–92.

———. "Homilies on the Kabbalistic *Ilan* of Yosef ibn Ẓur" [in Hebrew]. *Kabbalah: Journal for the Study of Jewish Mystical Texts* 37 (2017): 101–57.

———. "The Kabbalistic *Ilan* of Yitzhaq Wannah: Local Kabbalah in a Global World" [in Hebrew]. *Daʿat* 87 (2019): 359–82.

———. "Notes on R. Naftali Bacharach's Treatment of Pre-Lurianic Sources" [in Hebrew]. *AJS Review* 37, no. 2 (2013): 1–23.

———. "Visualization of Knowledge in the Thought of R. Moses Chaim Luzzatto: Between Prophecy and Kabbalah" [in Hebrew]. *Peʿamim* 150 (2017): 289–321.

Baumgarten, Eliezer, J. H. Chajes, and Uri Safrai. "Rabbi Moses Zacuto's Tree: Classical and Lurianic Kabbalah Re-viewed." Forthcoming.

Baumgarten, Eliezer, and Uri Safrai. "Rabbi Moses Zacuto and the Kabbalistic Circle of Amsterdam." *Studia Rosenthaliana* 46 (2020): 29–49.

———. "'The Wedding Canopy Is Constituted by the Being of These *Sefirot*': Illustrations of the

Kabbalistic Huppah and Their Derivatives." *Jewish Quarterly Review* 110, no. 3 (2020): 434–57.

Baumgarten, Eliezer, Uri Safrai, and J. H. Chajes. "'See the Whole World in the Likeness of a Ladder': A Kabbalistic Ilan by R. Joshua ben David of Kurdistan" [in Hebrew]. In *Benayahu Memorial Book*, edited by Moshe Bar-Asher, Yehuda Liebes, Moshe Asis, and Yosef Kaplan, 843–72. Jerusalem: Carmel, 2019.

Beit-Arié, Malachi. *Hebrew Codicology: Tentative Typology of Technical Practices Employed in Hebrew Dated Medieval Manuscripts*. Jerusalem: Israel Academy of Sciences and Humanities, 1981.

Beker, Y., ed. *Ma'arekhet ha-elohut*. Jerusalem: Beker, 2013.

Ben Abraham, Isaac, ed. *Raziel ha-malakh*. Amsterdam, 1701.

Benayahu, Meir. "R. Samuel Barzani: Leader of Kurdistan Jewry" [in Hebrew]. *Sefunot: Studies and Sources on the History of the Jewish Communities in the East* 9 (1964): 21–125.

———. *Toledot ha-AR″I* [in Hebrew]. Jerusalem: Ben-Zvi Institute, 1967.

Benjacob, Itzhak Eisik. *Ozar ha-sefarim*. Vilna, 1880.

Benjamin, Walter. "Das Kunstwerk im Zeitalter seiner technischen Reproduzierbarkeit." In *Walter Benjamin: Gesammelte Schriften*, Band 1, Teil 2, 471–508. Frankfurt am Main: Suhrkamp, 1980.

Benmelech, Moti. *Shlomo Molcho: The Life and Death of Messiah Ben Joseph* [in Hebrew]. Jerusalem: Ben-Zvi Institute, 2016.

Ben-Shachar, Na'ama. "Ms. Stadtbibliothek Nürnberg Cent. V. App. 5 and the Ashkenazic Esoteric Tradition from the Second Half of the Thirteenth Century: A New Examination" [in Hebrew]. *Da'at* 82 (2016): 73–123.

Berbara, Maria, and Karl A. E. Enenkel. *Portuguese Humanism and the Republic of Letters*. Leiden: Brill, 2012.

Bielik-Robson, Agata, and Daniel H. Weiss, eds. *Tsimtsum and Modernity: Lurianic Heritage in Modern Philosophy and Theology*. Berlin: De Gruyter, 2020.

Bilu, Yoram. "'With Us More than Ever Before': Making the Absent Rebbe Present in Messianic Habad." In *Toward an Anthropology of Nation Building and Unbuilding in Israel*, edited by Fran Markowitz, Stephen Sharot, and Moshe Shokeid, 195–213. Lincoln: University of Nebraska Press, 2015.

Biton, David. "Law, Intellect, and Time: Rabbi Joseph Messas, Halakhic Decisor in a Transitional Era" [in Hebrew]. PhD diss., Hebrew University of Jerusalem, 2002.

Blair, Ann. *Too Much to Know: Managing Scholarly Information Before the Modern Age*. New Haven: Yale University Press, 2010.

Blanco Mourelle, Noel. "Every Knowable Thing: The Art of Ramon Llull and the Construction of Knowledge." PhD diss., Columbia University, 2017.

Bland, Kalman P. *The Artless Jew: Medieval and Modern Affirmations and Denials of the Visual*. Princeton: Princeton University Press, 2000.

Bode, Wilhelm. *Die italienischen Hausmöbel der Renaissance*. Leipzig: Hermann Seemann, 1902.

Bohak, Gideon. "The *Charaktêres* in Ancient and Medieval Jewish Magic." *Acta Classica Universitatis Scientiarum Debreceniensis* 47 (2011): 25–44.

———. "Dangerous Books: The Hekhalot Texts as Physical Objects." *Henoch* 39, no. 2 (2017): 306–24.

———. "How Jewish Magic Survived the Disenchantment of the World." In "Practical Kabbalah," edited by J. H. Chajes and Yuval Harari, special issue, *Aries: Journal for the Study of Western Esotericism* 19 (2019): 7–37.

———. "The Magical Rotuli from the Cairo Genizah." In *Continuity and Innovation in the Magical Tradition*, edited by Gideon Bohak, Yuval Harari, and Shaul Shaked, 321–40. Leiden: Brill, 2011.

———. "Mezuzoth with Magical Additions from the Cairo Genizah" [in Hebrew]. *Dinei Israel* 26–27 (2009–10): 387–403.

Bohak, Gideon, and Anne-Hélène Hoog, eds. *Magie: Anges et démons dans la tradition juive*. Paris: Flammarion; Musée d'art et d'histoire du Judaïsme, 2015.

Bolzoni, Lina. *The Gallery of Memory: Literary and Iconographic Models in the Age of the Printing Press*. Translated by Jeremy Parzen. Toronto: University of Toronto Press, 2001.

———. "Giulio Camillo's Memory Theatre and the Kabbalah." In *Hebraic Aspects of the Renaissance*, edited by Ilana Zinguer, Abraham Melamed, and Zur Shalev, 14–26. Leiden: Brill, 2011.

Bonfil, Robert. "Halakhah, Kabbalah and Society: Some Insights into Rabbi Menahem Azariah da Fano's Inner World." In Twersky and Septimus, *Jewish Thought in the Seventeenth Century*, 39–61.

Boxer, C. R. *João de Barros: Portuguese Humanist and Historian of Asia*. New Delhi: Concept, 1981.

Bruno, Giordano. *Articuli Centum et Sexaginta Adversus huius Tempestatis Mathematicos atque Philosophos*. Prague, 1588.

———. *Corpus Iconographicum: Le incisioni nelle opere a stampa; Catalogo, ricostruzioni grafiche e commento di Mino Gabriele*. Milan: Adelphi, 2001.

Buda, Zsofi. "At the Crossroads of Cultures: A Hebrew Manuscript of Johannes Sacrobosco's *De sphaera mundi*." British Library, Asian and African Studies Blog, August 5, 2020. https://shar.es/aoPYxT.

Burmistrov, Konstantin. "Die hebräischen Quellen der *Kabbala Denudata*." *Morgen-Glantz: Zeitschrift der Christian Knorr von Rosenroth-Gesellschaft* 12 (2002): 341–76.

Busi, Giulio. "Beyond the Burden of Idealism: For a New Appreciation of the Visual Lore in the Kabbalah." In Huss, Pasi, and von Stuckrad, *Kabbalah and Modernity*, 29–46.

———. "'Engraved, Hewed, Sealed': Sefirot and Divine Writing in *Sefer Yetzirah*." In "Gershom Scholem (1897–1982): In Memoriam," vol. 2, special issue, *Jerusalem Studies in Jewish Thought* 21 (2007): 1–11.

———. *Qabbalah visiva*. Turin: Einaudi, 2005.

Busi, Giulio, ed., with Simonetta M. Bondoni and Saverio Campanini. *The Great Parchment: Flavius Mithridates' Latin Translation, the Hebrew Text, and an English Version*. Turin: Nino Aragno, 2004.

Bynum, Caroline W. "Avoiding the Tyranny of Morphology; or, Why Compare." *History of Religions* 53, no. 4 (2014): 341–68.

Campanini, Saverio. "Aperçu sur la représentation de l'arbre des Sephiroth dans la kabbale chrétienne." *Points de vue initiatiques* 179 (2016): 48–67.

———. "*Receptum est in recipiente per modum recipientis*: Traces of the *Liber de causis* in Early Kabbalah." In *Reading Proclus and the "Book of Causes,"* vol. 2, *Translations and Acculturations*, edited by Dragos Calma, 455–79. Leiden: Brill, 2020.

Carey, Hilary M. "What Is the Folded Almanac? The Form and Function of a Key Manuscript Source for Astro-Medical Practice in Later Medieval England." *Social History of Medicine* 16, no. 3 (2003): 481–509.

Carlebach, Elisheva. *Divided Souls: Converts From Judaism in Germany, 1500–1750*. New Haven: Yale University Press, 2001.

———. *The Pursuit of Heresy: Rabbi Moses Hagiz and the Sabbatian Controversies*. New York: Columbia University Press, 1990.

Carruthers, Mary. *The Craft of Thought: Meditation, Rhetoric, and the Making of Images, 400–1200*. Cambridge: Cambridge University Press, 2000.

———. "Moving Images in the Mind's Eye." In *The Mind's Eye: Art and Theological Argument in the Middle Ages*, edited by Jeffrey F. Hamburger and Anne-Marie Bouché, 287–305. Princeton: Princeton University Press, 2006.

Chajes, J. H. "Accounting for the Self: Preliminary Generic-Historical Reflections on Early Modern Jewish Egodocuments." *Jewish Quarterly Review* 95, no. 1 (2005): 1–15.

———. *Between Worlds: Dybbuks, Exorcists, and Early Modern Judaism*. Philadelphia: University of Pennsylvania Press, 2003.

———. "Diagramming Sabbateanism." *Images: A Journal of Jewish Art and Visual Culture* 13 (2020): 108–34.

———. "Durchlässige Grenzen: Die Visualisierung Gottes zwischen jüdischer und christlicher Kabbala bei Knorr von Rosenroth und van Helmont." *Morgen-Glantz: Zeitschrift der Christian Knorr von Rosenroth-Gesellschaft* 27 (2017): 99–147.

———. "Imaginative Thinking with a Lurianic Diagram." *Jewish Quarterly Review* 110, no. 1 (2020): 30–63.

———. "Judgments Sweetened: Possession and Exorcism in Early Modern Jewish Culture." *Journal of Early Modern History* 1, no. 2 (1997): 124–69.

———. "Kabbalah and the Diagrammatic Phase of the Scientific Revolution." In *Jewish Culture in Early Modern Europe: Essays in Honor of David B. Ruderman*, edited by Richard I. Cohen, Natalie B. Dohrmann, Adam Shear, and Elchanan Reiner, 109–23. Pittsburgh: University of Pittsburgh Press; Cincinnati: Hebrew Union College Press, 2014.

———. "Kabbalah Practices / Practical Kabbalah: The Magic of Kabbalistic Trees." *Aries: Journal for the Study of Western Esotericism* 19 (2019): 112–45.

———. "Kabbalistic Diagram as Epistemic Image" [in Hebrew]. *Pe'amim* 150 (2018): 235–88.

———. "The Kabbalistic Tree." In Kupfer, Cohen, and Chajes, *Visualization of Knowledge in Medieval and Early Modern Europe*, 449–73.

———. "The Kabbalistic Tree as Material Text." *Henoch* 43, no. 1 (2021): 162–96.

———. "Kabbalistic Trees (*Ilanot*) in Italy: Visualizing the Hierarchy of the Heavens." In *The Renaissance Speaks Hebrew*, edited by Giulio Busi and Silvana Greco, 170–83. Milan: Silvana, 2019.

———. *The Kabbalistic Trees of Christian Knorr von Rosenroth*. Forthcoming.

———. "The Kabbalistic Trees of Gershom Scholem." *Ars Judaica* 16 (2020): 125–54.

———. "Re-envisioning the Evil Eye: Magic, Optical Theory, and Modern Supernaturalism in Jewish Thought." *European Journal of Jewish Studies* 15, no. 1 (2021): 30–59.

———. "Spheres, *Sefirot*, and the Imaginal Astronomical Discourse of Classical Kabbalah." *Harvard Theological Review* 113, no. 2 (2020): 230–62.

———. "'Too Holy to Print': Taboo Anxiety and the Publishing of Practical Hebrew Esoterica." In "Essays in Honor of Kenneth Stow," special issue, *Jewish History* 26, nos. 1–2 (2012): 247–62.

Chajes, J. H., and Eliezer Baumgarten. "Nathan of Gaza's 'Discourse of the Circles'" [in Hebrew]. In *In the Footsteps of the Messiah: A Collection of Sources From the Beginning of the Development of the Sabbatian Faith*, edited by Jonatan Meir, 99–118. Jerusalem: Blima Books, 2021.

———. "Visual Kabbalah in the Italian Renaissance: The Booklet of Kabbalistic Forms." *Vatican Library Review* 1, no. 1 (2022): 1–55.

Chajes, Levana. "On the Discourse of Unity and the Discursive Unity of the *Ma'arekhet ha-elohut*." MA thesis, Hebrew University of Jerusalem, 2021.

Chavel, Ḥayyim D., ed. *Kitvei Rabbeinu Moshe ben Naḥman (Ramban)* [in Hebrew]. 2 vols. Jerusalem: Mosad HaRav Kook, 1963.

———. *Perushe ha-torah le-rabenu Moshe ben Naḥman (Ramban)* [in Hebrew]. 2 vols. Jerusalem: Mosad HaRav Kook, 1959.

Cohen, Adam S. "Diagramming the Diagrammatic: Twelfth-Century Europe." In Kupfer, Cohen, and Chajes, *Visualization of Knowledge in Medieval and Early Modern Europe*, 383–404.

———. *Signs and Wonders: 100 Haggada Masterpieces*. Jerusalem: Toby Press, 2018.

Cohen, Mark R., trans. and ed. *The Autobiography of a Seventeenth-Century Venetian Rabbi: Leon Modena's "Life of Judah."* Introductory essays by Mark R. Cohen and Theodore K. Rabb, Howard E. Adelman, and Natalie Zemon Davis. Princeton: Princeton University Press, 1988.

Cohen-Mushlin, Aliza. *Selected Hebrew Manuscripts from the Bavarian State Library*. Jerusalem: Center for Jewish Art, Hebrew University of Jerusalem; Wiesbaden: Harrassowitz, 2020.

Cole, Peter. *The Poetry of Kabbalah: Mystical Verse from the Jewish Tradition*. New Haven: Yale University Press, 2012.

Copenhaver, Brian P. *Magic and the Dignity of Man: Pico della Mirandola and His "Oration" in Modern Memory*. Cambridge, MA: Belknap Press of Harvard University Press, 2019.

Cordovero, Moses. *Or yakar*. Vol. 21, *Saba de-mishpatim, Shi'ur komah*. Jerusalem: Aḥuzat Yisrael, 1991.

———. *Pardes rimonim*. Cracow, 1592.

Coudert, Allison P. "A Cambridge Platonist's Kabbalist Nightmare." *Journal of the History of Ideas* 36, no. 4 (1975): 633–52.

———. *The Impact of the Kabbalah in the Seventeenth Century: The Life and Thought of Francis Mercury van Helmont, 1614–1698*. Leiden: Brill, 1999.

———. "The *Kabbala Denudata*: Converting Jews or Seducing Christians." In *Jewish Christians and Christian Jews: From the Renaissance to the Enlightenment*, edited by Richard H. Popkin and Gordon M. Weiner, 73–96. Dordrecht: Kluwer Academic, 1994.

———. *Leibniz and the Kabbalah*. Dordrecht: Kluwer Academic, 1995.

Coudert, Allison P., and Taylor Corse, eds. *The Alphabet of Nature*. Leiden: Brill, 2007.

Crupi, Gianfranco. "Volvelles of Knowledge: Origin and Development of an Instrument of Scientific Imagination (13th–17th centuries)." *JLIS.it* 10, no. 2 (2019): 1–27. doi: 10.4403/jlis.it-12534.

Dan, Joseph, ed. *The Christian Kabbalah: Jewish Mystical Books and Their Christian Interpreters: A Symposium*. Cambridge, MA: Harvard College Library, 1997.

———. "The Great Parchment." In *History of Jewish Mysticism and Esotericism: The Middle Ages.* Vol. 13, *Following the Zohar,* 2:242–61 [in Hebrew]. Jerusalem: Zalman Shazar Center for Jewish History, 2020.

———. *History of Jewish Mysticism and Esotericism: The Middle Ages.* Vol. 7, *Early Kabbalistic Circles* [in Hebrew]. Jerusalem: Zalman Shazar Center for Jewish History, 2012.

Darshan, David. *Shir haMa'alot l'David (Song of the Steps)* and *Ktav Hitnazzelut l'Darshanim (In Defense of Preachers).* Translated by Hayim Goren Perelmuter. Cincinnati: Hebrew Union College Press, 1984.

Dear, Peter. "Divine Illumination, Mechanical Calculators, and the Roots of Modern Reason." *Science in Context* 23, no. 3 (2010): 351–66.

DeLeón-Jones, Karen Silvia. *Giordano Bruno and the Kabbalah: Prophets, Magicians, and Rabbis.* New Haven: Yale University Press, 1997.

Deleuze, Gilles, and Félix Guattari. *A Thousand Plateaus: Capitalism and Schizophrenia.* Translated by Brian Massumi. Minneapolis: University of Minnesota Press, 1987.

Delmedigo, Joseph Solomon. *Novelot ḥokhmah.* Basel [Hanau], 1631.

———. *Ta'alumot ḥokhmah.* Basel [Hanau], 1629.

De Molière, Maximilian. "Studies in the Christian Hebraist Library of Johann Albrecht Widmanstetter." PhD diss., Ludwig-Maximilians-Universität München, 2021.

Deppermann, Andreas. *Johann Jakob Schütz und die Anfänge des Pietismus.* Tübingen: Mohr Siebeck, 2002.

Drucker, Johanna. *Graphesis: Visual Forms of Knowledge Production.* Cambridge, MA: Harvard University Press, 2014.

Dubrau, Irmi D. "Physiognomy in the Esoteric Treatises of Hasidei Ashkenaz" [in Hebrew]. PhD diss., University of Haifa, 2017.

Dweck, Yaacob. *The Scandal of Kabbalah: Leon Modena, Jewish Mysticism, Early Modern Venice.* Princeton: Princeton University Press, 2011.

Eizenbach, Ahron, Dovid Kamenetsky, Yeruham Becker, and Joshua Sternbuch, eds. *Supercommentaries and Summaries by Students of the Rashba (Rabbi Solomon ben Adret) on the Kabbala of the Ramban (Nachmanides, Moses ben Naḥman)* [in Hebrew]. Jerusalem: Mosad HaRav Kook, 2020.

Elbaum, Jacob. "Rabbi David Darshan of Krakow and His Hermeneutical Principles in Aggadah and Midrash" [in Hebrew]. *Asufot* 7 (1993): 291–302.

Elkins, James. "Art History and Images That Are Not Art." *Art Bulletin* 77, no. 4 (1995): 553–71.

———. "What Does Peirce's Sign Theory Have to Say to Art History?" *Culture, Theory and Critique* 44, no. 1 (2003): 5–22.

Elqayam, Avraham. "Issues in the Commentary of R. Reuben Ṣarfati on the book *Ma'arekhet ha-Elohut*" [in Hebrew]. MA thesis, Hebrew University of Jerusalem, 1987.

———. "The Mystery of Faith in the Writings of Nathan of Gaza" [in Hebrew]. PhD diss., Hebrew University of Jerusalem, 1993.

———. "On the Architectonic Structure of the Book *Ma'arekhet ha-elohut*" [in Hebrew]. *Kirjath sepher* 64 (1993): 289–304.

———. "The Rebirth of the Messiah: New Discovery of R. Issachar Baer Perlhefter" [in Hebrew]. *Kabbalah: Journal for the Study of Jewish Mystical Texts* 1 (1996): 85–166.

Erlanger, Chaim A., ed. *Sefer meirat 'einayim le-r: Yiḥzak de-min Akko.* Jerusalem: Chaim Aryeh Erlanger, 1975.

Esmeijer, Anna C. *Divina Quaternitas: A Preliminary Study in the Method and Application of Visual Exegesis.* Assen: Gorcum, 1978.

Evans, Michael. "The Geometry of the Mind." *Architectural Association Quarterly* 12, no. 4 (1980): 32–55.

Farber-Ginat, Asi, with Daniel Abrams, eds. *R. Joseph Gikatilla's Commentary to Ezekiel's Chariot.* Los Angeles: Cherub Press, 1998.

Ferguson, Eugene S. *Engineering and the Mind's Eye.* Cambridge, MA: MIT Press, 1992.

Fidora, Alexander, Harvey J. Hames, and Yossef Schwartz, eds. *Latin-into-Hebrew: Texts and Studies.* Vol. 2, *Texts in Contexts.* Leiden: Brill, 2013.

Fine, Lawrence. *Physician of the Soul, Healer of the Cosmos: Isaac Luria and His Kabbalistic Fellowship.* Stanford: Stanford University Press, 2003.

Fishbane, Eitan P. *As Light Before Dawn: The Inner World of a Medieval Kabbalist.* Stanford: Stanford University Press, 2009.

Fishberg, Maurice. "Nose." In *The Jewish Encyclopedia*, edited by Cyrus Adler et al., 9:338–39. New ed. New York: Funk & Wagnalls, 1925.

Fishman, David E. "Rabbi Moshe Isserles and the Study of Science Among Polish Rabbis." *Science in Context* 10, no. 4 (1997): 571–88.

Flynn, Lawrence J. "The *De arte rhetorica* of Cyprian Soarez, S. J." *Quarterly Journal of Speech* 42, no. 4 (1956): 367–74.

Foucault, Michel. *The Order of Things: An Archaeology of the Human Sciences*. New York: Tavistock, 1970.

Franks, Paul. "Rabbinic Idealism and Kabbalistic Realism: Jewish Dimensions of Idealism and Idealist Dimensions of Judaism." In *The Impact of Idealism*, edited by Nicholas Boyle and Liz Disley. Vol. 4, *The Legacy of Post-Kantian German Thought*, edited by Nicholas Adams, 219–45. Cambridge: Cambridge University Press, 2013.

Friedberg, Ch. B. *Bet 'eked sefarim* [Bibliographical lexicon of the whole Hebrew and Jewish-German literature . . .]. 4 vols. Antwerp: Anvers, 1928.

Frojmovic, Eva. "Messianic Politics in Re-Christianized Spain: Images of the Sanctuary in Hebrew Bible Manuscripts." In *Imagining the Self, Imagining the Other: Visual Representation and Jewish-Christian Dynamics in the Middle Ages and Early Modern Period*, edited by Eva Frojmovic, 91–128. Leiden: Brill, 2002.

Fuks, Lajb, and R. G. Fuks-Mansfeld. *Catalogue of the Manuscripts of Ets Haim, Livraria Montezinos, Sephardic Community of Amsterdam*. Leiden: Brill, 1975.

Garb, Jonathan. *A History of Kabbalah: From the Early Modern Period to the Present Day*. Cambridge: Cambridge University Press, 2020.

———. *Kabbalist in the Heart of the Storm: R. Moses Ḥayyim Luzzatto* [in Hebrew]. Tel Aviv: Haim Rubin Tel Aviv University Press, 2014.

Geliebter, Efraim Fischel, and Josef Asher Zelig Weinryb, eds. *Ilan ha-gadol*. Warsaw, 1864.

Gikatilla, Joseph. *Sha'arei orah*. Commentary by Mattithiah ben Solomon Delacrut. Warsaw, 1883.

Giller, Pinchas. *Reading the Zohar: The Sacred Text of the Kabbalah*. New York: Oxford University Press, 2001.

Ginzburg, Carlo. "Clues: Roots of a Scientific Paradigm." *Theory and Society* 7, no. 3 (1979): 273–88.

Goldberg, Edward L. *Jews and Magic in Medici Florence: The Secret World of Benedetto Blanis*. Toronto: University of Toronto Press, 2011.

Goldish, Matt. *Judaism in the Theology of Sir Isaac Newton*. Dordrecht: Kluwer Academic, 1998.

———. *The Sabbatean Prophets*. Cambridge, MA: Harvard University Press, 2004.

Goldman-Ida, Batsheva. "Kabbalah and Art: Introduction." *Images* 13 (2020): 1–4.

Goldreich, Amos. "*Sefer meirat 'einayim le-r: Yizḥak de-min Akko*." PhD diss., Hebrew University of Jerusalem, 1981.

Goodman, Norman. "The Problem of Counterfactual Conditionals." *Journal of Philosophy* 44, no. 5 (1947): 113–28.

Gottlieb, Efraim. "Kabbalah in the Writings of R. Joseph Gikatilla and in the Book *Ma'arekhet ha-elohut*" [in Hebrew]. In *Meḥkarim be-sifrut ha-kabbalah*, 257–343.

———. *Meḥkarim be-sifrut ha-kabbalah* [Studies in the Kabbalah literature]. Edited by Joseph Hacker. Tel Aviv: Chaim Rosenberg School of Jewish Studies, Tel Aviv University, 1976.

———. "Regarding the Identity of the Author of the Anonymous Commentary on *Sefer ma'arekht ha-elohut*" [in Hebrew]. In *Meḥkarim be-sifrut ha-kabbalah*, 357–70.

———. "Regarding the Kabbalistic Orientation of R. Shem Tov ibn Shem Tov" [in Hebrew]. In *Meḥkarim be-sifrut ha-kabbalah*, 357–70.

Graf (Prager), Moses. *Va-yakhel Moshe* [Moses assembled]. Dessau, 1699. Reprint, Jerusalem: Yerid Ha-sefarim, 2005.

Grafton, Anthony. *Inky Fingers: The Making of Books in Early Modern Europe*. Cambridge, MA: Belknap Press of Harvard University Press, 2020.

Grafton, Anthony, and Joanna Weinberg, with Alastair Hamilton. *"I Have Always Loved the Holy Tongue": Isaac Casaubon, the Jews, and a Forgotten Chapter in Renaissance Scholarship*. Cambridge, MA: Belknap Press of Harvard University Press, 2011.

Grant, Edward. "Celestial Orbs in the Latin Middle Ages." *Isis* 78, no. 2 (1987): 152–73.

Greenup, A. W., ed. *The Iggereth Hamudoth of Elijah Hayyim ben Benjamin of Genazzano* [in Hebrew]. London: n.p., 1912.

———. *Sefer Shekel ha-kodesh of Moses de Leon* [in Hebrew]. London: n.p., 1911.

Hackspan, Theodor. "Cabbalae Judaicae Brevis Expositio." In *Miscellaneorum Sacrorum Libri Duo*,

Quibus Eccessit Eiusdem Exercitatio de Cabbala Judaica. Altdorf, 1660.

Halbertal, Moshe. *Concealment and Revelation: Esotericism in Jewish Thought and Its Philosophical Implications*. Translated by Jackie Feldman. Princeton: Princeton University Press, 2007.

———. *Nahmanides: Law and Mysticism*. Translated by Daniel Tabak. New Haven: Yale University Press, 2020.

Halperin, David J. *The Faces of the Chariot: Early Jewish Responses to Ezekiel's Vision*. Tübingen: J. C. B. Mohr (Paul Siebeck), 1988.

Hamburger, Jeffrey. "*Haec figura demonstrat*: Diagrams in an Early-Thirteenth Century Parisian Copy of Lothar de Segni's *De Missarum Mysteriis*." *Wiener Jahrbuch für Kunstgeschichte* 58 (2009): 7–75.

Hames, Harvey J. *The Art of Conversion: Christianity and Kabbalah in the Thirteenth Century*. Leiden: Brill, 2000.

Hanegraaff, Wouter J. "Esotericism." In *Dictionary of Gnosis and Western Esotericism*, edited by Wouter Hanegraaff in collaboration with Antoine Faivre, Roelof van den Broek, and Jean-Pierre Brach, 336–40. Leiden: Brill, 2006.

———. *Esotericism and the Academy: Rejected Knowledge in Western Culture*. Cambridge: Cambridge University Press, 2012.

Harari, Yuval. "'Practical Kabbalah' and the Jewish Tradition of Magic." In "Practical Kabbalah," edited by J. H. Chajes and Yuval Harari, special issue, *Aries: Journal for the Study of Western Esotericism* 19 (2019): 38–82.

Harari, Yuval, and J. H. Chajes. "Practical Kabbalah: Guest Editors' Introduction." In "Practical Kabbalah," edited by J. H. Chajes and Yuval Harari, special issue, *Aries: Journal for the Study of Western Esotericism* 19, no. 1 (2019): 1–5.

Harding, Catherine. "Opening to God: The Cosmographical Diagrams of Opicinus de Canistris." *Zeitschrift fur Kunstgeschichte* 61, no. 1 (1998): 18–39.

Hayman, A. Peter. *Sefer Yeṣira: Edition, Translation and Text-Critical Commentary*. Tübingen: Mohr Siebeck, 2004.

Hegel, Georg Wilhelm Friedrich. *Lectures on the Philosophy of World History: Introduction; Reason in History*. Translated by H. B. Nisbet. Cambridge: Cambridge University Press, 1980.

Heller, Marvin J. "Often Overlooked: Hebrew Printing in Porstejov (Prossnitz)." In *Further Studies in the Making of the Early Hebrew Book*, 117–27. Leiden: Brill, 2013.

———. *The Seventeenth Century Hebrew Book: An Abridged Thesaurus*. 2 vols. Leiden: Brill, 2010.

Hellner-Eshed, Melila. *Seekers of the Face: Secrets of the Idra Rabba (the Great Assembly) of the Zohar*. Stanford: Stanford University Press, 2021.

Herva, Vesa-Pekka. "Maps and Magic in Renaissance Europe." *Journal of Material Culture* 15, no. 3 (2010): 323–43.

Hillel, Yaacov Moshe. *Kitvuni le-dorot*. Jerusalem: Ahavat Shalom, 1992.

Hillel, Moshe. "New Information on the History of R. Meir Poppers, His Works and Writings, and the Publication of His Book 'Or ha-bahir'—A Lurianic Commentary on Sefer ha-bahir" [in Hebrew]. Special issue, *Min ha-genazim* 14 (2021).

———. *'Over la-sofer* [Paid to the scribe]. Jerusalem: Kehillot Yisrael, 2016.

———. "The Rashash's Meditation Prayer Books: Between Tradition and Innovation." In Sabar, Schrijver, and Wiesemann, *Windows on Jewish Worlds*, 205–39.

Hock, Simon. *Die Familien Prags: Nach den Epitaphien des alten jüdischen Friedhofs in Prag*. Edited by David Kaufmann. Pressburg, 1892.

Hoffman, Adina, and Peter Cole. *Sacred Trash: The Lost and Found World of the Cairo Geniza*. New York: Schocken, 2011.

Hooper, John. "Poison Pen is Eating Away Bach's Manuscripts." *The Guardian*, January 11, 2000. https://www.theguardian.com/world/2000/jan/11/johnhooper.

Horowitz, Elliott. "The Early Eighteenth Century Confronts the Beard: Kabbalah and Jewish Self-Fashioning." *Jewish History* 8, nos. 1–2 (1994): 95–115.

Hosne, Ana Carolina. "The 'Art of Memory' in the Jesuit Missions in Peru and China in the Late 16th Century." *Material Culture Review* 76 (2012): 30–40.

Huss, Boaz. *Like the Radiance of the Sky: Chapters in the Reception History of the Zohar and the Construction of

Its Symbolic Value [in Hebrew]. Jerusalem: Ben Zvi Institute and Bialik Institute, 2008.

———. *Mystifying Kabbalah: Academic Scholarship, National Theology, and New Age Spirituality*. Translated by Elana Lutsky. New York: Oxford University Press, 2020.

———. "The Text and Context of the 1684 Sulzbach Edition of the *Zohar*." In *Tradition, Heterodoxy, and Religious Culture; Judaism and Christianity in the Early Modern Period*, edited by Chanita Goodblatt and Howard Kreisel, 117–38. Beer Sheva: Ben-Gurion University of the Negev Press, 2006.

———. "Translations of the Zohar: Historical Contexts and Ideological Frameworks." *Correspondences* 4 (2016): 81–128.

Idel, Moshe. *Absorbing Perfections: Kabbalah and Interpretation*. New Haven: Yale University Press, 2002.

———. *Ascensions on High in Jewish Mysticism: Pillars, Lines, Ladders*. Budapest: Central European University Press, 2005.

———. "*Binah*, the Eighth *Sefirah*: The Menorah in Kabbalah" [in Hebrew]. In *Le-or ha-menorah: Gilgulo shel semel*, edited by Yael Yisraeli, 129–31. Jerusalem: Israel Museum, 1998.

———. "A Commentary on the Entering of the Orchard from the Beginning of Kabbalah" [in Hebrew]. *Maḥanaim* 6 (2004): 32–39.

———. "Differing Conceptions of Kabbalah in the Early Seventeenth Century." In Twersky and Septimus, *Jewish Thought in the Seventeenth Century*, 137–200.

———. "Jewish Thinkers Versus Christian Kabbalah." In Schmidt-Biggemann, *Christliche Kabbala*, 49–65.

———. *Kabbalah and Eros*. New Haven: Yale University Press, 2005.

———. "Kabbalah, Hieroglyphicity and Hieroglyphs." *Kabbalah: Journal for the Study of Jewish Mystical Texts* 11 (2004): 11–47.

———. *Kabbalah in Italy, 1280–1510: A Survey*. New Haven: Yale University Press, 2011.

———. *Kabbalah: New Perspectives*. New Haven: Yale University Press, 1988.

———. "The Magical and Neoplatonic Interpretations of the Kabbalah in the Renaissance." In *Jewish Thought in the Sixteenth Century*, edited by Bernard Dov Cooperman, 186–242. Cambridge, MA: Harvard University Center for Jewish Studies, 1983.

———. *Messianic Mystics*. New Haven: Yale University Press, 1998.

———. *The Mystical Experience in Abraham Abulafia*. Albany: State University of New York Press, 1988.

———. "'One from a Town, Two from a Clan'—The Diffusion of Lurianic Kabbala and Sabbateanism: A Re-Examination." *Jewish History* 7, no. 2 (1993): 79–104.

———. "On Jerusalem as a Feminine and Sexual Hypostasis: From Late Antiquity Sources to Medieval Kabbalah." In *Memory, Humanity, and Meaning: Selected Essays in Honor of Andrei Pleşu's Sixtieth Anniversary Offered by New Europe College Alumni and Friends*, edited by Mihail Neamţu and Bogdan Tătaru-Cazaban, 65–110. Bucharest: Zeta Books, 2009.

———. "Particularism and Universalism in Kabbalah, 1480–1650." In *Essential Papers on Jewish Culture in Renaissance and Baroque Italy*, edited by David B. Ruderman, 324–45. New York: New York University Press, 1992.

———. "Perceptions of Kabbalah in the Second Half of the 18th Century." *Journal of Jewish Thought and Philosophy* 1 (1991): 55–114.

———. *Primeval Evil in Kabbalah: Totality, Perfection, Perfectibility*. Brooklyn: Ktav, 2020.

———. "*Prisca Theologia* in Marsilio Ficino and In Some Jewish Treatments." In *Marsilio Ficino: His Theology, His Philosophy, His Legacy*, edited by Michael Allen and Valery Rees, 137–58. Leiden: Brill, 2002.

———. "Ramon Lull and Ecstatic Kabbalah: A Preliminary Observation." *Journal of the Warburg and Courtauld Institutes* 51 (1988): 170–74.

———. *R. Menaḥem Recanati, ha-mekubal* [R. Menaḥem Recanati, the kabbalist]. 2 vols. Jerusalem: Schocken, 1998.

———. "R. Neḥemiah ben Shlomo on the Shield of David and the Name *Taftafia*: From Jewish Magic to Practical and to Theoretical Kabbalah" [in Hebrew]. In *Ta Shma: Research in Jewish Studies in Memory of Israel M. Ta-Shma*, edited by Avraham (Rami) Reiner, Moshe Idel, Moshe Halbertal, Yosef Hacker, Ephraim Kanarfogel, and Elchanan Reiner, 1:1–76. Alon Shvut: Tevunot, 2011.

———. "The *Sefirot* Above the *Sefirot*" [in Hebrew]. *Tarbiz* 51, no. 2 (1982): 239–80.

———. "Shlomo's Lost Books: On the Attitude Toward Science in *Sefer ha-meshiv*" [in Hebrew]. *Da'at* 32 (1994): 235–46.

———. "Swietlicki's *Spanish Christian Cabala*." *Jewish Quarterly Review* 78, nos. 3–4 (1988): 310–13.

———. "Visualization of Colors, I: David ben Yehudah he-Ḥasid's Kabbalistic Diagram." *Ars Judaica* 11 (2015): 31–54.

———. "Wedding Canopies for the Divine Couple in R. Moses Cordovero's Kabbalah" [in Hebrew]. In *Reflections on Booklore: Studies Presented to Avidov Lipsker*, edited by Claudia Rosenzweig, Lilach Nethanel, Rona Tausinger, and Yigal Schwartz, 21*–39*. Ramat Gan: Bar-Ilan University Press, 2020.

———. "The World of the Angels in the Image of Man" [in Hebrew]. In *Studies in Jewish Mysticism, Philosophy, and Ethical Literature Presented to Isaiah Tishby on His Seventy-Fifth Birthday*, edited by Joseph Dan and Joseph Hacker, 1–66. Jerusalem: Hebrew University Magnes Press, 1986.

Idelson-Shein, Iris. "Shabbethai Bass and the Construction—and Deconstruction—of a Jewish Library." *Jewish Culture and History* 22, no. 1 (2021): 1–16.

Isaacson, Walter. *Steve Jobs*. New York: Simon & Schuster, 2011.

Jacobs, Louis. *Hasidic Prayer*. London: Littman Library of Jewish Civilization, 1993.

Juhasz, Esther. "The '*Shiviti*-Menorah': A Representation of the Sacred; Between Spirit and Matter" [in Hebrew]. PhD diss., Hebrew University of Jerusalem, 2004.

Jurgan, Susanne, and Saverio Campanini, eds. *The Gate of Heaven: Flavius Mithridates' Latin Translation, the Hebrew Text, and an English Version*. 2 vols. Turin: Nino Aragno, 2012.

Kahana, Maoz. "The Allure of Forbidden Knowledge: The Temptation of Sabbatean Literature for Mainstream Rabbis in the Frankist Moment, 1756–1761." *Jewish Quarterly Review* 102, no. 4 (2012): 589–616.

Kalik, Judith. "Christian Kabbala and Polish Jews: Attitudes of the Church to Jewish Conversion and the Idea of 'Jacob's Return' in the Polish-Lithuanian Commonwealth." *Kwartalnik Historii Żydów = Jewish History Quarterly* 4 (2004): 492–501.

Kallus, Menachem. "Additional Witnesses to *Dapei Tziur* of RH Vital: A Survey of the Earliest Known Lurianic-Influenced Cosmographic Illustrations; Drawings and Comment in Two Early Manuscripts, from the Hand of R Menachem de Lonzano 1593(?)–1610." Unpublished paper, 2011; revised 2013. Available at Scholem Library, National Library of Israel, Jerusalem.

———. "Graphic Representation in Kabbalah, 1350–1850." Unpublished paper delivered at University of Oxford, 2009; revised 2011. Available at Scholem Library, National Library of Israel, Jerusalem.

———. "Historical Background and Methodological Considerations Concerning the Published 'Poppers Ilan': A Proposed Reconstruction of Its Formation." Unpublished paper, delivered at INASWE Conference, Jerusalem, May 2013. Available at Scholem Library, National Library of Israel, Jerusalem.

Kamenetsky, David. "From the Depths of the Heart: The Gaon and Kabbalist Rabbi Aryeh Leib Lipkin" [in Hebrew]. *Yeshurun* 23 (2010): 130–76.

Kapashian, David, ed. *'Ez ha-ḥayyim she-ba-gan: Ziyyurim ve-tavlaot le-hamḥashat ha-nosim she-ba-sefer ha-kadosh 'Ez Ḥayyim le-rabenu ha-ARIZ"L* [The Tree of Life in the garden: Pictures and tables to illustrate topics in the holy book 'Ez Ḥayyim by our teacher the Arizal]. Jerusalem: Kapashian, 2009.

Kaufmann, David. *Die letzte Vertreibung der Juden aus Wien und Niederösterreich: Ihre Vorgeschichte (1625–1670) und ihre Opfer*. Budapest, 1889.

Kelly, Joan. *Leon Battista Alberti: Universal Man of the Early Renaissance*. Chicago: University of Chicago Press, 1969.

Kelly, Thomas F. *The Role of the Scroll: An Illustrated Introduction to Scrolls in the Middle Ages*. New York: W. W. Norton, 2019.

Kemp, Martin. "The Heart." In *Christ to Coke: How Image Becomes Icon*, 81–113. Oxford: Oxford University Press, 2012.

———. "Science in Culture: Eggs and Exegesis." *Nature* 440, no. 7086 (2006): 872.

———. "Vision and Visualisation in the Illustration of Anatomy and Astronomy from Leonardo to Galileo."

In *1543 and All That: Image and Word, Change and Continuity in the Proto-Scientific Revolution*, edited by Guy Freeland and Anthony Corones, 17–51. Dordrecht: Kluwer Academic, 2000.

Kilcher, Andreas B. "Kabbalistische Buchmetaphysik: Knorrs Bibliothek und die Bedeutung des Zohar." In Schmidt-Biggemann, *Christliche Kabbala*, 211–23.

———. "Lexikographische Konstruktion der Kabbala: Die *Loci communes cabbalistici* der *Kabbala Denudata*." *Morgen-Glantz: Zeitschrift der Christian Knorr von Rosenroth-Gesellschaft* 7 (1997): 67–125.

———. "Philology as Kabbalah." In Huss, Pasi, and von Stuckrad, *Kabbalah and Modernity*, 13–28.

———. "Verhüllung und Enthüllung des Geheimnisses: Die *Kabbala Denudata* im Okkultismus der Moderne." In Kilcher and Theisohn, "*Kabbala Denudata*," 343–83.

Kilcher, Andreas B., and Philipp Theisohn, eds. "Die *Kabbala Denudata*: Text und Kontext: Akten der 15. Tagung der Christian Knorr von Rosenroth-Gesellschaft," special issue, *Morgen-Glantz: Zeitschrift der Christian Knorr von Rosenroth-Gesellschaft* 16 (2006).

Klapisch-Zuber, Christiane. "The Genesis of the Family Tree." *I Tatti: Studies in the Italian Renaissance* 4 (1991): 105–29.

———. *Stammbäume: Eine illustrierte Geschichte der Ahnenkunde*. Munich: Knesebeck, 2004.

Klatzkin, Jacob. *Ozar ha-munaḥim ha-filosofiyim ve-etnologia philosophit* [*Thesaurus philosophicus linguae hebraicae et veteris et recentioris*]. 3 vols. Berlin: Eschkol, 1928–33.

Kline, Naomi Reed. *Maps of Medieval Thought: The Hereford Paradigm*. Woodbridge, UK: Boydell Press, 2003.

Knorr von Rosenroth, Christian. *Kabbala Denudata*. Sulzbach, 1677–84. Facsimile ed. 2 vols. Hildesheim: Georg Olms, 1974.

Kogman-Appel, Katrin. *Catalan Maps and Jewish Books: The Intellectual Profile of Elisha ben Abraham Cresques (1325–1387)*. Turnhout: Brepols, 2020.

———. "The Messianic Sanctuary in Late Fifteenth-Century Sepharad: Isaac de Braga's Bible and the Reception of Traditional Temple Imagery." In *Between Jerusalem and Europe: Essays in Honour of Bianca Kühnel*, edited by Renana Bartal and Hanna Vorholt, 233–54. Leiden: Brill, 2015.

———. "The Role of Hebrew Letters in Making the Divine Visible." In *Sign and Design: Script as Image in Cross-Cultural Perspective (300–1600 CE)*, edited by Brigitte M. Bedos-Rezak and Jeffrey F. Hamburger, 153–71. Washington, DC: Dumbarton Oaks Research Library and Collection, 2016.

Koren, Sharon Faye. "Kabbalistic Physiology: Isaac the Blind, Nahmanides, and Moses de Leon on Menstruation." *AJS Review* 28, no. 2 (2004): 317–39.

Krämer, Sybille. *Figuration, Anschauung, Erkenntnis: Grundlinien einer Diagrammatologie*. Frankfurt am Main: Suhrkamp, 2016.

———. "'Schriftbildlichkeit' oder: Über eine (fast) vergessene Dimension der Schrift." In *Bild, Schrift, Zahl*, edited by Sybille Krämer and Horst Bredekamp, 157–76. Munich: Wilhelm Fink, 2003.

Krämer, Sybille, and Christina Ljungberg, eds. *Thinking with Diagrams: The Semiotic Basis of Human Cognition*. Berlin: De Gruyter, 2016.

Kupfer, Marcia A. *Art and Optics in the Hereford Map: An English Mappa Mundi, c. 1300*. New Haven: Yale University Press, 2016.

Kupfer, Marcia, Adam S. Cohen, and J. H. Chajes, eds. *The Visualization of Knowledge in Medieval and Early Modern Europe*. Turnhout: Brepols, 2020.

Lachter, Hartley. "An Anonymous Commentary on the Ten *Sefirot*: Text and Translation." In *To Fix Torah in their Hearts: Essays on Biblical Interpretation and Jewish Studies in Honor of B. Barry Levy*, edited by Jaqueline S. du Toit, Jason Kalman, Hartley Lachter, and Vanessa R. Sasson, 331–72. Cincinnati: Hebrew Union College Press, 2018.

Ladner, Gerhart B. "Medieval and Modern Understanding of Symbolism: A Comparison." *Speculum* 54, no. 2 (1979): 223–56.

Lawee, Eric. "Graven Images, Astromagical Cherubs, and Mosaic Miracles: A Fifteenth-Century Curial-Rabbinic Exchange." *Speculum* 81, no. 3 (2006): 754–95.

Lefler, Noam. "'When They Came to Take Her from the Clouds She was Already Adorned': The Homily of the Generation of the Flood in *And I Came This Day unto the Fountain*" [in Hebrew]. In *And I Came*

This Day unto the Fountain, edited by Paweł Maciejko, 211–42. Los Angeles: Cherub Press, 2014.

Leitão, José Vieira. "A Very Handsome Book: A Case Study on the Reception of Heinrich Cornelius Agrippa in Portugal." *Melancolia: Revista de Historia del Centro de Estudios sobre el Esoterismo Occidental de la UNASUR* 5 (2020): 54–80.

Lelli, Fabrizio. "L'albero sefirotico di Eliyyà Menaḥem ben Abba Mari Ḥalfan (Ms. Firenze, Biblioteca Medicea Laurenziana, Plut. 44, 18)." *Rinascimento*, 2nd ser., 48 (2008): 271–90.

———. *Eliyyah Hayim ben Binyamin of Genazzano: La lettera preziosa*. Florence: Giuntina, 2002.

———. "Osservazioni sull'uso del termine ṣiyyur in alcuni trattati cabbalistici dell'Italia rinascimentale." *Materia giudaica* 15–16 (2010–11): 331–38.

Leon, Moses de. *Ha-nefesh ha-ḥakhamah*. Basel, 1608.

Lev El, Noam. "On the Editions of R. Menachem Azariah da Fano's *Sefer Pelaḥ ha-rimon*" [in Hebrew]. *Kabbalah: Journal for the Study of Jewish Mystical Texts* 42 (2018): 209–36.

———. "Organization, Clarification, and Reception of Kabbalistic Knowledge: Moses Cordovero and Menachem Azariah da Fano." MA thesis, Hebrew University of Jerusalem, 2020.

Levie Bernfeld, Tirtsah. "Confrontation Between East and West: Balkan Sephardim in Early Modern Amsterdam." In *Caminos de leche y miel: Jubilee Volume in Honor of Michael Studemund-Halévy*, vol. 1, *History and Culture*, edited by Harm den Boer, Anna Menny, and Carsten L. Wilke, 328–62. Barcelona: Tirocinio, 2018.

Levin, Benjamin M., ed. *Oẓar ha-geonim* [Thesaurus of the geonic responsa]. Vol. 4, *Ḥagigah*. Jerusalem: Hebrew University Press, 1931.

Levine, Hillel. "Paradise Not Surrendered: Jewish Reactions to Copernicus and the Growth of Modern Science." In *Epistemology, Methodology and the Social Sciences*, edited by R. S. Cohen and Marx W. Wartofsky, 203–25. Dordrecht: Reidel, 1983.

Levine, Shalom DovBer, ed. *Mibeis HaGenozim* [Treasures from the Chabad library]. Brooklyn: Kehot, 2009.

Levinsohn, Isaac Baer. *Beit Yehudah* [in Hebrew]. 2 vols. Vilna, 1858.

Liebes, Yehuda. *The Cult of the Dawn: The Attitude of the Zohar Towards Idolatry* [in Hebrew]. Jerusalem: Karmel, 2011.

———. "New Directions in the Study of Kabbalah" [in Hebrew]. *Pe'amim* 50 (1992): 150–70.

———. "*Perakim be-milon sefer ha-Zohar*" [Chapters of a Zohar dictionary]. PhD diss., Hebrew University of Jerusalem, 1976.

———. "Sabbetai Zevi's Religious Faith." In *Studies in Jewish Myth and Jewish Messianism*, translated by Batya Stein, 107–14. Albany: State University of New York Press, 1993.

———. "Shabbetai Zevi's View of His Conversion" [in Hebrew]. In Liebes, *Sod ha-emunah ha-Shabtait*, 20–34.

———. *Sod ha-emunah ha-Shabtait*. Jerusalem: Bialik Institute, 1995.

———. "Towards a Study of the Author of '*Emek ha-melekh*: His Personality, Writings, and Kabbalah" [in Hebrew]. *Jerusalem Studies in Jewish Thought* 11 (1993): 101–37.

———. "The Vilner Gaon School, Sabbateanism, and *Dos Pintele Yid*" [in Hebrew]. *Da'at* 50/52 (2003): 255–90.

———. "The Zoharic Story: Occurrences of Hurmenuta and Semitra" [in Hebrew]. In *The Zoharic Story*, edited by Yehuda Liebes, Jonathan M. Benarroch, and Melila Hellner-Eshed, 1:14–40. Jerusalem: Ben Zvi Institute, 2017.

Lipkin, Aryeh Leib, and Aharon Meir Altshuler, eds. *Sefer ilan ha-gadol*. Warsaw, 1893.

Loewe, Herbert. *Catalogue of the Manuscripts in the Hebrew Character Collected and Bequeathed to Trinity College Library by the Late William Aldis Wright*. Cambridge: University Press, 1926.

Lüthy, Christoph. "Bruno's *Area Democriti* and the Origins of Atomist Imagery." *Bruniana and Campanelliana* 4, no. 1 (1998): 59–92.

———. "Centre, Circle, Circumference: Giordano Bruno's Astronomical Woodcuts." *Journal for the History of Astronomy* 41 (2010): 311–27.

Lüthy, Christoph, and Alexis Smets. "Words, Lines, Diagrams, Images: Towards a History of Scientific Imagery." *Early Science and Medicine* 14 (2009): 398–439.

Luzzato, Moses Ḥayyim. *Igrot Ramḥal u-vene doro.* Edited by Mordekhai Shriki. Jerusalem: Mekhon Ramḥal, 2001.

———. *Shaʿarei Ramḥal.* Edited by Ḥayyim Friedlander. Bnei Brak: Sifriati, 1989.

Maciejko, Paweł, ed. *Sabbatian Heresy: Writings on Mysticism, Messianism, and the Origins of Jewish Modernity.* Waltham: Brandeis University Press, 2017.

Magee, Glenn Alexander. *Hegel and the Hermetic Tradition.* Ithaca: Cornell University Press, 2001.

Magid, Shaul. *From Metaphysics to Midrash: Myth, History, and the Interpretation of Scripture in Lurianic Kabbala.* Bloomington: Indiana University Press, 2008.

Margoliouth, G. *Catalogue of the Hebrew and Samaritan Manuscripts in the British Museum.* Part III. London: British Museum, 1915.

Mathiesen, Robert. "The Key of Solomon: Toward a Typology of the Manuscripts." *Societas Magica Newsletter* 17 (2007): 1–9.

Matt, Daniel C., trans. and comm. "Idra rabba." In Matt, *The Zohar*, 8:318–459.

———. *The Zohar = Sefer ha-Zohar: Pritzker Edition.* Translated by Daniel C. Matt. Vol. 1. Stanford: Stanford University Press, 2004.

———. *The Zohar = Sefer ha-Zohar: Pritzker Edition.* Translated by Daniel C. Matt. Vol. 4. Stanford: Stanford University Press, 2007.

———. *The Zohar = Sefer ha-Zohar: Pritzker Edition.* Translated by Daniel C. Matt. Vol. 5. Stanford: Stanford University Press, 2009.

———. *The Zohar = Sefer ha-Zohar: Pritzker Edition.* Translated by Daniel C. Matt. Vol. 8. Stanford: Stanford University Press, 2014.

Mazzeo, Tilar J. *Plagiarism and Literary Property in the Romantic Period.* Philadelphia: University of Pennsylvania Press, 2007.

McKenzie, D. F. *Bibliography and the Sociology of Texts.* Cambridge: Cambridge University Press, 1999.

Meir, Jonatan. "Haskalah and Esotericism in Galicia: The Unpublished Writings of Elyakim Gezel Hamilzahgi" [in Hebrew]. *Kabbalah: Journal for the Study of Jewish Mystical Texts* 33 (2015): 273–313.

———. "Haskalah, Kabbalah and Mesmerism: The Case of Isaac Baer Levinsohn" [in Hebrew]. In *Am ve-ʿolam: Shai le-Yiśraʾel Barṭal* (Am ve-olam, A Tribute to Israel Bartal), edited by Dimitry Shumsky, Jonatan Meir, and Gershon D. Hundert, 137–57. Jerusalem: Zalman Shazar, 2019.

Melamed, Abraham. *The Myth of the Jewish Origins of Science and Philosophy* [in Hebrew]. Jerusalem: Hebrew University Magnes Press; Haifa: University of Haifa Press, 2010.

Melion, Walter S. "*Ad ductum itineris et dispositionem mansionum ostendendam*: Meditation, Vocation, and Sacred History in Abraham Ortelius's *Parergon.*" *Journal of the Walters Art Gallery* 57 (1999): 49–72.

Menaḥem Azariah da Fano. *Pelaḥ ha-rimon.* Venice, 1600.

———. *Sefer shivʿim ve-shtayim yediʿot.* Lemberg, 1867.

Meroz, Ronit. "An Anonymous Commentary on *Idra Rabba* by a Member of the Saruq School, Or: What Threads Run Between Saruq, Spinoza and Others" [in Hebrew]. *Jerusalem Studies in Jewish Thought* 12 (1997): 307–78.

———. "Between *Sefer Yezirah* and Wisdom Literature: Three Binitarian Approaches in *Sefer Yezirah.*" *Journal for the Study of Religions and Ideologies* 6, no. 18 (2007): 101–42.

———. "Contrasting Opinions Among the Founders of R. Israel Sarug's School." In *Expérience et écriture mystiques dans les religions du Livre: Actes d'un colloque international tenu par le Centre d'études juives Université de Paris IV-Sorbonne 1994*, edited by Paul B. Fenton and Roland Goetschel, 191–202. Leiden: Brill, 2000.

———. "Faithful Transmission Versus Innovation: Luria and His Disciples." In *Gershom Scholem's "Major Trends in Jewish Mysticism" 50 Years After: Proceedings of the Sixth International Conference on the History of Jewish Mysticism*, edited by Peter Schäfer and Joseph Dan, 257–74. Tübingen: J. C. B. Mohr (Paul Siebeck), 1993.

———. "R. Israel Sarug, Student of the AR"I—A New Examination of the Problem" [in Hebrew]. *Daʿat* 28 (1992): 41–50.

———. "The Saruk School: A New History" [in Hebrew]. *Shalem* 7 (2002): 151–93.

———. "The Tree That Is an Angel: On a Binitarian Approach Reflected in *Sefer HaBahir.*" *Jewish Thought* 2 (2020): 218–49.

Messas, Joseph. *Oẓar ha-mikhtavim.* Vol. 1. Jerusalem: Isaac Abukasis, 1968.

Michelini Tocci, F. "Una tecnica recitativa e respiratoria di tipo sufico nel libro *La Luce dell'Intelletto* di Abraham Abulafia." *Annali della Facoltà di lingue e letterature straniere di Ca' Foscari* 14 (1975): 221–36.

Michman, Jozeph. *David Franco Mendes: A Hebrew Poet*. Amsterdam: Joachimsthal, 1951.

Morlok, Elke. *Rabbi Joseph Gikatilla's Hermeneutics*. Tübingen: Mohr Siebeck, 2011.

Mulsow, Martin. "Antiquarianism and Idolatry: The *Historia* of Religions in the Seventeenth Century." In *Historia: Empiricism and Erudition in Early Modern Europe*, edited by Gianna Pomata and Nancy G. Siraisi, 181–209. Cambridge, MA: MIT Press, 2005.

Murdoch, John E. *Antiquity and the Middle Ages. Album of Science* 3. New York: Scribner, 1984.

Nadav, Yael. "An Epistle of the Qabbalist R. Isaac Mar Ḥayyim Concerning the Doctrine of 'Supernal Lights'" [in Hebrew]. *Tarbiz* 26, no. 4 (1957): 440–58.

———. "Rabbi Shlomo Ayllon and His Sabbatian Kabbalah Booklet" [in Hebrew]. *Sefunot: Studies and Sources on the History of the Jewish Communities in the East* 3–4 (1960): 301–47.

Necker, Gerold. *Einführung in die lurianische Kabbala*. Frankfurt am Main: Verlag der Weltreligionen, 2008.

Neher, André. "Copernicus in the Hebraic Literature from the Sixteenth to the Eighteenth Century." *Journal of the History of Ideas* 38, no. 2 (1977): 211–26.

Nerlich, Michael. "Qu'est-ce qu'un iconotexte? Réflexions sur le rapport texte-image photographique dans *La Femme se découvre* d'Evelyne Sinnassamy." In *Iconotextes*, edited by Alain Montandon, 255–302. Paris: C.R.C.D.-Ophrys, 1990.

Neubauer, Adolf. *Catalogue of the Hebrew Manuscripts in the Bodleian Library and in the College Libraries of Oxford*. Vol. 1. Oxford: Clarendon Press, 1886.

Norbye, Marigold Anne. "*Arbor genealogiae*: Manifestations of the Tree in French Royal Genealogies." In Salonius and Worm, *The Tree*, 69–93.

Norman, Jesse. *After Euclid: Visual Reasoning and the Epistemology of Diagrams*. Stanford: CSLI, 2006.

Obrist, Barbara. "Wind Diagrams and Medieval Cosmology." *Speculum* 72, no. 1 (1997): 33–84.

Ogren, Brian. *The Beginning of the World in Renaissance Jewish Thought: "Ma'aseh Bereshit" in Italian Jewish Philosophy and Kabbalah, 1492–1535*. Leiden: Brill, 2016.

Olszowy-Schlanger, Judith. "Cheap Books in Medieval Egypt: Rotuli from the Cairo Geniza." *Intellectual History of the Islamicate World* 4 (2016): 82–101.

O'Reilly, Jennifer. *Studies in the Iconography of the Virtues and Vices in the Middle Ages*. New York: Garland, 1988.

Oron, Michal. *Sefer ha-Shem: Attributed to R. Moses de León* [in Hebrew]. Los Angeles: Cherub Press, 2010.

Pachter, Mordechai. "Circles and Straightness: A History of an Idea." In *Roots of Faith and Devequt: Studies in the History of Kabbalistic Ideas*, 131–85. Los Angeles: Cherub Press, 2004.

Papo, Eliezer. "'Meliselda' and Its Symbolism for Sabbatai Ṣevi, His Inner Circle and His Later Followers." *Kabbalah: Journal for the Study of Jewish Mystical Texts* 35 (2016): 113–32.

Parpola, Simo. "The Assyrian Tree of Life: Tracing the Origins of Jewish Monotheism and Greek Philosophy." *Journal of Near Eastern Studies* 52, no. 3 (1993): 161–208.

Pedaya, Haviva. *Nachmanides: Cyclical Time and Holy Text* [in Hebrew]. Tel Aviv: Am Oved, 2003.

———. "*Ziyyur* and *Temunah* in the Kabbalistic Exegesis of Nachmanides" [in Hebrew]. *Maḥanaim* 6 (1993): 114–23.

Peleg, Erez. "On the Kabbalistic Literary Activities of Rabbi Aryeh Lipkin of Krotinga." *Da'at* 79/80 (2015): 137–51.

Pines, Shlomo, ed. and trans. *The Guide of the Perplexed by Moses Maimonides*. Chicago: University of Chicago Press, 1963.

Poppers, Meir. *Or zaru'a* [Light is sown]. Jerusalem: Ahavat Shalom, 1985.

———. *Torah or* [Torah light]. Jerusalem: Sofer, 1989.

Porat, Oded. "Aimed Inquiry and Positive Theology in *Sefer Ma'ayan ha-Ḥokhmah*." *Journal of Jewish Thought and Philosophy* 24, no. 2 (2016): 224–78.

———. *"Founding of the Circle": Rudiments of Esse and Linguistic Creation in "The Book of Fountain of Wisdom" and Its Related Treatises* [in Hebrew]. Los Angeles: Cherub Press, 2020.

Ramalho, Américo da Costa. "Ropicapnefma: Um bibiónimo mal enxertado." *Humanitas* 27–28 (1975): 201–8.

Randles, W. G. L. *The Unmaking of the Medieval Christian Cosmos, 1500–1760: From Solid Heavens to Boundless Aether*. Aldershot, UK: Ashgate, 1999.

Philosophique de la France et de l'Étranger 157 (1967): 165–85.

Richarz, Monika. *Der Eintritt der Juden in die akademischen Berufe: Jüdische Studenten und Akademiker in Deutschland, 1678–1848*. Tübingen: J. C. B. Mohr, 1974.

Richler, Benjamin, ed. *Hebrew Manuscripts in the Vatican Library: Catalogue*. Palaeographical and codicological descriptions by Malachi Beit-Arié with Nurit Pasternak. Vatican City: Biblioteca Apostolica Vaticana, 2008.

Riemer, Nathanael. "The *Mystery of Adam, David, Messiah*: Reincarnations of the Messianic Soul in 'Beer Sheva' (Seven Wells) by R. Beer Perlhefter." *Kabbalah: Journal for the Study of Jewish Mystical Texts* 26 (2012): 117–34.

———. *Zwischen Tradition und Häresie: "Beer Sheva," eine Enzyklopädie des jüdischen Wissens der Frühen Neuzeit*. Wiesbaden: Harrassowitz, 2010.

Rosenberg, Daniel, and Anthony Grafton. *Cartographies of Time: A History of the Timeline*. New York: Princeton Architectural Press, 2010.

Róth, Ernst. *Hebräische Handschriften*. Part 2. Edited by Hans Striedl with Lothar Tetzner. Wiesbaden: Franz Steiner, 1965.

Rubin, Rehav (Buni). *Portraying the Land: Hebrew Maps of the Land of Israel from Rashi to the Early 20th Century* [in Hebrew]. Jerusalem: Ben Zvi Institute, 2014.

Rudavsky, T. M. *Jewish Philosophy in the Middle Ages: Science, Rationalism, and Religion*. Oxford: Oxford University Press, 2018.

Ruderman, David B. "The Italian Renaissance and Jewish Thought." In *Renaissance Humanism: Foundation, Forms, and Legacy*, vol. 1, *Humanism in Italy*, edited by A. Rabil Jr., 382–433. Philadelphia: University of Pennsylvania Press, 1988.

———. *Jewish Thought and Scientific Discovery in Early Modern Europe*. New Haven: Yale University Press, 1995.

———. "The Mental Image of Two Cherubim in Pinḥas Hurwitz's *Sefer ha-brit*: Some Conjectures" [in Hebrew]. In *Picturing the Past: Essays in Honor of Richard I. Cohen*, edited by Ezra Mendelsohn, 289–300. Jerusalem: Shazar, 2016.

———. "Science, Medicine, and Jewish Culture in Early Modern Europe." *Spiegel Lectures in European Jewish History* 7 (1987): 1–36.

Sabar, Shalom, Emile Schrijver, and Falk Wiesemann, eds. *Windows on Jewish Worlds: Essays in Honor of William Gross, Collector of Judaica, on the Occasion of His Eightieth Birthday*. Zutphen, NL: Walburg Pers, 2019.

Saiber, Arielle. *Giordano Bruno and the Geometry of Language*. Aldershot, UK: Ashgate, 2005.

———. "Ornamental Flourishes in Giordano Bruno's Geometry." *Sixteenth Century Journal* 34, no. 3 (2003): 729–45.

Salonius, Pippa. "The Tree of Life in Medieval Iconography." In *The Tree of Life*, edited by Douglas Estes, 280–343. Leiden: Brill, 2020.

Salonius, Pippa, and Andrea Worm, eds. *The Tree: Symbol, Allegory, and Mnemonic Device in Medieval Art and Thought*. Turnhout: Brepols, 2014.

Sansó, Julio, and Juan Casanovas. "Cosmografía, astrología y calendario." In *El atlas catalán de Cresques Abraham*, edited by Lluís Mercadé Nubiola, 23–36. Barcelona: Diáfora, 1975.

Saraiva de Carvalho, João Manuel de Almeida. "The Fellowship of St Diogo: New Christian Judaisers in Coimbra in the Early 17th Century." PhD diss., University of Leeds, 1990.

Sarfati, Rachel. *The Florence Scroll: A Fourteenth-Century Pictorial Pilgrimage from Egypt to the Land of Israel* [in Hebrew]. Jerusalem: Ben Zvi Institute, 2020.

Saruq, Israel (attributed on title page to Ḥayyim Vital). *Limmudei azilut*. Munkatch [Mukachevo], Ukraine: Samuel Kahn, 1897.

Sasson, Abraham. *Apiryon Shlomo: Hu kol sasson ḥelek sheni*. Venice, 1608.

Scafi, Alessandro. *Mapping Paradise: A History of Heaven on Earth*. Chicago: University of Chicago Press, 2006.

Schadt, Hermann. *Die Darstellungen der Arbores consanguinitatis und der Arbores affinitatis: Bildschemata in juristischen Handschriften*. Tübingen: Wasmuth, 1982.

Schäfer, Peter. *The Hidden and Manifest God: Some Major Themes in Early Jewish Mysticism*. Albany: State University of New York Press, 1992.

Schmidt-Biggemann, Wilhelm, ed. *Christliche Kabbala*. Ostfildern: Thorbecke, 2003.

———. "Christliche Kabbala oder Philosophia Hebraeorum: Die Debatte zwischen Knorr von Rosenroth und Henry More um die rechte Deutung der Kabbala." *Morgen-Glantz: Zeitschrift der Christian Knorr von Rosenroth-Gesellschaft* 16 (2006): 285–322.

———. *Geschichte der christlichen Kabbala.* Vol. 3, *1660–1850.* Stuttgart: Frommann-Holzboog, 2013.

———. "Knorr von Rosenroths missionarische Intentionen." *Morgen-Glantz: Zeitschrift der Christian Knorr von Rosenroth-Gesellschaft* 20 (2010): 189–204.

Schochet, Jacob Immanuel, ed. *Keter shem tov ha-shalem.* Brooklyn: Kehot, 2004.

Scholem, Gershom. *Be-'iḳvot mashiaḥ.* Jerusalem: Sifrei Tarshish, 1944.

———. *Ḥalomotav shel ha-Shabtai R' Mordechai Ashkenazi.* Jerusalem: Schocken, 1938.

———. "Index to Commentaries on the Ten Sefirot" [in Hebrew]. *Kirjath sepher* 10 (1933–34): 498–515.

———. *Jewish Gnosticism, Merkabah Mysticism, and Talmudic Tradition.* New York: Jewish Theological Seminary of America, 1960.

———. "Kabbala." In *Encyclopaedia Judaica: Das Judentum in Geschichte und Gegenwart,* edited by Ismar Elbogen and Jakob Klatzkin, 9:630–732. Berlin: Eschkol, 1932.

———. *Kabbalah.* New York: New York Times Books, 1974.

———. *Kuntress 'alu le-Shalom: Desiderata in Kabbala and Jewish Mysticism* [in Hebrew]. Jerusalem: Scholem, 1937.

———. *Magen David: The History of a Symbol; Expanded Edition, Including Additions From the Author's Estate* [in Hebrew]. Ein Harod: Mishkan le-Omanut, 2009.

———. *Major Trends in Jewish Mysticism.* Jerusalem: Schocken, 1941.

———. "Notes to Sonne's Article on R. Jacob Ẓemaḥ" [in Hebrew]. *Kirjath sepher* 27 (1951): 107–9.

———. "On the Biography and Literary Activity of the Kabbalist R. Jacob Ẓemaḥ" [in Hebrew]. *Kirjath sepher* 26 (1950): 185–94.

———. *Origins of the Kabbalah.* Philadelphia: Jewish Publication Society; Princeton: Princeton University Press, 1987.

———. "R. Israel Sarug: Student of the AR″I?" [in Hebrew]. *Zion* 5 (1940): 214–43.

———. *Sabbatai Ṣevi: The Mystical Messiah, 1626–1676.* Princeton: Princeton University Press, 1973.

———. "Seridei sifro shel R. Shem Tob ibn Gaon 'al yesodot torat ha-sefirot." *Kirjath sepher* 8 (1932): 397–408, 534–42; 9 (1932–33): 126–33.

———. "Zehn unhistorische Sätze über Kabbala." In *Geist und Werk, aus der Werkstatt unserer Autoren: Zum 75 Geburtstag von Dr. Daniel Brody,* 209–15. Zurich: Rhein, 1958.

Schrire, Theodore. *Hebrew Amulets: Their Decipherment and Interpretation.* London: Routledge & Kegan Paul, 1966.

Schulte, Christoph. *Zimzum: Gott und Weltursprung.* Berlin: Suhrkamp, 2014.

Schwager, Lipa, and David Fränkel, eds. *Reshimah mi-sefarim yeshanim yekirei ha-meziyut (Incunabeln) ha-'omdim le-mekhirah ezel L. Schwager & D. Fränkel, Husiatyn, (Oesterreich).* Cat. no. 14. Husiatyn, 1907.

Schwartz, Dov. *Studies on Astral Magic in Medieval Jewish Thought.* Translated by David Louvish and Batya Stein. Leiden: Brill, 2004.

———. "Towards the Study of the Sources of R. Meir Aldabi's *Shevilei emunah*" [in Hebrew]. *Sinai* 114 (1994): 72–77.

Sed-Rajna, Gabrielle. "Un diagramme kabbalistique de la bibliothèque de Gilles de Viterbe." In *Hommage à Georges Vajda: Études d'histoire et de pensée juives,* edited by Gérard Nahon and Charles Touati, 363–76. Louvain: Peeters, 1980.

Sefer ha-temunah. Korets, 1784.

Segol, Marla. *Word and Image in Medieval Kabbalah: The Texts, Commentaries, and Diagrams of the "Sefer Yetsirah."* New York: Palgrave Macmillan, 2012.

Sela, Shlomo, ed. *Abraham Ibn Ezra's Introductions to Astrology: A Parallel Hebrew-English Critical Edition of the Book of the Beginning of Wisdom and the Book of the Judgments of the Zodiacal Signs.* Leiden: Brill, 2017.

Selcer, Daniel. "The Mask of Copernicus and the Mark of the Compass: Bruno, Galileo, and the Ontology of the Page." In *Thinking Allegory Otherwise,* edited by Brenda Machosky, 60–86. Stanford: Stanford University Press, 2010.

Sendor, Mark Brian. "The Emergence of Provençal Kabbalah: Rabbi Isaac the Blind's *Commentary on Sefer Yezirah.*" 2 vols. PhD diss., Harvard University, 1994.

Septimus, Bernard. "What Did Maimonides Mean by *Madda'*?" In *Me'ah she'arim: Studies in Medieval Jewish Spiritual Life in Memory of Isadore Twersky*, edited by Ezra Fleischer, Gerald Blidstein, Carmi Horowitz, and Bernard Septimus, 83–110. Jerusalem: Hebrew University Magnes Press, 2001.

Seroussi, Edwin. "Rabbi Menaḥem de Lonzano: Ethnomusicologist" [in Hebrew]. In *Prof. Meir Benayahu Memorial Volume*, edited by Moshe Bar Asher, Yehuda Liebes, Moshe Assis, and Yosef Kaplan, 1:597–620. Jerusalem: Carmel, 2019.

Shalev, Zur. *Sacred Words and Worlds: Geography, Religion and Scholarship, 1550–1700*. Leiden: Brill, 2012.

Sherman, Claire Richter, ed. *Writing on Hands: Memory and Knowledge in Early Modern Europe*. Carlisle, PA: Trout Gallery, Dickinson College; Washington, DC: Folger Shakespeare Library, 2000.

Sisman, Cengiz. *The Burden of Silence: Sabbatai Ṣevi and the Evolution of the Ottoman-Turkish Dönmes*. Oxford: Oxford University Press, 2015.

Skinner, Stephen. *Terrestrial Astrology: Divination by Geomancy*. London: Routledge & Kegan Paul, 1980.

Smith, David Chaim. *Deep Principles of Kabbalistic Alchemy*. N.p.: David Chaim Smith, 2017.

Sobol, Neta. *Transgression of the Torah and the Rectification of God: The Theosophy of Idra Rabba in the Zohar and Its Unique Status in Thirteenth-Century Spanish Kabbalah* [in Hebrew]. Los Angeles: Cherub Press, 2017.

Sofer, Gal. "The Hebrew Manuscripts of *Mafte'aḥ Shelomoh* and an Inquiry into the Magic of the Sabbateans" [in Hebrew]. *Kabbalah: Journal for the Study of Jewish Mystical Texts* 32 (2014): 135–74.

Sonne, Isaia. "I dati biografici contenuti negli scritti di Shelomoh Molco riesaminati alla luce di un nuovo documento." *Annuario di studi ebraici* 1 (1934): 183–204.

———. "On R. Jacob Ẓemaḥ" [in Hebrew]. *Kirjath sepher* 27 (1951): 97–106.

———. "The Place of Kabbalah as a Means of Incitement of the Church in the Seventeenth Century" [in Hebrew]. *Bitzaron* 18–19 (1957): 7–12, 57–66.

Spector, Sheila A., trans. and ed. *Francis Mercury van Helmont's "Sketch of Christian Kabbalism."* Leiden: Brill, 2012.

Sperber, Daniel. "Jerusalem: Axis Mundi." *Jerusalem and Eretz Israel* 12–13 (2020): 7*–90*.

———. *Minhagei Yisrael*. 8 vols. Jerusalem: Mosad HaRav Kook, 1990.

Springer, Daniel. *Derekh ha-nesher: Divrei ha-yamim shel ha-kaysar Leopoldus be-loshon ha-kodesh, ve-arami, ve-lashon Ashkenaz*. Dyhernfurth [Wrocław], 1705.

Stallybrass, Peter. "Books and Scrolls: Navigating the Bible." In *Books and Readers in Early Modern England: Material Studies*, edited by Jennifer Andersen and Elizabeth Sauer, 42–79. Philadelphia: University of Pennsylvania Press, 2002.

Steimann, Ilona. "Jewish Scribes and Christian Patrons: The Hebraica Collection of Johann Jakob Fugger." *Renaissance Quarterly* 70, no. 4 (2017): 1235–81.

Steinschneider, Moritz. *Die Handschriften Verzeichnisse der Königlichen Bibliothek zu Berlin: Verzeichniss der hebraeischen Handschriften*. Vol. 1, part 2. Berlin, 1878.

Stillman, Avinoam J. "Living Leaves: Printing Kabbalah at Korets, 1778–1786." MA thesis, Ben Gurion University of the Negev, 2019.

———. "Nathan of Gaza, Ya'akov Koppel Lifshitz, and the Varieties of Lurianic Kabbalah." *El Prezente: Journal for Sephardic Studies* 12–13 (2018–19): 198–227.

———. "A Printed Primer of Kabbalistic Knowledge: *Sha'arei Orah* in East-Central Europe." *European Journal of Jewish Studies* 15 (2021): 1–28.

Stolzenberg, Daniel. "Four Trees, Some Amulets, and the Seventy-two Names of God: Kircher Reveals the Kabbalah." In *Athanasius Kircher: The Last Man Who Knew Everything*, edited by Paula Findlen, 143–63. New York: Routledge, 2004.

Sweeney, Marvin A. "Dimensions of the Shekhinah: The Meaning of the *Shiur Qomah* in Jewish Mysticism, Liturgy, and Rabbinic Thought." *Hebrew Studies* 54 (2013): 107–20.

Tamari, Assaf M. "The Body Discourse of Lurianic Kabbalah" [in Hebrew]. PhD diss., Ben-Gurion University of the Negev, 2016.

Telle, Joachim. "Knorr von Rosenroth." In *Killy Literaturlexikon: Autoren und Werke des deutschsprachigen Kulturraums*, edited by Wilhelm Kühlmann, 6:528–30. Berlin: De Gruyter, 2009.

Temerles, Eliezer. "Twenty-Two Principles" [in Hebrew]. In Jacob Temerles, *Sifra de-zniyuta de-Ya'akov*, 3a–4b. Amsterdam, 1699.

Teplitsky, Joshua. *Prince of the Press: How One Collector Built History's Most Enduring and Remarkable Jewish Library*. New Haven: Yale University Press, 2019.

Theisohn, Philipp. "Zur Rezeption von Naphtali Herz Bacharachs *Sefer Emeq ha-Melech* in der *Kabbala Denudata*." In Kilcher and Theisohn, "*Kabbala Denudata*," 221–41.

Tirosh-Samuelson, Hava. "Kabbalah and Science in the Middle Ages." In *Science in Medieval Jewish Cultures*, edited by Gad Freudenthal, 476–510. Cambridge: Cambridge University Press, 2012.

Tishby, Isaiah. "Between Sabbateanism and Hasidism: The Sabbateanism of the Kabbalist R. Ya'aqov Kopel Lifshitz of Miedzyrec" [in Hebrew]. In Tishby, *Netivei emunah u-minut*, 204–26.

———. "The Confrontation Between Lurianic Kabbalah and Cordoverian Kabbalah in the Writings of R. Aharon Berakhia Modena" [in Hebrew]. *Zion* 39 (1974): 8–85.

———. "The Controversy Regarding the Zohar in Sixteenth-Century Italy" [in Hebrew]. In *Ḥikrei kabbalah u-shluḥoteha*, 1:131–82. Jerusalem: Hebrew University Magnes Press, 1982.

———. *The Doctrine of Evil in Lurianic Kabbalah*. Translated by David Solomon. London: Kegan Paul, 2002.

———. "The First Sabbatean 'Maggid' in the Academy of R. Abraham Rovigo" [in Hebrew]. In Tishby, *Netivei emunah u-minut*, 81–107, 295–305.

Trachtenberg, Joshua. *Jewish Magic and Superstition: A Study in Folk Religion*. New York: Behrman's Jewish Book House, 1939.

Turg'eman, Ohad, ed. *Even ha-shoham of Yosef Tsiyah* [The onyx stone of Yosef Tsiyah]. Jerusalem: Sages of Jerusalem Institute, 2019.

Twersky, Isadore, and Bernard Septimus, eds. *Jewish Thought in the Seventeenth Century*. Cambridge, MA: Harvard University Press, 1987.

Vajda, Georges, and Efraim Gottlieb, eds. *Sefer meshiv devarim nekhoḥim le R. Ya'akov ben Sheshet*. Jerusalem: Israeli Academy of Sciences and Humanities, 1968.

Valabregue-Perry, Sandra. *Concealed and Revealed: "Ein Sof" in Theosophic Kabbalah* [in Hebrew]. Los Angeles: Cherub Press, 2010.

Verboon, Annemieke R. "Einen alten Baum verpflanzt man nicht: Die Metapher des Porphyrianischen Baums im Mittelalter." In *Visuelle Modelle*, edited by Ingeborg Reichle, Steffen Siegel, and Achim Spelten, 251–68. Munich: Wilhelm Fink, 2008.

———. "Lines of Thought: Diagrammatic Representation and the Scientific Texts of the Arts Faculty, 1200–1500." PhD diss., University of Leiden, 2010.

———. "The Medieval Tree of Porphyry: An Organic Structure of Logic." In Salonius and Worm, *The Tree*, 95–116.

Verman, Mark. *The Books of Contemplation: Medieval Jewish Mystical Sources*. Albany: State University of New York Press, 1992.

Vital, Ḥayyim. *'Ez Ḥayyim*. Edited by Meir Poppers. Korets, 1782.

———. *'Ez Ḥayyim*. Edited by Meir Poppers; re-edited by Zvi Yehudah Brandwein. Jerusalem: n.p., 1988.

———. *'Ez Ḥayyim*. Edited by Meir Poppers. Jerusalem: Yerid Hasefarim, 2011.

———. *Kehilat Ya'akov*. Edited by Jacob Ẓemaḥ. Jerusalem: Ahavat Shalom, 1994.

———. *Mevo she'arim*. Edited by Jacob Ẓemaḥ. Jerusalem: Ahavat Shalom, 2019.

———. *Ozrot Ḥayyim*. Edited by Jacob Ẓemaḥ. Jerusalem: I. N. Lowe, 1907.

———. *Ozrot Ḥayyim ha-shalem*. Edited by Jacob Ẓemaḥ. Jerusalem: Ahavat Shalom, 1995.

———. *Sefer ha-ḥezyonot*. Edited by A. Z. Aescoly. Jerusalem: Mosad HaRav Kook, 1954.

———. *Sha'ar ha-gilgulim*. Edited by Zvi Yehuda Brandwein. Jerusalem: n.p., 1988.

———. *Sha'ar ha-hakdamot*. Jerusalem: Back, 1865.

———. *Sha'ar ha-tefilah*. Jerusalem: Ahavat Shalom, 2008.

Vital, Ḥayyim, and Yitzhak Isaac Safrin. *Jewish Mystical Autobiographies: Book of Visions and Book of Secrets*. Translated by Morris M. Faierstein. New York: Paulist Press, 1999.

Walker, Alan. *Fryderyk Chopin: A Life and Times*. New York: Picador, 2018.

Wallis, Faith. "What a Medieval Diagram Shows: A Case Study of *Computus*." *Studies in Iconography* 36 (2015): 1–40.

Wannah, Yitzhaq. *Rekhev Elohim*. Bnei Brak: Peulat Tzaddik, 1999.

Weinstein, Roni. *Kabbalah and Jewish Modernity*. Oxford: Littman Library of Jewish Civilization, 2016.

Weiss, Judith. *A Kabbalistic Christian Messiah in the Renaissance: Guillaume Postel and the Book of Zohar* [in Hebrew]. Bnei Brak: Hakibbutz Hameuchad, 2017.

Weiss, Tzahi. *Letters by Which Heaven and Earth Were Created: Origins and Meanings of the Perceptions of Alphabetic Letters as Independent Units in Jewish Sources of Late Antiquity* [in Hebrew]. Jerusalem: Bialik Institute, 2014.

———. *Sefer Yeṣirah and Its Contexts: Other Jewish Voices*. Philadelphia: University of Pennsylvania Press, 2018.

Whittington, Karl. *Body-Worlds: Opicinus de Canistris and the Medieval Cartographic Imagination*. Toronto: Pontifical Institute of Mediaeval Studies, 2013.

Wilkinson, Robert J. *Orientalism, Aramaic and Kabbalah in the Catholic Reformation: The First Printing of the Syriac New Testament*. Leiden: Brill, 2007.

Wilson, Catherine. *The Invisible World: Early Modern Philosophy and the Invention of the Microscope*. Princeton: Princeton University Press, 1995.

Wirszubski, Chaim. *Ben ha-shitin* [Between the lines]: *Kabalah, Kabalah Notsrit, Shabta'ut*. Edited by Moshe Idel. Jerusalem: Hebrew University Magnes Press, 1990.

Wolfson, Elliot R. "The Body in the Text: A Kabbalistic Theory of Embodiment." *Jewish Quarterly Review* 95, no. 3 (2005): 479–500.

———. "By Way of Truth: Aspects of Naḥmanides' Kabbalistic Hermeneutic," *AJS Review* 14, no. 2 (1989): 103–78.

———. "The Engenderment of Messianic Politics: Symbolic Significance of Sabbatai Ṣevi's Coronation." In *Toward the Millennium: Messianic Expectations from the Bible to Waco*, edited by Peter Schäfer and Mark Cohen, 203–58. Leiden: Brill, 1998.

———. "Iconic Visualization and the Imaginal Body of God: The Role of Intention in the Rabbinic Conception of Prayer." *Modern Theology* 12, no. 2 (1996): 137–62.

———. "Metaphor, Dream, and the Parabolic Bridging of Difference: A Kabbalistic Aesthetic." *Images* 14 (2021): 1–14.

———. "Sacred Space and Mental Iconography: *Imago Templi* and Contemplation in Rhineland Jewish Pietism." In *"Ki Baruch Hu": Ancient Near Eastern, Biblical, and Judaic Studies in Honor of Baruch A. Levine*, edited by Robert Chazan, William W. Hallo, and Lawrence H. Schiffman, 593–634. Winona Lake, IN: Eisenbrauns, 1999.

———. *Through a Speculum that Shines: Vision and Imagination in Medieval Jewish Mysticism*. Princeton: Princeton University Press, 1994.

———. "The Tree That Is All: Jewish-Christian Roots of a Kabbalistic Symbol in *Sefer ha-Bahir*." *Journal of Jewish Thought and Philosophy* 3, no. 1 (1994): 31–76.

———. *Venturing Beyond: Law and Morality in Kabbalistic Mysticism*. New York: Oxford University Press, 2006.

Wolski, Nathan, and Joel Hecker, trans. and comm. *The Zohar = Sefer ha-Zohar: Pritzker ed.* Vol. 12. General editor Daniel C. Matt. Stanford: Stanford University Press, 2017.

Worm, Andrea. "*Arbor autem humanum genus significat*: Trees of Genealogy and Sacred History in the Twelfth Century." In Salonius and Worm, *The Tree*, 35–67.

———. *Geschichte und Weltordnung: Graphische Modelle von Zeit und Raum in Universalchroniken vor 1500*. Berlin: Deutscher Verlag für Kunstwissenschaft, 2021.

Yassif, Eli. *The Legend of Safed: Life and Fantasy in the City of Kabbalah*. Detroit: Wayne State University Press, 2019.

Yates, Frances A. *The Art of Memory*. Chicago: University of Chicago Press, 1966.

———. *Giordano Bruno and the Hermetic Tradition*. Chicago: University of Chicago Press, 1964.

Yerushalmi, Yosef Hayim. *Haggadah and History: A Panorama in Facsimile of Five Centuries of the Printed Haggadah from the Collections of Harvard University and the Jewish Theological Seminary of America*. Philadelphia: Jewish Publication Society of America, 1974.

Yisraeli, Oded. "The Mezuzah as an Amulet: Directions and Trends in the Zohar." *Jewish Studies Quarterly* 22, no. 2 (2015): 137–61.

———. *R. Moses b. Naḥman: An Intellectual Biography* [in Hebrew]. Jerusalem: Hebrew University Magnes Press, 2020.

Yosha, Nissim. *Captivated by Messianic Agonies: Theology, Philosophy and Messianism in the Thought of Abraham Miguel Cardozo* [in Hebrew]. Jerusalem: Ben-Zvi Institute, 2015.

Zacuto, Moses. *Sefer Igrot ha-Remez*. Edited by Ya'akov Nunes Vais. Livorno, 1780.

Zeller, Rosmarie. "Böhme-Rezeption am Hof von Christian August von Pfalz-Sulzbach." In *Offenbarung und Episteme: Zur europäischen Wirkung Jakob Böhmes im 17. und 18. Jahrhundert*, edited by Wilhelm Kühlmann and Friedrich Vollhardt, 125–41. Berlin: De Gruyter, 2012.

———. "Der Nachlaß Christian Knorr von Rosenroths in der Herzog August-Bibliothek in Wolfenbüttel." In Kilcher and Theisohn, "*Kabbala Denudata*," 55–90.

———. "Der Paratext der *Kabbala Denudata*: Die Vermittlung von jüdischer und christlicher Weisheit." *Morgen-Glantz: Zeitschrift der Christian Knorr von Rosenroth-Gesellschaft* 7 (1997): 141–69.

Zemaḥ, Jacob. *Kol be-Ramah: Perush 'al ha-idra rabba*. Jerusalem: Bene Issachar Institute, 2001.

———. *Tiferet Adam*. Bnei Brak: Machon Torah Or, 1982.

Zinger, Nimrod. *The Ba'al Shem and the Doctor: Medicine and Magic Among German Jews in the Early Modern Period* [in Hebrew]. Haifa: University of Haifa Press; Rishon LeZiyyon: Yediot Aḥaranot, Sifre Ḥemed, 2017.

Zohar, Zvi. "Halakha as a Non-Fundamentalist Religious Language: Rabbi Joseph Messas and the Tlemcen Budget Affair" [in Hebrew]. In *Jewish Culture in the Eye of the Storm: A Jubilee Book in Honor of Yosef Ahituv*, edited by Avi Sagi and Nahem Ilan, 569–91. Tel Aviv: Hakibbutz Hameuchad, 2002.

Ẓror, Isaac. *Sefer ilan Ramḥal*. Jerusalem: Y. B. Ẓror, 2006.

INDEX

Italicized page references indicate illustrations. Endnotes are referenced with "n" followed by the endnote number.

Abba, 91, 125, 132, 134, 143, 145, 152, 179, 281, 341
 See also *Ḥokhmah*
Abrams, Daniel, 17
Abravanel, Isaac, *Mifʻalot Elohim*, 275
Abulafia, Abraham, 67, 171
Acre, Isaac of, *Meirat ʻeinayim*, 10, 17–18, 21–25, *22*, *23*, 29, 30, 32
Adam Kadmon, 89–95, 122–23, *124–25*, 135, 140–43, 145–47, 149, 171, *172*, 178, 179–83, 187, 201–14, 221–23, 227–33, 238, 240–43, 247–55, 262, 263, 267–68, 273, 276, 279–82, 289, 297, 317–18, 329–32, 350–52, 362
 See also *moḥin*; "requires further consideration" gloss
ADNY (Lord), 46
Adrichem, Christian van, *Theatrum Terrae Sanctae et Biblicarum Historiarum*, 107–8
 See also *Chronicon*; Munich: BSB, Hbks/F 118 za
aggadah, 1
Agrippa, Heinrich Cornelius, 68
Agrippa, Heinrich Cornelius
 De Incertitudine et Vanitate Scientiarum, 109
 De Occulta Philosophia, 108–9
Ahava, 38
Akiva, Rabbi, 65, 71–72
ʻakudim, 142, 261, 268
Alberti, Leon Battista Alberti, 59
Aldabi, Meir ibn, *Shevilei emunah*, 75
Alemanno, Yoḥanan, 65
Aleppo, Syria, 113
Altdorf, Germany, 137
 University of, 137
Altona, Germany, 158
Altshuler, Aharon Meir, 326
ʻAmidah, 24

Amsterdam Haggadah, 145, *147*
 See also Tel Aviv: GFCT, B.66
Amsterdam, Netherlands, 197, 225, 249, 251, 266
 Embassy of the Free Mind, Bibliotheca Philosophica Hermetica Collection, MS M 474, 257, *259*
 Ets Haim Bibliotheek, Livraria Montezinos, MS 47 E 53, *219*
 Ets Haim Bibliotheek, Livraria Montezinos, MS D 47 20, 68
 Ets Haim, Bibliotheek, Livraria Montezinos, MS EH Pl.A-7, 251–52
amulets, 35, 65, 207, 209, 210, 211, 214, 257, 347, 364
 ilan amulets, *290*, 291–306, 325, 334–35, 356–62
 rabbinic strictures on, 308
 See also *mezuzot*; phylacteries; *tefillin*
angels, 59, 71, 87, 161, 162, 164, 198–99, 257, 272, 283, 293, 317
 See also *maggid*; Michael; Metatron; Special Cherub
aniconism, 5, 24, 70–73, 83–84, 144–47, 222, 236, 330–32
 See also anthropomorphism; Commandments, second
An-Sky, S. (Shloyme Zanvl Rappoport), 214
anthropomorphism, 28–29, 89, 123, 132, 147, 152, 159, 173, 204, 209, 221–23, 229–36, 247, 249, 269, 317–18, 329–30, 341, 349, 351
 See also aniconism
ʻArik, 243, 281
Arikh Anpin, 91, 118–22, *119–20*, 125, 128–35, 143, 173, 179, 196, 207–8, 210, 213, 221–23, 243–49, 269, 269–72, *270*, *271*, 281–82, 313, 314, 317, 329, 351–52
 See also *Keter*; Zacuto, Moses, *Arikh and the Enrobings* ilan; Ilan of *Arikh Anpin*
Aristotle, *Categories*, 2–4

Ark of the Covenant, 18, 53
 See also Tabernacle
Arzei ha-Levanon, 82
Ashkenazi, Joseph ben Shalom, 67
 commentary on *Sefer yeẓirah*, 283
Ashkenazi, Mordechai, 239
Ashkenazi, Samuel, 315–17
Ashkenazim, 130, 162, 164, 196, 202, 204, 266, 285
 script of, 202–4, 221, 223, 241, 303–4
 texts of, 241
ʿAssiah, 82–83, 85, 87, 91, 108, 125, 135, 164, 179, 198–200, 210–11, 223, 251, 254, 283, 293, 314, 329, 354, 362
 See also Kabbalah: Four Worlds of
astrology, 68–70, 82, 102, 272
 See also zodiac
astronomy, 5, 13, 40, 68–69, 73, 87, 95, 100, 108, 210–11, 254, 261, 276, 315, 335
ʿAtarah, 22, 60
 See also Malkhut
ʿAtik Yomin, 125, 142, 255, 351
ʿAtik, 125, 131–32, 142, 179, 253, 341
ʿAtika Kadisha, 125, 238, 269
Augsburg, Germany, Universitätsbibliothek Augsburg, 02/VIII.3.8.16 (Tobias Cohen, *Maʿaseh Tuvia*), 166, 168
Ayllon, Solomon, 253, 255
Aẓilut, 82–83, 85, 86, 91, 124–25, 134, 145, 155, 164, 183, 198, 206, 210, 223, 241, 249, 253–54, 261, 272, 274, 314–18
 See also Kabbalah: Four Worlds of
ʿaẓmut, 6, 312
ʿaẓmut ve-kelim, 312, 313
Azriel of Krotoszyn, 148, *150*

Baʿal Shem Tov, 215, 280
 See also Hasidim
Bach, Johann Sebastian, 159
Bacharach, Naftali Hertz, *ʿEmek ha-melekh*, 162, 173–77, *175*, 209, 266–67, 275, 279, 281, 285, 289, 315, 328
Bacharach, Yair Ḥayyim, 307–8
Baghdad, Iraq, 80, 225, 262, 266, 269, 273, 328, 356
 Jewish community of, 262–65
Bahir, 1–2, 16, 22, 28
 See also trees: All-Tree
Balmes, Abraham de, 65
Barros, João de, *Ropicapnefma*, 101
 See also Vienna: Osterreichische Nationalbibliothek, *31.J.117

Barzani, Samuel, 75
Basola, Moses, 309
Bass, Shabtai, 197–98, 321
Bassan, Isaiah, 245, 249
Baumgarten, Eliezer, 75, 243, 256, 269, 310, 347, 364–65
Beatus manuscripts, 15
Beethoven, Ludwig van, 103
Bek, Leonhard, frontispiece for *Portae Lucis*, 25, *26*
Belgrade, Serbia, 253
Benjamin, Elijah Ḥayyim ben (Genezzano), 65
 Iggeret hamudot, 30–31
Benjamin, Walter, 309, 334
Berdichev, 173, 321
Beriah, 82, 85, 86, 91, 125, 135, 164, 179, 183, 187, 198, 210, 223, 249, 254, 261, 314, 317, 362
 See also Kabbalah: Four Worlds of
Berlin, Germany, 253
 Berlin State Library Ms. or. fol. 130, 3 (Tobias Cohen, *Maʿaseh Tuvia*), *167*, 168
 Berlin State Library, MS or. oct. 3078, 288
 Berlin State Library, MS or.fol.130, 2, 162, *163*, *165*, 168
Besht, the. *See* Baʿal Shem Tov
Binah, 25, 29, 44, 125, 131, 152, 155, 313, 314
 See also *Imma*
Blanis, Benedetto, 65
Booklet of Kabbalistic Forms, 60–62
Braginsky Collection, 211
Brescia, Italy, Biblioteca Queriniana, MS L FI 11, *45*, *46*, *47–49*, 53
Brit menuha, 256, *257*
Brod, Abraham ben Moses, 197
Bruno, Giordano, 106, 177, 319
 Articuli Centum, 177–78, *178*
 De Umbris Idearum, 103–7, *106*, 108 (*see also* Munich: BSB, Res/Paed.th.670)
Buchbinder, Israel ben Asher, 158–61, 192
 Copies of *ʿEẓ Ḥayyim*, 159, 269 (*see also* Tel Aviv: GFC, MS GR.011.012)
Busi, Giulio, *Qabbalah visiva*, 2

Cairo, Egypt, 266, 289
 Genizah of, 35, 291
Cambridge, England, F.18.11 (*Trinity Scroll*), 145, *146*, 204–7, *gatefold following p. 206*, 221, 283, 304, 352
cantor, 226, 238, 264
cardinal directions, 20–21
Cardozo, Abraham, 253

Carlebach, Shlomo, 93
Carpzov, Johann Benedict, 319
cartography. *See* ilanot: as maps; maps
Casaubon, Isaac, 49
Castile, Spain, 98
Chabad Library Ilan, 202–07, 209, 221, 325
 See also New York: Library of Agudas Chasidei Chabad, Megillah 4902 ל
Chariot, divine, 18, 21, 24, 38, 49–51, 53, 55, 71, 77, 79–80, 82–83, 237, 266
 as Four Worlds of Kabbalah, 86–88, *86*, *87*, 91
cherubim, 18, 49–51, 53, 71, 77, 80, 161, 202
 See also Special Cherub
chiromancy, 109, 189–92, 258, 283, 354
Christian August (Count Palatine of Sulzbach), 168, 227, 319
Christianity
 art of, 5–6, 49 (*see also* Virtues and Vices)
 study of Kabbalah, 47, 49–51, 65, 108–9, 128, 135, 168–69, 177, 318–19 (*see also* Adrichem, Christian van; Agrippa, Heinrich Cornelius; Bruno, Giordano; Hepburn, James: *Virga Aurea*; Knorr von Rosenroth, Christian: *Kabbala Denudata*; Ẓemaḥ, Jacob: and gentile scholarship)
 trees in, 10, 17
Chronicon, 107–8
 See also Adrichem, Christian van, *Theatrum Terrae Sanctae et Biblicarum Historiarum*; Munich: BSB, Hbks/F 118 za
Cincinnati, Ohio
 HUC, Klau Scrolls 65.1 (copy of *Magnificent Parchment*), 69
 HUC, Klau Scrolls 65.2, 279, 280, 283
 HUC, Klau Scrolls 69 (*Grupa Ilan*), 215–21; *216–18*, *219*, 282
circles, as Kabbalistic diagrammatic device, 93–97, 100, 111, 116, 122, 132, 143, 152, 164–65, 179–87, 201, 210, 222, 254, 257–58, 261–62, 272, 275, 352
 See also ʿiggulim ve-yosher; ilanot: medallions of; volvelles
Clavicula Salomonis, 100
cloud of unknowing, 51
Coen, Ethan and Joel, *A Serious Man*, 124
Cohen, Tobias, *Maʿaseh Tuvia*, 166–68
 See also Augsburg, Germany, Universitätsbibliothek Augsburg, 02/VIII.3.8.16; Berlin, Germany: Berlin State Library Ms. or. fol. 130, 3

colophons, 43, 127, 137, 158, 196, 218–19, 226, 227, 238, 251, 256–57, 273, 349, 355
Commandments, Ten, 10, 122, 192
 second, 147 (*see also* aniconism)
"Commentaries on the Ten Sefirot," 38
conversos, 97–98, 100–102, 109, 123, 132, 266, 334
 See also Ẓemaḥ, Jacob
Copenhagen, Denmark, Royal Library, MS Cod. Hebr. XLIII, 161
Copernicus, Nicolaus, 166, 177, 329
Coppio, Isaac, 183–85, 225, 255–63, 268, 306, 356–57
 Great Tree of, 257–59, *258*, *259* (*see also* Tel Aviv: GFCT, MS 028.011.004)
 "Headline" Ilan, 257, 259–61 (*see also* Tel Aviv: GCT, MS 028.011.005)
 "Two-Column" Ilan, 257, 261–63, 295, 306, 354–55 (*see also* Tel Aviv: GFCT, MS 028.012.002; Tel Aviv: GFC, MS 028.012.026)
 See also Moscow, Russia: RSL, MS Guenzburg 543; New York: JTS, MS 2177; Tel Aviv: GFCT, MS 028.010.001
Cordovero, Moses, 7–8, 89, 123, 131, 200, 204, 275, 350
 Or neʿerav, 82, 87
 Pardes rimonim, 30, 31–33, 93, 118, 164, 198, 312–13 (*see also* Fano, Menaḥem Azariah da: *Pelaḥ ha-rimon*)
Cossacks, 173
Cracow, Poland, 123, 141
Crumb, R. 225, 243

Daʾat, 131, 134, 164, 271, 314
Damascus, Syria, 93, 97, 108, 110, 111, 116, 240, 266, 289
Darmstadt, Germany, Universitäts- und Landsbibliothek, MS 2282, 27
Darshan, David, 65, 66
 See also London: BL, MS Or. 6465
Darwin, Charles, 13
David, Joshua ben, 75, 84
Delacrut, Matathius, commentary on *Shaʿarei orah*, 28, 30
Deleuze, Gilles, 34
Delmedigo, Joseph Solomon, 124, 352
 Kizur ʿolam ha-tikkun, 205
 Novelot ḥokhmah, 206, 266, 315–18
 Sefer Elim, 317
 Taʿalumot ḥokhmah, 205–6

demonic forces, 44, 55, 56, 125, 164–68, 196, 198, 243, 254, 293, 302
 See also *klippot*; Lilith; Samael
diaspora, Jewish, 8, 233, 291, 356
 See also Vienna: Jewish expulsion from
Din, 23, 30
 See also *Gevurah*

Egypt, 89, 170, 173
 See also Cairo
Ein Sof, 2, 33, 37, 46–49, 53, 58, 60, 65, 73, 75, 85, 89, 93, 102, 111, 116, 124–25, 131, 134, 141, 145, 148, 162–64, 174, 176, 179–81, 202, 210–13, 236–37, 241, 249, 253, 255, 257, 261–62, 273, 282, 285, 293, 313–14, 337
Einstein, Albert, 75
Eisenstadt, Mordechai, 137
Eliashiv, Shlomo, 326
Elijah of Vilna. *See* Vilna Gaon
emanation, 7–8, 22, 34–36, 86, 89, 91, 93–94, 110–11, 122, 124, 135, 137, 164, 171, 206, 213, 249–51, 263, 266, 276, 280, 314–17, 334–35, 338, 354
 See also Siprut de Gabay, Joseph: *Tree of Circular and Linear Emanations*; *zimzum*
emblem books, 60–62
Emden, Jacob, 238
Encyclopaedia Judaica, 1
Erasmus, Desiderius, 109
 Moriae Encomium, 101
'eser zaḥzaḥot, 162–64
Ets Haim Ilan, 221
 See also Amsterdam: Ets Haim Bibliotheek, Livraria Montezinos, MS 47 E 53
evil, 55–56, 134, 165, 245, 254, 288–89, 295
 See also demonic forces; *klippot*; Lilith; Samael; *Sitra Aḥra*
Ezekiel (prophet), 70, 79
Ezra, Abraham ibn, 68

Fano, Menaḥem Azariah da, 33, 124, 328
 Pelaḥ ha-rimon, 31–32, 312
 Sha'ar ha-ẓinorot, 32
Fez, Morocco, 256–57
Ficino, Marsilio, 5
Florence, Biblioteca Medicea Laurenziana, MS Plut.44.18, 51–58, 52, 54, 56, 198
 as "letter," 57–58

Fludd, Robert, 319
Frankfurt, Germany, 106, 162, 319
Frederick William, Elector of Brandenburg, 168
Friedberg, Bernhard, 310
Friedman, David, 338–41
 Family Tree of Life, 340, 341
 Sefer Yetzirah Motherboard, 338–41, 339
Frierdiker Rebbe. *See* Schneerson, Yosef Yitzchak

Gabbai, Meir ibn, Tola'at Ya'akov, 82, 87, 283
Galante, Abraham, 82
gall ink, 159
Gaon, Shem Tov ibn, *Keter shem tov*, 21
Garden of Eden, 10, 49–51, 54–55, 60, 62, 271–72, 275
 See also Shandukh, Sasson ben Mordekhai: *Gates of Eden Ilan*
Garment, primordial (or divine), 86, 171, 174–75, 210
 See also *Malbush*
Gedulah, 23, 44, 132, 134
 See also *Ḥesed*
Gehennom, 165, 187
 See also hell
Geliebter, Efraim Fischel, and Josel Asher Zelig Weinryb (publishers), 321–25
gematria. *See* Kabbalah: numerology of
genealogy, 35
 See also tree, genealogical
Genezzano. *See* Benjamin, Elijah Ḥayyim ben
genizot, 206, 266
 See also Cairo, Egypt: Genizah of
Gentili, Hanna, 364
geometry
 Neoplatonist, 15–16
 medieval, 51
Gerard of Cremona, 58, 69
Gevurah, 23, 29, 32, 44, 58, 87, 122, 132, 134, 271
Gikatilla, Joseph, 43, 53, 83–84, 86, 196, 200
 commentary on Maimonides's *Guide of the Perplexed*, 75
 Sha'arei orah, 25–28, 27, 34, 82, 153–55, 198 (see also Delacrut, Matathias, commentary on *Sha'arei orah*)
Glory, 70, 73
 See also Throne of Glory
God, 81
 "back" of, 55, 56

in ilanot, 2, 5, 29–30, 34, 36, 40, 53, 56, 70, 83, 176, 213, 226, 241, 243, 247, 269, 285, 314–15, 317, 328–29, 332, 337 (see also *Ein Sof*; Special Cherub)
in Kabbalistic prayer, 24
in Lurianic Kabbalah, 89–94, 127 (see also *Adam Kadmon*; *ʿazmut*; *Ein Sof*; *kelim*; *sefirot*; *shefa*; *Shekhinah*)
two aspects of in Kabbalah, 2
Goodman, Nelson, 111
Graf, Moses
 Va-yakhel Moshe, 194, 195, 261–62, 266–67, 269, 270, 273–75, 285 (see also Tel Aviv: GFC, B.433A)
 Maamar Adam de-Azilut, 280–90
Grand Circles of Vital, 208, 209, 210, 227, 251, 275
Grand Venetian Parchment. See Florence, Biblioteca Medicea Laurenziana, MS Plut.44.18
Great Parchment. See *Iggeret sippurim*
Great Tree, 128–29, 137, 145, 161, 169–70, 173–75, 178–89, 196, 197, 200, 202–24, 226–27, 240, 249, 251, 253, 256–57, 261, 267, 268, 280, 282–85, 293, 297–302, 315, 318, 326, 329, 333–34, 350, 358–59, 361
 definition of, xiv
 key to, 208
 See also Amsterdam: Ets Haim Bibliotheek, Livraria Montezinos, MS 47 E 53; Cambridge: F.18.11 (*Trinity Scroll*); Cincinnati, Ohio: HUC, Klau Scrolls 69; ilanot: compound (modular); Poppers, Meir, *Great Tree of R. Meir Poppers*; St. Petersburg, Russia, Russian Museum of Ethnography, inv. no. 6396–101; Tel Aviv: GFCT, MS 028.011.003; Tel Aviv: GFCT, MS 028.012.010; Tel Aviv: GFCT, MS 028.012.012; Tel Aviv: GFCT, MS 028.012.016; Tel Aviv: GFCT, MS 028.012.022; Tel Aviv: GFCT, MS 028.012.025
grimoire, 100, 192, 291, 309
 See also *Raziel ha-malakh*; science: occult
Gross Family Collection, 347–62, 363–65
 numbering system for, 347–49
Gross, William, 73, 256, 261, 309, *348*
Grupa, Isaac, 219
 Grupa Ilan, 215–21, *216–17*, *218* (see also Cincinnati, Ohio: HUC, Klau Scrolls 69)
Guattari, Félix, 34

Habsburg dynasty, 233
 crown of, 236–37

Habsburg jaw, 238
 See also Leopold I; Vermayen, Jan (crown of Rudolf II)
Hackspan, Theodor, *Miscellaneorum Sacrorum*, 319
Ḥai-Ricchi, Immanuel, *Mishnat ḥasidim*, 249, 266, 269, 315
Ḥajaj, Isaac, 185
Ḥalfan, Elijah Menaḥem, 51–58, *52*, *54*, *56*
 See also Florence, Biblioteca Medicea Laurenziana, MS Plut.44.18; Ṣarfati, Abraham
ḥalon, 16
Hamburg, Germany, 158
Hamilzahgi, Elyaqim, 202, 222
Hammerschlag, Nosen Neta, 192, 225–26
 "The Hammerschlag *Poppers*," 240–43, *241* (see also Tel Aviv: GFC, MS 028.011.009)
 Ilan dikduk ha-torah, 227 (see also Munich: BSB, Cod. hebr. 451)
 Ilan of Adam Kadmon, 140, 226–40, *229*, *232*, *237*, *241* (see also Munich: BSB, Cod.hebr. 450; Oxford, England: BL, MS Michael 88)
Hasidism, 214, 280, 309, 322, 325
 See also Baʿal Shem Tov; Lubavitch dynasty; *misnagdic*; Muskat, Isaiah
Ḥayyat, Judah, 47, 83
 Minḥat Yehudah (commentary on *Maʿarekhet ha-elohut*), 29–30, 83–84, 227, 283
Ḥayyim of Volozhin, R., 326
Ḥayyun, Neḥemiah, 253, 255
 ʿOz le-Elohim, 253
heavens, the, 59–60, 70–73, 108, 164–65
 Heavenly City motif, 15
 See also *heikhalot*
heikhalot, 71, 86, 198–99, 265, 279, 354
hell, 164–65, 198–200
 See also *Gehennom*
Helmont, Francis Mercury van, 319
Hepburn, James, 49
 Great Parchment, 48, 49–51, 53, 79 (see also Oxford, England: BL, MS Hunt. Add. E.)
 Virga Aurea, 49–51, *50*
Hereford Map, 15
Herrera, Abraham, 99
Ḥesed, 23, 25, 29–30, 32, 34, 38, 97, 122, 132, 155, 271–72
 See also *Gedulah*
hieros gamos, 60

Hillel, Moshe, *'Over la-sofer*, 256
hitlabshuyot, 118–23, 124–25, 127, 129, 131–32, 143, 152
 See also ilanot: enrobing in
Hod, 23, 29–30, 54, 87, 122, 132, 273
 Ḥokhmah, 14, 15, 16, 25, 29, 39, 46, 51, 125, 131, 143, 152, 155, 189, 313–14
 See also *Abba*
ḥokhmat ha-nistar, 5
Holy Temple, 46, 49, 272, 277
Holy tree, 206, 210, 293–95, 303
 See also Tree of Holiness
Holywood, John. See Sacrobosco, Johannes de
Homem, Dr. António, 98
Hook, Robert, *Micrographia*, 177
Hopstein, Yisroel (Maggid of Kozhnitz), 322
horror vacui, 140, 335, 354–55
humanism, 47, 49, 97–99, 101–3, 109–10, 249, 334
 See also Ẓemaḥ, Jacob: and gentile scholarship
ḥuppah, 60, 62

iconotexts, 1, 8, 46, 59, 226, 333, 341
 See also ilanot: as iconotexts
Idel, Moshe, *Kabbalah, New Perspectives*, 1
Iggeret sippurim (*Great Parchment*), 49–51
 as "letter," 58
 See also Hepburn, James; Ṣarfati, Reuben: *Perush ha-yeri'ah ha-gedolah* (Commentary on the *Great Parchment*)
'iggulim ve-yosher, 93–97, 94, 124, 149, 162, 177, 179, 181, 213, 222, 249–51, 253, 255, 267, 268, 351
Ilan ha-gadol. See Great Tree
Ilan ha-ḥokhmah, 13–16, 17, 14, 16, 46
Ilan ha-kadosh. See Holy tree
Ilan of Expanded Names, 152–61, 192, 201, 207, 208, 210, 229, 231, 240–42, 327
 See also Knorr van Rosenroth, Christian: *Kabbala Denudata*; Sartorius, Johann Christoph: *Ilan of Expanded Names*; Tel Aviv: GFCT, NHB.136
Ilanot Project, x, 295, 310, 364–65
ilanot, 7–8, 363–65
 absence in modern scholarship, 2
 and Judaica market, 363–64
 apotropaic (or talismanic) use of (see amulets: ilanot as)
 artisanal, 201, 209, 215, 225–293, 354–56
 as devotional instrument/ritual objects, 7, 35–36, 39, 44, 80–82
 as iconotexts, 1, 8, 37, 46, 49, 55, 59, 161, 209, 225–26, 239, 333, 338, 341
 as maps, 53, 55–56, 59–70, 83, 127, 153, 164, 200, 271, 333
 channels of, 7, 32, 38, 40, 43, 46, 49, 93–94, 116, 131–34, 145, 149, 179, 187, 189, 197, 247, 255, 262, 334, 352 (see also Fano, Menaḥem Azariah da: *Sha'ar ha-zinorot*; *Sefer ha-zinorot*)
 classical, 8, 38, 39, 40, 53, 75, 82, 120, 127, 132, 140, 152, 156–57, 334, 349
 use of color in, 40, 49–51, 65, 73, 238, 274–75, 283, 338, 340
 commentaries on, 38
 compound, 200–299
 modular, 129, 140, 178, 206–289, 328; key to, 208
 spliced, 129, 201–7, 208, 221, 251, 261, 283, 321, 326–27
 contemporary, 243, 335–45
 "deconstructed," 39, 39–40, 43–44, 82 (see also Great Tree; *Ilan of Expanded Names*; *Ilan ha-ḥokhmah*; Tree of Holiness; Trees of the Worlds)
 digitization of, x, 58 (see also Ilanot Project)
 emergence of term, 28–31, 34
 enrobing in, 97, 118–26, 204–7, 210–11, 229, 239, 241, 243, 247, 262, 271, 280, 317–18, 338, 341 (see also *hitlabshuyot*; Poppers, Meir: *Ilan of Adam Kadmon and the Enrobings*; Zacuto, Moses: *Arikh and the Enrobings* ilan; Ẓemaḥ, Jacob: *Ilan of the Enrobings*)
 folded, 57–58, 93, 94, 201, 206, 275, 285, 315–18, 321 (see also Knorr von Rosenroth, Christian: *Kabbala Denudata*)
 geographical and cultural diversity of, 8
 grammatical, 168
 of Kurdistan, 75–82, 76, 77, 266, 293 (see also Barzani, Samuel; David, Joshua ben; Jerusalem: NLI, MS 1257; Jerusalem: NLI, MS 28°6247; Sidkani, Judah; Tel Aviv: GFCT, MS KU.011.009; Tel Aviv: GFC, MS 027.010.009)
 Lurianic, 8, 13, 34–35, 80, 116–26, 127ff, 334, 349–54
 definition of, 1, 28
 makers of, 333
 margins and other interstitial spaces of, 37–38, 85, 131, 152, 334
 medallions of, 33, 34, 37, 38, 40, 43–49, 56, 60, 67, 81, 82, 131–32, 143, 152, 156, 164, 189, 198, 210, 221, 243, 247, 268, 329, 334
 of North Africa, 181, 214, 256–57, 266, 295–97, 303, 352, 364 (see also Ẓur, Moses ibn)

of the seventeenth century, 98, 123, 127–200
performative, 6, 73, 81, 83, 93, 125–26, 279–80, 295, 333
printed, 307–32 (*see also* Sasson, Abraham: *Kol sasson*)
rabbis represented in, 60, 70
reading of, 35, 37, 73, 75–77, 126, 214, 265, 277–79, 331
of the Renaissance, 47–75, 131, 265, 334
Saruqian, 178, 206–25, 257, 266, 268, 282, 283–90, 315–17, 321, 328–29
women's use of, 293, 303
of Yemen, 75, 82–88 (*see also* Wanneh, Isaac ben Abraham)
Images
Epistemic, 2, 9, 17, 25, 40, 93–94, 319
Synoptic, 93–97, *113*, 122, 153, 155, 161, 179, *181*, 186, 201, 222–25, 241, 251, 317
See also iconotexts
Imma, 91, 125, 134, 143, 145, 152, 179, 181, 341
See also *Binah*
Inquisition, Catholic, 98, 106
Isaac (patriarch), 58
Ishmael (patriarch), 44
Israel, 364
See also Jerusalem; Mount Meron; Mount of Olives; Safed; Sinai; Tel Aviv
Israel, Menasseh ben, 99

Jacob (patriarch), 46, 58, 91
ladder of, 226
Jacob (sub-parzuf), 125, 134, 143, 243, 352
Jacob, Abraham bar, 145
Jerusalem, 89, 110–11, 145, 266, 295, 306
Benayahu Collection, MS K 109 (Jacob Zemaḥ, *Tiferet Adam*), 104–5
IM, B50.02.1945, 345–46
NLI, MS 1257, 75, *76*, 79, 80, 266–67, *271*
NLI, MS 28°6247, 75–80, *77*
NLI, MS Heb. 28°613, 40
NLI, MS Heb. 28°7991 (Lonzano copy of Vital, Ḥayyim: *Sefer ha-drushim*), 180, *183*
NLI, MS Heb. 28°8815 (Vital, Ḥayyim: *Mevo she'arim [Toldot Adam]*), 112, *113*, 114–15, 268
NLI, MS Heb. 4°200.4, 329–32, *331*
NLI, MS Heb. 8°2964, 5, 60
NLI, MS Heb. 8°404 (Shem Tov ibn Shem Tov, commentary on the sefirot), 17, 28, 29, 118
NLI, MS Heb. 8°963, 204, *205*

NLI, MS Heb.38°6330, 27
Rabbi Yakov Moshe Hillel Library, MS 572 (Vital, Ḥayyim: *Sefer ha-drushim*), 96
Jesuits, 98, 103
Jobs, Steve, 362
Joseph, Raphael, 289

Kabbalah, 1, 7–8
classical, 8, 34, 155, 211, 238
concealed knowledge within, 18, 38, 102–4, 237, 239–40, 263, 319, 326
cosmogony of, 10–16, 35, 59–60, 91, 93–94, 99, 111, 118, 124–26, 135, 143, 162, 165, 169, 176, 185–86, 189, 201, 222, 226, 236, 239, 245, 249, 251, 254–55, 262, 265, 266, 274, 275, 280, 285, 289, 318–19, 341, 351
definition of, 2
description of, 6–7
diagrams in, 9–15, 82–83, 111–118, 122–26, 149, 152–55, 159, 174–200, 201, 206, 240–42, 257, 317, 336 (*see also* circles; *ḥalon*; *hitlabshut*; *parsah*; *pirkei ha-zelem*; "Steps to Infinity" motif; trees; volvelles)
Four Worlds of, 82–85, 86–88, 111, 124–25, 127, 148, 162–63, 171, 174, 179, 183, 197–98, 206–211, 241, 257, 262, 266, 275, 281, 338 (see also *'Assiah*; *Azilut*; *Beriah*; Chariot, divine; *Yezirah*)
Girona school of, 21
in Iberia, 10, 15–16, 18, 29, 46–47, 82, 84, 98–103, 108, 196, 202, 256, 304 (*see also* Ḥayyat, Judah; Zemaḥ, Jacob)
in Italy, 29, 30–32, *31*, 32–33, 47, 51–74, 75, 82, 84, 124, 148, 170, 225, 227, 243, 247, 249, 309, 334
Lurianic, 8, 34, 75, 89–116, 123–26, 155, 236, 239, 322, 334 (*see also* God: in Lurianic Kabbalah; ilanot: Lurianic)
numerology of, 15, 38, 46, 91, 108, 142, 165, 196–97, 238, 240, 312
"twelves," 46
"palaces" of, 87, 317 (see also *heikhalot*)
practical, 80–82, 192, 295, 354
prayer in, 7–8, 24, 53, 71, 81, 82, 303, 322 (see also *'Amidah*)
310 (or 390) worlds of, 238
Kaddish, 117
Kallus, Menachem, 280, 364
Kalman, Kalonymus, 326–30
Kapashian, David, Diagram of *'Ez Ḥayyim* Gate 29:7, 336

Karl Theodor (Elector of the Palatinate in Mannheim), 227
Katsh Scroll, 279, 282, 283
kavanot, 7, 126, 192, 239
kelim, 6, 312
Keter, 2, 5, 12, 22, 25, 37, 38, 44, 46, 49, 51, 60, 71, 82, 125, 131, 134, 143, 152, 155, 164, 183, 236–37, 261, 274, 314
 See also *Arikh Anpin*
Khunrath, Heinrich, 319
Kircher, Athanasius, 319
Kitzes Ilan, 214–15, 257, 325
 See also St. Petersburg: Russian Museum of Ethnography, inv. no. 6396–101
Kitzes, Zev, 215
 See also *Kitzes Ilan*
Klalut ve-pratut ha-hishtalshelut, 148–52, *150*, *151*
 See also Oxford: BL, Opp. MS 456
klippot, 44, 116, 165, 196, 283, 288
 See also demonic forces; Lilith; Samael
Knorr von Rosenroth, Christian, 140, 173, 198, 209, 215–21, 223, 233, 280, 285, 315, 318, 326, 328–29, 331–32
 Kabbala Denudata, 128–78, 187, 208, 227, 251, 275, 281, 288, 312, 318–21 (see also Poppers, Meir: *Ilan of Adam Kadmon and the Enrobings*; Tel Aviv: GFCT, NHB.136)
 Clavis Sublimioris Kabbalae, 156–57, *158*
 frontispiece, 319, *320*
 Ilan of Expanded Names, 152–55, *153*, 229 (see also Tel Aviv: GFC, MS GR.011.012)
 Saruqian ilan of, 208, 209, 215
kruvim. See cherubim

ladder, 51, 77–79
 See also Jacob (patriarch): ladder of
Ladner, Gerhart, 16
Lady Dialectic, 25, 27
Laniado, Samuel. copy of Vital, Ḥayyim: *Mevo she'arim* (*Toldot Adam*), 113–16, *114–15*, 268, 269
Leah (sub-*parzuf*), 134, 143, 243
Leeds, England, Leeds University Library, MS Roth 418 (fragment copy of *Magnificent Parchment*), *62*, *63*
Leibniz, Gottfried Wilhelm, 318
Leipzig, Germany, 319
Leon, Moses de, 16–17
Leonardo da Vinci, notebooks of, 152

Leopold I (Holy Roman Emperor), 233, 240
 "Leopoldus I" etching, *234*
Levinsohn, Isaac Baer, 173–74
Liebes, Yehuda, 280
Lifshitz, Jacob Koppel, *Sha'arei Gan 'Eden*, 285, 287, 289, 328
light, in Lurianic ilanot, 89–93,' 122, 125, 134, 135–37, 142, 176, 183, 245, 253, 255, 262, 263, 268, 282, 312–14, 331–32
 See also '*akudim*; '*eser zaḥzaḥot*; *nekudim*; *Tehiru*
Lilith, 56, 165, 293, 308
Lipkin, Aryeh Leib, 326–28, 331–32
Lisbon, Portugal, 101
Lithuania, 158, 326, 328
Llull, Ramon
 Arbor scientiae, 16
 Ars generalis ultima, 32
Loewenthal, Avraham, 338, 341
 Ilan, 338
 Seeing the Sounds, 338
London, 196
 BL, Add. MS 26997 (Jacob Ẓemaḥ, *Kol be-Ramah*), 117–18
 BL, MS Or. 12260, 22–23, 29
 BL, MS Or. 6465 (David Darshan copy of *Magnificent Parchment*), 65, *66*
 BL, MS Or. 6996, *248*, 249
 BL, MS Or. 9045, *39*
Lonzano, Menaḥem de, 179, 251
 copy of Vital, Ḥayyim: *Drush Adam Kadmon*, 154 (see also New York: COL MS X 893 K 11
 copy of Vital, Ḥayyim: *Sefer ha-drushim*, 180 (see also Jerusalem: NLI, MS Heb. 28°7991)
 copy of Vital, Ḥayyim: *Mevo she'arim* [*Toldot Adam*], 179 (see also New York: COL MS X 893 V 837)
luaḥ, 83–84, 197–98, 247, 321
Lubavitch dynasty, 202
Luria, Isaac, 8, 34, 89, 109, 123, 170, 192, 197, 226, 240, 251, 255, 256, 263, 266, 313, 321, 350, 357
 See also ilanot: Lurianic; kabbalah: Lurianic
Luria, Shlomo, "The Commentary on the Ilan," 326
Luzzatto, Moses Ḥayyim, 225, 243–249, 326, 328–29, 338
 '*Ez Ḥayyim*, 328
 KL"H pithei ḥokhmah, 328
 Mesilat yesharim, 243 (see also New York: JTS, MS K103; New York: JTS, MS K106)

Ma'ayan ha-ḥokhmah, 164, 312, 313–14
Ma'arekhet ha-elohut, 7, 21, 28–29, 31, 37–39, 67, 82
 See also Hayyat, Judah: *Minḥat Yehudah*
Magen David. See Star of David
Maggid of Kozhnitz. See Hopstein, Yisroel
maggid, 137, 239, 243
 See also angels
magical literature, Jewish, 80–82
Magnificent Parchment, 33, 58–74, 196, 210
 copies of, 64, 62–69, 63, 64, 66, 69, 74, 211 (see also Cincinnati: HUC, Klau Scrolls 65.1; Leeds, Leeds University Library, MS Roth 418; Rome, Historical Archive of the Jewish Community of Rome "Giancarlo Spizzichino," MS ASCER—Aa 2; Tel Aviv: GFCT, MS 083.012.001; Vatican: BAV, MS Vat.ebr. 598)
 zodiac in, 68–73
 See also Oxford, England: BL, MS Hunt. Add. D
Maimon, Abraham, 204
Maimonides, 67
 Guide of the Perplexed, 24, 75
Malbush, 86, 169, 171–78, 170, 171, 175, 206, 215, 223, 267–68, 275, 277, 280–81, 285, 288–89, 317
 See also Garment, primordial
Malkhut, 2, 5, 10, 13, 22, 25, 40, 44, 49, 54–55, 56, 60, 87, 124–25, 131, 142–43, 145, 152, 155, 164, 176, 183, 236, 249, 255, 272, 273
 See also *Nukba*
mandalas, 37
manicules, 73, 237
Mannheim, Germany, 227
 See also Karl Theodor
Mantua, Italy, Biblioteca della Comunità Ebraica, MS ebr. 109 (Azriel of Krotoszyn, *Klalut ve-pratut ha-hishtalshelut*), 151
maps, 8, 35, 83, 93, 127, 132, 145, 183
 genealogical, 4
 of God, 7–8, 36, 53, 70
 of Holy Land, 36, 107, 272
 mappae mundi, 15
 See also Olaus Magnus, *Carta Marina*; Hereford Map; ilanot: as maps
Maragheh, Iran, 75, 80
mareh, 243, 245–49
marginalia, 8, 101, 103, 111–13, 116, 152, 226, 313, 350
Marseille, France, 303

mathematics, 75, 124, 177–78, 241, 315
Medici, Catherine de', 49
Medici, Don Giovanni de', 65
Mendes, David Franco, 251
menorot
 Hanukkah menorah, 233
 menorah and table motif, 18–20, *19*, *20*, 40, *41*, 49, 53, 67
Meirat 'einayim, 43
Merian, Mattheus, 145, *147*
 See also Tel Aviv: GFCT, MS NHB.382
Messas, Joseph, 303–4
Messiah, 165, 168–69, 237–38, 240, 242, 254–55
 See also messianic theology
messianic theology, 51, 168–69, 233–36, 237–38, 312, 315
 See also Messiah
Metatron (angel), 85, 302–3
Mezhbizh, 215
mezuzot, 35–6, 75, 291, 307–8
Michael (archangel), 81, 313
microscope, invention of, 177
miluim, 91, 155, 192
Mintz, Sharon Liberman, 240
Mirandola, Giovanni Pico della, *De hominis dignitate*, 47
Mishnah, 6, 71, 238, 247, 262, 263
 See also *Pirkei Mishnah*
misnagdic, 325–26
mnemonic, 7, 103, 106, 108, 165, 175, 226, 333
Modena, Italy, 65, 137–40, 196, 309
Modena, Leon, 309–10, 313
moḥin, 123, 132, 144
Molcho, Shlomo, 51, 98
Montpellier, David, 196–200
 See also New York: JTS, MS S436
Moravia, 225, 226
More, Henry, 128, 135, 319
Morocco, 184
 See also Fez
Moscow, Russia
 RSL, MS Guenzburg 53, *121*, 243
 RSL, MS Guenzburg 543, 181–83, *182*, 187, 257
 RSL, MS Guenzburg 82, 20
Moses (Moschides), Felix Gabriel ben, *167*, 168
Moses (prophet), 18, 55, 102, 196, 198, 275
Moshkat, Isaiah, 309
Mount Meron, Israel, 89

Mount of Olives, 254, 256
Munich, Germany
 BSB, ESlg/P.o.lat.259#Beibd.1, *178*
 BSB, Cod.hebr. 449, *130*, *133*, 130–35, 137, 162, 177
 BSB, Cod.hebr. 450, 226–27, gatefold following p. 226, *230*, *232*, *237*, *238*, 329
 BSB, Cod.hebr. 451, 227, *228*, *229*
 BSB, Cod.hebr.119, 40–43, *41*, 46–47
 BSB, Hbks/F 118 za (Adrichem, Christian van, *Theatrum Terrae Sanctae et Biblicarum historiarum*), 107–8
 BSB, Res/Paed.th.670 (Giordano Bruno, *De umbris idearum*), *106*
Murdoch, John E., 241
Muskat, Isaiah, 322–25
mysticism, Jewish, 1, 7

Nachmanides (Moses ben Naḥman), 24
 Commentary on the Pentateuch, 17–18
 Torat ha-adam, 18–21
Nadav, Yael, 253
names
 sefirotic, 9–10, 17, 21, 23, 32, 34, 37–38, 46, 49, 60, 67, 81–82, 131, 134, 292 (see also *Ilan of Expanded Names*; *miluim*; Tel Aviv: GFC, MS GR.011.012; Tel Aviv: GFCT, NHB.136
 of God, 25, 43, 49, 71, 102–3, 117, 153–55, 157, 164, 198, 229, 236, 247, 287, 302–3, 354, 362 (see also Tetragrammaton)
Nathan of Gaza, 233–37, *236*, 253–55, 285, 287–89
 "Discourse of the Circles," *288*
 Drush ha-teninim, 253–54 (see also Tel Aviv: GFCT, 117.011.055)
necromancy, 192
nekudim, 91, 94, 95, 122, 142, 247, 268
Neo-Platonism, 58, 70, 128
 See also More, Henry
neshama, 125
New Christians. See *conversos*
New York
 COL General MS 247, 297–99, *300*, *301*, 302–3
 COL MS X 893 K 11 (Vital, Ḥayyim: *Drush Adam Kadmon*), 153, *154*
 COL MS X 893 V 837, 92 (see also Vital, Ḥayyim: *Mevo she'arim* [*Toldot Adam*])
 Columbia University Rare Book & Manuscript Library, MS X893 C81, 33, 187–89, *188*
 JTS, MS 1985 (Vital, Ḥayyim: *Sefer ha-drushim*), 94
 JTS, MS 1996 (Jacob Ẓemaḥ, *Kol be-Ramah*), 117–18
 JTS, MS 2177 (Moses ibn Ẓur, *Me'erat sdeh ha-makhpelah*), 184
 JTS, MS K103, 245–49, *246*
 JTS, MS K106, 243–45, *244*
 JTS, MS S435, 306
 JTS, MS S436, 197, *199*
 Library of Agudas Chasidei Chabad, Megillah 4902 ל, 202–4, *203*, 206–7, *209*, 325
Newton, Isaac, 5, 75, 168
Nezaḥ, 23, 29–30, 87, 122, 132, 243
Nukba, 91, 125, 145, 179, 268, 281, 314, 318, 341
 See also *Malkhut*
Nürnberg, Germany, 137

Okeanos, 183, 187
Olaus Magnus, *Carta Marina*, 59, *60*
onion skin, as metaphor for structure of the cosmos, 13, 22, 95, 253–54, 262
Oppenheim, David, 193–94
Ottoman empire, 233
Oxford, England
 BL, MS Hunt. Add. D. (*Magnificent Parchment*), 58–62, gatefold following p. 60, 65, *61*, *62*, *63*, 67, 72, 79, 131, 210
 BL, MS Hunt. Add. E. (*Great Parchment*), 48, 49–51, 53, 79, 153 (see also Hepburn, James: *Great Parchment*)
 BL, MS Mich. 134, 242
 BL, MS Michael 620, 159–61
 BL, MS Michael 88, 229
 BL, MS Opp. 128, 94
 BL, MS Opp. 458, 156–58, *157*
 BL, MS Opp. 551, 156
 BL, MS Opp. Add. Fol. 32, 190
 BL, MS Reggio 24, 78, 79–80
 BL, Opp. MS 456 (Azriel of Krotoszyn, *Klalut ve-pratut ha-hishtalshelut*), 148–51, *151*

Paḥad. See *Gevurah*
palmistry. See chiromancy
Panigel, Elijah Moshe, 355–56

Panoply Tree, 161–69, *162*, *163*, 251, 272, 312
 See also Berlin: Berlin State Library, MS or.fol.130, *3*
parchment, 1, 7, 30–31, 34–35, 37, 39, 40, 43, 59, 75, 127, 168, 201–4, 307, 333, 335
 See also *Magnificent Parchment*; rotuli; scrolls; *yeri'ot*
Paris, France
 BnF, MS hébr. 763, 10, *11*, 25, 46
 Bnf, MS hébr. 819, *19*
 Bnf, MS hébr. 857, *31*
 BnF, MS hébr. 876, *38*
Parma, Italy
 BP, Cod. Parm. 3547 (Vital, Ḥayyim: *Oẓrot Ḥayyim*), *181*
 BP, Cod. Parm. MS 2784, 10–13, *12*, *13*, 22, 46
parsah, 142, 151, 204, 207–9
 See also "requires further consideration" gloss
parzufim, 91, 95–97, *96*, 116–23, 125, 131–34, 142–44, 145–6, 152, 155, 157, 164, 179, *180*, 183, 197–98, 202, 207, 211, 223, 238–39, 241, 243–47, 254, 263, 268, 271, 273, 282, 313–18, 334, 341, 351–52
 sub-*parzufim*, 125, 143, 243 (see also *Jacob*; *Leah*; *Rachel*)
 ilan-ha-parzufim, 131
 See also *Abba*; *Arikh Anpin*; *Imma*; *Nukba*; *Ze'ir Anpin*
Pascal, Blaise, 176
pedagogy (in ilanot), 7, 126, 209, 226, 277–79, 317, 318–19, 325
Pentateuch, 297, 304
 See also Torah
Penzieri, Efraim, edited version of Vital, Ḥayyim: *Sefer ha-drushim*, *96*, 261
peot, 131–32
Perlhefter, Behr Eibeschütz, 137–40, 243
 Beer sheva, 140
 copy of Poppers, *Ilan of Adam Kadmon and the Enrobings*, 137, *138–39*
phylacteries, 36, 291
 See also *tefillin*
Pires, Diego. See Molcho, Shlomo
pirkei ha-ẓelem, 143, 221, 283, *221*, *283*
 See also Tel Aviv: GFCT, NHB.136
Pirkei Mishnah, 247
Pisa, Isaac de, 65
pitaron, 243, 245, 249

Poland, 226, 266
 See also Cracow; Warsaw
Poppers, Meir, 93, 110, 123–26, 127, 128, 152–53, 171, 193, 201–4, 208, 223–25, 283, 334
 '*Eẓ Ḥayyim* (edited corpus of Ḥayyim Vital), 111, 118, 122–23, 130, 144, 145, *160*, 190–91, 196, 223 (see also Prague: Jewish Museum, MS 69)
 Derekh 'eẓ Ḥayyim, 193, 266
 Great Tree of R. Meir Poppers, 170, 207, 223, 226, 321–32, 334 (see also Tel Aviv: GFCT, MS 028.011.001)
 Ilan of Adam Kadmon and the Enrobings, 135–144, *136*, *138–39*, *141*, *142*, *143*, 145–52, 173, 178, 208, 209, 227, 247, 321, 329 (see also Tel Aviv: GFCT, MS 028.012.015)
 Pri 'eẓ Ḥayyim, 192, 266
Porphyrian trees. See trees: Tree of Porphyry
Portugal, 97–99, 102, 103, 108
 exploration by, 145
 Portuguese community in Amsterdam, 249, 253
 See also conversos; Lisbon
Postel, Guillaume, 1
Prague, 137–40, 197
 Jewish Museum, MS 69 (Vital, Ḥayyim: '*Eẓ Ḥayyim*, Poppers edition), 159–61, *160*, *161*, 191
 Jewish Museum, MS 69, *191*
Princeton, New Jersey, Princeton University Art Museum, MS Y1937-266, 4, *4–5*
Pseudo-Aristotle, *Liber de causis*, 48

Rachel (sub-*parzuf*), 125, 143, 243, 352
Ramat Gan, Bar-Ilan University Library, Rare Books Collection, Moussaieff MS 1095 (Vital, Ḥayyim: *Mevo she'arim* [*Toldot Adam*]), 112, *113*, 114–15
Ramḥal. See Luzzatto, Moses Ḥayyim
Rappoport, Shloyme Zanvl. See An-Sky, S.
Rashi script, 218, 221
Rashi (Shlomo Yiẓḥaki), 272, 304, 314, 335
 See also Rashi script
Raziel ha-malakh, 293, 309
Recanati, Menaḥem, 29, 43, 67
Reisha de-lo ityada, 125, 131, 142–43, 227–29
reki'im, 85
"requires further consideration" gloss, 204, 209, 211, 221, 229, 354
Riccius, Paulus, *Portae Lucis*, 25, 26, 27

rimonim, 233
Romano, Judah, 58
 Hebrew translation of *Liber de causis*, 58, 65
Rome, Italy, Historical Archive of the Jewish Community of Rome "Giancarlo Spizzichino," MS ASCER—Aa 2, 74
Roshei prakim mi-ma'aseh merkavah, 71
rotuli, 35–36, 75, 97, 127, 135, 201–2, 249, 318, 326
 See also amulets
Rovigo, Abraham, 137
Russia, 214, 326, 328
 See also Moscow; St. Petersburg

Sabbateanism, 137, 140, 236–40, 243, 253, 255, 287–89
 See also Zevi, Shabtai
Sacrobosco, Johannes de, 168
Safed, Israel, 7, 89, 108, 109, 111, 204, 256, 266, 337
Safrai, Uri, 364
Salonica (Thessaloniki), 97, 98, 108, 256
Samael, 55, 56, 165
Ṣarfati, Abraham, 51–58, 52, 54, 56
 See also Florence, Biblioteca Medicea Laurenziana, MS Plut.44.18; Ḥalfan, Elijah Menaḥem
Ṣarfati, Reuben, 30, 47
 Perush ha-yeri'ah ha-gedolah (Commentary on the Great Parchment), 31, 49, 58
 Perush ha-yeri'ah ha-ketanah (Commentary on the Small Parchment), 31, 39
 Perush zulati, 38, 55
 Sha'ar ha-shamayim, 58
Sartorius, Johann Christoph, 140–41, 156, 161, 173–74, 178, 319
 Ilan of Expanded Names, 152–55, 153 (*see also* Tel Aviv: GFCT, NHB.136)
Saruq (Sarug), Israel, 170–73, 178, 206, 215, 226, 257, 266–68, 274, 275–76, 280, 281, 289, 315
 followers of, 240
Sasson, Abraham, *Kol sasson*, 310–15, 311
 See also Tel Aviv: GFC, B.2521
Schneerson, Yosef Yitzchak, 202–4
Scholem, Gershom, 58, 60, 124, 239, 240, 281, 309
 Major Trends in Jewish Mysticism, 1
Schrödinger, Erwin, 124
Schütz, Johann Jakob, 319
Schwager, Lipa, and David Fränkel, bookstore in Husyatin (Husiatyn, Ukraine), 309

science, 321, 335
 medieval, 5, 7, 9, 251, 271
 occult, 221, 334 (*see also* Agrippa, Heinrich Cornelius: *De Occulta Philosophia*; astrology; grimoire)
 Renaissance, 102, 108–9, 166–68 (*see also* Copernicus; Hook, Robert; microscope; Newton, Isaac; Pascale, Blaise)
 See also astronomy; Darwin, Charles
Scroll of Esther, 35, 168, 304
scrolls. *See rotuli*
Sefer ha-zinorot, 32
Sefer Torah, 35
Sefer yezirah, 6, 10, 13, 15–16, 43, 46, 67, 134, 161, 171, 189–92, 283, 338–41
 and the Hebrew alphabet, 15, 58, 189
sefirot, 1, 2, 5, 25, 43, 58, 155, 193, 197, 236, 266, 281, 312, 333
 configured as wagon wheel, 10–12, *11*
 definition and description, 6
 graphic representation of, 21, 28–29, 55, 88, 122
 "heraldic" view of, 23
 shattered, 91, 94–95, 125, 262, 264, 281–82, 285, 317
 suckling of, 24, 245, 272
 triangulation of, 21, 29, 46, 314
 See also Abba; Ahava; Arikh Anpin; Binah; "Commentaries on the Ten Sefirot"; *Din*; *Gedulah*; *Gevurah*; *Ḥesed*; *Hod*; *Ḥokhma*; ilanot: medallions of; *Imma*; *Keter*; *Malkhut*; names: sefirotic; *nekudim*; *Nezaḥ*; *Nukba*; *Paḥad*; *Tiferet*; *Yesod*; Ze'ir Anpin
Sejera, Nissim, 306
Sephardim, 82, 196, 334, 356
 script of, 79, 218, 223
serpent, biblical, 54–55
Shaddai, 238, 393
Shandukh, Sasson ben Mordekhai, 80, 192, 225, 262–89, 328, 337, 355–56
 Gates of Eden Ilan, 284, 285–90, 286, 288, 289. (*see also* Tel Aviv: GFCT, MS 028.012.005)
 Tofes ilana de-ḥayei, 274–79 (*see also* Tel Aviv: GFC, MS 028.011.008)
 See also Tel Aviv: GFC, MS 028.011.007; Tel Aviv: GFC, MS IQ.011.011; Tel Aviv: GFCT, MS 028.012.003; Tel Aviv: GFC, MS 028.012.009
Shas Party, 334
 election amulet, 334–35
shefa, 7, 71

Shekhinah, 24, 274–75, 314
Shem 'ayin bet, 67
Shem Tov, Shem Tov ibn, commentary on the sefirot, 17, 28, 29, 118
　　See also Jerusalem: NLI, MS Heb. 8°404
shemot ha-middot, 37–39
　　See also Shem 'ayin bet; shemot ne'elamim
shemot ne'elamim, 67
shevirat ha-kelim, 91
　　See also sefirot: shattered
Shi'ur komah, 53, 193, 239, 393
Shiviti, 292–93, 308
Shma, 117
shofar, 338
Shuaib, Joshua ibn, 18
siddur, 117
Sidkani, Judah, 75
sin, human, 125
Sinai, 18, 97
Siprut de Gabay, Joseph, 225, 249, 251–55, 289
　　and father, Abraham, 251–3
　　Tree of Circular and Linear Emanations, 249–55, 250
　　Wedding Riddle, 251, 252
Sitra Aḥra, 56
Small Parchment, 53
　　See also Ṣarfati, Reuben: Commentary on the Small Parchment
Smith, David Chaim, 341
　　Lightning Flash of Alef, 341, 342–43
Soarez, Cyprian, De Arte Rhetorica, 103
Soffer, Jacob, 303–3
Solomon, King, 100, 240
　　palanquin of (Apiryon Shlomo), 310, 313
　　See also Clavicula Salomonis
Son of David. See Messiah
Sonne, Isaiah, 98, 101
Special Cherub, 53, 55, 70
spheres
　　of Adam Kadmon, 253
　　of brilliance (kadur ha-Tehiru), 281
　　cosmic (astronomical; celestial), 12–13, 40, 70, 85, 210, 223, 261, 272 (see also zodiac)
　　planetary, 10, 68, 164, 187, 198, 210, 225, 329
　　primordial (originary), 255, 289
　　See also circles; Tehiru: sphere of
St. Petersburg, Russia, Russian Museum of Ethnography, inv. no. 6396–101, 214–15, 257, 325

Stallybrass, Peter, 35
Star of David, 293
Steinschneider, Moritz, 168
"Steps to Infinity" motif, 241, 242
Sulzbach, Germany, 128, 137, 227, 318–18
　　See also Christian August
synecdoche, 1, 30

Tabernacle, 8, 18–21, 262
　　See also Ark of the Covenant
tabur, 122
Talmud, 10, 30, 219, 238
　　Babylonian, 71
　　　　four sages of the, 71–72
tav, floating or hanging, 175–76, 219
tefillin, 75, 98, 291, 307–8
　　See also phylacteries
Tehiru, 124, 176, 254–55, 287, 288–89
　　sphere of, 281
Tel Aviv, Israel
　　GFC, B.2521, 311
　　GFC, B.2545, 310
　　GFC, B.265, 309, 321, 325–32, 327
　　GFC, B.433A, 195, 267
　　GFC, MS 027.010.009, 292, 293, 303
　　GFC, MS 028, 012.024, 249–55, 250, 254, 355
　　GFC, MS 028.011.007, 265–69, 267, 268, 356, 268
　　GFC, MS 028.011.007, 355–56
　　GFC, MS 028.011.008 (Tofes ilana de-ḥayei), 266–72, 267, 268, 269, 270, 271, 272, 274–76, 274, 276, 285, 287, 355
　　GFC, MS 028.011.009 ("The Hammerschlag Poppers"), 240–43, gatefold following p. 240; 241, 349
　　GFC, MS 028.012.009, 265, 267, 273–74, 355
　　GFC, MS 028.012.025, 187, 221–23, 222, 351
　　GFC, MS 028.012.026, 352, 353
　　GFC, MS 028.012.026, 353–54
　　GFC, MS GR.011.012, 158–61, 159, 202
　　GFC, MS IQ.011.011, 266, 276–79, 277, 306, 355
　　GFCT, 027.011.214, 308
　　GFCT, B.2493, 315–17, 316
　　GFCT, B.66 (Amsterdam Haggadah), 147
　　GFCT, MS 027.012.048, 293
　　GFCT, MS 028.010.001, 354–55
　　GFCT, MS 028.011.001, 309, 318, 321–25, 323, 324, 326, 327, 329–31, 330

Tel Aviv, Israel (*continued*)
 GFCT, MS 028.011.003, 223–25, *224*, *324*, *325*, *328*, *349*
 GFCT, MS 028.011.003, 349–50
 GFCT, MS 028.011.004, *186*, 257–59, *258*, *259*, *354*
 GFCT, MS 028.011.005, 259–61, *260*, *261*, *354*
 GFCT, MS 028.011.006, 208, 210–11, *gatefold following p. 210*
 GFCT, MS 028.012.001, 290, *291*, 305, *358*, *359*, *361*
 GFCT, MS 028.012.002, 261–63, *262*, *263*, 269, 295, 296, *354*, *356*
 GFCT, MS 028.012.003, 278, *279*, *280*, 281, *282*, 285, *287*, 325, *355*
 GFCT, MS 028.012.004, *359*
 GFCT, MS 028.012.005 (*Gates of Eden Ilan*), 204, *205*, 283–90, *284*, *286*, *288*, *289*, *356*
 GFCT, MS 028.012.006, 295, *296*, 304–6, *305*, *356*, *357*
 GFCT, MS 028.012.007, *351*
 GFCT, MS 028.012.008, 295, *296*, 356–57
 GFCT, MS 028.012.010, *148*, 350–51
 GFCT, MS 028.012.011, 352–54, *353*
 GFCT, MS 028.012.012, *gatefold following p. 210*, 220, *221*, 285, *351*
 GFCT, MS 028.012.013, 295, *297*, *358*–*59*
 GFCT, MS 028.012.014, *359*
 GFCT, MS 028.012.015 (Meir Poppers, *Ilan of Adam Kadmon and the Enrobings*), 140–44, *141*, *142*, *143*, *152*, *349*
 GFCT, MS 028.012.016, 211–14, *212*, *213*, 230, *231*, 243, *297*–*99*, *300*, *301*, *352*
 GFCT, MS 028.012.017, 290, *291*, 295, *359*–*60*
 GFCT, MS 028.012.018, 294, 295, *360*–*61*
 GFCT, MS 028.012.019, *360*–*61*
 GFCT, MS 028.012.020, 297, *298*, *361*
 GFCT, MS 028.012.021, 297–99, *298*, *361*–*62*
 GFCT, MS 028.012.022, 211, *212*, *352*, *358*, *362*
 GFCT, MS 028.012.023, *352*
 GFCT, MS 083.011.002, *2*, *3*
 GFCT, MS 083.011.003, *90*, *155*
 GFCT, MS 083.012.001, 73–74, *349*
 GFCT, MS 117.011.055, 235, *236*
 GFCT, MS B.52, *239*
 GFCT, MS EE.011.021, 189–93, *191*
 GFCT, MS KU.011.009, 80–82, *81*, *82*, *349*
 GFCT, MS NHB.382, *147*
 GFCT, MS YM.011.035 (Isaac ben Abraham, *Rekhev Elohim*), *84*, *349*
 GFCT, NHB.136 (Christian Knorr von Rosenroth, *Kabbala Denudata*), 128–78, *129*, *133*, *136*, *144*, *158*, *169*, *170*, *171*, *172*, 229, *236*, 251, 275, 281, 318–21, *318*, *320* (see also *Ilan of Expanded Names*)

Temerles Tree, 187–93, *188*, 208, 271, 283
Temerles, Eliezer, 193
Temerles, Jacob, 159, 187
 Commentary on the Pathways of the Letters, 283
 disambiguation, 192
 Sifra de-zniyuta de-Yaakov, 189, *193*
 Perush mahalakh ha-otiyot, 189
 See also *Temerles Tree*
Tetragrammaton, 25, 46, 49–51, 56, 81, *90*, *91*, 108, 125, 142, 155, 156, 174, 236–38, *237*, 293, 314
 "Tetragrammaton of Eyes," 281
 See also *Tiferet*
Thirteen Enhancements of the Beard, 193–96, *194*, *195*, 208, 210, 245, 266, 270–71, 314
 See also Graf, Moses: *Va-yakhel Moshe*; Oxford: BL, MS Opp. 105; Tel Aviv: GFC, B.433A; Vital, Ḥayyim: *Derekh ʿez Ḥayyim*
Thirty-Two Paths of Wisdom, 164, 189, *190*, 198, 261
 See also Oxford: BL, MS Opp. Add. Fol. 32; Tel Aviv: GFCT, MS 028.011.005
Thomassin, Philippe, 49
Throne of Glory, 9, 49, 51, 70, 73
tibbura de-liba, 173, 179
Tiferet, 10, 25, 28, 30, 46, 56, 58, 60, 81, 82, 87, 122, 131–32, 134, 152, 155, 189, 236, 239, 272
 See also Tetragrammaton; *Zeʿir Anpin*
tikkun, 7, 91, 126, 131, 193, 206, 226, 238, 263, 317, 350–51
tikkunin (enhancements), 131, 132, 196
 See also Thirteen Enhancements of the Beard
tofes, 274–75
Torah shield (Tel Aviv: GFC), 233
Torah, 100, 102, 240, 263–4, 275, 314
 Terumah, 18, 264
 Torah scrolls, 75, 279, 303, 304, 306, 307–8, 350
 See also Pentateuch
Tree of Holiness, 192, 278, *279*, 279–87, 288
 See also Holy Tree
Tree of the [Four] Worlds, 196–200, 208, 210, 271, 283, 321
trees
 All-Tree, 16-17, 28, 34, 341 (see also *Bahir*)
 as cultural motif, 9–10
 as diagrammatic device for sefirot, 2, 5, 24–25, 97, 118, 122, 131, 134

"tree of life," 2, 274–75
 as expression of the body, 9–10, 29, 132
 genealogical, 4–5, 6, 28
 in the Garden of Eden, 10, 54–55
 as expression of God, 9–10, 16–17, 70, 72, 93
 Tree of Porphyry, 2–4, 5, 17, 25
 Tree of Jesse, 4–5, 6
 See also Great Tree; Ilan ha-ḥokhmah; Panoply Tree; Tree of Holiness; Trees of the Worlds
Treister, Suzanne, 341
 Historical Diagrams / From MKULTRA via the Counterculture to Technogaianism, 344

Ukraine, 185, 189
 See also Mezhbizh; Schwager, Lipa, and David Fränkel, bookstore in Husyatin (Husiatyn, Ukraine)

Valabreque, Sandra, 336–37
 Up in the Palm Tree, 336–37
Vatican, 49
 BAV, MS Vat.ebr 456, 43, 44, 43–49, 53
 BAV, MS Vat.ebr.530 III, 42, 43, 44; as "letter," 57–58
 BAV MS Vat.ebr. 598 (copy of *Magnificent Parchment*), 65, 73
Venice, 51, 53, 56, 59, 166, 245, 249
Vermayen, Jan, crown of Rudolf II, 233
Vienna, 156, 233
 Jewish expulsion from, 233
 Osterreichische Nationalbibliothek, *31.J.117 Titelblatt (João de Barros, *Ropicapnefma*), 101
Vilna Gaon, 219, 325–26, 328
Virtues and Vices, 5, 56
Vital, Ḥayyim, 34, 89, 99, 103, 110, 122–26, 131, 164, 170–71, 200, 206, 214, 227, 236, 251, 256–57, 263, 266–68, 275, 277, 280, 289, 315, 350, 357
 Adam yashar, 99, 124, 210, 261, 354
 Derekh 'ez Ḥayyim, 193–96, 194 (see also Oxford: BL, MS Opp. 105)
 dream of, 97
 Drush Adam Kadmon, 154
 'Ez Ḥayyim, 93, 110–11, 144, 145, 156, 158–61, 179, 267, 329, 331 (see also Prague: Jewish Museum, MS 69)
 Kehilat Ya'akov, 99, 144
 Mevo she'arim [Toldot Adam], 92, 110–17, 112, 113, 114–15, 179, 275 (see also Jerusalem: NLI, MS Heb. 28°8815; New York: COL MS X 893 V 837; Ramat Gan, Bar-Ilan University Library, Rare Books Collection, Moussaieff MS 1095)
 Ozrot Ḥayyim, 99, 110, 118, 120–21, 129, 130, 134, 137, 148–49, 152, 179–81, 183, 185, 238, 241, 242, 247, 256–57, 266
 Seder ha-azilut be-kizur muflag, 124, 143
 Sefer ha-drushim, 94, 261 (see also Jerusalem: NLI, MS Heb. 28°7991; Jerusalem: Rabbi Yakov Moshe Hillel Library, MS 572; New York: JTS, MS 1985)
 Sefer ha-ḥezyonot, 97
 Sha'ar ha-gilgulim, 254
 Sha'ar ruaḥ ha-kodesh, 117
Vital, Samuel, 93, 97, 103, 110, 123, 170, 266, 289
 Eight Gates, 111
 See also *Grand Circles of Vital*
Viterbo, Cardinal Egidio da, 49
volvelles, 32, 33, 34, 106, 164

Wagenseil, Johann Christoph, 137–40
Wanneh, Isaac ben Abraham, 82–88, 91, 197
 Rekhev Elohim, 82–88, 84, 85, 86, 87, 88 (see also Tel Aviv: GFCT, MS YM.011.035)
 Sha'ar ha-shamayim, 82
 Tiklāl, 82
 gloss on Meir ibn Gabbai, *Tola'at Ya'akov*, 82
Warsaw, Poland, 170, 309, 318, 321–25, 326, 328, 329
Wolfenbüttel, Germany, Herzog August Bibliothek, Cod. Guelf. 800 Helmst, 4
Wolfson, Elliot R., *Through a Speculum That Shines: Vision and Imagination in Medieval Jewish Mysticism*, 1, 7
World of *Tohu*, 264, 350
Worms, Germany, 189

Yates, Frances, 177
yeri'ot, 30–31, 37, 43, 127, 335
 See also parchment
Yerushalmi, Yosef Hayim, 145
Yesod, 25, 60, 87, 91, 122, 132, 134, 142, 155, 272, 313
 See also Ze'ir Anpin
Yezirah, 82, 83, 86, 87, 91, 125, 135, 155, 164, 179, 198, 223, 249, 254, 314, 317, 362
 See also Kabbalah: Four Worlds of
yiḥud, 46
Yisrael of Salanter, R., 326

Yitzchaki, Shlomo. *See* Rashi
Yoḥai, Shimon bar, 89, 147
yosher. *See Adam Kadmon*
yud
 descending (orphaned), 275–76, *276*, 279, 281–82 287
 thorn of, 25, 125, 155, 314

Zacuto, Moses, 118–22, 137–40, 151, 204, 226, 247, 256–57, 266, 334
 Ilan of *Arikh Anpin*, *120*
 copy of Vital, Ḥayyim: *Ozrot Ḥayyim*, 118, 120, 129, 130, 137, 148–49, 152, 256–57, 271
 copy of Jacob Ẓemaḥ, *Arikh and the Enrobings* ilan, *119*, 129–35, *129*, *130*, *133*, 137, 202, 208, 352 (*see also* Munich: BSB, Cod.hebr. 449; Tel Aviv: GFCT, NHB.136)
 concept of *solet nekiah* ("pure fine flour"), 215, 257, 264, 289, 263, 289
zaḥzaḥot. *See 'eser zaḥzaḥot*
Zakkai, Yoḥanan ben, *Masekhet sofrim*, 30
Ẓarfati, Reuben. *See* Ṣarfati, Reuben
Ze'ir Anpin, 91, 125, 132, 134, 143–44, 145, 179, 196, 209, 222–23, 238, 243, 251, 271–72, 281, 283, 313, 314, 317–18, 341
 zelem, 144, 314
 See also *pirkei ha-zelem*
Ẓemaḥ, Jacob, 97–122, 123–26, 135, 144, 145, 152–53, 200, 226, 243, 247–49, 251, 257, 261, 275, 279, 283, 315, 334
 Arikh and the Enrobings ilan (copy by Moses Zacuto), *119*, 129–35, *129*, *130*, *133*, 137, 202, 208 (*see also* Munich: BSB, Cod.hebr. 449; Tel Aviv: GFCT, NHB.136)
 edited work of Vital, Ḥayyim: *Ozrot Ḥayyim*, 99, 110, 118, 134, 137, 148–49, 183, 266 (*see also* Vital, Ḥayyim: *Ozrot Ḥayyim*)

'Edut be-Ya'akov, 99
 and gentile scholarship, 99–109 (*see also* Christianity: study of Kabbalah)
 Ilan of the Enrobings, *121*, 334
 ilanot of, 110, 116–22, 127, 128
 Kol be-Ramah (commentary on the *Idra rabba*), 117–18, 183–84, 247, 256 (*see also* London: BL, Add. MS 26997; New York: JTS, MS 1996)
 Mevo she'arim [*Toldot Adam*], 111, 179, 181, 183, 268–69, 275
 Tiferet Adam, 99, 101–9, *104–5* (*see also* Jerusalem: Benayahu Collection, MS K 109)
Ẓevi, Shabtai, 75, 233–40, *235*, 242–43, 253
 See also Tel Aviv: GFCT, MS 117.011.055
zimzum, 116, 124, 170, 171, 213, 285
zinorot. *See* ilanot: channels of
zodiac, 46, 60, 68–70, 71, 73, 189, 198, 210, 272
 See also Amsterdam: Ets Haim Bibliotheek, Livraria Montezinos, MS D 47 20; astrology; *Magnificent Parchment*: zodiac in
Zohar, 1–2, 17, 28, 29, 30, 75, 82, 87, 89, 91, 100–101, 131, 141, 173–74, 254, 269, 285, 319
 Idrot, 89, 91
 Idra rabba, 131, 147, 183, 196, 256, 263, 312–14
 Idra zuta, 269
 Sifra de-zni'uta, 189, 313–14
 Pikudei, 279
Ẓur, Moses ibn, 184, 256–57, 354
 Me'arat sdeh ha-makhpelah, 184–85, *184*, *185*, 256–57, 354 (*see also* New York: JTS, MS 2177)